summer of love

"Music has the power to transform people, and in doing so, it has the power to transform situations — some large and some small."

JOAN BAEZ

"No society can be expected to reevaluate its entire history, mythology, morality, and state of consciousness within a single generation."

THEODORE ROSZAK

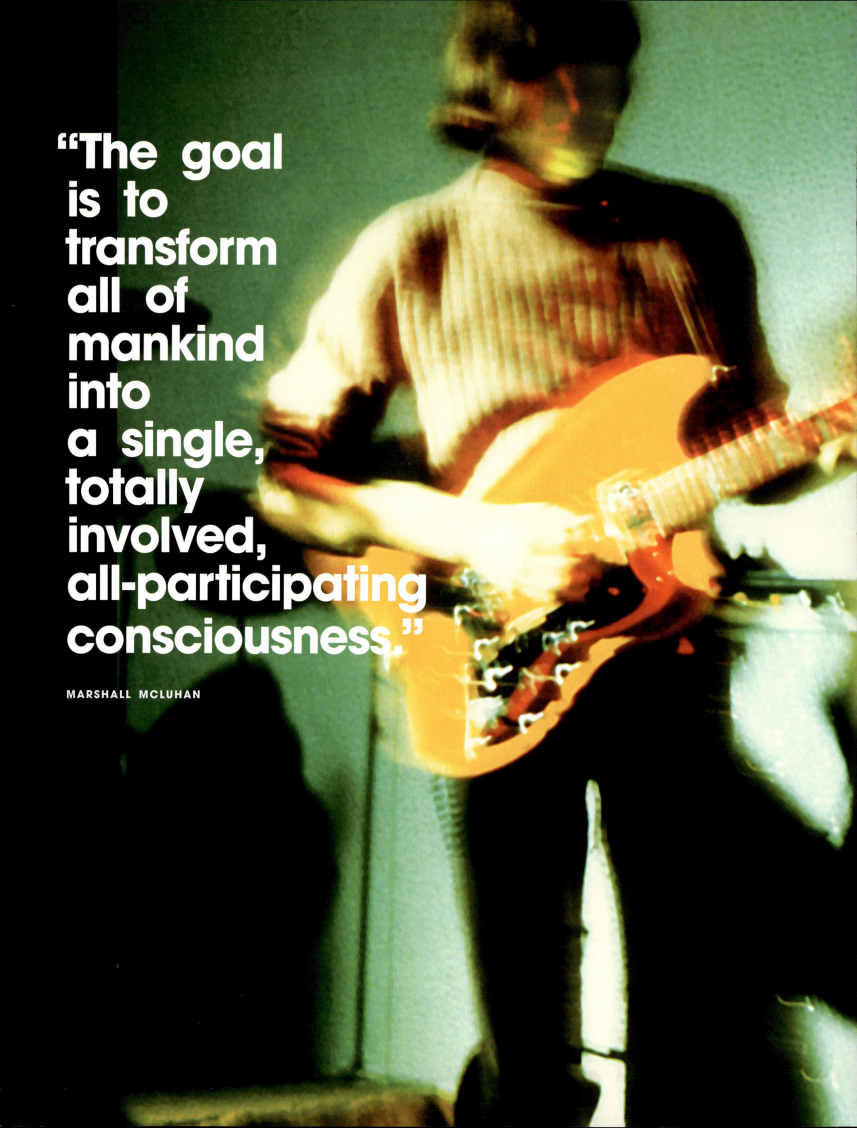

"The goal is to transform all of mankind into a single, totally involved, all-participating consciousness."

MARSHALL MCLUHAN

summer of love

art fashion and rock and roll

JILL D'ALESSANDRO
and
COLLEEN TERRY

with
VICTORIA BINDER
DENNIS MCNALLY
JOEL SELVIN
and
BEN VAN METER

Fine Arts Museums of San Francisco • de Young
University of California Press

12 foreword
14 map

essays

19 **not past at all**
DENNIS MCNALLY

31 **selling san francisco's sound**
COLLEEN TERRY

53 **stitching a new paradigm**
JILL D'ALESSANDRO

79 **if you're going to san francisco**
JOEL SELVIN

contents

catalogue
JILL D'ALESSANDRO and COLLEEN TERRY

- 91 (sittin' on) the dock of the bay
- 107 a trip without a ticket
- 117 the gathering of the tribes
- 131 love and haight
- 175 the poster shop
- 197 feed your head
- 231 the music never stopped
- 271 what are we fighting for?

and more

- 297 san francisco psychedelic rock posters
 VICTORIA BINDER
- 315 the sixties in san francisco
 BEN VAN METER

- 320 time line
- 325 selected bibliography
- 326 checklist
- 336 index
- 340 acknowledgments
- 342 picture credits
- 343 contributors

foreword

MAX HOLLEIN

DIRECTOR AND CEO
FINE ARTS MUSEUMS OF
SAN FRANCISCO

FIFTY YEARS AGO, San Francisco's Golden Gate Park and Haight-Ashbury district teemed with about 100,000 youth who arrived from around the country, drawn by a vibrant music scene and seeking like-minded individuals. Though their numbers overwhelmed the city's infrastructure, their energy and enthusiasm for social and political change found its way into every corner of the neighborhood, crowding traditional gathering places and spilling out into the streets.

Though the 1960s counterculture was an international phenomenon, the "Summer of Love," as it was proclaimed by the media, in San Francisco was unique, namely because it was as much a creative movement as it was a political one. Artists, designers, poets, writers, musicians, and performers developed their own visual language and new forms of communication, leaving a legacy of material culture that owes an aesthetic debt to the city of its origin.

The Summer of Love Experience: Art, Fashion, and Rock and Roll is one of the first projects that I involved myself in upon joining the Fine Arts Museums of San Francisco in 2016. With the institution's long-standing commitment to creative expression originating in the Bay Area, along with the de Young's central location in Golden Gate Park, I saw the museum as the ideal venue to organize a significant presentation of artistic material from this unique period in our city's history. Originally planned as a modest showcase for the Museums' significant collections of 1960s rock posters

and fashion, the exhibition has grown to include period photography, avant-garde films, dynamic light shows, and more. Together, these varied elements provide a glimpse into the multisensory experiences shared by members of San Francisco's counterculture in the years around the Summer of Love.

This presentation was conceived by Jill D'Alessandro, curator of costume and textile arts, and Colleen Terry, assistant curator of the Achenbach Foundation for Graphic Arts, who have together created an exhilarating exhibition filled with immersive environments that will be the cornerstone of a city-wide celebration of the fiftieth anniversary of the Summer of Love. Additional thanks go to Julian Cox, chief curator and founding curator of photography, for his work with the exhibition's photography and new media programs; associate paper conservator Victoria Binder, who has interviewed many of the poster artists and printers to conduct a thorough study of their technical processes; and historian Dennis McNally, music critic Joel Selvin, and filmmaker Ben Van Meter — their unique contributions to this volume add a richness and depth to the context in which the art from San Francisco's Summer of Love must rightly be understood.

Our donors have enabled us to make this special presentation possible. With deep gratitude we acknowledge an anonymous donor, in honor of Max Hollein; the Lisa and Douglas Goldman Fund; Diane B. Wilsey; Nion McEvoy and Leslie Berriman; the Ray and Dagmar Dolby Family Fund; Levi's; Yurie and Carl Pascarella; Edith and Joseph O. Tobin II; M. H. de Young Tobin II; and The Paul L. Wattis Foundation. Additional support has been provided by Nancy and Joachim Bechtle; Jack Calhoun and Trent Norris; Lauren Hall and David Hearth; Debbie and Blake Jorgensen; Fred Levin and Nancy Livingston, The Shenson Foundation, in memory of Ben and A. Jess Shenson; and Dorothy Saxe. We are also grateful to our many lenders who have graciously shared their works of art with us, in many cases bringing key objects from the time back together in the very area where such works were originally made and used. Artists of the period are among these lenders, and we hope that our show celebrates the enormous creativity that they have given to the Bay Area from the time of the Summer of Love to the present day. We are further appreciative of the Museums' Board of Trustees for its continuing advocacy of all of our programs. Alongside the exhibition curators, we acknowledge the staff at the Museums whose incredible dedication and hard work have brought this project to fruition.

Our desire is that this presentation will provide our audiences with a renewed appreciation for the Summer of Love and the qualities that it promoted, including peace, community, and idealism. We hope that, fifty years after this pivotal moment in history, our project stands both as an electrifying tribute to so many inspired artists and a hopeful reminder that significant changes in political and social mores are possible when people lift their voices and stand together.

central san francisco
ca. 1967

0 ½ 1 mile

◆ EVENT VENUES (1–11)
1. Avalon Ballroom: 1268 SUTTER
2. California Hall: 625 POLK
3. Carousel/Fillmore West: 10 SOUTH VAN NESS
4. Fillmore Auditorium: 1805 GEARY
5. Great Highway: 660 GREAT HIGHWAY
6. Light Sound Dimension: 1572 CALIFORNIA
7. Longshoremen's Hall: 400 NORTH POINT
8. The Matrix: 3138 FILLMORE
9. San Francisco State College: 1600 HOLLOWAY
10. Straight Theater: 1702 HAIGHT
11. Winterland Ballroom: 1725 STEINER

▲ CELEBRITY HOMES (12–20)
12. Albin Rooming House: 1090 PAGE
13. Big Brother and the Holding Company House: 625 POLK
14. Dog House: 1836 PINE
15. The Family Dog Commune: 2125 PINE
16. Grateful Dead house: 710 ASHBURY
17. Hells Angels' Headquarters: 719 ASHBURY
18. Jefferson Airplane Mansion: 2400 FULTON
19. Pine Commune: 2111 PINE
20. William Westerfeld House (aka the "Russian Embassy"): 1198 FULTON

■ ART AND PRINTING STUDIOS (21–30)
21. Bindweed Press: 141 NOE
22. California Litho Plate Co.: 335 5TH
23. Contact Printing: 523 CLAY
24. Double-H Press: 1790 HAIGHT
25. East Wind Printers: 643 MERCHANT
26. Mouse Studios: 74 HENRY
27. Neal, Stratford & Kerr: 1025 SANSOME
28. Rapid Reproductions: 3159 16TH
29. Tea Lautrec Lithography:
 A. 1005 SANSOME (1967–1968)
 B. 41 SHERIDAN (1968–1991)
30. West Coast Lithograph Co.: 523 CLAY

● SHOPS (31–54)
31. Anastasia's: 631 CLAY
32. The Bead Store: 417 CASTRO
33. The Blushing Peony: 1671–1673 HAIGHT
34. Changing Faces: 1398 GRANT
35. City Lights Bookstore: 261 COLUMBUS
36. East West Musical Instruments Co.: 1175 FOLSOM
37. Friedman Enterprises (later Gorilla Records): 1300 GRANT
38. House of Nile: 1435 GRANT
39. House of Richard: 1541 HAIGHT
40. In Gear: 1580 HAIGHT
41. Middle Earth: A. 852 STANYAN (1967–1969)
 B. 1452 HAIGHT (1968–1969) C. 1317 GRANT (1969–1980s)
42. Miki: 1315 GRANT
43. Mnasidika: 1510 HAIGHT
44. North Beach Leather: 611 VALLEJO
45. The Pacific Ocean Trading Company: 1711 HAIGHT
46. Passion Flower: 1332-1/2 GRANT
47. The Phoenix: 1377 HAIGHT
48. Print Mint/Calm Center: 1542 HAIGHT
49. Psychedelic Shop: 1535 HAIGHT
50. Third Hand Store: 1839 DIVISADERO
51. The Town Squire: 1318 POLK
52. Wild Colors: 1418 HAIGHT
53. Xanadu: 1764 HAIGHT
54. Yone: 478 UNION

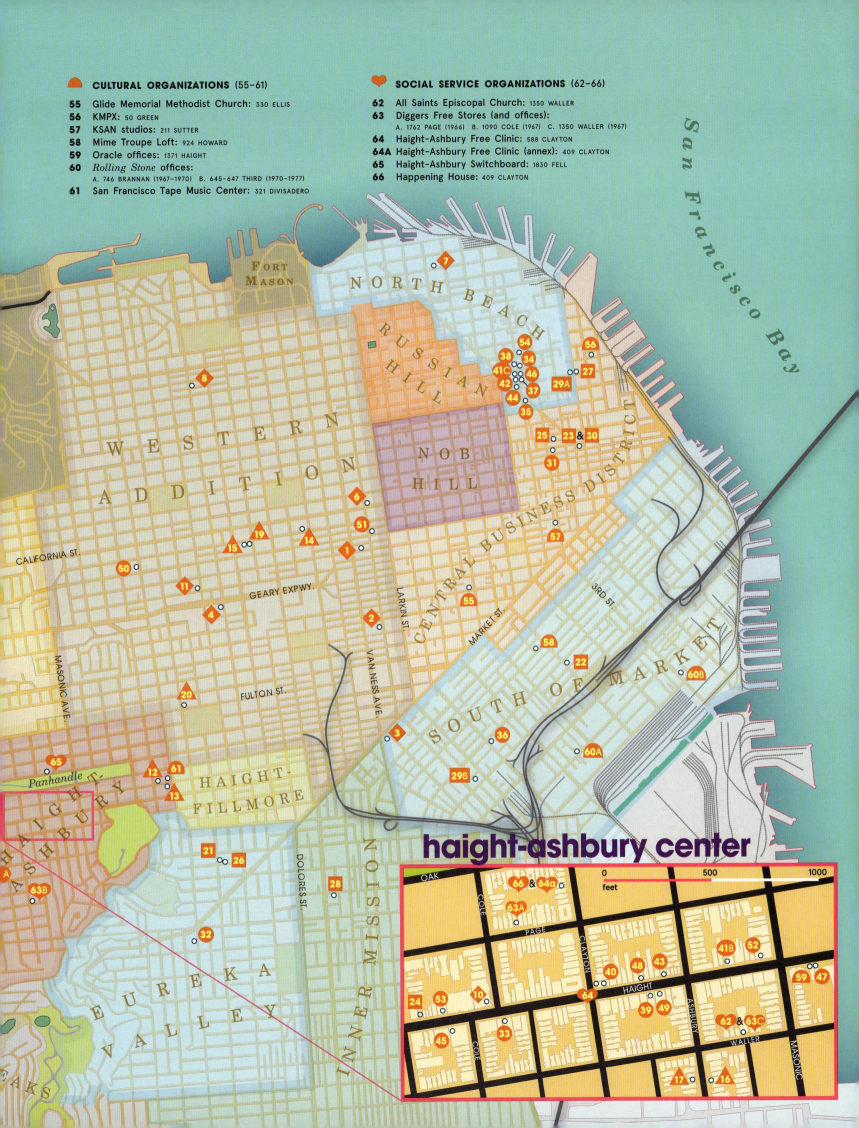

essays

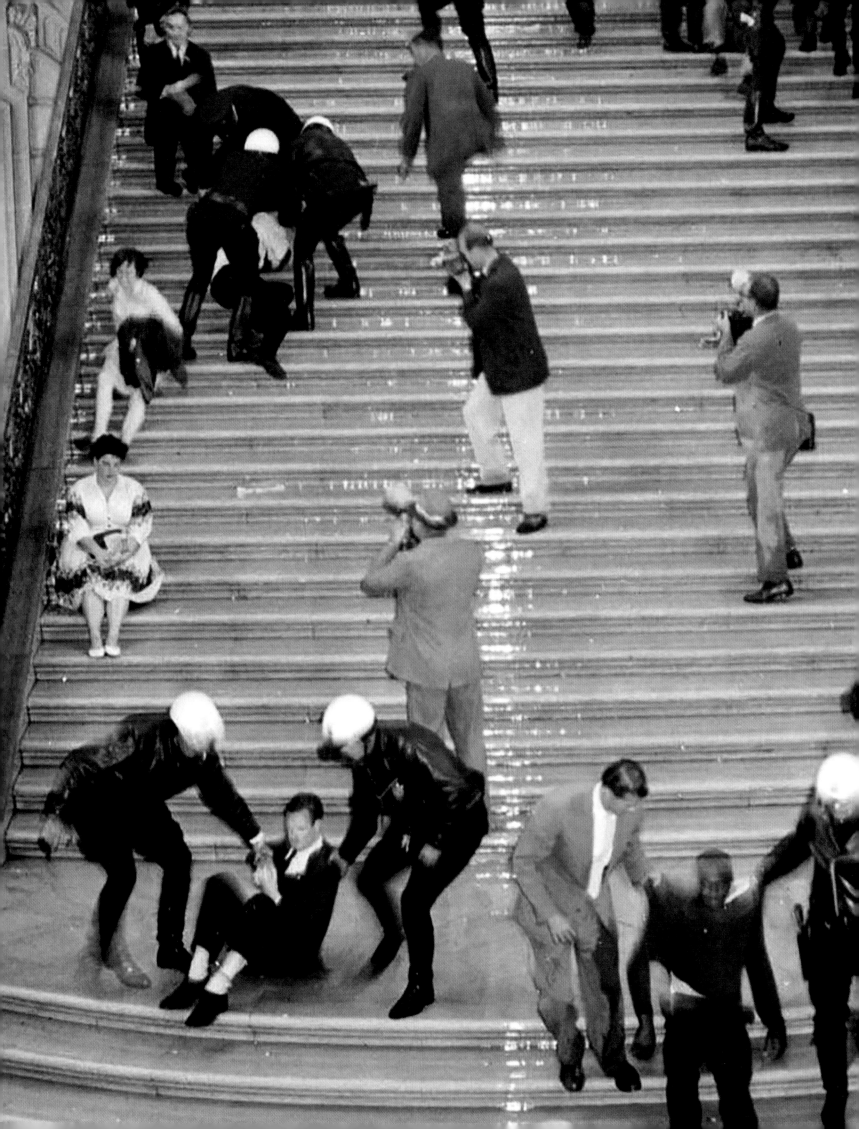

not past at all

the legacy of san francisco's summer of love

DENNIS MCNALLY

AS WILLIAM FAULKNER so wisely put it in another context, "The past isn't dead. It isn't even past." The Summer of Love era has never really left us; our current national culture wars are rooted in the profound intellectual challenges of the 1960s, which themselves go at least as far back as the 1840s, when bohemianism — art and the spiritual arrayed against bourgeois achievement — arose in Europe, and when Henry David Thoreau confronted American notions of its own exceptionalism, the Protestant work ethic, and humankind's relationship to nature. (And also when San Francisco began, not as an economic construct but as a refuge for maddened gold-seekers marginalized in their birth homes on the East Coast, in Chile, and in China.)

In fact, Thoreau's visionary philosophizing was so dramatically ahead of its time that it wasn't *until* the 1960s that a large part of his analysis came to be fully grasped by more than the smallest group of people. Although he utterly lacked the hedonist gene that permeated the sixties, the antimaterialist message of *Walden* and his other books is at the core of the sociocultural revolt that characterized the period.

The three decades preceding the 1960s brought a catastrophic depression, a war against

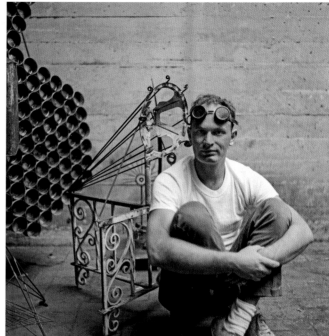

1
Allen Ginsberg, North Beach, San Francisco, ca. 1957. Photo by Gui Mayo (de Angulo).
PRIVATE COLLECTION

2
Wally Hedrick in his studio, 1958. Photo by Jerry Burchard.
PRIVATE COLLECTION, COURTESY OF THE ESTATE OF JERRY BURCHARD

manifest evil that was won by technology and large-scale social organization, and a postwar reaction to Depression-era radicalism that saw a runaway campaign of political repression called McCarthyism squelch all dissent. Finally, the '50s saw a blossoming prosperity substantially nurtured by postwar GI Bill benefits that boosted access to higher education and home ownership for an entire generation. The result was stasis. Affluence, yes, but at a cost: Don't make waves. Conform. Don't argue. Believe that the sitcom world of *Father Knows Best* — with no black people, no gay people, no alcoholism or incest or domestic violence — is real.

In October 1955, poet Allen Ginsberg (fig. 1) stood in front of a hundred fellow doubters at the Six Gallery at 3119 Fillmore Street in San Francisco and roared out a prophetic ode named "Howl" that warned that America had become Moloch, a soul-destroying monster. Published by fellow poet Lawrence Ferlinghetti's City Lights Press in 1956, "Howl" became notorious when Shigeyoshi "Shig" Murao, the clerk at City Lights Bookstore, was arrested and charged with obscenity for selling the poem to an undercover police officer in June of 1957; Ferlinghetti was also charged for publishing it. Their subsequent acquittal that October was a popular victory for anticensorship forces, and, of course, made it required reading for one and all. That same fall, Ginsberg's friend Jack Kerouac's newly published *On the Road*, which depicted young wanderers seeking a more profoundly felt life than contemporary America offered, was streaking up the best-seller lists. Suddenly, those who doubted the status quo had a name — the "Beats." (It would be San Francisco's own Herb Caen who would note the mutual far-out-ness of the Sputnik satellite and the Beats, and coin the phrase "Beatnik."[1])

"Howl" had lit a fuse and defined a mass of disaffected proto-artists who didn't buy in to mainstream values. Over the next decade in San Francisco, a series of youth-led political protests and a fascinating mélange of avant-garde arts groups catalyzed a mindset that would, with the addition of psychedelic drugs and rock and roll, culminate in the countercultural social phenomenon called "hippie" and various kindred events in the winter, spring, and summer of 1967.

Of course, the city had housed a bohemian community since the days of Mark Twain, but the Six Gallery signaled a new flowering, with North Beach at its center. Two of the other readers at the Six Gallery, Gary Snyder and Philip Whalen, had lived in North Beach, and City Lights was (and is) just across Broadway from the neighborhood. The pair brought to the Six Gallery reading a significant knowledge and deep connection to Asian thought and spirituality that was another San Francisco–centric divergence from mainstream America, at that time most notably manifested in the various activities of philosopher Alan Watts.

The Six Gallery had originally been the King Ubu Gallery, founded by the bohemian, if not Beat, poet Robert Duncan. One of Duncan's associates in the gallery was an artist and teacher at the California School of Fine Arts (since 1961 the San Francisco Art Institute) by the name of Wally Hedrick (fig. 2). From 1955 to 1965, Hedrick and his wife, Jay DeFeo (fig. 3) lived not far from the Six Gallery at 2322 Fillmore

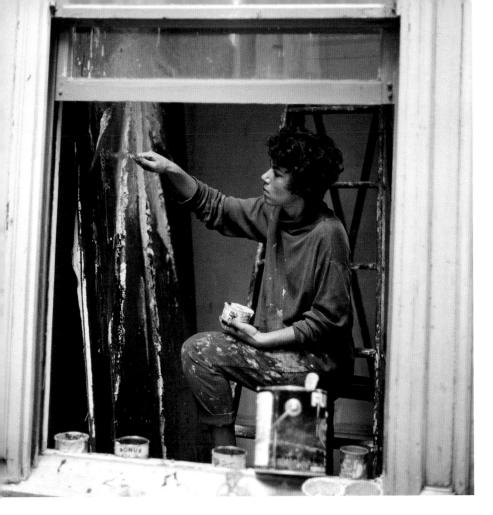
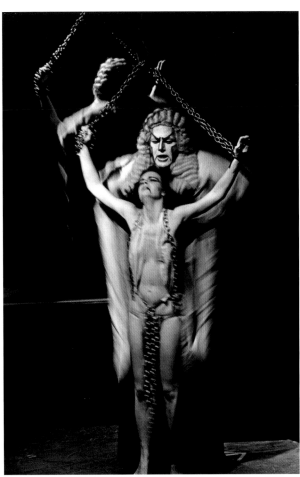

Street, which poet, sometime tenant, and Six Gallery reader Michael McClure dubbed "Painterland." Painterland was a four-flat building above a store that became a fundamental node in the post-Beat avant-garde art world of San Francisco, and over time also housed Bruce Conner, the influential artist, filmmaker, and cofounder of Canyon Cinema, and Dave Getz, an Art Institute student and later faculty member.

Getz would witness DeFeo's devotion to her masterpiece, a painting called *The Rose*, which over the eight years (1958–1966) of its painting — it would eventually weigh more than a ton — would eventually go beyond the contemporary mode of Abstract Expressionism into something more. "*The Rose* itself was something that really was, like, a psychedelic piece . . . it kind of heralded in some way the new consciousness [of the '60s]," Getz reflected. "And other people, I think, like Wally and Jay and Bruce Conner, saw it as the next thing. They wanted in some way to connect with it."[2]

A new consciousness was also burgeoning in the San Francisco theater world. In 1952, two San Francisco State University professors, Jules Irving and Herbert Blau, each married to gifted actresses, established the Actor's Workshop. They wanted to present "plays that will shock, disturb, remind, tease and infuriate our audiences," and they succeeded beyond their wildest dreams.[3] Interestingly, Blau had no background at all in theater, but soon he was writing program notes that made, he'd later write, "drama part of public discourse, a challenge to McCarthyism's lies and petty tyrannies."[4]

The Actor's Workshop stirred up the city's performing arts scene, lending it weight and seriousness. The company staged the US premiere of Harold Pinter's *The Birthday Party* (1957) and Bertolt Brecht's *Mother Courage* (1939), the West Coast premiere of Samuel Beckett's *Waiting for Godot* (1948/49) (including a legendary restaging at San Quentin Prison), and a production of Jean Genet's *The Balcony* (1957) so incendiary — Blau wrote of it that, "The reward of life is nightmare. But there is laughter at the gallows, and erections" — that the San Francisco Police Department took over the front row, although they never shut it down (fig. 4).[5]

An even more vivid piece of theater unfolded inside San Francisco's city hall (fig. 5). In May 1960, the House Un-American Activities Committee (HUAC), which had terrified and silenced dissenters ever since the end of World War II, came to San Francisco to hold hearings. Students from the University of California, Berkeley and SF State crowded into city hall to attend them, but the

3
Jay DeFeo painting *The Rose* (1958–1966) in her studio at 2322 Fillmore Street in San Francisco, ca. 1960. Photo by Jerry Burchard.
PRIVATE COLLECTION, COURTESY OF THE ESTATE OF JERRY BURCHARD

4
Two actors performing the roles of the judge and the judged in Jean Genet's play *The Balcony* (1957) performed at the Actor's Workshop, San Francisco, 1962. Photo by Hank Kranzler.
PRIVATE COLLECTION, COURTESY OF THE ESTATE OF HANK KRANZLER

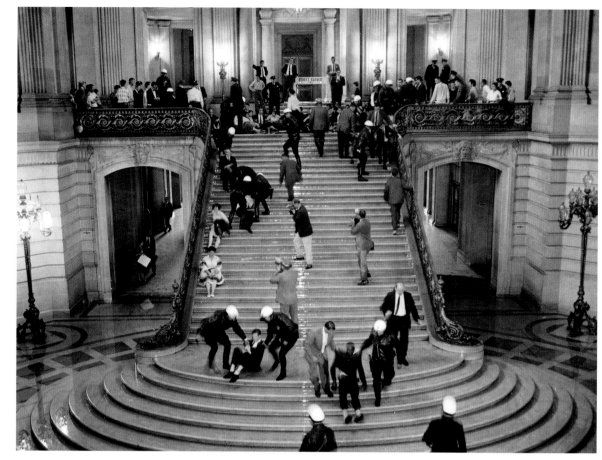

5
Police attack protesters of the House Un-American Activities Committee at San Francisco's city hall, May 13, 1960. Photo by Bob Campbell.
COURTESY OF THE
SAN FRANCISCO CHRONICLE

6
San Francisco Tape Music Center founders and composers (left to right: Tony Martin, William Maginnis, Ramon Sender, Morton Subotnick, and Pauline Oliveros), ca. 1962–1964.
PRIVATE COLLECTION,
COURTESY OF THE SAN FRANCISCO TAPE MUSIC CENTER

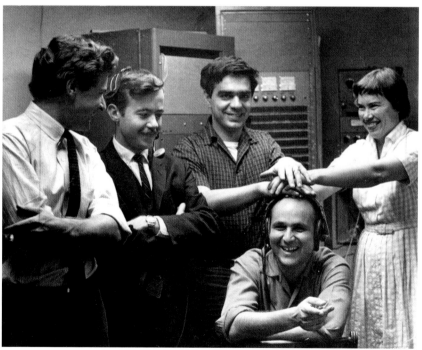

committee limited entrance to its allies. Push came to shove, and the police department ordered fire hoses trained on the students, washing them down the grand staircase. The next day, left-leaning union members such as the Longshoremen and even more students surrounded city hall and threw up mocking one-arm Nazi salutes, effectively destroying, at least in the Bay Area, HUAC's credibility. The terror had been confronted — and neutralized.

Emboldened, progressive elements of the Bay Area student culture such as the W.E.B. DuBois Club at SF State allied themselves in 1964 with the leadership of the African-American civil rights group the Congress of Racial Equality (CORE) to protest the white-only hiring policies of the auto dealerships along San Francisco's grand Van Ness Avenue and at the Sheraton Palace Hotel. Thousands surrounded the temples of commerce and hundreds were arrested — and then enjoyed victory when the auto dealers and hotel agreed to integrate their work forces.

The student movement came to full fruition in the fall of 1964 on the campus of UC Berkeley in what would be known as the Free Speech Movement (FSM). The immediate issue concerned the students' ability to advocate civil rights issues on campus at Sproul Plaza, but in essence the demonstrations were a countercultural protest against a university that treated students as a product and their education as training. It began when a former graduate student named Jack Weinberg was arrested for refusing to show identification while sitting at the CORE table on Sproul Plaza. He was placed in a police car that was immediately surrounded by thousands of students who, for the next thirty-two hours, refused to allow it to move. Instead, the car became a stage and podium for speakers who led a serious inquiry into the nature of free speech and

7
San Francisco Mime Troupe in Duboce Park, San Francisco, June 1964. Photo by Erik Weber.
PRIVATE COLLECTION

academic freedom. Over the next months, the FSM introduced building takeovers and mass arrests into the lexicon of American education — and once again the students won.

Against this backdrop of youth rejecting the '50s mainstream consensus — socially, politically, intellectually — the arts in San Francisco had a grandly receptive audience for what Herb Blau called "an open terrain of dissidence."[6] One of the most fascinating elements of this art world was its propensity for cross-fertilization with other arts institutions, so that the Actor's Workshop could bring in the Beat painter Robert LaVigne to design sets, or invite the Tape Music Center composer Morton Subotnick to compose the music for the workshop's production of *King Lear*.

The Tape Music Center in particular was a major pivot point for a great deal of artistic collaboration (fig. 6). Emerging from the San Francisco Conservatory, composers Morton Subotnick, Ramon Sender, and Pauline Oliveros, aided by the painter (and later "visual composer") Tony Martin and the musician-technician William Maginnis, would expand the very notion of what music was. Events like the 1963 *City Scale*, a collaborative moving concert that involved a hundred artists and performers, the sounds in the Broadway tunnel, and a ballet of cars and their headlights on Telegraph Hill, left its audience wondering if events they witnessed were part of the piece or simply the city being the city: What is art? What is real?

It was very much a Bay Area phenomenon. As Martin recalled, "When I got there, it seemed natural to go beyond the canvas, to pick up things that were different, to think about assemblage, to put things together in different ways. . . . And I really enjoyed being in the Bay Area. There was nobody to answer to, in a way. I didn't feel that there was a cultural authority hanging over my head the way it did in New York City."[7]

In 1963, the center established itself at 321 Divisadero Street (at Page), foretelling a population shift out of a North Beach where Beat-ogling tourists had driven up the rents toward what would prove to be the Haight-Ashbury neighborhood. Another way station in the migration from North Beach was a cluster of apartments on Pine Street, roughly halfway between North Beach and the Haight. A painter named Bill Ham became the building manager at 2111 in 1960, and soon a gaggle of dancers, painters, actors/actresses, and musicians began to fill up the various flats. One of those people was Lee Breuer, an assistant director at the Actor's Workshop (and later one of the cofounders of New York's Mabou Mines, a distinguished experimental theater group). One day he told Ham about a play he'd written, *The*

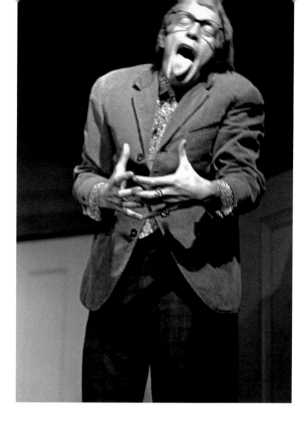
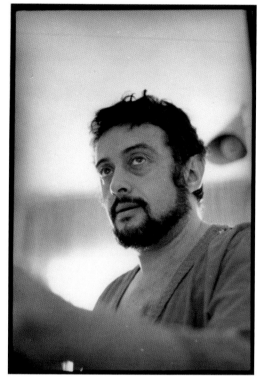

8
Howard Hesseman (Don Sturdy) performing with the Committee in San Francisco, August 1966. Photo by Steve Rees.
PRIVATE COLLECTION, COURTESY OF STEVE REES

9
Lenny Bruce, 1966. Photo by Edmund Shea.
PRIVATE COLLECTION

Run, which would be performed at the Tape Music Center in the spring of 1964.

Around the same time, another Actor's Workshop member and Pine Street resident, Susan Darby, told Bill about some experiments going on at a church on Capp Street, which was the rehearsal space for the R.G. "Ronnie" Davis Mime Troupe, which soon became the San Francisco Mime Troupe (fig. 7). Davis had also been an assistant director at the Actor's Workshop, but his aggressively left politics had led him to resign over the organization's funding policies.

"Sunday nights," Ham recalled, "they'd have a collective whatever-happened thing — Ronnie and some of his people would do things. . . . So there was music and dance and Elias Romero had come up from LA and was renting the downstairs with Ronnie and he would do projections. So that was the first time that I saw Elias Romero do projections."[8] Early in the fifties, an artist and teacher at SF State named Seymour Locks had begun using an overhead projector and a bowl of colors and oil to create liquid lights. Elias Romero studied with Locks and pursued this new art form, and soon moved to Pine Street and encouraged Bill to experiment with it as well.

Breuer invited both Ham and Romero to contribute to *The Run*. Bill was commissioned to build a beast/wolf/dog sculpture, while Romero did the lights. What Ham took away from the experience was a fascination with the light projections, with what he thought of as kinetic painting, painting in real time (pl. 219). Soon he'd become famous for it.

"In *The Run*," Breuer later wrote, "Bill Spencer accompanied the actors on the harp of an altered piano, Elias Romero projected a liquid light dialogue with Ruth Maleczech. Bill Ham sculptured a dog that flew. Anna Halprin dancers Norma Leistiko and Fumi Spencer, the runaway movie star Diane Varsi, the Mime Troupe, and Bill Raymond welded together a performing ensemble that was decades ahead of its time."[9]

Bill Ham would remember something else about the night of *The Run*. The Magic Theater for Madmen Only, a combination art gallery and the city's first "head shop," operated by Michael Ferguson, who would a year later also help begin the first San Francisco rock band, the Charlatans, coincidentally opened that very night next door to the Tape Music Center.

"So as the people left this strange theater piece trying to figure out what they'd just watched," Ham recalled, "they'd go past the Magic Theater, and it was a storefront, and several people were posed in the window, and people couldn't decide if they were real or not, and behind them there's an incredible scene going on, the beginnings of all that (the hippie pothead trip) . . . everybody smoking dope. You had to go in the back door to get in."[10] The future was flashing in front of them.

In Berkeley, Ben and Rain Jacopetti formed the Open Theater; inspired by the liquid light projections they were seeing from Romero, they created "Revelations," in which nude actors and actresses were clothed by the swirling forms of light.

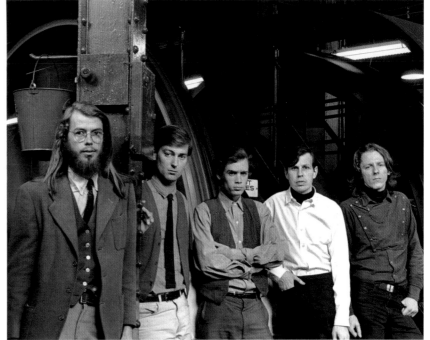

Other arts took their place in the Bay Area mix. The Committee opened on Broadway in San Francisco in 1963 and introduced group improvisational comedy to the city, with Garry Goodrow, Larry Hankin, Howard Hesseman (aka Don Sturdy; fig. 8), and Hugh Romney (later Wavy Gravy) among many others joining the immortal Lenny Bruce (fig. 9) in a systematic deconstruction of what constituted appropriate subject matter in humor.

Anna Halprin's Dancers' Workshop, which shared space with the Tape Music Center, would bring an entirely new sensibility to dance, very much of an organic, natural ethos and as such very San Francisco. She, too, would be part of a vital collaborative tradition among all these artists.

Finally, there was yet another art form thriving in the city at the time, kindred in its insistence on authenticity though not avant-garde. The folk revival filled such Grant Street clubs as Coffee and Confusion with traditional music that resonated against commercial American pop, and young musicians named Jerry Garcia, Janis Joplin (fig. 10), Jorma "Jerry" Kaukonen, Paul Kantner, Dan Hicks, and David Freiberg among many others would work there.

Just as San Francisco experienced *The Run* and the Magic Theater, America welcomed the arrival of the Beatles (see Selvin, this volume). And fairly soon those very folkies began finding electric guitars extremely attractive. In the course of 1965, the Charlatans (Dan Hicks among them) debuted on June 21 at the Red Dog Saloon in Virginia City, Nevada. That same month the Warlocks (later the Grateful Dead, with Jerry Garcia) began performing down the Peninsula in Menlo Park. In August, it was Jefferson Airplane (with Paul Kantner and Jorma Kaukonen) opening at the Matrix in the Marina District of San Francisco. Joplin and Freiberg would join Big Brother and the Holding Company (fig. 11) and Quicksilver Messenger Service, respectively, the next year.

Something else became ubiquitous in hip San Francisco circles in 1965: LSD, most commonly known as "acid." Spiritual exploration using psychedelic drugs was not new; the Beats had sampled peyote. But LSD was easier to ingest, extraordinarily powerful, inexpensive, and widely available thanks in large part to the industrious exertions of one Augustus Owsley Stanley III.

Author Ken Kesey had gotten his first LSD from the CIA's MK-Ultra mind control program, but soon he and his friends, nicknamed the "Merry Pranksters" (one of whom was Neal Cassady, the model for the Dean Moriarty character in *On the Road*), decided that a more informal study of LSD and its effects was called for. Along with their friends the Grateful Dead, they threw parties called "Acid Tests" at which it was freely available. Over two months, attendance at the weekly gatherings grew exponentially, cresting in January 1966 with a weekend event called the Trips Festival at Longshoremen's Hall, near Fisherman's Wharf (fig. 12 and pls. 22–35).

Many of the avant-garde groups, from the Open Theater to the Dancers' Workshop to the Tape

10
Janis Joplin, 1963. Photo by Marjorie Alette.
PRIVATE COLLECTION

11
Chet Helms with Big Brother and the Holding Company, (left to right: Chet Helms, Sam Andrews, Peter Albin, Chuck Jones, and James Gurley), 1966. Photo by Michael Raichoff.
PRIVATE COLLECTION, COURTESY OF PETER ALBIN

Music Center, were represented. But LSD, rock and roll — the Grateful Dead and Big Brother and the Holding Company (soon to have a drummer named Dave Getz, once a resident of Painterland) — and Tony Martin's light show were the big takeaways. "Thousands of people, man," recalled the Dead's Jerry Garcia, "all helplessly stoned, all finding themselves in a roomful of other thousands of people, none of whom any of them were afraid of. It was magic, far out, beautiful magic."[11]

The magic found a focus in the Haight-Ashbury neighborhood, where perhaps a thousand people had settled, most of whom were connected with the bands who would be playing at the emerging two major venues, the Fillmore Auditorium, run by former Mime Troupe business manager Bill Graham, and Chet Helms's Avalon Ballroom, where Bill Ham created the light show. As well, there were the poster artists who helped to advertise these shows (see Terry, this volume), and stores such as Mnasidika (see D'Alessandro, this volume), In Gear, and the Psychedelic Shop. Together, they comprised the world's first psychedelic neighborhood.

The residents experimented with sexual liberation, with freedom; they challenged the nuclear family, materialism, violence, the war in Vietnam, and the bulk of the ideas they'd been raised on. They developed social institutions like their visionary neighborhood newspaper, the *Oracle* (pls. 106–119), and prophetic street theater social activists like the Diggers, who furthered the implicit social protest and new consciousness that was the Haight by asking people to stand in a large frame, like a disembodied door, called "The Free Frame of Reference" — because if it has a frame, it's a work of art. The Diggers even anticipated the commercial appropriation of the emerging subculture and acted as missionaries for the concept of "free" — because that was the one thing that could not be co-opted. So the Grateful Dead, for instance, would become legendary for playing for free in the Panhandle, a strip of parkland that bordered the Haight (fig. 13). On a more practical plane, the Diggers also offered free food for those who needed it (fig. 14).

Through 1966, the new counterculture functioned beautifully — so well, in fact, that a celebration was called for. Allen Cohen, editor of the *Oracle,* and local artist Michael Bowen conceived a grand celebration for January 14, 1967, called the Gathering of the Tribes for a Human Be-In (pls. 36–42) that would bring together the various rock bands, their Beat poet mentor/predecessors Allen Ginsberg, Gary Snyder, and Michael McClure, spiritual leaders like Timothy Leary and — perhaps more authentically — the primary apostle of Zen Buddhism in America, Shunryu Suzuki Roshi (fig. 15), and even Berkeley radicals such as Jerry Rubin. It was a fabulous day. And people looked around and realized that there were a whole lot of "freaks" — actually the preferred term — that there were tens of thousands of freaks sitting there in Golden Gate Park, far more than the Haight neighborhood held, and it was glorious.

And it was also the end, because the freaks had blown their cover. Until then, the Haight had flown largely under society's radar, but the Human Be-In was far too large to ignore. Now the freaks were called "hippies," and soon they would be on the cover of *Time.* And seemingly every young

12
Ramon Sender on the platform at the Trips Festival, San Francisco, January 1966. Photo by Susan Elting Hillyard.
PRIVATE COLLECTION

13
The Grateful Dead at the Love Pageant Rally in the Panhandle, San Francisco, October 1966. Photo by Susan Elting Hillyard.
PRIVATE COLLECTION

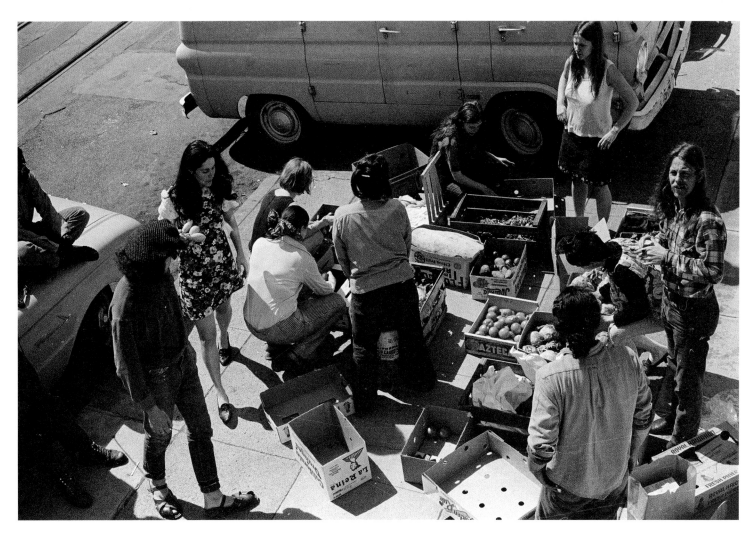

14
The Diggers organize a food distribution, Haight-Ashbury, San Francisco, 1967. Photo by Chuck Gould.
PRIVATE COLLECTION

person in America looked at the pictures of flower-bedecked dancers at the Be-In and started plotting how to get to San Francisco.

Along with the publicity generated by the Be-In, a musical festival in Monterey attracted massive attention, not least because organizer John Phillips, the front man for the Mamas and the Papas, would write a catchy pop song as a promotional device: "San Francisco (Be Sure to Wear Flowers in Your Hair)." Ironically, every dream associated with the Haight came true that weekend. One hundred twenty miles south of the city, the Monterey International Pop Festival from June 16 to 18 would feature 10,000 orchids flown in from Hawaii, Owsley's finest elixir, an atmosphere so peaceful that, the head of security said, his guards could have been kindergarteners, and the Technicolor introduction to America of psychedelic bands from England (the Who) and San Francisco (the Grateful Dead, Big Brother and the Holding Company — now with Janis Joplin — and Jefferson Airplane).

It blasted the message of rock and roll across the country and around the world, and accelerated the pilgrimage of youth dying to get to the promised land of the Haight-Ashbury. Much younger than the original settlers, they came by the thousands, and they overloaded the environment, rendering the label "Summer of Love 1967" a slightly cruel joke. By Labor Day, the Haight was a tourist carnival nightmare. By 1968 Haight Street would be inhabited by children shooting methedrine and heroin. The magic died hard.

But the challenge that the Haight represented catalyzed ideas that would eventually become the new normal in much of the Western world. The sensitivity to pollutants, synthetic products, and food additives induced by LSD would result in a natural food industry worth billions on the personal level and a Thoreauvian respect for the environment on the macro level. Sexual liberation and the communal challenges to the nuclear family would alter American attitudes about gender and sexuality and set off a chain reaction of experimentation. LSD and countercultural values would be a significant part of the subsequent growth of Silicon Valley as the nation's new technological center. And so forth. The counterculture epitomized by the Summer of Love touched every facet of American culture, offering alternatives to the mainstream that still flourish.

Fifty years gone, but not past at all.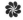

This essay was derived from research conducted for the photographic exhibition *On the Road to the Summer of Love* (California Historical Society, San Francisco, 2017). The author extends his gratitude to the California Historical Society and the artists who assisted with the research.

1 Herb Caen, *San Francisco Chronicle*, April 2, 1958.
2 Interview with the author, September 1, 2016, Fairfax, CA.
3 Herbert Blau, *Programming Theater History / The Actor's Workshop of San Francisco* (London and New York: Routledge, 2013), 27.
4 Ibid., 2.
5 Ibid., 144.
6 Ibid., 24.
7 As quoted in David W. Bernstein, ed. *The San Francisco Tape Music Center* (Berkeley: University of California Press, 2008), 149.
8 Interview with the author, August 30, 2016, San Francisco.
9 As quoted in Bernstein, 16.
10 Interview with the author, August 30, 2016, San Francisco.
11 Jerry Garcia, as quoted in Michael Lydon, *Rock Folks* (New York: Delta Books, 1973), 120–121.

15
Shunryu Suzuki Roshi at the Human Be-In in Golden Gate Park, San Francisco, January 14, 1967. Photo by Lisa Law.
PRIVATE COLLECTION

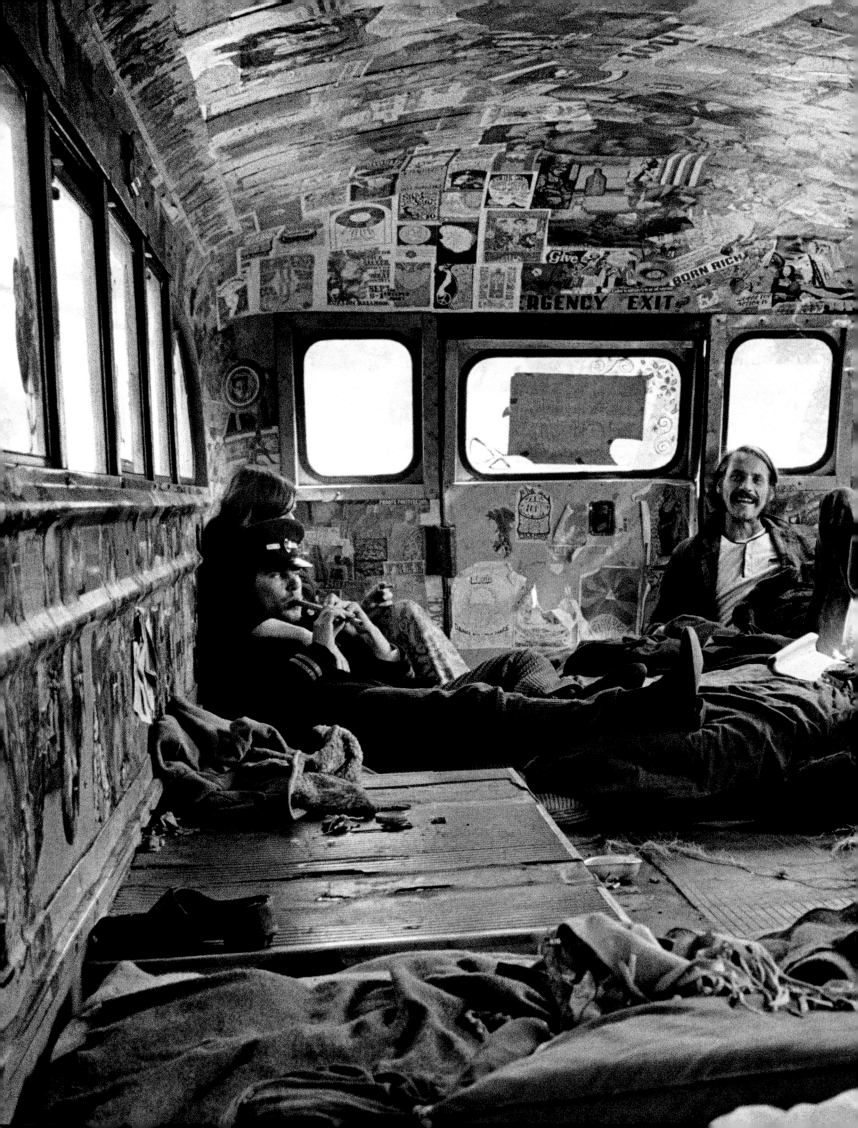

selling san francisco's sound

artistry in 1960s rock posters

COLLEEN TERRY

"EXPENDABLE GRAPHIC ART becomes America's biggest hang-up."[1] So reads the subtitle of an article in a September 1967 issue of *Life*, a weekly magazine that reached a broad segment of the American population.[2] San Francisco's Summer of Love had come and nearly gone as *Life* reported that more than a million posters a week were being "gobbled up by avid visual maniacs who apparently abhor a void" and that those most avidly acquired "serve mainly to jolt the eye, or make the mind go topsy-turvy."[3]

Surely a reference to the psychedelic rock posters that were being created in San Francisco, the article and its accompanying illustrations (fig. 16) emphasize the wide-reaching popularity of art made as advertisements. The lineage of such posters is popularly traced back to *"The Seed,"* the 1965 poster designed by Charlatans autoharpist George Hunter and keyboardist Michael Ferguson (pl. 226) to announce the San Francisco band's folk-rock residency at the Red Dog Saloon in Virginia City, Nevada — the edge of the civilized world. What started in 1965 as a small-scale venture to promote the band had, less than two years later, become big business. Yet by 1968 *San Francisco Chronicle* art critic Thomas Albright would, in an article for *Rolling Stone*, declare "the death of the great poster trip," and the celebrated San Francisco poster shop the Print Mint would shutter its Haight Street doors.[4]

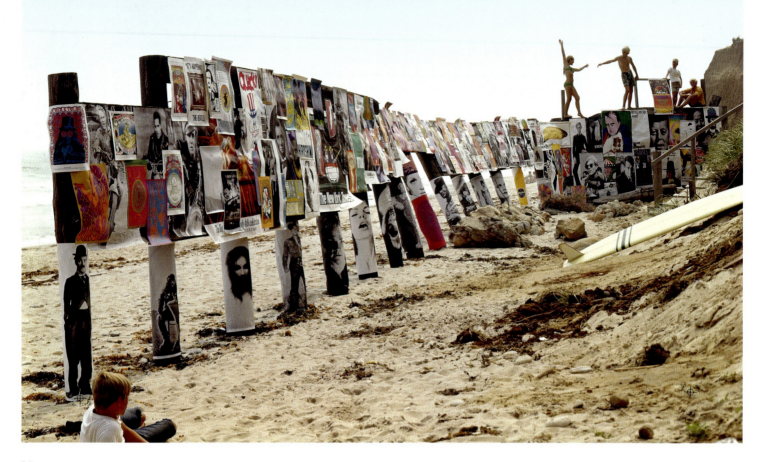

16
East Coast surfers below the cliffs at Long Island's Montauk Point teeter atop an old bulkhead slathered with two hundred posters of practically every genre, 1967. Printed in Jon Borgzinner, "The Great Poster Wave," *Life* (September 1, 1967)

As much as psychedelic rock posters were signifiers of the electric dance concert experience of the counterculture and "unreadable" to a large segment of "straight" society, in 1967 they were also items around which youth throughout the nation, and even the world, could band.[5] In 1971, an article in *Print* magazine went on the record to confirm that, "instead of implying values by association, posters [of the 1960s] became open declarations in favor of love, sex, peace, nature, or a combination of all four."[6] Even earlier, they had become collector's items, eagerly sought by young enthusiasts in what the 1967 periodical *Horizon* termed "a personal act of self definition."[7] Certainly "Funky" Sam Ridge, salesman for the independent poster company Funky Features, demonstrated such inclinations, proudly posing in the center of his poster-encased living space for the camera of Elaine Mayes (pl. 78).[8]

Curators at museums across the country joined the frenzy, keen to add works by poster artists such as Rick Griffin, Alton Kelley, Victor Moscoso, Stanley Mouse, and Wes Wilson — together popularly known as the Big Five (fig. 17) — to growing collections of graphic design and plan exhibitions that would further spread the reach of this dynamic new genre.[9] In the Bay Area, venues hosted exhibitions of the posters and related artwork; for example, the Moore Gallery at 535 Sutter Street organized a special exhibition of the Big Five in the summer of 1967. Known as the "Joint Show" (fig. 77), it included a variety of works by all five artists, including posters that each designed specially for the exhibition. Rarely had commercial art obtained such status within both the popular realm and the fine art world. The genesis of the uniquely Bay Area strain of the rock poster genre can readily be considered within the realm of 1960s visual culture. Like their contemporaries in the fine art world, the rock poster artists mixed together a range of styles and cultural referents in typical postmodernist fashion, to create a form that — in the words of Albright — "parallels the tendency of current mainstream art toward breaking down the lines between artist and viewer, art-work and environment, art and life."[10]

When Ferguson and Hunter created their poster, *"The Seed,"* they drew upon graphic elements that signaled a specific time and place: turn-of-the-century Virginia City. Inspired by a circus poster from 1900 (fig. 18) and informed by the engravings decorating the masthead of the *Territorial Enterprise,* the local newspaper where Mark Twain once worked, they created a hand-drawn mash-up of late-nineteenth-century popular visual culture grounded in the hometown of the Red Dog Saloon.[11] Victorian graphics met Wild West antics, thus preparing those who saw the poster for the unconventional performances they could expect of the Charlatans during the first public shows of their

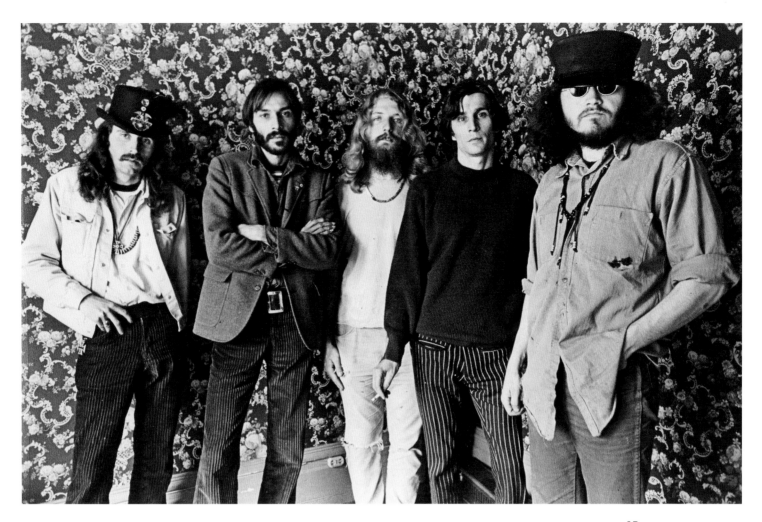

17
Five San Francisco poster artists (left to right: Alton Kelley, Victor Moscoso, Rick Griffin, Wes Wilson, and Stanley Mouse), 1967. Photo by Bob Seidemann.
COLLECTION OF THE ARTIST

six-week stint at the Red Dog in the summer of 1965. The jarring combination of Victorian and Wild West typography and graphic illustration that appeared in *"The Seed"* was the perfect complement to the band itself, and the choice of graphic vocabulary may be clearly ascribed to their roots in the West.

Long before they rehearsed their folk-rock musical set, band members worked to cultivate public personae rooted in San Francisco's storied past. From their wide-brimmed hats, bandannas, and bolo ties down to their three-piece suits, watch chains, and boots, the Charlatans assumed the air of Victorian cowboys. Over the next few years they would continue to refine this look, eventually posing for a series of images by photographer Herb Greene that would be the central feature of a triptych of posters made to advertise concerts that the band headlined for the Avalon Ballroom in the summer of 1967. Antique lamps, carpets, and furniture set the period stage, and poster artists Rick Griffin and Robert Fried further suggest period details in the style of their lettering and the formatting of the photographs, rounding each corner to keep the suggestion of an earlier epoch alive.[12]

By the time Griffin's and Fried's images were made in the summer of 1967, the San Francisco rock poster style had undergone a dramatic professionalization thanks in large part to the intervention of two major figures within the city's music industry: Bill Graham and Chet Helms. Graham was a businessman; Helms, a self-proclaimed hippie. One-time business partners, for much of the period the two music promoters competed for acts and artists, as well as audiences for the legendary dance concerts at the Fillmore Auditorium (Graham) and Avalon Ballroom (Helms, as the head of Family Dog Productions) for which the 1960s San Francisco music scene is best known. Though their management styles differed, both worked with some of the most memorable names in the business, and under the direction of each some of the most iconic posters of the period were achieved.

In standard histories of the rock poster, Graham is generally credited with professionalizing the burgeoning San Francisco music industry, but he did so in part on the back of the Family Dog, a collective first spearheaded by Luria Castell, Ellen Harmon, Alton Kelley, and Jack Towle, who together organized groundbreaking musical "happenings" throughout San Francisco such as the storied "A Tribute to Dr. Strange" at the Longshoremen's Hall on October 16, 1965 (pl. 227).[13] This event, named

for the Marvel Comics superhero who had made his debut in 1963, was San Francisco's first psychedelic dance concert, and two days later *San Francisco Chronicle* music critic Ralph J. Gleason declared, "It was a gorgeous sight. The lights played over the floor, the bands wailed out their electronic music, and the audience had a blast!"[14] A year later Castell explained to Gleason, then writing for the *Examiner*, the group's original intent: "To bring in the artistic underground, use light machines, boxes projecting a light pulse from the tonal quality of the music . . . to have a good time and meet people and not be dishonest and have a good profitable thing going on . . . music is the most beautiful way to communicate. It's the way we're going to change things."[15]

Soon after the concert, Kelley and Castell approached Graham, offering to stage the benefit he was planning for the San Francisco Mime Troupe. In return they asked only a mention of their collective in advertisements of the event. As Kelley recalled, "We told him that we had found out that the old Fillmore Auditorium . . . could be rented at only $60 a night, and we were planning to put on dances there. He said he'd get back to us."[16] Graham preferred to go his own way, however, and tracked down the Fillmore's leasing agent, Charles Sullivan, ultimately negotiating a four-year option for first rights to the venue at $45 a night. The Family Dog, now without a financially viable venue, collapsed until Texas émigré Chet Helms took over the name and the operation in early 1966. For a short period, Helms and Graham shared the Fillmore, but when Graham took over the lease in April, Helms was forced to look elsewhere, eventually settling on the Avalon Ballroom.[17] With its Victorian architectural details and featuring lush interior finishes such as red-flocked wallpaper and crenellated balconies, the Avalon spoke directly to San Francisco's flourishing countercultural aesthetic.

Before Graham was ensconced at the Fillmore, he held, in a loft on Howard Street, the first of what turned into a series of benefit concerts for the San Francisco Mime Troupe during the winter of 1965/1966. In August 1965, the troupe's founder Ronnie Davis had been arrested in Lafayette Park while performing Giordano Bruno's *Il Candelaio*, a four-hundred-year-old play believed by the Recreation and Park Commission to be, as a staff reporter for the *Chronicle* put it, "a bit racy for public consumption."[18] Months later and with court fees mounting, Graham, who at the time worked as the troupe's manager, produced the first of three "appeal" parties. On November 6, he brought together a roster of literary, musical, and theatrical figures that represented the city's diverse artistic community. Word got out, and with tickets priced on a sliding scale, the first benefit netted more than $4,000. Inspired by his success, Graham planned another, and another, both in his new digs at the Fillmore. By January 1966, he had caught the promoter's bug.[19]

Word of mouth was the primary means by which news of the Mime Troupe benefits spread throughout the Bay Area, but rudimentary handbills were also helpful. Posters, too, were designed for the second and third appeals (fig. 19). Executed in the day's style of boxing posters, photographs of the musical lineup appear in symmetrical blocks across the page, while key words are heavily emphasized per the common practice of the era's graphic design.[20] This fondness for photographic representation of the bands in concert posters was soon to change.

Early in 1966, when Graham was hired to manage the logistics of the Trips Festival, a three-day acid test co-organized by writers Stewart Brand and Ken Kesey and composer Ramon Sender, he met Wes Wilson.[21] At the time, Wilson was beginning to work as a freelance artist, having previously done presswork and graphic layouts for a company — Contact Printing — that Bob Carr had established in 1964.[22] Wilson had already created some handbills for the local acid tests held by Kesey and the Merry Pranksters, and it was his pulsing poster design that became a lasting image of the Trips (pl. 23). Working with a limited palette of black and white, Wilson created the optical illusion of a swirling vortex, teeming with energy, simulating, perhaps, the intense visual stimulation that Trips Festival participants might expect to experience.

Wilson's choice of black and white wasn't just an aesthetic consideration but a financial one as well. In the early days of rock posters, money was at the heart of the design question. To save on printing costs, artists designed for one-color printing, sometimes on colored card stock. In 1966 Wilson chose a gold-colored paper stock for his first poster for Graham's new Fillmore venture; playing with the popular enthusiasm for Batman already in the air,

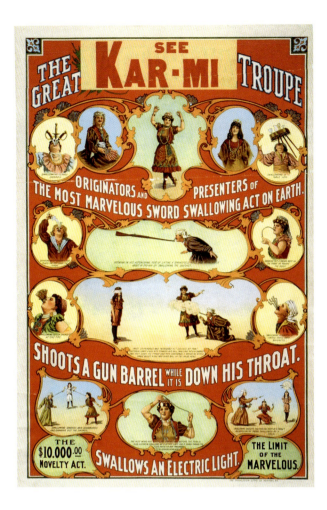
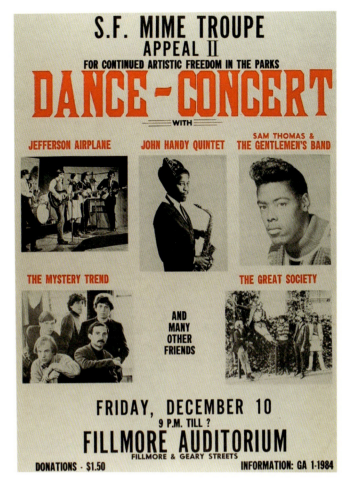

he put at the center of his design a line drawing of the superhero, his trusty sidekick Robin, and a mynah bird (pl. 232).[23] Advertising a three-day dance concert and film festival, the poster is filled with information that Graham kept adding to the design brief. More than anything, Wilson remembers thinking, "Well, I can always write it all in somewhere."[24] The final poster, which included an announcement of a drawing for giveaways such as sweatshirts, comic books, photographs, and even a mynah bird, helped ensure the event's success. It also solidified Graham's interest in hiring Wilson to make posters to promote his events, which he would go on to do more than fifty times, through December 1968.

Graham may have inserted his business needs into the design process, but Helms injected a far greater level of involvement, at least for a time. In addition to his work booking acts and promoting shows, Helms served as art director for the early Family Dog posters, providing artists with photographic source materials for use in the posters. To feature in the first of the numbered series of posters made for the Avalon (see Binder, this volume), Helms selected for the designer Wilson a photograph by Edward S. Curtis that was reproduced in *The American Heritage Book of Indians*, and proclaimed the February 1966 concert "A Tribal Stomp" (pl. 13).

Such cooption of Native American imagery and social groupings had emerged as a political statement of the counterculture earlier in the decade and proliferated throughout its second half, thanks to then-fashionable media theorist Marshall McLuhan's ideas linking small-scale collectives with advanced technology and aesthetic experimentation.[25] It was also a reference embraced by both the popular and countercultural press, with articles such as "Happy Hippie Hunting Ground" and "The Community of the Tribe" appearing in *Life* magazine and the *San Francisco Oracle*, respectively.[26] When it therefore materialized in a poster design advertising the musical appearance of Jefferson Airplane and Big Brother and the Holding Company at the Fillmore, Native American imagery announced an affiliation with the counterculture and its "tribal social form" (see D'Alessandro, this volume).[27] Further cementing an allegiance to this newly proposed social order, Helms provided Wilson with a photographic image of a First Nations man (fig. 20), with instructions to transform it into a logo for the Family Dog. Wilson applied the resulting figure — altered to accommodate a thick joint in place of a pipe — to the poster's upper left-hand corner, thus establishing the presence of source material featuring Native Americans throughout posters promoting Family

18
Donaldson Litho. Co., *The Great Kar-Mi Troupe. The Great Victoriana Troupe Originators and Presenters of the Most Marvelous Sword Swallowing Act on Earth*, 1900. Color lithograph poster, 42¹⁄₈ x 28 in. (107 x 71 cm).
LIBRARY OF CONGRESS, MAGIC POSTER COLLECTION, POS-MAG-.K37, NO. 2 (C SIZE) [P&P]

19
San Francisco Mime Troupe Appeal II, Fillmore Auditorium, San Francisco, December 10, 1965. Color offset lithograph poster

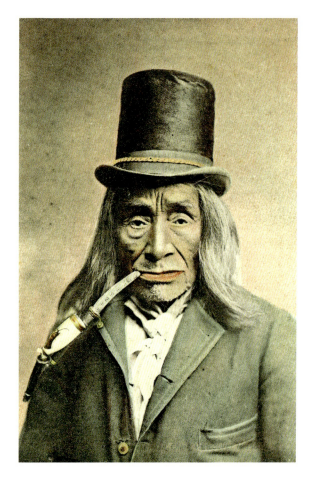

20
Postcard of a Thompson River fur trade First Nations man smoking a pipe, ca. 1910 from a photograph dated ca. 1897. Hand-tinted postcard. Photo by Jones Brothers, Vancouver, BC, Canada. Printed by Barber Brothers, Victoria, BC, Canada.
UNO LANGMANN COLLECTION, VANCOUVER, BC

Dog productions.[28] Acclaimed poster artist Victor Moscoso was one of many who went on to adapt the logo for his own Family Dog poster (pl. 208). He later explained of the poster, which he considers his first in a truly psychedelic vein, "I liked the logo, and at that point [it] was still pretty new. So I figured, great, I'll make a poster using the logo as the basis. Only I added my twist to it."[29] This twist, the close juxtaposition of red and blue to affect optic vibration, would become one of the signatures of Moscoso's style.

Moscoso was the only one of the Big Five with a substantive academic background in visual art, learning color theory at Yale University from the master, Josef Albers (figs. 86–89). In a well-known statement he made often, the elder art-world statesman crafted what would turn out to be a particularly apt description of psychedelic art: "Experience teaches that in visual perception there is a discrepancy between the physical fact and psychic effect."[30] Moscoso later explained his professor's words: "Between the colors that are equal at the opposite end of the color wheel, and your mind, which has been trained to read figure and ground, you can't figure which is ground and which is figure. That's why it vibrates. The mind can't handle it."[31] Moscoso wasn't the first poster artist to apply these concepts; early in his tenure as a designer for Graham, Wilson exploited this concept, turning, for example, color complements red and green into a vibrating, flickering flame (pl. 179).

Poster artists often combined the retinal effects of vibrating colors with lettering that *Ramparts* magazine editor Warren Hinckle III termed "18, 24, and 36 point Illegible."[32] Though Hinckle may have had Wilson in mind, he could easily have been speaking of the work of any number of poster artists. Nonetheless, Wilson is the one usually credited with taking this element of poster art to the extreme (see, for example, pl. 175), carving his letters out of the poster's negative space. To the *San Francisco Chronicle* Wilson admitted that his lettering style was adapted from a poster by the Austrian Secessionist artist Alfred Roller that he saw reproduced in a catalogue for the exhibition *Jugendstil Expressionism in German Posters* organized for the University Art Gallery of the University of California, Berkeley.[33] This early admission may have inadvertently inspired the mainstream press to distill the rock poster movement into something easily digestible to their widespread readers: Art Nouveau.[34]

The self-designed, hand-drawn fonts of the poster artists took a variety of forms (Moscoso referred to his creation as "Psychedelic Playbill"), and when deployed across a range of poster designs, these fonts forced audiences to stop and stare in order to fully absorb their message.[35] As Dugald Stermer, art director for *Ramparts*, observed of the genre in 1967:

> The lettering meanders all over the place with complete disregard for our Gutenberg training, so that it takes considerable time and visual acrobatics to find out what the words say. This illegibility is no disadvantage; on the contrary, it is essential. It comes right out of the same bag that requires one to hear the same song by the Rolling Stones quite a few times before the words become clear.[36]

The poster artists were, in effect, speaking directly to the targeted consumer. Nearly fifty years later, Moscoso explained:

> The goal of my posters was, ideally, if somebody was across the street, they'd see the vibrating

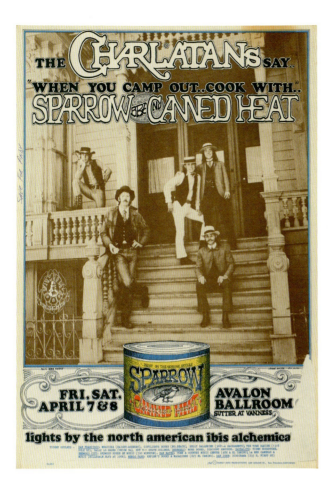
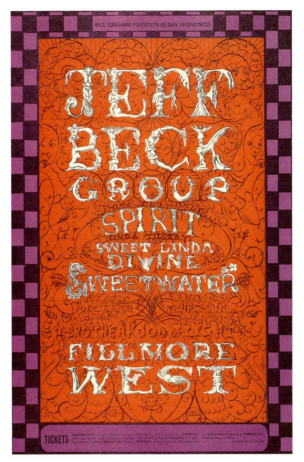

colors and say, What's that? They'd cross the street and spend a half hour or a week trying to read it. It was a game. . . . Here are these advertisements telling you who's playing and where, but you can't read it . . . or can you? Can you read this? Are you hip? We never said that, but that's what it implied.[37]

And, in Wilson's view, "The information is secondary."[38]

Even in those instances where the words were perfectly clear, the names of the bands must have, to the uninitiated, contributed to the sense of confusion. Is "Euphoria" the name of a musical group or the feeling you experience as a concertgoer at the Avalon (pl. 216)? Does "The Turtles" refer to a carnival sideshow act in which a bale of the shelled reptiles comically jangles tambourines, or is it a band playing the Fillmore with Oxford Circle (pl. 150)?[39] Occasionally the poster artists assisted their audience, using visual puns to riff on the dance concert's lineup. Birds fill posters advertising both the Byrds and the Yardbirds (pls. 183 and 200); in 1969 a zeppelin airship in its hangar sells the English rock band Led Zeppelin (pl. 152). In a more comprehensive example printed for the Family Dog (fig. 21), Rick Griffin positioned a Herb Greene photograph of the headlining band (the Charlatans) above a hand-drawn can onto which he added a line drawing of a bird.

Griffin drew upon the Charlatans' Old West persona, designing a poster reminiscent of the day's advertising principles, complete with multiple font treatments.[40] The band becomes the spokesman for the "product" it sells, namely Sparrow brand Canned Heat. To those in the know, this was a play on the vernacular. Canned Heat, a blues and boogie band from Los Angeles and the third act in the Avalon show, got their name from a song of 1928 called the "Canned Heat Blues," which told the story of an alcoholic who in desperation drank Sterno, a cooking fuel. Sterno was generically called "canned heat," so, in a pun on the band's name, Griffin transformed the third act into a fuel container. Then he took it one step further, positioning the Canadian blues-rock band the Sparrows, the weekend's second act, as the Canned Heat's "brand." In true Victorian style, the brand appears in both word and image, and is preceded by the phrase "Insist on the Genuine Article."

The proliferation of messages encoded in a rock poster's image ensured that the eye of the initiate would keep circling across the printed page, as his or her mind struggled to comprehend. Almost as soon as the message was clear, it receded back into the design and the process of decoding began again. From the perspective of artist and client, the more time a person spent with the poster, the better. In 1967, Wilson went on the record, explaining: "The

21
Rick Griffin and George Hunter, *"Charlatans Front Porch," Charlatans, Sparrow, Canned Heat, April 7 & 8, Avalon Ballroom*, 1967. Color offset lithograph poster, 20 x 14 in. (50.8 x 35.6 cm).
FINE ARTS MUSEUMS OF SAN FRANCISCO, MUSEUM PURCHASE, ACHENBACH FOUNDATION FOR GRAPHIC ARTS, 1974.13.23

22
Lee Conklin, *Jeff Beck Group, Spirit, Linda Tillery, Sweet Linda Divine, Sweetwater, December 5–8, Fillmore West*, 1968. Color offset lithograph poster, 21¼ x 14 in. (54 x 35.6 cm).
FINE ARTS MUSEUMS OF SAN FRANCISCO, MUSEUM PURCHASE, ACHENBACH FOUNDATION FOR GRAPHIC ARTS ENDOWMENT FUND, 1972.53.281

poster is supposed to involve people in a sort of self experience."[41] And if a person was intrigued enough, he might just find his way to the Fillmore, the Avalon, the Matrix, or any one of the other venues where the San Francisco Sound was finding a voice.[42]

The posters announced dance concerts featuring an eclectic range of musical sounds; like their counterparts in the postmodern art world and the musicians themselves, the poster artists "sampled" a variety of popular and cultural sources, but often they did so in a distinctly Western mode, generating images packed with references to their unique position in a former frontier town on the edge of the Pacific Rim. From references to the Wild West and Victoriana to the mind-enhancing spiritual practices of Eastern mysticism and Native American rituals, the first generation of San Francisco poster artists created a visual equivalent to the concerts they sought to promote. Though their inspiration varied, the poster artists, like their fine art peers, created works indisputably of their era, teeming with the preoccupations of the day.

In some cases, the San Francisco poster artists were inspired by earlier artists and artistic movements. Sometimes they quoted them verbatim, as Stanley "Mouse" Miller and Alton Kelley did in their renowned 1966 poster for the Avalon Ballroom (pl. 184), which features at a reduced scale the famed "JOB" cigarette paper girl of Czech fin-de-siècle artist Alphonse Mucha. The pair — who often worked together as creative partners — also used an Edward Steichen photograph of well-known silent film star Gloria Swanson as the centerpiece of the 1966 poster made for the concert that would take place on the weekend of the Family Dog's first anniversary (pl. 186). But poster artists also produced works that can be viewed more as a translation of an earlier movement or idea. Made up of a variety of grotesque forms, the lettering of Lee Conklin's 1968 Fillmore West poster (fig. 22) hearkens back to the engraved alphabet of the fifteenth-century German Master E. S. and the fantastical creatures of his Netherlandish contemporary Hieronymus Bosch. And Wilson loosely based the figure of a 1967 poster for Winterland Ballroom and the Fillmore on that of the German artist Franz von Stuck's 1893 Symbolist painting *Die Sünde (The Sin)*.[43] The poster artists also occasionally gravitated to Surrealism, irrationally bringing together unrelated objects and ideas (pls. 157–159). With the Surrealists they also shared an interest in unlocking the creative potentials of the subconscious, giving artistic form to the popular dogma of counterculture intellectual Timothy Leary: "Turn on, tune in, drop out."[44]

As distinctive and subversive as the rock poster genre is, many of the posters do share a visual relationship with the artistic movements of the late nineteenth century. Albright discusses the idea at length, finding that "its [rock poster art's] closest counterpart would seem to be happenings in Europe and England (and New England) that formed an undercurrent through much of the 19th century, from Blake and the pre-Raphaelite Brotherhood through the Transcendentalists, the Gothic Revival, William Morris and Art Nouveau."[45] Albright rightly notes that the ideologies behind many of these stylistic predecessors were firmly rooted in questioning the idea of progress; similar philosophies might be said to characterize the counterculture in San Francisco in the years surrounding the Summer of Love.

Aesthetic inspiration was not restricted to the historical period, however; Bonnie MacLean's bold vortex of black and white (pl. 168) immediately connotes the Op, or Optical, Art movement — itself heavily influenced by the work of Moscoso's teacher Albers — that had recently taken the world by storm. Tricks of visual perception found their way into all aspects of American life, with popular news media reporting not only on the art, but also on the science behind Op's ocular assault.[46] Op had achieved national attention — even fashion and textile designers got in on the act — when in 1965 William C. Seitz organized a breakthrough exhibition at New York's Museum of Modern Art (MoMA) that later traveled to Saint Louis, Seattle, Pasadena, and Baltimore (fig. 23). Titled *The Responsive Eye*, it tested the perceptual experiences of viewers, foregrounding artists such as Albers, Bridget Riley, and Victor Vasarely whose work largely reduced the subject of their paintings and sculptures to studies of geometry and color. Dizzying and potentially disorienting, works created in this idiom could provoke physical reactions; whereas the artists celebrated in the New York exhibition engaged the intersections of perception and reality, for MacLean and other poster artists such as Moscoso and Wilson, these optical effects may simply have been another tool by which they could compete with the period's

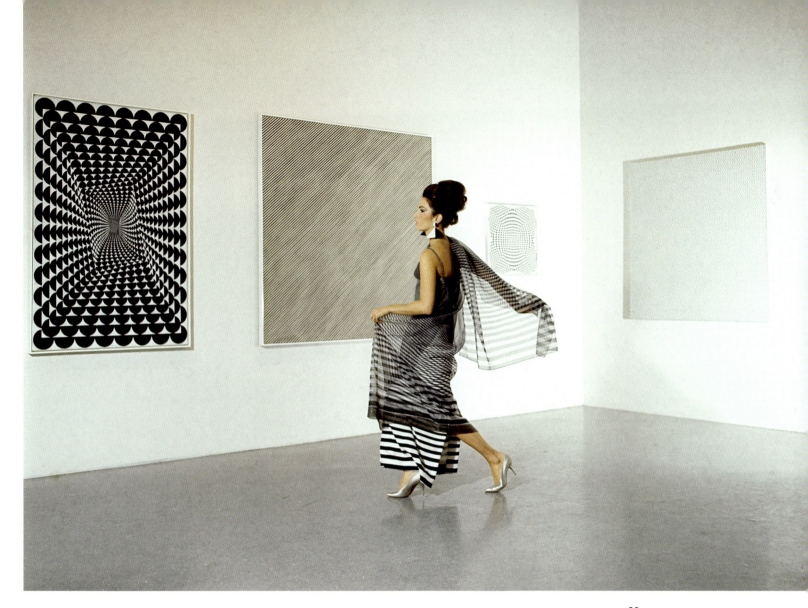

near-constant barrage of sensory stimuli to capture the attention of passersby.

Sometimes the poster artists didn't have to look far for inspiration or source material. Producing two or three posters a week could be a challenge, but seeing what their peers were doing to attract audiences for alternative music venues sparked new creative solutions. Wilson later observed: "A kind of competitive graphic thing was happening" between artists working for Graham and those who worked for Helms. Wilson continued, "Each party would try to outdo the other. And it created a great deal of positive energy in the field."[47] Though there may have been competition, there was also a collaborative spirit of sorts. In a recent interview with Victoria Binder, Bob Schnepf fondly remembered the camaraderie — as well as, on occasion the content — the artists shared (see Binder, this volume). Moscoso would, on occasion, share jobs if he was overextended; if asked, Kelley and others would look at and critique the designs of others. The give-and-take ranged into content, as well. As Schnepf recalls, it was Griffin

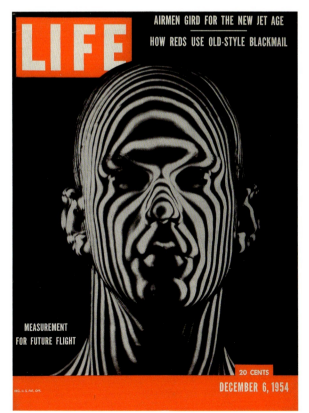

23
Fashions drawn from Op Art, featuring a model in a Pauline Trigère dress (fabric designed by Gerald Oster) alongside paintings by Jeffrey Steele, Bill Komodore, and Ernst Benkert, 1965. Photo by Milton H. Greene. Printed in "It's Op for Toe to Top," *Life* (April 16, 1965)

24
Life (December 6, 1954), cover. Photo by Ralph Morse

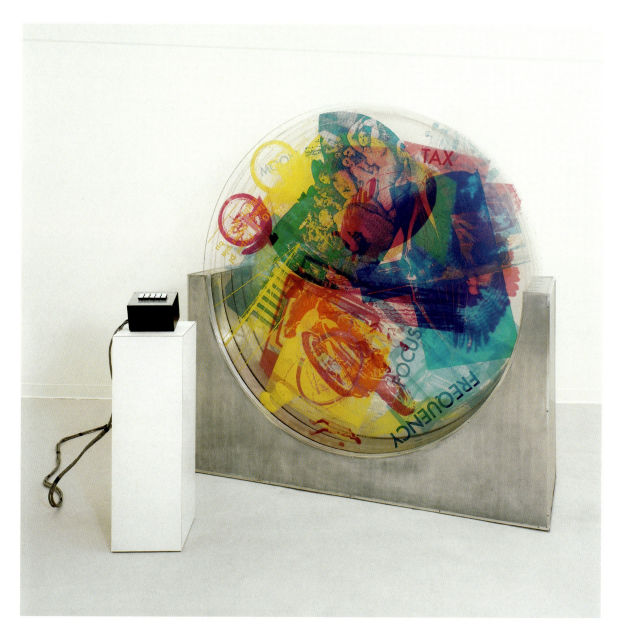

25
Robert Rauschenberg, *Revolver II*, 1967. Screenprint ink on five rotating Plexiglas discs in metal base with electric motors and control box, 78¼ x 77 x 24½ in. (198.6 x 195.6 x 62.2 cm).
ROBERT RAUSCHENBERG FOUNDATION, RRF 67.003

who first came up with the concept of the flying eyeball (pl. 253); a short time later, a similar motif appeared in the work of Mouse and Kelley.[48]

The international Pop Art movement was also a source of inspiration — conscious or not — for the poster artists.[49] Simultaneously a critique and celebration of a booming consumer age, Pop Art monumentalized the everyday. Pop artists such as Roy Lichtenstein and Andy Warhol sourced their subject matter from the world around them, mining ephemeral consumer goods such as advertisements, comic strips, television, and images from the popular press that they removed from their original context, often expanding the scale while retaining the commercial medium of lithography or screenprint. In a collision of worlds, some of the posters — with their heavy reliance on imagery pulled from popular culture — might rightly be considered an extension of Pop Art.[50] When, for example, Mouse and Kelley used a photograph by Ralph Morse that had appeared on the cover of an issue of *Life* magazine in 1954 (fig. 24) to create their enduring *Zebra Man* (pl. 190), they distorted the symbolic content of the image.[51] The pair substituted the black of Morse's photograph for blue, and selected blue's complement, orange, to take the place of the white in the photograph. With just this simple transformation of color, and with the addition of two modern band names, the music promotion company, and the dance concert information in hand-lettered script, Morse's image of an Air Force pilot being measured for a flight helmet now reads as a figure in the grips of the total-immersion psychedelic dance-concert experience. As Mouse and Kelley demonstrate, context is everything.

The pair was deliberate in their work, from the beginning selecting images and phrases within the vernacular that were liable to resonate with their targeted demographic. In their first jointly made design for a dance concert at the Avalon Ballroom produced by the Family Dog (pl. 189),

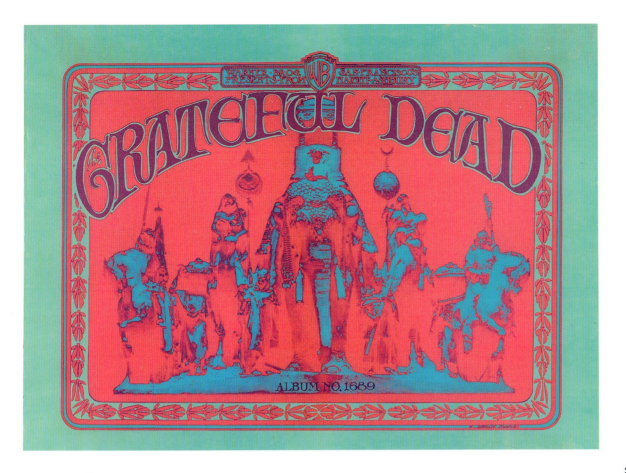

Mouse and Kelley lifted a number of elements from the packaging design for Zig-Zag cigarette rolling papers. The figure at the center of the poster is the same bold line drawing of a nineteenth-century French soldier, or Zouave, that had, by the mid-1960s, become synonymous in the San Francisco counterculture with the brand that was widely used for rolling joints.[52] Beneath the requisite listings of bands, venue, and dates, Mouse and Kelley inserted the tongue-in-cheek statement: "What you don't know about copying and duplicating won't hurt you" — a phrase that was, itself, lifted directly from the day's advertising, in this case for the copy machine company A. B. Dick.[53] Appropriate though their selection of text and image may have been, Mouse and Kelley cannot have anticipated the enthusiasm with which members of the San Francisco counterculture would respond to their poster. It became so popular, in fact, that a counterfeit version of it was soon available for sale within the Haight-Ashbury neighborhood. Not to be had, Helms and his associates, armed with rubber stamps, swarmed the store in which the fake was being sold and impressed upon all the copies they could find the words "Genuine Counterfeit."[54]

Looming deadlines may have made the temptation to lift an image from another source too much for many of the rock poster artists to resist, and in the context of the contemporary American art world, there was no particularly good reason why they should. In the Bay Area, artists of the Beat generation such as Bruce Conner and Jess had for years been drawing upon found objects for both inspiration and content in their assemblage work (pls. 2 and 211, respectively).[55] Robert Rauschenberg, Larry Rivers, and others of the New York School employed a similar strategy, occasionally harnessing technology to enable an endless variation of layered combinations (fig. 25). In both assemblage — shorthand for sculpture made of found materials within the context of twentieth-century art — and collage — in which artists paste together unrelated text and image to form a new original — American artists of the 1960s relied upon the unorthodox juxtaposition of dissimilar and unrelated parts to form a complex, if undecipherable, whole.[56] For the San Francisco rock poster artists such techniques had the added benefit of approximating the psychedelic experience that their posters often implied.

On occasion the poster artists displayed their collages as independent works of art. At the Moore Gallery Joint Show, for instance, Kelley exhibited ten collages that the *Berkeley Barb* described as, "cut-outs from the real world made more real, ranging from the nuclear hell that hangs behind the White House to the soft tones of sweet bodies of time."[57] Thomas Albright likened the same collages to a "psychedelic picture scrapbook of

26
Stanley Mouse and Alton Kelley, Grateful Dead Poster for Warner Brothers album production, 1967. Color offset lithograph poster, 16¾ x 22⅛ in. (42.4 x 56.1 cm).
COLLECTION OF JOHN J. LYONS

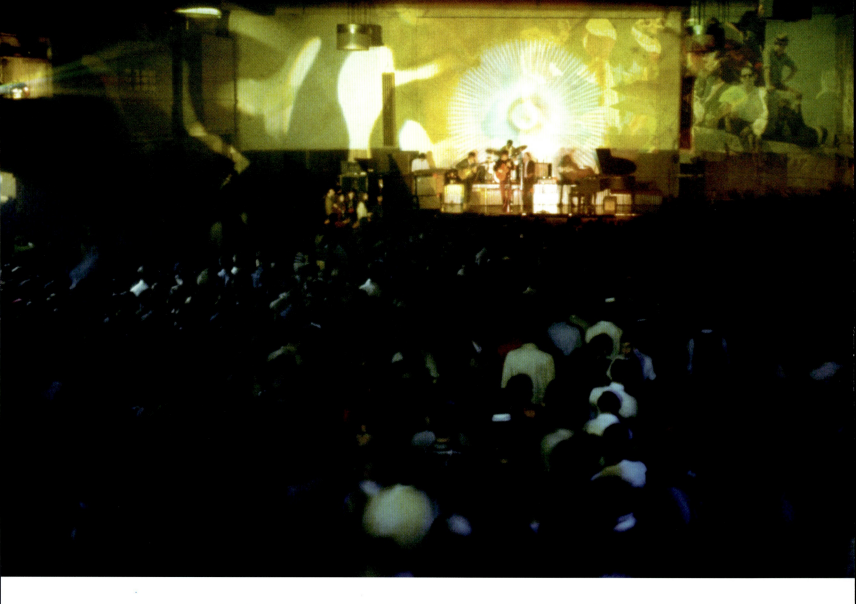

modern history," seeing "Marilyn Monroe pensively posed above a romp of bears, Muhammad Ali looming above an Alpine mountain against a foreground curve of bare white hips, 'John Lennon 2 and the Alps.'" Such juxtapositions suggested to Albright the work of Belgian Surrealist René Magritte, and parallels may also be drawn to the "quick-out montage in contemporary film. . . . Essentially, they are a brilliant synthesis of surrealism and pop, with the eerie verisimilitude of a news photo out of the latest issue of 'Look' magazine."[58]

More often, however, the rock poster artists' collages were used as studies and printing mockups for the posters themselves. Within the San Francisco circle of poster artists, David Singer made greatest use of the collage technique, combining source images that he culled from the popular press to achieve a range of fantastical tableaux. In one made in 1970

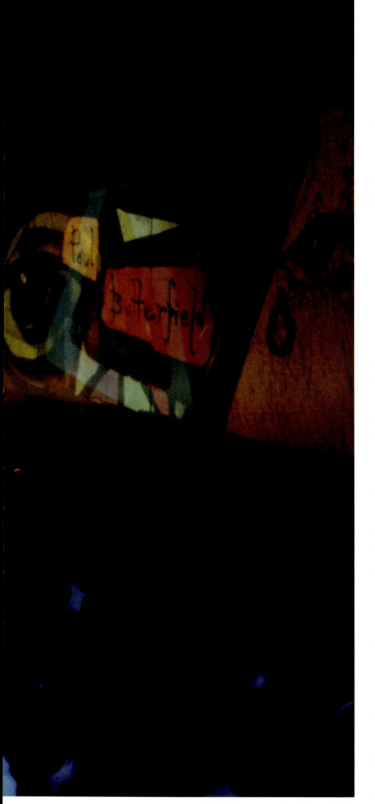

for a Fillmore West concert featuring John Sebastian, Buddy Miles, and Rig, the Statue of Liberty is submerged up to her mouth in water and a four-lane highway meanders off stable land, crossing an expanse of water until it intersects with the figure as if it were her tongue. In another (pl. 210), the corona of a solar eclipse illuminates a figure photographically captured mid-motion, who Singer has positioned within Harold Edgerton's *Milk Drop Coronet*, a 1936 photograph heralded for "freezing time." And in the poster made to commemorate the closing of the Fillmore in 1971, Singer positioned in the foreground a cat stretched up on its hind legs on top of a sleeping dog, while in the background a pair of cat eyes glower out from beneath the ringed-planet Saturn (pl. 261).

Photomontages appeared on the record album covers of the day, too. On occasion, the poster artists were commissioned for this additional work outright, since artists such as Mouse and Kelley — who were the first of the San Francisco poster artists to obtain such an opportunity — had personal relationships with the bands. In fact, for the release of the Grateful Dead's debut album, the band's manager commissioned Mouse and Kelley to design not only the cover (pl. 277), but also a promotional poster that was circulated to promote the album in the Bay Area and enclosed within the album itself (fig. 26). Often, however, it appears that their style was transformed at the behest of studio executives far removed from the Bay Area. As Ralph J. Gleason reported, "Album jackets are being designed wholesale in New York and Chicago and Los Angeles by straight designers who have seen a *Time* picture of a Wes Wilson poster or have read the *Ramparts* hippie article."[59]

To achieve new ends, the San Francisco poster artists manipulated a vast range of source material and certainly found in this postmodern practice of "sampling" an appropriate way to picture their expanding world.[60] Albright considered such actions a direct validation of Marshall McLuhan's theories of media functioning as an "overall, mosaic-like structure, similar to the flashing images of a TV screen, replacing our traditional straight-line, printed page way of seeing things."[61] Additionally, the television images bombarding the generation coming of age in the mid-1960s fostered a so-called "global village" in which art and cultures of the Near and Far East, Africa, and American native cultures were just as relevant to visual expression as the lineage dating back to ancient Greece and Rome.[62] It is undeniable that in the Bay Area the influences of India and Tibet as well as native cultures resonated with the popular practice of meditation to achieve spiritual enlightenment, as well.

Occasionally mind-enhancing substances such as marijuana, peyote, mescaline, and the synthetic

27
A light show covers the walls of Bill Graham's Fillmore Auditorium during a performance, San Francisco, 1966. Photo by Ted Streshinsky

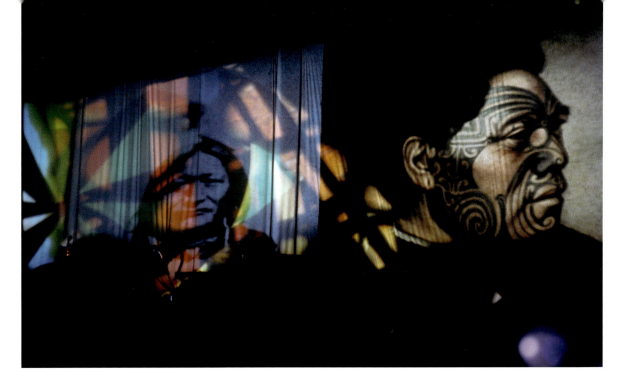

28
North American Ibis Alchemical Company light show, Avalon Ballroom, San Francisco, ca. 1967. Photo by Steve Schapiro

hallucinogen LSD may have aided the poster artist's task, "assisting" particularly in aspects of densely packed patterning and color selection.[63] Certainly the "glow" that Moscoso, Wilson, and others achieved through the juxtaposition of complementary colors was an effect similar to that experienced by users of LSD.[64] "You look at your hand, and it goes in all directions. Its outline is lost, but the colors are beautiful."[65] Though a reporter for *Time* magazine was commenting on the work of Wilson when he used these words of a San Francisco hippie to describe the visual experiences of an LSD tripper, he might equally have had Conklin's 1968 poster for Fillmore West in mind (pl. 220). In this poster — and in others — it is almost as if the design was intended as a surrogate for the dance concert it was charged with promoting. These dance concerts had, by November of 1966, achieved a visual quality unique to San Francisco's music scene (fig. 27) and a parallel social scene thrived. As one reporter for *California Living* magazine explained:

> It is the public dance as psychedelic experience — public dance meaning an amalgam of arts, a Happening, and psychedelic meaning simply "soul-freeing," without chemical reference. To visit the Avalon Ballroom today (and to a lesser extent, at the teeny-boppers' Fillmore Auditorium) is to inhabit an ambiance of strictly sensuous charisma, of extraordinary goodwill.[66]

With its torrent of multicolored shapes superimposed on disembodied heads, Conklin's imagery must have felt familiar to those acquainted with the light show projections that accompanied concerts at the San Francisco music venues. In fact, the relationship of some posters to that of the light show aesthetic was so strong that it led at least one news reporter of the day to remark on his suspicion that a significant visual source of influence was "the fluid patterns of colored light which Anthony Martin and William Ham have been projecting at the dance concerts and at avant-garde concerts hereabouts."[67] Larry Stark's 1968 poster for the Avalon is certainly suggestive of the participatory role played by San Francisco dance-concert attendees (pl. 215); in it, the woman at the center of the image partially dissolves into an abstracted mandala — a favored motif of the period with roots in Indian religions.

With the introduction of the light show to San Francisco's dance concerts early in 1966 — whether liquid, as exemplified by the work of Bill Ham (pl. 219), or multimedia as achieved by Ben Van Meter and Roger Hillyard's North American Ibis Alchemical Company (pl. 238) — concertgoers were enveloped by projections, becoming another part of the show (see Van Meter, this volume). This participatory nature of the San Francisco dance concerts differed from the traditional setup back East, and was, in part, the result of the spatial arrangement of the early venues that Graham and Helms occupied; former ballrooms, the large, vacant spaces called out to be filled by music enthusiasts keen to dance (see Selvin, this volume).

Not only were light shows a way to literally absorb people into the show, they could also provide further opportunities for members of the counterculture to be exposed to appropriated images

combined for unanticipated effect. They also added in the fourth dimension: time. In the hands of Van Meter, Hillyard, and others at the North American Ibis, the light show consisted of liquid light and slide projections as well as color wheels, film, strobe, and other lighting devices (fig. 28).[68] Each member of the group would bring to the performance their own materials, and over the course of the evening they would layer and blend these visual elements to create (in combination with the musicians' sounds) a fleeting *Gesamtkunstwerk*, or universal work of art, that challenged the audience to discover its significance. A hand-drawn mandala of Bruce Conner or an image of the Buddha might be layered over Van Meter's films; a Haight-Ashbury "pilgrim" juxtaposed with a tarot card. The interaction of still imagery further expanded the eyes of the viewer when projections of film, stills, and liquid light were superimposed one upon the other. As Hillyard has recently said of their message to concertgoers at the time: "the world is all one place," a sentiment that was surely shared by young people engaged in promoting social and political change.[69]

Alternative film- and video-makers of the day were also deeply invested in the recombination of images, both found and self-generated. In San Francisco, filmmakers working in this idiom such as Bruce Conner, Lawrence Jordan, Robert Nelson, and Ben Van Meter shared their work with sympathetic audiences through Canyon Cinema, Inc., an organization that they, along with others, founded in 1967 as a distribution company.[70] A master of recombination in his sculptural assemblage and paper collages, Conner also tested its capacity for the moving image. In REPORT (fig. 29), for instance, he relies on the juxtaposition of stock footage of President Kennedy's assassination to implicate players throughout society in the destruction implicit in the contemporary nuclear arms race. Van Meter took an alternative approach in his filmmaking. Rather than splicing together a series of found and appropriated imagery, his preferred technique involved layering his own footage.[71] He found early success in his breakout film *S.F. Trips Festival, An Opening* of 1966

29
Bruce Conner, REPORT, 1963–1967. 16mm film, duration: 13 minutes.
COURTESY OF ANTHOLOGY FILM ARCHIVES, NEW YORK

30
Ben Van Meter, film poster for the documentary *Acid Mantra: A Rebirth of a Nation*, 1968. Color lithograph poster, 41 × 27 in. (104.1 × 68.6 cm).
COURTESY OF BONHAMS

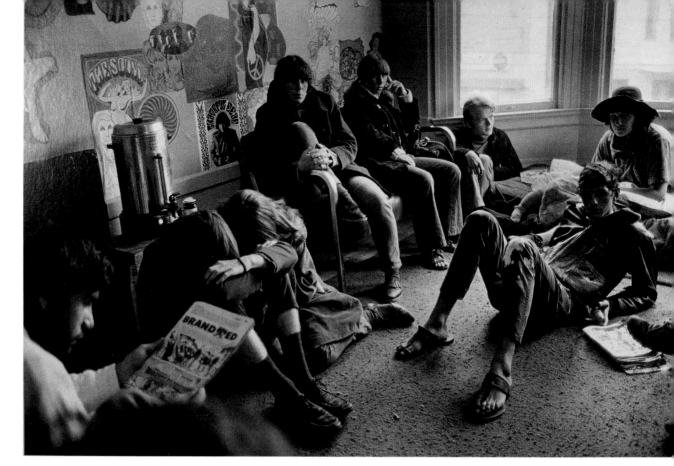

31
558 Clayton Street: The waiting room, ca. 1967. Photo by Elaine Mayes.
COLLECTION OF ELAINE MAYES

32
School bus interior, the week after Monterey Pops, June 1967. Photo by Jim Marshall.
COURTESY OF JIM MARSHALL PHOTOGRAPHY LLC

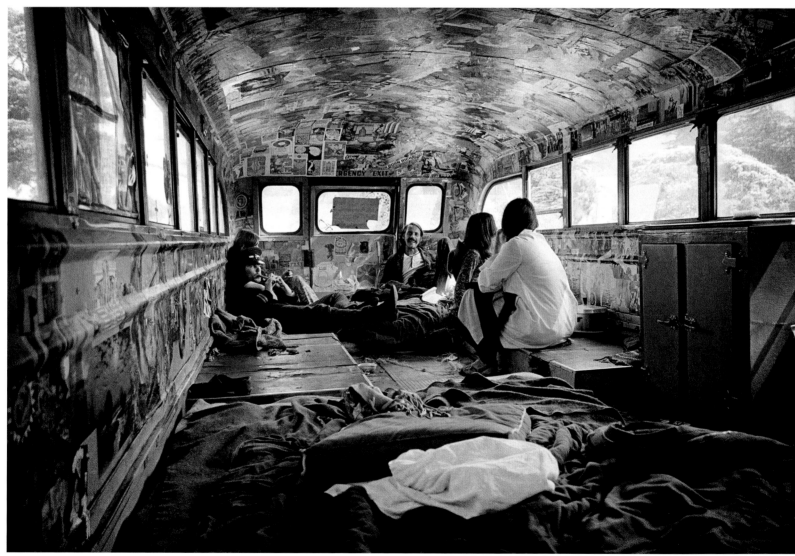

(pl. 27). However, the artist regards *Acid Mantra, or Rebirth of a Nation* (1968), a project that was the result of double- and triple-exposed footage that he shot around the Bay Area during the tumultuous years of 1966 and 1967, as the culmination of his experimentation with multiple exposures; the poster made to publicize the film certainly embodies this mode of visual expression (fig. 30).[72]

With the mass presentation of appropriated and recombined imagery used in San Francisco rock posters, light shows, and experimental film, it is no surprise that the practice would extend beyond the counterculture's visual spokesmen. Just as many of the poster artists created new statements by recombining familiar visual tropes, others aligned with the spirit of the age assembled found text and image to create a powerful form of communication. Disjointed headlines occasionally appeared in the windows of shops and residences throughout the Haight-Ashbury neighborhood, spreading messages of hope and tolerance (for example) as distinct alternatives to those found in the day's mainstream media (pl. 18). Issues of the Haight-Ashbury's psychedelic newspaper, the *San Francisco Oracle,* too, were inundated with printed collage. In the *Youth Quake* issue, a photo collage prefaced an article discussing the clash between hippies and the San Francisco police force in the fall of 1966. And on the cover of the so-called "Houseboat Summit Issue," Paul Kagan's photographs of counterculture intellectuals Allen Ginsberg, Timothy Leary, Gary Snyder, and Alan Watts appear in triplicate, superimposed on one another in descending scale (pl. 114).[73]

Members of San Francisco's counterculture also used collage to create spaces for independent and communal reflection and creative expression. The waiting room, or so-called "calm center" at the Haight-Ashbury Free Medical Clinic was one such public space, with figural fragments of posters by the Big Five and others covering a wall (fig. 31 and pl. 124). Hands, wide open, and those grasping peace symbols reflect the center's mission to serve the medical needs of the young people who descended upon the neighborhood in the summer of 1967. While conventional medical clinics were ill-equipped to respond to the special needs of this subset of the population, namely drug addiction, Dr. David E. Smith and his colleagues made themselves available to assist "bum trippers" twenty-four hours a day for as long as their resources allowed.[74] The waiting room was busy that summer, and the poster wall became not only a focus for young tripped-out minds; it was also something to which additions were periodically made, as a comparison of the photograph by Elaine Mayes and that of Gene Anthony attest.

Private spaces, too, could be sites of creative expression through the recombination of print media. With its unobstructed interior surfaces, the decommissioned school bus, popularized as an inexpensive mobile living space by the exploits of Ken Kesey and the Merry Pranksters, was a prime candidate for such practice. In June 1967, soon after the Monterey International Pop Festival, photographer Jim Marshall captured the interior of one such bus (fig. 32). Emptied of its rows of seats, the bus's interior is strewn with cushions and bedding, a Crock-Pot and cabinet lean up against one wall, and in the back a group of young people chill out. On the walls surrounding them, posters and handbills by the Big Five and their peers abut and overlap reproductions of paintings such as Leonardo da Vinci's *Mona Lisa* and the visages of social and political icons. Text adds another dimension, as words and phrases like "Give," "Born Rich," and "Wrong" are combined with headlines like "How It Feels to Be Brainwashed" and "Mistakes We Make." A hand-drawn glyph, partially askew, changes the declaratory "Emergency Exit" sign into a question. As participants in the San Francisco counterculture melded contemporary graphics and newspaper clippings, they engaged in the continuing evolution of individual and communal identities. Their building

33
The Print Mint, Haight Street, 1967. Photo by Elaine Mayes.
COLLECTION OF ELAINE MAYES

34
Advertisement for
Neutrogena Soap, 1968

blocks could be reminders of memorable dance concerts in which they were active participants, and as such function as souvenirs.[75] Alternatively, their source imagery could simply conjure the youthful optimism that the abstracted notion of the San Francisco dance concert invoked for young people throughout the world.

Posters and handbills for such interior montages could be obtained from a number of sources. By the autumn of 1966, the *Chronicle* reported that the Fillmore distributed 3,000 posters and 6,000 handbills for each dance concert.[76] A year later, the Family Dog is estimated to have printed at least 5,000 posters every weekend.[77] The number of posters printed grew as the period went on, likely due — at least in part — to the realizations of Graham and Helms that people far beyond the Bay Area were interested in the posters, coveting these signifiers of the lively San Francisco scene, even if their physical interaction with it was limited. Displayed in dance clubs in New York, the posters were sold nationally, apparently on a sliding scale, with one newspaper reporting that posters that sold for $1 in San Francisco brought $3.50 in Los Angeles and $5 in New Jersey poster shops.[78]

It was not by chance that Graham, Helms, and others settled on an advertising strategy based in posters and handbills, rather than, largely speaking, in billboards, television spots, or advertisements taken out in local mainstream periodicals.[79] They understood well the power of the medium. As the eminent cultural theorist Susan Sontag has rightly observed, "A poster claims attention — at a distance. It is visually aggressive. . . . The form of the poster depends on the fact that many posters exist — competing with (and sometimes reinforcing) each other."[80] The promoters' choice of posters also says something of the target audience and their social scene in the Haight. By their physical nature, posters can attract the attention of slowly moving passersby, but the message is quickly lost when speed is increased. The poster can therefore be most successful in conveying its message when deployed in highly pedestrianized areas such as the Haight-Ashbury. Tacked on telephone poles and pasted in shop windows throughout the Haight and college campuses around the Bay Area, the poster was the ideal medium for the message, assuming, of course, that it remained posted.

In the summer of 1966, it was Graham's practice to staple the advertisements for his folk-rock happenings to light poles. He observed, however, that no sooner had they gone up than they would be taken down. As David Swanston wrote for the *San Francisco Chronicle* in November 1966, Graham stapled up 150 posters along Berkeley's Telegraph Avenue, only to find that three remained after he had finished a cup of coffee.[81] Posters were also snapped up when they were posted around San Francisco State College's campus, disappearing within an hour of their appearance.[82] If aficionados were not in the right place at the right time, they could look for the posters in local head, music, or poster shops such as the Print Mint (fig. 33 and pls. 103–105). They could also go right to the source, the venue itself. They might even catch a glimpse of the posters in the windows of any number of shops and boutiques that catered to the young audience that Graham and Helms wished to reach. And, if feeling acquisitive, they could ask a store clerk or manager to set the poster aside

when its advertising function had passed, as "Andy" evidently did in 1967 (fig. 21).

The posters advertised a lifestyle as much as an event, and their style targeted a self-selecting audience. Swanston observed a tourist peering at a poster in a Haight-Ashbury shop window, bemusedly questioning the advertising value of a poster that cannot be read. "It seems silly," the tourist said, "to make a poster that people can't even read."[83] But of course it was not this person who Wilson and others hoped to address. The "illegible," "pyrotechnic calligraphy" embedded in the poster designs spoke to the intended audience while remaining incomprehensible to "straight" society.[84]

Counterculture's claim to the style was not, however, to last. Within months of its first appearance, it would be co-opted for the national advertisement of products as banal as cottage cheese, gum, and soap (fig. 34), and the counterculture would find new ways of expressing its constantly evolving self. Nonetheless, combined with imagery appropriated from a range of sources, San Francisco's rock posters became important signifiers of the city's counterculture in the years not only surrounding the Summer of Love but also into our present time. Even in the period, there was a sense that this would be so. Helms believed the posters to be, as one reporter synthesized, "The expressive mechanism for a whole generation."[85] For when the music ended and the lights came on, what remained was a series of innovative graphics that could instantly transport the scene's participants back to a time and place where creative freedom mingled with the rarefied idealism for which San Francisco continues to be known. ✿

1. Jon Borgzinner, "The Great Poster Wave," *Life*, September 1, 1967, 36.
2. James L. Baughman, "Who Read *Life*? The Circulation of America's Favorite Magazine," in *Looking at Life Magazine,* edited by Erika Doss (Washington [D.C.]: Smithsonian Institution Press, 2001).
3. Borgzinner, "Great Poster Wave," 36.
4. Thomas Albright, "The Death of the Great Poster Trip," *Rolling Stone,* May 25, 1968, http://www.rollingstone.com/culture/features/the-death-of-the-great-poster-trip-19680525.
5. The term "counterculture" originated within the Academy, but found its way into the mainstream with the 1969 publication of historian Theodore Roszak's best-selling book *The Making of a Counter Culture: Reflections on the Technocratic Society and Its Youthful Opposition.* By the end of the decade, it was understood to refer to a social group (usually consisting of young people) bent on reimagining the day's political agenda and social order. Michael J. Kramer, *The Republic of Rock: Music and Citizenship in the Sixties Counterculture* (Oxford: Oxford University Press, 2013), 9.
6. Jean Progner and Patricia Dreyfus, "The Poster Revolution: Artifact into Art," *Print* 25, no. 4 (July/August 1971): 82.
7. As quoted in Elizabeth E. Guffey, *Posters: A Global History* (London: Reaktion Books, 2015), 156.
8. Throughout 1967, Funky Sam crisscrossed the country, bringing San Francisco psychedelic posters to music and poster shops in major cities and college towns. Sam described his product to the *Saturday Evening Post*, "I'm a-selling of that good old rock baroque, I'm selling pretties and meanings, it's the psychedelic cultural revolution. . . . This is Obscenity Junction where we bend your minds." Herbert Gold, "Pop Goes the Poster," *Saturday Evening Post,* March 23, 1968, 34.
9. The Oakland Museum received a gift of posters from Bill Graham in June 1967, while in 1968 New York's Museum of Modern Art began their collection through both purchase and gift. That year they organized the exhibition *Word and Image: Posters and Typography from the Graphic Design Collection of the Museum of Modern Art, 1879–1967,* which included posters by Moscoso and Wilson. The first artworks related to the San Francisco rock poster scene to enter the Fine Arts Museums of San Francisco's collection were mechanicals for the preparation of Wilson's posters *"A Tribal Stomp"* and *"The Sound."* The bulk of the museum's posters came through purchase in 1972 and 1974. Significant gifts were made to the museum in 1996 and 1997. The 2017 gift of Gary Westford has further transformed the museum's holdings, expanding the collection beyond the BG (Bill Graham) and FD (Family Dog) sequences.
10. Thomas Albright, "A Psychedelic Flowering," *San Francisco Examiner,* July 16, 1967.
11. George Hunter and Engrid Barnett, in conversation with the author, Legion of Honor, San Francisco, June 17, 2016. Barnett has written extensively about the performance and styling of the Charlatans at the Red Dog Saloon in "Rockin' the Comstock: Exploring the Unlikely and Underappreciated Role of a Mid-Nineteenth Century Northern Nevada Ghost Town (Virginia City) in the Development of the 1960s Psychedelic Esthetic and 'San Francisco Sound'" (PhD diss., University of Nevada, Reno, 2014).
12. Christian A. Peterson discusses the role of these and other photographs in rock posters of the period in "Photographic Imagery in Psychedelic Music Posters of San Francisco," *History of Photography* 26, no. 4 (2002): 319, doi: 10.1080/03087298.2002.10443305.
13. Popular histories of the group describe the origins of their moniker coming from the original

members' home at the "Dog House" (pl. 271), a rooming house at 1836 Pine Street managed by Bill Ham, who would soon go on to liquid light show fame. As photographer Gene Anthony attests, early on, everyone at the rooming house had a dog, hence the name. Gene Anthony, *The Summer of Love: Haight-Ashbury at Its Highest* (San Francisco: Last Gasp, 1995), 48.

14 Ralph J. Gleason, "Wild Weekend Around the Bay," *San Francisco Chronicle*, October 18, 1965.

15 Quoted in Ralph J. Gleason, "Another Dancing Generation," *San Francisco Examiner*, October 16, 1966.

16 Quoted in John Glatt, *Live at the Fillmore East and West: Getting Backstage and Personal with Rock's Greatest Legends* (New York: Lyons Press, 2016), 43.

17 Sally Tomlinson, "Psychedelic Rock Posters: History, Ideas, and Art," in *The Portable Sixties Reader*, ed. Ann Charters (London: Penguin Books, 2003), 296. In his role as leader of the Family Dog, Helms would go on to organize shows at San Francisco's Carousel Ballroom and in 1969 off San Francisco's Great Highway at the old Playland at the Beach amusement park, where as part of the doomed cooperative Wild West Festival, he became embroiled in a labor dispute with members of the Light Artists Guild, who sought recognition for the visual contributions they made to the dance concerts. Historian Michael J. Kramer recounts this and other details of the San Francisco music scene in *The Republic of Rock*, 94–129.

18 "Mimers' Director Arraigned," *San Francisco Chronicle*, August 10, 1965.

19 For first-person accounts by some of the major figures associated with planning the event and subsequent appeals, see Bill Graham and Robert Greenfield, *Bill Graham Presents: My Life Inside Rock and Out* (Cambridge, MA: Da Capo, 2004), 119–132.

20 The same "boxing style" was used for posters in virtually all of rock and roll's early period, dating 1955 to 1965. Paul Grushkin, *The Art of Rock: Posters from Presley to Punk* (New York: Artabras, 1987), 10. In late-1960s San Francisco, where the rock musicians were not yet celebrities, lived amongst their countercultural fans, and performed on ballroom floors rather than elevated on a stage, a preference emerged for a more creative approach to advertising, one that did not so consistently rely on headshots and staged concert photographs. Peterson, "Photographic Imagery," 318.

21 The brainchild of Kesey, "Acid Tests" were designed to spread insider knowledge of LSD, as well as a taste for the drug itself. At the early tests at his home in La Honda and on West Coast college campuses, Kesey prosthelytized the mind-altering substance's effect on perception and offered participants the opportunity to break free of unnatural (traditional) institutions and social structures. When Kesey added the groundbreaking San Francisco rock group the Grateful Dead and light shows to the mix, he engaged participants' auditory and visual senses, masterminding what he called "trips." Kesey, the Merry Pranksters (his followers), and their LSD-inspired antics were the subject of Tom Wolfe's acclaimed *Electric Kool-Aid Acid Test*, first published in 1968. See also McNally, this volume.

22 Contact Printing was also the printer of record for the Mime Troupe benefit posters, but in his autobiography Graham remembers first meeting Wilson at the Trips Festival. See Graham and Greenfield, *Bill Graham Presents*, 162.

23 A new *Batman* television series premiered in the winter of 1966, with the season finishing just a few days before Graham's event.

24 Quoted in Graham and Greenfield, *Bill Graham Presents*, 162.

25 See Marshall McLuhan, *The Gutenberg Galaxy: The Making of Typographic Man* (Toronto: University of Toronto Press, 1962) and *Understanding Media: The Extensions of Man* (Corte Madera, CA: Gingko Press, 2003) (originally published 1964). This statement is heavily informed by historian Mark Watson, who positions McLuhan as a major figure in the cultural appropriation of Native American cultures within the 1960s counterculture in "The Countercultural 'Indian': Visualizing Retribalization at the Human Be-In," in *West of Center: Art and the Counterculture Experiment in America, 1965–1977*, eds. Elissa Auther and Adam Lerner (Minneapolis and London: University of Minnesota Press, 2012), 209–223.

26 "Happy Hippie Hunting Ground" is part of *Life* magazine's cover story "Return of the Red Man," which appeared December 1, 1967; "The Community of the Tribe" appeared in the February edition of the *San Francisco Oracle*.

27 The phrase is Watson's. "Countercultural Indian," 212.

28 Watson contextualizes the design of this poster within the larger cultural movement. Ibid., 209–213.

29 Moscoso tells the story of the logo's development in John Mackie, "A San Francisco Psychedelic Icon, from B.C.: Early Postcard Ended Up Gracing City's Music Scene," *Vancouver Sun*, April 8, 2016, http://vancouversun.com/news/local-news/a-san-francisco-psychedelic-icon-from-b-c.

30 Josef Albers, *Interaction of Color*, rev. and exp. ed. (New Haven and London: Yale University Press, 2006), 1.

31 Nicole Rudick, "Only the Dreamer: An Interview with Victor Moscoso," *Paris Review*, March 30, 2015, http://www.theparisreview.org/blog/2015/03/30/only-the-dreamer-an-interview-with-victor-moscoso/.

32 Warren Hinckle, "A Social History of the Hippies," *Ramparts*, March 1967, 24.

33 David Swanston, "Bay Area's Own Poster Revolution," *San Francisco Chronicle*, November 3, 1966.

34 One of the earliest national stories to emphasize this aspect of the San Francisco rock poster design was "Nouveau Frisco," *Time*, April 7, 1967, 88.

35 Moscoso's style is an adaptation of Playbill, a font designed by Robert Harling in 1938 that took inspiration from "Wanted" posters of the Wild West. Under Moscoso's hand, the Wild West meets the psychedelic through the creative stretching (in length and width) of serifs.

36 Dugald Stermer, "Rock Posters," *Communication Arts Magazine* 9, no. 3 (1967): 63.

37 Rudick, "Only the Dreamer."

38 Quoted in Geoffroy Link, "Influences of Psychedelic Art Reach Far and Wide," *Lowell Sun*, November 17, 1967.

39 Wes Wilson adapted a drawing by the German cartoonist Heinrich Kley for his 1966 Fillmore poster.

40 Throughout his posters, Griffin uses variations on a range of old typefaces — from Gold Rush to Bank Note, P. T. Barnum to Jim Crow — often selecting more than one to achieve an amalgamation similar to that contained in late-nineteenth-century advertising.

41 Quoted in Link, "Influences of Psychedelic Art."

42 The "San Francisco Sound" has become common parlance when characterizing the unique musical content of the bands that played San Francisco in the years around the Summer of Love; however, the moniker was not widely recognized in the period. In the autumn of 1966, the name for music played by San Francisco bands was very much in flux: rock and roll, folk-rock, mod, and mod-rock had all been bandied around, but in November of that year Chet Helms, drawing upon a central blues component, called it Apocalyptic Blues. R. B. Read, "These Are the Boys . . . ," *California Living, San Francisco Sunday Examiner and Chronicle*, November 29, 1966.

43 The same painting was used more literally in two other rock posters, one by Wilson and the other by Mouse and Kelley (pl. 185), both of 1966.

44 Leary popularized the phrase in 1966, recording an eponymous spoken-word album in which the intellectual shared his views on the world. Early the next year he famously reiterated the statement to the crowds gathered in Golden Gate Park for the Human Be-In. Leary later clarified the meaning in his autobiography:

> Turn On *meant go within to activate your neural and genetic equipment. Become sensitive to the many and various levels of consciousness and the specific triggers that engage them. Drugs were one way to accomplish this end.*
>
> Tune In *meant interact harmoniously with the world around you — externalize, materialize, express your new internal perspectives.*
>
> Drop Out *suggested an active, selective, graceful process of detachment from involuntary or unconscious commitments. Drop Out meant self-reliance, a discovery of one's singularity, a commitment to mobility, choice, and change. . . . Unhappily my explanations of this sequence of personal development were often misinterpreted to mean "get stoned and abandon all constructive activity."*

Timothy Leary, *Flashbacks: A Personal and Cultural History of an Era: An Autobiography* (New York: Putnam, 1990), 253. The phrase was not his, however. In a 1988 interview with Neil Strauss, Leary acknowledged that it was, in fact,

McLuhan's phrase, the media theorist having shared it with him at a lunch in New York. Neil Strauss, *Everyone Loves You When You're Dead: Journeys Into Fame and Madness* (New York: It Books, 2011), 337.

45 Albright, "Psychedelic Flowering."

46 See, for example, Warren R. Young, "Op Art: A Dizzying, Fascinating Style of Painting," *Life*, December 11, 1964, 132–40. In 1965, the Columbia Broadcast System (CBS) broadcast the half-hour special *The Responsive Eye*, written and produced by Gordon Hyatt and presented by Mike Wallace. The show included not only a description of the MoMA exhibition, but also an explanation (in layman's terms) of the optics therein featured.

47 Graham and Greenfield, *Bill Graham Presents*, 163.

48 Bob Schnepf, in conversation with Victoria Binder, February 18, 2016.

49 The internationality of Pop Art — often simplified as an American and British art movement — was recently the subject of exhibitions organized by the Tate Modern and the Walker Art Center. See *The World Goes Pop*, eds. Jessica Morgan and Flavia Frigeri (New Haven and London: Yale University Press, 2015) and *International Pop*, eds. Darsie Alexander and Ryan Bartholomew (Minneapolis: Walker Art Center, 2015).

50 Alton Kelley was forthright in his acknowledgment of sources. In a press conference given in advance of the Moore Gallery's Joint Show, he declared, "I've been influenced by all the arts — especially television. I got more out of television than I did at school." Reported in Thomas Albright, "An Artful Confrontation: Poster People Meet Press," *San Francisco Chronicle*, July 12, 1967.

51 Just three weeks later, Detroit-based poster artist Gary Grimshaw further manipulated the Morse photograph, using it to entice that city's youth to concerts on October 21 and 22 featuring MC5 and the Prime Movers Blues Band at the Grande Ballroom.

52 For more on the history of Zig-Zag's Zouave, see "Story of Le Zouave and Zig Zag," Zig-Zag website, accessed October 14, 2016, https://www.zigzag.com/story.

53 For an example of one of their ads, see *En Ville: The Business Family Paper*, September 2, 1968, https://news.google.com/newspapers?nid=2277&dat=19680902&id=F2wmAAAAIBAJ&sjid=-VQDAAAAIBAJ&pg=4347,3012170.

54 Eric King, *The Collector's Guide to Psychedelic Rock Concert Posters, Postcards and Handbills 1965–1973*, vol. 1, 10th ed. ([Berkeley?]: self-published, 2011), 48.

55 As Lisa Phillips explained in an anthology on Beat culture, Beat artists' work offered a visual equivalent to the realism inscribed by Beat authors such as Jack Kerouac and Allen Ginsberg. See "Beat Culture: America Revisioned," in *Beat Culture and the New America: 1950–1965* (New York: Whitney Museum of American Art, 1995), 39.

56 Curator William C. Seitz acknowledged the new art form in his now-historic exhibition at New York's MoMA in 1961. Titled *The Art of Assemblage*, the exhibition located contemporary assemblage practices within the art historical continuum, observing a lineage from artistic and literary movements such as Cubism, Futurism, Dadaism and Neo-Dadaism, and Surrealism. Where Seitz observed the work of the Assemblage artists differing from their predecessors was in two primary categories, identifying them as:

> (1) They are predominately *assembled* rather than painted, drawn, modeled, or carved.
> (2) Entirely or in part, their constituent elements are preformed natural or manufactured materials, objects, or fragments not intended as art materials.

William C. Seitz, *The Art of Assemblage* (New York: Museum of Modern Art, 1961), 6.

57 "Hippies Afield," *Berkeley Barb*, July 14, 1967.

58 Thomas Albright, "Spirit of Mother Lode, MAD and the Circus," *San Francisco Chronicle*, July 20, 1967.

59 Ralph J. Gleason, "The Influence of Hippie Art," *San Francisco Chronicle*, June 4, 1967.

60 Musicians in bands popularly considered as part of the "San Francisco Sound" participated in their own forms of appropriation too, drawing upon folk and blues, classical and pop, as well as a range of instrumentation such as harpsichord, cello, sitar, and *dilruba* not generally found in Western rock music of the period. Simon Reynolds, "Love or Confusion: Psychedelic Rock in the Sixties," in *Summer of Love: Art of the Psychedelic Era*, ed. Christoph Grunenberg (London: Tate Publishing, 2007), 147. See also Selvin, this volume.

61 Albright, "Psychedelic Flowering."

62 Thomas Albright, *Art in the San Francisco Bay Area, 1945–1980, An Illustrated History* (Berkeley and Los Angeles: University of California Press, 1985), 169.

63 To the press, Mouse acknowledged that he discovered "where it's really at when I got stoned," and Griffin admitted that his experience with psychedelics "intensified" the vision that had previously derived from "engravings in old books." Albright, "Psychedelic Flowering."

64 See James T. Carey, *The College Drug Scene* (Englewood Cliffs, NJ: Prentice Hall, 1968), 38.

65 "Nouveau Frisco," 69.

66 Read, "These Are the Boys. . . ."

67 "Looking for Art on Poster Scene," *San Francisco Chronicle*, January 17, 1967.

68 John J. Lyons is currently working with Ben Van Meter, Roger Hillyard, and others to document the various activities of the group in the year of its existence. Their book project is titled "Rebirth of a Nation," after the name of Van Meter's 1968 documentary. The author thanks John J. Lyons and Ben Van Meter for generously sharing their work.

69 Roger Hillyard, interview by John J. Lyons, unpublished transcript of "Liquid Magic: The Art and Journey of Roger Hillyard" for "Rebirth of a Nation," 8.

70 A history of the cooperative exists in the work of Scott MacDonald, *Canyon Cinema: The Life and Times of an Independent Film Distributor* (Berkeley: University of California Press, 2008).

71 Van Meter got his start in a photography class at San Francisco State College in 1963, defacing his negatives, printing, and then hand coloring the prints before photographing the prints and starting the whole process over until satisfied with a print's visual features. Lyons, "Rebirth of a Nation," 10. See Van Meter, this volume.

72 Ibid., 29.

73 *San Francisco Oracle*, April 1967.

74 David E. Smith and John Luce wrote a history and explanation of the Free Clinic in 1970, accompanied by photographs by Elaine Mayes, including some in this exhibition (pls. 51, 52, and 68). See *Love Needs Care: A History of San Francisco's Haight-Ashbury Free Medical Clinic and Its Pioneer Role in Treating Drug-Abuse* (Boston: Little, Brown, 1971). The term "bum trippers" comes from a sign posted on the Free Clinic door visible in Ruth Marion Baruch's 1967 photograph *"560 568" (sign), Haight Ashbury* (pl. 123).

75 Literary theorist Susan Stewart theorizes nostalgia and the role of the souvenir in the construction of an imagined past in *On Longing: Narratives of the Miniature, the Gigantic, the Souvenir, the Collection* (Durham, NC: Duke University Press, 1993), esp. 132–151.

76 Swanston, "Bay Area's Own Poster Revolution."

77 King, *Collector's Guide*.

78 Link, "Influences of Psychedelic Art." In 1967, the editor of *Communication Arts* added a postscript to an article on the rock poster, offering to send a selection of posters reproduced in the story to readers at a cost of $1.25 per poster (minimum two). See Stermer, "Rock Posters," 68.

79 One exception is the Robert Fried billboard that Chet Helms commissioned in 1969, in an attempt to keep the Family Dog visible while they waited for permit approvals for their new venue on the Great Highway (pl. 224).

80 Susan Sontag, "Posters: Advertisement, Art, Political artifact, Commodity," in *Looking Closer 3: Classic Writings on Graphic Design*, eds. Michael Bierut, Jessica Helfand, Steven Heller, and Rick Poynor (New York: Allworth, 1999), 196.

81 Swanston, "Bay Area's Own Poster Revolution."

82 Ibid.

83 Ibid.

84 "Pyrotechnic calligraphy" is Read's phrase in "These Are the Boys " In sociological terms, the posters became part of what Basil Bernstein has described as a restricted code. The restricted code stands opposed to the elaborated code; in the former, the speaker (or writer) assumes an audience well versed in a given subject and may speak in abbreviated terms, while in the latter, less knowledge is assumed and therefore more information is included. See Bernstein, *Class Codes and Control: Theoretical Studies Towards a Sociology of Language* (London: Routledge & Kegan Paul, 1971).

85 Read, "These Are the Boys. . . ."

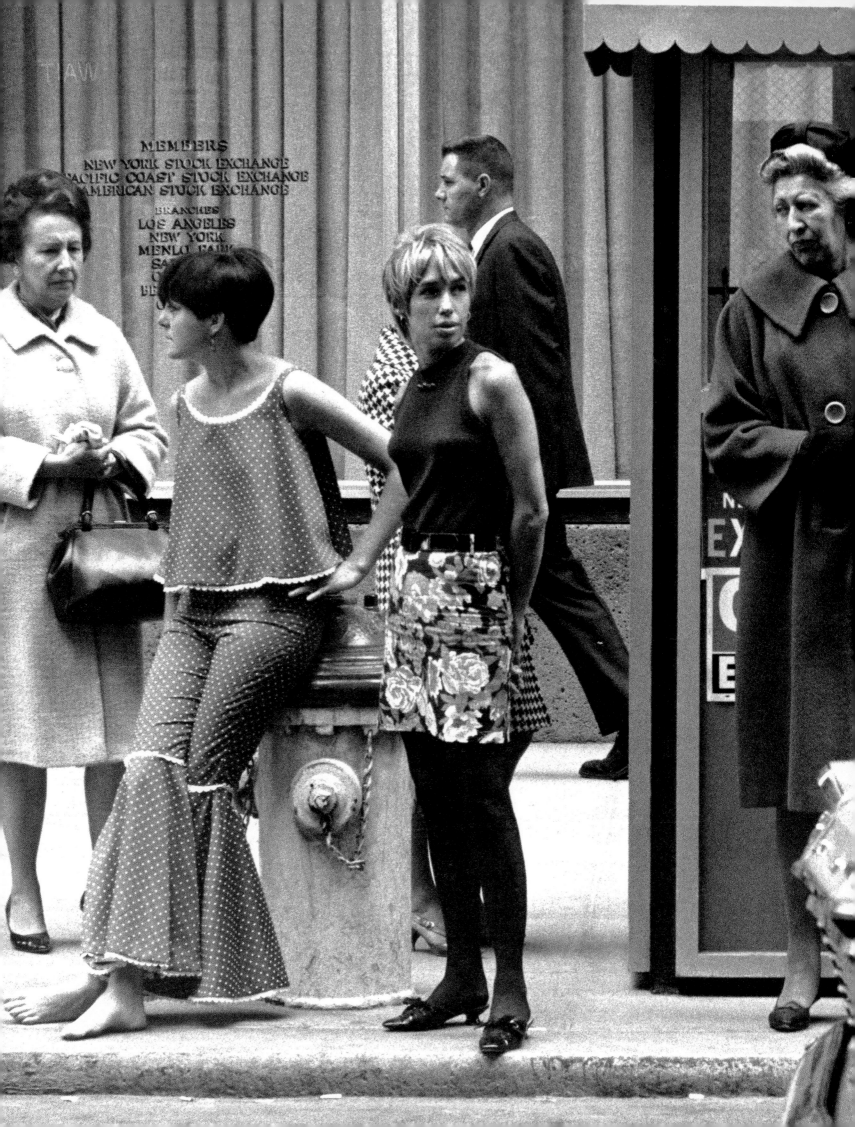

stitching a new paradigm

dress codes of the counterculture

JILL D'ALESSANDRO

THE SUMMER OF LOVE was far more than just a summer in 1967, and half a century later its cultural influence still resonates. The art and fashion associated with it, which were closely tied together, had deep roots that far preceded it and only reached their full fruition years later. Initially largely centered in the San Francisco Bay Area — especially in Marin County, just north of the city of San Francisco — this material culture quickly extended to national and international awareness.

What we think of as the fashion associated with the Summer of Love — and the hippie movement as a whole — comprises many unique elements that were particular to this place and time. Fluxus artist Jeff Berner described this zeitgeist in his "Astronauts of Inner Space" column for the *San Francisco Chronicle:* "There has never been a tribe of young people in history which took so much interest in life and its kaleidoscope of forms: Zuni culture, Oriental music, Zen, Nineteenth-Century British Digger Socialism, jazz, electronic composition, magics and religions from everywhere."[1] The sartorial result was an efflorescence of independent designers — many of whom would never describe themselves with that term — working with a wide array of materials such as denim, cotton, leather; techniques such as embroidery, crochet, and tie-dye; influences such as textile art, international travel, religion, Native American culture; and new outlets to present their fashions such as boutiques, happenings, dance

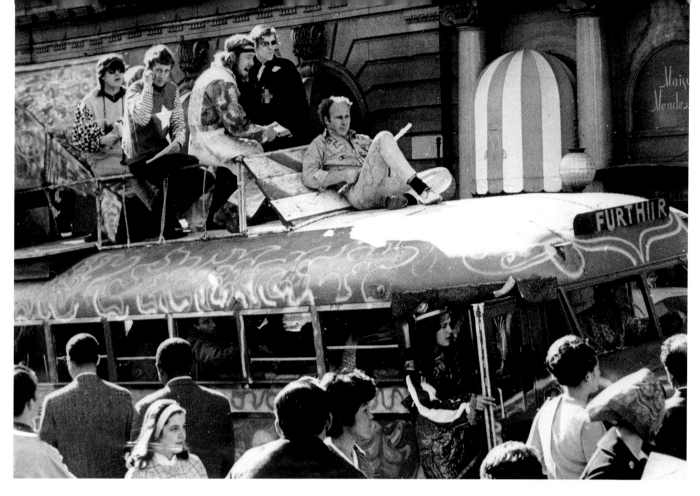

35
The Merry Pranksters (left to right: Ron Bevirt [Hassler], Steve Lambrecht [Zonker], Laird Grant, Page Browning, Ken Kesey, Carolyn Adams [Mountain Girl] in doorway, and Neal Cassady at the wheel) on their bus "Further," San Francisco, ca. 1966–1967. Photograph by Joe Rosenthal

concerts, and, most visibly, musicians. In a series of interviews with the author, the living designers from the era related their personal histories and discussed their myriad threads of influence, offering a matchless perspective on the age.

"Changes are going down in America. Music and fashion are the most obvious — the two, which eventually force the issue and give an indication of which side of the line you're on," wrote Baron Wolman in his letter from the editor in the 1970 inaugural issue of *Rags* magazine, a San Francisco–based street fashion magazine founded by the rock photographer-cum-magazine editor. During the late 1960s, America was at a crossroads: the baby boomer generation was coming of age, grappling with the advancing technological world and striving to create new societal paradigms while still responding to 1950s notions of domesticity.[2] It was also a time of great prosperity for the country and, despite the threat of war and social upheaval, it was a time of boundless optimism.[3] Susila Ziegler, a Marin boutique owner who was married to Grateful Dead drummer Bill Kreutzmann from 1967 to 1978, described this moment, "It started out so easy, trying to make a living or be active. It was magic, it was total magic. It was a very innocent time. We were baby boomers. Our families had gone through the war and they were giving us everything they never had"[4] (see McNally,

this volume). For artists and designers this affluence nourished personal expression and creative freedom, resulting in wildly individualistic forms of dress that reflected each person's singular philosophy.

In *The Electric Kool-Aid Acid Test,* author Tom Wolfe evoked a vivid picture of the participants at the Acid Test Graduation on Halloween night of 1966 at a warehouse in San Francisco, the culmination of the psychedelic parties thrown by counterculture icon Ken Kesey and the Merry Pranksters (fig. 35):

> Their faces are painted in Art Nouveau swirls, their Napoleon hats are painted, masks painted, hair dyed weird, embroidered Chinese pajamas, dresses made out of American flags, Flash Gordon diaphanous polyethylene, supermarket Saran Wrap, Indian-print coverlets shawls Cossack coats sleeveless fur coats piping frogging Bourbon hash embroidery serape sarongs saris headbands bows batons vests frock coats clerical magisterial scholar's robes stripes strips flaps thongs Hookah boots harem boots Mexicali boots Durango boots elf boots Knight boots Mod boots Day-Glo Wellington Flagellation boots beads medallions amulets totems polished bones pigeon skulls bat skeletons frog thoraxes dog femurs lemur tibia kneecap of a coyote. . . . These costumes aren't for a Halloween party

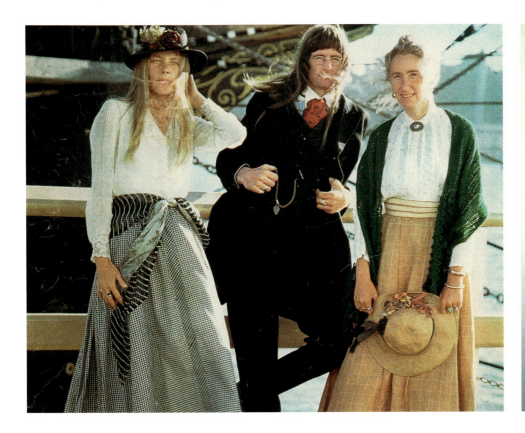

but for the liberation of dead souls . . . churchly vestiture, in truth.⁵

This description captures the frenzied playfulness of the blossoming counterculture fashion, especially the overriding impulse to borrow from faraway places, and illustrates the mélange of styles worn. It was an anything-goes attitude that embraced items ranging from bold print dresses adapted from mod London to blue jeans to ethnic imports, but perhaps most characteristic of San Francisco's emerging bohemian fashion was "old timey," or vintage dress.

OLD TIMEY DRESS

During the 1960s, the San Francisco Redevelopment Agency, led by Justin Herman, waged an urban renewal campaign that disrupted the Western Addition, the neighborhood adjacent to Haight-Ashbury. Some 2,500 Victorian homes were torn down, and as a result, the city's thrift stores, antique shops, street vendors, and flea markets were brimming with vintage clothes and collectibles. Scavenging was so prevalent by 1971 the *San Francisco Chronicle* ran numerous articles offering tips on the best scavenging locales and advice from a San Francisco police sergeant on how to do it legally.⁶

But it was perhaps when the Charlatans, the progenitors of the city's psychedelic sound, impeccably adopted the nineteenth-century dress of Victorian dandies and Wild West gunslingers, that old-timey styles became an identifier of the counterculture (see Terry, this volume). Founding member George Hunter explained, "Initially, we were searching for an identity. We wanted to promote something that was uniquely American and identified us as from San Francisco as opposed to being an imitation of the British, which is what everyone else was doing."⁷ When Jean and Charlie Stewart opened the Third Hand Store in the summer of 1967, Susan Olsen, wife of Charlatans bass player Richard Olsen, joined them as a partner. Believed to be the first vintage clothing store in San Francisco, it emerged from the overflow of discarded treasures the Stewarts had found and soon became a destination for the bohemian set looking for something rare and unusual.⁸ An article in *Rags* theorizes the appeal of retro fashions, "The prime reason is probably the ability old clothes have to transport the wearer back in time and transform him into anything he wants to be. It's a fantasy trip with no bummers — if you don't mind the stares you get on the bus."⁹ Correlating the vintage clothing trend to a revived interest in Americana, the piece continued, "It's the American compulsion for understanding ourselves, for digging into our roots to find out where we all come from and what that means about where we are."¹⁰ And while both the Stewarts and the Charlatans tended to dress with a sophisticated period-inspired aplomb (fig. 36 and pls. 7–8), many others altered their vintage pieces and adapted them to current silhouettes, for example, shortening 1920s dresses

36
Acacia Dries, Charlie Stewart, and Jean Stewart wearing vintage dress, 1974. Printed in *Amica* (August 1974)

37
Cicely Hansen, now the proprietor of the vintage boutique Decades of Fashion on Haight Street, wearing an Edwardian top on her way to the Monterey International Pop Festival in Monterey, California, June 16, 1967.
COLLECTION OF CICELY HANSEN

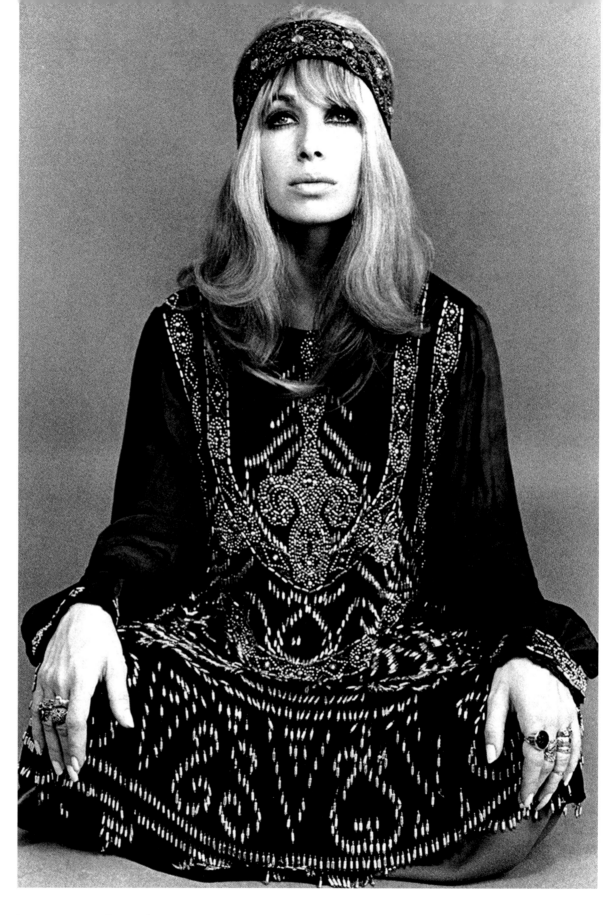

38
Helene Robertson in a 1920s dress, ca. 1970. Photo by Lloyd Johnson.
COLLECTION OF HELENE ROBERTSON

into minidresses (pl. 299); adding sleeves to a dress and wearing it over pants (pl. 193); or simply wearing just the bodice of a two-piece ensemble (fig. 37 and pl. 298). However, it is Jerry Garcia's "Captain Trips" hat (pl. 262) that may most aptly reflect the impulse to wear customized vintage pieces. The original 1883 top hat was manufactured by one of the leading American hatters of the late nineteenth century, the New York–based Dunlap & Co, whose 1890s advertisements declared, "To the hat-purchasing public the words 'Dunlap,' 'Style' and 'Quality' are synonymous." The silk hat, later painted in red

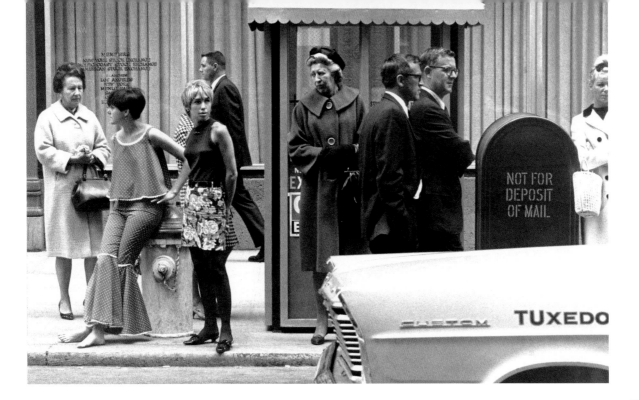

and white stripes and embellished with a miniature American flag and striped ribbon, became the quintessential icon of the counterculture's patriotic spirit, at once ironic and hopeful.[11]

BOUTIQUES

Born and raised in Hawaii, Helene Robertson (fig. 38) was working as a photographer's assistant in Los Angeles in 1961, but made frequent trips to Sausalito with her friends from the Big Island, folk musicians Cyrus Faryar, Bobby Shane, and Dave Guard. She became enchanted with the vibrant, colorful little town, and when her friends moved north to play with Nick Reynolds and the Kingston Trio (see Selvin, this volume), she joined them. Having frequented the small boutiques in Los Angeles, Robertson decided that what Sausalito needed was a funky little dress shop that would cater to the bohemian lifestyle at an affordable price and she was just the one to open it. "I would have done almost anything to live in Sausalito and go barefoot all day," Robertson told *Mademoiselle* magazine in 1964.[12]

Her parents supported her in the venture and even uprooted their lives in Hawaii to join her in Sausalito. With a $1,000 loan from her father, Robertson opened her boutique in 1962 with clothes exclusively designed and sewn by her and her mother. They stocked Anastasia's — so named because it sounded old-fashioned, kooky, and elegant — with shift dresses made from checked tablecloths and pants without side seams, and on their opening weekend they practically sold out. Robertson realized that she and her mother, who had sewn all of her daughter's clothes since childhood, would not be able to keep up with the demand, so she began sourcing styles in hip Los Angeles boutiques — minidresses, bikinis, hip huggers, and fitted sweaters — in addition to making their own designs.[13] *Mademoiselle* described the shop's decor as early Goodwill, with artificial flowers spilling out of the drawers of a treadle sewing machine and clearance items dumped into a steamer trunk.[14] Situated across the street from the Trident, a bar-restaurant and music venue run by the Kingston Trio, Anastasia's received a steady stream of musicians such as Sonny and Cher, Joan Baez, and Bob Dylan, and the wives of the Kingston Trio.[15] In a recent conversation with the author, Robertson fondly recalled Dylan sitting alongside her mother and talking with her while she sewed.[16]

A member of an international set of free spirits traversing the globe, Robertson traveled frequently to gather ideas, especially to Europe where the fashions were always a few months ahead of the States. Her two favorite destinations were Carnaby Street in London and the Spanish island of Ibiza, thus her designs were often an eclectic combination of mod and gypsy styles ranging from satin hot pants and yarn chubbies (waist-length jackets first made popular in the late 1930s; pl. 340) to printed peasant dresses (pl. 61). "I don't call myself a designer," Robertson explained to *Fashion Week* in 1969. "I don't think that we have many of those around. I'm what I call an adaptor. I look around at the world around me and adapt it into commercial design."[17] Her playful attitude toward dress captured the energy of the

39
Helene Roberston (third from left) and an employee (second from left) parade mod fashions near Anastasia's boutique in the financial district of San Francisco, ca. 1970. Photo by Baron Wolman.
COLLECTION OF HELENE ROBERSTON

Youthquake — a term coined in 1965 by *Vogue* editor-in-chief Diana Vreeland to describe the fun, spirited, teen-driven cultural movement of the moment.

In 1966, Robertson opened up a second shop right in the middle of the financial district in San Francisco (fig. 39). She wanted to shake things up in the mainstream world. As she put it, "When I see groovy people wearing something beautiful, maybe even a little outrageous, I want to give that something to all those straight people who would never think of it or do it themselves — and at a price they can easily afford. . . . Fashion should always be fun. There should always be a sense of humor."[18] To that end, Robertson outfitted her new boutique with a jungle gym, projected psychedelic light shows during the day, sold rock posters, and encouraged the young women working in the neighborhood to eat lunch in the shop and put clothes on layaway. She tried to keep her prices under twenty-five dollars to make them more accessible.

Robertson's impact downtown was immediate. As columnist Herb Caen wrote for the *San Francisco Chronicle*, "I turned onto Clay Street for a whiff of the past, but yesterday is fading fast. I found myself staring into the window of a new dress shop called Anastasia's, with a copy of *Tik-Tok of Oz* in the window, a Superman poster on the wall, and a Tiffany lamp hanging from the ceiling. I don't know if they are tenting tonight, but they are Camping on Clay."[19] Robertson rapidly became a much-watched style arbiter, drawing the attention of the national fashion press to San Francisco's counterculture. "We feel our clothes show what is happening in San Francisco with young people and what is good in the hippie movement," she told *Women's Wear Daily* in 1967.[20]

Like Robertson, Alvin Duskin focused on the fashion-forward youth culture, combining business acumen with social consciousness. In 1964, Duskin, a recent Stanford graduate, opened a North Beach storefront, Columbus Sweaters. Having grown up in the sweater business, with parents who operated a factory in Daly City, he had an innate understanding of the trade. He astutely realized that the $150 or even $70 that was then being asked for a knitted dress was exorbitant and that what San Francisco's North Beach — "an old Bohemian beatnik place" (see McNally, this volume) — needed was a $20 dress.[21] Duskin calculated that with the help of lead designer Marsha Fox he could simply add two inches to the same sweater that his parents manufactured and sold for $10, and sell it as a minidress, a recent import from London that had become the uniform of the young generation.

By 1967 the label Alvin Duskin by Marsha Fox had established a national reputation for youthful, stylish knitwear. That year they released their most successful design, the Peace Dress (pl. 310). This charming A-line scoop neck was patterned in a repeat of small peace signs and available in a number of color combinations — raspberry and aqua, yellow and gold, and black and white. An immediate hit, the Peace Dress stayed in production until 1970. Joan Chatfield-Taylor, fashion reporter for the *San Francisco Chronicle*, recognized its appeal: "What does the well-dressed peacenik wear these days? No longer need she wear a baggy smock, Levi's, bells or beads to proclaim her allegiance to the Love Generation. Alvin Duskin, San Francisco's young-thinking knitwear firm, has just produced a snappy Peace Dress."[22]

In an interview with the owner, Baron Wolman described the Alvin Duskin woman as an archetypal American woman: intelligent, athletic, and with a positive manner — a Gibson Girl among the baby boomers.[23] In the same interview, Duskin divulged the secret of his firm's success — his lead designers, Marsha Fox and later Betsey Johnson, designed for themselves or with a few friends in mind, as if they were designing for a small boutique. It was his challenge to take these prototypes and adapt them to mass production, with the factory designing and dying the yarns for their all-knit collections. Maureen Kirby of the *Chronicle* understood Duskin's skill at bringing the two together: "Knits can be groovy, knits can be fun, and San Francisco's just the place to wear them — and to manufacture them, it seems. Alvin Duskin, a local firm, is among the pioneers in knits that aren't just practical but have a youthful, way-out styling that the boutique boom needs."[24] Duskin, already a prominent political activist in the seventies, strove for a balance between the ideal and the practical, building a five-million-dollar company that employed more than two hundred workers while maintaining his anti-establishment reputation.

40
Dug Miles's submission for the Levi's Denim Art Contest, Valdosta, Georgia, 1973.
COURTESY OF BARON WOLMAN

DENIMOCRACY

Easily purchased at thrift and Army Navy surplus stores, denim was not only affordable, it was durable. For a generation of young people that rejected the trappings of their middle-class upbringings, the uniform of the working class was a comfortable fit. By the late 1960s, the all-American blue jean had become the ubiquitous look for the counterculture, with San Francisco–based Levi Strauss & Co. at the forefront. Patented in 1873, in the wake of the California Gold Rush, the riveted denim "waist overalls" popular among miners, cowboys, and agricultural workers became synonymous with tough work wear across the nation. By the middle of the nineteenth century, this nimble company had changed direction, marketing their denim as Western wear on the rodeo circuit and to weekend ranchers.

A seismic shift in the company occurred in 1958 when Walter Haas Jr. was appointed its president. Ushering in a new era, he surrounded himself with young leaders who would strengthen the company's commitment to social responsibility

while focusing their marketing efforts on a new and powerful consumer base — the teenager. Their ad campaigns, featuring classic surf scenes and drawing upon local talent found in the San Francisco music scene, were quintessentially 1960s California. Not only did they commission rock poster artists Stanley Mouse and Victor Moscoso to design ads in 1967, but they also hired the nascent psychedelic rock band Jefferson Airplane for the company's first-ever radio spot. In her iconic contralto, lead singer Grace Slick delivered the lines:

> Right now with your white Levi's
> White Levi's come in black
> Dashing bravo blue
> I love you

The commercial ran for six months but with the success of their second album, *Surrealistic Pillow*, the band did not renew their contract with the company.[25]

Levi's did not just market to the youth culture, they listened to it. Art Roth, general manager of Levi's For Gals, told *Women's Wear Daily* in 1971:

> "We're charged with maintaining quality. Youth dictates this. They clamor for quality in food, environment, government . . . it's a tremendous movement for social justice. . . . That's the essence. . . . San Francisco is the capital of the whole youth movement . . . the flare leg, fabric mixtures . . . the way they pull it all together. We learned from them. . . . We're definitely in the right place, because we plan to learn more."[26]

The experience of pioneering Haight Street boutique owner Peggy Caserta confirms just how tuned in and supportive Levi's was to the city's bohemian youth. Caserta opened her boutique Mnasidika in the Haight-Ashbury neighborhood in October 1965, and by 1966, she found herself at the center of the radical changes that were taking place there. Mnasidika became a frequent hangout for the Grateful Dead and for her girlfriend, Janis Joplin of Big Brother and the Holding Company, and a cornerstone for all that was happening in the Haight. The boutique carried a variety of unisex looks ranging from T-shirts and sweatshirts to European leather jackets and Levi's jeans that she purchased directly from their Valencia Street factory. According to Caserta, when it became the vogue to splay jeans' cuffs by adding a piece of fabric in order to fit them over cowboy boots (pl. 94), she asked the factory if they would make the flare wider as a custom order for her shop. Overhearing her conversation, "the old man in charge" called her into his office, and after a discussion consented to her design concept and fulfilled her order for twenty dozen pairs on a payment plan.[27] The design was an immediate success, and the bell-bottom was in the making.

Throughout the rest of the sixties and into the seventies, Levi Strauss & Co. continued to take their cues from the San Francisco streets, nurturing new trends like an encouraging parent. When patching one's jeans became the next big thing, Levi's sold patches. As Roth explained, "We give them the base, then they can use that to express themselves however they like . . . look at all the embroidered jeans right now . . . it's a homemade feeling . . . a cottage craft that Levi's inspires."[28]

With Levi's using their hometown as an incubator, the fashions of San Francisco's counterculture rippled across the nation. In 1971, the *Los Angeles Times* wrote, "What's scandalous about jeans is how you outrage them. The idea is to make a strong personal statement, to show off your expertise with embroidery, to create a collage masterpiece, to illustrate your personal opinions on love, politics, ecology. In short, to make them strictly your own through your own handcrafting. Start with new fall Levi's For Gals."[29] Two years later, the *New York Times* covered the jean skirt trend, commenting that the most desirable (and cheapest) skirts were home sewn (pl. 141), but for those with money but no sewing skills, a custom-made appliquéd skirt could be purchased at Serendipity on East 60th Street for $300 (more than $2,500 in today's money).[30]

Responding to the craze for "decorated denim," the company hosted the Levi's Denim Art Contest in 1973. The call for entries encouraged participants to put their unique stamp on their favorite blues by embroidering, painting, beading, shredding, patching, and more. An impressive 2,000 entries were judged by a prestigious panel that included designer Rudi Gernreich, Fine Arts Museums of San Francisco curator F. Lanier Graham, photographer Imogen

41
Melody Sabatasso (second from left) and Alma Petti (center) with the Love, Melody staff in the studio, Fairfax, California, 1973. Photo by David Keller.
COLLECTION OF MELODY SABATASSO

Cunningham, and *San Francisco Chronicle* art critic Thomas Albright. Nearly $8,000 in prize money was awarded, and an exhibition of the fifty winning entries toured the United States for eighteen months, with venues ranging from the de Young in Golden Gate Park to the Museum of Contemporary Craft (now the Museum of Art and Design) in New York City. "What is astonishing here is the range of adorning denims encompasses kitsch, erotica, acrobatic fantasies and simple elegance," a *Los Angeles Times* reporter wrote in his review.[31] This diversity is suggested in a comparison of two of the fourth-place winners, now in the collection of the Levi's Archives: Dug Miles's hand-painted white Levi's are a riot of color and playful psychedelic imagery (fig. 40 and pl. 136), whereas Eva Orsini's comically oversized Watergate jeans use political satire to address Nixon's follies in Watergate and Vietnam (pl. 320).

But it was the faded, sequined jeans that became the ultimate status symbol of the 1970s, as popular in Italy and France as they were in the United States. "A few Paris fashion designers are making a killing this summer selling clothes that are made out of either second-hand jeans or denim treated to look and feel old, and the French probably think they invented the idea. In fact, the world capital of second-hand jeans seems to be Fairfax," Joan Chatfield-Taylor wrote in the *Chronicle* in 1973. In the same article, noted denim designer Melody Sabatasso concurred, "It's hard to say who was the first to do anything — but I know I was."[32]

In 1969, Sabatasso, a recent transplant from New York and Parsons School of Design graduate, was living in Lake Tahoe, California. With a wedding to attend, she was looking for a dress that was as comfortable as her jeans, when inspiration struck. Putting her pattern-making skills to work, she deconstructed eleven pairs of her own blue jeans. She began by cutting them along the seams and then into differently shaped puzzle pieces. Next she laid these pieces over a dress pattern, piecing them together with a herringbone embroidery stitch into a fitted, full-length, long-sleeved dress. Soon she began selling patchwork denim outfits to boutiques in Lake Tahoe.

In 1970, Sabatasso moved to San Anselmo in Marin County and opened the boutique Love, Melody, where she transformed secondhand jeans into bikinis, pants, jackets, dresses, skirts, jumpsuits, and halter tops using her signature contrasting dark and faded denim with highlights of jewel-like Swarovski crystals. She signed every piece "Love Melody" in lipstick or red crayon, as if she were signing a letter (pls. 92 and 140).

42
Grace Slick of Jefferson Airplane wearing a North Beach Leather top at the Woodstock Music and Art Fair, New York, 1969

month (fig. 41). Rag merchants would deliver used jeans by the truckload, sourcing the denim from flea markets, Goodwill stores, and even San Quentin prison. Sabatasso would hand inspect every pair of jeans and used only Levi's because of the denim's high quality, often incorporating their label into her creations. Love, Melody designs sold around the country, and, with retail outlets in Nashville and the Suzy Creamcheese boutique in Las Vegas selling her line, developed a large clientele among musicians such as Loretta Lynn, Dolly Parton, Ann-Margret, and even Elvis Presley, for whom she made two suits in the final year of his life.

LEATHER

In 1966, the *San Francisco Oracle*, the underground newspaper of the Haight, published its "American Indian" issue, which, as its editors later explained, drew from the idea that "the hippies' creation myth centered on the notion that they were reincarnated Indians who returned to earth with the intention of bringing the land and people back to traditional ways"[35] (pl. 115). In searching for a purer existence, the children of the counterculture looked toward Native American society as a model for an alternative lifestyle (see Terry, this volume), although this solidarity was not necessarily shared by the First Nations. Nonetheless, this fascination materialized in the dress codes of the young seekers. Filled with romanticized notions of their own Indianness, as well as true reverence for native peoples, the hippies festooned themselves in leather and beads. In his September 1967 lecture at the Commonwealth Club of San Francisco, psychiatrist Louis Jolyon "Jolly" West shared his observations: "In the last three months in the Haight-Ashbury, the costumes are changing to buckskins and Indian garb. Many of them are interested in the American Indians not only because the Native American Church has a mind-expanding drug as the basis for the peyote cult but also because the Indians are noble, idealistic, live close to nature, and are able to get along on very little wampum and still have a good way of life."[36]

Sabatasso's big break came when Lauren Bacall spotted one of her friends in a Sabatasso original. Not only did Bacall commission a complete ensemble, she also wrote the check for more than twice what the designer had quoted, telling the twenty-year-old not to underestimate herself.[33] This was just the boost of confidence Sabatasso needed. Not long after, Sabatasso's mother, former Miami designer Alma Petti, left her home in Florida to manage the business. Within three and half years, Petti had built her daughter's enterprise into a healthy venture. "The clothes may look like they were lovingly made by a couple of ecology-conscious longhairs living on a farm, but Melody and her mother have a busy, efficient little operation," wrote Chatfield-Taylor in 1973.[34] In their Fairfax factory, with denim piled high to the ceiling, they employed twenty-three designers and seamstresses who processed more than 10,000 pairs of jeans a

By the late 1960s, leatherwork became so poplar in the Bay Area that more than a dozen tanneries were in operation and two of the most influential leather design houses, North Beach Leather (est. 1967–2002) and East West Musical

Instruments Company (est. 1967–1980), opened during the Summer of Love. Like many of the young entrepreneurs who started their businesses in the 1960s, Bill Morgan had perfect timing. In 1967, not wanting to miss out on the fun, he returned home to San Francisco, leaving his position as buyer for Cost Plus in Brazil. With his friend Michael Hoban, he began peddling women's dresses with modest success from various city locales. One day, Morgan's girlfriend found some split cowhide from Brazil in his closet and fashioned it into a double-breasted knee-length Edwardian-style coat. She placed it in the shop window, and it sold within the hour.[37]

Everything else fell into place after that: a perfect location opened up down the street from Caffe Trieste — a spot made popular by the Beats a decade earlier — and Morgan's brother Frank joined the venture, now called North Beach Leather. Bill Morgan, who grew up in the Haight, explains that during the Summer of Love the Haight had become so overrun by the indigent youth, bad drugs, and even violence that many of the true hippies abandoned the area. By the end of the summer, North Beach had re-emerged as a prime locale for hip boutiques, including the Middle Earth, Miki, and Changing Faces.[38] But, ultimately it was the music scene, the same element that drew so many young people to the Bay Area, that promoted their businesses. As Morgan maintained, "Every visiting or local band that was playing at Bill Graham's Fillmore West or Chet Helms's Avalon Ballroom had to come by our tiny store and see our latest designs and creations — obviously desired for stage."[39] Over the next decade, North Beach Leather would create some of the most iconic looks in rock and roll, including the white, fringed buckskin top Grace Slick wore at the Woodstock Music and Art Fair (fig. 42).

North Beach Leather was a twofold business: They designed and manufactured their own line, but also invited independent artists to sell their collections at their storefronts. Most notable among these was Burray Olson. In 1967, Olson was studying illustration at both the San Francisco Academy of Art and San Francisco Art Institute, but found it too commercial and shifted his focus to leatherwork. As he explained to the *Oakland Tribune*, "I devised a way where I could do my artwork and I could also do something I always wanted to do, which was make really creative clothing."[40] By 1968, he was selling his wares to shops in the Haight, and it was not long before musicians such as Dr. John and bands such as Quicksilver Messenger Service, Jefferson Airplane, the Grateful Dead, the Miles Davis Quintet, and Santana were contacting him for custom designs.[41]

Olson's fascination with Native American culture began around the age of ten, when his family went to live with his grandparents in Westwood, California. The two Sioux women working for his grandmother enthralled him with their legends, and he delighted in seeing them adorned in fully beaded buckskin regalia to attend powwows. His grandmother shared his interest in Native American culture, and together they learned the Sioux lazy-stitch beaded embroidery technique, which later he would use exclusively in his own beadwork. As an emerging artist, Olson visited Native American reservations and trading posts in the Southwest in order to absorb the culture and "pick up tips."[42] The authenticity of his work gained him the patronage of Cree singer-songwriter Buffy Sainte-Marie, a vocal critic of the appropriation of Native American dress by nonnatives. As she told the *New York Times* in 1970, "I just don't know why society women keep wearing those $700 forgeries. It is most insensitive in the light of Indian poverty to be publicizing those clothes and giving awards to people who design them. . . . We are sick of being told that we should feel honored that people want to look like us."[43]

Like many of the original Haight-Ashbury artists of the sixties, Olson migrated to Marin after the summer of 1967, setting up his business first in Sausalito and later in Larkspur, and eventually splitting his time between Marin and Hollywood. He was often quoted stating that he "did not design for the normal person," but strove to make something different from anything else you see walking down the street. "Fashion designers are not terribly inventive when it comes to leather. It is hard to work with and doesn't lend itself to all styles. But I consider myself more an artist than designer, an inventor of a new art form — wearable art."[44] His one-of-a-kind creations were embellished with embroidery, Native American quillwork, native furs, feathers, beadwork, silver coins, and semi-precious stones. He also would incorporate imported notions from India, Afghanistan, and South America. These works exemplify the interest in world culture that

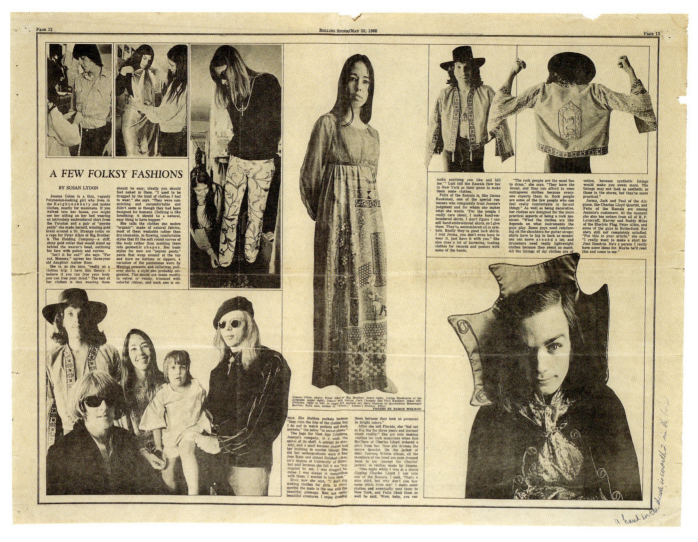

43
Rock musicians wearing New Age Designs (clockwise from left: Gary Duncan of Quicksilver Messenger Service; singer/songwriter Ruthann Friedman; Peter Kaukonen; designer Jeanne Rose; Jorma Kaukonen of Jefferson Airplane; Peter Albin of Big Brother and the Holding Company; Jeanne Rose and daughter Amber Rose with Jack Casady, Paul Kantner, and Jorma Kaukonen of Jefferson Airplane) wearing Jeanne Rose's designs, 1968. Photo by Baron Wolman. Printed in Susan Lydon, "A Few Folky Fashions," *Rolling Stone* (May 25, 1968)

permeated fashion of the era. In the full-length coat designed for his then-wife Barbara Moore, Olson references mid-nineteenth-century Athabaskan chiefs' coats that were fashioned in the style of European frock coats.[45] He adorned the coat with embroidered bands, beaded roundels, and coins from Afghanistan, further illustrating the pervasive and deep-rooted cultural borrowing within costuming traditions. Olson, who despised gimmicks or fads, continued to use the American West as a source of inspiration throughout his six-decade-long career. As he explained in a conversation with the author, "To me, clothing must be valid, representing the kind of lifestyle that I enjoy."[46]

SARTORIAL SAMPLING

Born in 1937, Jeanne Rose, who also worked under various other names including Alice Colon, Jean Rose, and Jeanne the Tailor, was raised on an almond orchard in Antioch, California. Though both of her parents worked on a local army base, they maintained their connection to the land: She remembers her mother going to work every day dressed in full nylons and a girdle, but also making her own simple skincare from the almonds on their farm. Both routines impacted Rose as a teenager. She studied to be a marine biologist at the University of Miami, but left her master's program because of the pressure she felt to compete with male students.

Rose moved to Big Sur, California, in 1964, in order to find herself. That same year she took LSD for the first time and it proved to be the catalyst for which she was looking. More than fifty years later in a conversation with the author, she recalled walking from her Page Street pad in San Francisco over to Buena Vista Park and being completely entranced by nature: "It was a revelation to me and even a revolution, in a sense that it was important to me to have objects — natural foods, natural clothes, natural feeling. I wanted to feel basically that I wasn't constructed in my clothes. When I put clothes on me or anyone else that it was freeing — more freeing than it was constricting." She continued, "In that moment, I actually wanted to change the world, I wanted to be part of a movement that would be important."[47] As a result of this experience, she made the conscious decision to live a healthy organic life, which she now sees

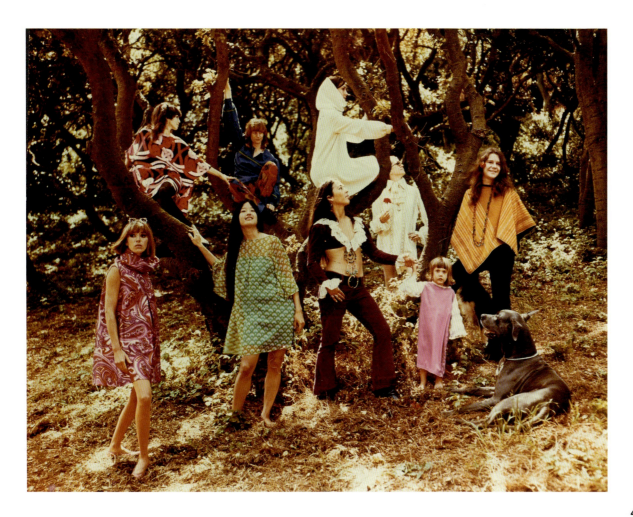

44
Fashions by Jeanne Rose, 1967. Printed in Walter Blum, "Out on a Limb," *San Francisco Sunday Examiner and Chronicle* (October 8, 1967)

as a natural progression of her family lineage — her maternal grandparents were flax farmers in Canada, her grandmother was a weaver, and her own mother made beautiful intricate clothes and passed on her skills to her daughter. In rejecting the confining culture and consumerism of the 1950s, Rose drew upon the deeper roots of her ancestry to find her true path.

Rose's career in fashion happened by coincidence. While living in Big Sur, she made clothes for her infant daughter Amber. Ron McClure, the bassist for the Charles Lloyd Quartet, asked if she would make him a shirt. Her designs soon garnered the attention of other musicians who performed in the same lineups as McClure, and custom orders followed. Over the course of the next three years under her label New Age Designs, Rose built a career as a designer, specifically focusing on creating one-of-a-kind looks for the musicians on the San Francisco scene. Her customers included Jefferson Airplane (guitarist Jorma Kaukonen was her top client), the Charles Lloyd Quartet, H. P. Lovecraft, Felix Cavaliere of the Rascals, Harvey Brooks and Buddy Miles of the Electric Flag, Peter Albin and Janis Joplin of Big Brother and the Holding Company, Mickey Hart of the Grateful Dead, and several members of the Butterfield Blues Band.[48]

Rose loved dressing musicians. As she told *Rolling Stone* in 1968, "The rock people are the most fun to dress (fig. 43). They have the bread, and they can afford to wear outrageous clothes because everyone expects them to. Rock people are some of the few people who can feel really comfortable in far-out things." And, in designing their clothes, it was important to take into account what instrument the musician played, "What the clothes are like depends on what instruments the guys play. Some guys need reinforcing on the shoulders for the guitar straps; shirts have to be big in the back so musicians can move around a lot; and drummers need really lightweight clothes because they sweat so much."[49]

By 1967, Rose had come to the attention of local papers (fig. 44), with national press coverage following.[50] During each interview, she was completely candid and never failed to share her ideologies, using the media as a platform to advocate for the use of natural fabrics, handcrafted clothing, and personal expression, and against the mass marketing of the ready-to-wear industry. She explained her ultimate fashion goal to the *San Francisco Chronicle* in 1967, "I like to feel as if I don't have anything on at all."[51] In May 1968 she expanded on that idea to Susan Lydon at *Rolling Stone*: "I have a theory: I believe if you can free your body you can free your mind.

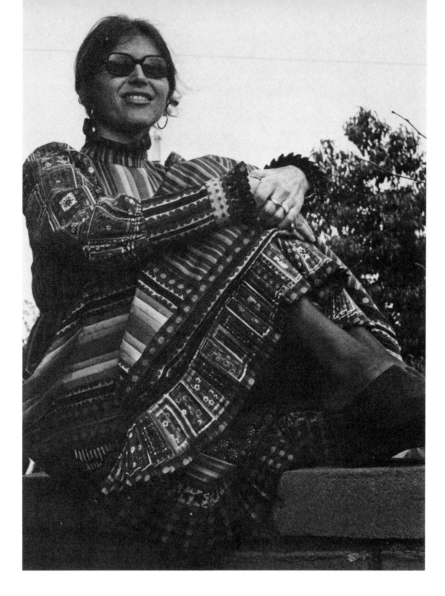

45
Yvonne Porcella, ca. 1972

I used to be dragged by the kind of clothes I had to wear. They were constricting and uncomfortable and they didn't seem as though they were designed for humans. Clothing is like breathing; it should be a natural, easy thing to have happen."[52]

Mindful of the impact musicians sought to make onstage, Rose fashioned her garments out of rich silks and velvets embellished with ornate lace and antique ribbon trims. Employing a wide lens on costume history, she drew influences ranging from historic fashion plates of a seventeenth-century jacket to folk costumes. Her signature "peyote pants" — with no zipper or buttons — were inspired by the traditional *pantalones* worn by the native Huichol people of Mexico. Rose's clothes showcase a mixture of styles, reflecting the crosscurrents that ran through the Haight during its peak years: from the DMT dress, uncharacteristically made with a synthetic knit that was expressly designed to vibrate under pulsating light shows (pl. 293), to a dress of printed cotton with an image of a fifteenth-century Persian painting (pl. 195), to a jacket modeled after an Edwardian frock coat worn by her then-husband Michael Moore (pl. 85). She was also known for shirts she called "love shirts" because "every shirt is individually styled, and I make each one with love for the wearer."[53]

Born just six months before Jeanne Rose, Yvonne Porcella (née Bechis) had a similar upbringing on her family's produce farm near Watsonville, California. Her grandparents on both sides were farmers. Her mother was insistent that at a young age her girls be accomplished in all types of handwork: sewing, knitting, and crocheting. By the time she was eleven, Porcella was a proficient seamstress making her own clothes. After graduating from the University of San Francisco with a degree in nursing in 1959, she married Robert Porcella and they moved to a remote military outpost in Michigan, where he was stationed.[54] This period became a springboard for her artistic endeavors when a neighbor and professional artist dared her to be more inventive with her sewing: "You do so many routine chores during the course of a day. If you can do one creative thing for yourself that pleases you, it will make your life abundant."[55]

The couple returned to California in 1962,

settled in Modesto, and had four children in nearly as many years. Like many of her generation, Porcella made clothes for herself and her children, but out of a strong desire for individuality, she also taught herself how to weave and used these textiles for her own clothing: "Rather than take the risk of making a garment from commercially produced fabric, only to see someone else wearing the same print, I would learn to make my own fabrics."[56] Her work stemmed out of domesticity rather than as a reaction against it, but cultural change was afoot, and as a textile enthusiast, she embraced the influx of world textiles that were being imported into California as young Americans traveled the globe and brought back these and other portable treasures such as jewelry. Porcella credits President Kennedy's Peace Corps initiative of 1961 for raising the country's awareness of third-world cultures. As her own interest in ethnic textiles grew during the early sixties, Porcella began to actively collect them in order to teach herself about color and design.[57] At the annual Conference of Northern California Handweavers, she purchased from bohemian travelers and entrepreneurs *molas* from the San Blas Islands of Panama, fabrics from Guatemala and Mexico, ikats from Burma, printed textiles from Indonesia, embroideries from Bedouin tribes, and — her favorite — pieced and embroidered textiles from nomads in Uzbekistan and Afghanistan. She also sought rare and exotic fabrics at Thousand Cranes in Berkeley and Shadows of the Forgotten Ancestors, the second of Jean and Charlie Stewart's three stores, in Larkspur.

By 1971 Porcella's research into world textile traditions expanded from embellishment techniques and fabric design into clothing construction, and her personal wardrobe reflected her new interests. She began wearing brilliant patchwork ensembles constructed from her own ethnographic fabric collection (fig. 45 and pls. 95 and 196). During the early 1970s, she was teaching weaving and sewing workshops throughout California, which culminated in her booklet *Five Ethnic Patterns* (1977), the first of her eleven publications.[58] In the introduction Porcella outlines the rising interest in historical clothing, referencing seminal world costume exhibitions such as *Cut My Cote* at the Royal Ontario Museum (1973) and *The Glory of Russian Costume* at the Metropolitan Museum of Art (1976), and the de Young's permanent collection of world costume and textiles. In the foreword, she writes, "The patterns offered in this booklet are an attempt by the author to extend to the modern world an opportunity to enjoy making and wearing this style of costume; a chance to look backwards and bring forward old styles and make them new."[59] Porcella was no hippie, yet her philosophy surrounding dress, consumerism, and individuality developed during the early 1960s and are reflective of the overriding ethos of the era. Her personal history demonstrates how widespread the interest in ethnic textiles and world culture was during the late 1960s and 1970s, particularly in California. An examination of her work raises questions about the notion of the divide between the counterculture and mainstream American society during that era.

Like Helene Robertson before him, Los Angeles–native Mickey McGowan was drawn to Sausalito in the late 1960s. There he found a vibrant art scene that centered around the Sausalito Art Center, the Ant Farm collective, and the Gate 5 houseboat community–artist colony and included British philosopher Alan Watts, collagist Jean Varda, musician Dan Hicks, writer Stewart Brand, and media artist Chip Lord and his Ant Farm cofounder, architect-designer Doug Michels. In his rented studio space at the art center, McGowan began to experiment with making his own shoes. Having recently become vegan, he was looking for an alternative to leather and started adopting leatherwork techniques to canvas and other cloth.

When the center closed, McGowan moved to Mill Valley and began selling his custom-made shoes and boots under the moniker Apple Cobbler. In the wake of the Summer of Love, Marin County was enjoying its own renaissance with hippies, many of them musicians, who had escaped the city to commune with nature. In a conversation with the author, McGowan described the early 1970s in Marin as an idyllic time of abundance and artistic freedom, when the ideological seeds that had been planted in the 1960s truly blossomed. He explained, "We wanted to make a statement that we were a new generation and there was a lot of room to do it."[60] With inexpensive rent and unmotivated by financial gain, he had very few constraints and was able to cover his monthly expenses by simply selling a few

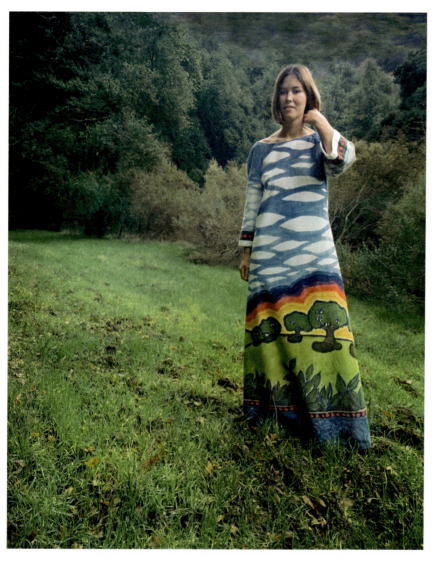

46
Candace Kling in the first Fred Kling hand-painted dress, Lafayette, California, 1969. Photo by John Bagley.
COLLECTION OF CANDACE KLING

47
Friends modeling hand-painted animal dresses designed by Candace and Fred Kling, Oakland, California, ca. 1973. Photo by John Bagley.
COLLECTION OF CANDACE KLING

pairs of shoes for $35 or a pair of boots for $65.

McGowan clarified that a vegan alternative was not the main driving force for his clients, but important to him, the cobbler. His motivations were straightforward, "It was fun to work with the fabric. I was just trying to make something fun for a handful of people. . . . I wanted to give color to people's feet."[61] Musicians represented a good portion of his client base, and, in particular, the drummers, who ordered their shoes with flat soles, perhaps because of their flexibility. These included Val Fuentes of It's a Beautiful Day, Greg Dewey of Dan Hicks and the Hot Licks, Keith Knudsen of the Doobie Brothers, all four members of the Tubes, Charles Lloyd, Steve Perry of Journey, and singer-songwriter Pamela Polland. Susila Ziegler, then wife of the Grateful Dead's Bill Kreutzmann, commissioned a pair each for herself and her husband.

The few remaining pairs of McGowan's boots capture both his spiritual and playful nature. His "Ocean Tantra" boot (pl. 322), which served as his display model, is based on the principle of the mandala, an Eastern geometric symbol popular in the sixties. As he explained, "Mandalas were very big in my life at the time and all the sewn artworks I created were based on this ritual symbol."[62] He sewed the boots flat, following the mandala formation, with little circles emanating from the central focal point. Conversely, the "Gambling" boot and "Cub Scout" boot (pls. 323 and 321, respectively) underscore his fascination with material culture. In the Gambling boot, he used felt from a casino table, vinyl inserts, cards, dice, and dollar bills to address the influence of gambling in America. The Cub Scout boot, his personal pair, is made completely from Cub Scout regalia — uniforms, patches, and scarves — that he and his wife Finnlandia actively collected. Though neither of them had been scouts, both were drawn to the uniforms for their textural and visual qualities. Unlike Jefferson Airplane singer Grace Slick, who often ironically donned a Girl Scout uniform (pl. 275), McGowan celebrates the scouts' cultural relevance. "There is a one-hundred-year history of the cub scouts," explained McGowan, "You are working with American culture. It's truly an American institution." A self-described "cultural patriot,"

McGowan continued, "We loved America. . . . I have always been after the good moments of childhood. . . . We should remember the good things."⁶³

THE FIBER ART MOVEMENT
An underlying influence for many independent designers of the era was the active fiber art movement that took hold on both a national and international level in the 1960s and 1970s, as artists gave textile traditions new expression, pushing them into the realms of sculpture, installation, and performance art. The movement established a broad base in Northern California, as universities developed fiber art programs, and weaving guilds and textile workshops emerged. Such endeavors resulted in increased resources, publications, and opportunities in the textile field. In her paper, "California and the Fiber Art Revolution," curator Suzanne Baizerman outlines the many factors that stimulated the growth of the movement and elucidates the symbiotic relationship between the fiber art movement and the counterculture:

> During and after World War II, California was a magnet for job-seeking Americans of different backgrounds. It was a state without the more historically based, entrenched traditions of the East Coast. Plus, it bordered on Latin America and faced the Pacific Rim. This independence and diversity bred a certain kind of open-mindedness and led California to influence the lifestyles of other Americans, especially in architecture and design. By the 1960s, the Civil Rights movement, the anti-war movement, and women's movements had changed the social and political climate of California. For fiber art, the women's movement was especially important because of the traditional association of women with textiles in the domestic sphere. . . . Anti-establishment sentiments and anti-materialist non-conformity could be seen on the streets where young people talked about 'sex, drugs and rock and roll' and 'doing their own thing.'⁶⁴

Candace and Fred Kling met as art students at the Oakland campus of the California College of Arts and Crafts (now California College of the Arts) in 1968. They studied art technique and history, especially drawn to the Dada, Surrealism, and Pop art movements (see Terry, this volume), and admired the writings of Alfred Frankenstein, the art and music critic for the *San Francisco Chronicle.* Fred took English 101 with Beat writer Michael McClure. Outside the classroom he and his friends studiously completed the lesson plan outlined in *The Psychedelic Experience: A Manual Based on the Book of the Dead* (1964) by Timothy Leary, Ralph Metzner, and Richard Alpert (later Ram Dass). Like many of their generation, both Candace and Fred read voraciously, from ancient Eastern divination texts such as *The Egyptian Tarot* and the *I Ching*⁶⁵ to J. R. R. Tolkien's fantasy novel *The Hobbit* (1937) to contemporary nonfiction such as Theodora Kroeber's *Ishi in Two Worlds* (1961) and Eldridge Cleaver's *Soul on Ice* (1968).

Very much children of the era, the Klings attended happenings and, like many of their friends, turned their communal homes into art installations, painting the interiors in a riot of colors and covering the ceilings and walls with a high-low mix of paintings and sculpture, rock posters, prints, antique textiles, feathers, beads, bones, branches, crystals, candles, Styrofoam popcorn, and a jungle of houseplants. They listened to Tom Donahue and Dusty Street on KMPX and Don Sherwood's report on the state of the Navajo nation on KSFO. All the while, the threat of the draft weighed upon their friends.

The couple married in 1970 while Fred was working toward his MFA in painting at Mills College, and Candace, who had studied fashion at Parsons and pattern drafting at the College of Alameda, was designing custom wedding dresses with historicized high-waisted silhouettes and puffed sleeves. The year before they married, Fred had made Candace a full-length dress and hand painted it with a brilliant rainbow and large cumulus clouds set against a blue sky (fig. 46 and pl. 49). As newlyweds, they decided to combine their talents and began to design and sell hand-painted dresses and skirts. In their home studio there was a division of labor: Once Candace designed and cut the pattern, Fred would conceive, lightly sketch, and then paint the imagery using Inkodye, a water-based vat dye. He worked directly onto the fabric, using squeeze bottles and brushes, and his fluid line gave immediacy to the piece. Candace would then fill in the colors and sew the

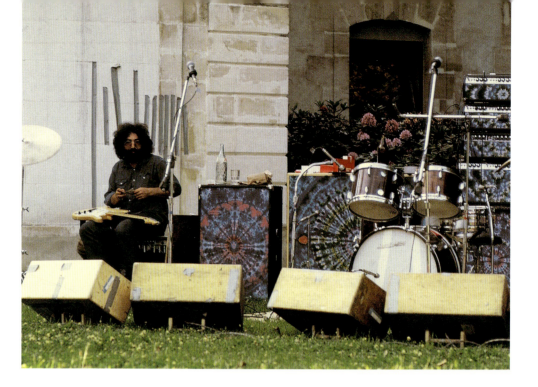

48
Jerry Garcia and Grateful Dead performance set including tie-dyed speaker covers designed by Courtenay Pollock, Château d'Hérouville, France, 1971. Photo by Rosie McGee

final garment.

The Klings' fashions first sold at Sew What, a Berkeley dress shop run by Marna Clark, where Candace was already selling her wedding dresses. Anticipating the desire of well-heeled Berkeleyites for high-quality, one-of-a-kind clothes, Clark had opened her boutique in 1969. Only nineteen years old, she conceived of an egalitarian system in which each of the five designers represented worked one day a week. Instead of being paid a salary, the designers received 85 percent of the commission on the sales of their own work. As their business expanded, the Klings also sold their work at Zooey's in Sausalito as well as Taylor & Ng, Family and Friends, and Obiko in San Francisco. By 1976, when they ended production, they had produced around five hundred garments, mostly wraparound skirts, yoked A-line skirts, and cotton knit dresses, each with a unique painting, and each individually cut, drawn, painted, and sewn.

The whimsical nature of the Klings' designs often reflected Fred's deeper musings, and today he recalls the overriding influences of Carl Jung's posthumous publication *Man and His Symbols* (1964) and the National Geographic Society's *The Marvels of Animal Behavior* (1972) on his work. The latter, tracing the relationship between humans and animals back to hunter-gatherer societies, examined the roots of man's fascination with animals. Along with botanical imagery, the animal world became a primary source of inspiration as Fred mined *National Geographic* magazines for ideas. As he stated in a conversation with the author, "I became amazed how similar animal and human societies were and thought about what would happen if you took away the animal and replaced it with a human."[66]

Over time, Fred became increasingly conflicted about commercialism, which he viewed as an affront to artistic purity. He explained, "It really irritated me that everything sold. I would try to do things that wouldn't sell, like a purple gorilla or an anteater that sold to a willowy blonde. I would do things like paint a hippopotamus and have its big rear right on top of the woman's backside, and still it would sell."[67] The popularity of the Klings' quirky designs reflects a time when people wanted to have fun with their clothing and did not take themselves too seriously; after all, parading around as an animal was a good laugh (fig. 47).

TIE-DYE

Now synonymous with hippie fashion, tie-dye is an age-old craft using a resist-dye technique that is still practiced around the world. In tie-dye, the penetration of dye is blocked or resisted by binding selected areas of the cloth with threads, strings, or other materials. Related resist-dye techniques such as stitch-resist, in which a running stitch is used to block the penetration, and fold-resist, in which folds in the fabric are used as the resist, are commonly referred to by the more popular term "tie-dye." The exact historical origins of tie-dye are unknown, and, despite its ubiquity in the United States in the 1960s, it is equally difficult to pinpoint the genesis of the technique in North America. Despite the latter, certain threads can be traced, revealing a fascinating and diverse story.

One of the most influential progenitors of tie-dye on the West Coast was Luna Moth Robbins

(born Jodi Paladini). Robbins was member of the Diggers, an anarchist group of street performers and activists based in the Haight from 1966 to 1968. The Diggers ran a free food program that provided daily meals in the Panhandle of Golden Gate Park, and the Free Stores, including one in the basement of the All Saints' Episcopal Church on Waller Street, where nothing was for sale. Facilitated completely by donations, both the food program and stores were a comment on the excess and wealth of contemporary American society and a call to examine values.[68] A Bennington College graduate, Robbins was an adept textile artist skilled in weaving, embroidery, and dyeing who actively researched world textile traditions and techniques, in particular tie-dye. Fellow Digger Judy Goldhaft recalls that when the Free Store received a large donation of men's white oxford shirts in 1967, Robbins suggested that they tie-dye them in order to give everyone something individual and beautiful.[69] Later that year, Robbins and Goldhaft taught tie-dye and sewing classes at the store. It was there that Ann Thomas, who came to be known as "Tie-Dye Annie," first learned her craft. Thomas had been working as a copywriter for Capitol Records when she dropped out to join the Summer of Love festivities in San Francisco. She later migrated to a semi-commune in the Hollywood Hills of Los Angeles where she started her business, Water Baby Dye Works, eventually selling her designs to rock and rollers including "Mama Cass" Elliot of the Mamas and the Papas, Janis Joplin, and singer-songwriter John Sebastian.[70]

Meanwhile, on the East Coast, Don Prince, an ingenious marketing executive at Best Foods, was conceiving of a way to save one of company's struggling divisions, Rit dye. After researching dyes around the world, Prince headed to New York City's Greenwich Village around 1965, armed with books on African and Indian resist-dyeing techniques and in search of artists willing to experiment with Rit. Eileen and Will Richardson accepted the challenge and by 1968 they had established their own successful design house, Up-Tied, and within two years were selling hand-dyed fabrics to leading fashion designers of the day such as Giorgio di Sant' Angelo and Halston.[71] By the time of the Woodstock Festival in August 1969, tie-dye had arrived: John Sebastian walked onstage in a completely tie-dyed outfit by Tie-Dye Annie, and Rit hosted a booth selling T-shirts by their stable of artists. Perhaps more than any other fashion trend, tie-dye truly captured the era's thirst for colorful, unique, handcrafted fashions, and its appeal was universal. By the early 1970s, tie-dye was omnipresent from the fashion pages to the music halls, yet the work of two Bay Area artists — Marian Clayden and Courtenay Pollock — truly stands out.

By the time Marian Clayden arrived in Palo Alto, California, in 1967, she was already a proficient tie-dye artist. Born Marian Bolton in 1937, Clayden was raised in the town of Preston in Northern England and worked as a grammar school teacher in the industrial city of Nottingham while taking evening painting classes at the local art school. In 1961, she married Roger Clayden, and the following year they immigrated to Australia. At home with two children, she was casting about for a creative project when she recalled a dyeing class she had taken in college. She purchased a copy of Anne Maile's landmark

49
Grateful Dead performance set including tie-dyed speaker covers designed by Courtenay Pollock, Château d'Hérouville, France, 1971. Photo by Rosie McGee

publication *Tie and Dye as a Present Day Craft* (1963) and systematically began to teach herself the various resist-dye techniques as presented in the book.

Clayden's earliest wall hangings, utilizing a straightforward binding or wrapping technique to create the classic sunburst effect, were exhibited at her first one-person exhibition at the El Dorado Gallery in Sydney in 1966. She quickly progressed to incorporate a combination of folding, stitch-resist, and discharge techniques. In examining the evolution of her early work, it almost appears that her experimentations follow the progression of techniques outlined in the various chapters of Maile's book, yet her compositions are wholly unique. With a background in painting, Clayden approached her cloth as a canvas, always envisioning the finished piece as a wall hanging. As she explained, "I came to find dyeing fabric to be even more expressive than painting, perhaps because attempting to control all the variables was an exciting challenge. Even though I tried to envision the final result as a painter would, I had to dance with the technique to reach a happy conclusion."[72] In Australia, Clayden had little exposure to other dyers, resulting in a style that was her own. Breaking away from a traditional pattern repeat, she used the stitching technique to its fullest advantage by creating organic shapes that meander across the visual plane. Then she used discharge (the removal of dye) to build up multiple layers of contrasting colors (pls. 1, 213, and 214).

For Clayden, moving to the Bay Area in 1967 was kismet. The young bohemians gathering in San Francisco brought a new enthusiasm for the textile arts and a desire for colorful clothing, creating a ready local market for her work. National sales followed, and, in 1968, she met Nancy Potts, the fashion and set designer for the musical *Hair*, who commissioned her to design textiles for the production. This resulted in a larger commission to produce all the textiles for the subsequent nine tours of the show, which brought her work increased recognition around the country.[73]

For a generation that surrendered willingly to the cosmos, their personal histories read like fairy tales, with the plots guided by serendipity and fate. In 1968 Courtenay Pollock was living in London and had a budding career as a quantity surveyor in construction when he abruptly decided that this was not his future. Without any hesitation or significant funds, he left his job and moved to Greenwich Village, the center of New York's bohemian scene, where he opened a head shop and was first introduced to tie-dye. As Pollock related to the author, one day a beautiful woman walked into his shop wearing a simple tie-dyed tunic, not more than a bedsheet with a crude sunburst design made from rings of rubber bands.[74] He remembers being attracted by the colors, but surprised by the textile's lack of symmetry or organization. Right away Pollock started experimenting with tie-dye, trying to figure out how to create patterns and devising his own resist-dyeing technique.[75] With a background in building, he brought to the craft an innate ability to plan, calculate, and execute with a high degree of precision. He also played around with synthetic acid (aniline) dyes, further developing the signature fold-resist and dip-dye technique that he has continued to use throughout his career.

In 1969, Pollock moved upstate to Syracuse. Within a week of his arrival, he was selling T-shirts and shifts in town and had received his first large commission: a complete tie-dyed environment for a meditation room in a local coffee shop. The proprietor asked him to create a large mandala for the end wall as the focal point for meditation practice. That night, Pollock researched the meaning of a mandala, which he understood to be a graphic interpretation of the cosmos according to the philosophy of the artist.

The very next day he crafted his first tie-dyed mandala while under the influence of sunshine LSD — another first. Pollock described the creation of the mandala as a hypnotic, meditative process, commanding his full attention: "In folding the mandala, I am folding in the rays of consciousness, folding in the levels of my personal philosophy at that moment, envisioning the bodhisattva and revolving scarabs, and always dyeing from the center out."[76] Like many of his generation, he was reading Eastern philosophy, specifically the writings of British philosopher Alan Watts and Armenian mystic G. I. Gurdjieff. The latter's notions of classical harmony and geometry appealed to the artist's own inclinations. From that day onward, the mandala would remain the central motif and guiding principle of his work.

In 1970, consulting the *I Ching*, Pollock

50
Birgitta Bjerke wearing her own crocheted creation, Ibiza, Spain, 1969. Photo by Karl Ferris.
COLLECTION OF BIRGITTA BJERKE

read, "There is fortune in the west," and headed out to San Francisco. He went straight to the Haight-Ashbury Switchboard, which was founded in 1967 as a communication vehicle and evolved into a much-needed housing referral service. While he was there, the phone miraculously rang — there was a room for rent at a ranch in Nicasio Valley in west Marin County. During his first day in the country, Pollock filled his backpack with tie-dye T-shirts and walked down the road in search of "like-minded individuals."[77] The first house he came to was Rucka Rucka Ranch, a communal compound where Grateful Dead guitarist Bob Weir lived. Upon showing his work to the band, their road manager Rex Jackson commissioned Pollock to design their speaker fronts. "It was that immediate. I just landed in the middle of the Grateful Dead family," Pollock reminisced.[78] For the commission, he examined the arrangement of the three guitarists' speakers: Jerry Garcia, Bob Weir, and Phil Lesh each had their own grouping of four speakers stacked in quadrants. He decided to create a mandala, with different colorways to reflect each of their personalities and zodiac signs — purple and red for Garcia, a Leo; blue for Lesh, a Pisces; and green for Weir, a Libra with a deep connection to nature (figs. 48–49).[79] The project garnered Pollock instant recognition and an enormous audience for his work within the immediate and extended Grateful Dead community. He described that particular milieu, "In the early days the Grateful Dead experience was all about the magic and the consciousness of a new era. I was fortunate to come onto the scene in those magical times. There was a renaissance of consciousness about living a lifestyle that was in tune with Mother Earth. It was about seeking out one's own spiritual path and living in an awareness of a better way. We were untouched by social stigmas we felt free!" (pl. 292).[80]

Tie-dye was soon ever-present at Grateful Dead concerts, with the fans awash in tie-dye T-shirts and the band framed by Pollock's expansive stage backdrops. Comprising up to twenty-six separate panels, the hangings are breathtaking in their beauty and mind-boggling in their complexity. In the tie-dyed mandala, Pollock found an artistic direction from which he has never deviated. To this day, with every new dye bath, he begins by creating a mandala before commencing on his orders.

GYPSY ARTIST

Of all the designers of this diverse generation, one person, Birgitta Bjerke (fig. 50), perhaps best embodies the vibrant, eclectic spirit of the day's fashion, its global influences, and its emphasis on time-honored handicraft. In a four-page piece about Bjerke in the Style section of the *Sunday Examiner and Chronicle* in 1976, Joan Wiener Bordow evoked her essence:

> Birgitta bursts into situations the way circus parades and gypsy bands do — like jingling, plumed quarter horses and jugglers, elephants in floor-sweeping, spangled satin cloaks, and tambourine-wielding women in shining ribbons and rags do. She comes equipped with musical accompaniment; a solid Swedish tread . . . the form and color of her garments is incredible, supraworldly [sic] — crocheted clothing that rivals sunsets and candy. . . . To my mind, Birgitta Bjerke should be a very wealthy woman by now. Or at least famous. And while there are a number of people on a number of continents who either possess or are familiar with her work, she is neither rich nor internationally acclaimed. Her garments bear the label '100% Birgitta.' They are truly unique and, to my experience, are unsurpassed.[81]

Just a few months later, the wandering artist would leave the Bay Area after a six-year stint for Santa Fe, New Mexico, to design costumes for the film industry, leaving behind what she declares the most fertile era of her artistic career.

Birgitta Bjerke was born into an artistic family in Stockholm, Sweden, in 1940.[82] With the sudden death of her mother when Bjerke was eighteen, her life was turned upside down. Still reeling from this traumatic event, she enrolled in commercial art school, but, feeling suffocated and alone, she left after just two years to become a flight attendant for Pan Am. Paraphrasing feminist writer Betty Friedan, the designer described Sweden in the 1950s and early 1960s as a "mental concentration camp,"[83] and, as for so many women of her generation, the airlines offered an escape from the traditional role of domesticity. However,

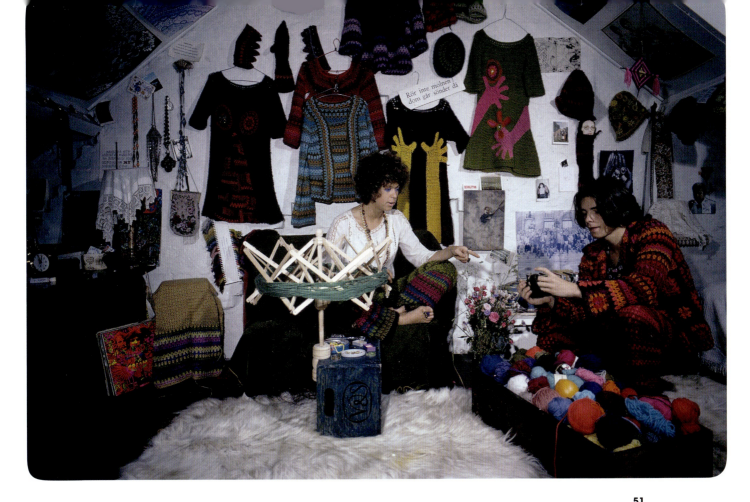

51
Birgitta Bjerke in her apartment with Swedish scenographer Jan Öqvist, surrounded by Bjerke's work, London, 1968. Photo by Lennart Osbeck.
COLLECTION OF BIRGITTA BJERKE

she soon discovered that she hated to fly and began a new chapter in her life in New York City in 1964. While working as a tour guide for the United Nations, she began to crochet caps, a craft she had learned from her maternal grandmother. These caps soon evolved into see-through dresses so stylish that she began selling them at Paraphernalia, the hippest boutique in the city. Bjerke's work also caught the eye of fashion designer Oleg Cassini, who asked her to create a collection for him. Ultimately her playful designs, which overlaid facial expressions in brilliant colors onto body parts, were too far-out for him and the line never went into production. Undeterred, she incorporated the ideas into her own work, moving it in a new direction (pl. 311).

In 1967, Bjerke found herself in London just after the peak of its reign as the center of pop music and fashion (fig. 51). She frequently filled her days at the Chelsea Antique Market, hanging out in the stall of fellow Swede Ulla Larsson, who was busy dressing the international bohemian set in vintage fineries. Bjerke spent the next few years traipsing through Europe's high hippie scene, visiting some of the same meccas as Helene Robertson. With London as her base, she spread her brilliant crochet creations and sharp wit far and wide, from Paris, Amsterdam, and Rome to Positano, Morocco, and Ibiza. Her exploits included creating customized sweaters for guitarist Eric Clapton and the Who's Roger Daltrey and his wife Heather; offering support and critique to the editors of the counterculture magazine *OZ* during its profanity trial; selling her designs at Mia-Vicky, the Paris boutique of It girls Mia Fonssagrives and Vicki Tiel; creating a fantasy collection for Parisian couturier Louis Féraud's 1969 runway show; and teaching singer-songwriter Joni Mitchell how to crochet in Ibiza.[84] As Bjerke described to the author, "It was an international scene and above all we were travelers. We were flocks and every flock of people fed from each other and inspired each other to go to new and better heights." Crochet was her sole source of income and, like McGowan, she only produced what she needed to survive. She designed clothes and dressed herself "to blow peoples' minds." As she explained, "I aimed at turning myself into my own gallery in protest to all those who were putting me down."[85] By 1968, waves of San Franciscans were passing through London including the Grateful Dead's manager Danny Rifkin, rock poster artist Stanley Mouse, rock photographer Bob Seidemann, and Merry Pranksters Ken Kesey and Bobby "Bobby Sky" Steinbrecher. Their message to Bjerke was clear: London is dead, come to America.

Landing in San Francisco in 1970, Bjerke sought out Rifkin, who introduced her to the women of the Dead, of whom she remarked, "The women

ruled."[86] Susila, the wife of drummer Bill Kreutzmann, in particular, became a generous supporter of her work, commissioning bar stool covers for their home in Mill Valley as well as numerous outfits (pl. 304). Frankie Azzara, girlfriend of guitarist Bob Weir, was also a customer. The crocheted bedspread she commissioned for Weir's birthday became the masterwork from her years in the Bay Area. The second in what she had envisioned as a series of twelve large-scale murals, it gave her the leeway to push her craft to the limit and to understand, as she explained, "How far I could take it from the original potholder, which my grandmother had taught me to make."[87] Though she had originally envisioned it to be circular, she constructed *Pioneer* (pl. 222) in three separate panels, due to its size and to the fact that she was constantly moving. She started at the top center with cyclamen pink, turquoise, and light green, the same yarns used in the Kreutzmann's bar stools. The second panel centered around a loose interpretation of the Grateful Dead rose, and the third included the ace of spades, a nod to Weir's newly released solo album. Humming the melody to the Dead's "Cassidy" while she worked, Bjerke toiled on *Pioneer* for more than a year until the couple's relationship ended. Azzara reimbursed the designer for the yarns and told her she could keep the piece.[88] Never seen by its intended, *Pioneer* showcases Bjerke's prowess during her most fruitful period: "That is where I blossomed. It was fabulous. I got my start in London but it was the Bay Area where I was my most creative."[89]

During the Summer of Love, *Time* magazine ran a feature article titled "The Hippies," which declared that the counterculture movement's "professed aim is nothing less than the subversion of Western society by 'flower power' and force of example."[90] The detailed histories of each of the era's independent designers demonstrates that their motivating forces were not subversive but free-spirited and optimistic. They created novel modes of dress to usher in the new society they wished to create.

The diversity of styles created by this small cross section of Bay Area designers dispels any preexisting and limited notions of sixties counterculture fashions as does the shared aesthetic of contemporary mainstream designers from the period. Their continued relevance, which manifests today in the enduring trope of so-called "bohemian chic," often represented in colorful free-flowing styles, natural fabrics, handwork, and the appropriation of global textile traditions, has left a lasting influence. While their original sources may not be well known, deep in our collective psyche these fashions conjure memories of a time of freedom and hope, one of the many lasting gifts from San Francisco's Love Generation.

1. Jeff Berner, "Astronauts of Inner Space," *San Francisco Sunday Examiner and Chronicle,* June 18, 1967.
2. In 1968 there were an estimated 42–44 million home sewers in the US, and 85% of all teenage girls sewed. See "Retail Fabric Sales Seen at $2 Billion Next Year," *Women's Wear Daily,* October 15, 1968.
3. In his seminal book Theodore Roszak aptly points out that this movement, "arose not out of misery but out of plenty; its role was to explore a new range of issues raised by an unprecedented increase in the standard of living." Roszak, *The Making of the Counterculture* (Berkeley and Los Angeles: University of California Press, 1995), xii.
4. Susila Ziegler, phone conversation with the author, June 16, 2016. Ziegler owned successive boutiques, Kumquat Mae and Rainbow Arbor, and also designed and sold Grateful Dead T-shirts until 1971 when she turned the enterprise over to Bill Graham.
5. Tom Wolfe, *The Electric Kool-Aid Acid Test* (New York: Bantam, 1972), 391–392.
6. K.S., "Scavenging and Law," *San Francisco Chronicle,* June 21, 1971.
7. George Hunter, in-person conversation with the author, November 8, 2016, San Francisco.
8. Jean and Charlie Stewart, in-person conversation with the author, August 8, 2016, Fairfax, CA.
9. Alexa Davis, "Old Clothes, Never Trust Anything Under 30," *Rags,* January 1971, 42.
10. Ibid., 43.
11. "Men's Hat Department," *Sacramento Daily Union,* February 26, 1890, 3.
12. Rita Hoffman, "Happily Ever After . . . Four San Francisco Stories and a Fortune Cookie," *Mademoiselle,* May 1964, 141.
13. Helene Robertson, in-person conversation with the author, June 14, 2016, San Anselmo, CA.
14. Hoffman, "Happily Ever After," 141.
15. The Trident (1966–1976) was a legendary club and hangout for Bay Area musicians. Singer-songwriter David Crosby of the Byrds and Crosby, Stills and Nash famously referred to it as "Ground zero for sex, drugs and Rock and Roll." "Welcome to the Trident," website of the original Trident Restaurant, http://www.thetridentrestaurant.com, accessed November 11, 2016. See also Jim Wood, "The Trident: Sausalito's Legendary Waterfront Restaurant," *Marin Magazine,* July 2010.
16. Robertson conversation.

17 A.C., "After Psychedelia," *Fashion Week*, February 14, 1969.
18 Quoted in "Designer Profile," *California Stylist*, October 1970.
19 Herb Caen, "The New City," *San Francisco Chronicle*, Sunday, January 23, 1966.
20 Quoted in "Anastasia's Boutique Shows What's Happening on Coast," *Women's Wear Daily*, May 2, 1967.
21 Duskin, quoted in Baron Wolman, "An Alvin Duskin Dress in Every Closet!," *Rags*, July 1970, 19.
22 Joan Chatfield-Taylor, "It's a Cinch for Fall," *San Francisco Chronicle*, May 31, 1967.
23 Wolman, "Alvin Duskin Dress," 18.
24 Maureen Kirby, "Hits in Knits For With-Its," *San Francisco Sunday Examiner and Chronicle*, October 6, 1968.
25 Tracey Panek, historian, Levi Strauss & Co., in-person conversation with the author, March 21, 2016, San Francisco.
26 Karin Winner, "The Coast: Levi's For Gals Official Finds Talking Fashion Easy," *Women's Wear Daily*, May 5, 1971.
27 Peggy Caserta, phone conversation with the author, July 22, 2016.
28 Quoted in Winner, "Levi's For Gals."
29 Sales figures for Levi's For Gals for the first nine months of 1968 placed them in the top ten women's wear firms in the country. See Ki Hackney, "Levi Country," *Women's Wear Daily*, June 24, 1970.
30 Angela Taylor, "If Jeans Seem on Their Last Legs, It's Only the Beginning — As Skirts," *New York Times*, September 1, 1973.
31 Henry J. Sedis, "Riveting Show of Decorated Levi's," *Los Angeles Times*, September 30, 1974.
32 Joan Chatfield-Taylor, "New Duds Out of Old Jeans," *San Francisco Chronicle*, August 2, 1973.
33 Melody Sabatasso, in-person conversation with the author, May 24, 2016, Sausalito, CA.
34 Chatfield-Taylor, "New Duds."
35 Sherry L. Smith, *Hippies, Indians, and the Fight for Red Power* (Oxford: Oxford University Press, 2012), 65.
36 Louis J. West, "Hippies, Teeny-Boppers, and the Asphalt Sherwood Forest" (lecture, Commonwealth Club, San Francisco, September 22, 1967), http://www.commonwealthclub.org/node/82133. Jolly West was a fellow at the Center for Advanced Study in Behavioral Sciences at Stanford University (1966–1969) and conducted fieldwork in the Haight.
37 Bill Morgan, *North Beach Leathers, Tailors to the Stars* (San Mateo, CA: William Morgan, 2010), 22.
38 Ibid., 23–24.
39 Ibid., 31.
40 Peter Rowan, "Leather, Feathers for Boutique Babies," *Oakland Tribune*, January 2, 1977.
41 Doug Mirell, "Burray Olson Turns Talent to Creating Wearable Arts," *Hollywood Reporter*, July 24, 1975.
42 Ibid.
43 Quoted in Judy Klemesrud, "Fighting a War on Behalf of the Indians," *New York Times*, October 24, 1970. In the same article, Sainte-Marie says one of her recurring daydreams is to take Giorgio di Sant' Angelo, a designer who had recently won the prestigious Coty American Fashion Critics' Award for his "Indian" fashions, and other designers on a tour of the reservations.
44 Quoted in Rowan, "Leather, Feathers for Boutique Babies."
45 See James Austin Hanson, *Clothing and Textiles of the Fur Trade* (Chadron, NE: Museum of the Fur Trade, 2014). The Athabaskans are native peoples of Alaska.
46 Burray Olson, in-person conversation with the author, June 25, 2016, Sonoma, CA.
47 Jeanne Rose, in-person conversation with the author, May 19, 2016, San Francisco.
48 On the Charles Lloyd Quartet's album cover for *Journey Within*, recorded live at the Fillmore Auditorium in 1967, all of the clothes worn by the band are her designs, with the exception of Lloyd's suit.
49 Quoted in Susan Lydon, "A Few Folksy Fashions: Far Out Outfits from the Haight-Ashbury," *Rolling Stone*, May 25, 1968, 13.
50 Rose was featured in the *Berkeley Barb* (June 30–July 6, 1967), the *San Francisco Sunday Examiner and Chronicle* (October 8, 1967), *Rolling Stone* (March 25, 1968), and *Women's Wear Daily* (April 24, 1969).
51 Quoted in Walter Blum, "Out on a Limb," *San Francisco Sunday Examiner and Chronicle*, October 8, 1967.
52 Lydon, "Few Folksy Fashions," 12.
53 Ibid., 28.
54 She was a member of the first class of female undergraduate nursing students at the previously all-male university.
55 Yvonne Porcella, *Art and Inspirations* (Lafayette, CA: C and T, 1998), 11. Her neighbor's name was Harlene Anthony.
56 Ibid., 16.
57 Ibid., 24.
58 Yvonne Porcella, *Five Ethnic Patterns* (printed by the author), 1977.
59 Ibid., introduction.
60 Mickey McGowan, in-person conversation with the author, June 22, 2016, San Rafael, CA.
61 Ibid.
62 Ibid.
63 Ibid.
64 Suzanne Baizerman, "California and the Fiber Art Revolution," Textile Society of America Symposium Proceedings, Paper 449, Oakland, California, October 7–9, 2004, http://digitalcommons.unl.edu/cgi/viewcontent.cgi?article=1449&context=tsaconf.
65 The *I Ching* or *Classic of Changes* (ca. 10th–4th centuries BCE) is one of the oldest and most influential Chinese classics. It has played a significant role in the Western understanding of Eastern thought since it was first translated. Offering insights into religion, philosophy, metaphysics, and cosmology, it had widespread appeal to the 1960s counterculture.
66 Fred Kling and Candace Kling, in-person conversation with the author, June 30, 2016, Oakland, CA.
67 Ibid.
68 One of the founders of the Diggers, Peter Coyote, describes the Free Stores as little more than bins of free goods, "designed to encourage reflection on the relationships among goods and roles — owner, employee, customer — implied by a store." The stores were filled with "the available detritus of an industrial culture . . . the store's existence advertised its own premise: 'stuff' is easy to acquire; why trade time in thrall in order to get it?" Peter Coyote, *Sleeping Where I Fall: A Chronicle* (Washington, DC: Counterpoint, 1998), 89.
69 Judy Goldhaft, in-person conversation with the author, August 25, 2016, San Francisco.
70 "The Psychedelic Tie-Dye Look," *Time*, January 26, 1970.
71 Erin Weinger, "Psychedelic Beginnings," *Los Angeles Times*, April 6, 2008, and Mark Hughes, *Buzzmarketing: Get People to Talk about Your Stuff* (New York: Portfolio, 2005).
72 "The Textile Art Period," Marian Clayden website, accessed October 30, 2016, http://www.marianclayden.com/textile-art-period.html.
73 Soon after, she began collaborations with Ben Compton and Mary McFadden in New York, Rudi Gernreich in Los Angeles, and Cecil Beaton in London. See "Marian Clayden: A Dyer's Journey through Art and Fashion," exhibition guide, Bonington Gallery website, accessed December 13, 2016, http://www.boningtongallery.co.uk/wp-content/uploads/2013/08/Marian-Clayden-Gallery-guide-for-web1.pdf.
74 The woman was dancer Francis Davis, the soon-to-be ex-wife of jazz musician Miles Davis.
75 Courtenay Pollock, phone conversation with the author, July 19, 2016.
76 Ibid.
77 Courtenay Pollock, phone conversation with the author, April 4, 2016.
78 Ibid.
79 Pollock, conversation, July 19, 2016.
80 "Grateful Dead Days," Courtenay Tie Die website, accessed October 27, 2016, http://www.courtenaytiedye.com/grateful-dead-days/.
81 Joan Wiener Bordow, "The Birgitta Touch," *San Francisco Sunday Examiner and Chronicle*, August 22, 1976.
82 Bjerke outlined her life adventures during an in-person conversation with the author, May 15, 2016, Pecos, NM.
83 Betty Friedan, *The Feminine Mystique* (New York: W.W. Norton, 1963). Friedan refers to the family as a "comfortable concentration camp," 294.
84 The collection was featured in the November 1969 issue of *Vogue*.
85 Bjerke conversation.
86 Brigitta Bjerke, e-mail message to the author, July 22, 2016.
87 Ibid.
88 Ibid.
89 Bjerke conversation.
90 "The Hippies," *Time*, July 7, 1967, 22.

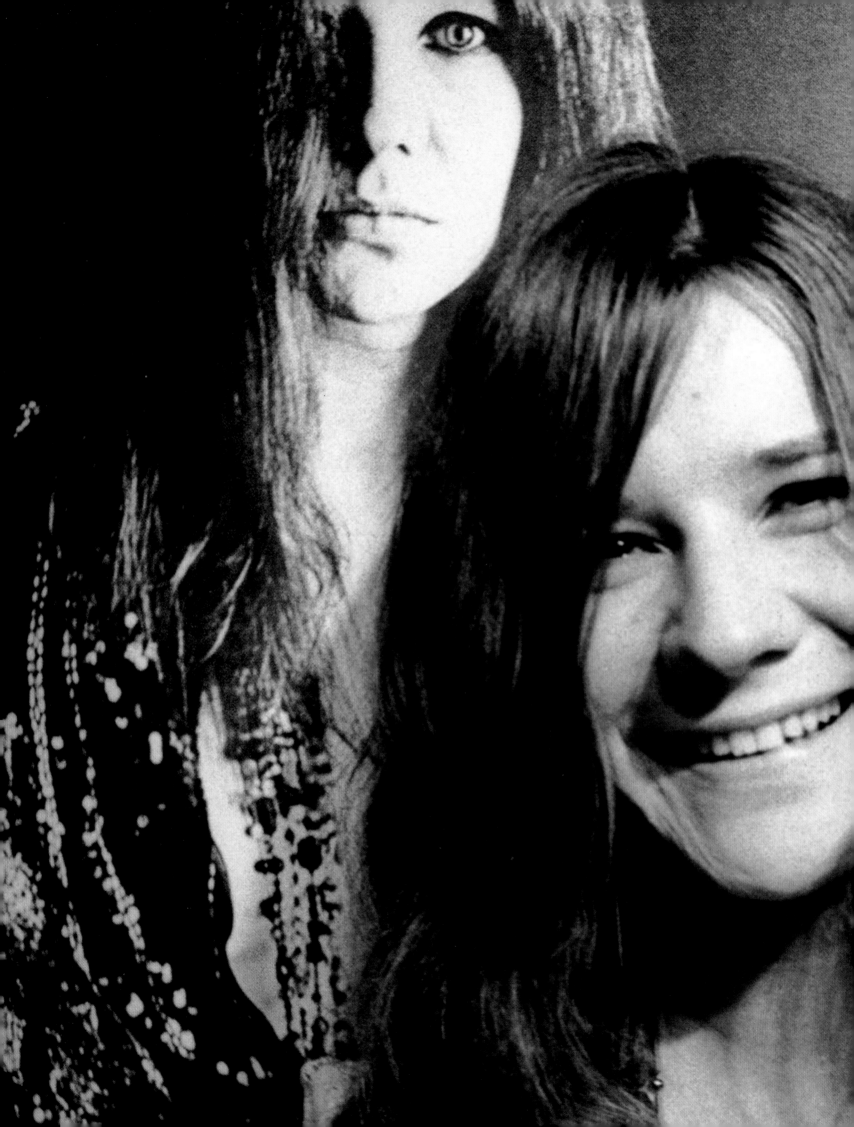

if you're going to san francisco

rock music in the summer of love

JOEL SELVIN

ON THE FIRST WEEKEND school let out for the so-called Summer of Love, thousands of young music fans streamed to the Monterey International Pop Festival, a three-day event from June 16 to 18, 1967, that turned out to be the pivot point on which the modern rock movement swiveled. Held on the same shady fairgrounds 120 miles south of San Francisco that had hosted the Monterey Jazz Festival since 1958, the musicians performed in the horse show arena that seated a mere 8,500, although as many as 25,000 people showed up to peacefully mingle on the festival grounds or outside the surrounding chain-link fence.

That weekend, the new rock music on display from San Francisco, London — the musical axis of the Summer of Love — and elsewhere swept across the stage like beams of blinding white light: the Jimi Hendrix Experience, Janis Joplin, Otis Redding, Jefferson Airplane, the Who. In a single weekend, everything changed. Although few knew it that Monday, Top 40 was dead and the underground had taken over.

The festival's producers, John Phillips of the Mamas and the Papas and their manager–record producer Lou Adler, set out to showcase a panorama of the best of the day's exciting new rock sounds and paradoxically made a persuasive argument for their

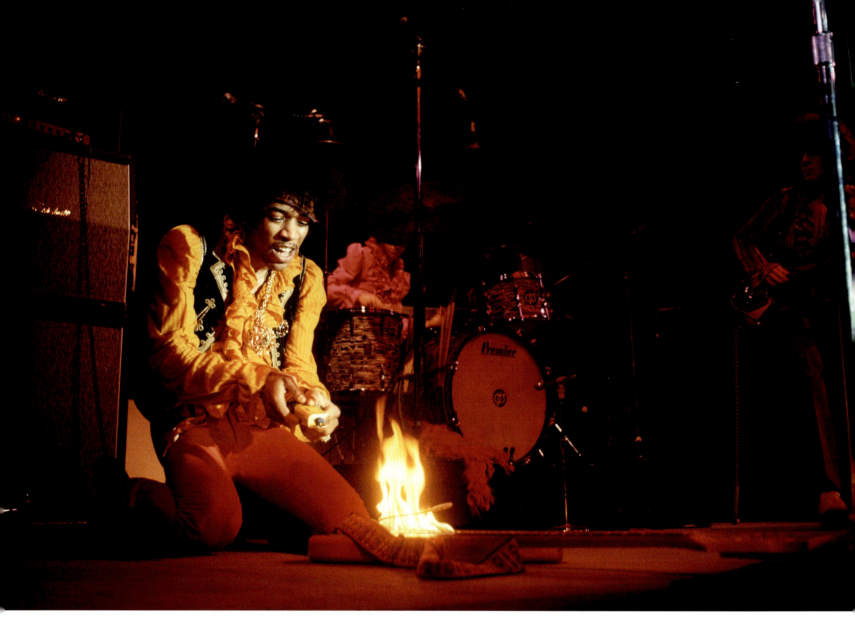

52
Jimi Hendrix ignites the Summer of Love at the Monterey International Pop Festival, June 18, 1967. Photo by Jim Marshall.
COURTESY OF JIM MARSHALL PHOTOGRAPHY LLC

own obsolescence and the ascendancy of music from an emerging rock underground. In fact, the Mamas and the Papas, hot off a string of six consecutive Top 10 records, would never have another hit again. Jimi Hendrix, on the other hand, would light up the rock world as he notoriously did his guitar that Sunday night at Monterey (fig. 52).

The Monterey festival was the convergence of subterranean streams in pop music that had been brewing since at least three years earlier when the Beatles first burst forth on this continent with their hit single "I Want to Hold Your Hand" and their subsequent US tour. It was the greening of rock music, a generation's effort at creating its own culture and the result of complex shifts in the American musical landscape since World War II. As the pop music mainstream grew ever more puerile and soporific as the musical vitality of Swing Era ebbed and Mitch Miller ushered in a fifties pop sound awash in strings, vocal choirs, and chirpy female vocalists, more provocative subcultural developments in rhythm and blues, and country and western inflamed the imagination of a younger generation exposed to this music through late-night, high-watt radio broadcasts. What came to be called "rock and roll" first emerged on a nationwide scale in 1954 and was little more than white people playing black vernacular music. Bill Haley and His Comets, whose massive "Rock Around the Clock" announced the beginning of the rock-and-roll era, was essentially a mediocre hillbilly outfit that put away the steel guitar and cut out the yodels, switching to a repertoire drawn from rhythm and blues.

But rock and roll was resolutely teenage music, and by the end of the fifties, older youth gravitated to the more mature folk music, led on the pop charts by the Kingston Trio, while rock and roll turned ever more determinedly and explicitly teen with the rise of the "American Bandstand" idols, all greasy haircuts and toothy smiles. The Beatles arrived on US shores in 1964, the biggest new wave in pop since rock and roll ten years earlier, and

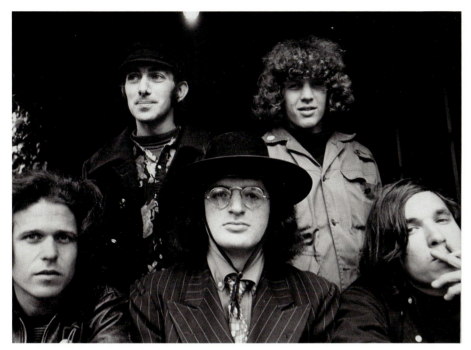

were no different — except for the haircuts. What ultimately made the Beatles different was that they refused to remain constricted in such limited teen idol roles and quickly began to grow as artists. With them evolved the whole pop music movement.

In San Francisco, as the psychedelic drug LSD spread through the youth community, bands and audiences came together to experiment with an altogether new kind of rock music. The music of the city's standing-room-only ballrooms emphasized long, sinewy guitar playing, vocal harmonies drawn from folk music, and tough, compact instrumental groups that owed more to Chicago blues than Memphis rock and roll. They played for dancers under the influence of psychedelic drugs and were often under the influence of the same drugs themselves. Despite the moniker given to the music of the city during this era, there was no distinct "San Francisco Sound," but there was a willingness to experiment, on the part of both audiences and musicians, that quickly produced a variety of new rock bands employing a wide array of resources and styles; from the post-folk electric rock of Jefferson Airplane and extended blues improvisations of the Grateful Dead to the agitprop acid rock of Berkeley's Country Joe and the Fish (fig. 53) or the Bo Diddley–infused extrapolations of Quicksilver Messenger Service. The common components were courage, wit, a commitment to exploration, and LSD.

San Francisco and the psychedelic realm loomed over rock in June 1967. The Beatles' new album *Sgt. Pepper's Lonely Hearts Club Band* was a valentine to San Francisco psychedelia by British musicians who could only imagine what it was like. The exotic whiff of psychedelia was seeping through the rock scene everywhere. Even the dark, foreboding debut album by Los Angeles rock band the Doors, released in January 1967, came with psychedelic swirls and instrumental flights inspired by the San Francisco sound.

Little more than a rumor outside their own area code in 1965, in less than two years these San Francisco bands had exploded the boundaries, raised the stakes, and captured the imagination of the music world without even actually being heard much outside the walls of the city's Fillmore Auditorium and Avalon Ballroom. Jefferson Airplane's second album *Surrealistic Pillow* had only just been released in February 1967 (the band's debut album had been almost entirely ignored outside the Bay Area), and the hit singles "White Rabbit" and "Somebody to Love" were all over the airwaves at the top of summer. Even the treacly, ubiquitous hit that month — Scott McKenzie's "San Francisco (Be Sure to Wear Flowers in Your Hair)," written by Phillips to publicize the Monterey Pop Festival — paid obeisance to the central truth of rock music around the world: the heart of the Summer of Love was San Francisco.

Three years before, San Francisco wasn't even on the rock-and-roll music map. San Francisco disc jockey Tom Donahue and his partner Bobby Mitchell ran a small independent label called Autumn Records, which managed nationwide hits with fifties' rocker Bobby Freeman and the British-styled quintet Beau Brummels, both produced by a nineteen-year-old wunderkind discovered by Donahue who called himself Sly Stone. But that was the only blip on the screen.

53
Country Joe and the Fish (left to right: Joe McDonald, Gary "Chicken" Hirsh, David Bennett Cohen, Barry Melton, and Bruce Barthol), 1966. Photo by Barry Oliver.
THE SELVIN COLLECTION

54
Jerry Garcia (Captain Trips) (left) and Ron (Pigpen) McKernan (right) of the Grateful Dead, November 29, 1966. Photo by Bob Campbell.
THE SELVIN COLLECTION / COURTESY OF THE SAN FRANCISCO CHRONICLE

55
The Great Society
(left to right: Darby Slick, Peter van Gelder, Grace Slick, Jerry Slick, and David Miner), San Francisco, 1966.
THE SELVIN COLLECTION

In 1964, with the release of the movie *A Hard Day's Night,* the Beatles began to steer rock and roll toward adulthood, winning over a collegiate crowd with its flip, irreverent wit and hearty, blues-based pop songs. It was a relief for many to see teen idols smoke and drink and behave like grown-ups. And, the music itself was growing up too. When Augustus Owsley Stanley III became the first private party to synthesize LSD in Berkeley in 1964 and produced the first few million doses of the mind-altering chemical, he unleashed in the Bay Area a catalyst for great social and personal change, especially, it turned out, musical. Jefferson Airplane founder Paul Kantner, a seasoned folk musician at the time, always remembered the first time he stroked an electric guitar under the influence of LSD, the way the reverberations echoed through his every cell.

As the Beatles and LSD spread through legions of former folk musicians in Northern California, the incipient rock culture grew. At the May 1965 concert by the Rolling Stones at the San Francisco Civic Auditorium, several groups of musicians who attended would be leading bands of their own by fall — Jefferson Airplane, Big Brother and the Holding Company, the Charlatans, Quicksilver Messenger Service. In the South Bay, under the influence of Stanford University and a government-sponsored drug-testing program at the nearby veterans' hospital, a former group of folkies turned electric to play as house band for the psychedelic free-for-alls thrown by author Ken Kesey and his band of LSD evangelists, the Merry Pranksters, at their Acid Tests; they would become the Grateful Dead (fig. 54). In Berkeley, a jug band picked up electric guitars to protest the Vietnam War with "I-Feel-Like-I'm-Fixin'-to-Die Rag" and adopted the new, psychedelicized name of Country Joe and the Fish.

These changes had been occurring privately in a few isolated neighborhoods, but there was no sense of any widespread community until October 1965, when four hippie communards calling themselves the Family Dog threw a dance concert at Longshoremen's Hall in San Francisco's North Beach. They printed up hand-lettered, almost childish-looking flyers advertising "A Tribute to Dr. Strange" that more than hinted at the event's psychedelic underpinnings.

The Charlatans, a jangly group of Edwardian dandies whose sound was modeled loosely on the folk-rock of the Byrds, was the headline attraction. Jefferson Airplane, a new band that had only started performing at a converted pizza parlor in the Marina District the previous month, was second-billed above the Great Society (fig. 55), which featured female vocalist Grace Slick, and a band from the East Bay called the Marbles. One thousand people filled the cavernous concrete bunker, dressed in Goodwill castoffs and colorful costumes, hair growing past their shoulders, and, in an instant, everybody had the same sodden realization: *I didn't know there were so many of us.*

That November, San Francisco Mime Troupe manager Bill Graham was astonished when an overflow crowd jammed the troupe's tiny loft for a defense fund concert (the Mime Troupe had been arrested on obscenity charges stemming from performing a sixteenth-century Italian play free in the park). After two subsequent, equally successful benefits at the Fillmore Auditorium, an upstairs ghetto music hall long consigned to the Chitlin' Circuit, the exclusive province of black entertainers and audiences, Graham left the theater troupe and started throwing regular dance concerts for hippies at the hall in January 1966. In April, his erstwhile associate Chet Helms of the Family Dog began producing weekly shows at the nearby Avalon Ballroom. Bands also appeared nightly at the small nightclub built by Jefferson Airplane called the Matrix. The San Francisco scene started to heat up.

56
Jefferson Airplane performs at the Matrix, San Francisco, October 1966. Photo by Jim Marshall.
THE SELVIN COLLECTION

57
Grace Slick backstage at the Matrix, on the night of her first official performance with Jefferson Airplane, October 1966. Photo by Jim Marshall.
THE SELVIN COLLECTION

In March 1966, the Paul Butterfield Blues Band arrived in San Francisco for a series of concerts for Bill Graham. With guitarists Mike Bloomfield and Elvin Bishop fronted by the extraordinary vocalist and harmonica-master Butterfield and backed by a rhythm section they stole from Howlin' Wolf, the Chicago group showed the nascent local bands how

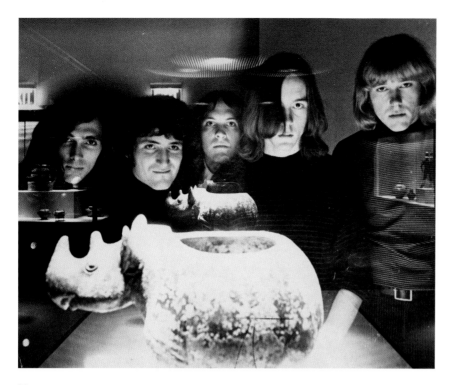

58
Quicksilver Messenger Service (left to right: John Cipollina, David Freiberg, Greg Elmore, Gary Duncan, and Jim Murray), 1966. Photo by Fred Roth.
THE SELVIN COLLECTION

it could be done — a combination of instrumental prowess and daring improvisations the San Francisco bands, at that stage, could only aspire to. But the Butterfield shows sparked combustion. With Jefferson Airplane on the bill, the Butterfield band played several weekends, including dates at the nearby, larger Winterland Arena and across the bay at UC Berkeley's Harmon Gym.

Like-minded bands streamed through town that year from Los Angeles, Texas, Seattle, New York, even England, rubbing up against the original psychedelic warriors and spreading the sound. These were golden days. Every week, each of the halls featured three bands playing two sets apiece for three bucks admission. In addition to the psychedelic San Francisco bands, the bills often featured diverse and adventuresome bookings such as Brazilian guitarist Bola Sete or Chicago blues greats such as Muddy Waters or Howlin' Wolf. Fifties' rock-and-roll guitarist Bo Diddley revitalized his career with ecstatically received appearances at the Avalon. Everybody going to these concert halls that year knew immediately they were entering a special, enchanted realm. And the music was fantastic.

Almost immediately, the first band to emerge from this new San Francisco rock underground was Jefferson Airplane (fig. 56), former folkies who brought practiced three-part harmonies from vocalists Kantner, Marty Balin, and their female colleague, Signe Anderson. Guitarist Jorma Kaukonen, a brilliant student of the finger-picking blues giant Reverend Gary Davis, brought a virtuoso touch to the band, which tried various rhythm-section members before settling on the formidable Jack Casady on bass and slightly older, jazz-inclined drummer Spencer Dryden. The Airplane headlined the early Fillmore shows and quickly arranged to record with RCA Victor records, whose producers insisted on adding glockenspiel parts to the band's debut album. Anderson was replaced in October 1966 by Grace Slick (fig. 57), a gorgeous and charismatic model-turned-vocalist the Airplane pulled from rival band the Great Society. Slick's joining the Airplane not only ended the Great Society, but her marriage to the band's drummer, Jerry Slick. When the Airplane went into the studio to record their second album, they not only brought two Grace Slick songs from the Great Society's songbook, "Somebody to Love" and "White Rabbit," but also the immensely skilled and confident guitarist Jerry Garcia of the Grateful Dead.

Garcia was a former banjo instructor and bluegrass musician from the Palo Alto folk scene who had gathered around him a group of similar outcasts who would become the Grateful Dead, initially a blues-based outfit built around the rhythm-and-blues stylings of vocalist Ron "Pigpen" McKernan. The Dead quickly established themselves as a favorite on the early Fillmore and Avalon bills — and Garcia as one of the scene's leading instrumentalists — often alongside the Airplane or Quicksilver Messenger Service, another keystone band in those heady, early days of the San Francisco scene.

Quicksilver Messenger Service (fig. 58) was a quintet with four members who shared two birthdays, a powerful astrological influence responsible for the band's name (Quicksilver being another name for Mercury, the planet that ruled the band's charts). Guitarist John Cipollina was among the most swashbuckling of the San Francisco hero guitarists, with his hot-rodded equipment and long flowing locks, but fellow guitarist Gary Duncan also could burn up long, extemporaneous solos on folk-based Quicksilver specialties such as "Babe I'm Gonna Leave You," "Codeine," or Bo Diddley's "Who Do You Love?" which the band often extended past the half-hour mark.

Big Brother and the Holding Company (fig. 59) served as practically the house band at the Avalon, where proprietor Chet Helms also acted as the band's manager. (Nobody doubted who "Big Brother" was and who was "the Holding Company.")

In June 1966, Helms inveigled an old friend from the University of Texas to move to San Francisco and join the band, Janis Joplin. At first, Joplin was sequestered on the side of the stage, the "chick singer" with this rowdy bunch of psychedelic musicians including incendiary guitarist James Gurley, but she would bring her fierce spirit and genuine sex appeal to the band. Photos of her coyly posed topless started appearing in Haight-Ashbury head shops, making Joplin the first hippie pinup girl (fig. 60).

With guitarists such as Garcia, Kaukonen, Duncan, Gurley, and Barry Melton of Country Joe and the Fish leading the way, the San Francisco bands began to dissolve long-standing boundaries in rock music and explore fresh vistas of instrumental flight and fancy. Their music brought esoteric strains of Django Reinhardt gypsy jazz and Indian sitar ragas to rock compositions taking new shapes beyond the simple verse-chorus-verse structure of the three-minute pop song. Their experiments were not lost on visiting bands such as Los Angeles–based Buffalo Springfield, whose guitarists Stephen Stills and Neil Young would expand on what they heard in San Francisco in their own band, or 13th Floor Elevators from Austin, Texas, who got lost in a San Francisco psychedelic haze of their own that summer, only returning home after months in San Francisco working the ballrooms and dropping acid.

New bands turned up almost every other week. In late 1966 Moby Grape, a band formed around Alexander "Skip" Spence, who had played for split seconds in early versions of the Airplane and Quicksilver, started playing the dance halls. The band's three-guitar, three-vocal attack made Grape an instant favorite with a bright, tuneful sound that rapidly landed the band on Columbia Records.

From Chicago, where work on the blues scene had dried up and word of plentiful jobs in San Francisco came from the Butterfield bunch, guitarist Steve Miller arrived in town with five dollars in his pocket and started his band in an empty UC Berkeley basement during Thanksgiving break. The next month, he was playing the Avalon. Mike Bloomfield, probably the most famous guitarist in rock at that point, left the Butterfield band and relocated in San Francisco, where he started to put his own thing together.

Other musicians followed. Harmonica player Charlie Musselwhite and guitarist Harvey Mandel also came from Chicago. The Youngbloods moved from New York. The city was thriving with music and culture, and the possibilities seemed endless. As word spread of a new community growing in San Francisco's Haight-Ashbury neighborhood, more like-minded young people came West.

In January 1967, tribal leaders of the Haight sponsored an event they called the Human Be-In, a massive gathering in Golden Gate Park that attracted a huge, overflowing crowd. If the one thousand people who attended "A Tribute to Dr. Strange" in October 1965 experienced a certain culture shock of self-recognition attending that seminal event, the enormous throng at the Be-In — as much as ten times the Longshoremen's Hall crowd — served notice that this movement had mushroomed beyond the wildest imagination. They listened to the bands — the Airplane, the Dead, Quicksilver — and heard acid guru Timothy Leary tell them to "tune in, turn on and drop out." Beat poets such as Allen Ginsberg and Lawrence Ferlinghetti, representing the hippies' spiritual precursors from the Beat Generation (see McNally, this volume), shared the stage with the hippie rock bands. It was altogether a convocation of new and diverse emergent forces in society.

Soon the record industry began to pay attention. The Airplane released their second album that February, and the Grateful Dead put out their debut LP on Warner Brothers in March. Country Joe and the Fish and Moby Grape brought out their first albums before Monterey. Although the Airplane scored two Top 10 hits off their new album, the rest of the country had heard little of the other San Francisco bands, whose music was not geared for the AM radio stations that controlled the pop music airwaves (although little-known San Francisco group Sopwith Camel did manage a modest Top 40 hit called "Hello Hello" in early 1967).

The AM-radio stranglehold started to break in February 1967, when disc jockey Larry Miller began broadcasting a late-night folk music show on the foreign-language station KMPX-FM in San Francisco. Within weeks, he was joined on the air by former Top 40 kingpin Tom Donahue — and underground radio was on the air. The free-form radio station proved so popular so quickly that when Jimi Hendrix played the Fillmore as opening act for the Airplane in June the week after his coming out in Monterey, the audience

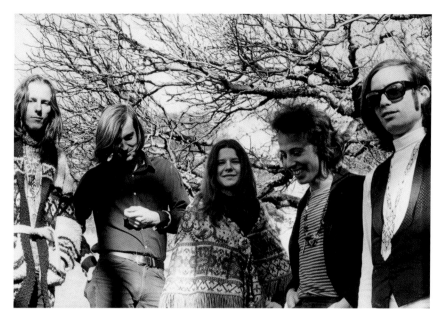

59
Big Brother and the Holding Company (left to right: James Gurley, Sam Andrew, Janis Joplin, Dave Getz, and Peter Albin), 1968. Photo by Lisa Law.
THE SELVIN COLLECTION

60
Janis Joplin poses in front of her poster in her San Francisco apartment, 1967. Photo by Baron Wolman.
THE SELVIN COLLECTION / SONY MUSIC COLLECTION, 67437-5

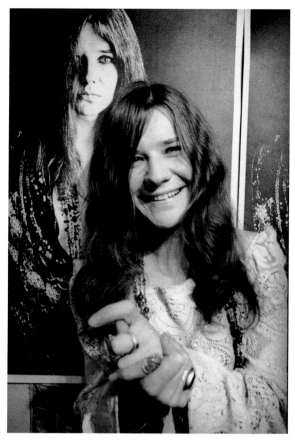

arrived already primed for his appearance by KMPX, which slammed "Foxy Lady," "Purple Haze," "Red House," and other cuts from import copies of his first album, which would not even be released in the States until August.

In fact, Hendrix proved so popular as opening act that headliners Jefferson Airplane canceled their appearances after the first of six scheduled shows. The band left the next morning for Los Angeles to work in the recording studio, while Big Brother and the Holding Company took their place on the Fillmore bill. There were no hard feelings; the Airplane provided their flatbed truck for the Jimi Hendrix Experience to play a free concert that week in the Panhandle, the long, narrow park that extends from the eastern end of Golden Gate Park, before a crowd of a few hundred, one of the signal events of those first weeks of that summer in San Francisco.

As the Summer of Love dawned that June 1967, the sun was rising over San Francisco. At the landmark Monterey Pop Festival that weekend, San Francisco bands had been given an entire afternoon — Quicksilver Messenger Service, Big Brother and the Holding Company, Country Joe and the Fish, Steve Miller Blues Band, and the first public performance by Mike Bloomfield's new band, Electric Flag. The Airplane, appearing Saturday night, was the most anticipated act of the weekend and Moby Grape and the Grateful Dead, performing Saturday and Sunday nights, respectively, also appeared. Janis Joplin, Jimi Hendrix, and Otis Redding emerged from that weekend anointed as new stars. The world had turned and San Francisco appeared to be at the center.

There seemed to be no end of inventive, attractive new groups coming from San Francisco. The months following Monterey would see a breathtaking procession of new bands breaking in at the ballrooms. Santana (fig. 61) harnessed the fire power of Latin rhythms. With a violin as the lead instrument, the rock combo It's a Beautiful Day played Balkan melodies. Blue Cheer, a somewhat brutish combination of loud electric guitar and Fender bass played through Marshall amplifiers and thundering drums, was one of rock's first power trios. Creedence Clearwater Revival brandished a reverb-laden swamp rock sound. Sly and the Family Stone obliterated borders between rock and R & B. The all-female Ace of Cups and the rhythm and blues–oriented Marin County hippies the Sons of Champlin brought a new, more soulful sound.

British rock bands, always quick to adopt new fashion trends in music, intuitively understood the message of the San Francisco bands. That fall, British groups such as Cream, Pink Floyd, and Procol Harum brought San Francisco–style rock from London to the Fillmore. The British trio Cream featuring Eric Clapton on guitar dazzled the crowds with crystalline improvisations and their confident command, taking the music of the ballrooms a step further, and every rock musician in San Francisco attended the shows. The movement had become truly international.

Of course, it was the Beatles who bestowed the ultimate judgment on the rise — and fall — of San Francisco psychedelic rock. As obvious as the influence of San Francisco was on the *Sgt. Pepper's*

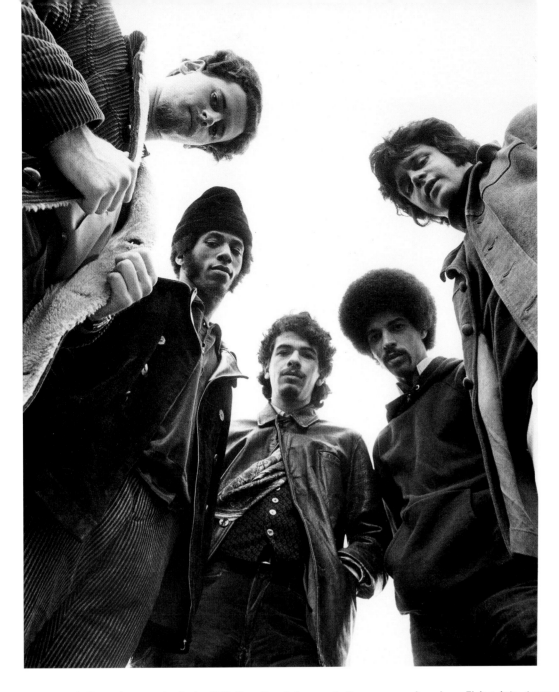

album and the subsequent single "All You Need Is Love," it was the worldwide distribution of photos of guitarist George Harrison wearing heart-shaped dark glasses strolling through the Haight in August that became the single most enduring image from the city in the Summer of Love. This was particularly ironic since Harrison, who walked the streets with his wife like a Pied Piper followed by a mass of trailing hippies, was disgusted by what he saw. By the end of the summer, the streets of the Haight-Ashbury were awash with flotsam and jetsam that had drifted into town like a wretched human logjam. Instead of the flower children of the year before, Harrison encountered the street people — and it was not a pretty sight.

As famous as the Harrison tour became, less was said about bandmate Paul McCartney's stealth visit to San Francisco the previous May, just ahead of the summer invasion. Flying into town on Frank Sinatra's Learjet, he showed up unannounced at a Jefferson Airplane rehearsal in the old synagogue next to the Fillmore, carrying a test pressing of *Sgt. Pepper's*. McCartney and the Airplane later retreated to the band's mansion, smoked some highly potent psychedelic called DMT, and listened to the record. This was the real London–San Francisco accord, the rock movement summit meeting, celebrating an axis that was turning the world of rock at that moment toward some of its most vivid, brilliant days. ❈

61
Santana (left to right: Bob "Doc" Livingston, David Brown, Carlos Santana, Michael Carabello, and Gregg Rolie), 1968.
THE SELVIN COLLECTION. COURTESY OF SONY MUSIC / BMG

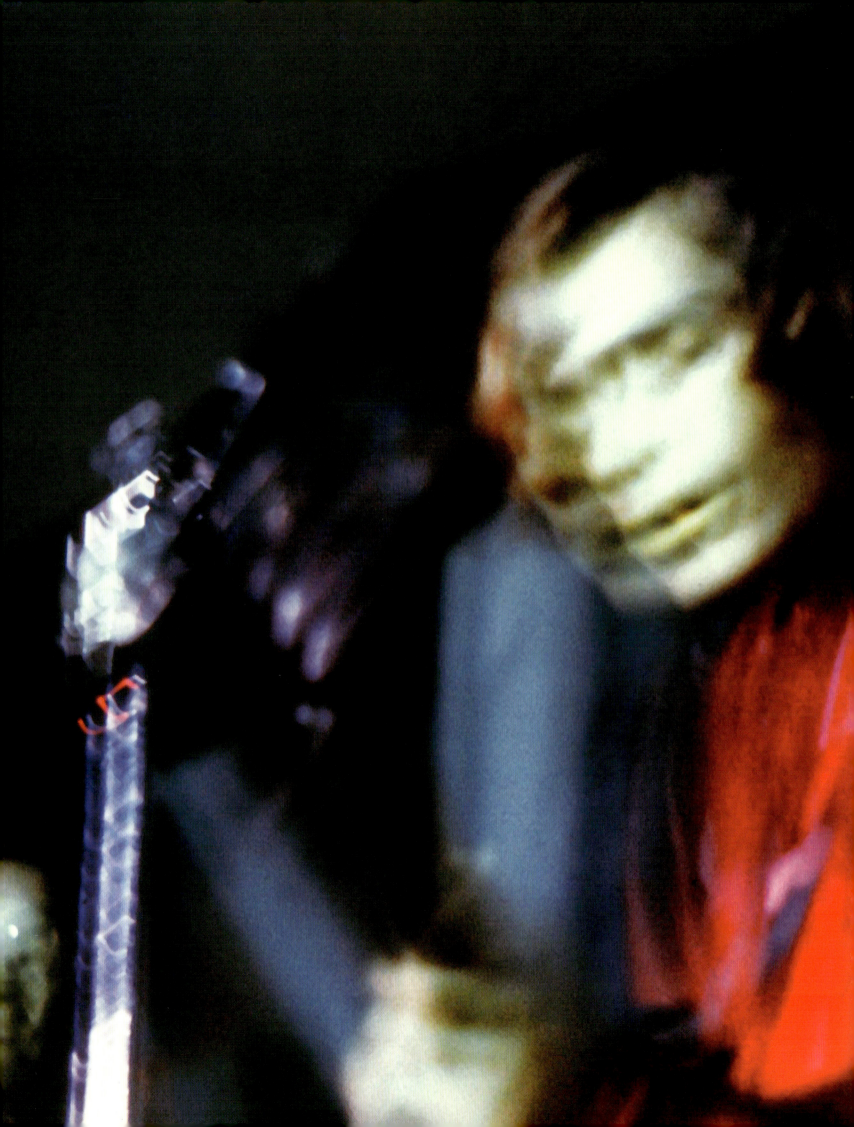

catalogue

TEXTS BY JILL D'ALESSANDRO
and COLLEEN TERRY

"What is called the hippie movement involves an alteration of consciousness towards some kind of greater awareness and greater individuality. Hopefully the future will see a spread of that gentleness and consideration poetically and artistically."

ALLEN GINSBERG

SECTION 1

(sittin' on) the dock of the bay

NESTLED BETWEEN the Pacific Ocean and the San Francisco Bay, San Francisco has served as the cultural, commercial, and financial hub of Northern California for more than a century. In the mid-nineteenth century, reports of gold in the nearby Sierra Nevada Mountains captured the world's imagination, and as a natural gateway to gold country, the city boomed. By August 1967, when soul singer Otis Redding found himself in a Sausalito houseboat (after playing the Fillmore) writing song lyrics about the city by the bay, San Francisco had returned again to the international stage, with word of psychedelic happenings, a new sound in music, and campaigns for social change permeating the mainstream press.

Long before the city's legendary Summer of Love, San Francisco was awash in distinctive forms of creative expression. One of the most significant progenitors of what would become the 1960s countercultural movement was the cross-disciplinary artistic and literary movement known as Beat, which blossomed from the mid-1950s in the coffee shops, galleries, and night clubs of San Francisco's North Beach neighborhood. A purely literary phenomenon from the start, Beat included poets and writers such as Michael Bowen (pls. 5–6), Lawrence Ferlinghetti, Allen Ginsberg (pl. 4), and Jack Kerouac, and later grew to encompass visual artists such as Bruce Conner (pl. 2), all working in an aesthetic of appropriation that rendered a critique on contemporary mainstream society.

A similar practice appears in the work of local poster artists, who, from the mid-1960s, drew upon the city's storied past, incorporating aesthetics from the Wild West, the Victorian era, and Art Nouveau into work steeped with a dynamic sense of place (pls. 12–15). Their creative peers took a similar approach to constructing unique dress codes. From the mid-1960s, portions of San Francisco's Western Addition neighborhood were razed to make room for new housing developments; as the old Victorian houses were demolished, their contents were snapped up by youth such as George Hunter, founding member of the psychedelic rock band The Charlatans (pl. 7). Fashion designers also looked to Native American traditions, incorporating such details as hand beading and fringe into clothing destined to be worn by musicians such as Peter Kaukonen (pls. 9–10). In a similarly shared aesthetic, both poster and fashion designs were also informed by Eastern cultures and religions (pls. 16–17), due in part to the city's position at the edge of the Pacific Rim, which inspired many to travel to Asia in search of new spiritual paths. A comparable variety of creative influences can be seen in the music and light shows (pl. 11) that accompanied dance concerts at the Fillmore Auditorium, the Avalon Ballroom, and other venues throughout the city. World cultures, art historical movements, spirituality, and psychedelics all played a role in what has come to define the look of 1960s San Francisco. By sampling such wide-ranging sources, the city's artists generated a multilayered visual aesthetic reflective of the region's multicultural spirit that was soon transported throughout the world.

Though San Francisco offered a haven from the 1950s conservatism still lingering elsewhere in the country, the social and political climate of the day weighed heavily on the city's inhabitants. Whether collaging headlines as part of a critical exercise of reinterpretation (pl. 18), harnessing bold graphic design elements for provocative messaging (pl. 19), or creating moveable spectacles to draw attention to American foreign policy and the lives lost near American military camps in Vietnam (pls. 20–21), the city's residents forced to the visual fore contemporary issues of identity and politics.

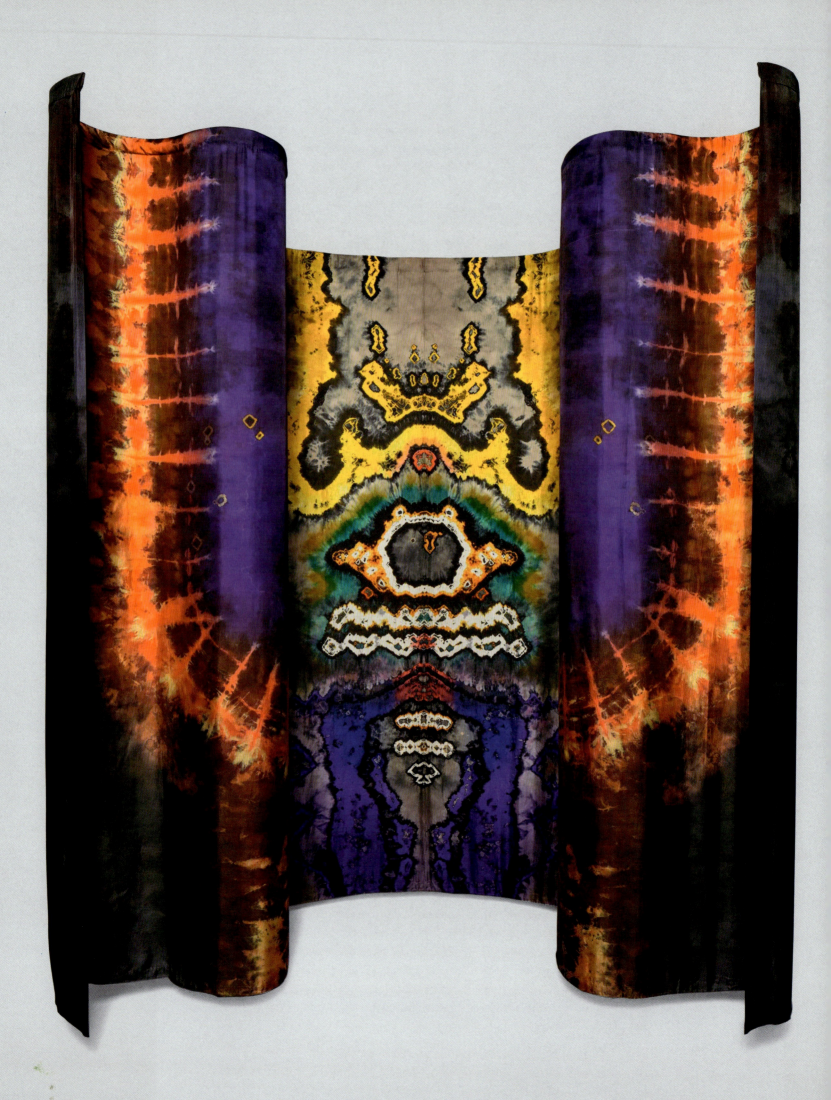

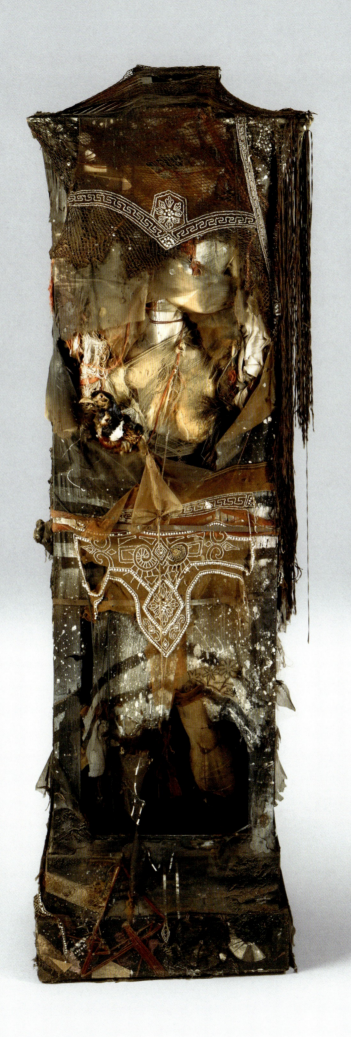

1 OPPOSITE
MARIAN CLAYDEN,
Ceremonial Enclosure,
ca. 1970. Silk; stitch-resist and discharge dyeing.
COLLECTION OF THE CLAYDEN FAMILY

2
BRUCE CONNER,
WEDNESDAY,
1960. Wood cabinet, mannequin, costume jewelry, fabric, taxidermied bird, sequins, beads, mirror, metal, yarn, wallpaper, fur, and paint.
FINE ARTS MUSEUMS OF SAN FRANCISCO, GIFT OF BRUCE AND JEAN CONNER AND PETER AND CAROLE SELZ, 1998.189

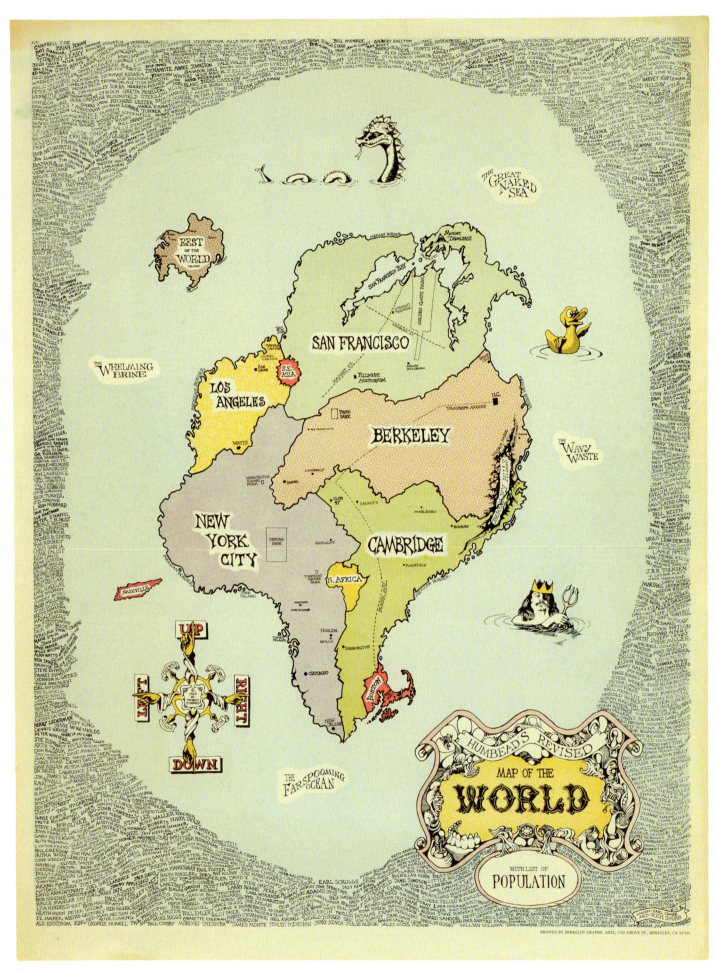

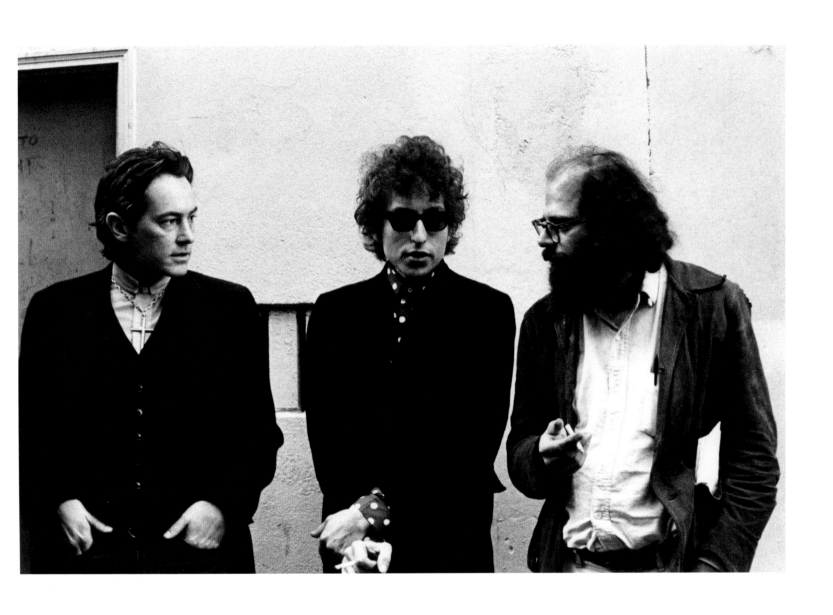

3 OPPOSITE
EARL CRABB and **RICK SHUBB,**
Humbead's Map of the World, 1968. Color offset lithograph poster.
COLLECTION OF JOHN J. LYONS

4
LARRY KEENAN,
Michael McClure, Bob Dylan, Allen Ginsberg, 1965. Gelatin silver print.
COURTESY OF THE BANCROFT LIBRARY, UNIVERSITY OF CALIFORNIA, BERKELEY, BANC PIC 2009.050.001:049-AX

**5
MICHAEL BOWEN,**
New Direction, pages from the artist's diary, 1963. Collage of stained paper with pen and black ink, albumen silver print on card, rotogravure segment, and torn gelatin silver print, with black ink rubber stamps.
FINE ARTS MUSEUMS OF SAN FRANCISCO, GIFT OF MICHAEL AND ISABELLA BOWEN, 1997.157.4

6 OPPOSITE
MICHAEL BOWEN,
Nervous System, pages from the artist's diary, 1963. Collage of stained paper with color lithograph book page, brush and black ink and grey wash, red and clear wax droplets, red pencil, pen and blue ink, black ink leaf imprints, brown crayon, and graphite.
FINE ARTS MUSEUMS OF SAN FRANCISCO, GIFT OF PHIL AND VICKI JOHNSON, 1997.163

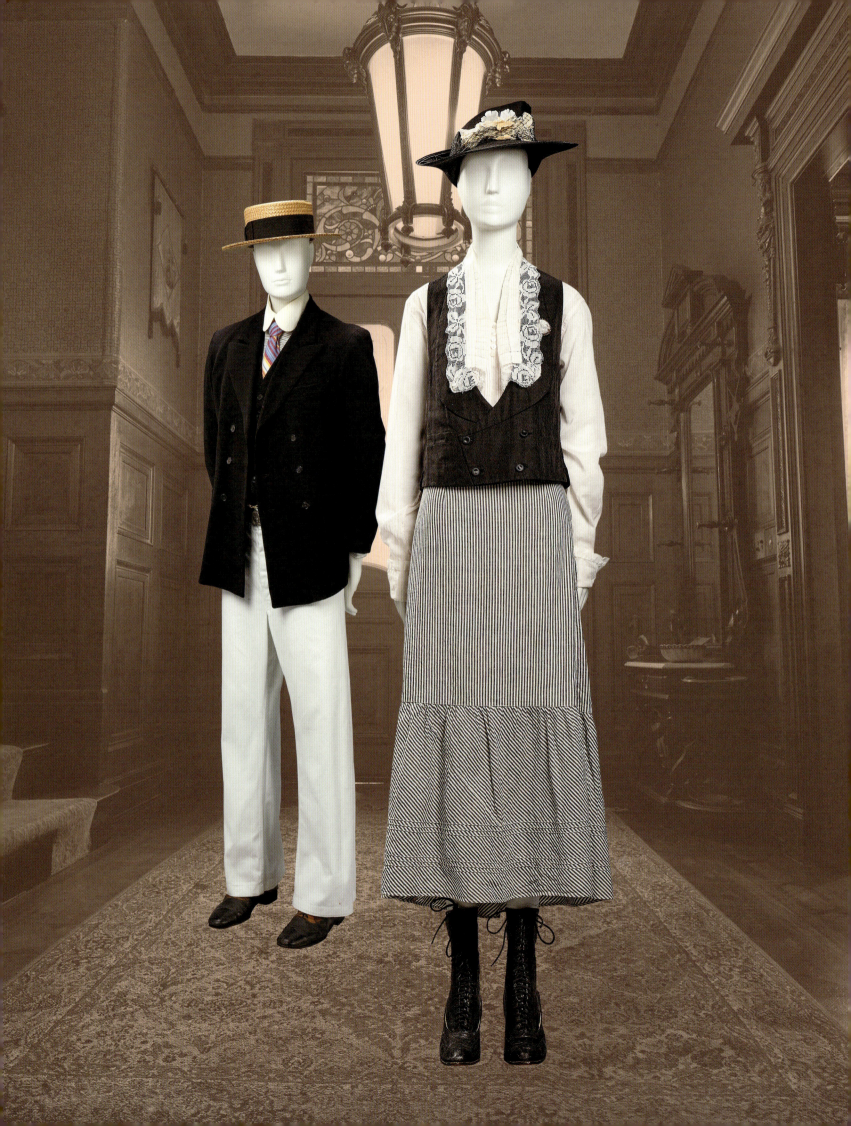

7 OPPOSITE LEFT
Ensemble, ca. 1890–1960s. Wool blend twill-weave jacket; wool twill-weave vest with metal watch fob chain; cotton plain-weave shirt with striped bib and starched cotton plain-weave detachable collar; cotton twill pants; leather shoes; and plaited straw hat with grosgrain ribbon.
COLLECTION OF GEORGE HUNTER

8 OPPOSITE RIGHT
Ensemble, ca. 1890s. Cotton plain-weave blouse with drawnwork cuffs and collar trimmed with machine-made lace and shell buttons; silk supplementary-weft patterned vest; striped cotton plain-weave skirt; and plaited synthetic hat with grosgrain ribbon, synthetic flowers, net, and metal hat pin.
COLLECTION OF JEAN STEWART

9
"PATHFINDER" FRANK BERRY, man's ensemble (jacket and pants), ca. 1970. Leather with silver buttons, bone and brass beads, tin cones with horsehair, and nineteenth-century sinew-sewn Sioux beadwork strip.
COLLECTION OF PETER KAUKONEN

10
GENIE THE TAILOR, shirt, ca. 1968. Chamois with silver buttons.
COLLECTION OF PETER KAUKONEN

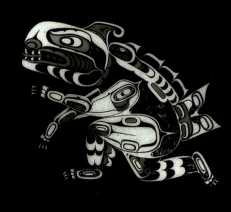

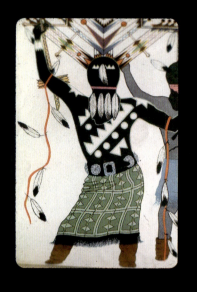
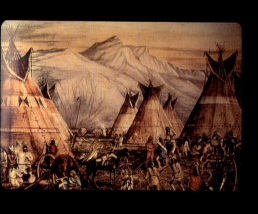
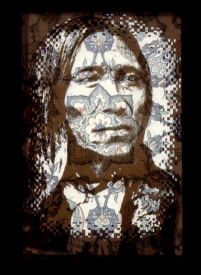
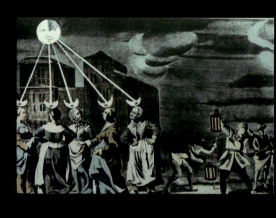
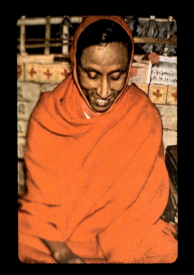

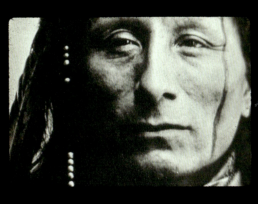

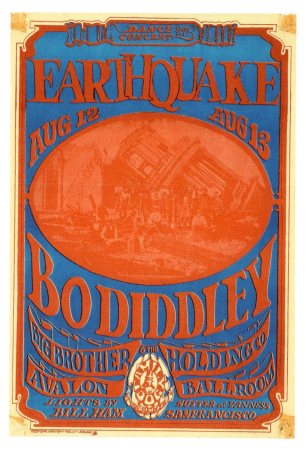
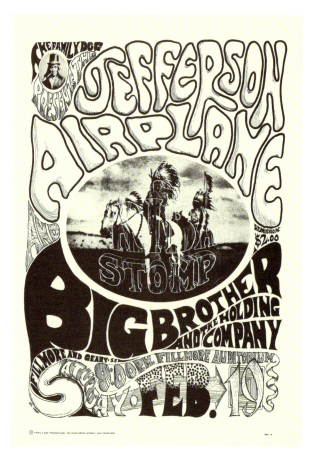
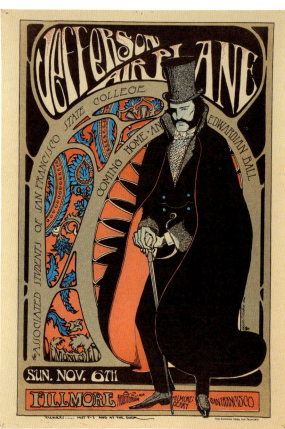
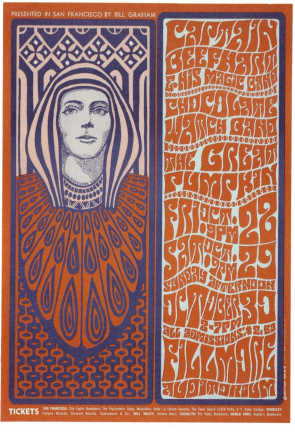

11
PREVIOUS SPREAD
BEN VAN METER / ROGER HILLYARD NORTH AMERICAN IBIS ALCHEMICAL COMPANY, slides from *Appropriations*, ca. 1967. 35mm slides.
COLLECTION OF BEN VAN METER AND JOHN J. LYONS

12 ABOVE LEFT
STANLEY MOUSE and **ALTON KELLEY,** "Earthquake," Bo Diddley, Big Brother and the Holding Company, August 12 & 13, Avalon Ballroom, 1966. Color offset lithograph poster.
FINE ARTS MUSEUMS OF SAN FRANCISCO, GIFT OF THACKREY AND ROBERTSON, 1981.1.33

13 ABOVE RIGHT
WES WILSON, "A Tribal Stomp," Jefferson Airplane, Big Brother and the Holding Company, February 19, Fillmore Auditorium, 1966. Offset lithograph poster.
FINE ARTS MUSEUMS OF SAN FRANCISCO, MUSEUM PURCHASE, ACHENBACH FOUNDATION FOR GRAPHIC ARTS ENDOWMENT FUND, 1974.13.196

14 BELOW LEFT
STANLEY MOUSE and **ALTON KELLEY,** "Edwardian Ball, San Francisco State College Homecoming Dance," Jefferson Airplane, November 6, Fillmore Auditorium, 1966. Color offset lithograph poster.
FINE ARTS MUSEUMS OF SAN FRANCISCO, GIFT OF THE GARY WESTFORD COLLECTION, IN HONOR OF STANLEY MOUSE, ALTON KELLEY, AND SAN FRANCISCO STATE COLLEGE, 2017.7.20

15 BELOW RIGHT
WES WILSON, *Captain Beefheart, Chocolate Watchband, The Great Pumpkin,* October 28–30, Fillmore Auditorium, 1966. Color offset lithograph poster.
FINE ARTS MUSEUMS OF SAN FRANCISCO, GIFT OF MR. JULIAN SILVA, 1997.64.6

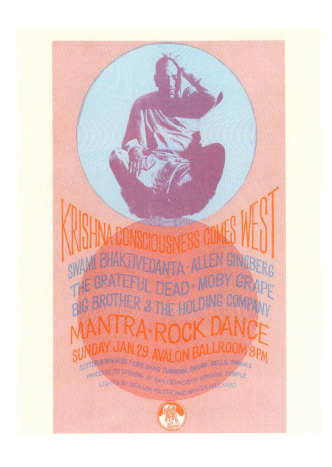
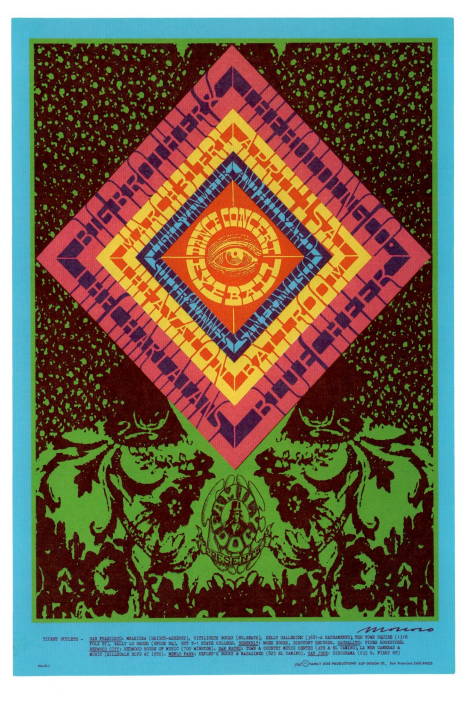

16 LEFT
Krishna Consciousness Comes West: Swami Bhaktivedanta, Allen Ginsberg, The Grateful Dead, Moby Grape, Big Brother & The Holding Company, Mantra Rock Dance, January 29, Avalon Ballroom, 1967. Color offset lithograph handbill.
COLLECTION OF JOHN J. LYONS

17 RIGHT
VICTOR MOSCOSO,
"God's Eye," Big Brother & the Holding Company, The Charlatans, Blue Cheer, March 31–April 1, Avalon Ballroom, 1967. Color offset lithograph poster.
FINE ARTS MUSEUMS OF SAN FRANCISCO, MUSEUM PURCHASE, ACHENBACH FOUNDATION FOR GRAPHIC ARTS ENDOWMENT FUND, 1974.13.22

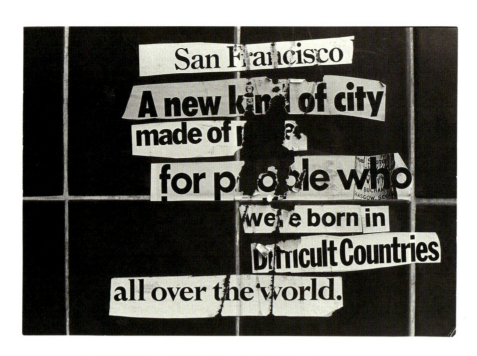

18 ABOVE
RUTH-MARION BARUCH,
"San Francisco" (sign), Haight Ashbury, 1967. Gelatin silver print.
COURTESY SPECIAL COLLECTIONS, UNIVERSITY LIBRARY, UNIVERSITY OF CALIFORNIA, SANTA CRUZ. PIRKLE JONES AND RUTH-MARION BARUCH PHOTOGRAPHS

19 BELOW
WES WILSON,
Are We Next?, 1965. Color offset lithograph poster.
FINE ARTS MUSEUMS OF SAN FRANCISCO, GIFT OF THE GARY WESTFORD COLLECTION, IN HONOR OF WES WILSON AND THE TRUTH, 2017.7.35

20 OPPOSITE ABOVE
Staff photographer for the *San Francisco Examiner,* Anti-Vietnam demonstrators carry flag-draped "caskets" in Market Street parade, March 1966. Gelatin silver print with ink corrections.
COLLECTION OF JOHN J. LYONS

21 OPPOSITE BELOW
Staff photographer for the *San Francisco Examiner,* "Vietnam reactions in U.S.," March 1966. Gelatin silver print with ink corrections.
COLLECTION OF JOHN J. LYONS

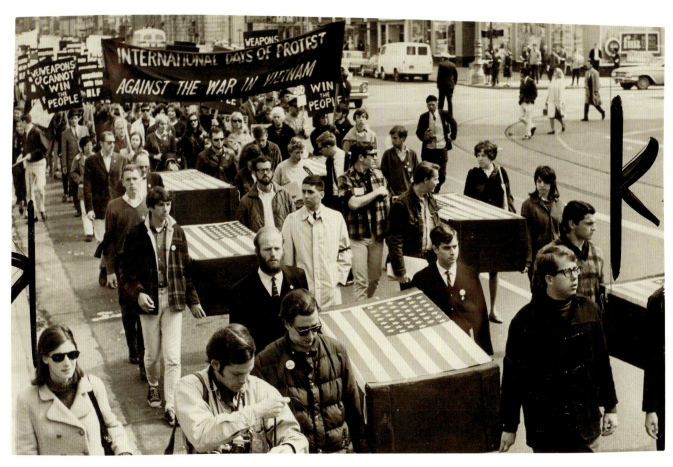
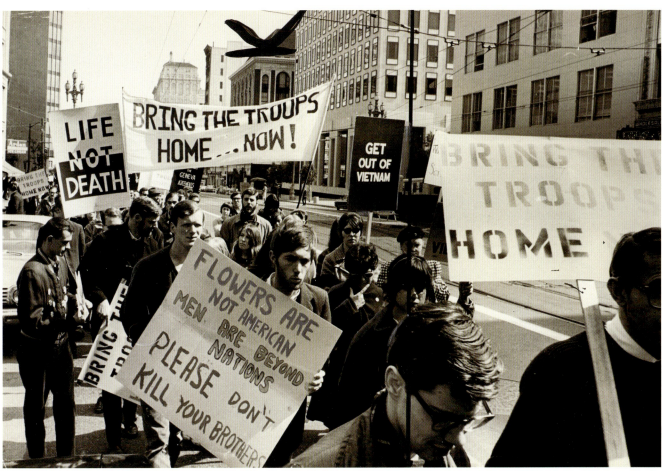

"Outside is inside, how does it look?"

KEN KESEY

SECTION 2

a trip without a ticket

ORGANIZED BY ACTIVIST STEWART BRAND, promoter Bill Graham, author Ken Kesey and his cognoscenti, the Merry Pranksters, and composer and artist Ramon Sender at Longshoremen's Hall for January 21 to 23, 1966, the Trips Festival was a multimedia extravaganza — complete with liquid light and slide shows, film projections, electronic sounds, rock groups, experimental theater performers, dance companies, and more. The handbill with the schedule of events professed: "The general tone of things has moved on from the self-conscious happening to more JUBILANT occasion where the audience PARTICIPATES because it's more fun to do so than not. maybe this is the ROCK REVOLUTION. audience dancing is an assumed part of all shows, & the audience is invited to wear ECSTATIC DRESS & bring their own GADGETS (a.c. outlets will be provided)" (pl. 23).

While the opening on Friday night was a relatively tame event focused on Brand's "America Needs Indians" slide shows and performances by Berkeley's Open Theater, Saturday night was a riot of activity that was conceived by Kesey and the Pranksters (pl. 31) with five movie screens on the wall, a center platform with projectors, and blinking traffic lights. Brand hired an Olympic gymnast, Dan Millman, to dive off the balcony onto a trampoline under a strobe light, and Sender and the Tape Music Center introduced Don Buchla's machine — the original Buchla box — his first voltage-controlled instrument.

While the Pranksters climbed the Tower of Control, a vaulting scaffolding of pipes and platforms, mikes, amplifiers, and projectors in the center of the hall, high up in the balcony, Kesey, dressed in a silver suit complete with helmet, scrawled messages on acetate that projected in large scale across the walls: "ANYBODY WHO KNOWS HE IS GOD GO UP ON THE STAGE" and "OUTSIDE IS INSIDE, HOW DOES IT LOOK?" Big Brother and the Holding Company and the Grateful Dead performed, and throngs of participants imbibed punch spiked with LSD, a legal substance at the time. There and then, many realized that they were part of a larger movement to expand emotional and perceptual consciousness and to upend traditional society. A young filmmaker, Ben Van Meter, attended all three nights armed with his Bolex REX video camera and three rolls of film. Every night he exposed each roll and rewound them all in the darkroom the next day for re-exposure. The result of the triple-exposed film, *S.F. Trips Festival, An Opening* (pl. 27), is a jumbled collage that encapsulates the pure unfettered energy of the occasion (see Van Meter, this volume).

The Trips Festival, attracting upwards of ten thousand people over the three nights, was the first event to gather members of the counterculture in a significant way. It remains the pinnacle of the psychedelic era that had been gaining momentum every since Kesey, after volunteering in the CIA mind control and chemical warfare tests being conducted at the Menlo Park Veterans' Hospital, started hosting his own Acid Tests, first in his La Honda home and later in select destinations around the Bay Area (pl. 28 and 33–35) and Los Angeles. Like the Trips Festival, these events were fueled by the generous benefactor, Augustus Owsley Stanley III, audio engineer, chemist, and the first private individual to manufacture mass quantities of LSD, who between the years 1965 and 1967 produced approximately ten million doses.

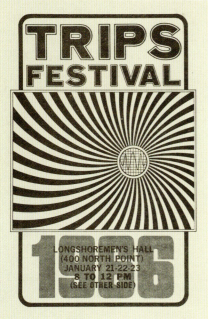

22 ABOVE
BRUCE CONNER, *Mandala,* cover of Trips Festival program, 1966. Stencil duplicate print (mimeograph) pamphlet on pink paper.
COLLECTION OF JOHN J. LYONS

23 BELOW
WES WILSON, front and back of the program for *"Trips Festival,"* Ken Kesey, Merry Pranksters, Allen Ginsberg, Stewart Brand, Grateful Dead, Big Brother & the Holding Company, and many, many others, January 21–23, Longshoremen's Hall, 1966. Offset lithograph handbill.
COLLECTION OF JOHN J. LYONS

24 OPPOSITE TOP
GENE ANTHONY, *Man with arms spread open being lifted up. Trips Festival at Longshoremen's Hall, January 21,* 1966. Gelatin silver print.
COURTESY OF THE BANCROFT LIBRARY, UNIVERSITY OF CALIFORNIA, BERKELEY, BANC PIC 2001.196:49-B

25 OPPOSITE MIDDLE
GENE ANTHONY, *Soundboard mixer Ken Babbs and crowd in background. Trips Festival at Longshoremen's Hall, January 21,* 1966. Gelatin silver print.
COURTESY OF THE BANCROFT LIBRARY, UNIVERSITY OF CALIFORNIA, BERKELEY, BANC PIC 2001.196:41-B

26 OPPOSITE BOTTOM
GENE ANTHONY, *Wide-angle view of center stage and crowd. Trips Festival at Longshoremen's Hall, January 21,* 1966. Gelatin silver print.
COURTESY OF THE BANCROFT LIBRARY, UNIVERSITY OF CALIFORNIA, BERKELEY, BANC PIC 2001.196:45-B

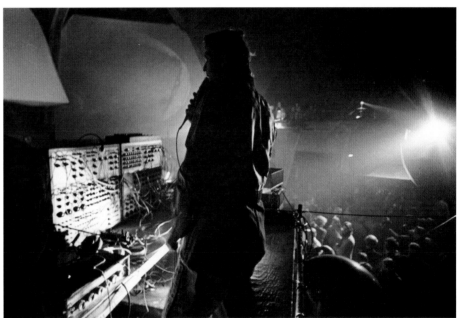
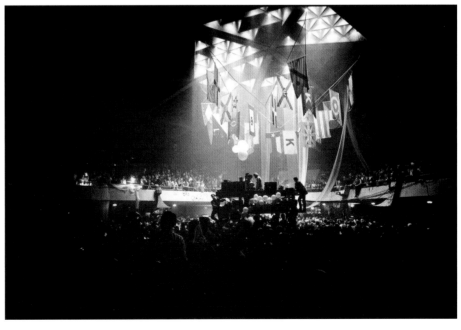

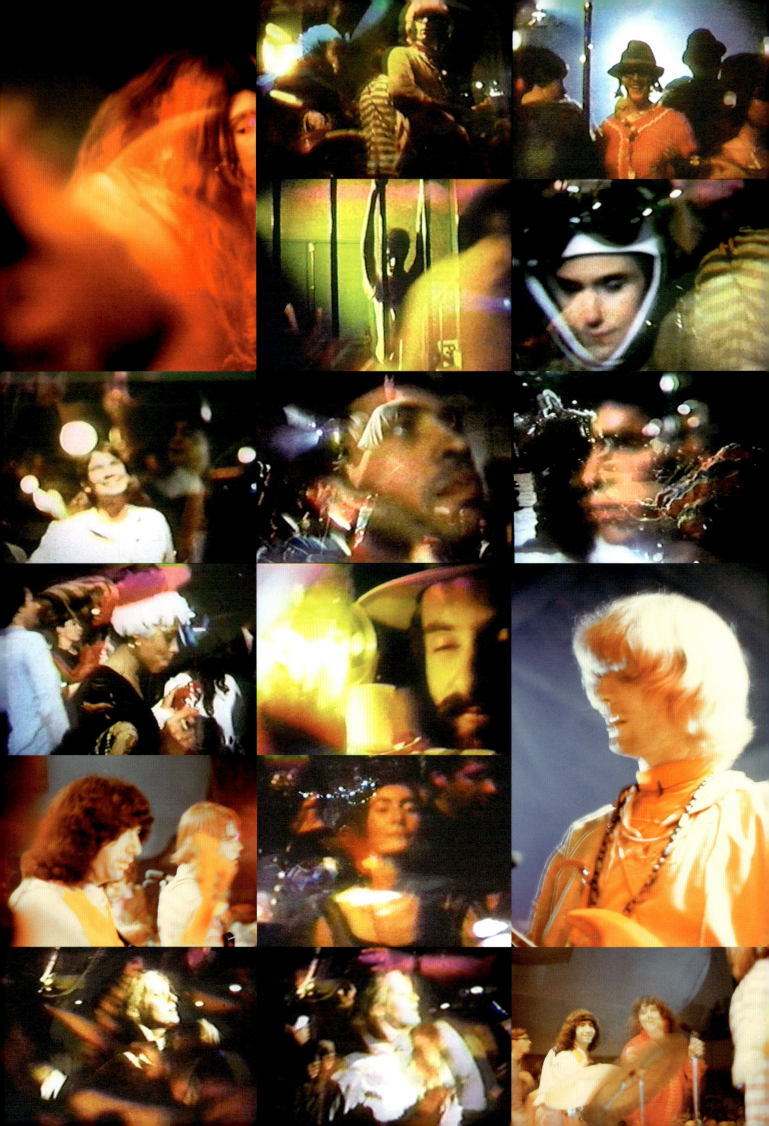

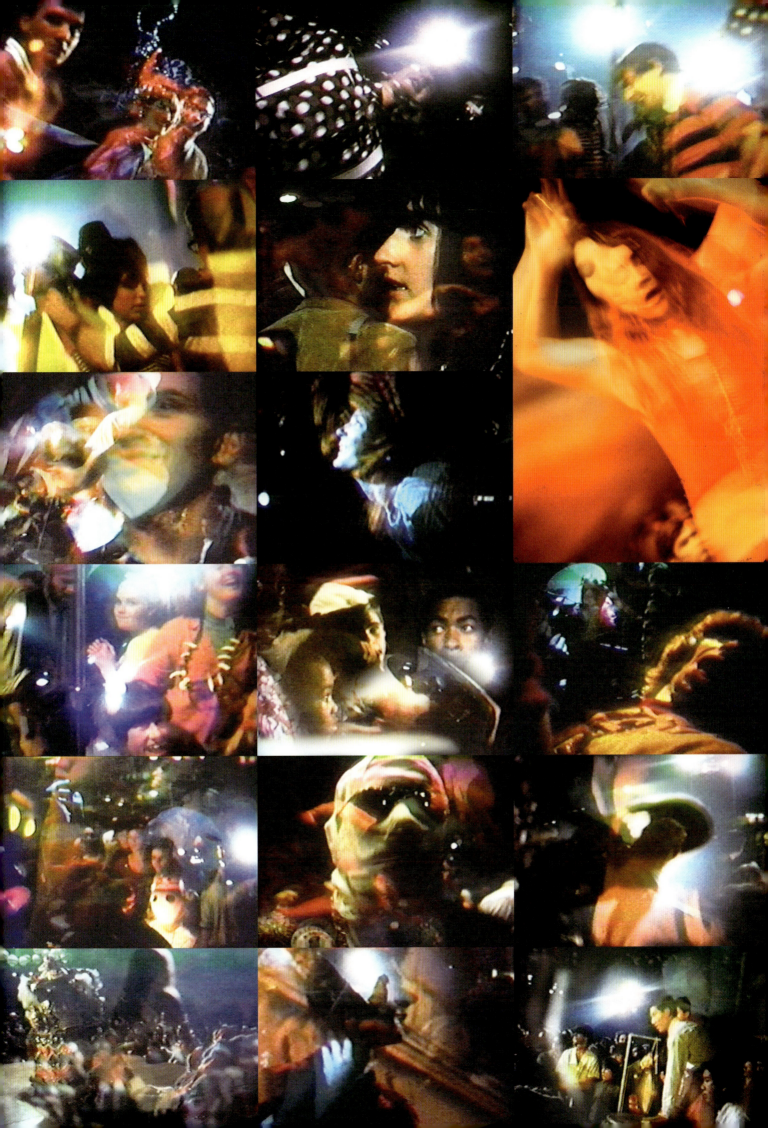

27 PREVIOUS SPREAD
BEN VAN METER,
film stills from *S.F. Trips Festival, An Opening*, 1966. Film (color), duration: 9 minutes, sound.
COURTESY OF THE ARTIST

28 OPPOSITE
PAUL FOSTER,
"Can You Pass the Acid Test?" The Fugs, Allen Ginsberg, The Merry Pranksters, Neal Cassady, The Grateful Dead, Roy's Audioptics, December, Muir Beach, California, 1965. Offset lithograph poster, with hand coloring in porous point pen on blue paper.
HAIGHT STREET ART CENTER

29 ABOVE
WES WILSON,
"Can You Pass the Acid Test?": The Merry Pranksters And Their Psychedelic Symphony, Neil Cassady Vs. Ann Murphy Vaudeville, The Grateful Dead Rock 'n' Roll, Roy's Audioptics, Movies, Ron Boise And His Electric Thunder Sculpture, The Bus, Ecstatic Dress, Many Noted Outlaws, And The Unexpectable, ca. 1966. Offset lithograph handbill printed in blue ink on pink paper.
CENTER FOR COUNTERCULTURE STUDIES

30 BELOW
"The Acid Test," Grateful Dead, Ken Kesey Acid Test, January 29, 1966. Offset lithograph album cover.
COURTESY OF MICKEY MCGOWAN, SAN RAFAEL, CA

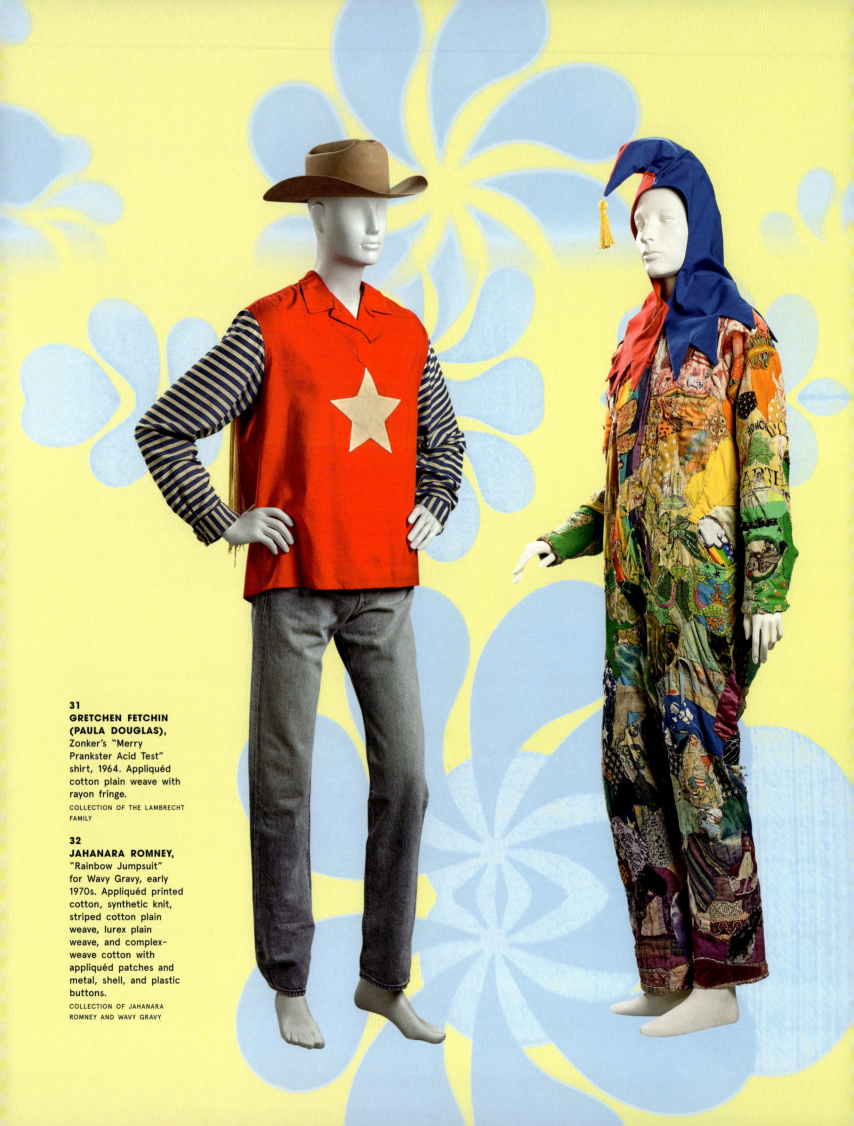

**31
GRETCHEN FETCHIN
(PAULA DOUGLAS),** Zonker's "Merry Prankster Acid Test" shirt, 1964. Appliquéd cotton plain weave with rayon fringe.
COLLECTION OF THE LAMBRECHT FAMILY

**32
JAHANARA ROMNEY,** "Rainbow Jumpsuit" for Wavy Gravy, early 1970s. Appliquéd printed cotton, synthetic knit, striped cotton plain weave, lurex plain weave, and complex-weave cotton with appliquéd patches and metal, shell, and plastic buttons.
COLLECTION OF JAHANARA ROMNEY AND WAVY GRAVY

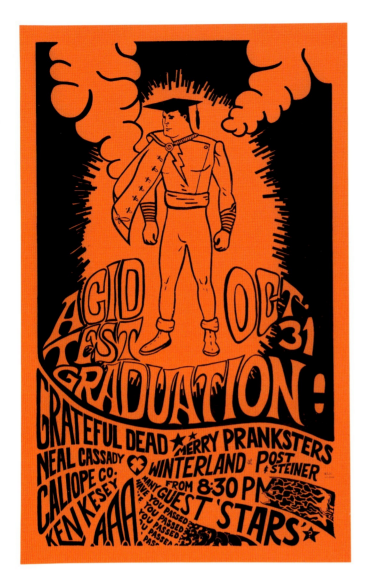
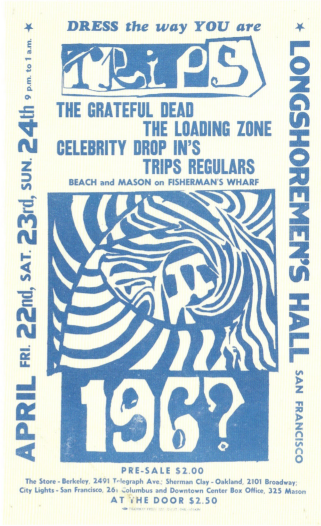

33 ABOVE LEFT
GUT (ALLEN TURK),
Acid Test Graduation: Grateful Dead, Merry Pranksters, Neal Cassady, Caliope Co., Ken Kesey, and Many Guest Stars, October 31, Winterland, 1966. Offset lithograph poster printed on red daylight fluorescent paper.
CENTER FOR COUNTERCULTURE STUDIES

34 ABOVE RIGHT
TRIPS?, The Grateful Dead, The Loading Zone, Celebrity Drop In's, Trips Regulars, April 22–24, Longshoremen's Hall, 1966. Offset lithograph handbill printed in blue ink.
CENTER FOR COUNTERCULTURE STUDIES

35 BELOW
PAUL FOSTER,
Acid Test Graduation Diploma for Jerry Garcia, 1966. Offset lithograph.
COURTESY OF BONHAMS

115

"The good hippies, of course, wear quaint and enchanting costumes, hold peaceful rock n' roll concerts, and draw pretty pictures (legally) on the sidewalk, their eyes aglow all the time with poetry of love."

MIKE MAHONEY

SECTION 3

the gathering of the tribes

DURING THE 1960S, Golden Gate Park and its adjoining Panhandle emerged as a playground for San Francisco's countercultural movement. Youths mingled at Hippie Hill, a sheltered sunny slope just past where Haight Street ends at Stanyan Street, to listen to the sounds of sitar, guitar, and flute or to observe the Hare Krishna chanting (pl. 55). The parks were home to free concerts by local bands, free performances by the San Francisco Mime Troupe, and even a free food service provided by the Diggers, a related anarchist group of street performers that became a voice of social consciousness during the Summer of Love.

Yet, the most pivotal gathering took place on a bright winter's day, January 14, 1967. Aware of the disunity between the radical political activists in Berkeley and the bohemians of the Haight-Ashbury, the editors of the Haight's underground newspaper, the *San Francisco Oracle,* Allen Cohen and Michael Bowen, organized an event that would unify these often divided factions. Envisioned as a sort of powwow, the event was officially christened "A Gathering of the Tribes for a Human Be-In" by Richard Alpert (later Ram Dass), who would address the crowds in the park that day. Rick Griffin's poster for the happening featured a Native American on horseback, with a blanket in one hand and a guitar in the other, underscoring the counterculture's fascination with and reverence for indigenous cultures (pl. 39). The symbolism was clear: this new tribe was being summoned by the power of music. Cohen's press release for the Be-In read: "Now in the evolving generation of American young the humanization of the American man and woman can begin in joy and embrace without fear, dogma, suspicion, or dialectic righteousness. A new concert of human relations being developed within the youthful underground must emerge and be shared so that a revolution of form can be filled with a Renaissance of compassion, awareness and love in the Revelation of the unity of all mankind. The Human Be-In is the joyful, face-to-face beginning of the new epoch." The event was advertised in both the *Oracle,* whose cover duplicated the event poster, and the *Berkeley Barb,* which featured an interview with activist Jerry Rubin, and posters and handbills (pls. 36–39 and 112) papered the city's streets, an invitation to the day's festivities.

More than 40,000 costumed youth gathered, bringing with them beads, bells, blankets, cymbals, drums, incense, and flowers (pls. 40–42). Beat luminaries Allen Ginsberg, Lenore Kandel, Timothy Leary (pl. 41), Gary Snyder, and Alan Watts presided over the ceremonies, and the city's top rock bands — Big Brother and the Holding Company, Jefferson Airplane, Quicksilver Messenger Service, and the Grateful Dead — played. Leary delivered his already famous mantra, "Tune in, turn on, and drop out," and Ginsberg chanted, "We are all one, we are all one."

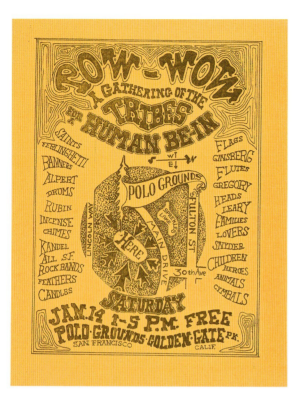
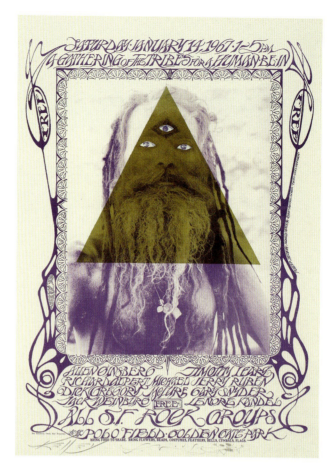
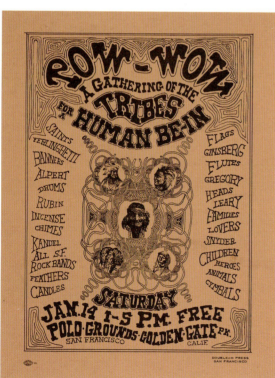
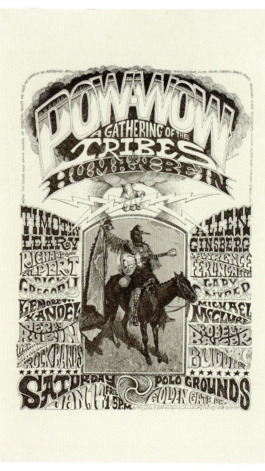

36 ABOVE LEFT
Pow-Wow: A Gathering of the Tribes for a Human Be-In, January 14, Polo Grounds, Golden Gate Park, 1967. Electrophotographic print (Xerox) handbill printed on yellow paper.
CENTER FOR COUNTERCULTURE STUDIES

37 ABOVE RIGHT
STANLEY MOUSE, ALTON KELLEY, and **MICHAEL BOWEN,** "A Gathering of the Tribes for a Human Be-In," Allen Ginsberg, Timothy Leary, Richard Alpert, Michael McClure, Jerry Ruben, Dick Gregory, Gary Snyder, Jack Weinberg, Lenore Kandel, All S.F. Rock Groups, January 14, Polo Field, Golden Gate Park, 1967. Color offset lithograph poster.
COLLECTION OF JOHN J. LYONS

38 BELOW LEFT
MICHAEL BOWEN, *Pow-Wow: A Gathering of the Tribes For A Human Be-In, January 14, Polo Grounds, Golden Gate Park,* 1967. Offset lithograph handbill.
COLLECTION OF JOHN J. LYONS

39 BELOW RIGHT
RICK GRIFFIN, *Pow-Wow: A Gathering of the Tribes Human Be-In,* Timothy Leary, Richard Albert, Dick Gregory, Lenore Kandel, Jerry Rubin, All San Francisco Rock Bands, Allen Ginsberg, Lawrence Ferlinghetti, Gary Snyder, Michael McClure, Robert Baker, Buddha, January 14, Polo Grounds, Golden Gate Park, 1967. Offset lithograph poster.
FINE ARTS MUSEUMS OF SAN FRANCISCO, GIFT OF THE GARY WESTFORD COLLECTION, IN CELEBRATION OF GOLDEN GATE PARK AND THE CITY OF SAN FRANCISCO, 2017.7.13

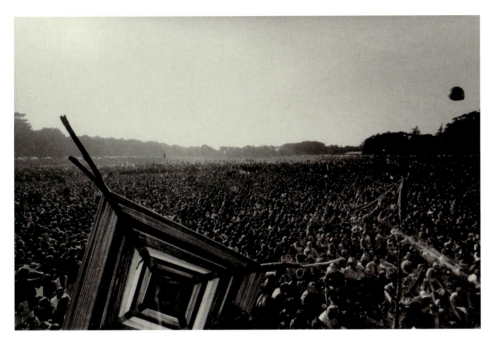

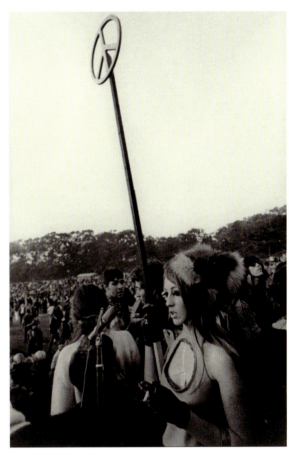

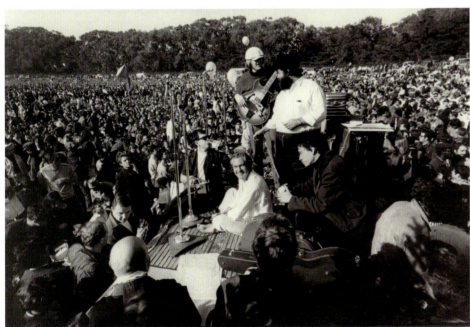

40 ABOVE LEFT
GENE ANTHONY,
Large Crowd at the Human Be-In at Polo Fields. Golden Gate Park, January 14, 1967. Gelatin silver print.
COURTESY OF THE BANCROFT LIBRARY, UNIVERSITY OF CALIFORNIA, BERKELEY, BANC PIC 2001.196:60-B

41 BELOW LEFT
GENE ANTHONY,
Timothy Leary on stage at Human Be-In at Polo Fields. Golden Gate Park, January 14, 1967. Gelatin silver print.
COURTESY OF THE BANCROFT LIBRARY, UNIVERSITY OF CALIFORNIA, BERKELEY, BANC PIC 2001.196:62-B

42 ABOVE RIGHT
GENE ANTHONY,
Woman holding peace sign in front of microphone at Human Be-In at Polo Fields. Golden Gate Park, January 14, 1967. Gelatin silver print.
COURTESY OF THE BANCROFT LIBRARY, UNIVERSITY OF CALIFORNIA, BERKELEY, BANC PIC 2001.196:64-B

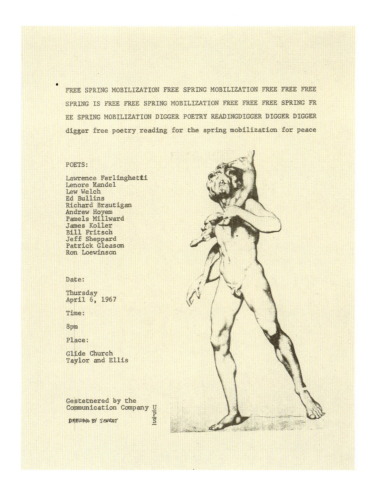
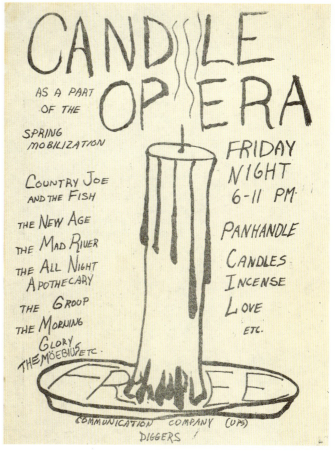
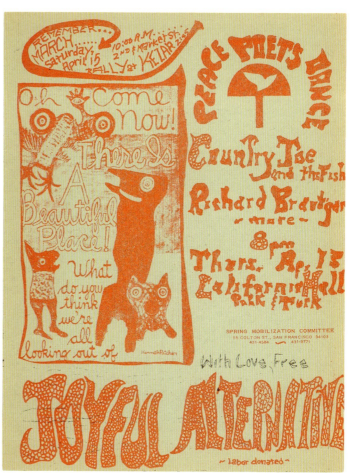

45 ABOVE RIGHT
THE COMMUNICATION COMPANY,
Candle Opera, As A Part of the Spring Mobilization, Country Joe and the Fish, The New Age, The Made River, The All Night Apothecary, The Group, The Morning Glory, The Möebius, etc., Panhandle, 1967. Electrophotographic print (Xerox) handbill.
COLLECTION OF JOHN J. LYONS

46 BELOW
SPRING MOBILIZATION COMMITTEE with **KENNETH PATCHEN,**
"Joyful Alternative Peace Poets Dance," Country Joe and the Fish, Richard Brautigan, and more, April 13, California Hall, 1967. Stencil duplicate print (mimeograph) printed in red and black ink on green brown paper.
COLLECTION OF JOHN J. LYONS

43 OPPOSITE
Spring Mobilization March to End the War in Vietnam, April 15, Montgomery and Market to Kezar Stadium, 1967. Screenprint.
COLLECTION OF JOHN J. LYONS

44 ABOVE LEFT
THE COMMUNICATION COMPANY with drawing by Georges Seurat, *Free Spring Mobilization Poetry Reading, April 6, Glide Church,* 1967. Stencil duplicate print (mimeograph) handbill.
COLLECTION OF JOHN J. LYONS

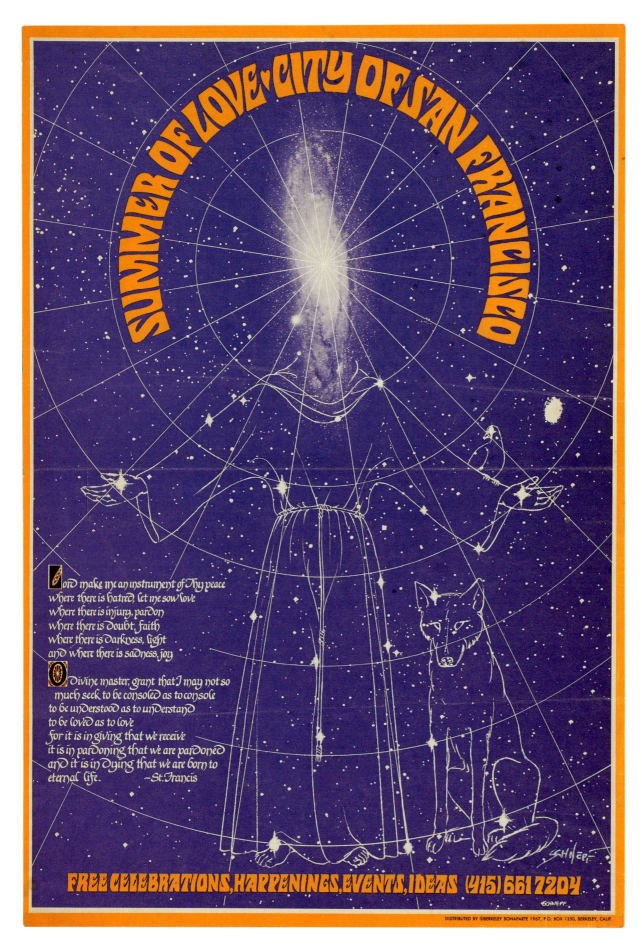

**47
BOB SCHNEPF,**
Summer of Love/City of San Francisco, 1967.
Color offset lithograph poster.
FINE ARTS MUSEUMS OF SAN FRANCISCO, GIFT OF THE GARY WESTFORD COLLECTION, IN HONOR OF BOB (RAF) SCHNEPF, 2017.7.11

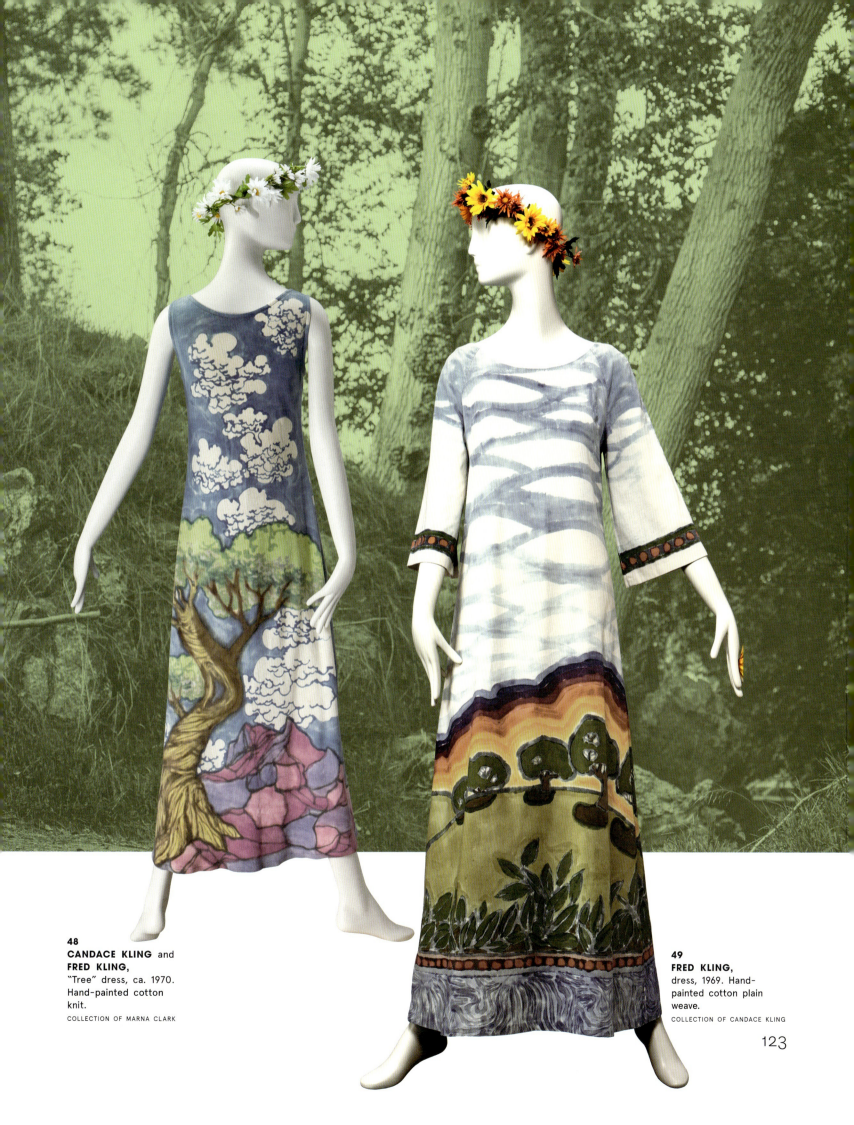

48
CANDACE KLING and
FRED KLING,
"Tree" dress, ca. 1970. Hand-painted cotton knit.
COLLECTION OF MARNA CLARK

49
FRED KLING,
dress, 1969. Hand-painted cotton plain weave.
COLLECTION OF CANDACE KLING

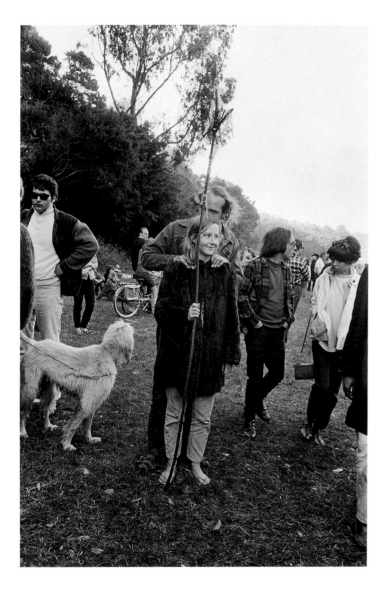

50 ABOVE LEFT
ELAINE MAYES,
Summer Solstice, God's Eye, Golden Gate Park, 1967. Gelatin silver print.
COLLECTION OF THE ARTIST

51 ABOVE RIGHT
ELAINE MAYES,
Couple with Child, Golden Gate Park, San Francisco, 1968. Gelatin silver print.
COURTESY OF JOSEPH BELLOWS GALLERY

52 BELOW RIGHT
ELAINE MAYES,
Eugene, Pan Handle, Haight Ashbury, 1968. Gelatin silver print.
COURTESY OF JOSEPH BELLOWS GALLERY

53 OPPOSITE ABOVE
LARRY KEENAN,
Peace Rally, Kezar Stadium, San Francisco, 1967. Gelatin silver print.
COURTESY OF THE BANCROFT LIBRARY, UNIVERSITY OF CALIFORNIA, BERKELEY, BANC PIC 2009.050.001:004 AX VAULT

54 OPPOSITE BELOW
ELAINE MAYES,
Hugging and Dancing, Summer Solstice, Golden Gate Park, 1967. Gelatin silver print.
COLLECTION OF THE ARTIST

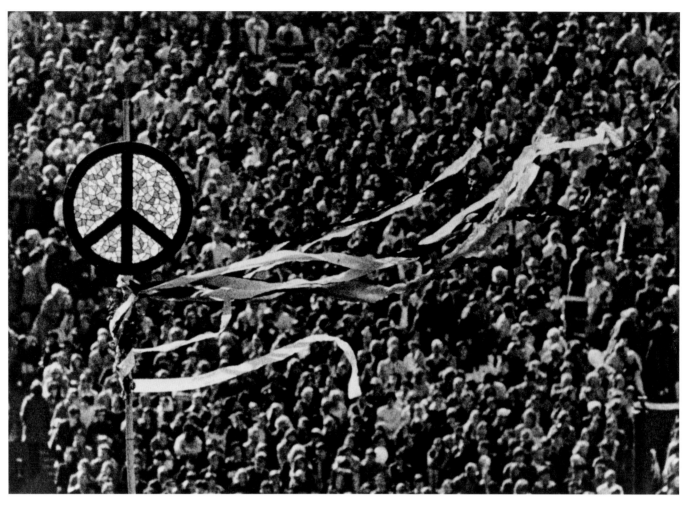
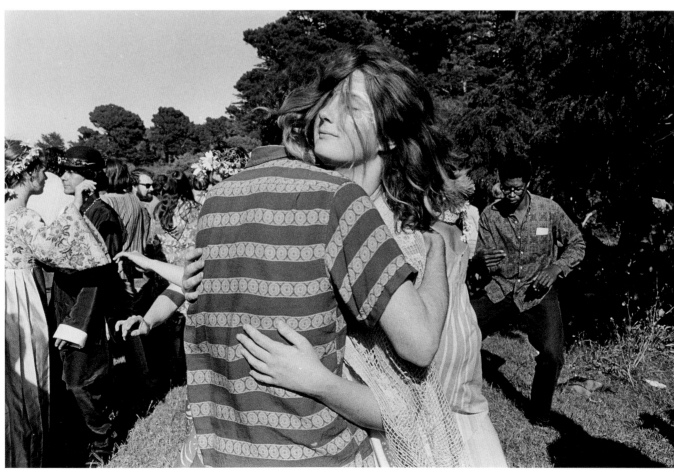

125

55 OPPOSITE ABOVE
RUTH-MARION BARUCH,
Hare Krishna Dance in Golden Gate Park, Haight Ashbury, 1967. Gelatin silver print.
LUMIÈRE GALLERY, ATLANTA, AND ROBERT A. YELLOWLEES

56 OPPOSITE BELOW
ELAINE MAYES,
Solstice Metal Dress, 1967. Gelatin silver print.
COLLECTION OF THE ARTIST

57 ABOVE
LELAND RICE,
Golden Gate Park, 1967. Gelatin silver print.
COLLECTION OF THE ARTIST

58 BELOW
ELAINE MAYES,
Grateful Dead, Solstice, Golden Gate Park, 1967. Gelatin silver print.
COLLECTION OF THE ARTIST

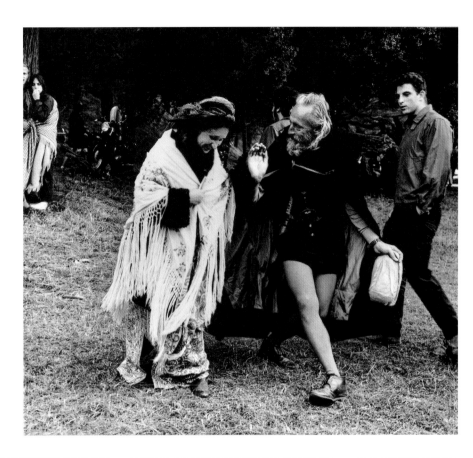

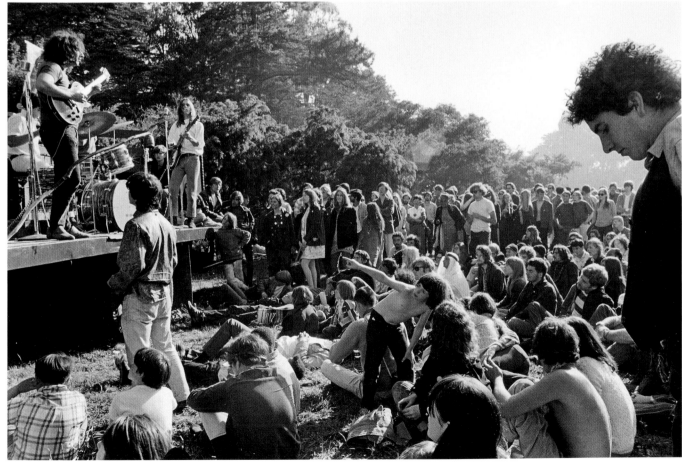

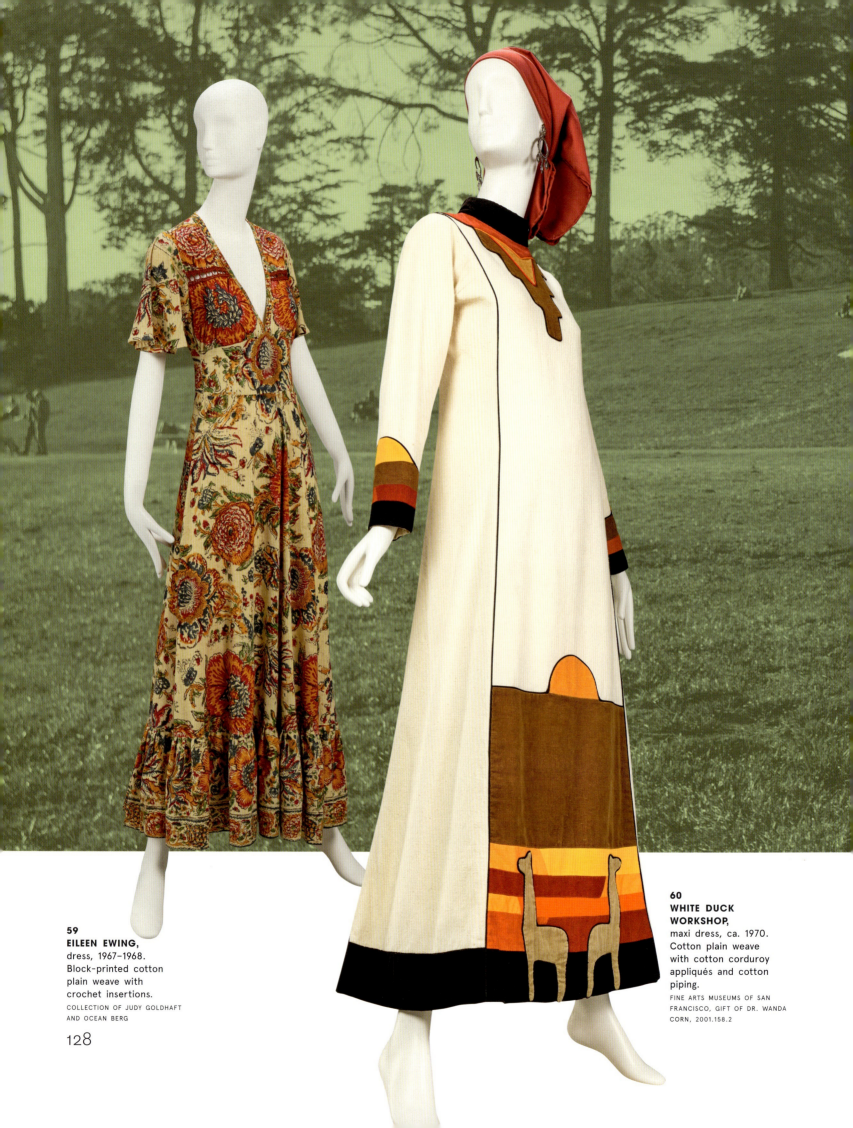

59
EILEEN EWING,
dress, 1967–1968.
Block-printed cotton
plain weave with
crochet insertions.
COLLECTION OF JUDY GOLDHAFT
AND OCEAN BERG

60
**WHITE DUCK
WORKSHOP,**
maxi dress, ca. 1970.
Cotton plain weave
with cotton corduroy
appliqués and cotton
piping.
FINE ARTS MUSEUMS OF SAN
FRANCISCO, GIFT OF DR. WANDA
CORN, 2001.158.2

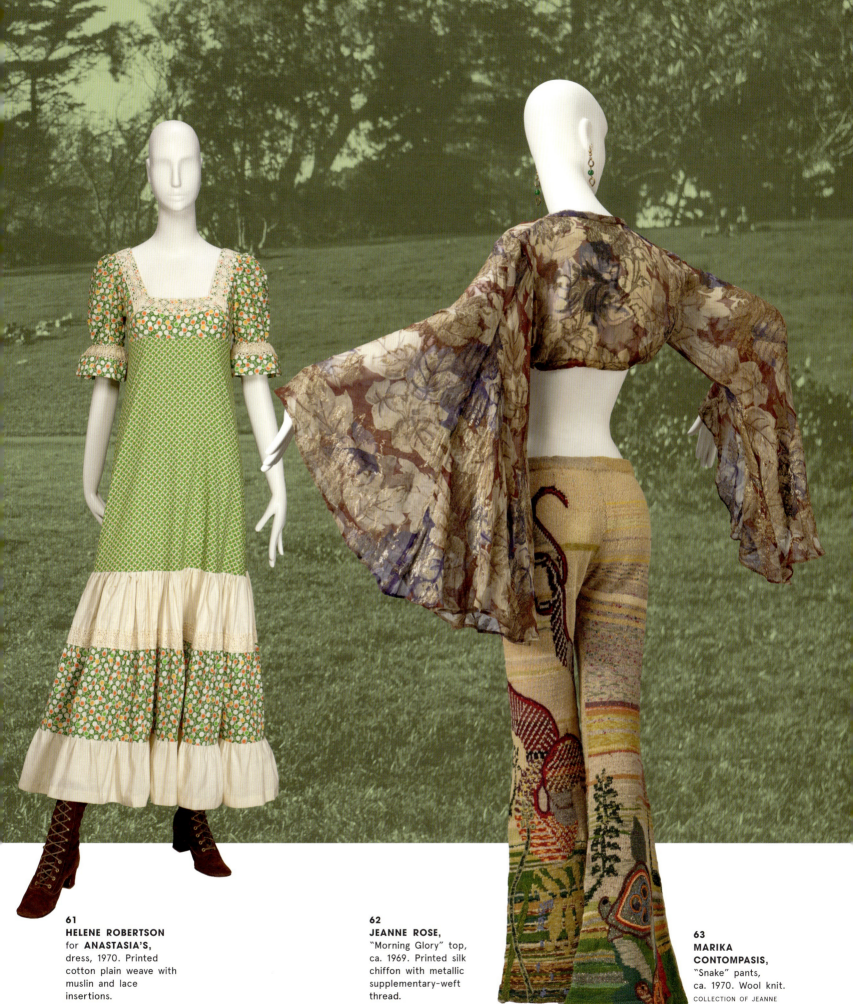

61
HELENE ROBERTSON
for **ANASTASIA'S**,
dress, 1970. Printed cotton plain weave with muslin and lace insertions.
PRIVATE COLLECTION

62
JEANNE ROSE,
"Morning Glory" top, ca. 1969. Printed silk chiffon with metallic supplementary-weft thread.
COLLECTION OF THE ARTIST

63
MARIKA CONTOMPASIS,
"Snake" pants, ca. 1970. Wool knit.
COLLECTION OF JEANNE ROSE

"We would all like to be able to live an uncluttered life, a simple life, a good life, and think about moving the whole human race ahead a step."

JERRY GARCIA

SECTION 4

love and haight

DURING THE MID-1960S, artists, writers, musicians, and activists moved into San Francisco's Haight-Ashbury district, lured by inexpensive rent and an inclusive environment that was fostered by the multicultural heritage of its residents and its proximity to San Francisco State College, which in 1965 founded the Experimental College. A college within a college, it became a pioneer in student-initiated curriculum, attracting a freethinking student body, whose studies focused on the arts, psychology, occult religions, and community organization, and who took up communal residence in the Victorian homes that lined the neighborhood.

America was at a cultural crossroads, and the burgeoning social unrest was pronounced in this community of mostly well-educated, artistic youth from middle-class backgrounds. These young people did not just protest against political and social issues such as the Vietnam War and civil injustice, but on a more personal level they challenged the status quo of the mainstream American society from which they hailed. With hopes of creating a new social paradigm largely informed by their experimentations with psychedelics and their interest in Native American cultures and Eastern spirituality, they made the neighborhood the epicenter of their activities. Exotic boutiques that catered to the bohemian tastes of San Francisco's Youthquake such as Mnasidika (pl. 90), In Gear, the Blushing Peony (pl. 89), the Print Mint (pls. 103–105), and the Psychedelic Shop (pl. 88), began to populate the empty storefronts, offering paraphernalia, posters, crafts from local artisans, and a wide selection of contemporary literature on spirituality and religion. Before long the community began to organize, publishing their own newspapers such as the *San Francisco Oracle* (pls. 106–119) and the *Haight-Ashbury Tribune* (pls. 120–121) and opening their own performance hall, the Straight Theater (pls. 81–84). Among their myriad activities, Haight-Ashbury's preeminent community organizers, the Diggers, established a series of free stores where nothing was for sale as a comment on the excessive wealth of American society, and organized political street theater (pls. 129–136). In a similar spirit, neighborhood bands such as the Grateful Dead and Big Brother and the Holding Company regularly held free concerts in Golden Gate Park and the Panhandle as well as on the streets of the Haight (pl. 75).

During the highly publicized Summer of Love, the Haight attracted as many as 100,000 young people from all over the nation, many more than the neighborhood could safely absorb. Pleas for help from the Council for the Summer of Love — a coalition of the Diggers, Family Dog, the *Oracle,* and the Straight Theater — to the city officials went unanswered, galvanizing the community to create their own social service organizations such as the Switchboard, Huckleberry House, Haight-Ashbury Legal Organization (pl. 126), and the Haight-Ashbury Free Medical Clinic (pls. 123–125). Overrun by the end of the summer, many of the original Haight visionaries left the area for Marin County and beyond by 1968. Yet for a fleeting moment, the Haight was the home to many of the leading figures of the 1960s counterculture including Beat writers Allen Ginsberg, Lenore Kandel, and Michael McClure, and musicians from Big Brother and the Holding Company, Jefferson Airplane, the Charlatans, and the Grateful Dead.

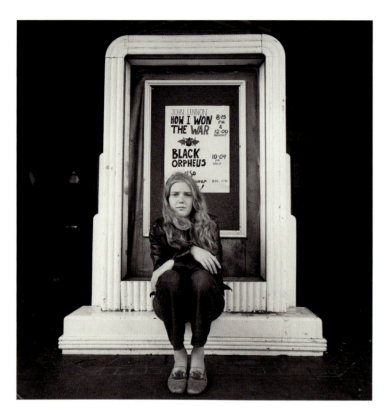
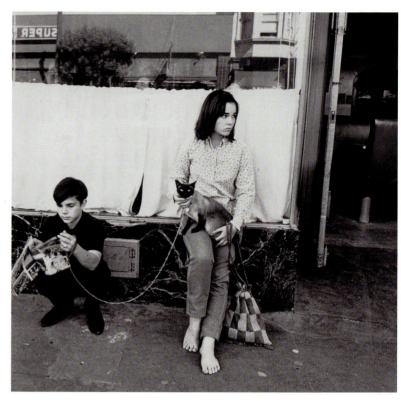
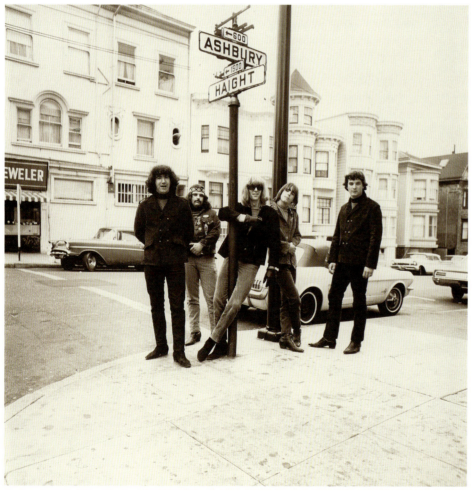

64 ABOVE LEFT
ELAINE MAYES,
Linda, 20, Haight Ashbury, 1968. Gelatin silver print.
COURTESY OF JOSEPH BELLOWS GALLERY

65 ABOVE RIGHT
LELAND RICE,
Haight Street, 1967. Gelatin silver print.
COLLECTION OF THE ARTIST

66 BELOW
HERB GREENE,
Dead on Haight [left to right: Jerry Garcia, Ron "Pigpen" McKernan, Phil Lesh, Bob Weir, and Bill Kreutzmann], 1967 (printed 2006). Platinum print.
PRIVATE COLLECTION

67 OPPOSITE ABOVE
RUTH-MARION BARUCH, *All the Symbols of the Haight*, 1967. Gelatin silver print.
LUMIÈRE GALLERY, ATLANTA, AND ROBERT A. YELLOWLEES

68 OPPOSITE BELOW LEFT
ELAINE MAYES,
Young Man with Guitar "Preacher," Haight-Ashbury, San Francisco, 1968. Gelatin silver print.
COLLECTION OF THE ARTIST

69 OPPOSITE BELOW RIGHT
HERB GREENE,
Couple on Haight Street (Allen Cohen and Monica Collier), 1967 (printed 2006). Gelatin silver print.
FINE ARTS MUSEUMS OF SAN FRANCISCO, GIFT OF RENE AND JIM CRESS, 2016.88

70 ABOVE LEFT
ELAINE MAYES,
Shari Maynard, Bunny Bael (Red Pappas), Stefani Wyatt, Michael, and Sean Hervick, Haight Street, 1968. Gelatin silver print.
COLLECTION OF NION MCEVOY

71 ABOVE RIGHT
FAYETTE HAUSER,
The Cockettes (left to right: John Flowers, Marshall Olds, Link Martin, Pristine Condition, Sweet Pam Tent), 1971. Gelatin silver print.
COLLECTION OF THE ARTIST

72 BELOW
BOB SEIDEMANN,
Haight Street, 1967. Gelatin silver print.
COLLECTION OF THE ARTIST

73 OPPOSITE ABOVE LEFT
ELAINE MAYES,
Haight Ashbury (young man against plywood), 1968. Gelatin silver print.
COURTESY OF JOSEPH BELLOWS GALLERY

74 OPPOSITE ABOVE RIGHT
ELAINE MAYES,
Katrinka Haraden (Trinka), Age 19, Haight Street, 1968. Gelatin silver print.
COLLECTION OF NION MCEVOY

75 OPPOSITE BELOW
JIM MARSHALL,
Grateful Dead playing on Haight Street, March 1968 (printed 2016). Inkjet print.
COURTESY OF JIM MARSHALL PHOTOGRAPHY LLC

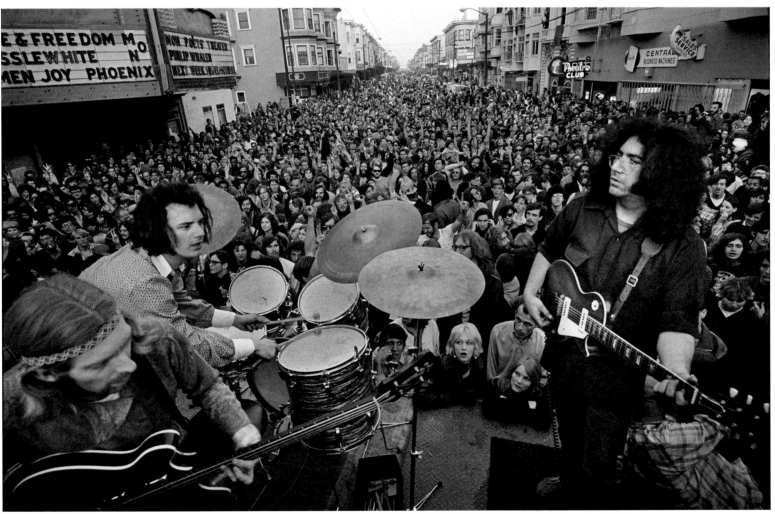

135

76 ABOVE LEFT
ELAINE MAYES,
Haight Ashbury (woman in checkered outfit), 1968. Gelatin silver print.
COURTESY OF JOSEPH BELLOWS GALLERY

77 ABOVE RIGHT
RUTH-MARION BARUCH,
Sailor Couple, Haight Ashbury, 1967. Gelatin silver print. LUMIÈRE GALLERY, ATLANTA, AND ROBERT A. YELLOWLEES

78 BELOW
ELAINE MAYES,
Funky Sam, Central Street, Haight-Ashbury, 1967. Gelatin silver print.
COLLECTION OF THE ARTIST

79 OPPOSITE ABOVE
ELAINE MAYES,
Kathleen and Baby Max Damen, Age 22, 1 Year, 1968. Gelatin silver print.
COLLECTION OF THE ARTIST

80 OPPOSITE BELOW
BOB SEIDEMANN,
Alton Kelley, 1967. Gelatin silver print.
COLLECTION OF THE ARTIST

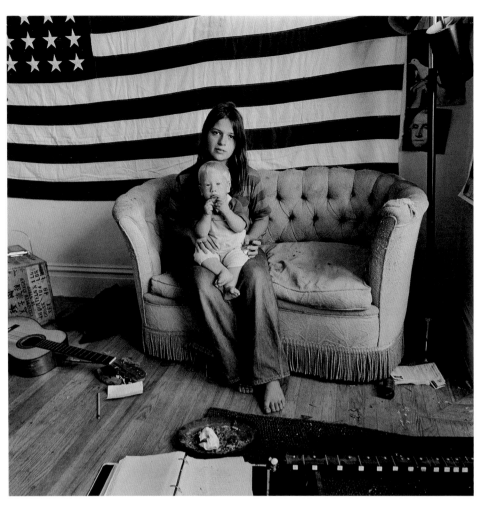

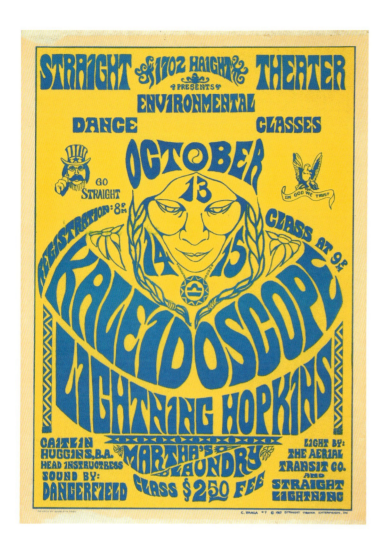

81 LEFT
C. BRAGA (CHRIS BRAGA),
Kaleidoscope, Lightning Hopkins, Martha's Laundry, October 13, Straight Theater, 1967. Color offset lithograph poster.
FINE ARTS MUSEUMS OF SAN FRANCISCO, GIFT OF THE GARY WESTFORD COLLECTION, IN MEMORY OF LIGHTNING HOPKINS, 2017.7.14

82 RIGHT
RANDY SALAS,
"The Equinox of the Gods," The Magick Powerhouse of Oz, Kenneth Anger, The Congress of Wonders, The Charlatans, The Mime Troupe, The Duncan Company, The Straight Dancers, September 21, Straight Theater, 1967. Color offset lithograph poster.
FINE ARTS MUSEUMS OF SAN FRANCISCO, GIFT OF THE GARY WESTFORD COLLECTION, IN MEMORY OF THE STRAIGHT THEATER, 2017.7.33

83 OPPOSITE LEFT
ELAINE MAYES,
Dancing, Straight Theater, Haight-Ashbury, San Francisco, 1967. Gelatin silver print.
COLLECTION OF THE ARTIST

84 OPPOSITE RIGHT
ELAINE MAYES,
Composite photo, Straight Theater with Jerry Garcia and Dancing, 1967. Gelatin silver print.
COLLECTION OF THE ARTIST

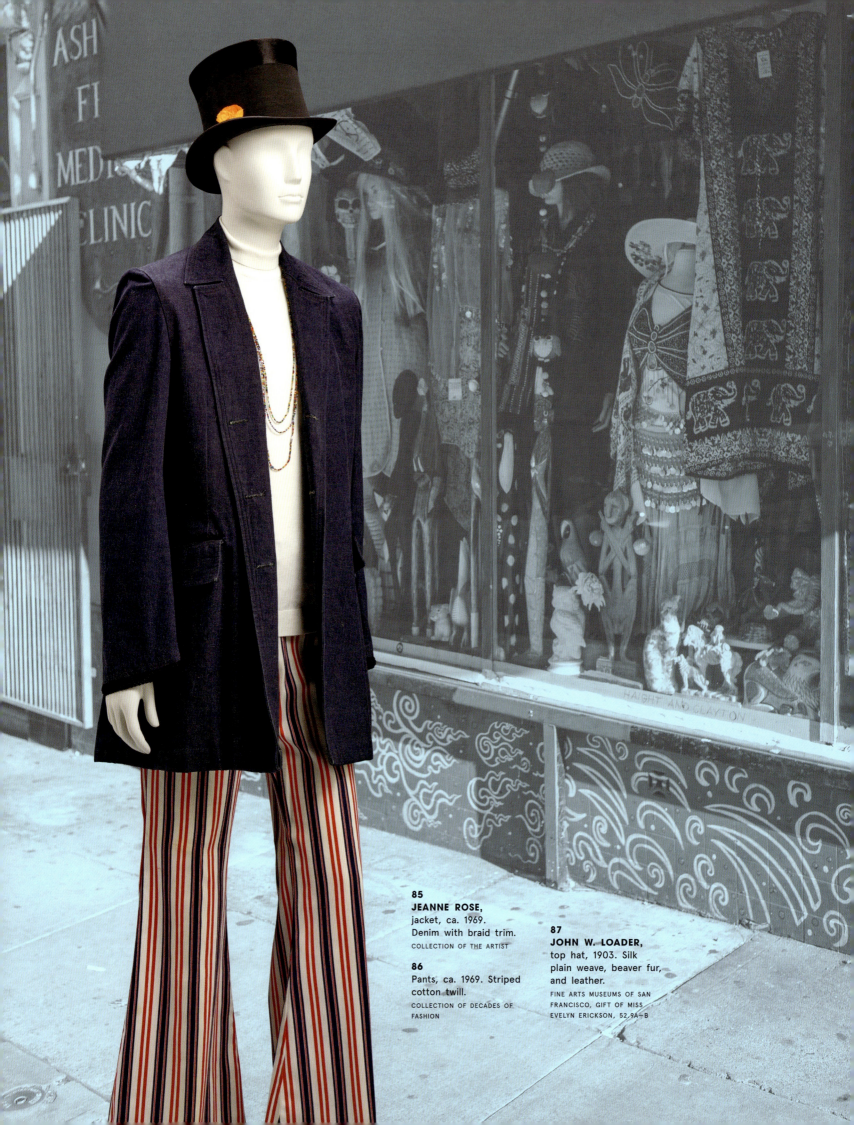

85
JEANNE ROSE,
jacket, ca. 1969.
Denim with braid trim.
COLLECTION OF THE ARTIST

86
Pants, ca. 1969. Striped
cotton twill.
COLLECTION OF DECADES OF
FASHION

87
JOHN W. LOADER,
top hat, 1903. Silk
plain weave, beaver fur,
and leather.
FINE ARTS MUSEUMS OF SAN
FRANCISCO, GIFT OF MISS
EVELYN ERICKSON, 52.9A–B

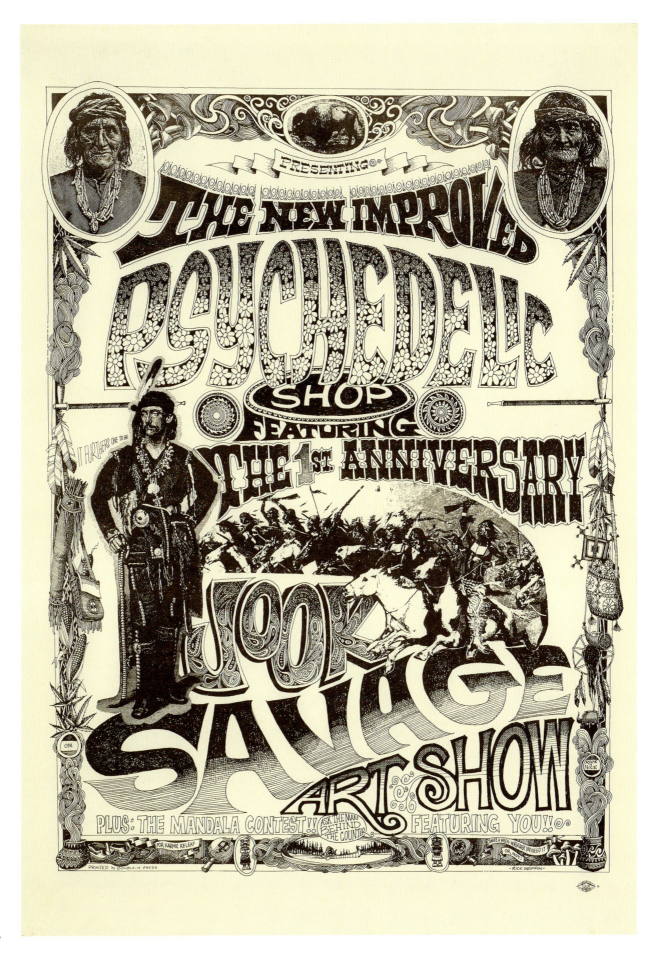

88
RICK GRIFFIN,
The New Improved Psychedelic Shop and Jook Savage Art Show, 1966. Offset lithograph poster.

FINE ARTS MUSEUMS OF SAN FRANCISCO, GIFT OF THE GARY WESTFORD COLLECTION, 2017.7.12

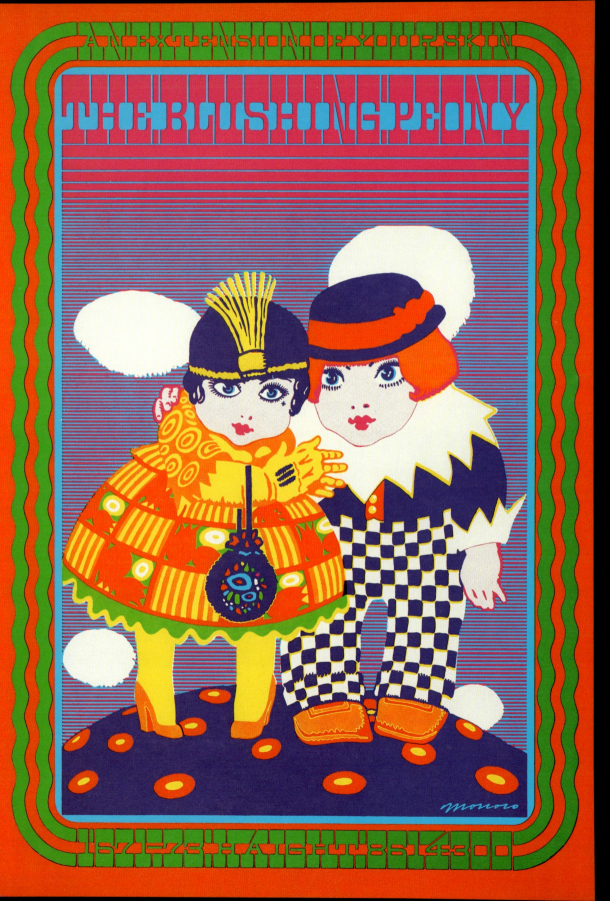

89
VICTOR MOSCOSO,
The Blushing Peony, 1571–73 Haight, 1967. Color offset lithograph poster.
FINE ARTS MUSEUMS OF SAN FRANCISCO, GIFT OF THE GARY WESTFORD COLLECTION, 2016.32.4

90 OPPOSITE
LOREN REHBOCK,
Mnasidika, 1510 Haight, 1967. Color offset lithograph poster.
FINE ARTS MUSEUMS OF SAN

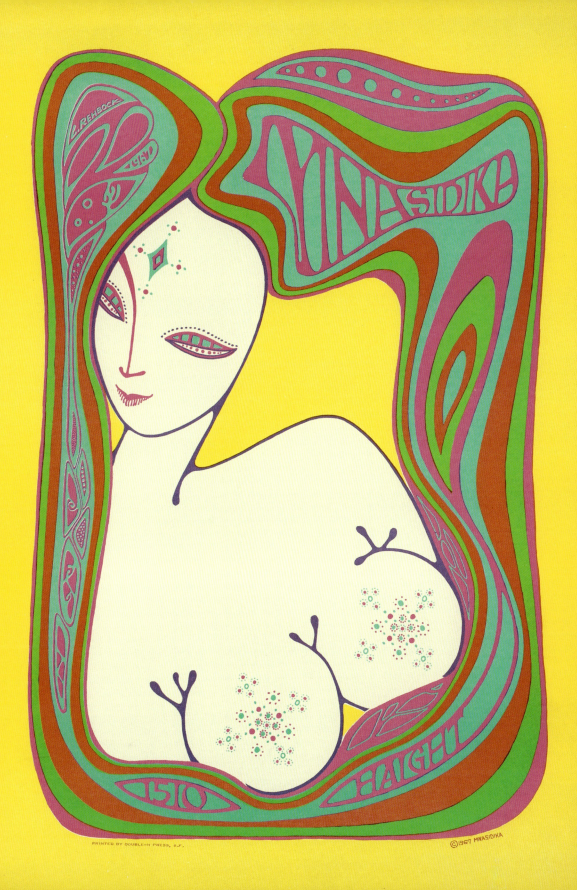

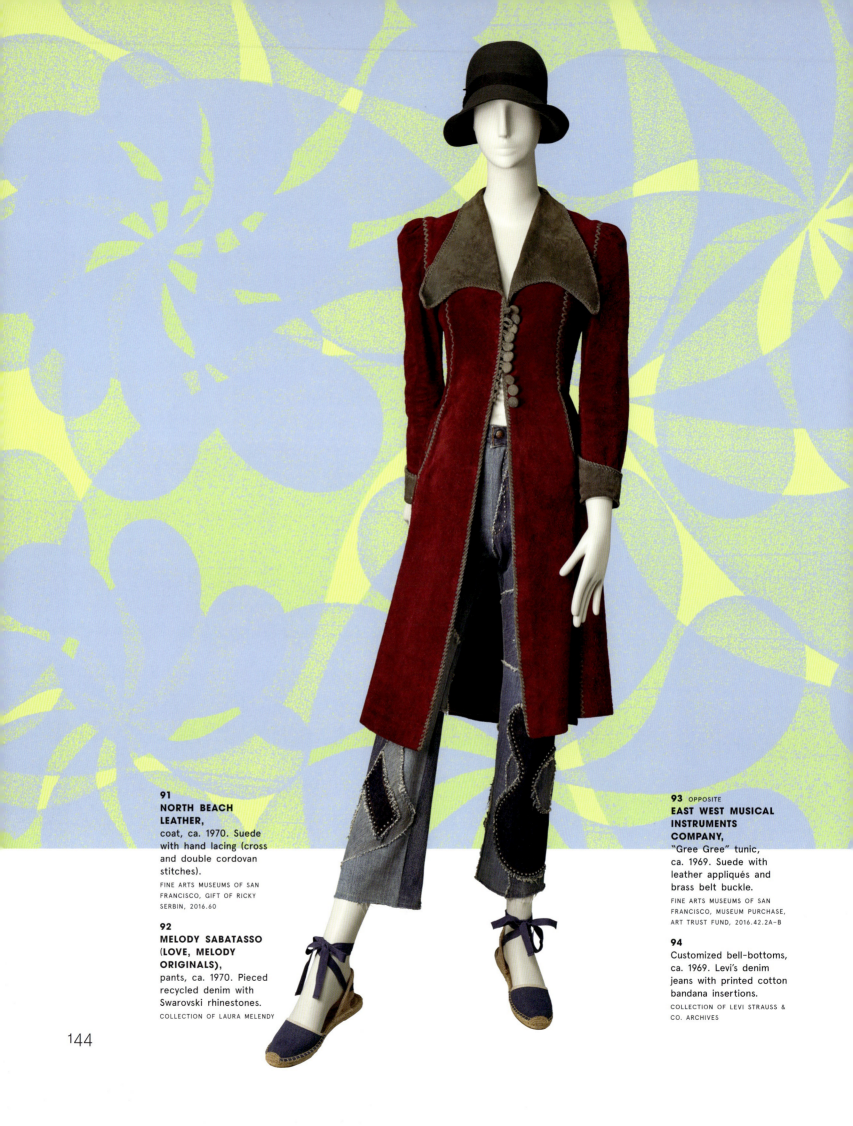

91
NORTH BEACH LEATHER, coat, ca. 1970. Suede with hand lacing (cross and double cordovan stitches).
FINE ARTS MUSEUMS OF SAN FRANCISCO, GIFT OF RICKY SERBIN, 2016.60

92
MELODY SABATASSO (LOVE, MELODY ORIGINALS), pants, ca. 1970. Pieced recycled denim with Swarovski rhinestones.
COLLECTION OF LAURA MELENDY

93 OPPOSITE
EAST WEST MUSICAL INSTRUMENTS COMPANY, "Gree Gree" tunic, ca. 1969. Suede with leather appliqués and brass belt buckle.
FINE ARTS MUSEUMS OF SAN FRANCISCO, MUSEUM PURCHASE, ART TRUST FUND, 2016.42.2A–B

94
Customized bell-bottoms, ca. 1969. Levi's denim jeans with printed cotton bandana insertions.
COLLECTION OF LEVI STRAUSS & CO. ARCHIVES

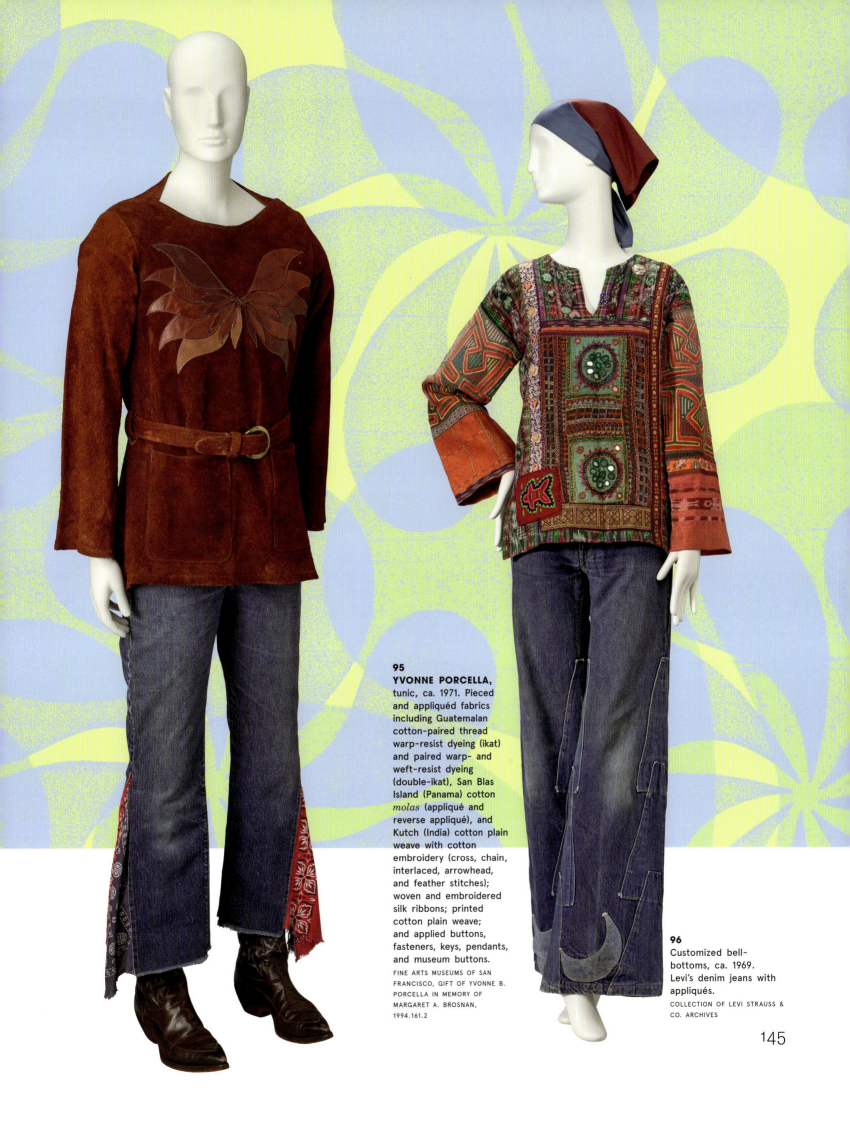

95
YVONNE PORCELLA, tunic, ca. 1971. Pieced and appliquéd fabrics including Guatemalan cotton-paired thread warp-resist dyeing (ikat) and paired warp- and weft-resist dyeing (double-ikat), San Blas Island (Panama) cotton *molas* (appliqué and reverse appliqué), and Kutch (India) cotton plain weave with cotton embroidery (cross, chain, interlaced, arrowhead, and feather stitches); woven and embroidered silk ribbons; printed cotton plain weave; and applied buttons, fasteners, keys, pendants, and museum buttons.
FINE ARTS MUSEUMS OF SAN FRANCISCO, GIFT OF YVONNE B. PORCELLA IN MEMORY OF MARGARET A. BROSNAN, 1994.161.2

96
Customized bell-bottoms, ca. 1969. Levi's denim jeans with appliqués.
COLLECTION OF LEVI STRAUSS & CO. ARCHIVES

145

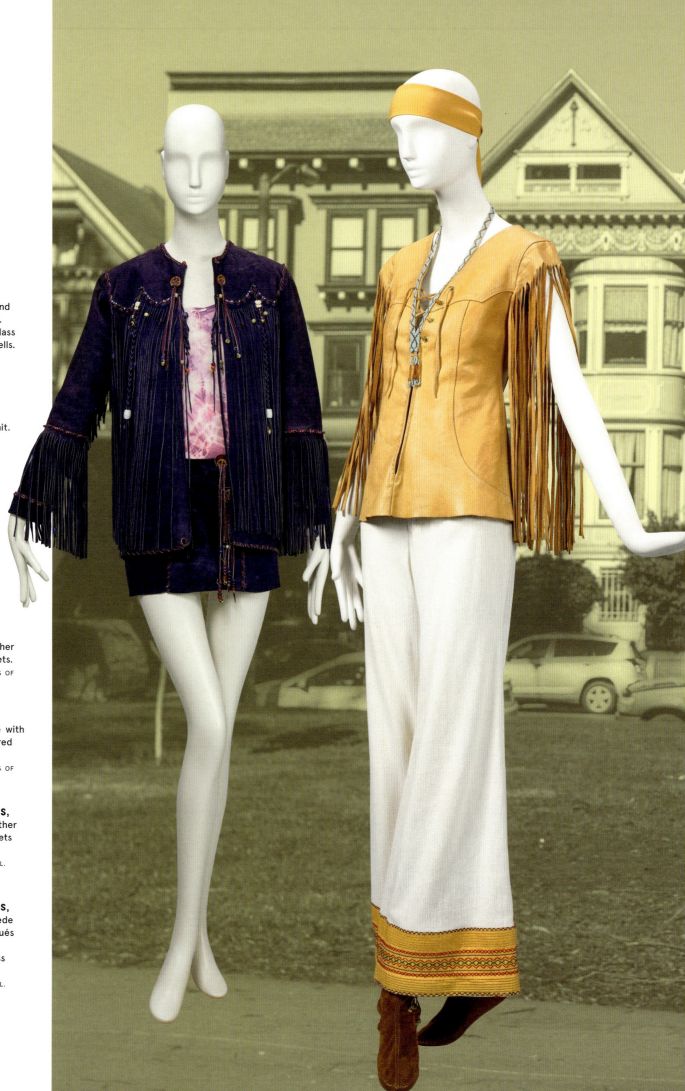

97 LEFT
BRIDGET,
ensemble (jacket and miniskirt), ca. 1969. Dyed suede with glass beads and brass bells.
COLLECTION OF HELENE ROBERTSON

98
RENAIS FARYAR,
tank top, ca. 1969. Tie-dyed cotton knit.
COLLECTION OF HELENE ROBERTSON

99 RIGHT
ZIG ZAG,
top, ca. 1969. Leather with metal grommets.
COLLECTION OF DECADES OF FASHION

100
Pants, ca. 1969. Cotton plain weave with machine-embroidered cuffs.
COLLECTION OF DECADES OF FASHION

101 OPPOSITE LEFT
LINDA GRAVENITES,
vest, ca. 1969. Leather and suede with rivets and metalwork.
COLLECTION OF ROSLYN L. ROSEN

102 OPPOSITE RIGHT
LINDA GRAVENITES,
cape, ca. 1969. Suede with leather appliqués and hand lacing (cordovan and cross stitches).
COLLECTION OF ROSLYN L. ROSEN

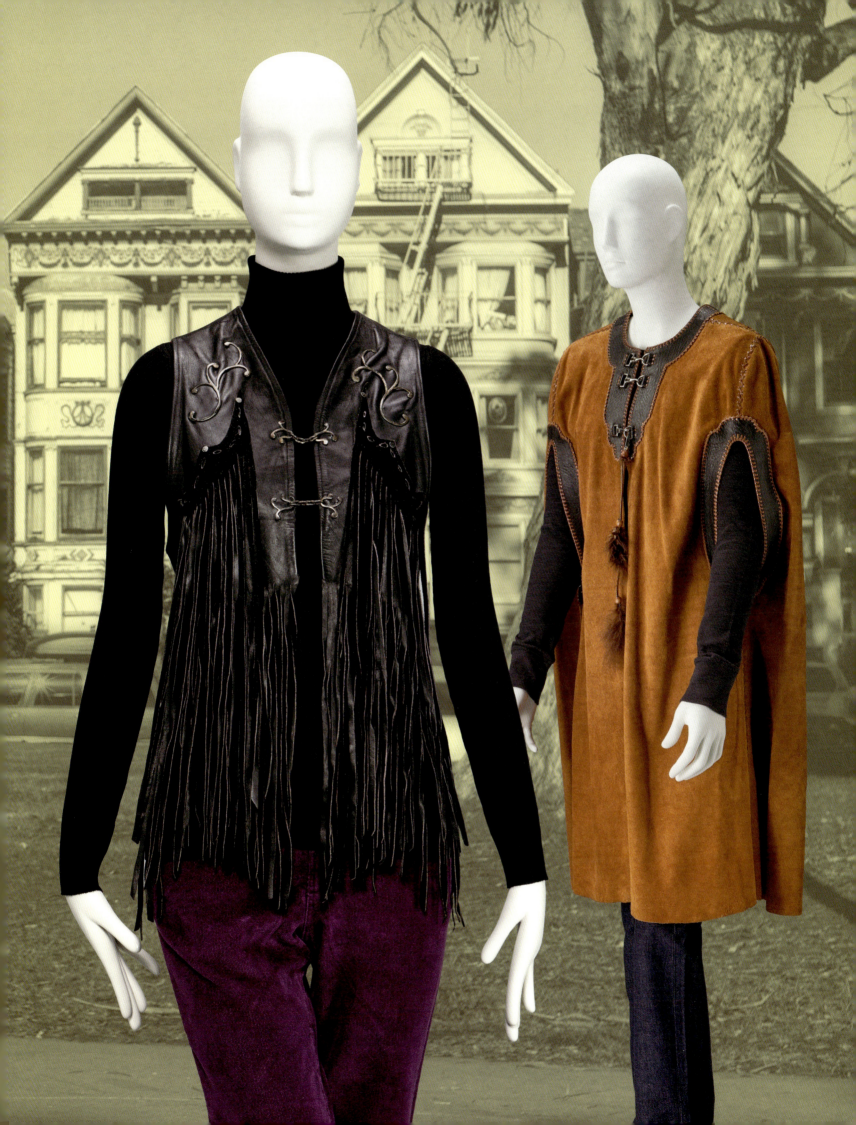

103 LEFT
The Print Mint Opening, December 1, 1542 Haight, 1966. Color offset lithograph poster.
FINE ARTS MUSEUMS OF SAN FRANCISCO, GIFT OF THE GARY WESTFORD COLLECTION, 2017.7.37

104 BELOW
JOHN SPENCE WEIR, *Window of the Print Mint*, ca. 1967. Gelatin silver print.
COLLECTION OF THE ARTIST

105 OPPOSITE
LELAND RICE, *The Print Mint, Haight Street*, 1967. Gelatin silver print.
COLLECTION OF THE ARTIST

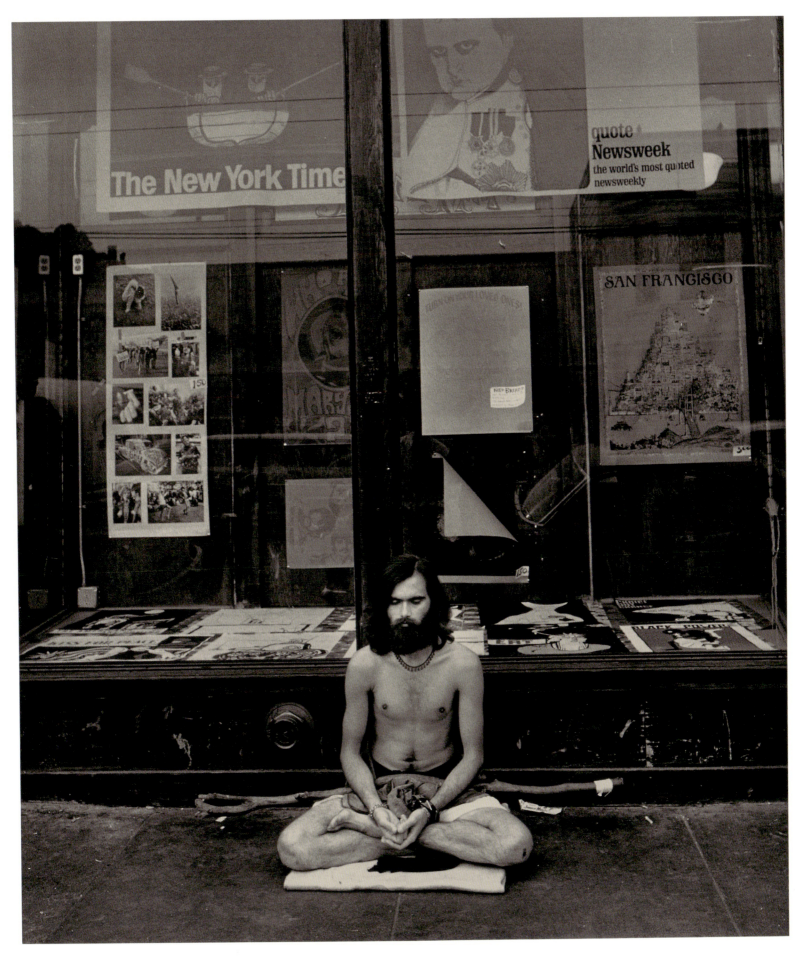

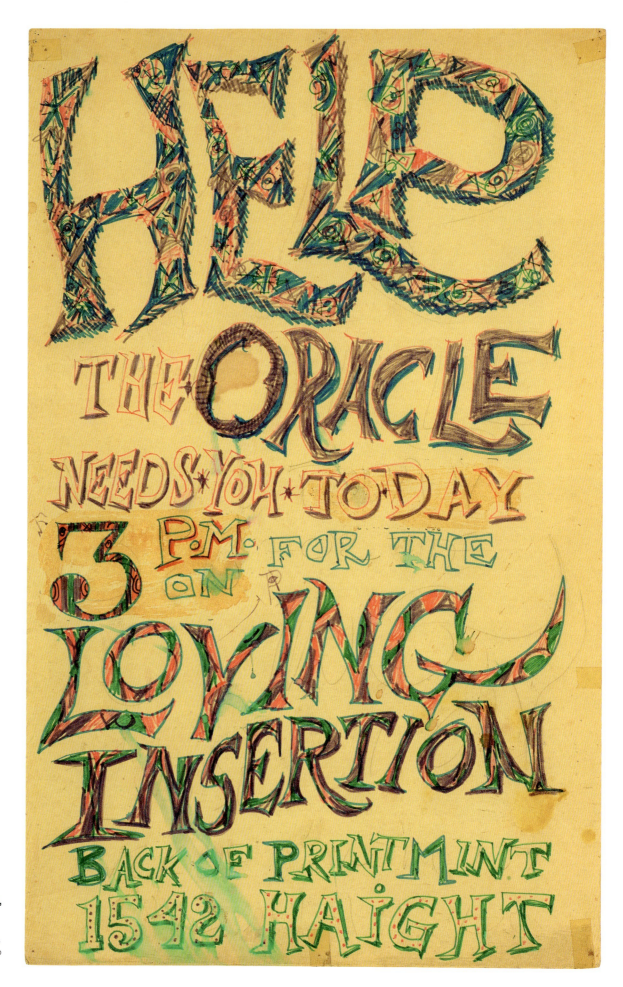

106
Help The Oracle Needs You Today for the Loving Insertion, ca. 1967. Porous point pen over graphite on yellow paper.
COLLECTION OF JOHN J. LYONS

107
OPPOSITE
RUTH-MARION BARUCH, *"Jesus" Selling the Oracle, Haight Ashbury*, 1967. Gelatin silver print.
LUMIÈRE GALLERY, ATLANTA, AND ROBERT A. YELLOWLEES

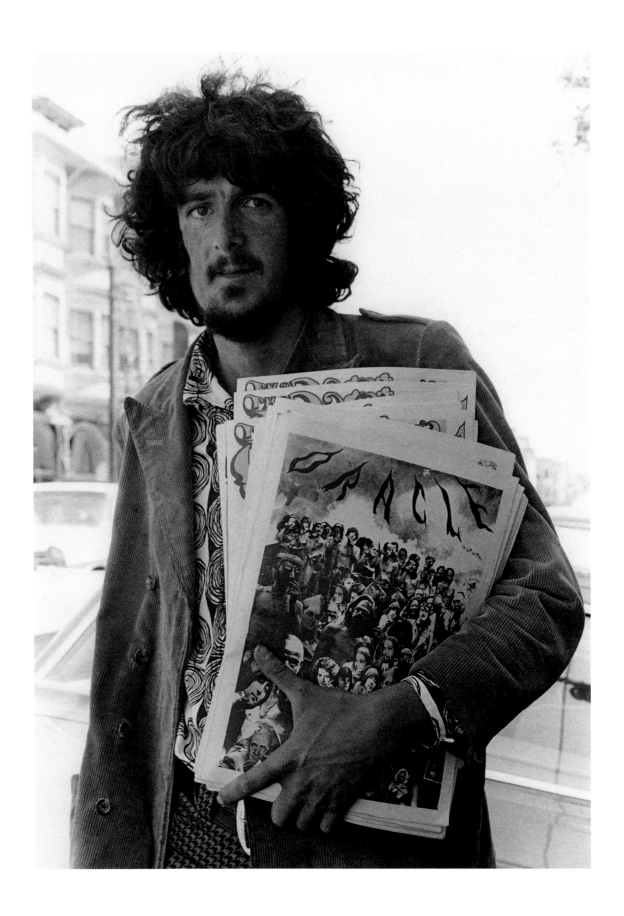

108
HAP SMITH, "Love Pageant Rally," *San Francisco Oracle*, vol. 1, no. 1, September 1966. Offset lithograph newspaper.
COLLECTION OF JAY THELIN

110
"Ken Kesey's Graduation Party," cover, *San Francisco Oracle*, vol. 1, no. 3, November 1966. Offset lithograph newspaper.
COLLECTION OF JAY THELIN

112
STANLEY MOUSE, ALTON KELLEY, and **MICHAEL BOWEN,** "The Human Be-In," cover, *San Francisco Oracle*, vol. 1, no. 5, January 1967. Color offset lithograph newspaper.
COLLECTION OF JAY THELIN

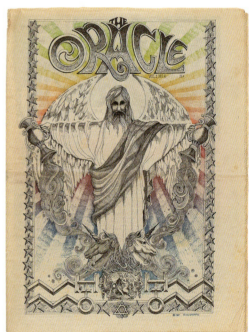

109
GEORGE TSONGAS and **JOHN BROWNSON,** "Youth Quake," cover, *San Francisco Oracle*, vol. 1, no. 2, October 1966. Offset lithograph newspaper.
COLLECTION OF JAY THELIN

111
GABRIEL ("GABE") KATZ, "Dr. Leary and the Love Book," cover, *San Francisco Oracle*, vol. 1, no. 4, December 1966. Offset lithograph newspaper.
COLLECTION OF JAY THELIN

113
RICK GRIFFIN, "The Aquarian Age," cover, *San Francisco Oracle*, vol. 1, no. 6, February 1967. Color offset lithograph newspaper.
COLLECTION OF JAY THELIN

114
MARK DEVRIES and **HETTY MCGEE MACLISE,** *"The Houseboat Summit,"* cover, *San Francisco Oracle*, vol. 1, no. 7, April 1967. Color offset lithograph newspaper.
COLLECTION OF JAY THELIN

116
BRUCE CONNER, *"Psychedelics, Flowers & War,"* cover, *San Francisco Oracle*, vol. 1, no. 9, August 1967. Color offset lithograph newspaper.
COLLECTION OF JAY THELIN

118
STEVE SCHAFER, *"The City of God,"* cover, *San Francisco Oracle*, vol. 1, no. 11, December 1967. Color offset lithograph newspaper.
COLLECTION OF JAY THELIN

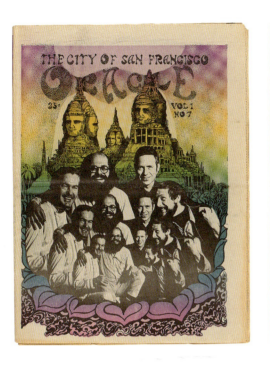
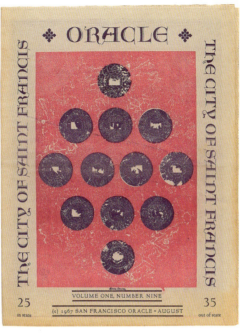
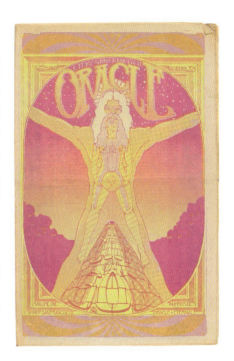
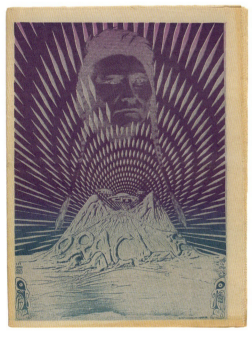
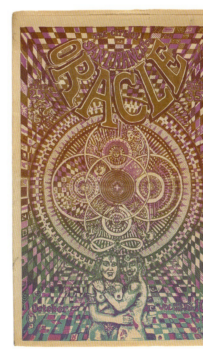

115
HETTY MCGEE MACLISE, *"The American Indian,"* cover, *San Francisco Oracle*, vol. 1, no. 8, June 1967. Color offset lithograph newspaper.
COLLECTION OF JAY THELIN

117
ROBERT ("BOB") BRANAMAN, *"Politics of Ecstasy,"* cover, *San Francisco Oracle*, vol. 1, no. 10, October 1967. Color offset lithograph newspaper.
COLLECTION OF JAY THELIN

119
BOB SCHNEPF, *"Symposium 2000 AD & the Fall,"* cover, *San Francisco Oracle*, vol. 1, no. 12, February 1968. Color offset lithograph newspaper.
COLLECTION OF JAY THELIN

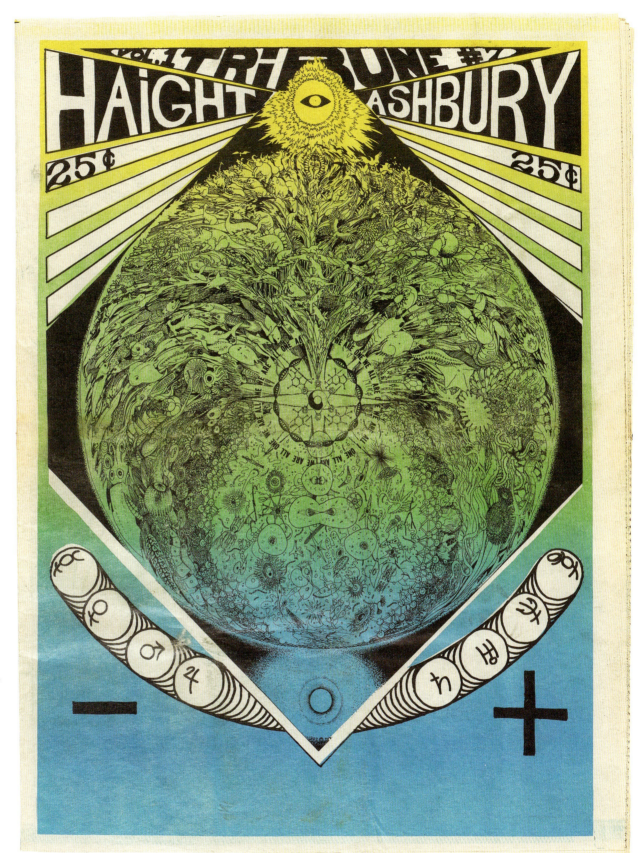

120 OPPOSITE
"Sock it to Me!" cover, *Haight-Ashbury Tribune*, vol. 2, no. 4, 1968. Color offset lithograph newspaper.
COURTESY OF MICKEY MCGOWAN, SAN RAFAEL, CA

121
Cover, *Haight-Ashbury Tribune*, vol. 1, no. 7, 1967. Color offset lithograph newspaper.
COURTESY OF MICKEY MCGOWAN, SAN RAFAEL, CA

122 OVERLEAF
Assortment of buttons, ca. 1967. Plastic and metal.
COURTESY OF MICKEY MCGOWAN, SAN RAFAEL, CA

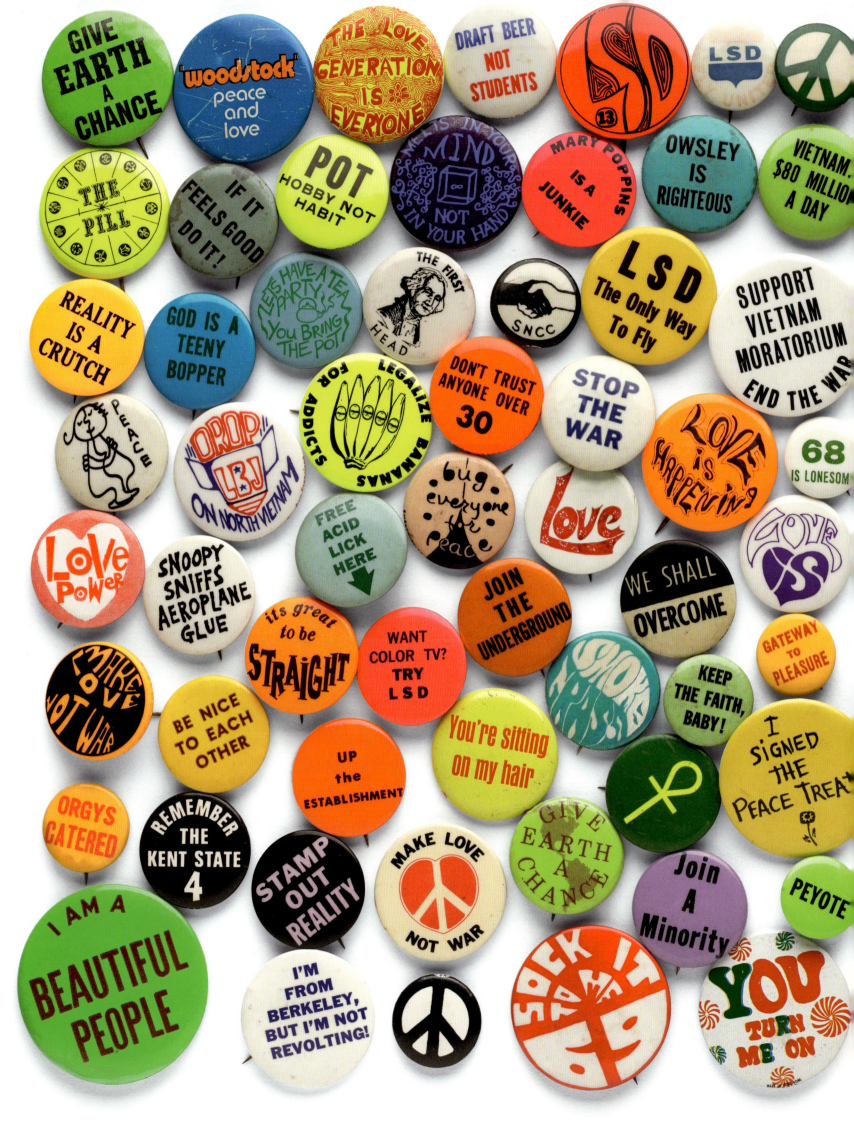

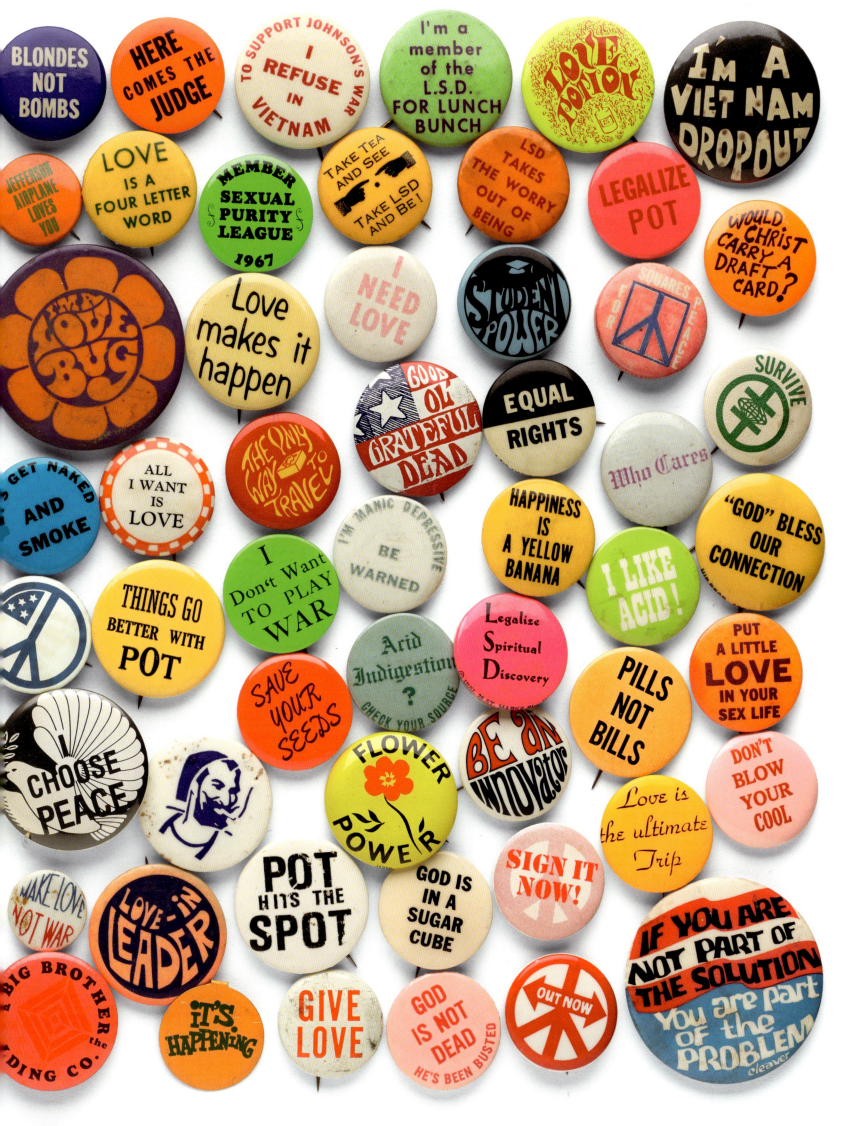

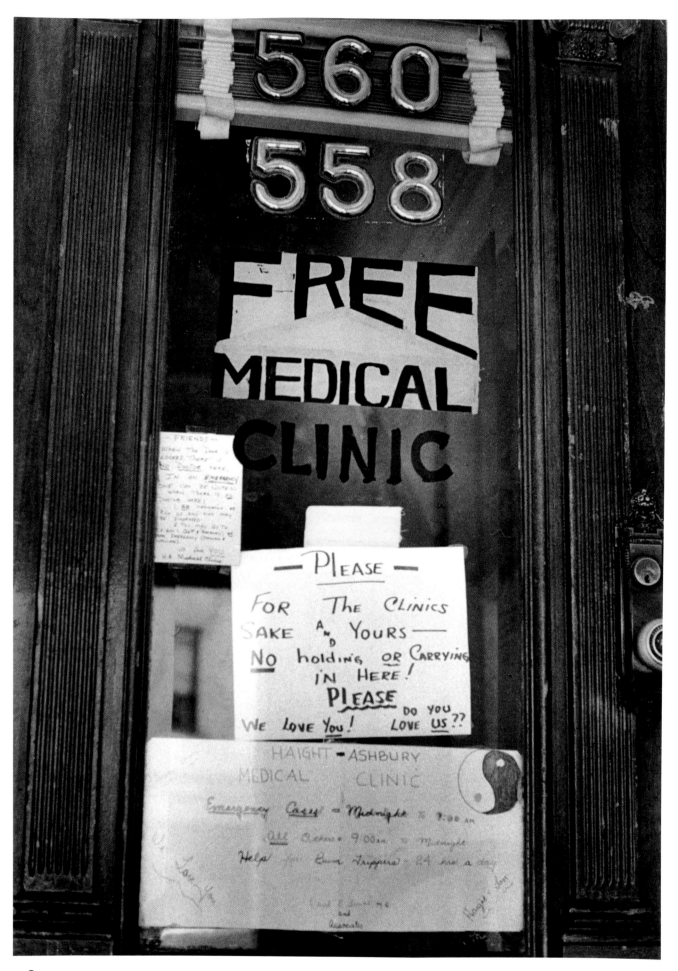

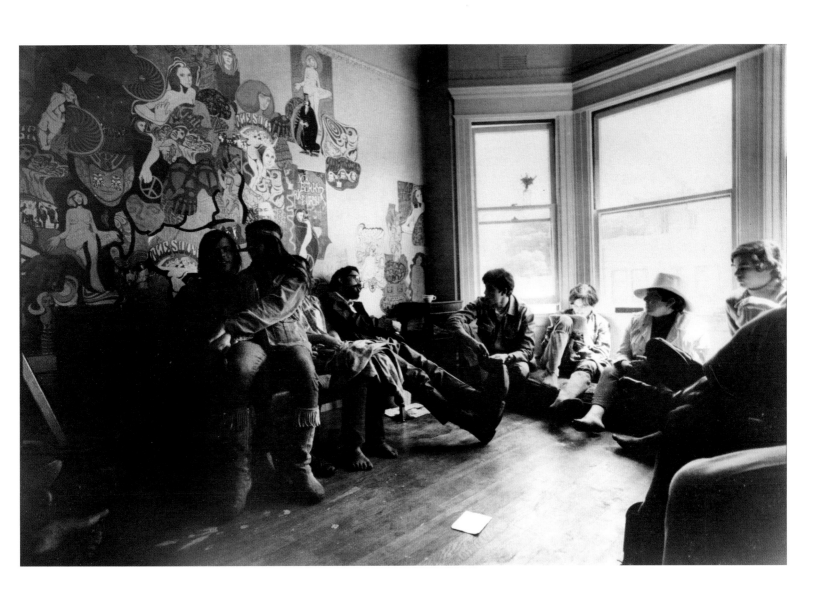

123 OPPOSITE
RUTH-MARION BARUCH, *"560 558" (sign), Haight Ashbury,* 1967. Gelatin silver print.
COURTESY SPECIAL COLLECTIONS, UNIVERSITY LIBRARY, UNIVERSITY OF CALIFORNIA, SANTA CRUZ. PIRKLE JONES AND RUTH-MARION BARUCH PHOTOGRAPHS

124
GENE ANTHONY, *Calm Center, Waiting at the Haight-Ashbury Free Medical Clinic. 558 Clayton St.,* 1966. Gelatin silver print.
COURTESY OF THE BANCROFT LIBRARY, UNIVERSITY OF CALIFORNIA, BERKELEY, BANC PIC 2001.196:27-B

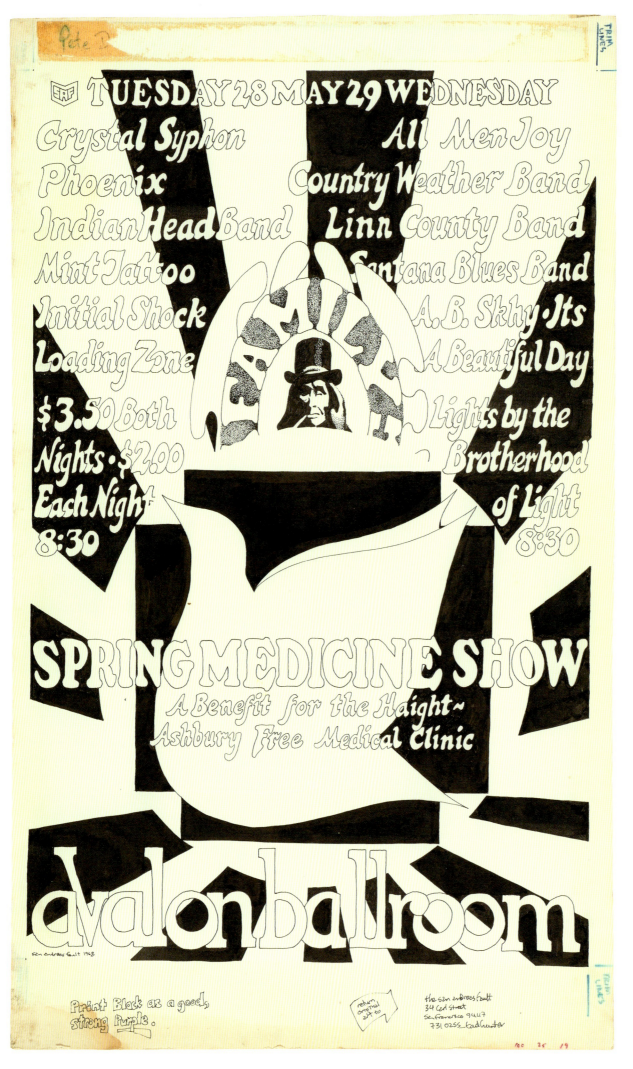

125
SAN ANDREAS FAULT (TAD HUNTER), printing mechanical for *Spring Medicine Show: A Benefit for the Haight-Ashbury Free Medical Clinic*, Crystal Syphon, All Men Joy, Phoenix, Country Weather Band, Indian Head Band, Linn County Band, Mint Tattoo, Santana Blues Band, Initial Shock, A. B. Skhy, It's a Beautiful Day, Loading Zone, May 28 and 29, Avalon Ballroom, 1968. Black ink with white opaque paint and blue and red ink notations on illustration board.
COLLECTION OF JOHN J. LYONS

126 OPPOSITE
RICK GRIFFIN, STANLEY MOUSE, and **ALTON KELLEY,** "Halo," Benefit for Haight Ashbury Legal Organization, Jefferson Airplane, Big Brother & The Holding Co., Quicksilver-Messenger Service, The Charlatans, The Grateful Dead, May 30th, Winterland, 1967. Color offset lithograph poster.
COLLECTION OF JOHN J. LYONS

HAIGHT ASHBURY LEGAL ORGANIZATION
HALO

BENEFIT FOR HAIGHT ASHBURY LEGAL ORGANIZATION,
AN ON-SCENE SUMMER LONG GUARANTEE OF YOUR
FREEDOM
JEFFERSON AIRPLANE, BIG BROTHER & THE HOLDING CO. QUICKSILVER
MESSENGER SERVICE, THE CHARLATANS, THE GRATEFUL DEAD. HEADLIGHTS
MAY 30TH TUESDAY 9:00 PM WINTERLAND $2.50 ADM.

127
Assortment of notes and poems posted at the Psychedelic Shop, 1967.
COLLECTION OF JAY THELIN

128 OVERLEAF
LARRY KEENAN, *Section of the Runaway Board at Park Police Station,* 1968. Gelatin silver print.
COURTESY OF THE BANCROFT LIBRARY, UNIVERSITY OF CALIFORNIA, BERKELEY, BANC PIC 2009.050.001:067

my friends.

THE GREAT - COME DOWN IS NEAR

BE NOT FRIGHTENED WHEN IT COMES
DO NOT PANIC AT IT
IT IS THE WAY OF ALL THINGS

SEEK OUT THY BROTHERS - KNOW AND
TRUST THEM

FIND AGAIN THE TRUE & GOOD

BE RESOLVED OF THE WAY

FORWARD, UPWARD, ONWARD

AND SO NOW, STAY HIGH!

LOST. - WHERE ARE YOU LOOK FOR? - I DON'T
- THEN YOU REALLY ARE LOST - YES I AM -
- YOU HAVE ANY GOALS OR PLACES YOU
TO GO - NO I AIN'T HUNG UP - HUNG
- THEN YOU WOULDN'T BE LOST - NO
N I WOULD BE STRUG-OUT - HOW
YOU LIVE THIS WAY? - I DON'T LIVE
IST TO LOVE - WHAT ARE YOU TRYING
PROVE? - I'M TRYING TO PROVE TO
SELF I CAN LIVE & LOVE WITHOUT
NG UPS & BEIN TIED DOWN - THEN
HY DID YOU SAY YOU ARE LOST -
MON A TRIP
 B. Tyme

AN YES REALITY IS
A NICE PLACE
TO VISIT -
I JUST DON'T
WANT TO
LIVE
THERE

the psychedelic shop — books records artworks

Remember what
the door-service
said

FEED YOUR HEAD!

when you come down from Avalon
button-on-your-breast, long-haired
dope is on our side existence
feed your head, Queen Jane.
 Tiny one

1535 HAIGHT STREET SAN FRANCISCO 94117 ph (861-7074

yes, the Circus is in Town on Haight
here comes the citizen with his Tour
Buses in one Hand the Camera
in the other. Gaze upon the Hippie
with his theatrical Dress and dirty
Body. The three Ring Circus is established.
There is Tracy's with is Psuedo Motor
Cycle Clowns, Lonely Hung up Spades
looking for Ophelia with her Clairol Hair
Lady and I are from the other Side of
Fillmore, to take a look in the Drugstore
Cafe where the Price goes up every
other Day. The Topless Clubs are slowly
coming, in a perfect image of
Pure Entertainment. Here comes the
Blind Pusher with his cut up Acid, And to
think that he was honest long ago.

AN ANSWER:

HERE HAS IT GONE - THIS LOVE
R LOVE? WHERE HAS IT GONE!?

HAS GONE INTO A LONGING -
LONGING - A "SPIRIT" OF LONGING -
INTO THE "WISDOM" OF BELONGING -
ONGING - ! THE SPIRIT OF BELONGING!

TO THE SPIRIT OF KNOWING - AND
 SHOWING OUR BELONGING - OUR
GING OF BELONGING
 WE ARE IN SPIRIT -
 ALLNESS OF ONE - I'M ALL -
LONGING - BELONGING ...
 WE ARE !
MEETING .. GREETING - THE FLOW
THE GLOW ...
BELONGING - OUR LONGING - SO WE KNOW!!
 ★ "STAR"

I THE LIFE YOU THE ESSENCE
I THE MIND YOU THE REALITY
I THE SOUL YOU THE INFINITY
AND YOU I AND I YOU

AND WE TIMELESS
 M

JUST BECAUSE I'M CHARMING
AND ATTRACTIVE...DON'T GET
THE IDEA THAT I'M RICH!

Hi Hippies,
I am a girl 12
years old and I want
to become a Hippie my
sister does not like
Hippies and will not
let me come into her room.
my mother understands
me and hippies. I took some
clay and made a hippie love
piece sing and wore
it around my neck now neck-
laces I understand hippies
 12 Year Old Hippie

life crawled in from a hole
 in the air

it's here to see but please
 don't stare

 Peg

When the hot winds
Meet the cold
In an area awe-filled
Crushed by crashing cacophony
Limitless, lightless
In the long limbs of living awareness
A boundary is sensed
But unacknowledged
For it cannot be
 but it is

 Jerry

am, and everywhere, god have mercy
 (response to 'Vietnam, Goddamn')

ints and pajama-clad liberators
flames into each other in the rice fields
between
e children
are our naked younger brothers and sisters
whom there are weepers
- far too few mourners

on a tall hill
the wind-tossed daisies
y into the sun all my short life long
il to the dying wisp of moon
these
 my and your
 nearest and only kin
urse no creation
ll i wish even the most just damnation
the most damnable injustices

only
d and my mother time
give
 and to help the land to forget

it is said
know not'

must beg for them mercy
d teach them
 -- Dave M. 6-12-67

"Ode to Haight Street"

Sure the hoods
 armed with knives and hate
 can come to destroy
 us-
the hustlers can open tourist clumps,
the pushers can turn crooked
 cutting the dope with sugar,
the pimps can come dealing in misery,
the cars can come and bring ugliness,
the merchants can profit off the system,
the cops can bully people on the street -
 but
we will survive
the love that has grown here
can not be washed away
even if our fascist system
toy locks us all away
to rot behind the barbing
 fences (electric-barb wire)
even if they burn our community to the ground
and pour concrete and gasoline
over the Panhandle
and turn the park into a bowling alley,
we will appear again
 elsewhere
for their system is so sick
it will breed its own
 destruction
its violence will give birth to
 our peace
its ugliness will give birth to
 our beauty
its hate will give birth to
 our LOVE
 alex

We all met on the sidewalk to make love and realize life
It was then that the erect black funnels turned to trees,
And the sidewalk became a brook,
And the country side smelled of yellow flowers
Once again we were all people
And
 Gods
 tears
 were
 dried
 by
 his
 eternal
 warmth,
 the
 sun.

 C. Henri

LOVE
LORD GOD
I MUST KNOW
YOU.

129
Front and back covers of *The Digger Papers,* 1968. Offset lithograph newspaper.
COLLECTION OF JOHN J. LYONS

130 OPPOSITE
THE COMMUNICATION COMPANY,
"Survival School," How to Stay Alive on Haight Street for Newcomers and Others, 1967. Stencil duplicate print (mimeograph) handbill.
COLLECTION OF JOHN J. LYONS

THE COMMUNICATION COMPANY

Haight/Ashbury

SURVIVAL SCHOOL

how to stay alive on Haight Street

for newcomers & others

free!

classes & discussions conducted by experts, professional men & experienced street kids

Every Monday night at 8

- The Scene
 where it's really at & what it is
- Drug Lore
 how to keep from getting killed for kicks
- Policemanship
 how to avoid getting busted & what to do if you are

Every Tuesday night at 8

- Sex Lore
 how to avoid gangbangs, rape, VD & pregnancy
- Health & Hygiene
 how to stay alive & well
- Street Wisdom
 how to avoid beatings & starvation, how to survive without money

a series of three classes designed to save you from becoming a psychedelic casualty -- six months' worth of knowledge in a mere three days, & all free

free

Every Wednesday night at 8

- Haight Street Seminar
 experienced hippies & others rapping, answering questions, filling you in, telling it like it is, so you needn't be a helpless newcomer very long

no cheap moralizing, no bullshit, nothing phoney, no lies, no beating around the bush, no salestalk, just straight information you can trust

-at-
THE TRIP WITHOUT A TICKET
901 Cole Street

"A MOVING TARGET IS HARD TO HIT

Whatever tribe I am the reincarnated member of, apparantly won, or lost, or survived, as Ishi's TRIBE, simply by fading away, dispersing, a whisp of fog no one can strike: "a moving target is hard to hit." This can be the reverse of cowardice, it takes great courage, at times, to back off from what is rightly your place to stand.

Therefore, this is not advice for all. Some of you are people who stand there and take it, as the poles did, the ones who did, attack the hordes of tanks on horseback, with futile swords. Beautiful, that is your shot. It is not mine.

When 200,000 folks from places like lima ohio and cleveland and lompoc and visalia and amsterdam and london and moscow and lodz suddenly descend, as they will, on the haight-ashbury, the scene will be burnt down. Some will stay and fight. Some will prefer to leave. My brief remarks are for the latter. I will stay. At some distance. Available. But my advice for those who have a way or ways similar to mine: <u>disperse.</u>

Gather into TRIBES of 15 or less. Communal "families" of 5 adults (however divided into sexes) and the natural number of children thereby made, is ideal for nomadic tribal dispersal action.

More than 3/4 of the state of California is national forest, national park, or state forest or park. Take your truck or car and make your camp in the part of the state you like most. Most parks require that you move in two weeks. Some places require moving every two days. This is only fair. The idea is, no one has the right to hog one campsite for the summer.

Choose unfamous forests. Avoid yosemite. Work, honestly, with the forest ranger. Write the state of california for their booklet. I think the feds have a similar campsite guide.

Also, volunteer for summer fire fighting work. It's good work, well paid, and necessary. When the fire starts they come to your camp and take you to the scene of disaster.

Another thing, as I was once quoted: "sometimes you only have to step 3 feet to the left and the whole insane machine goes roaring by." Or something like that.

The point is, for those who have this kind of way, not out of cowardice, but as WAY, that sitting in the haight-ashbury in all that heat and the terrible crowd you cannot help anyway (maybe), is simple insanity.

Disperse. Gather into smaller tribes. Use the beautiful public land your state and national governments have already set up for you, free. If you want to.

Most Indians are nomads. The haight-ashbury is not where it's at--it's in your head and hands. Take it anywhere.

....Lew Welch

CHURCH OF ONE
MARCH 29, 1967 SAN FRANCISCO
PLANET EARTH

Gestetnered by The Communication Company (UPS) 3/27/67

PRESS RELEASE
1/24/67

The Haight-Ashbury community is only one active manifestation of a world-wide youth revolution that has been infused with a revelation of the spiritual unity of all men and women of all races here and everywhere on all planets in all solar systems of all galaxies in the universe. The most recent example of the consciousness and size of this new community was expressed at the Human Be-In.

Further, as a community in the Haight-Ashbury we have initiated a rebirth of this neighborhood, and there are obvious accomplishments that we would like to bring to the attention of the public.

* The establishment of town hall meetings, opening new channels of dialogue within the community.

* The emergence of a community service group called the Diggers which provides free food, clothing and lodging.

* The opening of 26 new businesses within the past nine months.

* The establishment of the Haight-Ashbury Independent Proprietors job co-op supported by the community.

* The Haight-Ashbury Neighborhood Council's continuing project of re-foresting the neighborhood.

* The beautifying of homes and the organizing of street cleaning projects, which are a part of the increased aesthetic awareness of all segments of the community.

* The emergence of a newspaper, the San Francisco Oracle, a work of love expressing the spirit of the community.

* The establishment of a community theatre project, The Straight Theatre, with which we urge all possible official cooperation.

* The opening of a storefront lawyers' office to serve the legal needs of the community.

* The renewing of the ancient tradition of dancing as an expression of cultural awareness and as a healthy and constructive way for youth to involve themselves (and here let us recommend that no age limit be imposed by the city on these dances).

* The organizing of religious centers for meditation, prayer and spiritual discovery.

We are a delegation from H.I.P. representing at least 100 artists, merchants, craftsmen and professional people from this community. We are here today to suggest to the Chief of Police, Mr. Cahill, possible approaches for improved relations between the youthful new community and the older one.

First it is important to understand that the Haight-Ashbury represents a cultural renaissance and creative surge that is changing the bruted face of America. We recommend that the police and the community generally recognize and accept the beauty of

(more)

the people on Haight Street. They bring color, laughter, interest, creativity, excitement and dialogue to the neighborhood.

Since the Haight-Ashbury community involves an active street life, we recommend that the police recognize this as such and not view it as criminal. As proof of unwarranted harrassment in this neighborhood, the number of arrests far exceeds any reasonable proportion of convictions for alleged crimes. These street arrests are not only unjust to the people involved, but also constitute an economic disadvantage to all merchants on the street.

WE DON'T WANT PEOPLE BUSTED! We like and need them.

If the harrassment situation continues, the Haight-Ashbury Independent Propriators have been advised that a civil suit can be initiated against the City of San Francisco for economic damages caused by official harrassment.

Everyone in San Francisco must be aware by now of the vast number of unjust arrests and the general harrassment in the Haight-Ashbury, such as was seen on Haight Street Saturday night, January 14th. We suggest that the citizens of San Francisco seriously consider redefining the duties of their policemen. We recommend "peace officer" as a more useful definition.

Finally, because the Haight-Ashbury community is the reflection of a global youth movement, we suggest that we all remember these words from the Bible:

... and a little child shall lead them.

printed by The Communication Company

131 OPPOSITE
THE COMMUNICATION COMPANY,
"A Moving Target is Hard to Hit," March 29, Church of One, 1967. Red and black stencil duplicate print (mimeograph) handbill.
COLLECTION OF JOHN J. LYONS

132
THE COMMUNICATION COMPANY,
Press Release, January 24, 1967. Stencil duplicate print (mimeograph) handbill.
COLLECTION OF JOHN J. LYONS

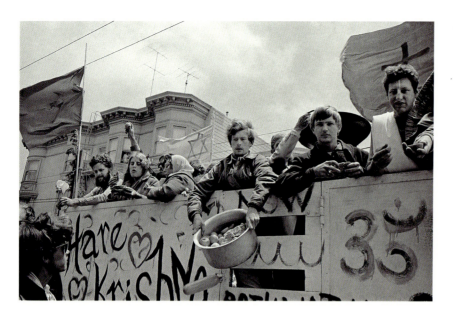

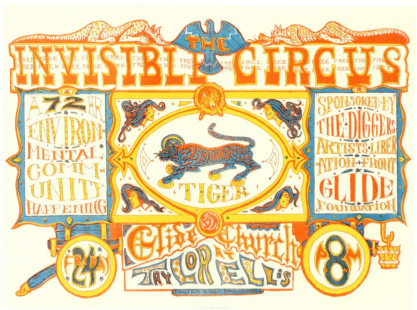

133 TOP
JIM MARSHALL,
Krishna/Digger March, June 1967 (printed 2016). Inkjet print.
COURTESY OF JIM MARSHALL PHOTOGRAPHY LLC

134 MIDDLE
DAVID HODGES,
"The Invisible Circus," Sponsored by The Diggers, Artists Liberation Front, Glide Foundation, Feb. 24–26, Glide Church, 1967. Color offset lithograph poster.
FINE ARTS MUSEUMS OF SAN FRANCISCO, GIFT OF THE GARY WESTFORD COLLECTION, 2017.7.25

135 BOTTOM
Death of the Hippie, 1967. Stencil duplicate print (mimeograph) handbill on tan paper.
COLLECTION OF JOHN J. LYONS

136 OPPOSITE
DUG MILES,
customized jeans, ca. 1973. Hand-painted white denim jeans with applied coix seeds, glass beads, leather, and patches.
COLLECTION OF LEVI STRAUSS & CO. ARCHIVES

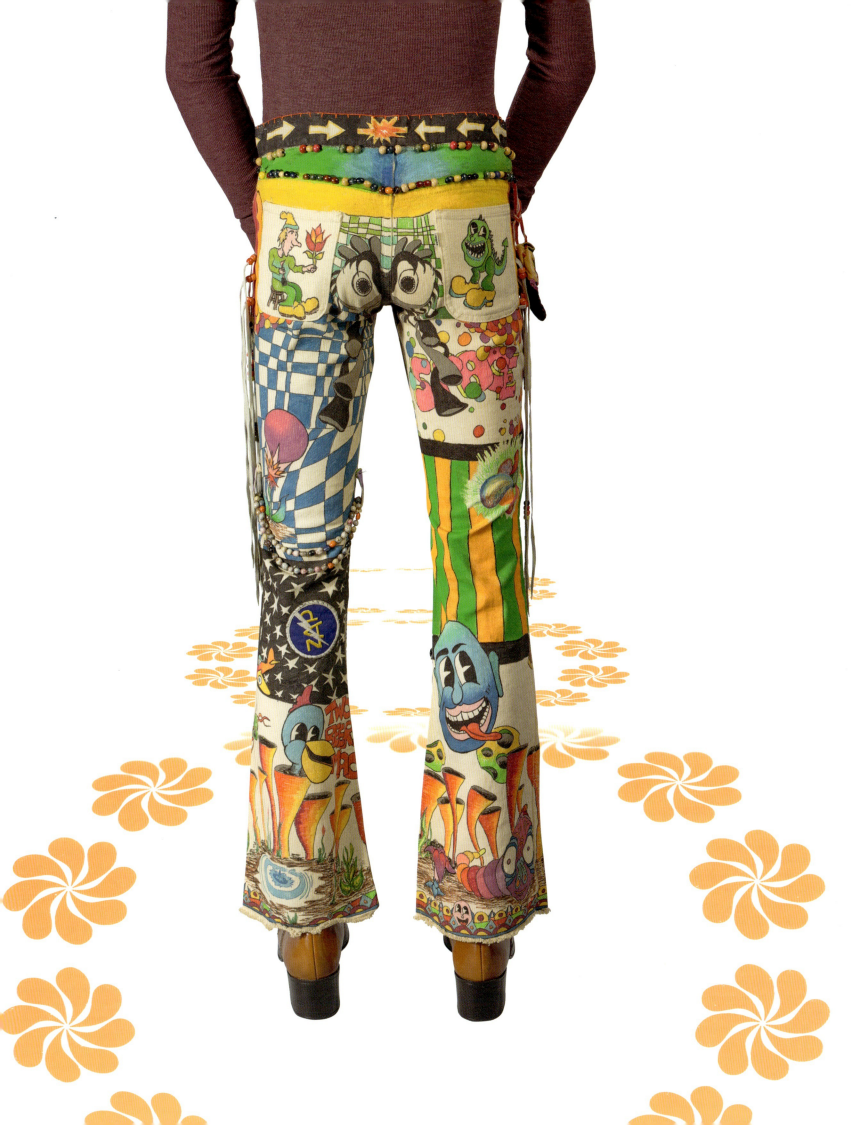

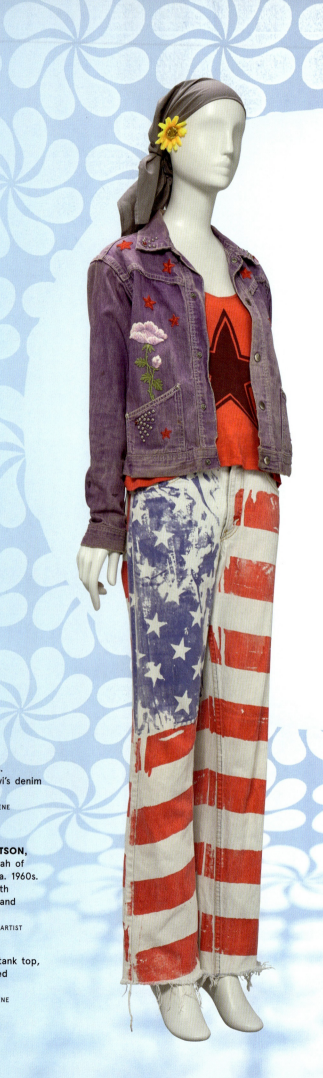

137
Pants, ca. 1960s.
Silkscreened Levi's denim jeans.
COLLECTION OF HELENE ROBERTSON

138
HELENE ROBERTSON, customized "Farah of Texas" jacket, ca. 1960s. Denim jacket with cotton patches and metal studs.
COLLECTION OF THE ARTIST

139
"Mr. Freedom" tank top, ca. 1960s. Printed cotton.
COLLECTION OF HELENE ROBERTSON

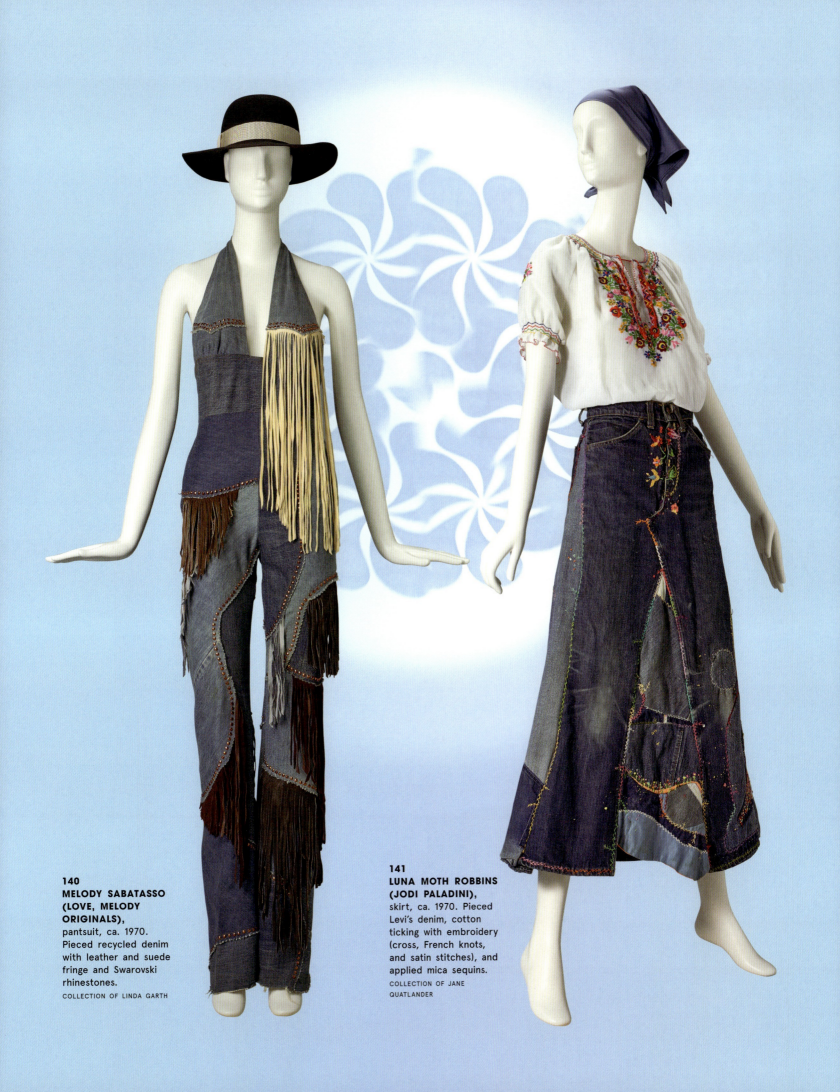

140
MELODY SABATASSO (LOVE, MELODY ORIGINALS), pantsuit, ca. 1970. Pieced recycled denim with leather and suede fringe and Swarovski rhinestones.
COLLECTION OF LINDA GARTH

141
LUNA MOTH ROBBINS (JODI PALADINI), skirt, ca. 1970. Pieced Levi's denim, cotton ticking with embroidery (cross, French knots, and satin stitches), and applied mica sequins.
COLLECTION OF JANE QUATLANDER

"Freaky, funny, and fashionable, these are the signs of our times."

HERBERT GOLD

SECTION 5

the poster shop

VIBRATING BEACONS of San Francisco's countercultural movement, rock posters were originally commissioned by Bill Graham, Chet Helms, and other intrepid entrepreneurs to promote dance concerts at the Fillmore Auditorium, the Avalon Ballroom, and additional venues located throughout the city. Characterized by striking juxtapositions of color (pls. 142–146), uniquely stylized lettering (pls. 178–182), and, on occasion, "trippy" graphics (pls. 157–160), the posters often required an attentive audience to be wholly understood, one in tune with the visual identity of the countercultural scene.

To ensure the posters found their mark, promoters tacked them onto telephone poles and pasted them on the windows of shops lining streets frequented by hip crowds. No sooner were posters put up, however, than interested parties would carefully remove them, preferring to see the intoxicating imagery embellishing their own living spaces. Though it may seem counter to traditional marketing, the relocation of these posters from public spaces into private likely guaranteed that the intended clientele did indeed receive word of the upcoming events.

Retail outlets for posters were also to be found throughout the city in such neighborhoods as the Haight-Ashbury and North Beach. Most famous among them, the Print Mint on Haight Street and Ben Friedman's Friedman Enterprises on Grant Avenue (later Gorilla Records and the Postermat) were papered from floor to ceiling in posters. According to at least one source, such shops did a thriving business during the years surrounding the Summer of Love, sometimes moving upwards of 25,000 posters a month.

Early on, the merchandise of such stores extended well beyond rock posters. Throughout the last months of 1965, for instance, Friedman Enterprises was filled primarily with personality- and political-driven imagery sourced from the poster wholesaler Portal Publications and second-hand records. It wasn't until the early months of 1966, when Graham and Helms began delivering weekly stacks of Fillmore and Avalon posters and customers began to inquire of them, that Friedman realized the economic potential of the genre, eventually becoming one of the posters' most significant commercial distributors.

The success of local poster shops was accompanied by the development of an entire industry in the Bay Area, with independent publishing companies and distributors such as East Totem West (see pls. 154 and 155) and Funky Features commissioning a range of posters with fine art, literature, and even spiritual referents, while commercial offset lithographic printing presses such as California Litho Plate Co. and Tea Lautrec Lithography emerged as hotbeds for the posters' production (see Binder, this volume). Amusing or serious, direct or impenetrable, the bold, mass-produced imagery from San Francisco found its way to towns near and far and became touchstones of a generation.

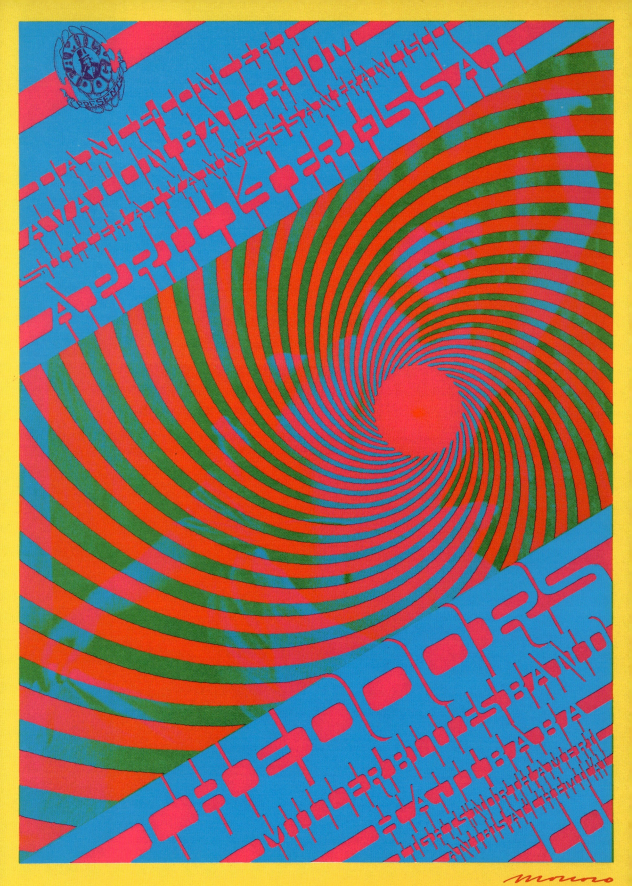

142 OPPOSITE
VICTOR MOSCOSO,
"Swirley," Doors, Miller Blues Band, Haji Baba, April 14 & 15, Avalon Ballroom, 1967. Color offset lithograph poster.
FINE ARTS MUSEUMS OF SAN FRANCISCO, MUSEUM PURCHASE, ACHENBACH FOUNDATION FOR GRAPHIC ARTS ENDOWMENT FUND, 1974.13.24

143 ABOVE LEFT
STANLEY MOUSE and **ALTON KELLEY,**
"Five Men in a Boat," Bo Diddley, Sons of Adam, Little Walter, August 5 & 7, Longshoremen's Hall, August 6, Avalon Ballroom, 1966. Color offset lithograph poster with split fountain.
FINE ARTS MUSEUMS OF SAN FRANCISCO, MUSEUM PURCHASE, ACHENBACH FOUNDATION FOR GRAPHIC ARTS ENDOWMENT FUND, 1974.13.112

144 ABOVE RIGHT
WES WILSON,
Jefferson Airplane, James Cotton Chicago Blues Band, Moby Grape, November 25–27, Fillmore Auditorium, 1966. Color offset lithograph poster with split fountain.
FINE ARTS MUSEUMS OF SAN FRANCISCO, GIFT OF MR. JULIAN SILVA, 1997.64.8

145 BELOW LEFT
VICTOR MOSCOSO,
"Neptune's Notions," Moby Grape, The Charlatans, February 24 & 25, Avalon Ballroom, 1967. Color offset lithograph poster.
FINE ARTS MUSEUMS OF SAN FRANCISCO, MUSEUM PURCHASE, ACHENBACH FOUNDATION FOR GRAPHIC ARTS ENDOWMENT FUND, 1974.13.33

146 BELOW RIGHT
JOE GOMEZ,
"Optical Occlusion," Big Brother and the Holding Company, Mt. Rushmore, November 23–25, Avalon Ballroom, 1967. Color offset lithograph poster.
FINE ARTS MUSEUMS OF SAN FRANCISCO, MUSEUM PURCHASE, ACHENBACH FOUNDATION FOR GRAPHIC ARTS ENDOWMENT FUND, 1974.13.171

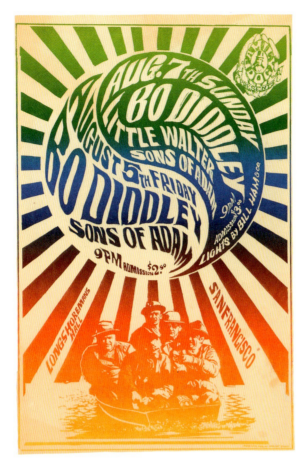
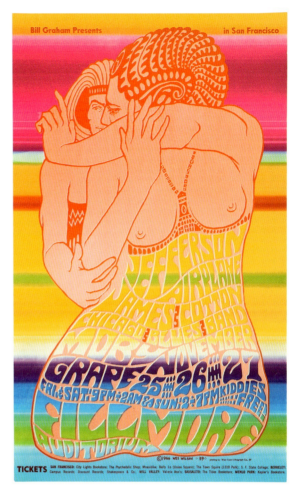
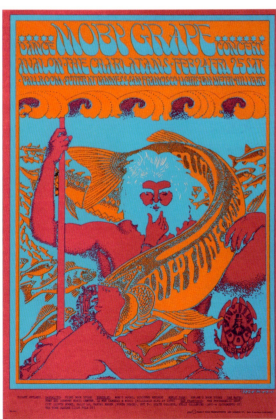
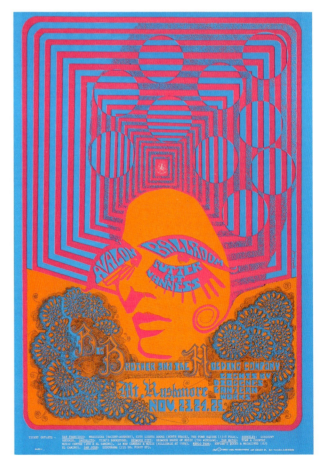

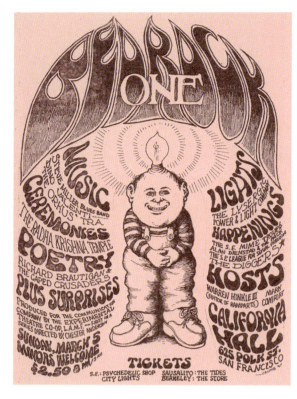

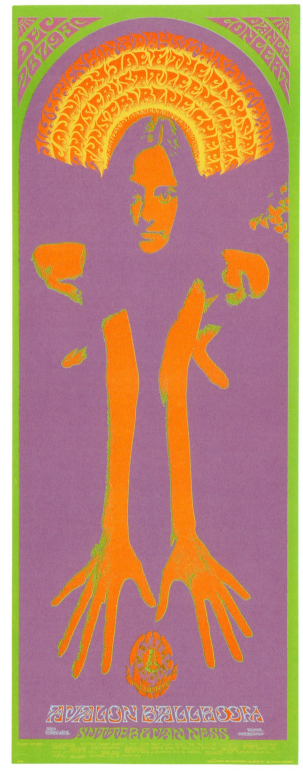

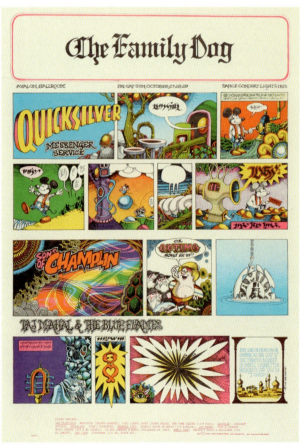

147 ABOVE LEFT
ROBERT CRUMB,
"Bedrock One," Music, Lights, Ceremonies, Happenings, Poetry, Hosts, Plus Surprises, March 5, California Hall, 1967. Electrophotographic print (Xerox) handbill on pink paper.
COLLECTION OF JOHN J. LYONS

148 RIGHT
BOB SCHNEPF,
"Tree Frog," Jim Kweskin Jug Band, Country Joe and the Fish, Lee Michaels, Blue Cheer, December 28, 29, 30, Avalon Ballroom, 1967. Color offset lithograph poster.
FINE ARTS MUSEUMS OF SAN FRANCISCO, MUSEUM PURCHASE, ACHENBACH FOUNDATION FOR GRAPHIC ARTS ENDOWMENT FUND, 1974.13.201

149 BELOW LEFT
RICK GRIFFIN,
"Mornin' Papa," Quicksilver Messenger Service, Sons of Champlin, Taj Mahal, October 27–29, Avalon Ballroom, 1967. Color offset lithograph poster.
FINE ARTS MUSEUMS OF SAN FRANCISCO, MUSEUM PURCHASE, ACHENBACH FOUNDATION FOR GRAPHIC ARTS ENDOWMENT FUND, 1974.13.173

150 ABOVE LEFT
WES WILSON,
The Turtles, Oxford Circle, July 6, Fillmore Auditorium, 1966. Color offset lithograph poster.
FINE ARTS MUSEUMS OF SAN FRANCISCO, MUSEUM PURCHASE, ACHENBACH FOUNDATION FOR GRAPHIC ARTS ENDOWMENT FUND, 1972.53.43

151 ABOVE RIGHT
GREG IRONS,
Santana, Collectors, Melanie, February 14–16, Fillmore West, 1969. Color offset lithograph poster.
FINE ARTS MUSEUMS OF SAN FRANCISCO, MUSEUM PURCHASE, ACHENBACH FOUNDATION FOR GRAPHIC ARTS ENDOWMENT FUND, 1972.53.258

152 BELOW LEFT
RANDY TUTEN,
Led Zeppelin, Bonzo Dog Band, Rahsaan Roland Kirk & His Vibration Society, November 6–8, Winterland, Rolling Stones, November 9, Oakland Coliseum, 1969. Color offset lithograph poster.
FINE ARTS MUSEUMS OF SAN FRANCISCO, MUSEUM PURCHASE, ACHENBACH FOUNDATION FOR GRAPHIC ARTS ENDOWMENT FUND, 1972.53.219

153 BELOW RIGHT
STANLEY MOUSE and **ALTON KELLEY,**
"Keep California Green," Sir Douglas Quintet, Everpresent Fullness, July 8–10, Avalon Ballroom, 1966. Color offset lithograph poster with green daylight fluorescent ink.
FINE ARTS MUSEUMS OF SAN FRANCISCO, MUSEUM PURCHASE, ACHENBACH FOUNDATION FOR GRAPHIC ARTS ENDOWMENT FUND, 1974.13.48

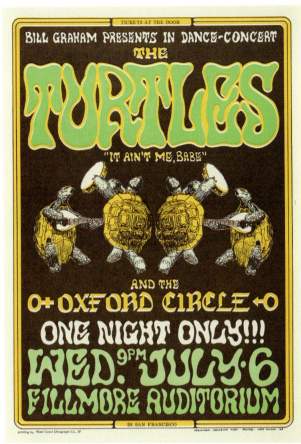

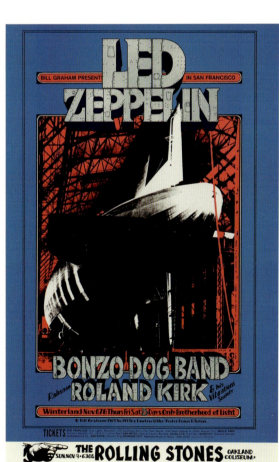
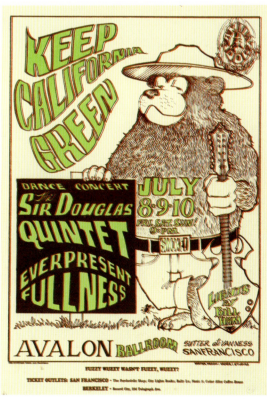

154
WILFRIED SÄTTY,
Stone Garden, 1967.
Color offset lithograph poster.
FINE ARTS MUSEUMS OF SAN FRANCISCO, BEQUEST OF JOHN GUTMANN, 2000.119.4.9

155 OPPOSITE
WILFRIED SÄTTY,
Turn on Your Mind (Jerry Garcia Wearing Flag Top Hat), ca. 1967.
Color offset lithograph poster.
FINE ARTS MUSEUMS OF SAN FRANCISCO, GIFT OF WALTER AND JOSEPHINE LANDOR, 2001.97.29A

156 OPPOSITE
WILLIAM HENRY,
"One Hundred Six," Youngbloods, Mount Rushmore, Phoenix, February 16–18, Avalon Ballroom, 1968. Color offset lithograph poster.
FINE ARTS MUSEUMS OF SAN FRANCISCO, MUSEUM PURCHASE, ACHENBACH FOUNDATION FOR GRAPHIC ARTS ENDOWMENT FUND, 1974.13.159

157 ABOVE LEFT
BONNIE MACLEAN,
Butterfield Blues Band, Roland Kirk Quartet, New Salvation Army Band, Mt. Rushmore, July 11–16, Fillmore Auditorium, 1967. Color offset lithograph poster.
FINE ARTS MUSEUMS OF SAN FRANCISCO, MUSEUM PURCHASE, ACHENBACH FOUNDATION FOR GRAPHIC ARTS ENDOWMENT FUND, 1972.53.101

158 ABOVE RIGHT
LEE CONKLIN,
Butterfield Blues Band, Santana, Hello People, Iron Butterfly, Canned Heat, Initial Shock, July 30–August 4, Fillmore West, 1968. Color offset lithograph poster.
FINE ARTS MUSEUMS OF SAN FRANCISCO, MUSEUM PURCHASE, ACHENBACH FOUNDATION FOR GRAPHIC ARTS ENDOWMENT FUND, 1972.53.147

159 BELOW LEFT
LEE CONKLIN,
The Who, Cannonball Adderly, The Vagrants, February 22, Fillmore Auditorium, February 23 & 24, Winterland, 1968. Color offset lithograph poster.
FINE ARTS MUSEUMS OF SAN FRANCISCO, MUSEUM PURCHASE, ACHENBACH FOUNDATION FOR GRAPHIC ARTS ENDOWMENT FUND, 1972.53.3

160 BELOW RIGHT
ROBERT FRIED,
Big Brother & the Holding Company, Crazy World of Arthur Brown, Foundations, June 13, Fillmore Auditorium, June 14 & 15, Winterland, 1968. Color offset lithograph poster.
FINE ARTS MUSEUMS OF SAN FRANCISCO, MUSEUM PURCHASE, ACHENBACH FOUNDATION FOR GRAPHIC ARTS ENDOWMENT FUND, 1972.53.40

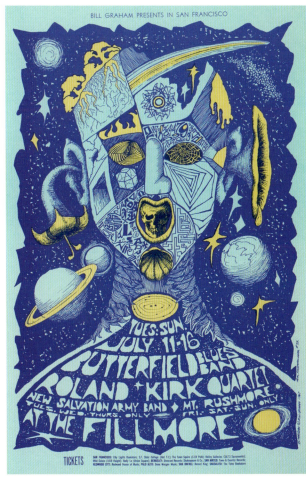
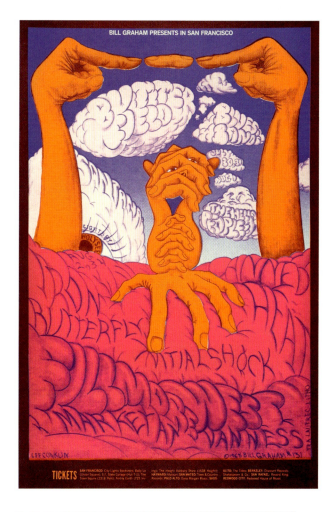
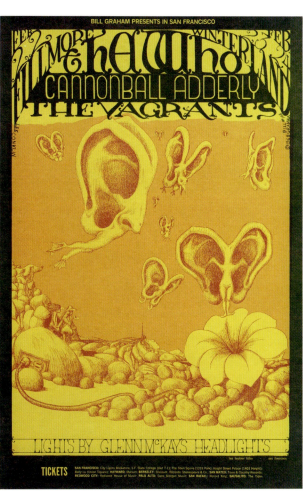
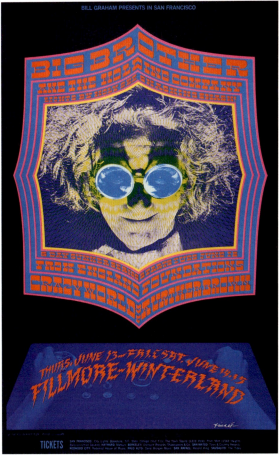

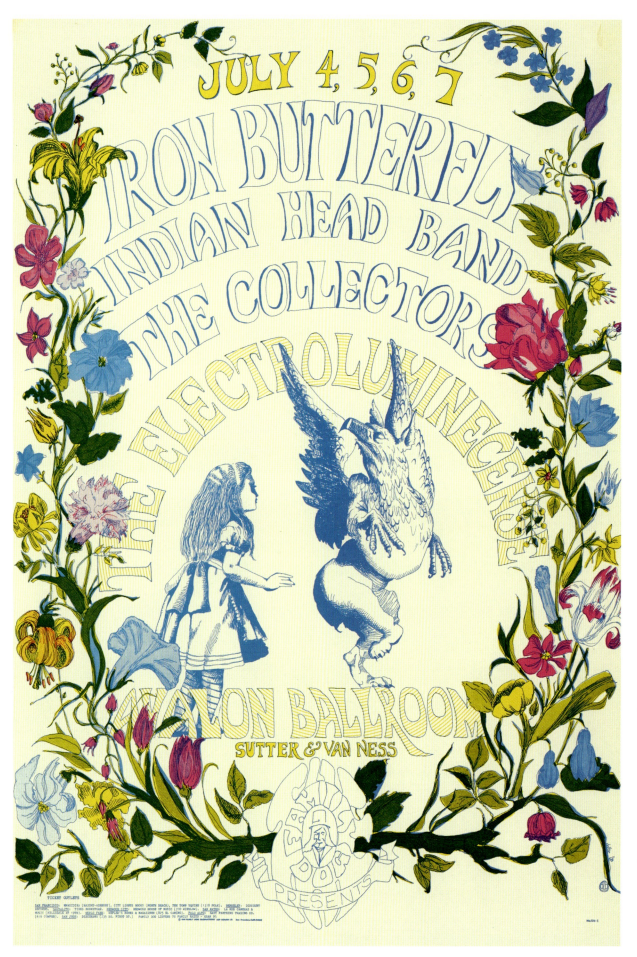

161
DOTTIE (DOTTIE H. SIMMONS),
"Alice Griffin," Iron Butterfly, Indian Head Band, The Collectors, July 4–7, Avalon Ballroom, 1968. Color offset lithograph poster.
FINE ARTS MUSEUMS OF SAN FRANCISCO, MUSEUM PURCHASE, ACHENBACH FOUNDATION FOR GRAPHIC ARTS ENDOWMENT FUND, 1974.13.134

162 OPPOSITE
LEE CONKLIN,
Steppenwolf, Staple Singers, Santana, August 27–29, Grateful Dead, Preservation Hall Jazz Band, Sons of Chaplan [sic], *August 30–September 1, Fillmore West,* 1968. Offset lithograph poster.
FINE ARTS MUSEUMS OF SAN FRANCISCO, MUSEUM PURCHASE, ACHENBACH FOUNDATION FOR GRAPHIC ARTS ENDOWMENT FUND, 1972.53.149

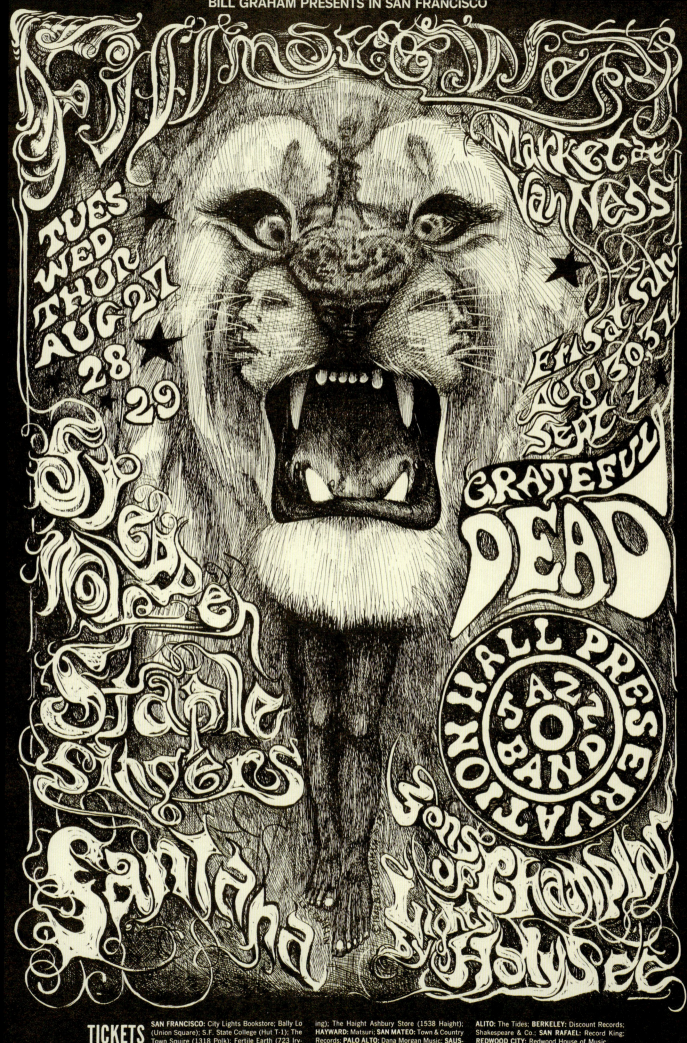

163 OPPOSITE
VICTOR MOSCOSO, Steve Miller promotion for Capitol Records, 1969. Color offset lithograph "animated" poster.
HAIGHT STREET ART CENTER

164 ABOVE LEFT
VICTOR MOSCOSO, *"Incredible Poetry Reading,"* Ferlinghetti, Wieners, Meltzer, Whalen, Welch, McClure, Ginsberg, June 8, *Nourse Auditorium*, 1968. Color offset lithograph "animated" poster.
FINE ARTS MUSEUMS OF SAN FRANCISCO, GIFT OF THE GARY WESTFORD COLLECTION, IN HONOR OF VICTOR MOSCOSO AND ALL THE POETS, 2017.7.27

165 ABOVE RIGHT
VICTOR MOSCOSO, *"Butterfly Lady,"* The Doors, The Sparrow, November 23–25, *Avalon Ballroom*, 1967. Color offset lithograph "animated" poster.
FINE ARTS MUSEUMS OF SAN FRANCISCO, MUSEUM PURCHASE, ACHENBACH FOUNDATION FOR GRAPHIC ARTS ENDOWMENT FUND, 1974.13.18

166 BELOW LEFT
VICTOR MOSCOSO, Pablo Ferro film advertisement, 1967. Color offset lithograph "animated" poster.
HAIGHT STREET ART CENTER

167 BELOW RIGHT
VICTOR MOSCOSO, *"Strongman,"* The Youngbloods, The Siegal Schwall [sic] Band, June 15–18, *Avalon Ballroom*, 1967. Color offset lithograph "animated" poster.
FINE ARTS MUSEUMS OF SAN FRANCISCO, MUSEUM PURCHASE, ACHENBACH FOUNDATION FOR GRAPHIC ARTS ENDOWMENT FUND, 1974.13.114

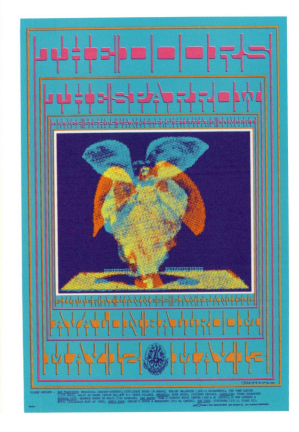
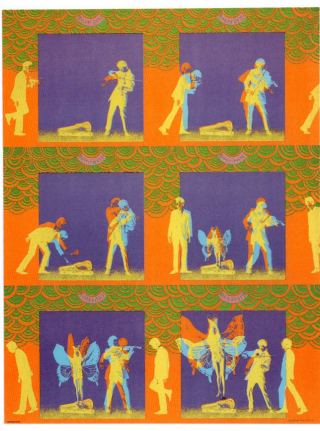
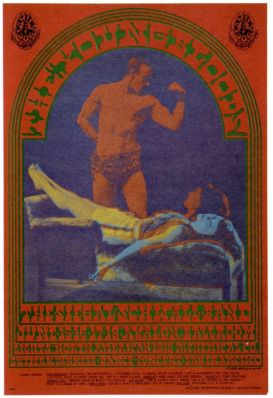

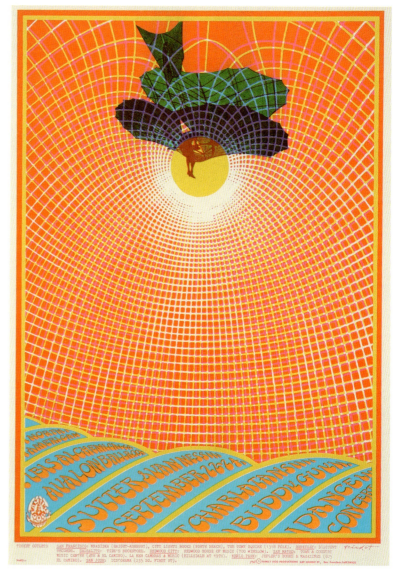

168 LEFT
BONNIE MACLEAN,
Chambers Brothers, Sunshine Company, Siegal Schwall [sic], *January 11–13, Fillmore Auditorium,* 1968. Color offset lithograph poster.
FINE ARTS MUSEUMS OF SAN FRANCISCO, MUSEUM PURCHASE, ACHENBACH FOUNDATION FOR GRAPHIC ARTS ENDOWMENT FUND, 1972.53.122

169 RIGHT
ROBERT FRIED,
"Sky Web," Charlatans, Buddy Guy, September 22–24, Avalon Ballroom, 1967. Color offset lithograph poster.
FINE ARTS MUSEUMS OF SAN FRANCISCO, MUSEUM PURCHASE, ACHENBACH FOUNDATION FOR GRAPHIC ARTS ENDOWMENT FUND, 1974.13.179

170 OPPOSITE
WES WILSON,
Butterfield Blues Band, Jefferson Airplane, Grateful Dead, October 7 & 8, Winterland, 1966. Color offset lithograph poster.
FINE ARTS MUSEUMS OF SAN FRANCISCO, MUSEUM PURCHASE, ACHENBACH FOUNDATION FOR GRAPHIC ARTS ENDOWMENT FUND, 1972.53.54

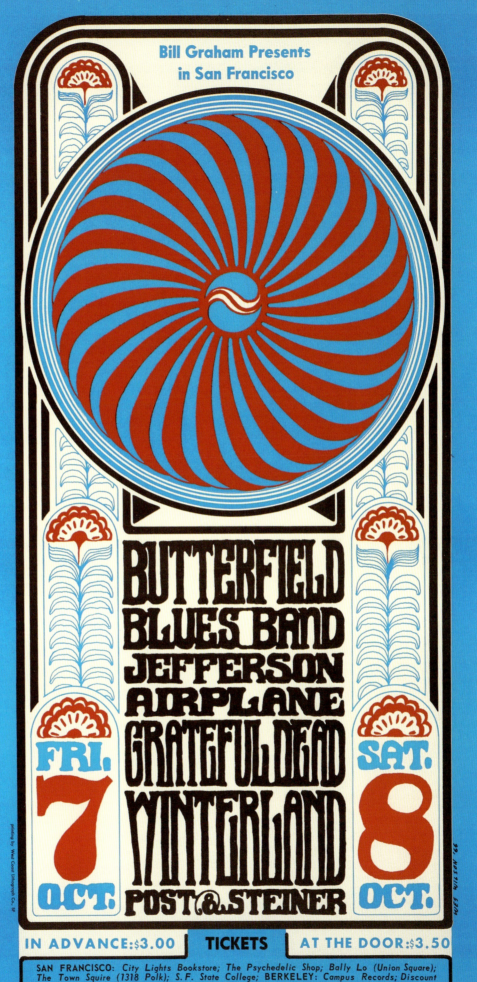

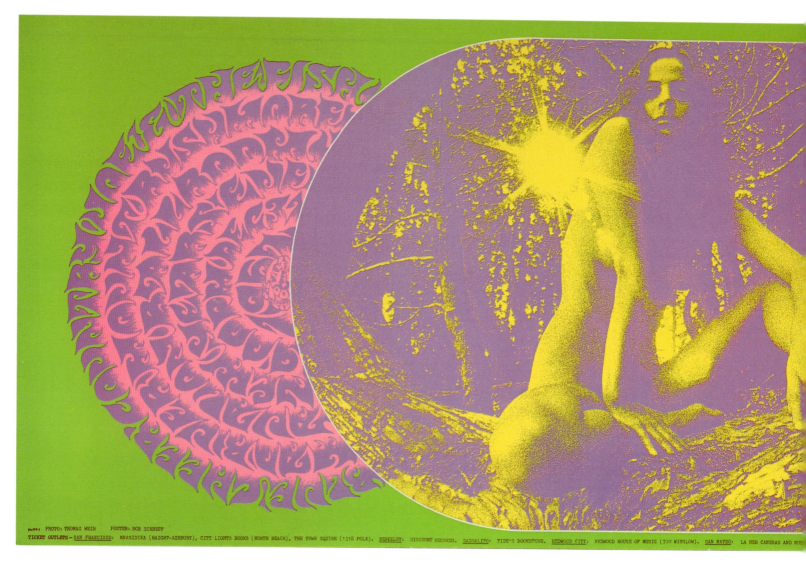
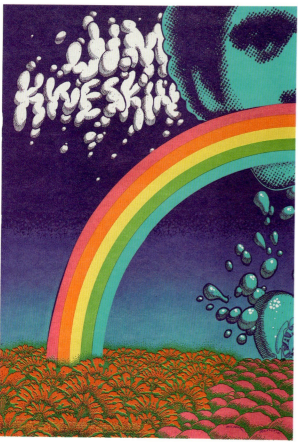
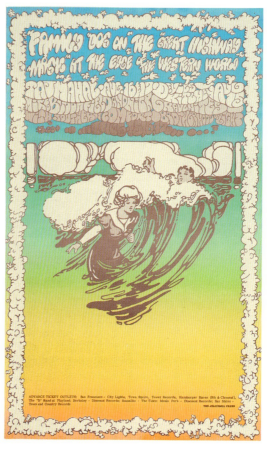

171 ABOVE
BOB SCHNEPF, *"Sitting Pretty,"* Blue Cheer, Country Joe & the Fish, Lee Michaels, Flamin' Groovies, Mad River, Mount Rushmore, December 31, Avalon Ballroom, 1967. **Color offset lithograph poster.** FINE ARTS MUSEUMS OF SAN FRANCISCO, MUSEUM PURCHASE, ACHENBACH FOUNDATION FOR GRAPHIC ARTS ENDOWMENT FUND, 1974.13.200

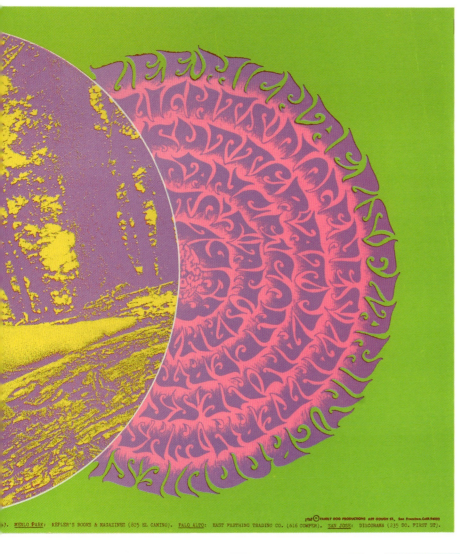
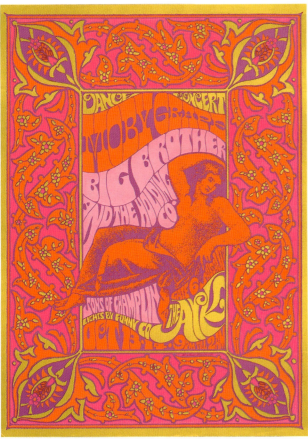
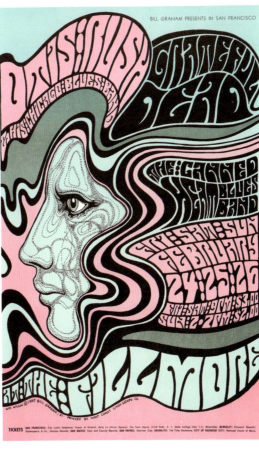

172 BELOW LEFT TO RIGHT
RICK GRIFFIN and **VICTOR MOSCOSO,** *"Avalon Splash," Jim Kweskin Jug Band, Sons of Champlin, December 8–10, Avalon Ballroom,* 1967. Color offset lithograph poster.
FINE ARTS MUSEUMS OF SAN FRANCISCO, MUSEUM PURCHASE, ACHENBACH FOUNDATION FOR GRAPHIC ARTS ENDOWMENT FUND, 1974.13.137

173
Magic at the Edge of the Western World, Taj Mahal, Mike Bloomfield and Nick Gravenites with Southern Comfort, Brotherhood Lights, August 15, Devil's Kitchen, August 16 and 17, Family Dog on the Great Highway, 1969. Color offset lithograph poster.
FINE ARTS MUSEUMS OF SAN FRANCISCO, GIFT OF THE GARY WESTFORD COLLECTION, IN MEMORY OF CHET HELMS, 2017.7.15

174
LICHTENWALNER,
Moby Grape, Big Brother and the Holding Company, Sons of Champlin, October 13 & 14, The Ark, 1967. Color offset lithograph poster.
FINE ARTS MUSEUMS OF SAN FRANCISCO, GIFT OF THE GARY WESTFORD COLLECTION, 2017.7.8

175
WES WILSON,
Otis Rush & His Chicago Blues Band, Grateful Dead, The Canned Heat Blues Band, February 24–26, Fillmore Auditorium, 1967. Color offset lithograph poster.
FINE ARTS MUSEUMS OF SAN FRANCISCO, MUSEUM PURCHASE, ACHENBACH FOUNDATION FOR GRAPHIC ARTS ENDOWMENT FUND, 1972.53.75

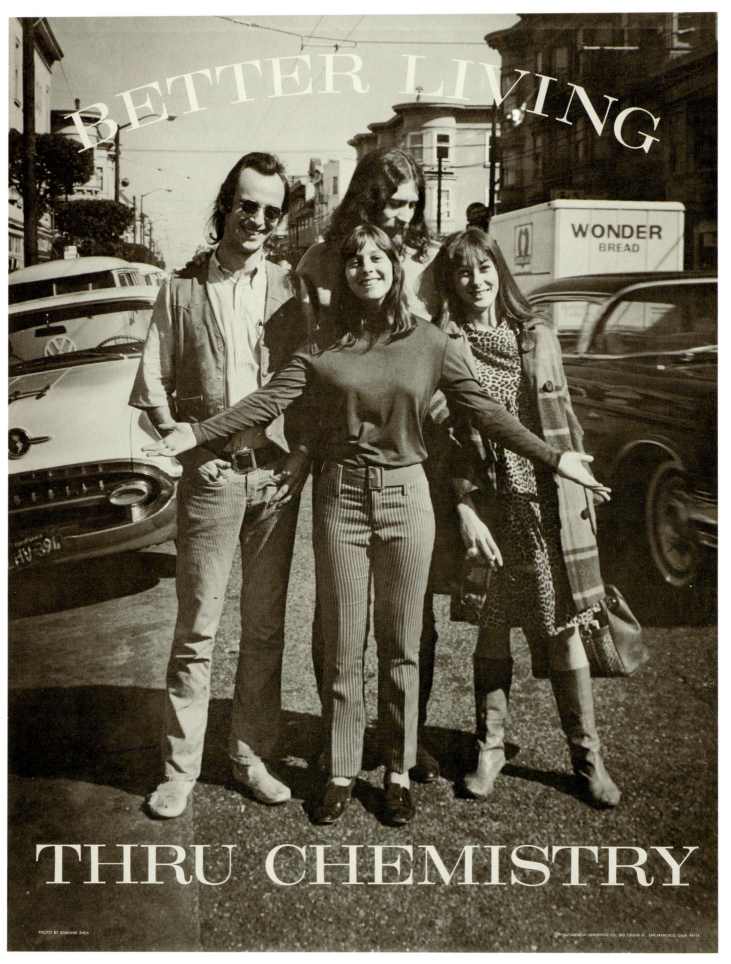

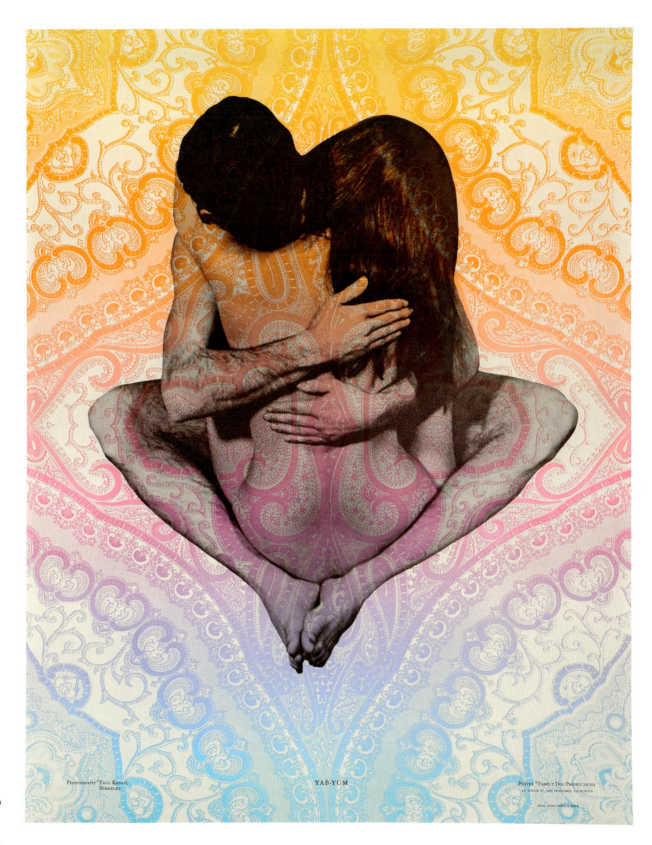

176 OPPOSITE
Photograph by **EDMUND SHEA**, *Better Living Thru Chemistry*, 1967. Offset lithograph poster.
COLLECTION OF JOHN J. LYONS

177
Photograph by **PAUL KAGAN**, *Yab-Yum*, 1967. Color offset lithograph poster.
FINE ARTS MUSEUMS OF SAN FRANCISCO, MUSEUM COLLECTION, Z2015.10

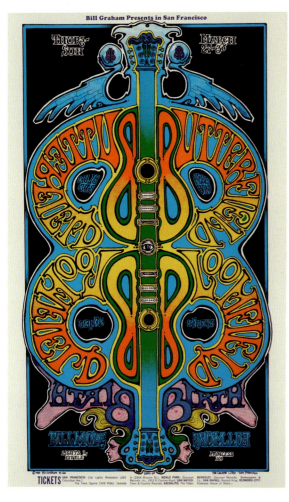
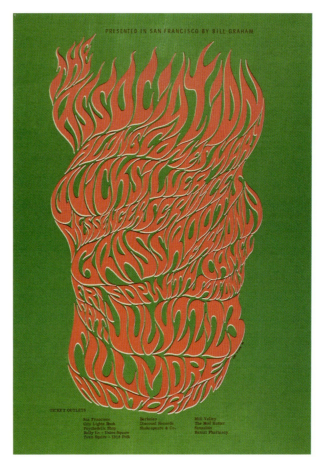
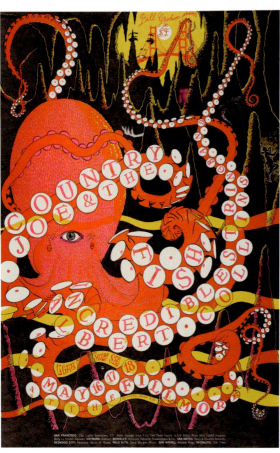
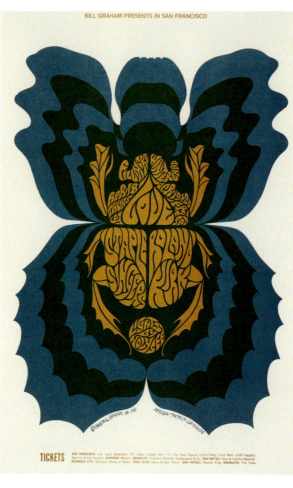

178 ABOVE LEFT
GREG IRONS,
Butterfield Blues Band, Bloomfield & Friends, Birth, March 27–30, Fillmore Auditorium, 1969. Color offset lithograph poster.
FINE ARTS MUSEUMS OF SAN FRANCISCO, MUSEUM PURCHASE, ACHENBACH FOUNDATION FOR GRAPHIC ARTS ENDOWMENT FUND, 1972.53.252

179 ABOVE RIGHT
WES WILSON,
Association, Quicksilver Messenger Service, Grass Roots, Sopwith Camel, July 22 & 23, Fillmore Auditorium, 1966. Color offset lithograph poster.
FINE ARTS MUSEUMS OF SAN FRANCISCO, GIFT FROM THE ESTATE OF FRED A. COUNTRYMAN, 2005.3.13

180 BELOW LEFT
WILFRED WEISSER,
Country Joe & the Fish, Incredible String Band, Albert Collins, May 16–18, Fillmore Auditorium, 1968. Color offset lithograph poster.
FINE ARTS MUSEUMS OF SAN FRANCISCO, MUSEUM PURCHASE, ACHENBACH FOUNDATION FOR GRAPHIC ARTS ENDOWMENT FUND, 1972.53.136

181 BELOW RIGHT
PATRICK LOFTHOUSE,
Love, Staple Singers, Roland Kirk, April 18, Fillmore Auditorium, April 19 & 20, Winterland, 1968. Color offset lithograph poster.
FINE ARTS MUSEUMS OF SAN FRANCISCO, MUSEUM PURCHASE, ACHENBACH FOUNDATION FOR GRAPHIC ARTS ENDOWMENT FUND, 1972.53.132

182 OPPOSITE
VICTOR MOSCOSO,
"Flower Pot," Blue Cheer, Lee Michaels, Clifton Chenier, October 6–8, Avalon Ballroom, 1967. Color offset lithograph poster.
FINE ARTS MUSEUMS OF SAN FRANCISCO, MUSEUM PURCHASE, ACHENBACH FOUNDATION FOR GRAPHIC ARTS ENDOWMENT FUND, 1974.13.176

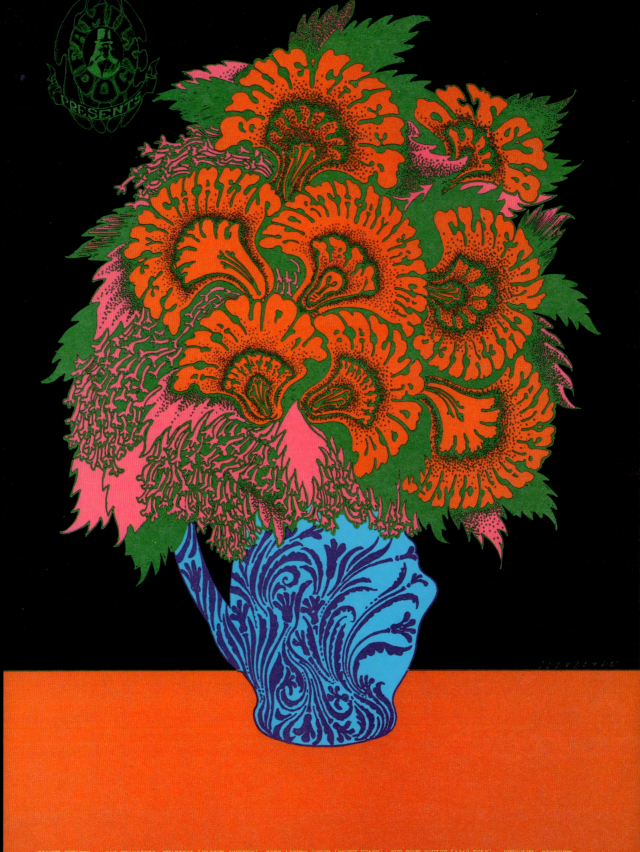

"In the decade since the turn-of-the-century's sinuous art-nouveau style first began to stage a comeback, its tendrils have crept into every phase of graphic design. . . . Like a butterfly bombarded by gamma rays, art nouveau is mutating, intermarrying with the eye-jarring color schemes of op and the gaudy commercialism of pop."

TIME, APRIL 7, 1967

SECTION 6

feed your head

THOUGH ART NOUVEAU has long been cited as a primary aesthetic inspiration behind San Francisco's rock posters of the 1960s, the posters are — more accurately in art historical terminology — postmodern in their deliberate appropriation of a range of historicist styles, from Art Nouveau and Surrealism to the contemporary expressions of Pop and Op. Largely drawing upon San Francisco's geographic location and colorful past, the independent fashion designers, like the rock poster artists, juxtaposed stereotypical elements of the imagery of the American West alongside those of the Victorian era and the Far East.

Native American iconography and heritage also found itself at the heart of both creative forms (pls. 203 and 205–208). Though a political statement earlier in the decade, by its end, the cultural appropriation of indigenous cultures was, for many, a genuine show of solidarity with and admiration for non-Western traditions. Communal living, respect for the environment, and the use of psychedelics were just a few of the borrowings from native societies.

By combining dissimilar and unrelated fragments from historical and contemporary ephemera to create new, complex images, Jess, Wilfried Sätty, and David Singer were able to create fine and commercial art that gave an aesthetic dimension to the psychedelic experience (pls. 209–211). The avant-garde filmmaker Lawrence Jordan looked to similar historical sources to create *Hamfat Asar* (pl. 212), a project that he has described as a "controlled hallucination, whereby I sat quietly without moving, looking at the background until the pieces began to move without my inventing things for them to do." Whether moving or static, all of these works comprise an inherent element of the psychedelic; the eye is encouraged to wander, rendering images a fluidity associated with the physiological effects of LSD.

Members of San Francisco's counterculture had ample places to "turn on" — in the words of acid advocate Timothy Leary — to the mental stimulation of LSD and explore the mind's potential. Dance concerts were one such venue, and the posters advertising the events were often suggestive of the "trip" one could expect (pls. 215–218 and 220). Once inside the concert, the spontaneous, abstract expressionist liquid light "paintings" that light show artists such as Bill Ham created through the use of multiple overhead projectors and transparent liquids colored with food dyes (pl. 219) absorbed musicians and concertgoers alike in projections that both amplified and resembled the visual experiences of an acid trip. On occasion, even a bad trip could lead to far-out artistic expression (pl. 221). The psychedelic aesthetic permeated the visual culture, even influencing those who did not "turn on" (pls. 213, 214, and 222). Some regard Scott Bartlett's experimental film *OffOn* (pl. 223)—with its distorted images and a pulsing blue-red eyeball that propel viewers into a meditative state—as a pinnacle of psychedelia. In the free-thinking, anything-goes creative world of the counterculture, almost everything was fair game for appropriation and imitation.

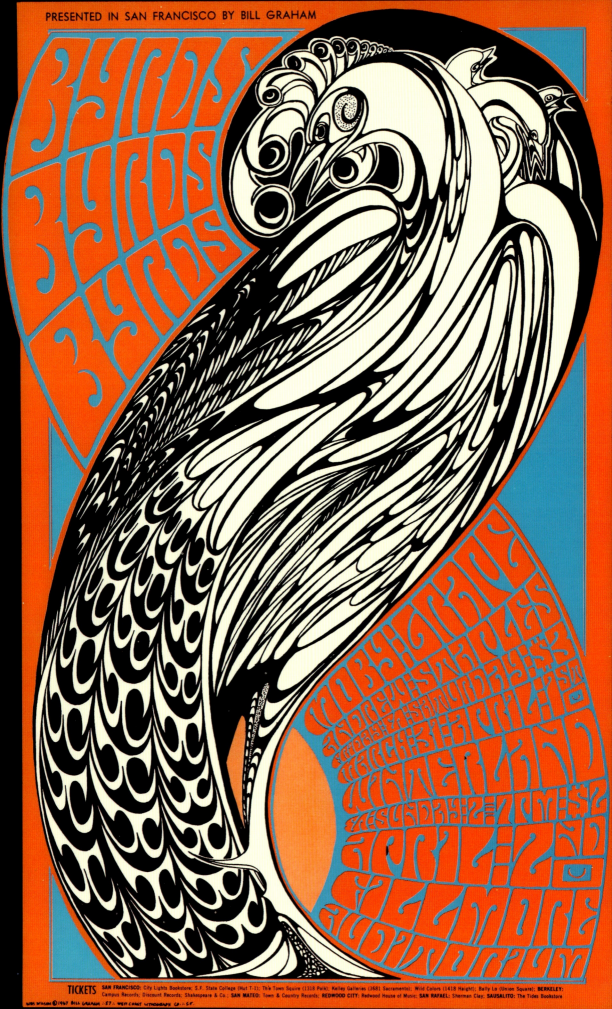

183 OPPOSITE
WES WILSON,
Byrds, Moby Grape, Andrew Staples, March 31 & April 1, Winterland, April 2, Fillmore Auditorium, 1967. Color offset lithograph poster.
FINE ARTS MUSEUMS OF SAN FRANCISCO, GIFT OF HAROLD AND EVELYN KORF, 1996.100.31

184 ABOVE LEFT
STANLEY MOUSE and **ALTON KELLEY,**
"The Woman with Green Hair," Jim Kweskin Jug Band, Big Brother and the Holding Company, Electric Train, October 7 & 8, Avalon Ballroom, 1966. Color offset lithograph poster.
FINE ARTS MUSEUMS OF SAN FRANCISCO, MUSEUM PURCHASE, ACHENBACH FOUNDATION FOR GRAPHIC ARTS ENDOWMENT FUND, 1974.13.94

185 ABOVE RIGHT
STANLEY MOUSE and **ALTON KELLEY,**
"Snake Lady," Jefferson Airplane, Great Society, July 22 & 23, Avalon Ballroom, 1966. Color offset lithograph poster.
FINE ARTS MUSEUMS OF SAN FRANCISCO, MUSEUM PURCHASE, ACHENBACH FOUNDATION FOR GRAPHIC ARTS ENDOWMENT FUND, 1974.13.45

186 BELOW LEFT
STANLEY MOUSE and **ALTON KELLEY,**
"Gloria Swanson," Big Brother & the Holding Company, Sir Douglas Quintet, October 15 & 16, Avalon Ballroom, 1966. Color offset lithograph poster.
FINE ARTS MUSEUMS OF SAN FRANCISCO, GIFT OF MR. JULIAN SILVA, 1997.64.12

187 BELOW RIGHT
DAVID WARREN,
"Alice Jaundice," Youngbloods, It's a Beautiful Day, Dog, Santana, June 28–30, Avalon Ballroom, 1968. Color offset lithograph poster.
FINE ARTS MUSEUMS OF SAN FRANCISCO, MUSEUM PURCHASE, ACHENBACH FOUNDATION FOR GRAPHIC ARTS ENDOWMENT FUND, 1974.13.136

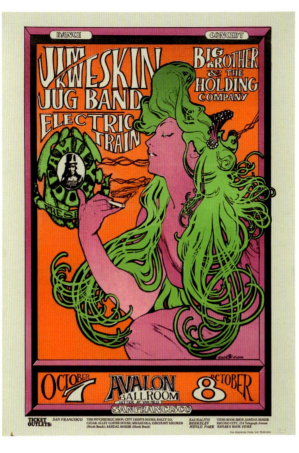
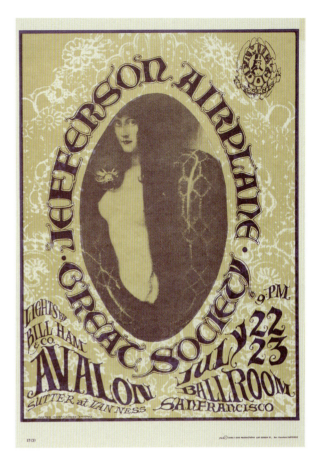
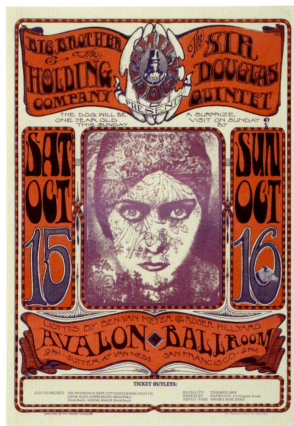
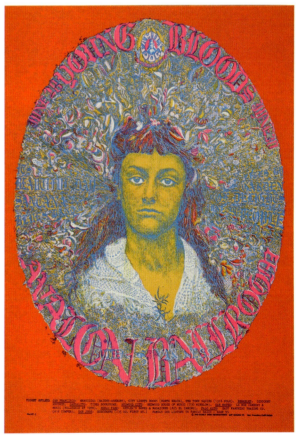

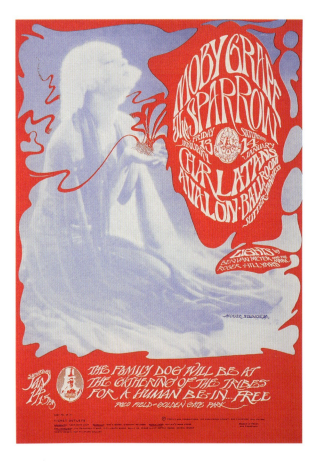
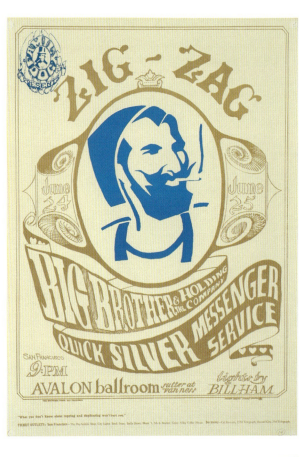

188 ABOVE LEFT
STANLEY MOUSE and **ALTON KELLEY,** "Moby Grape," Moby Grape, Sparrow, Charlatans, January 13 & 14, Avalon Ballroom, 1967. Color offset lithograph poster.
FINE ARTS MUSEUMS OF SAN FRANCISCO, MUSEUM PURCHASE, ACHENBACH FOUNDATION FOR GRAPHIC ARTS ENDOWMENT FUND, 1974.13.38

189 ABOVE RIGHT
STANLEY MOUSE and **ALTON KELLEY,** "Zig-Zag Man," Big Brother & the Holding Company, Quicksilver Messenger Service, June 24 & 25, Avalon Ballroom, 1966. Color offset lithograph poster.
FINE ARTS MUSEUMS OF SAN FRANCISCO, MUSEUM PURCHASE, ACHENBACH FOUNDATION FOR GRAPHIC ARTS ENDOWMENT FUND, 1974.13.50

190 BELOW LEFT
STANLEY MOUSE and **ALTON KELLEY,** "Zebra Man," 13th Floor Elevators, Quicksilver Messenger Service, September 30–October 1, Avalon Ballroom, 1966. Color offset lithograph poster.
FINE ARTS MUSEUMS OF SAN FRANCISCO, MUSEUM PURCHASE, ACHENBACH FOUNDATION FOR GRAPHIC ARTS ENDOWMENT FUND, 1974.13.102

191 BELOW RIGHT
STANLEY MOUSE and **ALTON KELLEY,** "Edgar Allan Poe," Daily Flash, Country Joe & the Fish, October 21 & 22, Avalon Ballroom, 1966. Offset lithograph poster.
FINE ARTS MUSEUMS OF SAN FRANCISCO, MUSEUM PURCHASE, ACHENBACH FOUNDATION FOR GRAPHIC ARTS ENDOWMENT FUND, 1974.13.93

192 OPPOSITE
EAST WEST MUSICAL INSTRUMENTS COMPANY, "Camel" jacket, ca. 1973–1975. Appliquéd leather with pelt.
FINE ARTS MUSEUMS OF SAN FRANCISCO, MUSEUM PURCHASE, ART TRUST FUND, 2016.42.1

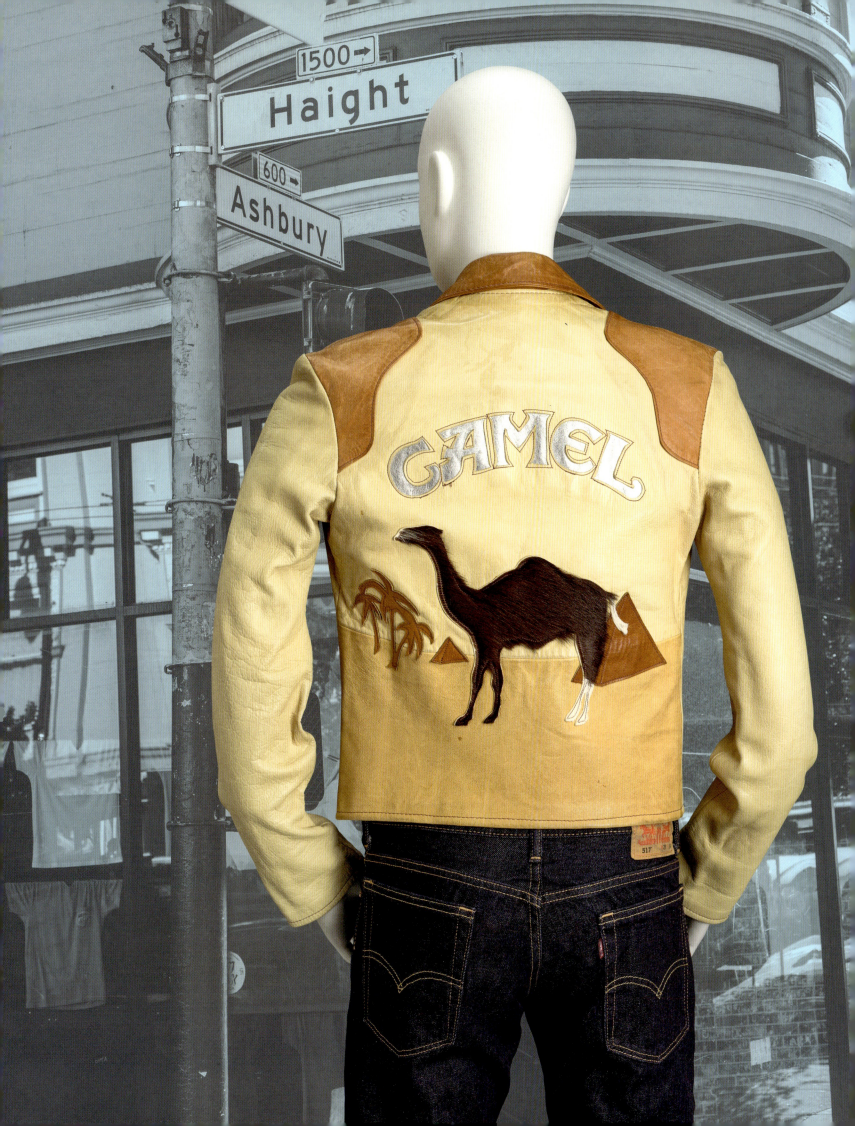

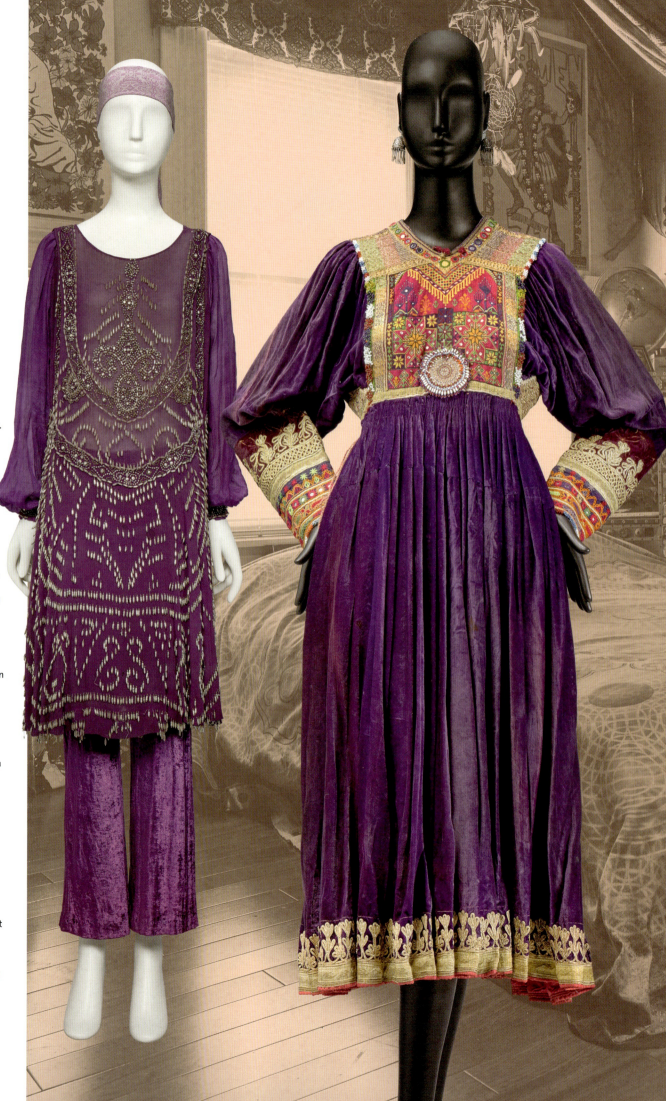

193 LEFT
Ensemble (dress and pants), 1920s and 1960s. Silk chiffon dress with glass bead embroidery and attached silk sleeves; crushed synthetic velvet pants, 1960s.
COLLECTION OF HELENE ROBERTSON

194 RIGHT
Afghanistan, Kuchi people, dress, ca. 1960. Pieced synthetic velvet with cotton cross-stitch embroidery and paste stones, applied glass bead medallion, couched metallic braid, galloon trim, mirror-work embroidery (button hole, chain, and satin stitches), printed plain-weave cotton, printed synthetic and lurex plain-weave, and machine embroidery.
COLLECTION OF ROSE SOLOMON

195 OPPOSITE LEFT
JEANNE ROSE, "Persian Nights" dress, 1966. Silk chiffon and printed cotton plain weave.
COLLECTION OF THE ARTIST

196 OPPOSITE RIGHT
YVONNE PORCELLA, dress, ca. 1970. Cotton with supplementary-weft patterning, printed cotton, ribbons, appliqué, and reverse-appliqué San Blas Island (Panama) cotton *mola*.
PRIVATE COLLECTION

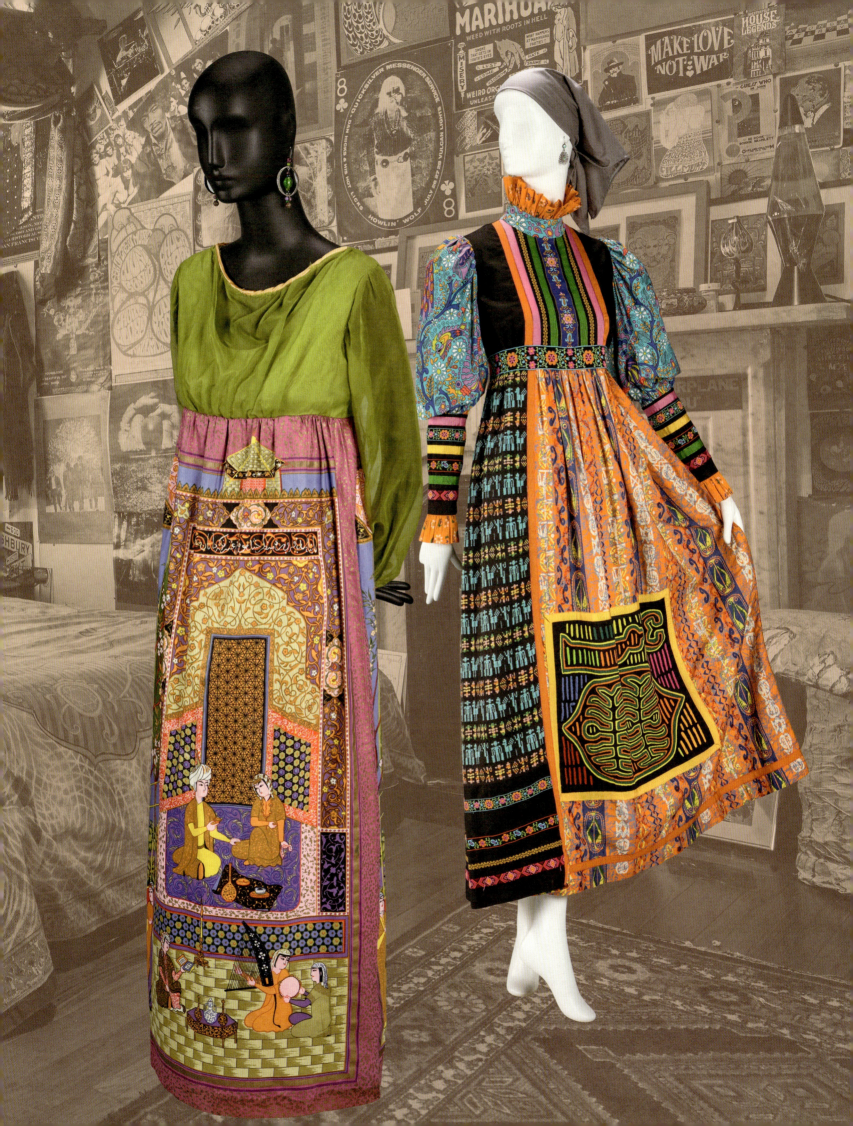

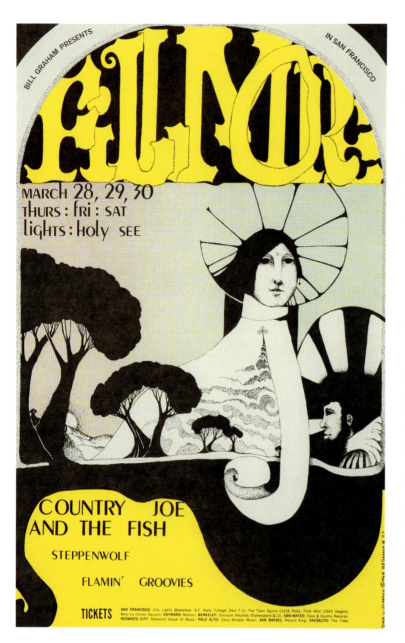
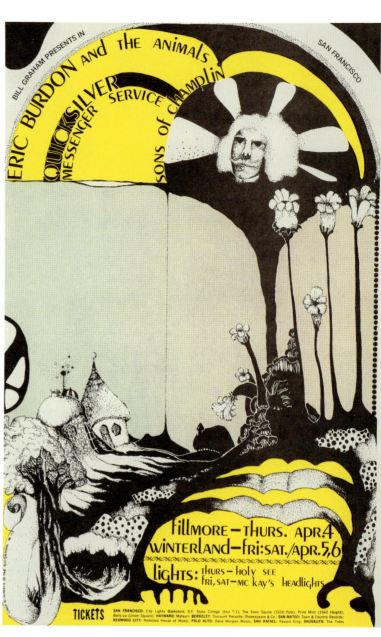

197 LEFT
DANA W. JOHNSON,
Country Joe and the Fish, Steppenwolf, Flamin' Groovies, March 28–30, Fillmore Auditorium, 1968. Color offset lithograph poster.
FINE ARTS MUSEUMS OF SAN FRANCISCO, MUSEUM PURCHASE, ACHENBACH FOUNDATION FOR GRAPHIC ARTS ENDOWMENT FUND, 1972.53.129

198 RIGHT
DANA W. JOHNSON,
Eric Burdon and the Animals, Quicksilver Messenger Service, Sons of Champlin, April 4, Fillmore Auditorium, April 5 & 6, Winterland, 1968. Color offset lithograph poster.
FINE ARTS MUSEUMS OF SAN FRANCISCO, MUSEUM PURCHASE, ACHENBACH FOUNDATION FOR GRAPHIC ARTS ENDOWMENT FUND, 1972.53.130

199 OPPOSITE
JEANNE ROSE,
ensemble (jacket and pants), 1967–1968. Cotton and silk cut and uncut velvet with guipure trim and pewter buttons.
COLLECTION OF THE ARTIST

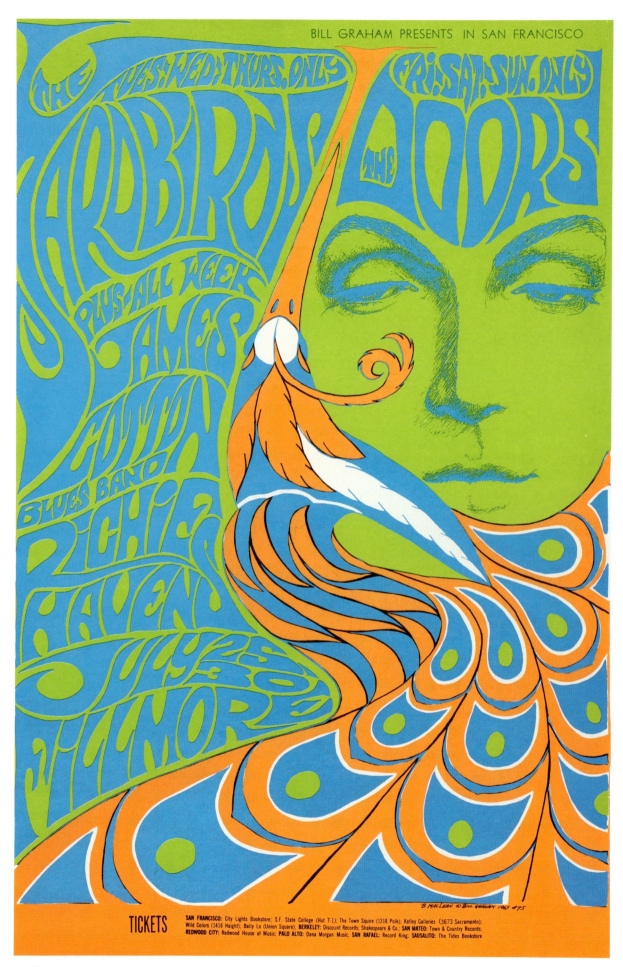

200
BONNIE MACLEAN,
Yardbirds, The Doors, James Cotton Blues Band, Richie Havens, July 25–30, Fillmore Auditorium, 1967. Color offset lithograph poster.
FINE ARTS MUSEUMS OF SAN FRANCISCO, MUSEUM PURCHASE, ACHENBACH FOUNDATION FOR GRAPHIC ARTS ENDOWMENT FUND, 1972.53.103

201 OPPOSITE LEFT
K. LEE MANUEL,
tunic blouse, 1964–1965. Hand-painted cotton plain weave.
FINE ARTS MUSEUMS OF SAN FRANCISCO, GIFT OF BARBARA FEIGEL, 1990.57.4

202 OPPOSITE RIGHT
K. LEE MANUEL,
tunic blouse, 1964–1965. Hand-painted cotton plain weave.
FINE ARTS MUSEUMS OF SAN FRANCISCO, GIFT OF BARBARA FEIGEL, 1990.57.2

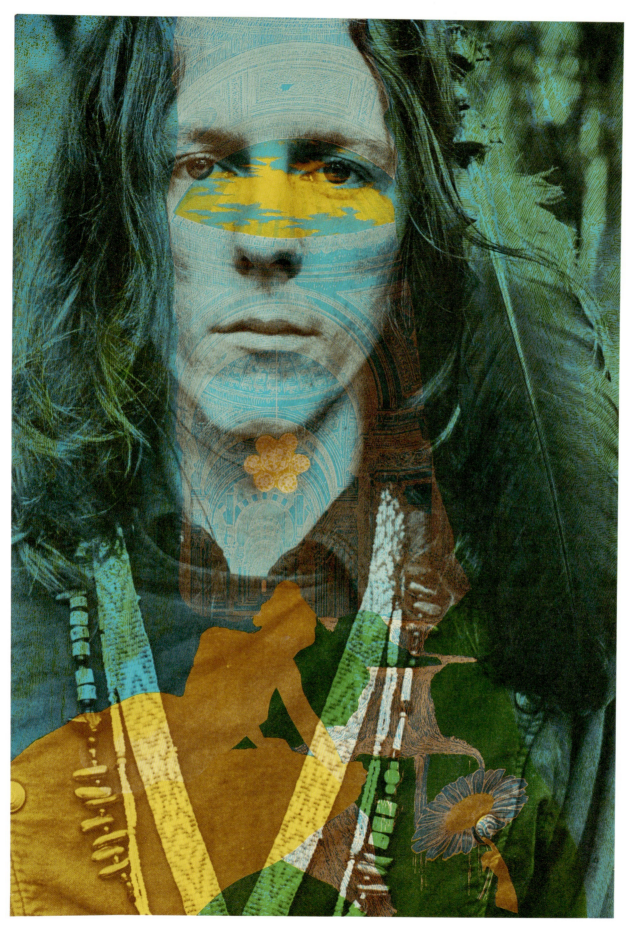

203
WILFRIED SÄTTY,
Untitled (James Gurley), ca. 1967. Color offset lithograph poster.
FINE ARTS MUSEUMS OF SAN FRANCISCO, GIFT OF WALTER AND JOSEPHINE LANDOR, 2001.97.30

204 OPPOSITE
RAINBOW COBBLERS,
"Sequoia" boots, ca. 1970. Appliquéd dyed leather.
COLLECTION OF JEANNE ROSE

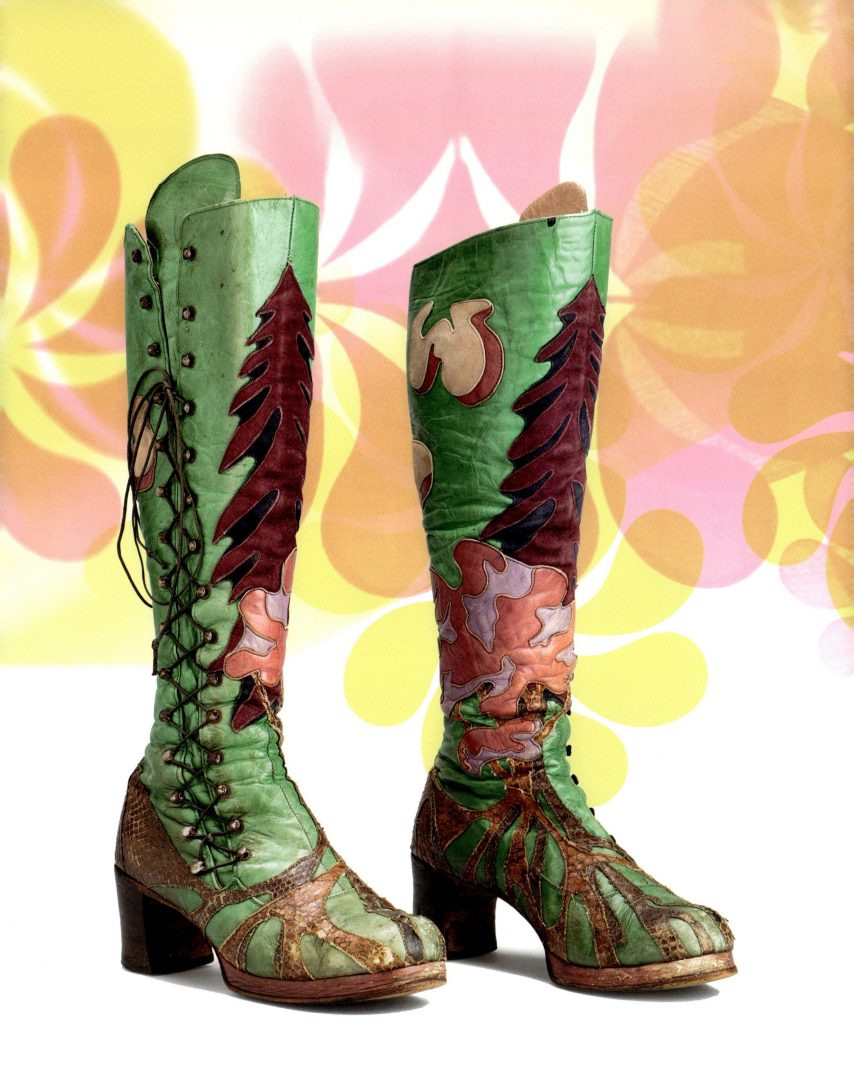

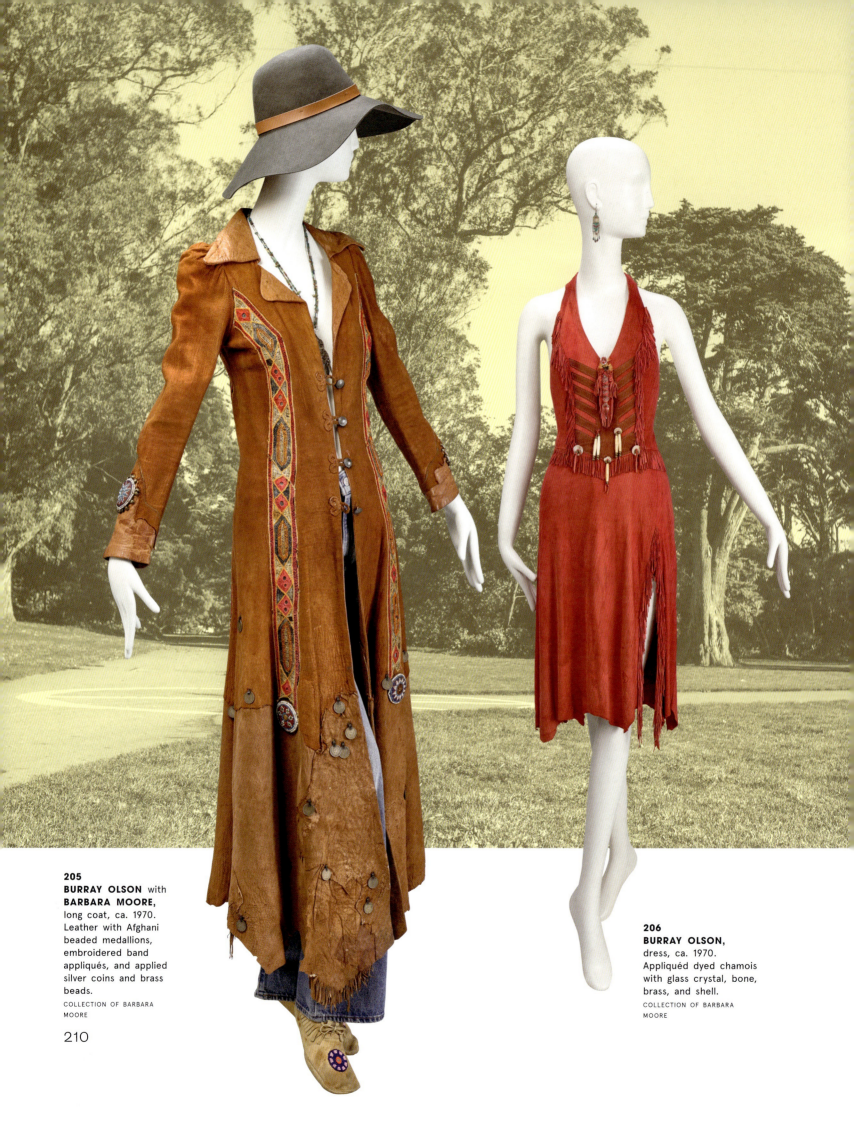

205
BURRAY OLSON with **BARBARA MOORE,** long coat, ca. 1970. Leather with Afghani beaded medallions, embroidered band appliqués, and applied silver coins and brass beads.
COLLECTION OF BARBARA MOORE

206
BURRAY OLSON, dress, ca. 1970. Appliquéd dyed chamois with glass crystal, bone, brass, and shell.
COLLECTION OF BARBARA MOORE

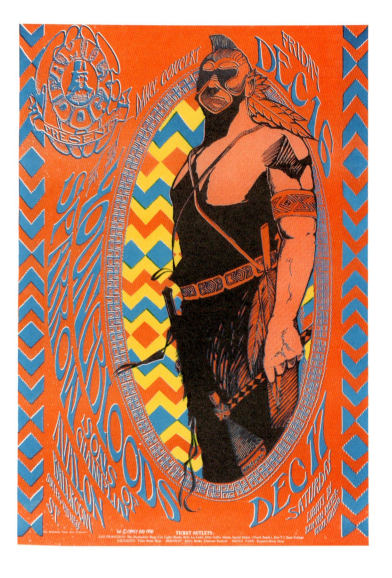
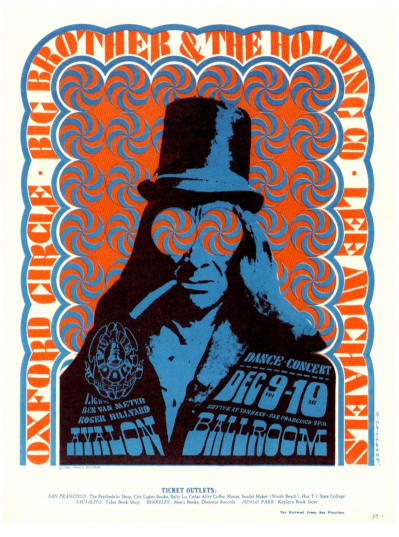

207 LEFT
STANLEY MOUSE and **ALTON KELLEY**, *"Redskin," Youngbloods, Sparrow, Sons of Champlin, December 16 & 17, Avalon Ballroom,* 1966. Color offset lithograph poster.
FINE ARTS MUSEUMS OF SAN FRANCISCO, MUSEUM PURCHASE, ACHENBACH FOUNDATION FOR GRAPHIC ARTS ENDOWMENT FUND, 1974.13.77

208 RIGHT
VICTOR MOSCOSO, *"Indian with the Swirling Eyes," Big Brother & the Holding Company, Oxford Circle, Lee Michaels, December 9 & 10, Avalon Ballroom,* 1966. Color offset lithograph poster.
FINE ARTS MUSEUMS OF SAN FRANCISCO, MUSEUM PURCHASE, ACHENBACH FOUNDATION FOR GRAPHIC ARTS ENDOWMENT FUND, 1974.13.78

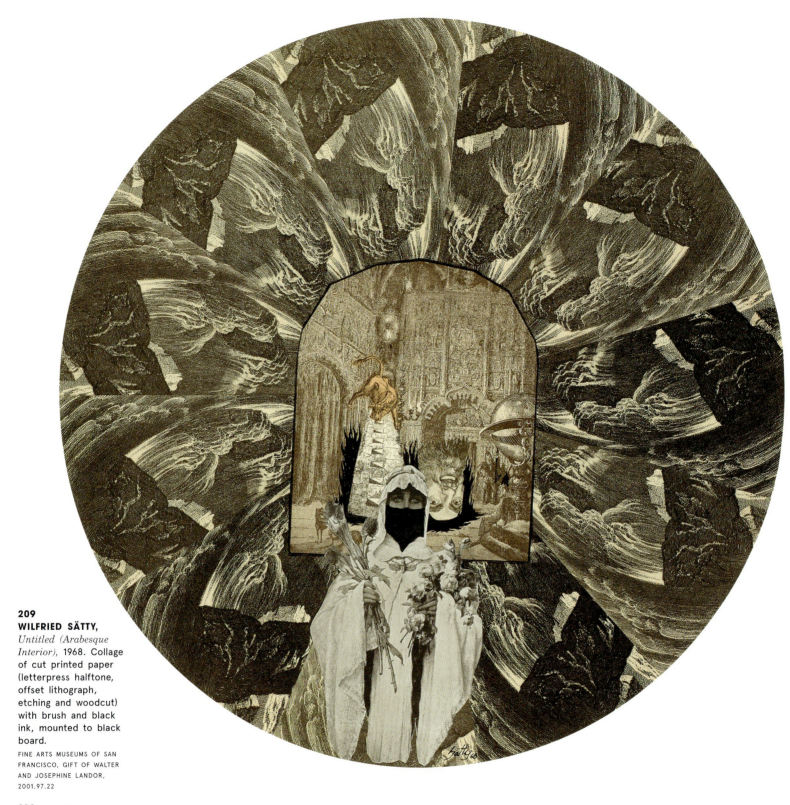

209
WILFRIED SÄTTY,
Untitled (Arabesque Interior), 1968. Collage of cut printed paper (letterpress halftone, offset lithograph, etching and woodcut) with brush and black ink, mounted to black board.
FINE ARTS MUSEUMS OF SAN FRANCISCO, GIFT OF WALTER AND JOSEPHINE LANDOR, 2001.97.22

210 OPPOSITE
DAVID SINGER,
Quicksilver Messenger Service, Mott the Hoople, Silver Metre, July 9–12, Fillmore West, 1970. Color offset lithograph poster.
FINE ARTS MUSEUMS OF SAN FRANCISCO, MUSEUM PURCHASE, ACHENBACH FOUNDATION FOR GRAPHIC ARTS ENDOWMENT FUND, 1972.53.183

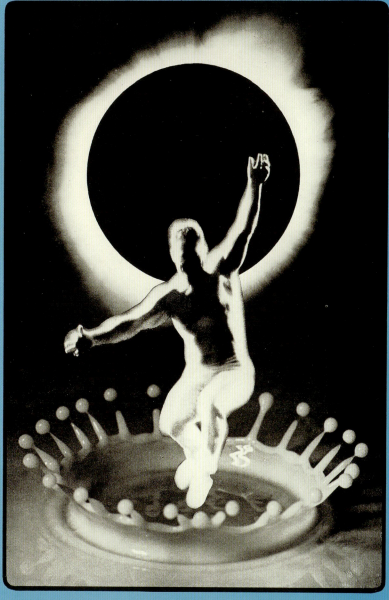

211
JESS (JESS COLLINS),
Echo's Wake Part IV,
1961–1966. Paste-up:
mixed-media collage.
PRIVATE COLLECTION, COURTESY
ANGLIM GILBERT GALLERY

212 OVERLEAF
LAWRENCE JORDAN,
film stills from *Hamfat Asar*, 1965. 16mm film
(black and white),
duration: 15 minutes,
sound.
COURTESY OF THE ARTIST AND
CANYON CINEMA

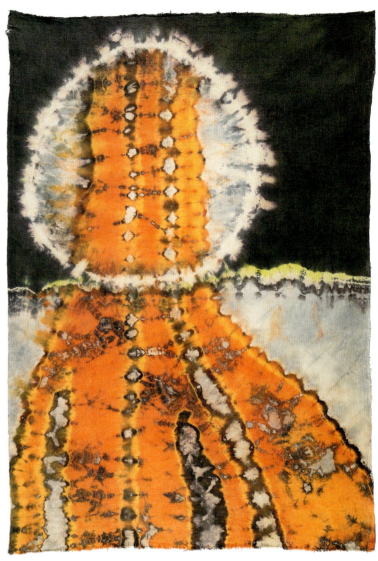

213 LEFT
MARIAN CLAYDEN,
Untitled, ca. 1968.
Silk; stitch-resist and discharge dyeing.
COLLECTION OF THE CLAYDEN FAMILY

214 RIGHT
MARIAN CLAYDEN,
Untitled, ca. 1968.
Silk; stitch-resist and discharge dyeing.
COLLECTION OF THE CLAYDEN FAMILY

215 ABOVE LEFT
LARRY STARK,
"Rorschach Test II,"
Frumius Bandersnatch
[sic], *Clear Light,*
Buddy Guy, June 14–16,
Avalon Ballroom, 1968.
Offset lithograph poster.
FINE ARTS MUSEUMS OF SAN FRANCISCO, MUSEUM PURCHASE, ACHENBACH FOUNDATION FOR GRAPHIC ARTS ENDOWMENT FUND, 1974.13.139

216 ABOVE RIGHT
WES WILSON,
"Euphoria," The Daily
Flash, The Rising Sons,
Big Brother & the
Holding Company, The
Charlatans, May 6 & 7,
Avalon Ballroom, 1966.
Color offset lithograph poster.
FINE ARTS MUSEUMS OF SAN FRANCISCO, MUSEUM PURCHASE, ACHENBACH FOUNDATION FOR GRAPHIC ARTS ENDOWMENT FUND, 1974.13.61

217 BELOW LEFT
WES WILSON,
"Rorschach Test," Blues
Project, It's a Beautiful
Day, Nazz-Are Blues
Band, April 5–7, Avalon
Ballroom, 1968. Color
offset lithograph poster.
FINE ARTS MUSEUMS OF SAN FRANCISCO, MUSEUM PURCHASE, ACHENBACH FOUNDATION FOR GRAPHIC ARTS ENDOWMENT FUND, 1974.13.148

218 BELOW RIGHT
VICTOR MOSCOSO,
"Break on Through to
the Other Side," The
Doors, The Sparrow,
Country Joe & the Fish,
March 3 & 4, Avalon
Ballroom, 1967. Color
offset lithograph poster.
FINE ARTS MUSEUMS OF SAN FRANCISCO, MUSEUM PURCHASE, ACHENBACH FOUNDATION FOR GRAPHIC ARTS ENDOWMENT FUND, 1974.13.28

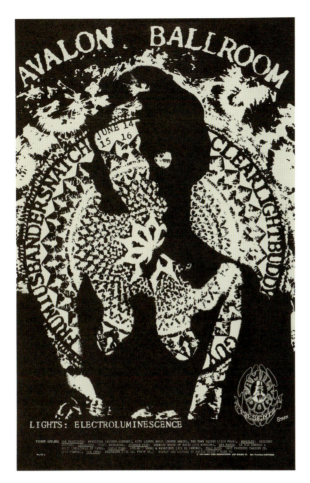
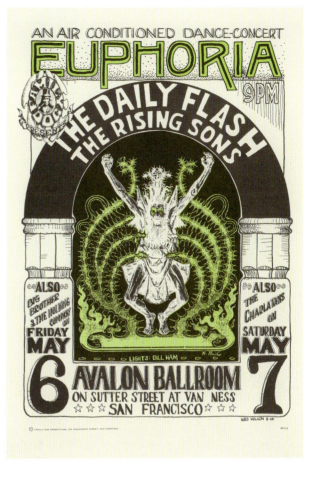
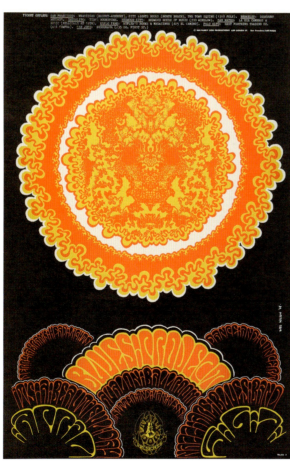
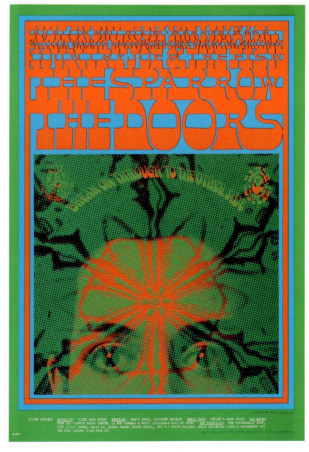

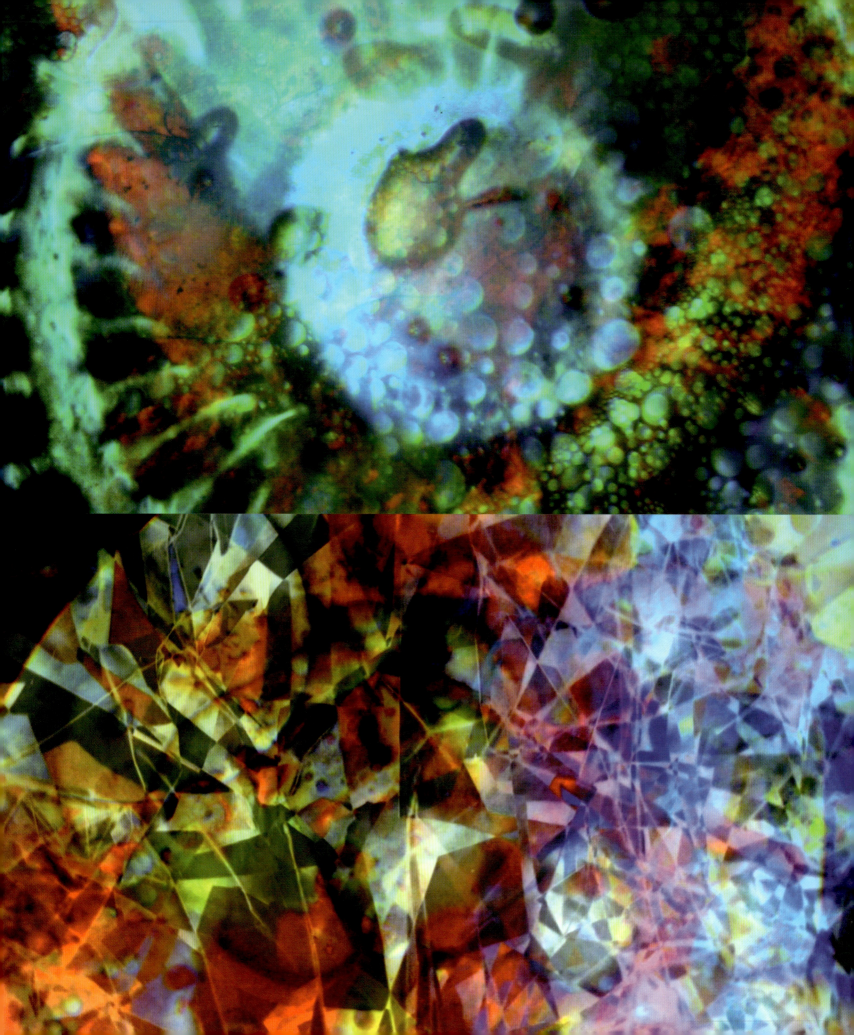

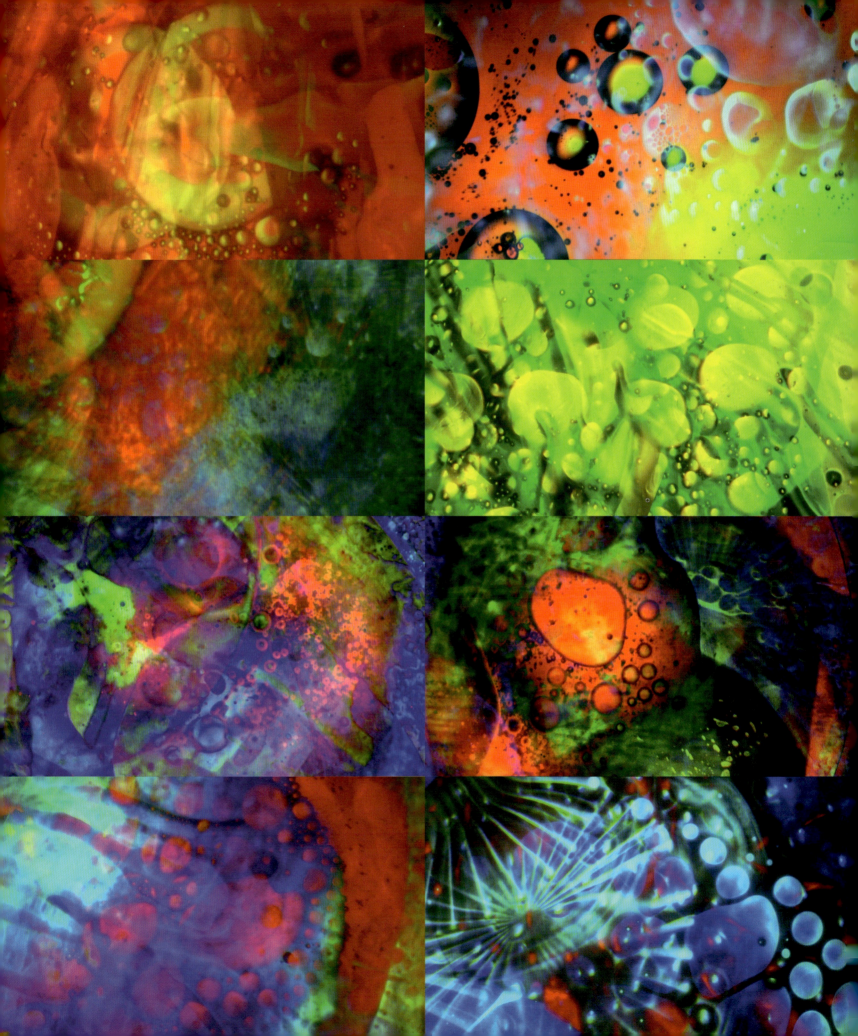

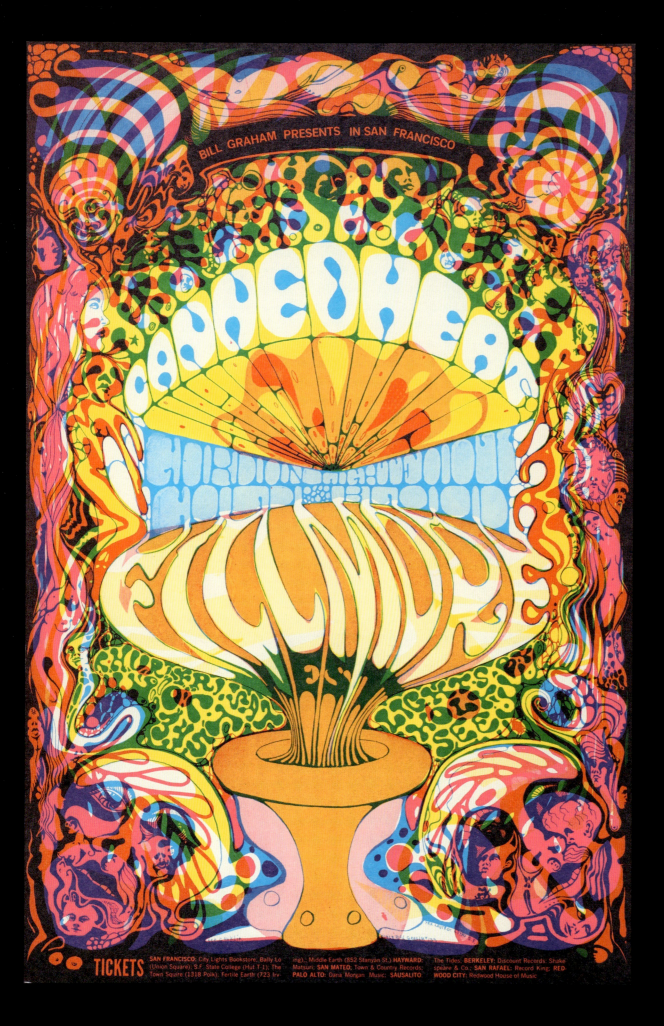

219 PREVIOUS SPREAD
BILL HAM,
Kinetic Light Painting, 2016–2017. Four films (color), duration: 64 minutes.
COURTESY OF THE ARTIST

220 OPPOSITE
LEE CONKLIN,
Canned Heat, Gordon Lightfoot, Cold Blood, October 3–5, Fillmore West, 1968. Color offset lithograph poster.
FINE ARTS MUSEUMS OF SAN FRANCISCO, MUSEUM PURCHASE, ACHENBACH FOUNDATION FOR GRAPHIC ARTS ENDOWMENT FUND, 1972.53.272

221
Embroidered hospital scrub top, ca. 1968. Cotton plain weave with cotton embroidery (bullion knots, encroaching satin, fly, running, and satin stitches).
COLLECTION OF ARTHUR LEEPER AND CYNTHIA SHAVER

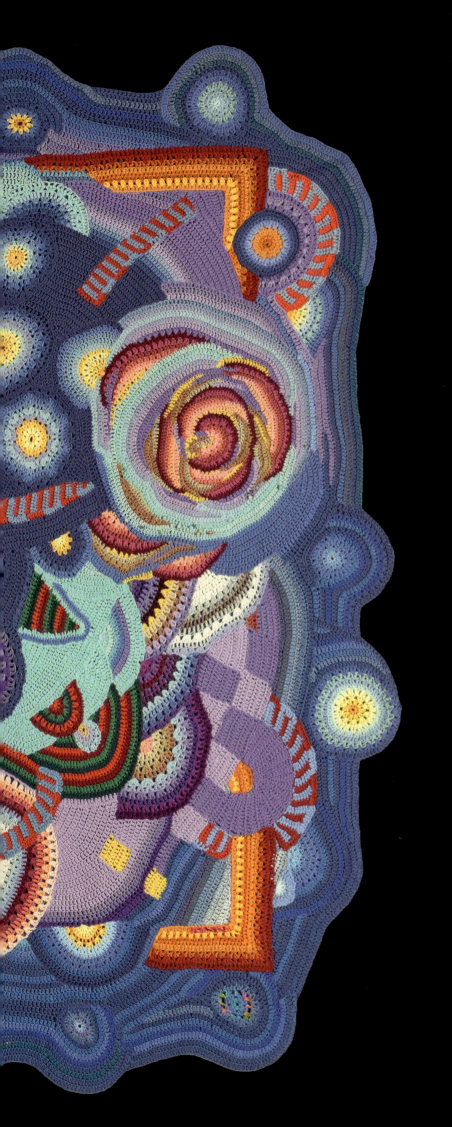

222
**BIRGITTA BJERKE
(100% BIRGITTA),**
Pioneer, ca. 1972–1973.
Crocheted wool.
COLLECTION OF THE ARTIST

223 OVERLEAF
SCOTT BARTLETT,
film stills from *OffOn,*
1968. Film (color),
duration: 1.37.9 minutes,
sound.
COURTESY OF THE ESTATE OF
SCOTT BARTLETT, CANYON
CINEMA, AND BERKELEY ART
MUSEUM AND PACIFIC FILM
ARCHIVE

224
ROBERT FRIED,
The Family Dog is coming down to Earth, 1969. Color screenprint billboard with daylight fluorescent inks, in 14 sheets.
FINE ARTS MUSEUMS OF SAN FRANCISCO, GIFT OF THE GARY WESTFORD COLLECTION, IN MEMORY OF ROBERT FRIED, AND IN HONOR OF ALL OF THE SAN FRANCISCO POSTER MAKERS AND MUSICIANS WHO MADE MAGIC HAPPEN, 2016.32.1

ming down to Earth

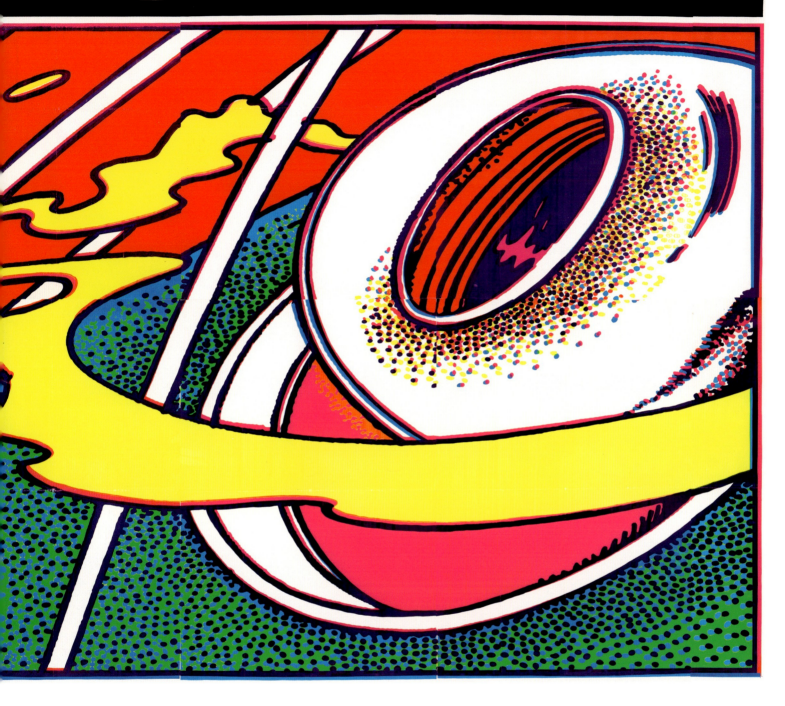

"Forms and rhythms in music are never changed without producing changes in the most important political forms and ways."

PLATO

SECTION 7

the music never stopped

A NOW-ICONIC MUSIC SCENE emerged from the rebellious and colorful counterculture growing in the heart of San Francisco in the mid-1960s. The "San Francisco Sound," as it would come to be known despite its lack of a single discernable sound, comprised such groups as Big Brother and the Holding Company, the Charlatans, Jefferson Airplane, Quicksilver Messenger Service, and, of course, the Grateful Dead. Whether impromptu and free in the park, or scheduled at the Fillmore Auditorium, Avalon Ballroom, or any number of additional venues, concerts featuring these and other bands — whose style drew upon a range of musical sources, from blues to pop, folk to classical — played an important role in bringing members of the counterculture together.

On any given night, the scene at the ballrooms around town was electric. Music filled the rooms, light shows covered the walls (pls. 238 and 296), and the people danced (pl. 295). Often they had a difficult choice to make just deciding between visiting the Fillmore or the Avalon: over the weekend of June 10, 1966, for example, someone looking to dance could head to the Fillmore to see Jefferson Airplane, the Great Society, and the Heavenly Blues Band (pl. 234), or they could go to the Avalon and be blown away by the Dead, Quicksilver Messenger Service, and the New Tweedy Brothers (pl. 233). At concerts such as these, the song-writing poets and the singers promoted a new worldview, one that *San Francisco Chronicle* music critic Ralph J. Gleason described as challenging "the whole of our social structure . . . causing New as well as Old Politics to crumble and a tribalization process to begin."

San Francisco's music found its way to audiences throughout the Bay Area thanks in part to an increased presence on FM radio, first on KMPX and later on KSAN (pls. 264–266). It also burst forth on the national stage, with news of the groundbreaking Monterey International Pop Festival (pl. 250) and the release of LPs (pls. 276–291) alongside appearances in periodicals including *Rolling Stone* magazine, which, beginning with its first issue in November 1967, spread news not only of the music, but also, as editor Jann Wenner remarked, expressed an interest in "the things and attitudes the music embraces." Though the music scene transformed from a local to an international phenomenon, aspects of it remained closer to home, for example, the photographs of the bands taken by friends such as Herb Greene and Jim Marshall (pls. 267–275), which remain today among the most iconic images of the period.

Not only was the music and its presentation revolutionary, so, too, was the dancing. Never before had a movement burst forth without a new "step," but in San Francisco concertgoers found countless ways to express their individuality. In addition to bringing to the dance floor a range of movements, they also delighted in communicating an abundance of originality and creativity through their dress, be it vintage fineries, hand-crafted creations, or a showcase of vibrating patterns. (pls. 293–294 and 297–306).

225
The We Five, September 25, ca. 1965. Color offset lithograph poster.
FINE ARTS MUSEUMS OF SAN FRANCISCO, GIFT OF THE GARY WESTFORD COLLECTION, IN HONOR OF THE WE FIVE, 2017.7.48

226 OPPOSITE
MICHAEL FERGUSON and **GEORGE HUNTER**, *"The Seed," The Amazing Charlatans, June 1–15, Red Dog Saloon, Virginia City, Nevada*, 1965. Offset lithograph poster printed in blue ink.
CENTER FOR COUNTERCULTURE STUDIES

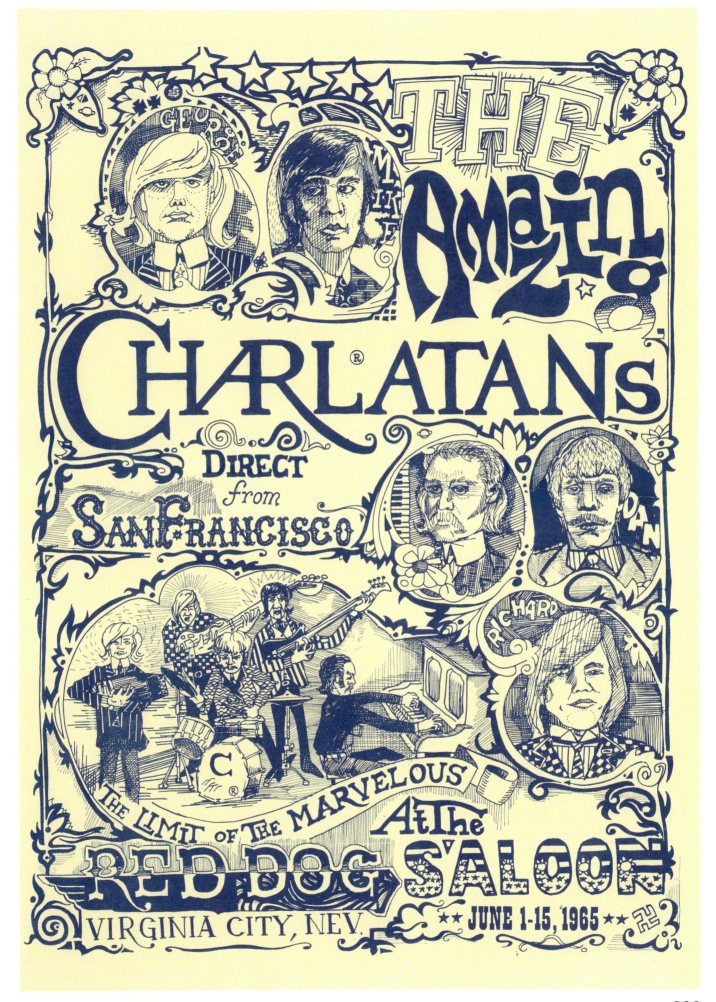

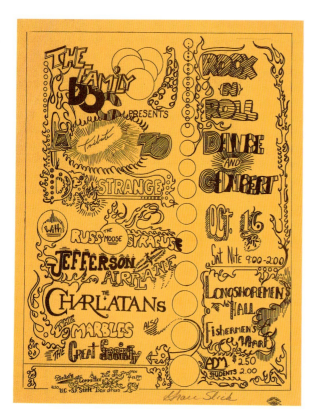
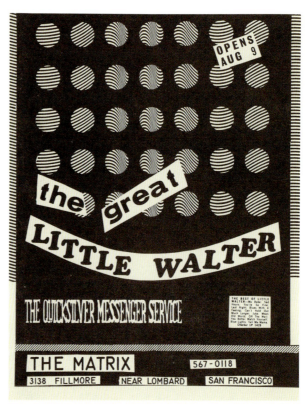
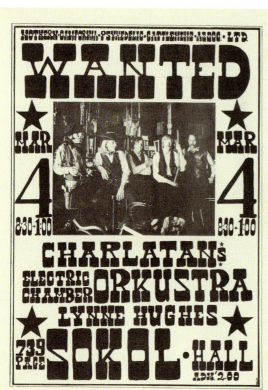
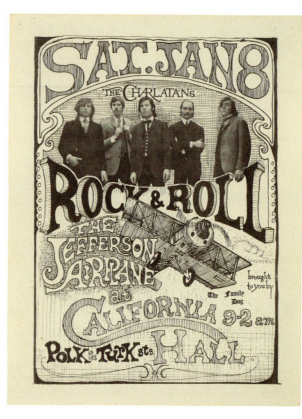

227 ABOVE LEFT
ALTON KELLEY and **AMI MAGILL**,
The Family Dog Presents A Tribute to Dr. Strange, Russ the Moose Syracuse, Jefferson Airplane, The Charlatans, The Marbles, The Great Society, October 16, Longshoremen's Hall, 1965. Stencil duplicate print (mimeograph) handbill on goldenrod paper.
CENTER FOR COUNTERCULTURE STUDIES

228 ABOVE RIGHT
RAY ANDERSEN,
The Great Little Walter, The Quicksilver Messenger Service, Opens August 9, The Matrix, 1966. Stencil duplicate print (mimeograph) handbill.
COLLECTION OF JOHN J. LYONS

229 BELOW LEFT
ALTON KELLEY,
"Wanted," Charlatans, Electric Chamber Orkustra, Lynne Hughes, March 4, Sokol Hall, 1966. Offset lithograph handbill.
COLLECTION OF JOHN J. LYONS

230 BELOW RIGHT
GEORGE HUNTER,
"Rock & Roll," The Charlatans, The Jefferson Airplane, January 8, California Hall, 1966. Offset lithograph handbill.
FINE ARTS MUSEUMS OF SAN FRANCISCO, MUSEUM PURCHASE, ACHENBACH FOUNDATION FOR GRAPHIC ARTS ENDOWMENT FUND, 1974.13.116

231 OPPOSITE
PETER BAILEY,
The Jefferson Airplane, February 4–6, Fillmore Auditorium, 1966. Color offset lithograph poster.
FINE ARTS MUSEUMS OF SAN FRANCISCO, MUSEUM PURCHASE, ACHENBACH FOUNDATION FOR GRAPHIC ARTS ENDOWMENT FUND, 1972.53.28

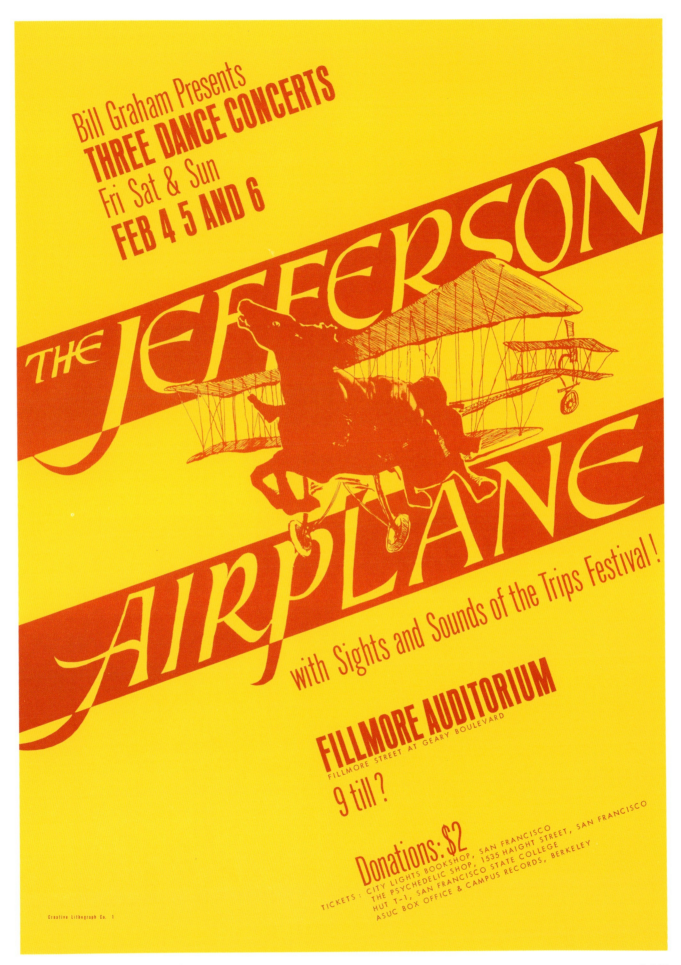

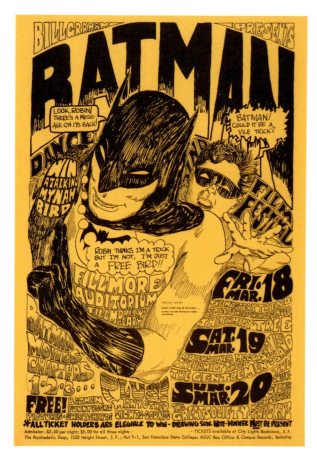

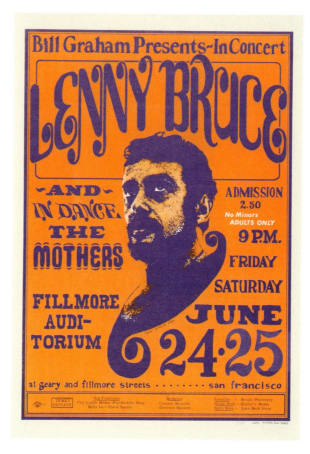

232 ABOVE LEFT
WES WILSON,
Mystery Trend, Big Brother & the Holding Company, Quicksilver Messenger Service, March 18–20, Fillmore Auditorium, 1966. Offset lithograph poster on yellow paper.
FINE ARTS MUSEUMS OF SAN FRANCISCO, MUSEUM PURCHASE, ACHENBACH FOUNDATION FOR GRAPHIC ARTS ENDOWMENT FUND, 1972.53.29

233 ABOVE RIGHT
WES WILSON,
"The Quick and the Dead," The Grateful Dead, The Quicksilver Messenger Service, The New Tweedy Brothers, June 10 & 11, Avalon Ballroom, 1966. Offset lithograph poster.
FINE ARTS MUSEUMS OF SAN FRANCISCO, MUSEUM PURCHASE, ACHENBACH FOUNDATION FOR GRAPHIC ARTS ENDOWMENT FUND, 1974.13.57

234 BELOW LEFT
WES WILSON,
Jefferson Airplane, Great Society, Heavenly Blues Band, June 10 & 11, Fillmore Auditorium, 1966. Color offset lithograph poster.
FINE ARTS MUSEUMS OF SAN FRANCISCO, MUSEUM PURCHASE, ACHENBACH FOUNDATION FOR GRAPHIC ARTS ENDOWMENT FUND, 1972.53.38

235 BELOW RIGHT
WES WILSON,
Lenny Bruce, The Mothers, June 24 & 25, Fillmore Auditorium, 1966. Color offset lithograph poster.
FINE ARTS MUSEUMS OF SAN FRANCISCO, MUSEUM PURCHASE, ACHENBACH FOUNDATION FOR GRAPHIC ARTS ENDOWMENT FUND, 1972.53.41

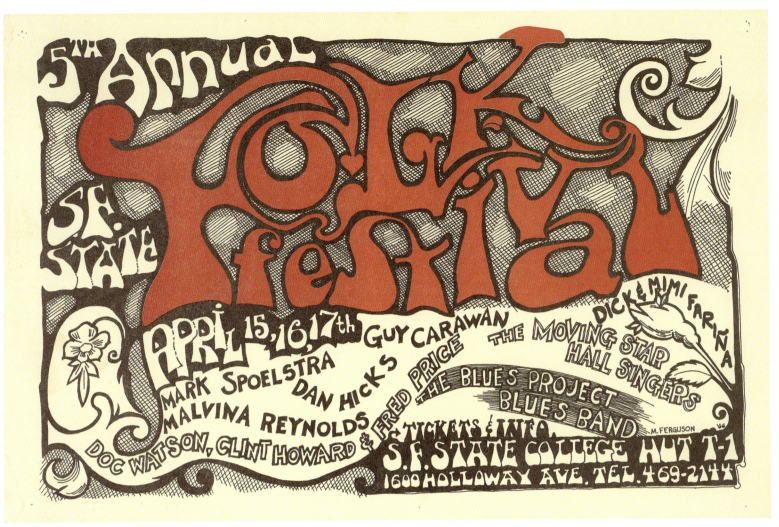

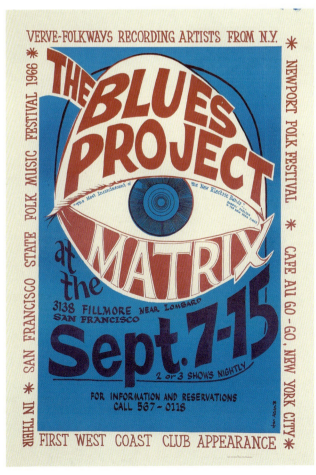

236 ABOVE
MICHAEL FERGUSON,
5th Annual S. F. State Folk Festival, Mark Spoelstra, Dan Hicks, Guy Carawan, Dick and Mimi Fariña, Malvina Reynolds, Doc Watson, Clint Howard & Fred Price, The Moving Star Hall Singers, and The Blues Project Blues Band, April 15, 1966. Color offset lithograph poster.
COLLECTION OF PETER ALBIN

237 BELOW
JON ADAMS,
The Blues Project, September 7–15, the Matrix, 1966. Color offset lithograph poster.
CENTER FOR COUNTERCULTURE STUDIES

238 OVERLEAF
BEN VAN METER,
Trip-Tych, 1967/2016. Mixed media digital video with 16mm film and 35mm slides.
COLLECTION OF BEN VAN METER AND JOHN J. LYONS

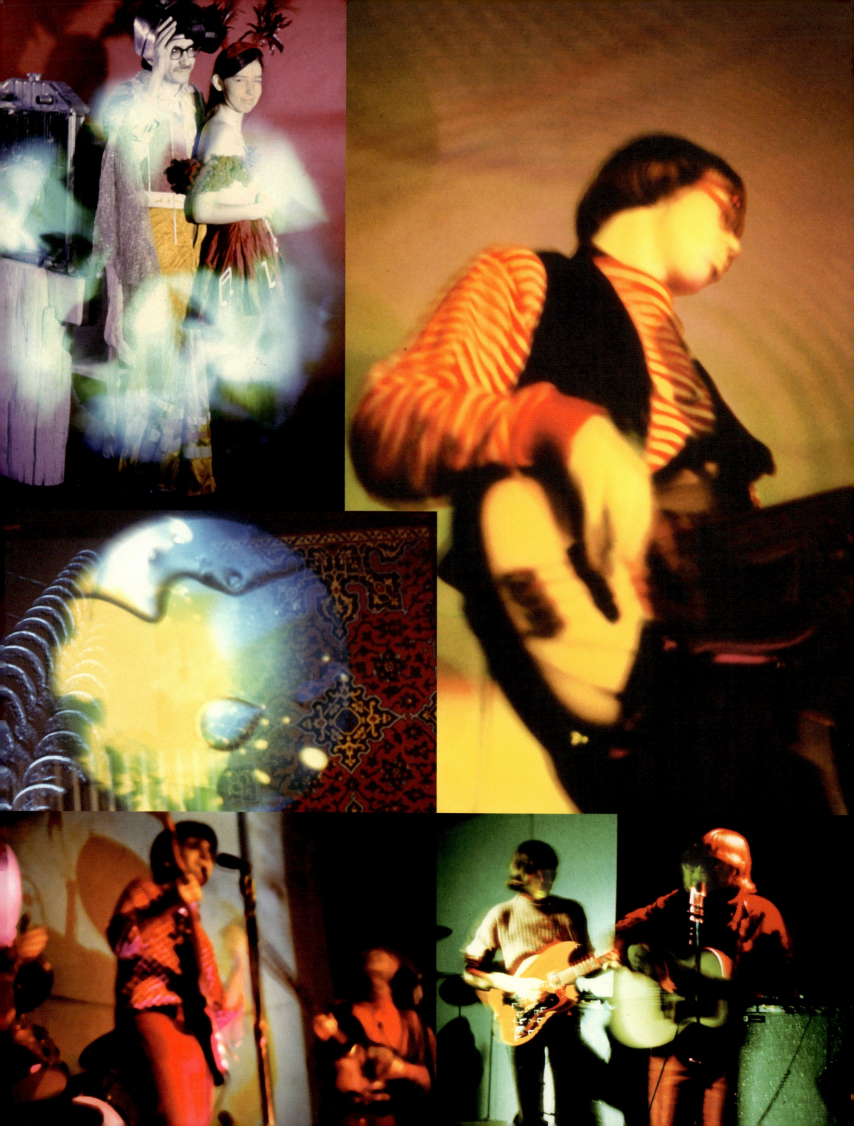

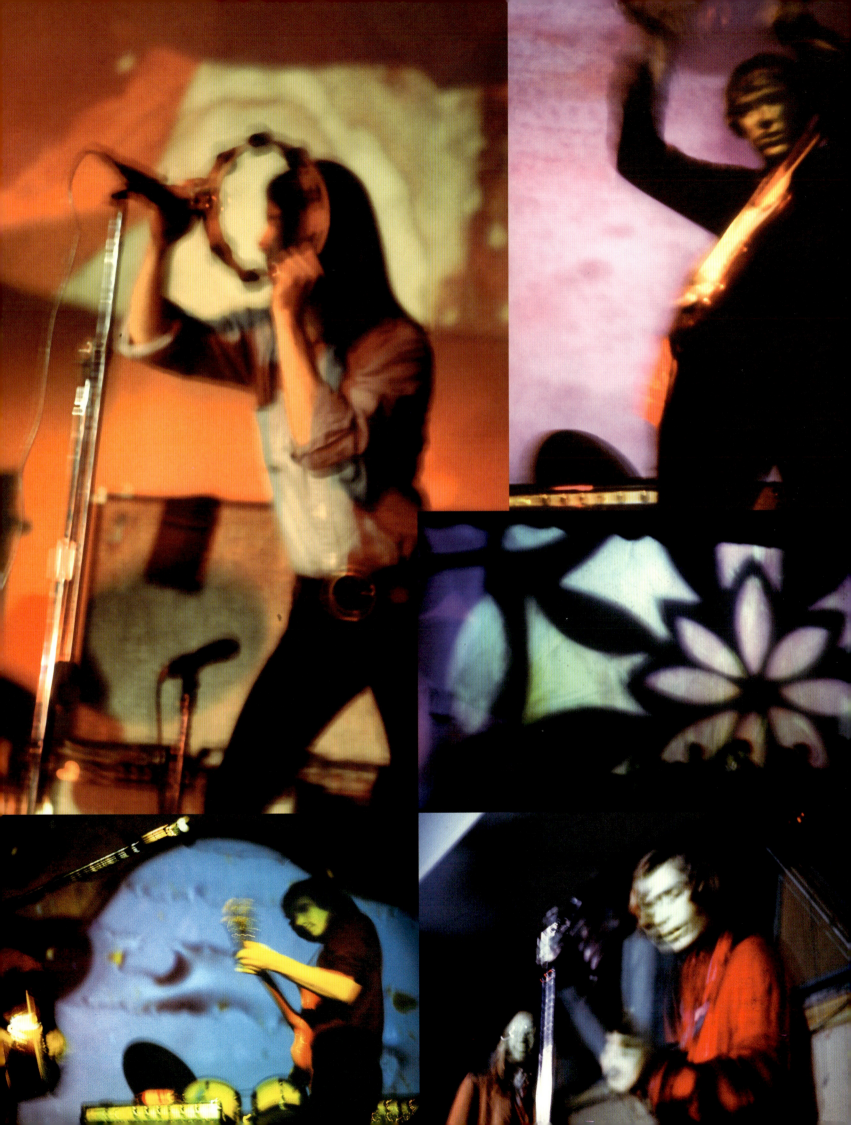

BILL GRAHAM PRESENTS:

POP-OP ROCK

ANDY WARHOL AND HIS PLASTIC INEVITABLE

WITH THE VELVET UNDERGROUND AND NICO "POP GIRL OF '66"

PLUS THE MOTHERS

FRI MAY 27
SAT MAY 28
SUN MAY 29

FILLMORE AUDITORIUM at 9PM

FILLMORE & GEARY STREETS IN S.F.

printing by West Coast Lithograph Co. SF

WES WILSON 661-8362

TICKET OUTLETS:

San Francisco
City Lights Books; Psychedelic Shop
Bally Lo - Union Square
S.F. State College, Hut T-1

Berkeley
Campus Records
Discount Records
A.S.U.C. Box Office

Sausalito
Rexall Pharmacy

Menlo Park
Kepler's Books

Santa Rosa
Apex Book Store

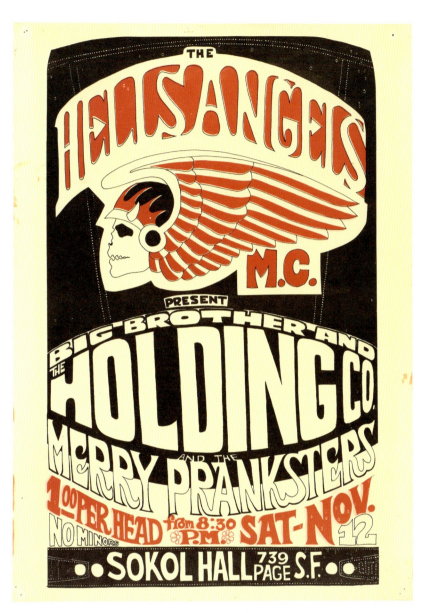

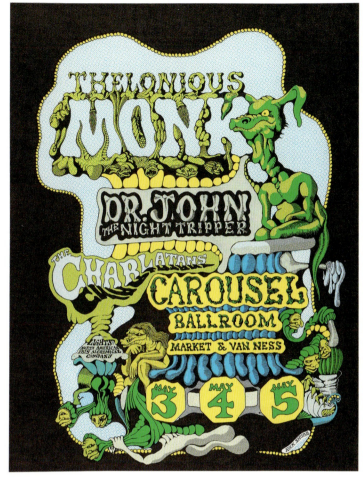

240 LEFT
GUT (ALLEN TURK),
The Hell's Angels M.C. Present Big Brother and the Holding Co. and the Merry Pranksters, November 12, Sokol Hall, 1966. Color offset lithograph poster.
COLLECTION OF PETER ALBIN

239 OPPOSITE
WES WILSON,
Andy Warhol and His Plastic Inevitable, The Velvet Underground, Nico, The Mothers, May 27–29, Fillmore Auditorium, 1966. Color offset lithograph poster.
FINE ARTS MUSEUMS OF SAN FRANCISCO, MUSEUM PURCHASE, ACHENBACH FOUNDATION FOR GRAPHIC ARTS ENDOWMENT FUND, 1972.53.36

241 RIGHT
RICK SHUBB,
Thelonious Monk, Dr. John the Night Tripper, The Charlatans, May 3–5, Carousel Ballroom, 1968. Color offset lithograph poster.
FINE ARTS MUSEUMS OF SAN FRANCISCO, GIFT OF THE GARY WESTFORD COLLECTION, 2017.7.3

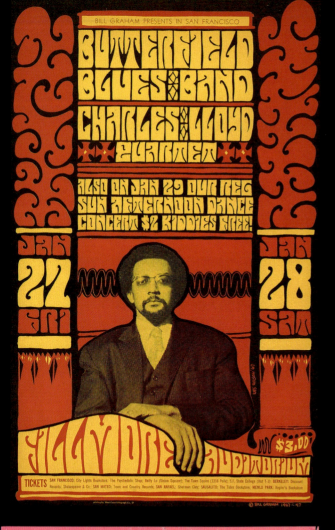
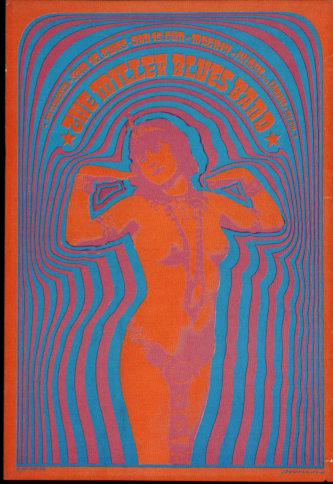
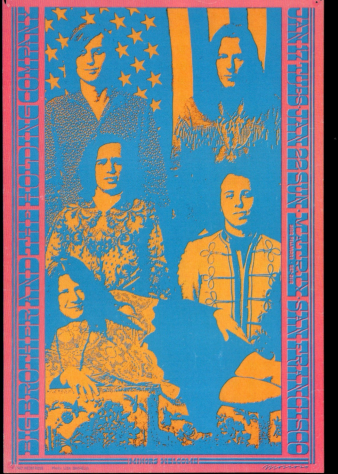
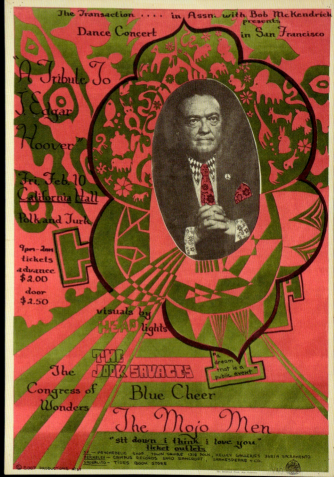

242 OPPOSITE ABOVE LEFT
WES WILSON,
Butterfield Blues Band, Charles Lloyd Quartet, January 27–29, Fillmore Auditorium, 1967. Color offset lithograph poster.
FINE ARTS MUSEUMS OF SAN FRANCISCO, MUSEUM PURCHASE, ACHENBACH FOUNDATION FOR GRAPHIC ARTS ENDOWMENT FUND, 1972.53.71

243 OPPOSITE ABOVE RIGHT
VICTOR MOSCOSO,
The Miller Blues Band, January 10–15, Matrix, 1967. Color offset lithograph poster.
HAIGHT STREET ART CENTER

244 OPPOSITE BELOW LEFT
VICTOR MOSCOSO,
Big Brother and the Holding Company, January 17–22, The Matrix, 1967. Color offset lithograph poster.
FINE ARTS MUSEUMS OF SAN FRANCISCO, GIFT OF THE GARY WESTFORD COLLECTION, IN HONOR OF MARTY BALIN AND THE MATRIX, 2017.7.21

245 OPPOSITE BELOW RIGHT
SOOT PRODUCTIONS,
"A Tribute to J. Edgar Hoover," The Jook Savages, Blue Cheer, The Congress of Wonders, The Mojo Men, February 10, California Hall, 1967. Color offset lithograph poster.
FINE ARTS MUSEUMS OF SAN FRANCISCO, GIFT OF THE GARY WESTFORD COLLECTION, 2017.7.19

246
WES WILSON,
Grateful Dead, Junior Wells Chicago Blues Band, The Doors, January 13–15, Fillmore Auditorium, 1967. Color offset lithograph poster.
FINE ARTS MUSEUMS OF SAN FRANCISCO, MUSEUM PURCHASE, ACHENBACH FOUNDATION FOR GRAPHIC ARTS ENDOWMENT FUND, 1972.53.69

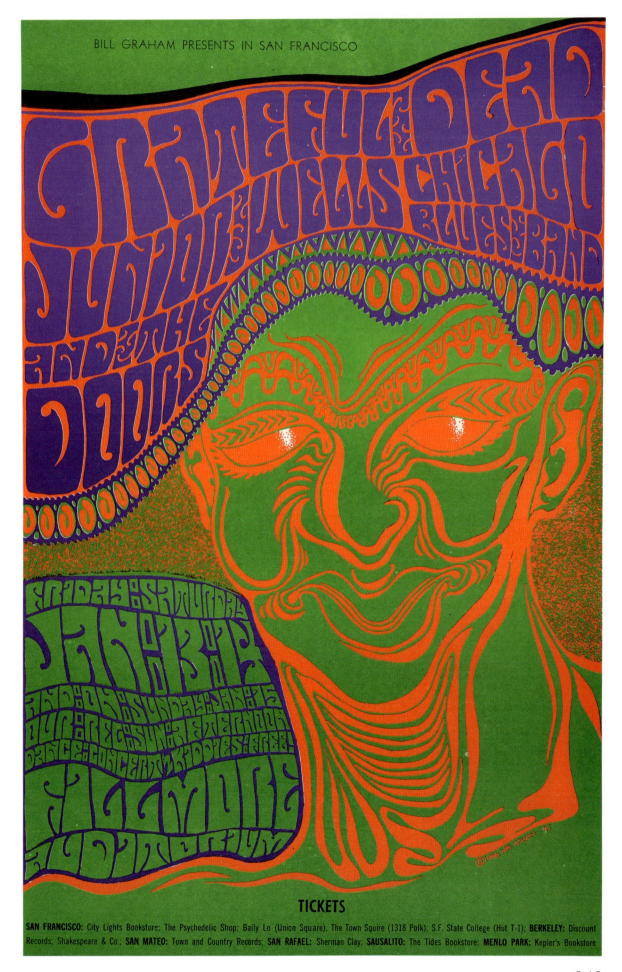

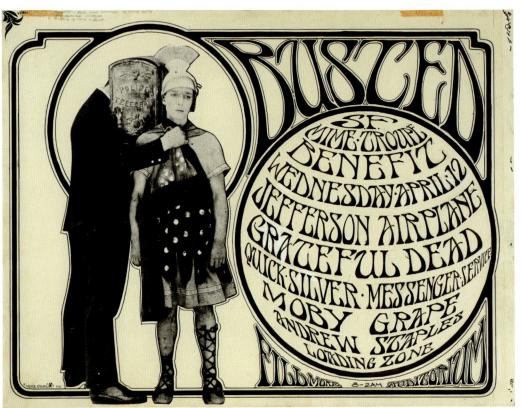

247 ABOVE
Hugh Masekela, January 31–February 12, Letta Mbulu, February 14–26, Both/And Jazz Club, ca. 1967. Color offset lithograph poster.
FINE ARTS MUSEUMS OF SAN FRANCISCO, GIFT OF THE GARY WESTFORD COLLECTION, IN HONOR OF THE BOTH/AND CLUB, 2017.7.16

248 BELOW
STANLEY MOUSE and **ALTON KELLEY,** printing mechanical for *Appeals IV Mime Troupe Benefit, "Busted," Jefferson Airplane, Grateful Dead, Quicksilver Messenger Service, Moby Grape, Andrew Staples, Loading Zone, May 12, Fillmore Auditorium,* 1967. Black ink, black porous point pen, offset lithograph cutouts, and white opaque paint with traces of graphite on illustration board.
COLLECTION OF JOHN J. LYONS

249 OPPOSITE
NICHOLAS KOUNINOS, *Procol Harum, Pink Floyd, H. P. Lovecraft, November 9, Fillmore Auditorium, November 10–11, Winterland,* 1967. Color offset lithograph poster.
FINE ARTS MUSEUMS OF SAN FRANCISCO, MUSEUM PURCHASE, ACHENBACH FOUNDATION FOR GRAPHIC ARTS ENDOWMENT FUND, 1972.53.114

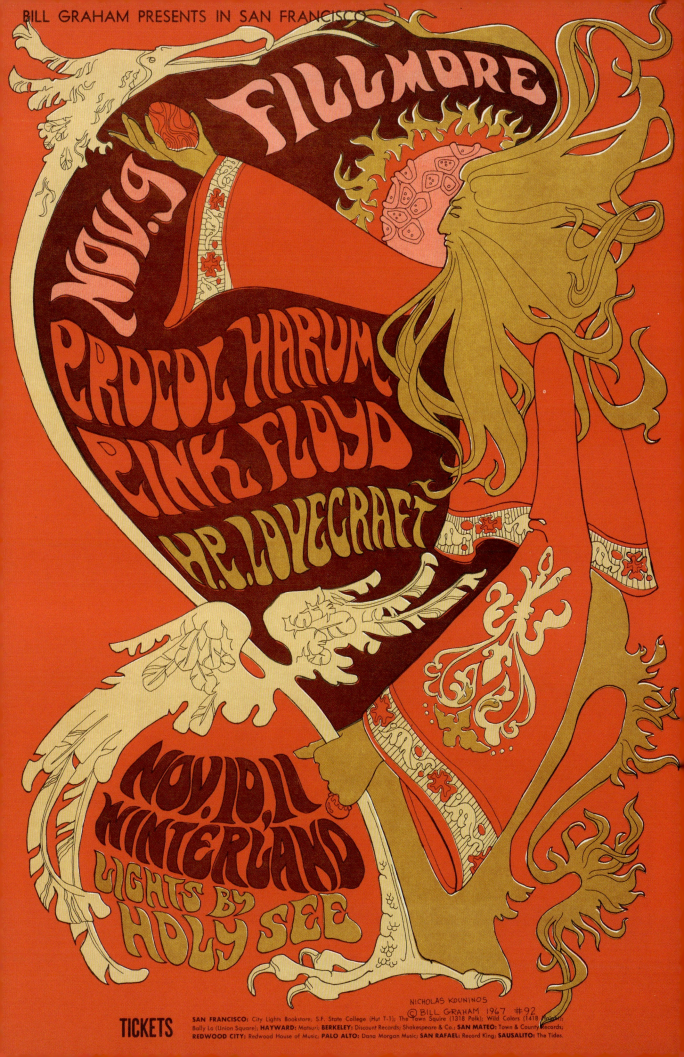

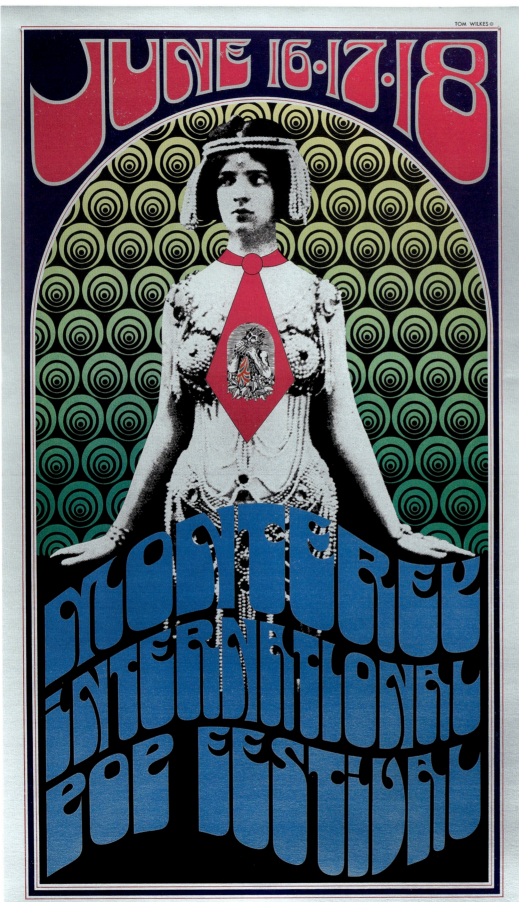

250
TOM WILKES,
Monterey International Pop Festival, June 16, 17, 18, 1967. Color offset lithograph poster on metallic foil paper.
COLLECTION OF RON AND JASMINE SCHAEFFER, THE ROCK POSTER SOCIETY

251 OPPOSITE
VICTOR MOSCOSO,
"Peacock Ball," Quicksilver Messenger Service, Miller Blues Band, The Daily Flash, March 10 & 11, Avalon Ballroom, 1967. Color offset lithograph poster.
FINE ARTS MUSEUMS OF SAN FRANCISCO, MUSEUM PURCHASE, ACHENBACH FOUNDATION FOR GRAPHIC ARTS ENDOWMENT FUND, 1974.13.30

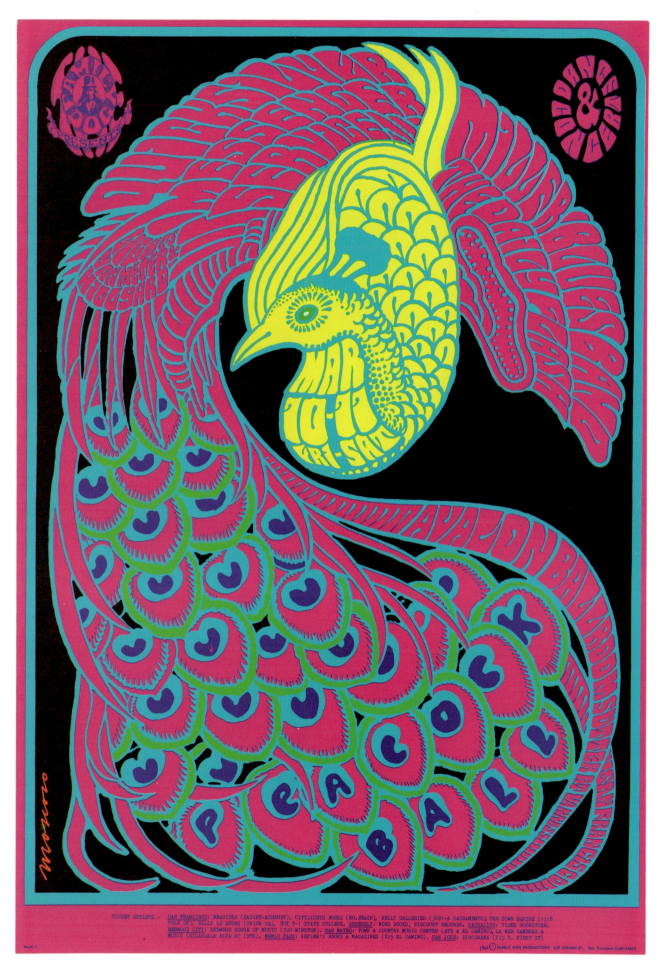

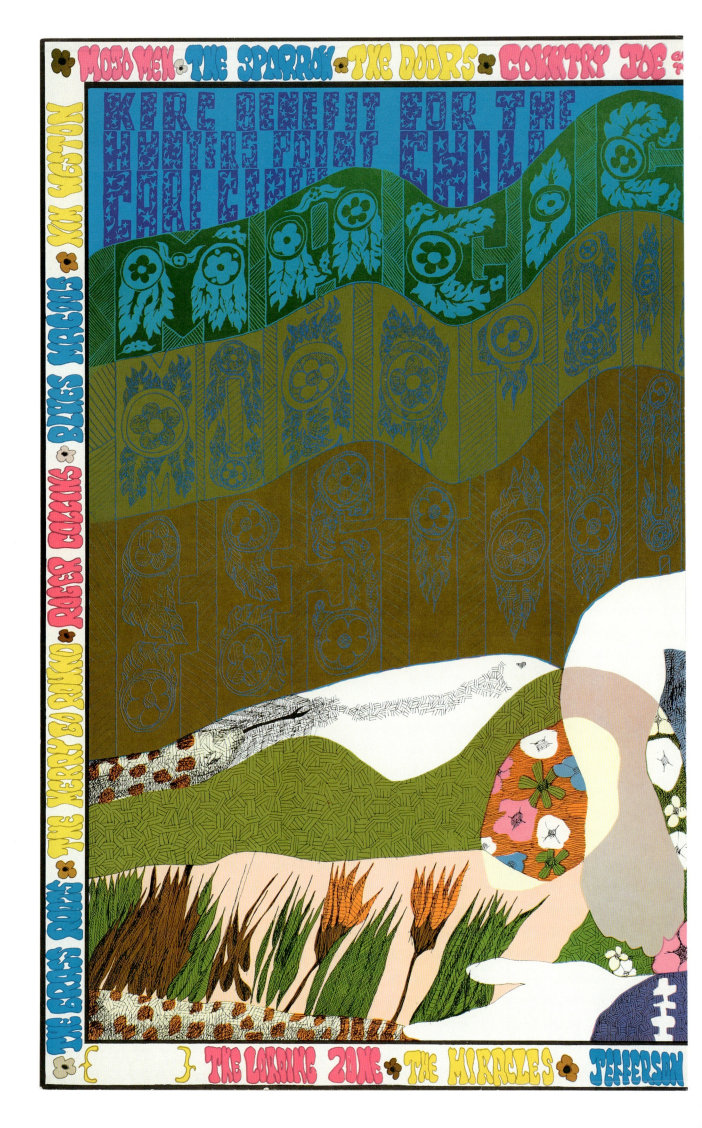

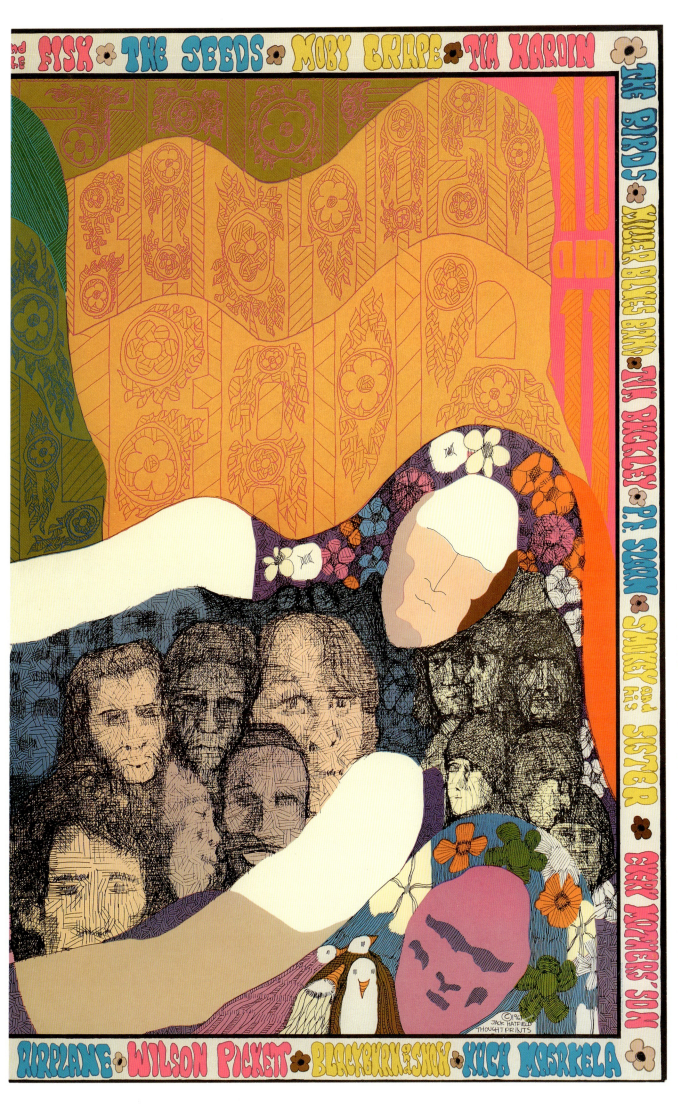

**252
JACK HATFIELD,**
Magic Mountain Music Festival KFRC Benefit For the Hunters Point Child Care Center, Mojo Men, The Sparrow, The Doors, Country Joe and the Fish, The Seeds, Moby Grape, Tim Hardin, The Byrds, Miller Blues Band, Tim Buckley, P. F. Sloan, Smokey and His Sister, Every Mothers' Son, Hugh Masekela, Blackburn and Snow, Wilson Picket, Jefferson Airplane, The Miracles, The Loading Zone, The Grass Roots, The Merry Go Round, Roger Collins, Blues Magoos, Kim Weston, June 10 and 11, Mt. Tamalpais, 1967. Color offset lithograph poster printed on two sheets.
CENTER FOR COUNTERCULTURE STUDIES

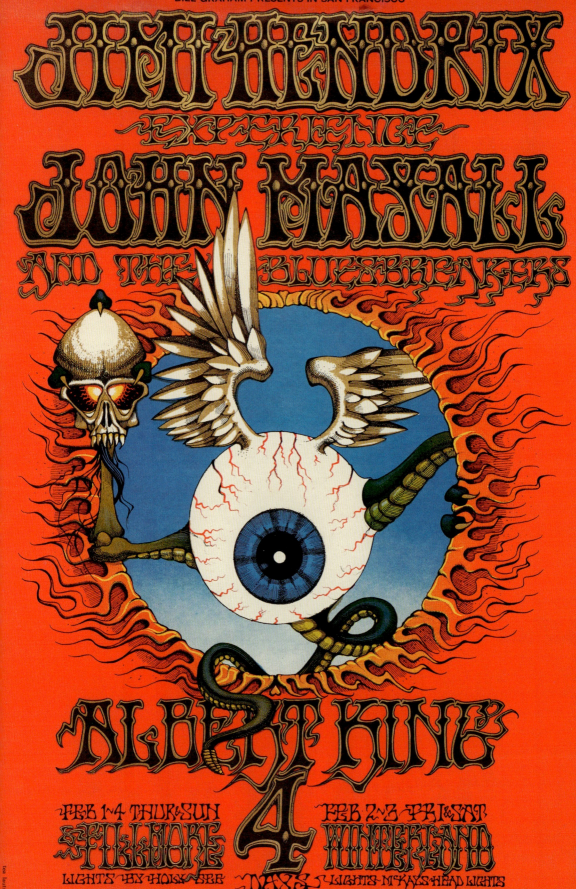

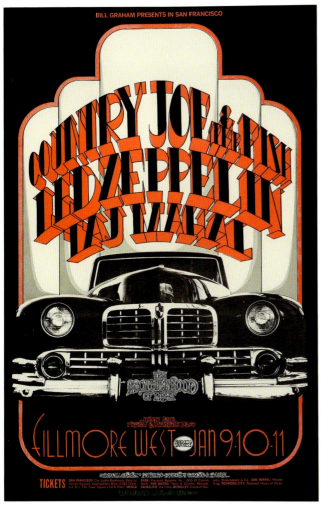

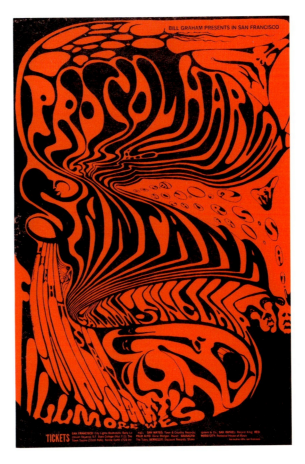

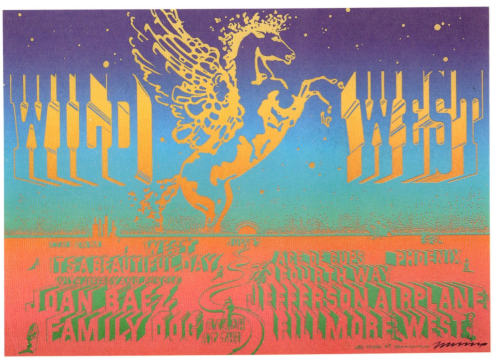

254 ABOVE LEFT
RANDY TUTEN and **D. BREAD (WILLIAM BOSTEDT** aka **"DADDY BREAD")**,
Country Joe & the Fish, Led Zeppelin, Taj Mahal, January 9–11, Fillmore West, 1969. Color offset lithograph poster.

FINE ARTS MUSEUMS OF SAN FRANCISCO, MUSEUM PURCHASE, ACHENBACH FOUNDATION FOR GRAPHIC ARTS ENDOWMENT FUND, 1972.53.263

255 ABOVE RIGHT
LEE CONKLIN,
Procol Harum, Santana, Salloom-Sinclair, October 31–November 2, Fillmore West, 1968. Color offset lithograph poster.

FINE ARTS MUSEUMS OF SAN FRANCISCO, MUSEUM PURCHASE, ACHENBACH FOUNDATION FOR GRAPHIC ARTS ENDOWMENT FUND, 1972.53.276

256 BELOW
VICTOR MOSCOSO and **WES WILSON**,
"Wild West," Joan Baez, It's a Beautiful Day, July 7, 660 Great Highway; Jefferson Airplane, Fourth Way, Ace of Cups, July 7, Fillmore West, 1969. Color offset lithograph poster.

FINE ARTS MUSEUMS OF SAN FRANCISCO, GIFT OF THE GARY WESTFORD COLLECTION, IN HONOR OF THE JEFFERSON AIRPLANE: MARTY BALIN, JACK CASADY, JORMA KAUKONEN, PAUL KANTNER, SPENCER DRYDEN, AND GRACE SLICK, 2017.7.31

253 OPPOSITE
RICK GRIFFIN,
Jimi Hendrix Experience, John Mayall & the Blues Breakers, Albert King, February 1 & 4, Fillmore Auditorium, February 2 & 3, Winterland, 1968. Color offset lithograph poster.

FINE ARTS MUSEUMS OF SAN FRANCISCO, GIFT OF THACKREY AND ROBERTSON, 1981.1.34

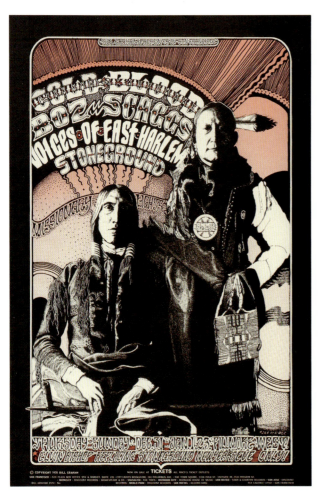
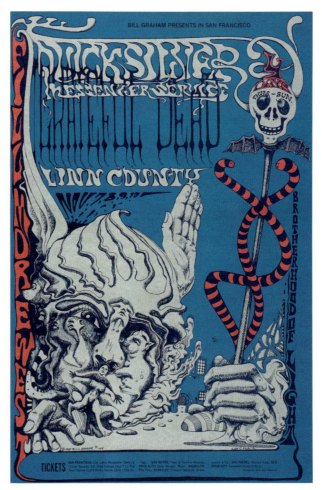
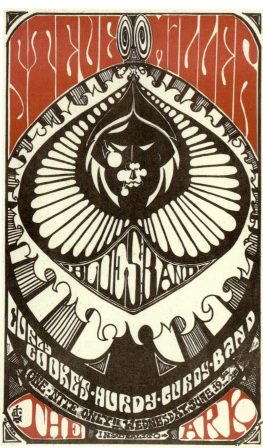
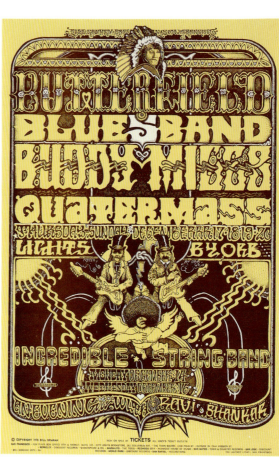

257 ABOVE LEFT
NORMAN ORR,
Cold Blood, Boz Scaggs, Voices of East Harlem, Elvin Bishop, Stoneground, December 31–January 3, Fillmore West, 1970. Color offset lithograph poster.
FINE ARTS MUSEUMS OF SAN FRANCISCO, MUSEUM PURCHASE, ACHENBACH FOUNDATION FOR GRAPHIC ARTS ENDOWMENT FUND, 1972.53.167

258 ABOVE RIGHT
LEE CONKLIN,
Quicksilver Messenger Service, Grateful Dead, Linn County, November 7–10, Fillmore West, 1968. Color offset lithograph poster.
FINE ARTS MUSEUMS OF SAN FRANCISCO, MUSEUM PURCHASE, ACHENBACH FOUNDATION FOR GRAPHIC ARTS ENDOWMENT FUND, 1972.53.277

259 BELOW LEFT
DAVE BROWN,
Steve Miller Blues Band, Curly Cooke's Hurdy Gurdy Band, June 19, The Ark, Sausalito, 1968. Color offset lithograph poster.
CENTER FOR COUNTERCULTURE STUDIES

260 BELOW RIGHT
NORMAN ORR,
Incredible String Band, December 14, Ravi Shankar, December 16, Butterfield Blues Band, Buddy Miles, Quatermass, December 17–20, Fillmore West, 1970. Color offset lithograph poster.
FINE ARTS MUSEUMS OF SAN FRANCISCO, MUSEUM PURCHASE, ACHENBACH FOUNDATION FOR GRAPHIC ARTS ENDOWMENT FUND, 1972.53.169

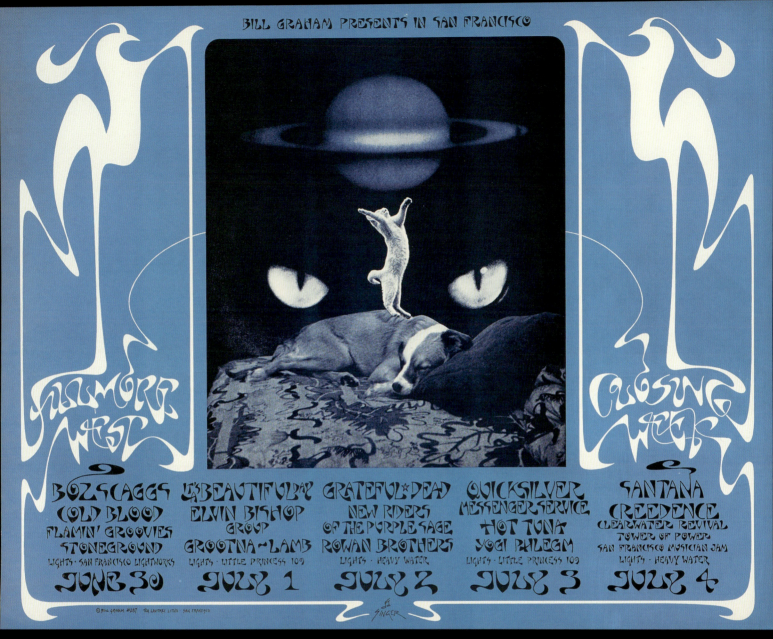

261
DAVID SINGER, Boz Scaggs, Cold Blood, Flamin' Groovies, Stoneground, June 30, It's a Beautiful Day, Elvin Bishop Group, Grootna, Lamb, July 1, Grateful Dead, New Riders of the Purple Sage, Rowan Brothers, July 2, Quicksilver Messenger Service, Hot Tuna, Yogi Phlegm, July 3, Santana, Creedence Clearwater Revival, Tower of Power, San Francisco Music Jam, July 4, Fillmore West, 1971. **Color offset lithograph poster.** FINE ARTS MUSEUMS OF SAN FRANCISCO, MUSEUM PURCHASE, ACHENBACH FOUNDATION FOR GRAPHIC ARTS ENDOWMENT FUND, 1972.53.22

262
DUNLAP & CO.,
Jerry Garcia's "Captain Trips" hat, 1883, with later alterations. Hand-painted silk with ribbon and flag.
PRIVATE COLLECTION

263 OPPOSITE
LINDA GRAVENITES,
handbag, ca. 1967. Goatskin with silk embroidery (chain stitch) and glass beads.
COLLECTION OF ROSLYN L. ROSEN

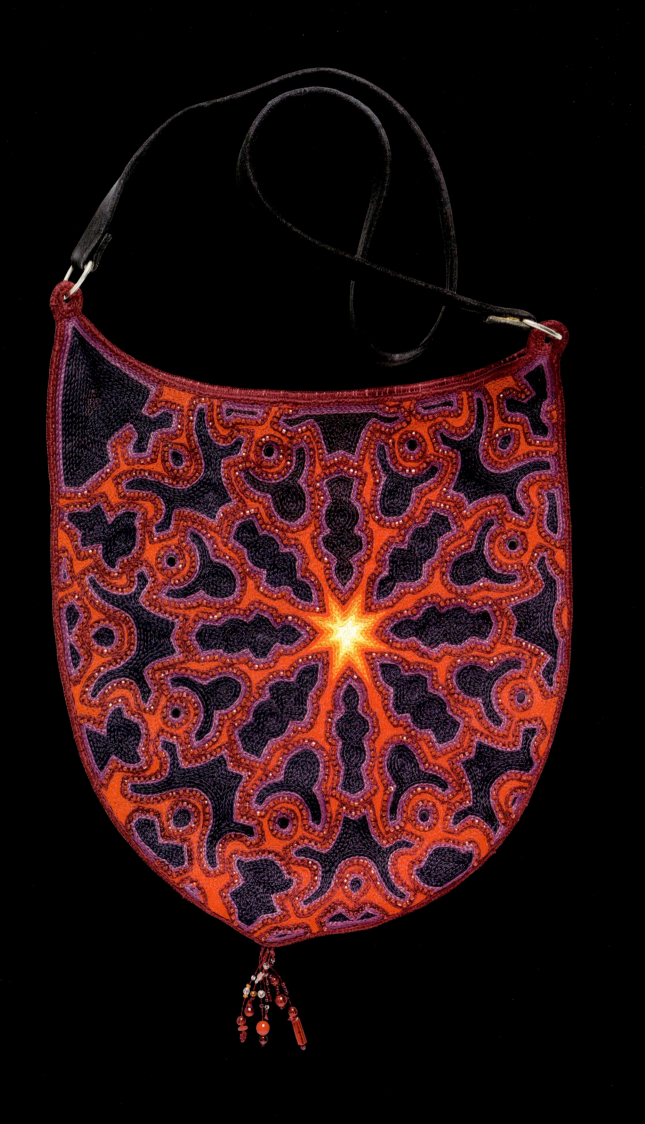

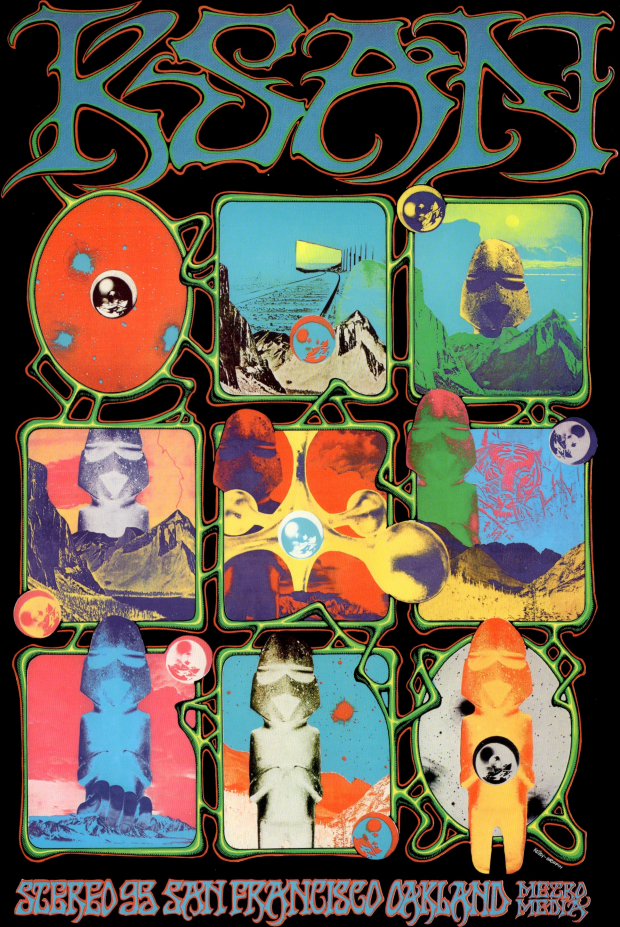

264 OPPOSITE
RICK GRIFFIN and **ALTON KELLEY**,
KSAN Radio, San Francisco, 1969. Color offset lithograph.
FINE ARTS MUSEUMS OF SAN FRANCISCO, GIFT OF THE GARY WESTFORD COLLECTION, IN APPRECIATION AND MEMORY OF TOM DONAHUE AND ALL THE DJS, 2017.7.7

265 LEFT
LARRY MILLER,
Larry Miller, Folk Rock, Midnight to 6 A.M., KMPX, 106.9 FM Stereo, 1967. Stencil duplicate print (mimeograph) handbill.
COLLECTION OF JOHN J. LYONS

266 RIGHT
GREG IRONS,
KMPX Multiplex Stereo in San Francisco, 1967. Stencil duplicate print (mimeograph) on red daylight fluorescent paper.
COLLECTION OF JOHN J. LYONS

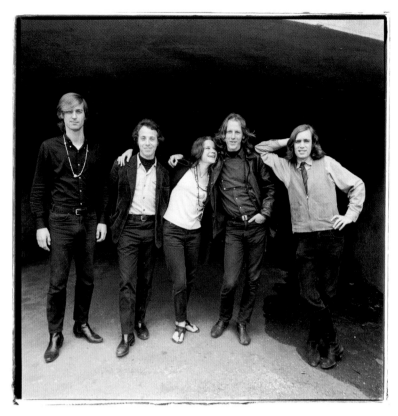
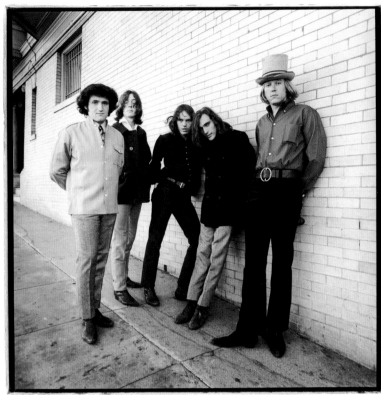

258

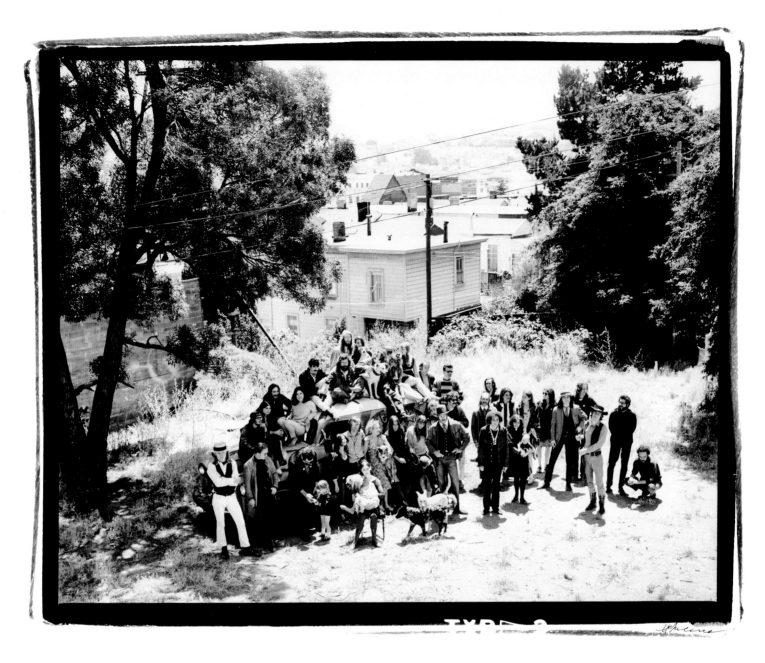

267 OPPOSITE ABOVE LEFT
HERB GREENE,
Big Brother and the Holding Company [left to right: Sam Andrews, David Getz, Janis Joplin, James Gurley, and Peter Albin], 1966 (printed 2006). Gelatin silver print.
FINE ARTS MUSEUMS OF SAN FRANCISCO, GIFT OF THE LASDON FOUNDATION, 2016.87.8

268 OPPOSITE ABOVE RIGHT
HERB GREENE,
Quicksilver Messenger Service [left to right: David Freiberg, Greg Elmore, Gary Duncan, John Cipollina, and Jim Murray], 1967 (printed 2006). Gelatin silver print.
FINE ARTS MUSEUMS OF SAN FRANCISCO, GIFT OF THE LASDON FOUNDATION, 2016.87.12

269 OPPOSITE BELOW LEFT
HERB GREENE,
Jefferson Airplane [back row, left to right: Jack Casady, Grace Slick, and Marty Balin; front row, left to right: Jorma Kaukonen, Paul Kantner, and Spencer Dryden], 1966 (printed 2006). Gelatin silver print.
FINE ARTS MUSEUMS OF SAN FRANCISCO, GIFT OF THE LASDON FOUNDATION, 2016.87.2

270 OPPOSITE BELOW RIGHT
HERB GREENE,
The Charlatans [left to right: George Hunter, Richie Olsen, Mike Wilhelm, Dan Hicks, and Mike Ferguson], 1967 (printed 2006). Gelatin silver print.
FINE ARTS MUSEUMS OF SAN FRANCISCO, GIFT OF THE LASDON FOUNDATION, 2016.87.3

271
HERB GREENE,
Pine Street, 1967 (printed 2016). Gelatin silver print.
FINE ARTS MUSEUMS OF SAN FRANCISCO, GIFT OF STEVEN EISENHAUER, 2016.89

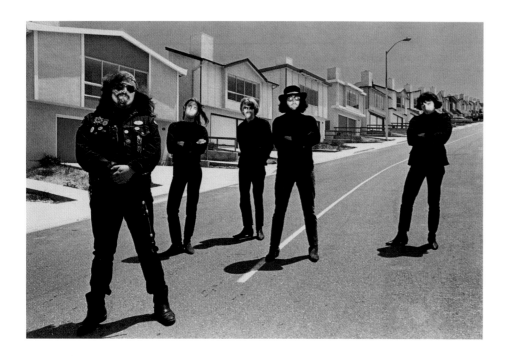

272 TOP
BOB SEIDEMANN,
Grateful Dead [left to right: Ron "Pigpen" McKernan, Bob Weir, Phil Lesh, Jerry Garcia, and Bill Kreutzmann], *Daly City,* 1967. Gelatin silver print.
COLLECTION OF THE ARTIST

273 MIDDLE
ELAINE MAYES,
Steve Miller at Home, Haight-Ashbury, 1967. Gelatin silver print.
COLLECTION OF THE ARTIST

274 BOTTOM
ELAINE MAYES,
Jimi Hendrix, Fillmore, San Francisco, 1967. Gelatin silver print.
COLLECTION OF THE ARTIST

275 OPPOSITE
JIM MARSHALL,
Grace & Janis, 1967 (printed 1991). Color dye transfer print.
COLLECTION OF JOHN J. LYONS

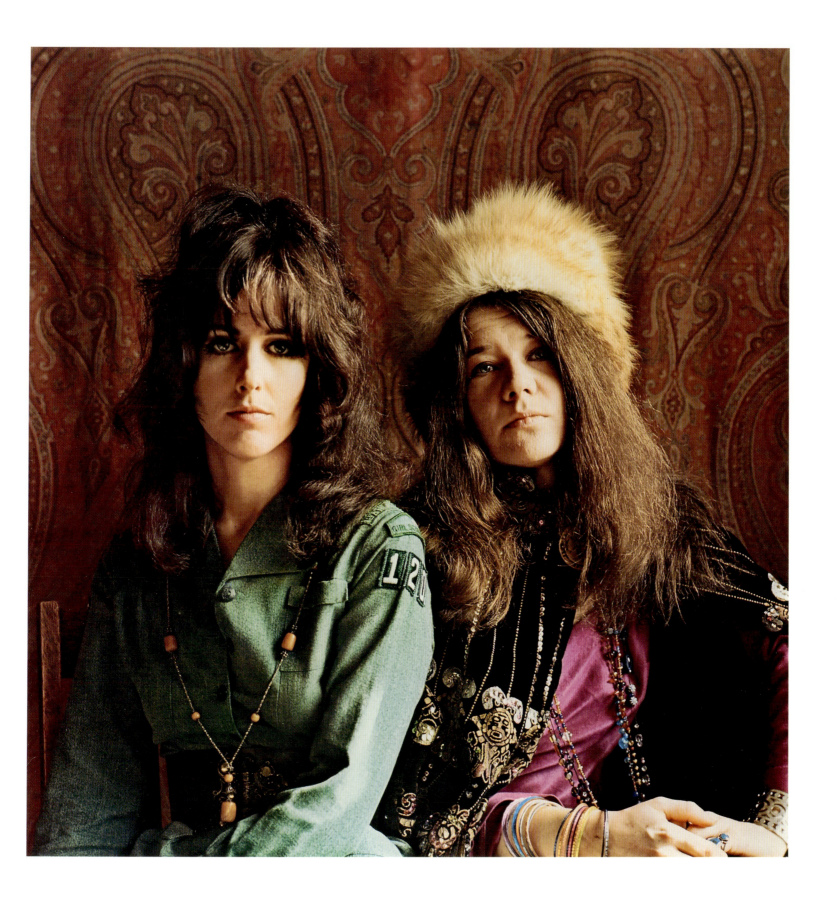

276
MARTY BALIN,
Jefferson Airplane — Surrealistic Pillow, 1967. RCA Victor label. Color offset lithograph album cover.
COURTESY OF MICKEY MCGOWAN, SAN RAFAEL, CA

277
STANLEY MOUSE and **ALTON KELLEY,**
The Grateful Dead, 1967. Warner Bros. label. Color offset lithograph album cover.
COURTESY OF MICKEY MCGOWAN, SAN RAFAEL, CA

278
JULES HALFANT,
Country Joe and the Fish — Electric Music for the Mind and Body, 1967. Vanguard label. Color offset lithograph album cover.
COURTESY OF MICKEY MCGOWAN, SAN RAFAEL, CA

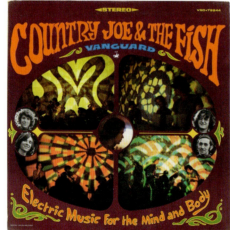

279
JIM MARSHALL,
Moby Grape, 1967. Columbia Records label. Color offset lithograph album cover.
COURTESY OF MICKEY MCGOWAN, SAN RAFAEL, CA

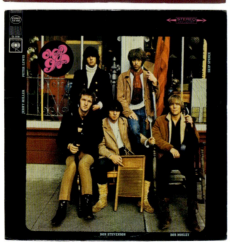

280
Big Brother & the Holding Company, 1967. Mainstream Columbia Records label. Color offset lithograph album cover.
COURTESY OF MICKEY MCGOWAN, SAN RAFAEL, CA

281
JOEL BRODSKY,
Country Joe and the Fish — I-Feel-Like-I'm-Fixin'-to-Die, 1967. Vanguard label. Color offset lithograph album cover.
COURTESY OF MICKEY MCGOWAN, SAN RAFAEL, CA

282
WILLIAM S. HARVEY and **BOB PEPPER,**
Love — Forever Changes, 1967. Elektra label. Color offset lithograph album cover.
COURTESY OF MICKEY MCGOWAN, SAN RAFAEL, CA

283
JULES HALFANT,
The Serpent Power, 1967. Vanguard label. Color offset lithograph album cover.
COURTESY OF MICKEY MCGOWAN, SAN RAFAEL, CA

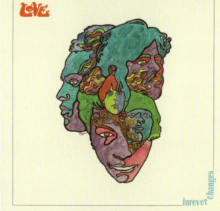

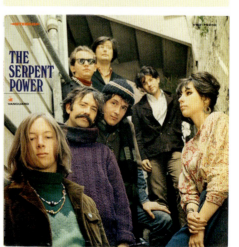

284
FRANK OBERLÄNDER for **RIVER OF MANY STREAMS PRODUCTIONS** in association with Dickie Peterson, *Blue Cheer — Vincebus Eruptum*, 1968. Philips label. Color offset lithograph album cover.
COURTESY OF MICKEY MCGOWAN, SAN RAFAEL, CA

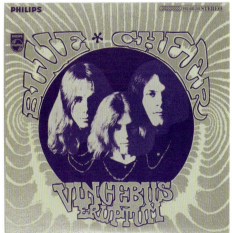

285
LAURIE CLIFFORD, *Creedence Clearwater Revival*, 1968. Fantasy Records label. Color offset lithograph album cover.
COURTESY OF MICKEY MCGOWAN, SAN RAFAEL, CA

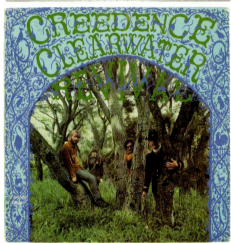

286
VICTOR MOSCOSO, *Steve Miller Band — Children of the Future*, 1968. Capitol Records label. Color offset lithograph album cover.
COURTESY OF MICKEY MCGOWAN, SAN RAFAEL, CA

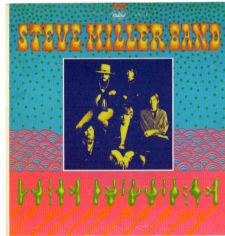

287
ROBERT CRUMB, *Big Brother & the Holding Company — Cheap Thrills*, 1968. Columbia Records label. Color offset lithograph album cover.
COURTESY OF MICKEY MCGOWAN, SAN RAFAEL, CA

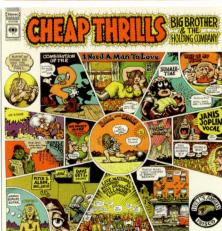

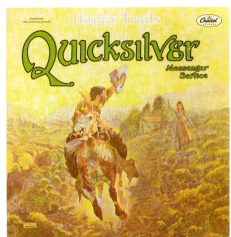

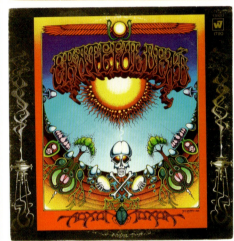

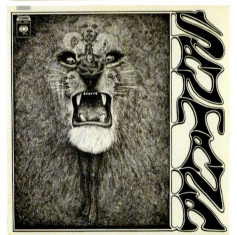

288
GEORGE HUNTER, *Quicksilver Messenger Service — Happy Trails*, 1969. Capitol Records label. Color offset lithograph album cover.
COURTESY OF MICKEY MCGOWAN, SAN RAFAEL, CA

289
RICK GRIFFIN, *The Grateful Dead — Aoxomoxoa*, 1969. Warner Bros.–Seven Arts label. Color offset lithograph album cover.
COURTESY OF MICKEY MCGOWAN, SAN RAFAEL, CA

290
LEE CONKLIN, *Santana*, 1969. Columbia Records label. Color offset lithograph album cover.
COURTESY OF MICKEY MCGOWAN, SAN RAFAEL, CA

291
GEORGE HUNTER, *It's a Beautiful Day*, 1969. Columbia Records CBC label. Color offset lithograph album cover.
COURTESY OF MICKEY MCGOWAN, SAN RAFAEL, CA

**292
COURTENAY POLLOCK,** *Pastel Stellar Blue Mandala,* ca. 1972. Cotton; resist-dyed (fold-resist).
COLLECTION OF THE ARTIST

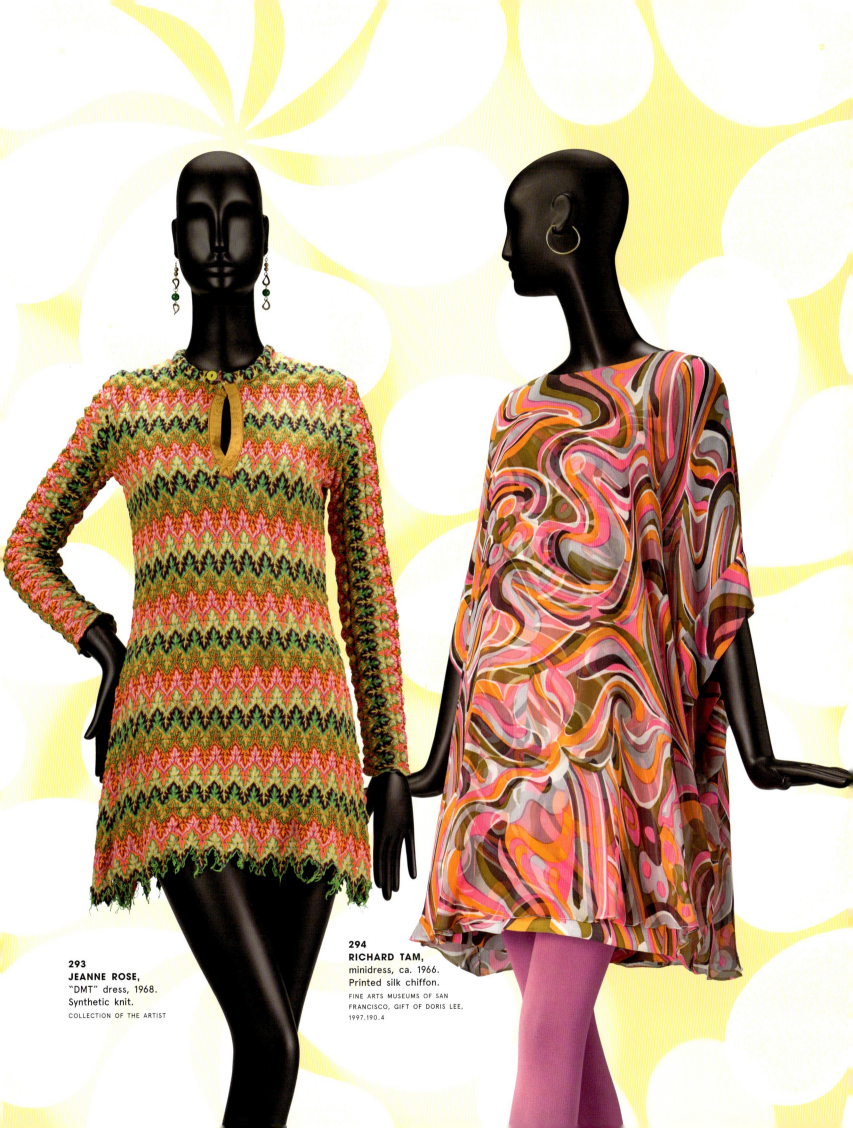

**293
JEANNE ROSE,**
"DMT" dress, 1968.
Synthetic knit.
COLLECTION OF THE ARTIST

**294
RICHARD TAM,**
minidress, ca. 1966.
Printed silk chiffon.
FINE ARTS MUSEUMS OF SAN FRANCISCO, GIFT OF DORIS LEE, 1997.190.4

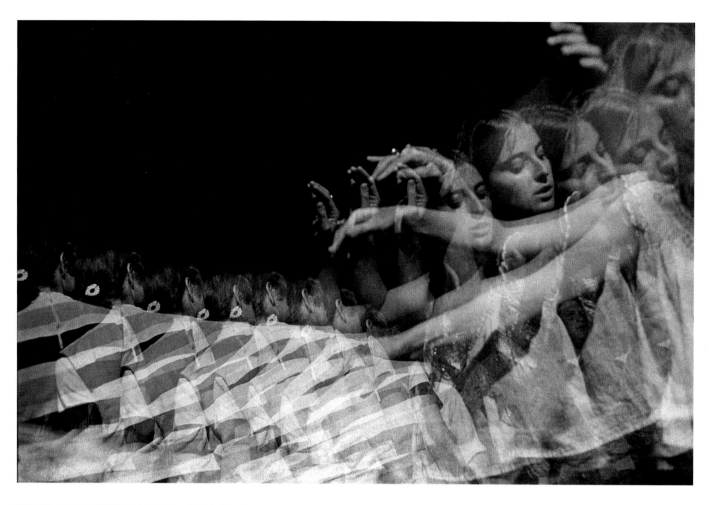
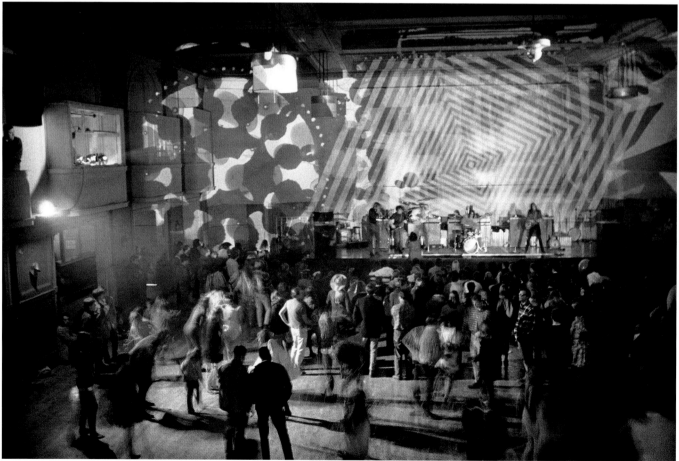

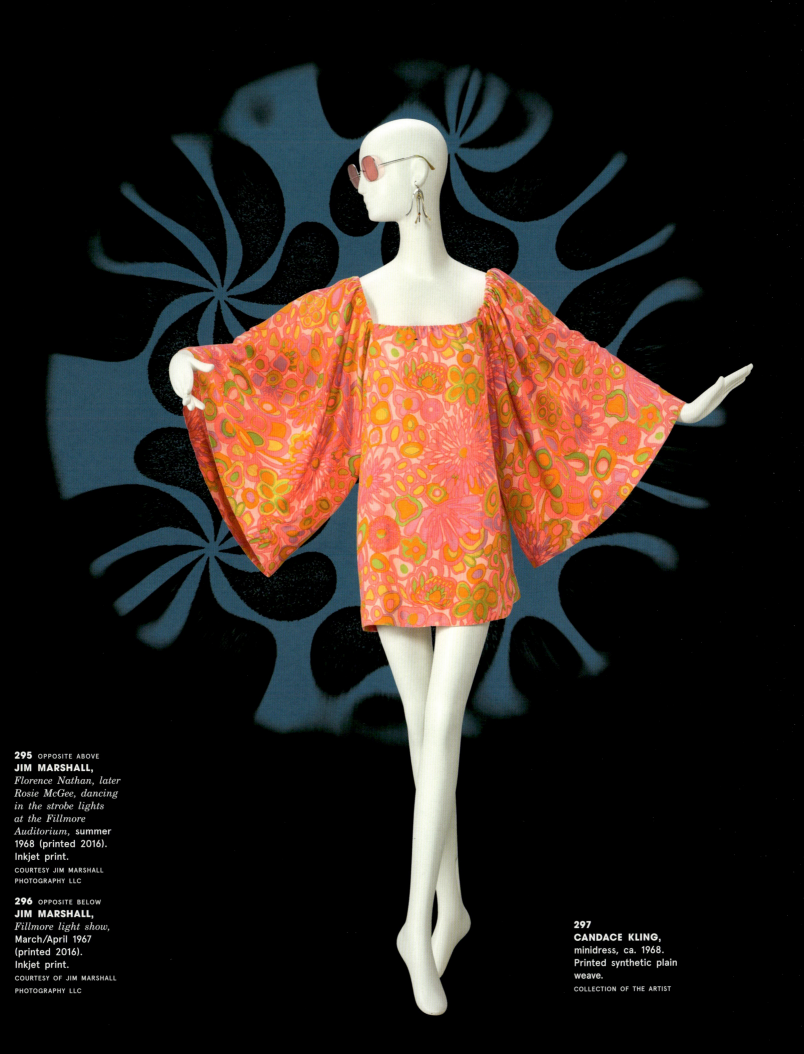

295 OPPOSITE ABOVE
JIM MARSHALL,
Florence Nathan, later Rosie McGee, dancing in the strobe lights at the Fillmore Auditorium, summer 1968 (printed 2016). Inkjet print.
COURTESY JIM MARSHALL PHOTOGRAPHY LLC

296 OPPOSITE BELOW
JIM MARSHALL,
Fillmore light show, March/April 1967 (printed 2016). Inkjet print.
COURTESY OF JIM MARSHALL PHOTOGRAPHY LLC

297
CANDACE KLING,
minidress, ca. 1968. Printed synthetic plain weave.
COLLECTION OF THE ARTIST

298
Top (worn as dress), ca. 1910. Silk net with glass bugle beads and sequin embroidery.
COLLECTION OF CICELY HANSEN

299
Dress, ca. 1920s (altered ca. 1970). Silk satin with embroidery (satin stitch), glass beads, and rhinestones.
COLLECTION OF THE KLING FAMILY

300
Shawl, ca. 1920. Silk mesh with metallic and silk thread embroidery (chain stitch).
COLLECTION OF MARNA CLARK

301
LESLIE ROWAN,
top, ca. 1970. Cotton velvet with sequin flower appliqués and ribbon trim.
COLLECTION OF PETER KAUKONEN

302
JACKY SARTI,
customized landlubber jeans, ca. 1970. Denim with cotton patches, ribbons, appliqué and reverse-appliqué San Blas Island (Panama) cotton *mola*, and applied rhinestone studs.
COLLECTION OF PETER KAUKONEN

303
JACKY SARTI,
choker, ca. 1970. Leather with beads.
COLLECTION OF PETER KAUKONEN

304
BIRGITTA BJERKE (100% BIRGITTA),
jacket, 1972. Crocheted wool.
COLLECTION OF SUSILA ZIEGLER

305
BIRGITTA BJERKE (100% BIRGITTA),
T-shirt, 1972. Hand-painted cotton knit with acrylic paint.
COLLECTION OF THE ARTIST

306
Bell-bottoms, ca. 1969. Levi's denim jeans.
COLLECTION OF LEVI STRAUSS & CO. ARCHIVES

"Every time I hear revolution, I hear evolution alongside it."

LENORE KANDEL

SECTION 8

what are we fighting for?

PARTICIPATION WAS AT THE HEART of San Francisco's counterculture, and nowhere was this felt more strongly than in gatherings where like-minded people came together in support of political and social change. Benefit concerts were one such space, with musicians, promoters, and concertgoers mobilizing in support of beneficiaries ranging from "Stop the Draft Week" and civil rights organizations to the burgeoning environmental and women's movements (pls. 308–309, 316, and 334). Posters advertising such events were, at least for artist Wes Wilson, "supposed to involve people in a sort of self experience," as he proclaimed in a November 1967 interview with the *Lowell Sun*. He continued, "I look at them as a way of getting some very heavyweight things out in front of the man on the street. Things I feel are important, such as learning to live in love and peace and not just euphemistically."

America's foreign policy and the war in Vietnam were areas of particular concern to the counterculture, and in San Francisco — as in urban centers throughout the United States — marches and rallies were one way to connect with others frustrated by the political climate. Notwithstanding philosophical beliefs, the war draft also had the potential to disrupt the lives of nearly all the youth who called the Haight-Ashbury home, and for many, their engagement with this movement was personal (pl. 307).

In addition to joining in protests and attending benefit concerts, members of the counterculture could also use dress to signal a particular affinity for a cause. Alvin Duskin's Peace Dress (pl. 310) was the ultimate sign of the times, while 100% Birgitta's Woman's "Hands" dress (pl. 311) announced an allegiance to the women's movement, which was gathering steam. Mickey McGowan's vegan boots (pls. 321–324) suggest an enthusiasm for the nascent environmental, organic, and health food movements.

In the Bay Area, the nation's Civil Rights movement took on a revolutionary feel thanks to Huey P. Newton and Bobby Seale's Black Panther Party for Self-Defense, founded in Oakland in October 1966. Photographs by Ruth-Marion Baruch, Pirkle Jones, and Stephen Shames capture the militant group's intense commitment to community-led action. With early goals to build a better community through service and outreach, the Panthers spoke out in defense of the oppressed and organized programs to benefit communities in need, such as the distribution of free food (pls. 332–333).

The 1960s are often discussed in terms of revolution. Throughout the decade and around the world, a generation of young people took direct action, effecting a series of social and political transformations. Fifty years later, government policies resulting from such interventions render a way of life in the West that would have been unimaginable to all but the surest of sixties visionaries. The aesthetic legacies of the period persist, too, felt most strongly in the world of fashion, where so-called "bohemian chic" continues to make its mark, conjuring memories of a turbulent yet hopeful period of American history. Intellectuals, philosophers, and poets of the day provided mounting evidence that change across all spectra of society was not only possible, but fundamentally preferable. Literature, both contemporary and historical, provided an important means by which members of the counterculture could evaluate and propose changes to the social order, and they gravitated particularly toward texts that explored such prospects (see pls. 345–360).

DRAFT AGE? Listen —

Ultimately you can listen to only One Thing,
not your President,
not your misguided Leaders, save a few,
not the Communists or the Socialists
or the Republicans or the Democrats,
But you must listen to your own Heart,
& do what it dictates.
Because your heart is the Only Thing
which can tell you what is Right
& what is wrong.
And after you have found out
what you think is right and what is wrong,
then you must know that You can say Yes
to what is Right & No to what is wrong.
& You Young Men, for instance,
If you feel that to Kill is wrong
& to go to war is wrong,
you have to say No to the Draft.
And if You Young Ladies think
it is wrong to kill, & war is wrong
You can say yes to the young men
who say no to the Draft.
Because it is not the leaders & the dictators,
it is not God
who is going to get us out
of the bloody mess we are in.
It is only you and only me.

— Joan Baez

american friends service committee
2160 lake street — san francisco

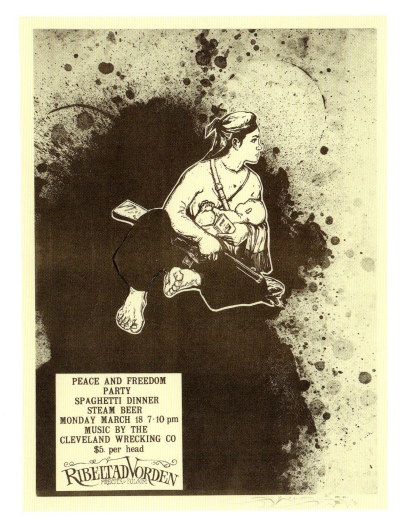
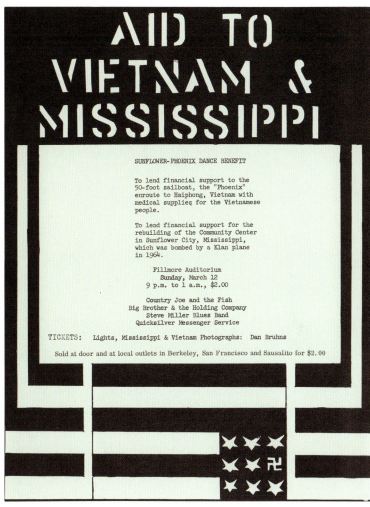

307 OPPOSITE
JOAN BAEZ, *Draft-Age? Listen,* ca. 1968. Electrophotographic print (Xerox) handbill on orange paper.
COLLECTION OF JOHN J. LYONS

308 LEFT
STANLEY MOUSE, "Peace and Freedom Party Dinner," Cleveland Wrecking Co., March 18, Ribeltad Vorden, 1968. Offset lithograph poster.
FINE ARTS MUSEUMS OF SAN FRANCISCO, GIFT OF THE GARY WESTFORD COLLECTION, IN HONOR OF PEACE AND FREEDOM EVERYWHERE, 2017.7.41

309 RIGHT
Aid to Vietnam & Mississippi, Sunflower — Phoenix Dance Benefit, Country Joe and the Fish, Big Brother & the Holding Company, Steve Miller Blues Band, Quicksilver Messenger Service, 1967. Stencil duplicate print (mimeograph) handbill.
COLLECTION OF JOHN J. LYONS

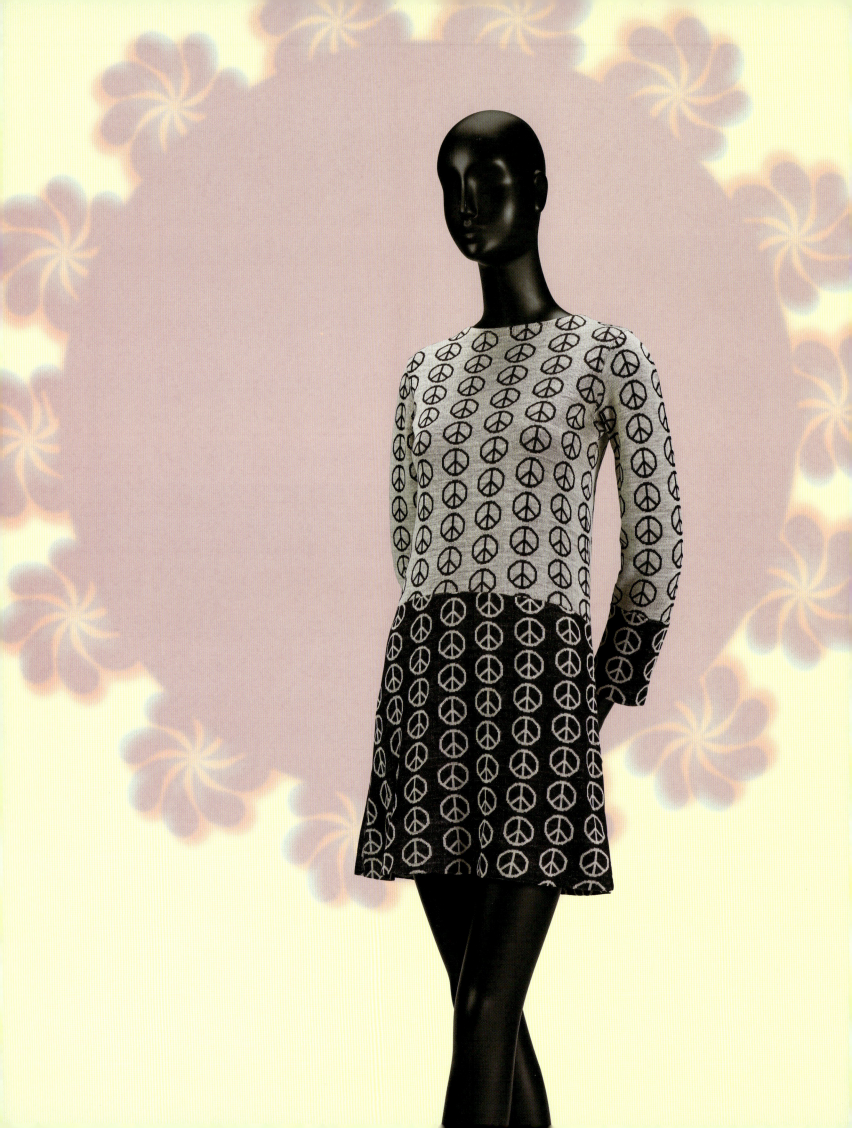

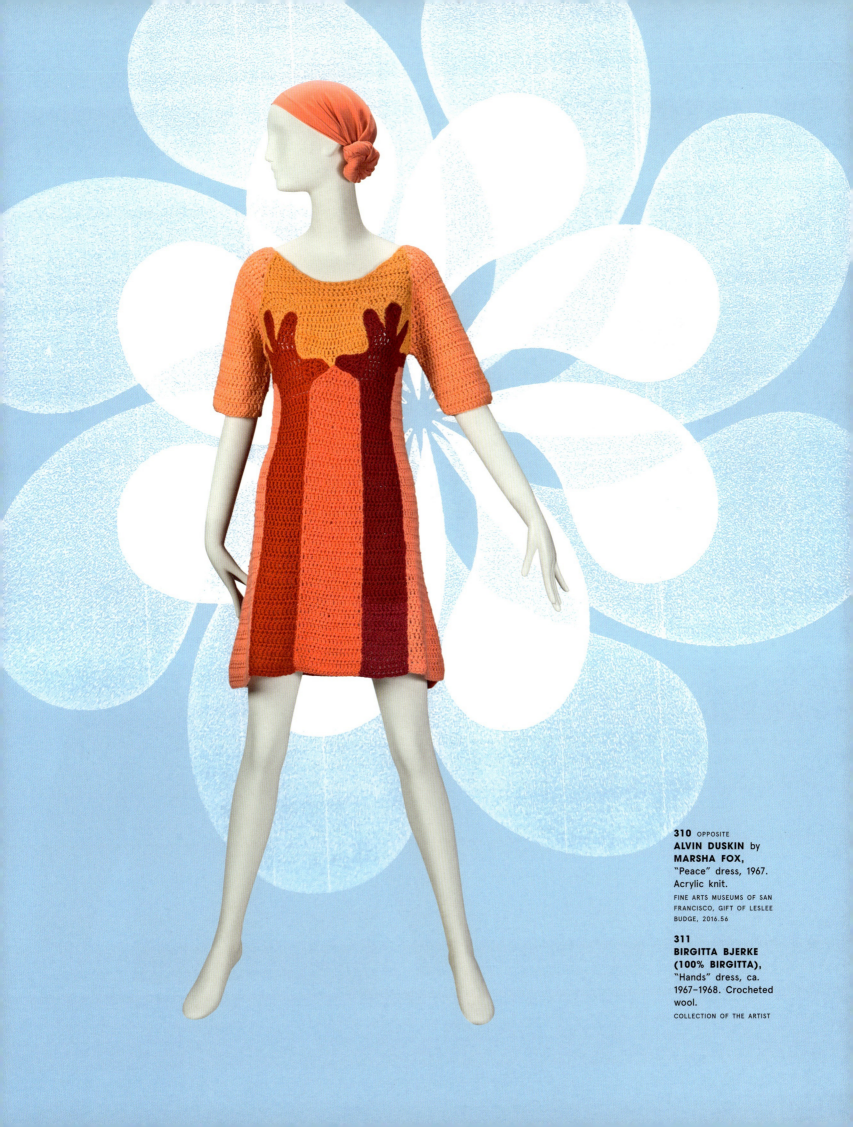

310 OPPOSITE
ALVIN DUSKIN by **MARSHA FOX**, "Peace" dress, 1967. Acrylic knit.
FINE ARTS MUSEUMS OF SAN FRANCISCO, GIFT OF LESLEE BUDGE, 2016.56

311
BIRGITTA BJERKE (100% BIRGITTA), "Hands" dress, ca. 1967–1968. Crocheted wool.
COLLECTION OF THE ARTIST

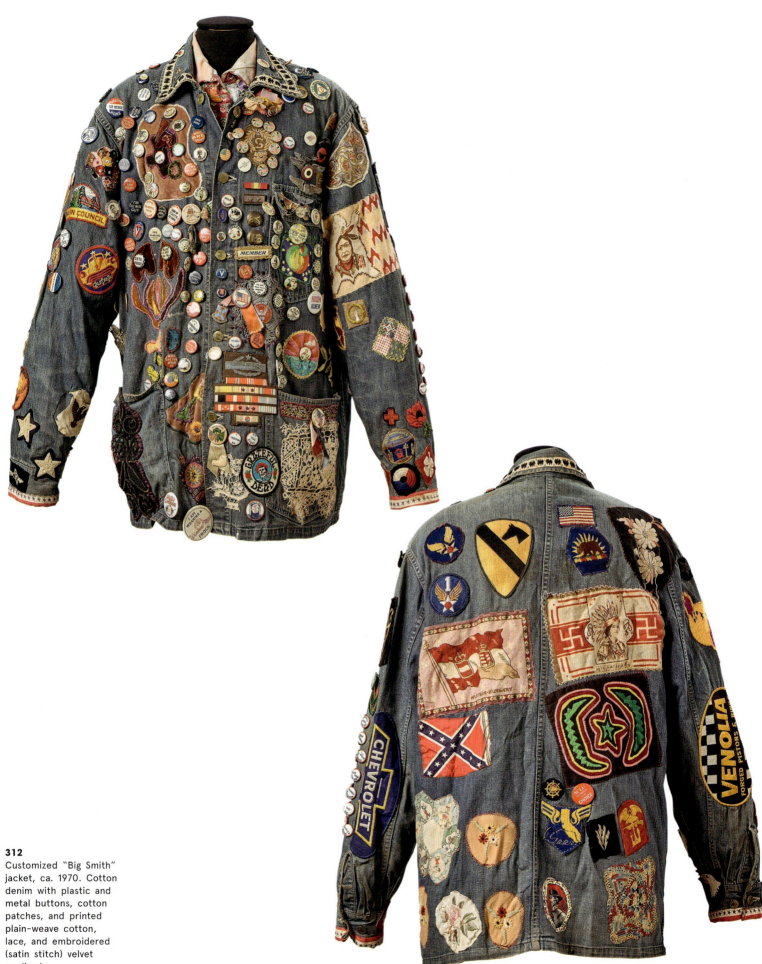

312
Customized "Big Smith" jacket, ca. 1970. Cotton denim with plastic and metal buttons, cotton patches, and printed plain-weave cotton, lace, and embroidered (satin stitch) velvet appliqués.
COLLECTION OF CHARLIE AND JEAN STEWART

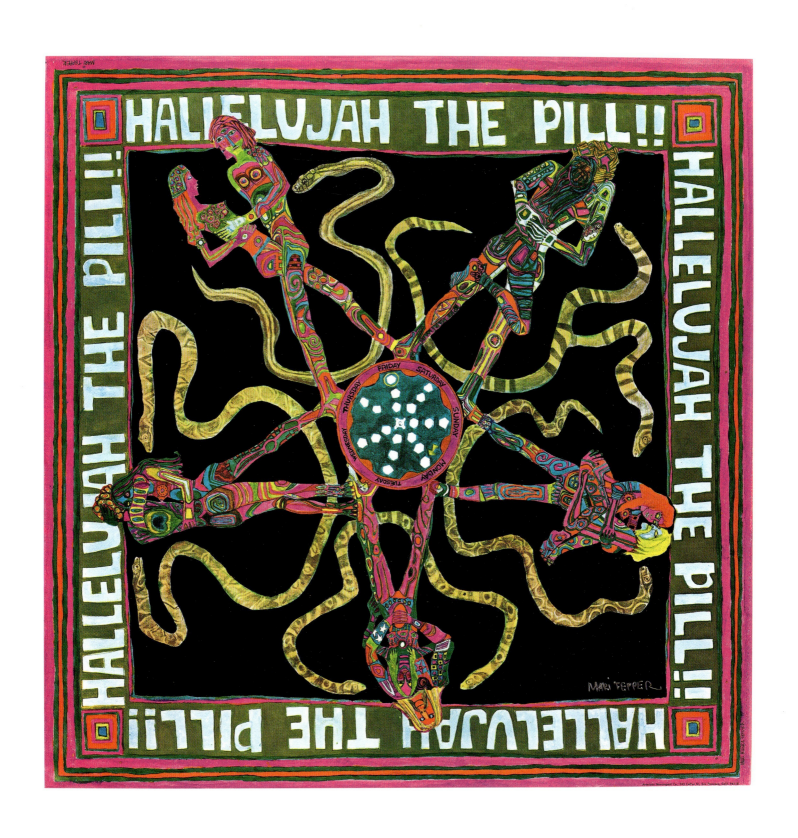

**313
MARI TEPPER,**
Hallelujah the Pill!!,
1967. Color offset
lithograph poster.
COLLECTION OF RON AND
JASMINE SCHAEFFER, THE ROCK
POSTER SOCIETY

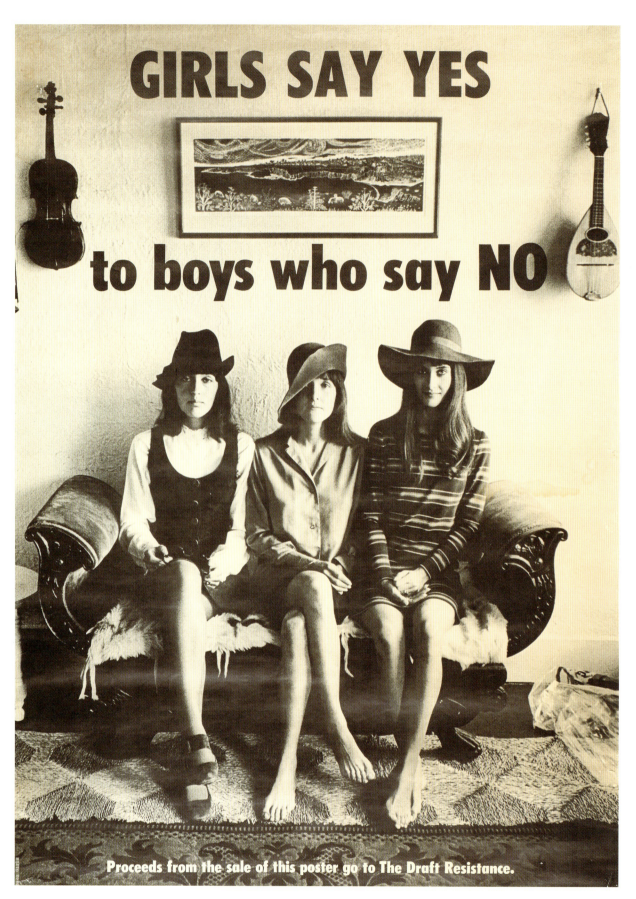

314
Photograph by **JIM MARSHALL**, *GIRLS SAY YES to boys who say NO*, 1968. Offset lithograph poster.
COLLECTION OF JOAN BAEZ

315 OPPOSITE ABOVE LEFT
Kiss In, April 7, Hall of Justice Steps, 1967. Color screenprint.
COLLECTION OF JOHN J. LYONS

316 OPPOSITE ABOVE RIGHT
Stop the Draft Week Defense Fund dance concert, Phil Ochs, Loading Zone, Blue Cheer, Mad River, Mt. Rushmore, The Committee, Light Show, January 7, Fillmore, 1968. Red and blue stencil duplicate print (mimeograph) handbill.
COLLECTION OF JOHN J. LYONS

317 OPPOSITE BELOW LEFT
RUPERT GARCIA, *The War and Children*, 1967. Etching.
FINE ARTS MUSEUMS OF SAN FRANCISCO, GIFT OF MR. AND MRS. ROBERT MARCUS, 1990.1.55

318 OPPOSITE BELOW RIGHT
STANLEY MOUSE, *"Libertie," Blood, Sweat and Tears, John Handy, Son House, March 15–17, Avalon Ballroom*, 1968. Color offset lithograph poster.
FINE ARTS MUSEUMS OF SAN FRANCISCO, MUSEUM PURCHASE, ACHENBACH FOUNDATION FOR GRAPHIC ARTS ENDOWMENT FUND, 1974.13.151

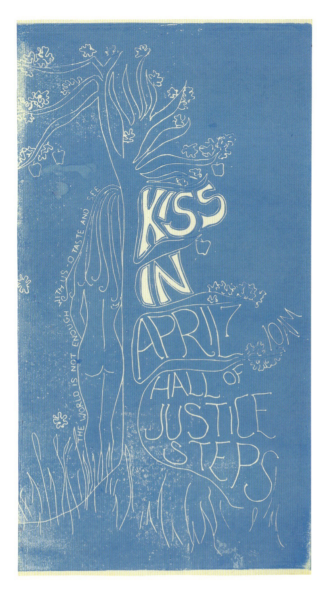
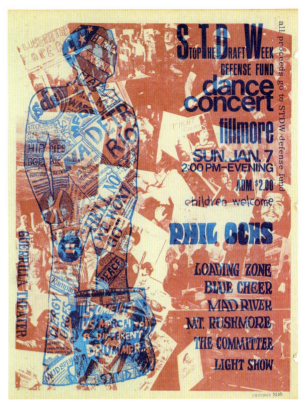

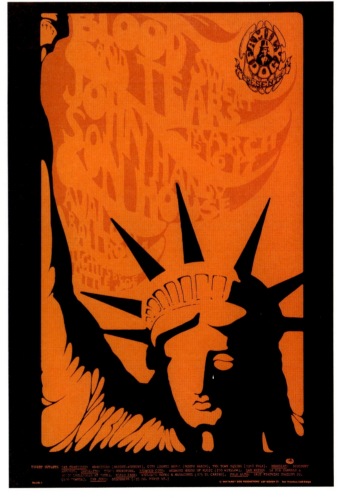

279

CRY FREEDOM

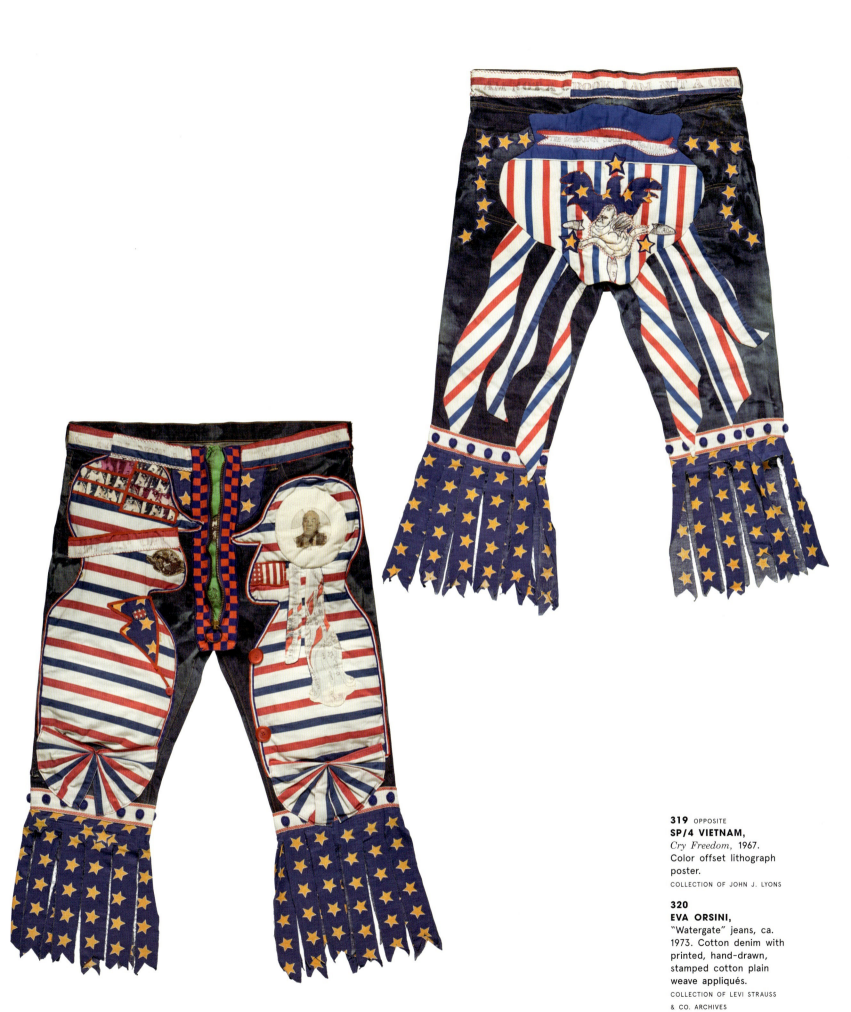

319 OPPOSITE
SP/4 VIETNAM,
Cry Freedom, 1967.
Color offset lithograph poster.
COLLECTION OF JOHN J. LYONS

320
EVA ORSINI,
"Watergate" jeans, ca. 1973. Cotton denim with printed, hand-drawn, stamped cotton plain weave appliqués.
COLLECTION OF LEVI STRAUSS & CO. ARCHIVES

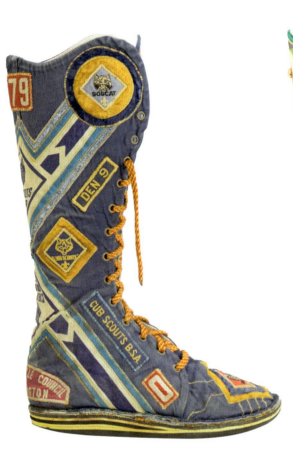
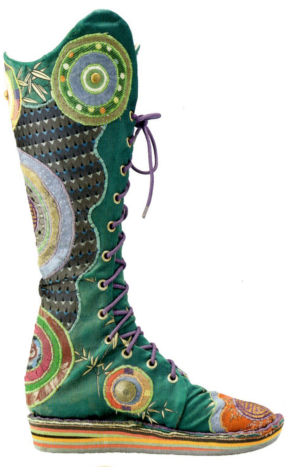
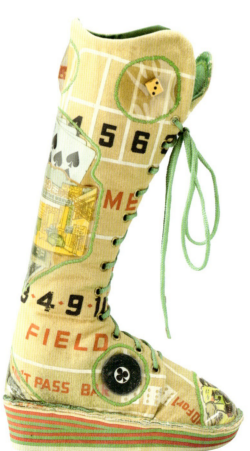
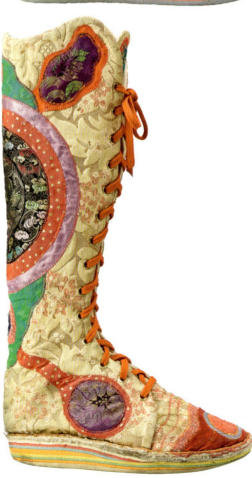

321 ABOVE LEFT
MICKEY MCGOWAN (APPLE COBBLER), "Cub Scout" boot, ca. 1975. Appliquéd cotton twill weave Cub Scout uniform, machine embroidered patches, and neoprene rubber soles.
COLLECTION OF THE ARTIST

322 ABOVE RIGHT
MICKEY MCGOWAN (APPLE COBBLER), "Ocean Tantra" boot, ca. 1975. Appliquéd silk and cotton complex weave, brass button, wood beads, and neoprene rubber soles.
COLLECTION OF THE ARTIST

323 BELOW LEFT
MICKEY MCGOWAN (APPLE COBBLER), "Gambling" boot, ca. 1975. Appliquéd gambling table felt, poker chips, playing cards, dice, and neoprene rubber soles.
COLLECTION OF THE ARTIST

324 BELOW RIGHT
MICKEY MCGOWAN (APPLE COBBLER), "Mandala" boot, ca. 1975. Appliquéd Chinese silk complex weaves, silk velvet, and neoprene rubber soles.
COLLECTION OF FINNLANDIA

325 OPPOSITE
STANLEY MOUSE and **ALTON KELLEY,** *10th Biennial Wilderness Conference sponsored by the Sierra Club, April 7, 8, 9, Hilton Hotel,* 1967. Color offset lithograph poster.
COLLECTION OF JOHN J. LYONS

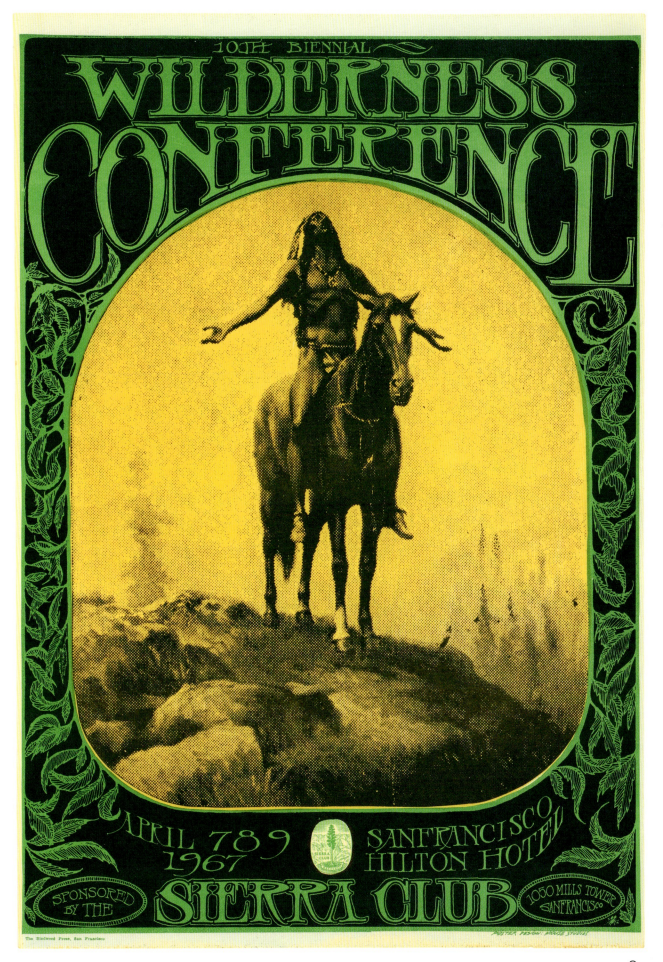

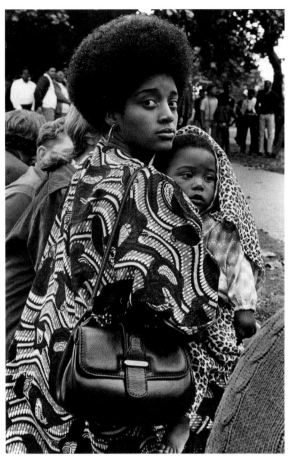
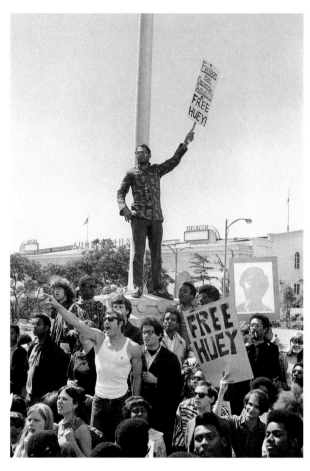

326 ABOVE LEFT
RUTH-MARION BARUCH, *Mother and Child, Free Huey Rally, De Fremery Park, Oakland, July 28, 1968.* Gelatin silver print.
LUMIÈRE GALLERY, ATLANTA, AND ROBERT A. YELLOWLEES

327 ABOVE RIGHT
STEPHEN SHAMES, *Oakland Courthouse at First Huey P. Newton Trial for "Murder," October 1968,* printed ca. 1968. Gelatin silver print.
STEVEN KASHER GALLERY

328 BELOW LEFT
STEPHEN SHAMES, *David Hilliard, Panther Chief of Staff, Looks over a Drawing by Emory Douglas in the March 7, 1970 issue of "The Black Panther," Oakland, California,* printed ca. 1970. Gelatin silver print.
STEVEN KASHER GALLERY

329 BELOW RIGHT
RUTH-MARION BARUCH, *Young Woman, Free Huey Rally, De Fremery Park, Oakland, July 14, 1968.* Gelatin silver print.
LUMIÈRE GALLERY, ATLANTA, AND ROBERT A. YELLOWLEES

330 OPPOSITE ABOVE
PIRKLE JONES, *Black Panthers from Sacramento, Free Huey Rally, Bobby Hutton Park, Oakland, #62, August 25, 1968.* Gelatin silver print.
COURTESY SPECIAL COLLECTIONS, UNIVERSITY LIBRARY, UNIVERSITY OF CALIFORNIA, SANTA CRUZ. PIRKLE JONES AND RUTH-MARION BARUCH PHOTOGRAPHS

331 OPPOSITE BELOW
PIRKLE JONES, *Black Panthers during drill, De Fremery Park, Oakland, #57, 1968.* Gelatin silver print.
COURTESY SPECIAL COLLECTIONS, UNIVERSITY LIBRARY, UNIVERSITY OF CALIFORNIA, SANTA CRUZ. PIRKLE JONES AND RUTH-MARION BARUCH PHOTOGRAPHS

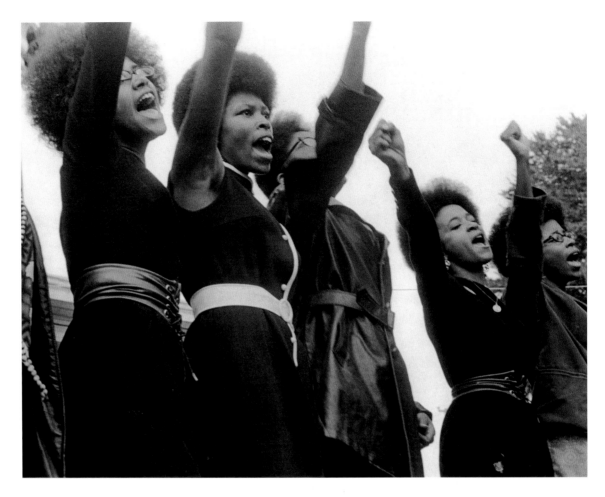
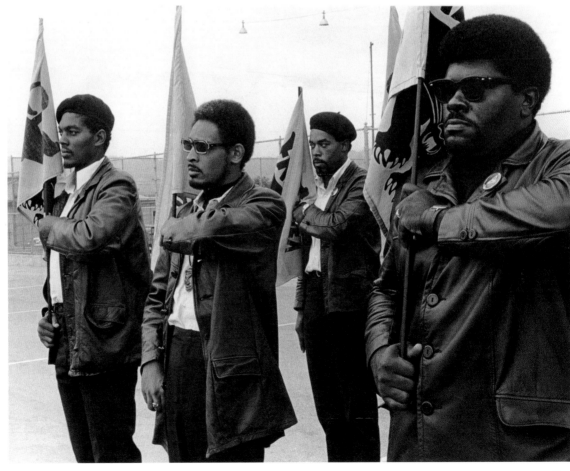

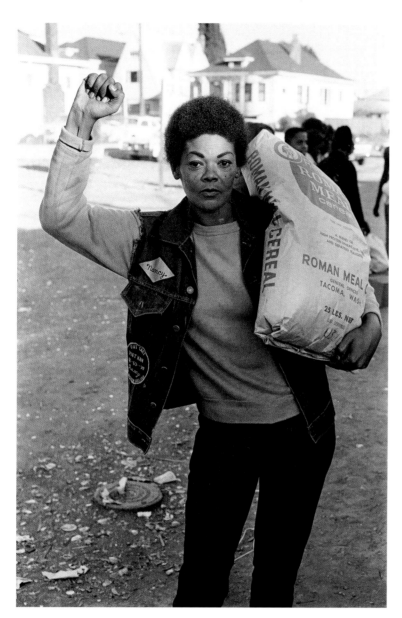
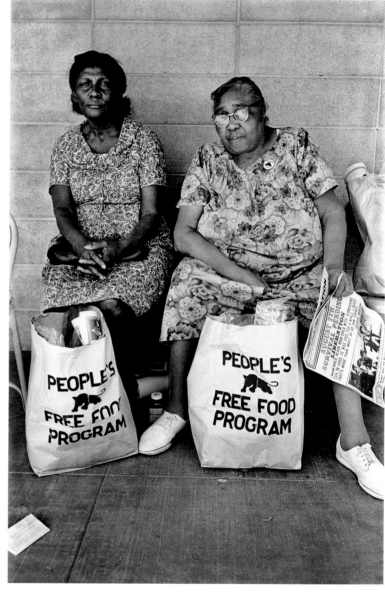

332 LEFT
STEPHEN SHAMES,
Free Food Program, California, 1972, ca. 1972. Gelatin silver print.
STEVEN KASHER GALLERY

333 RIGHT
STEPHEN SHAMES,
Two Women with Bags of Food at the People's Free Food Program, One of the Panther's Survival Programs, Palo Alto, California, October 1972, ca. 1972. Gelatin silver print.
STEVEN KASHER GALLERY

334 OPPOSITE
A Musical Concert for the Benefit and Welfare of The Widow and Children of Dr. Martin Luther King Jr., April 27, Fillmore Auditorium, 1968. Offset lithograph poster.
COLLECTION OF JOHN J. LYONS

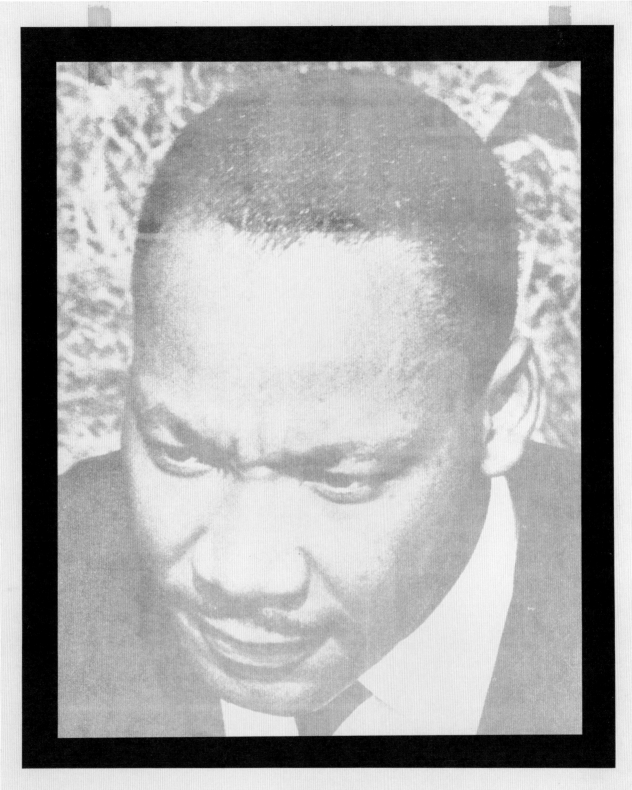

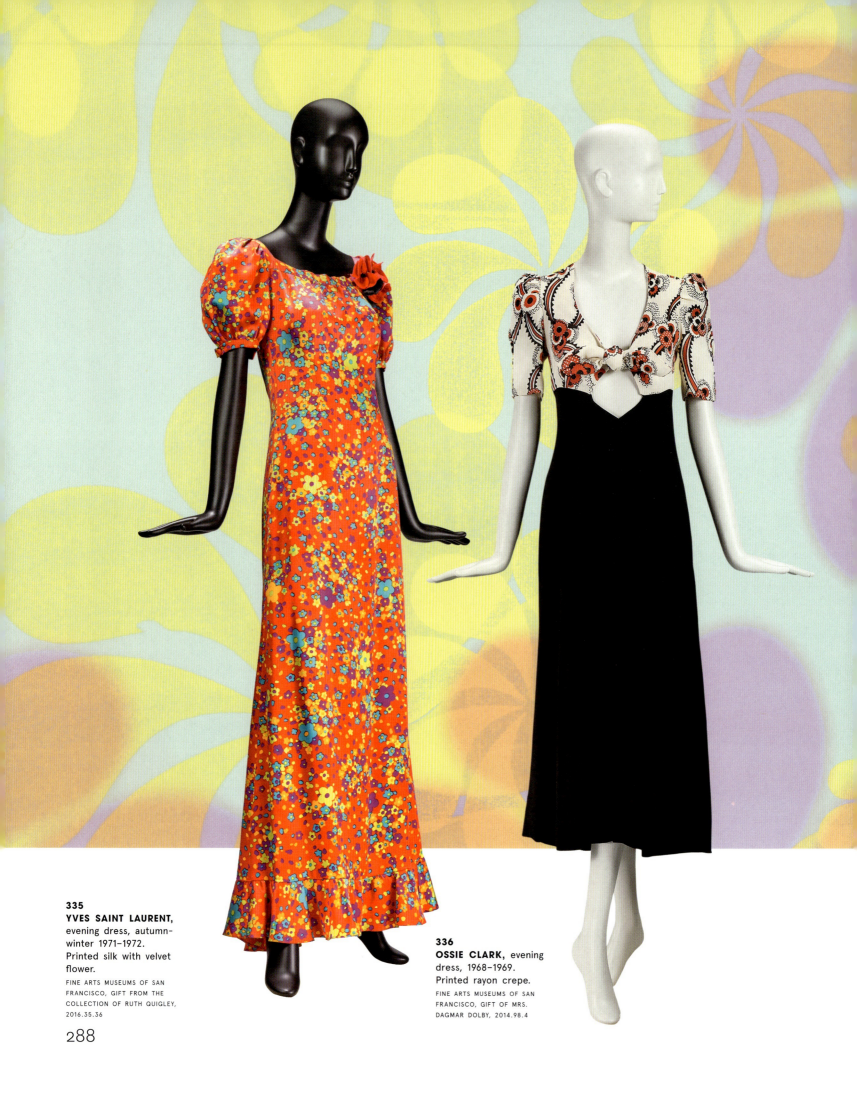

335
YVES SAINT LAURENT, evening dress, autumn-winter 1971–1972. Printed silk with velvet flower.
FINE ARTS MUSEUMS OF SAN FRANCISCO, GIFT FROM THE COLLECTION OF RUTH QUIGLEY, 2016.35.36

336
OSSIE CLARK, evening dress, 1968–1969. Printed rayon crepe.
FINE ARTS MUSEUMS OF SAN FRANCISCO, GIFT OF MRS. DAGMAR DOLBY, 2014.98.4

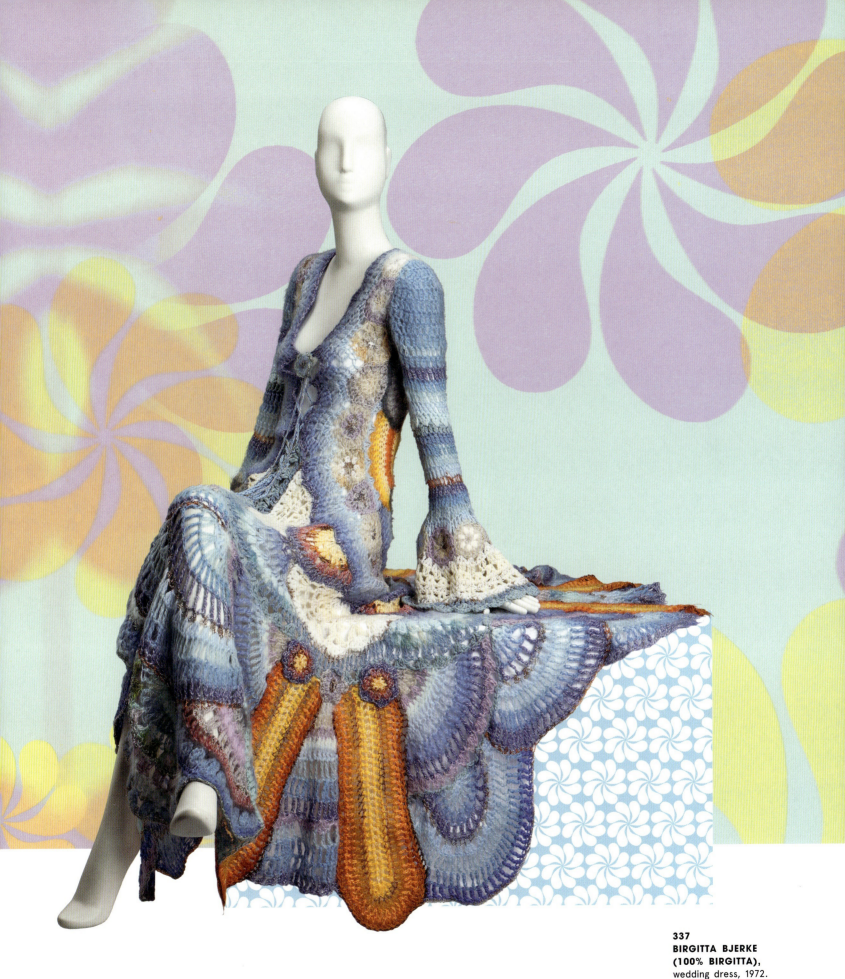

**337
BIRGITTA BJERKE
(100% BIRGITTA),**
wedding dress, 1972.
Crocheted wool.
COLLECTION OF BARBARA KAYFETZ

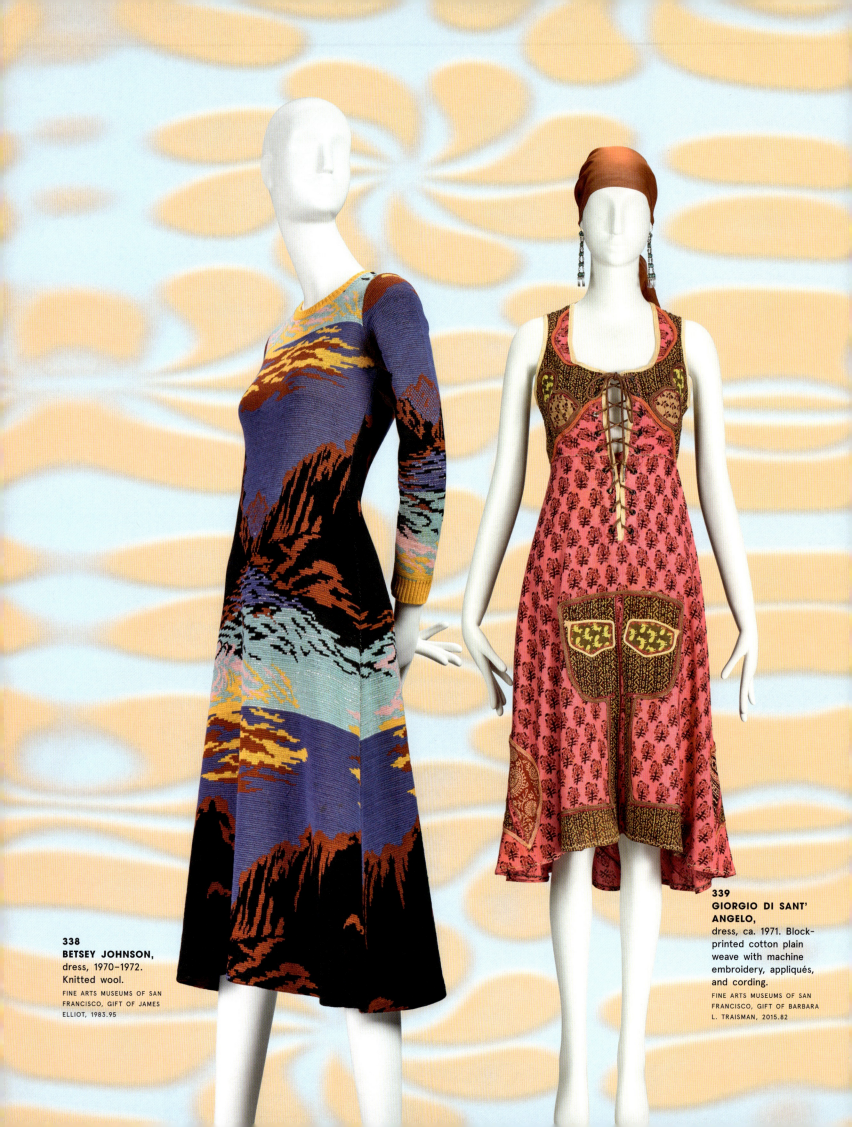

**338
BETSEY JOHNSON,** dress, 1970–1972. Knitted wool.
FINE ARTS MUSEUMS OF SAN FRANCISCO, GIFT OF JAMES ELLIOT, 1983.95

**339
GIORGIO DI SANT' ANGELO,** dress, ca. 1971. Block-printed cotton plain weave with machine embroidery, appliqués, and cording.
FINE ARTS MUSEUMS OF SAN FRANCISCO, GIFT OF BARBARA L. TRAISMAN, 2015.82

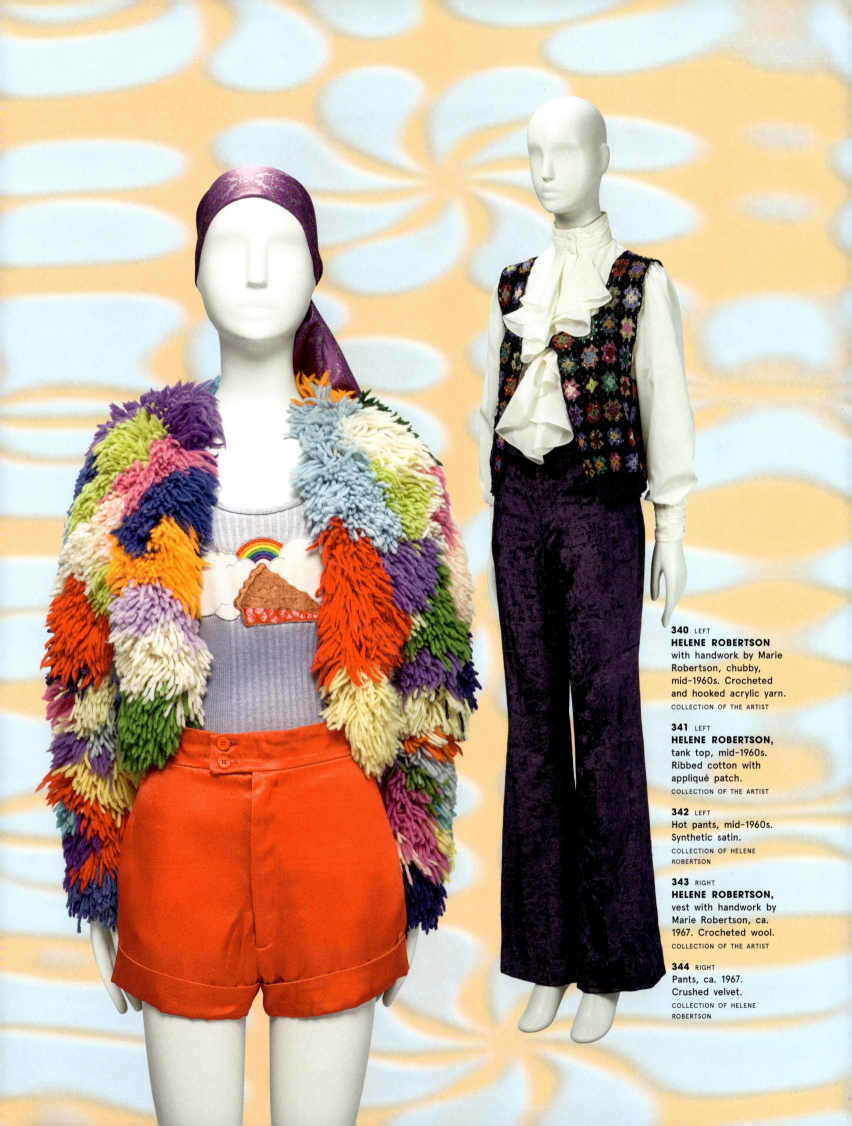

340 LEFT
HELENE ROBERTSON with handwork by Marie Robertson, chubby, mid-1960s. Crocheted and hooked acrylic yarn.
COLLECTION OF THE ARTIST

341 LEFT
HELENE ROBERTSON, tank top, mid-1960s. Ribbed cotton with appliqué patch.
COLLECTION OF THE ARTIST

342 LEFT
Hot pants, mid-1960s. Synthetic satin.
COLLECTION OF HELENE ROBERTSON

343 RIGHT
HELENE ROBERTSON, vest with handwork by Marie Robertson, ca. 1967. Crocheted wool.
COLLECTION OF THE ARTIST

344 RIGHT
Pants, ca. 1967. Crushed velvet.
COLLECTION OF HELENE ROBERTSON

345
HERMANN HESSE,
Siddhartha, 1951.
Published by New
Directions Books. Offset
lithograph book cover.
COLLECTION OF JOHN J. LYONS

349
**HENRY DAVID
THOREAU,**
Walden, 1962. Published
by Time Reading
Program. Color offset
lithograph book cover.
COLLECTION OF JOHN J. LYONS

346
ALDOUS HUXLEY,
The Doors of Perception,
1954. Published by
Chatto & Windus.
Color offset lithograph
book cover.
COLLECTION OF JOHN J. LYONS

350
GUY and **CANDIE
CARAWAN** for **THE
STUDENT NON-VIOLENT
COORDINATING
COMMITTEE,** *We Shall
Overcome! Songs of the
Southern Freedom
Movement,* 1963.
Published by Oak
Publications. Color
offset lithograph book
cover.
COLLECTION OF JOHN J. LYONS

347
ALLEN GINSBERG,
Howl and Other Poems,
1959. Published by City
Lights Books. Offset
lithograph book cover.
COLLECTION OF JOHN J. LYONS

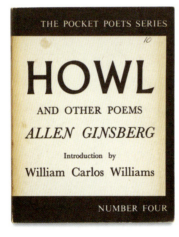

351
RICHARD BRAUTIGAN,
*Trout Fishing in
America,* 1964. Published
by Dell Publishing Co.,
Inc. Offset lithograph
book cover.
COLLECTION OF JOHN J. LYONS

348
KEN KESEY,
*One Flew Over the
Cuckoo's Nest,* 1962.
Published by New
American Library. Color
offset lithograph book
cover.
COLLECTION OF JOHN J. LYONS

352
**TIMOTHY LEARY,
RALPH METZNER,** and
RICHARD ALPERT,
*The Psychedelic
Experience: A Manual
Based on the Tibertan
Book of the Dead,* 1964.
Published by University
Books. Color offset
lithograph book cover.
COLLECTION OF JOHN J. LYONS

353
Now Now, 1965.
Published by Ari
Publications. Color
offset lithograph journal
cover.
COLLECTION OF JOHN J. LYONS

354
*We Accuse: A powerful
statement of the new
political anger in
America, as revealed in
the speeches given at the
36-hour "Vietnam Day"
protest in Berkeley,
California,* 1965.
Published by Diablo
Press. Color offset
lithograph book cover.
COLLECTION OF JOHN J. LYONS

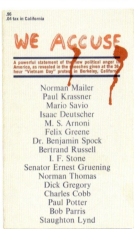

355
Evergreen, review
no. 42, August 1966.
Color offset lithograph
journal cover.
COLLECTION OF JOHN J. LYONS

356
LENORE KANDEL,
The Love Book,
1966. Published by
Stolen Paper
Review Editions.
Color offset
lithograph book
cover.
COLLECTION OF JOHN J. LYONS

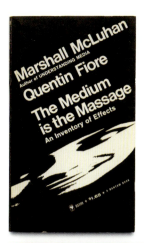

357
MARSHALL MCLUHAN
and **QUENTIN FIORE,**
*The Medium is the
Massage: An Inventory
of Effects,* 1967.
Published by Bantam
Books. Offset lithograph
book cover.
COLLECTION OF JOHN J. LYONS

358
STEWART BRAND,
*Whole Earth Catalog:
Access to Tools,* 1969.
Offset lithograph book
cover.
COURTESY OF MICKEY
MCGOWAN, SAN RAFAEL, CA

359
PETER MATTHIESSEN,
*Sal Si Puedes: Cesar
Chavez and the New
American Revolution,*
1969. Published by
Random House, Inc.
Color offset lithograph
book cover.
COLLECTION OF JOHN J. LYONS

360
GARY SNYDER,
Earth House Hold, 1969.
Published by New
Directions Books. Offset
lithograph book cover.
COLLECTION OF JOHN J. LYONS

san francisco psychedelic rock posters

the art of photo-offset lithography

VICTORIA BINDER

IN THE GARAGE of a three-story Victorian near the corner of Noe and Henry Streets, surrounded by a collection of old pump organs, a one-color offset lithographic press rhythmically cranked out some of the most iconic rock posters of 1960s San Francisco. There was the sultry green-haired Mucha-esque beauty of Stanley Mouse and Alton Kelley (pl. 184); the Family Dog's poker-faced logo of a Native American reinvented with blue-and-red pinwheel eyes by Victor Moscoso (pl. 208); and Wes Wilson's jubilant figure of Salvador Dalí leaping out of the poster on a bending waterfall of pink bands.[1] Bindweed Press, owned by Frank Westlake, was one of a handful of small offset lithographic shops that printed some the most vibrant and groundbreaking posters of the twentieth century.[2]

These posters were created to promote live music and dance events for venues such as the famed Avalon Ballroom, Fillmore Auditorium, and the Matrix, advertising many of the greatest rock bands of the late sixties and early seventies (see Selvin, this volume).[3] The psychedelic posters, designed by artists, including Wes Wilson, Alton Kelley, Stanley Mouse, Rick Griffin, Victor Moscoso, Bonnie MacLean, Lee Conklin,

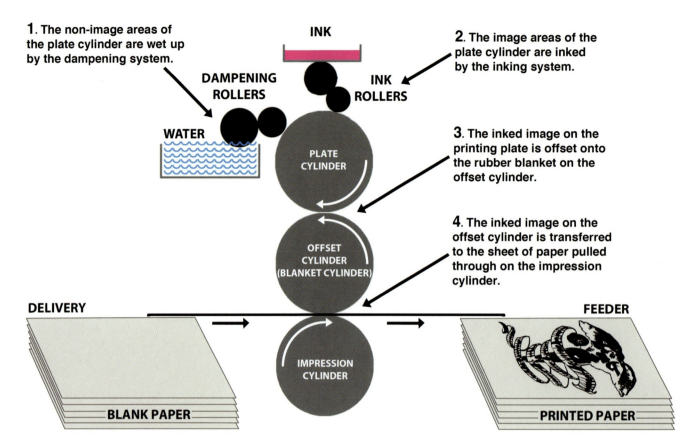

62
Diagram of an offset lithography press with one printing unit

and David Singer, reflect the sounds and visual chaos of the dance concerts, the mind-altering experience of psychotropic drugs, and the experimentation of the hippie counterculture. Working under tight deadlines, the artists broke every rule of conventional design, creating works using distorted forms, unreadable lettering, unusual color combinations, and various collage elements nicked from popular culture and art historical references (see Terry, this volume).

Though the posters are recognized around the world, few people know the story and process of how they were made. Fortunately, many of those involved in the creation of the posters have shared their stories firsthand for this essay, giving us a rare perspective on the working methods and approach of the artists and printers. A few of the early posters for the Family Dog concerts were screenprints, but the majority of the Family Dog, Bill Graham, and the Neon Rose posters were made using the process of photo-offset lithography. This workhorse of printing, with its complicated equipment and production sequence, left very little room for artistic experimentation. It was during the 1960s and early 1970s in the small photo-offset lithographic shops such as Bindweed Press that commercial need and artistic vision came together in the creation of psychedelic rock posters. They were printed at a number of other small offset lithography shops in San Francisco, including Rapid Reproductions; Contact Printing; West Coast Lithograph Co.; Double-H Press; Creative Litho; Neal, Stratford & Kerr; and, most famously, California Litho Plate Co. and Tea Lautrec Lithography. These were "job shops" that were convenient and affordable, printing advertisements such as posters and fliers, maps, menus, pamphlets, brochures, and small book runs.[4]

Double-H Press, nestled in the 1700 block of Haight Street in the heart of the emerging counterculture, was in the right place at the right time. The other shops were scattered throughout the city and could be found in neighborhoods as diverse as the Financial District, South of Market, and the Mission. These print shops ranged from one-man operations with a single press, such as Bindweed, to establishments like Neal, Stratford & Kerr, which was outfitted with a suite of departments, including typesetting, design, printing, and binding.[5]

These were not huge commercial establishments churning out large magazine, newspaper, and book runs, nor were they the small underground presses popping up in the Bay Area such as the Free Print Shop run by the Sutter Street Commune.[6] Rather, the offset lithographic shops that produced the rock posters hovered somewhere between the realms of commercial, radical, and experimental. Using small offset presses, the shops affordably produced runs of single-color and multicolored posters in a short period of time.

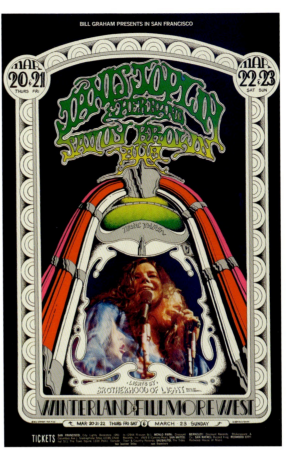

Unlike larger commercial shops, they often were able to provide an environment that was conducive to artistic input and collaboration.

OFFSET LITHOGRAPHY

Offset lithography, the dominant method of commercial printing in the twentieth and twenty-first centuries, is a planographic process, meaning that the image and non-image areas are on the same plane of the printing plate.[7] It is based on the same fundamental principle as traditional lithography: that oil and water do not mix. Offset lithographic printing plates are chemically prepared so that the non-image areas are receptive only to water, and the image areas are receptive only to ink.

The predominant mechanisms of an offset lithographic press are a series of rollers (fig. 62). There are three main types of rollers: the plate cylinder, on which a flexible printing plate is attached; the blanket cylinder, or offset cylinder, which is covered with a rubber blanket; and the impression cylinder, which carries the paper sheet. There is also a series of smaller rollers that make up the dampening and inking systems. Together they compose one printing unit.

Offset lithographic presses range in size depending on how many printing units the machine contains. A one-color press, such as those often used to make the rock posters, contained one printing unit and was about the size of a small car. Larger offset presses can contain as many as six or even ten printing units and are comparable in size to medium to large truck trailers. Manufacturers of one-color presses include Miehle and ATF Chief. Often these presses are distinguished by the largest width in inches of paper that the machine can print.

In the offset lithographic process, the printing plate is first wet up by the dampening system. The dampening rollers apply a thin film of water to the water-receptive non-image areas. When the ink is applied, it is repelled by the film of water in the non-image areas, and attaches only to the ink-receptive image areas of the plate.

The process is called "offset" lithography because the printing plate is never in direct contact with the sheet of paper; rather the inked image on the printing plate offsets onto the intermediate rubber blanket on the blanket cylinder. The inked image on the rubber blanket is then transferred to the sheet of paper pulled through on the impression cylinder. The advantages of offset lithography are its high speed, the relatively low cost of printing, the inked rubber blanket's ability to impart a sharp image on a variety of paper surfaces, and the fact that the final image is printed in the same orientation as that of the printing plate, as opposed to more traditional forms of printmaking in which the image on the print matrix is reversed in the final image.[8]

MULTICOLOR PRINTING

Multicolor prints are composed of two or more colors, and offset lithography relies on the transparency of overlapping inks to achieve multiple colors. The

63
Detail of Randy Tuten and D. Bread (William Bostedt aka "Daddy Bread"), *Janis Joplin and Her Band, Savoy Brown, Aum, March 20–22, Winterland, March 23, Fillmore West,* 1969 (fig. 64), showing the four-color process CMYK rosette pattern

64
Randy Tuten and D. Bread (William Bostedt aka "Daddy Bread"), *Janis Joplin and Her Band, Savoy Brown, Aum, March 20–22, Winterland, March 23, Fillmore West,* 1969. Color offset lithograph poster, 21 x 14⅛ in. (53.4 x 35.9 cm).
FINE ARTS MUSEUMS OF SAN FRANCISCO, MUSEUM PURCHASE, ACHENBACH FOUNDATION FOR THE GRAPHIC ARTS ENDOWMENT FUND, 1972.53.253

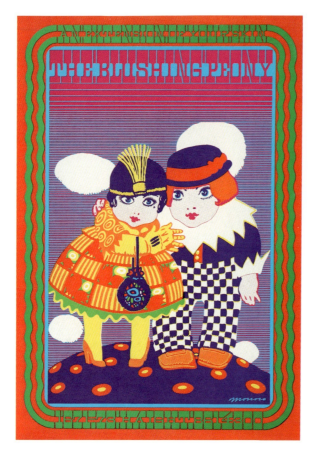

65
Victor Moscoso, *The Blushing Peony, 1571–73 Haight*, 1967 (pl. 89). Color offset lithograph poster, 20 × 14 in. (50.8 × 35.6 cm).
FINE ARTS MUSEUMS OF SAN FRANCISCO, GIFT OF THE GARY WESTFORD COLLECTION, 2016.32.4

66
Detail of Victor Moscoso, *The Blushing Peony, 1571–73 Haight*, 1967 (pl. 89 and fig. 65), showing the flat multicolor printing process with green dotted tint (cyan tint printed on solid yellow)

standard color printing inks, referred to as "process color," are cyan, magenta, yellow, and black, together called CMYK. When combined at various strengths, these colors can produce thousands of colors. In addition, manufacturers produce a variety of colors outside the process colors of CMYK. With offset lithography there are two main methods of producing a multicolor print: four-color process and flat multicolor printing.[9]

The four-color process is used to reproduce fully rendered color artworks such as paintings and color photographs into print. Using panchromatic film, the original artwork is photographed through a series of color filters and halftone screens to produce color separation negatives.[10] These negatives are used to create individual printing plates for each of the four process colors: cyan, magenta, yellow, and black. When the four plates are printed on a single sheet of paper, the color dots combine to reproduce the original full-color image, an appearance familiar to us from color magazines.[11] When viewed under magnification, the CMYK dots form rosette patterns. For example, this process was used to reproduce Jim Marshall's photograph of Janis Joplin in Randy Tuten and D. Bread's 1969 poster featuring Janis Joplin and Her Band (figs. 63–64).

However, the majority of the San Francisco rock posters were made using the flat multicolor printing process. It required the artist, working only in black and white, to create and manually separate the design elements according to the colors that eventually would be printed. Flat multicolor prints typically appear as compositions of solid color planes and lines. The strength of a flat color can be reduced to lighter values known as tints, using screens that break down the solid color into patterns, typically dots (figs. 65–66).[12] The flat-color process actually allows for greater flexibility than the four-color process, as artists can choose to work with process colors (CMYK) or whichever other colors they want. In addition, it invites the graphic creativity that gave rock posters their bold and distinct appearance.

PRE-PRESS WORK FOR FLAT MULTICOLOR PRINTING

Before the rock posters could be printed, there was pre-press work that included a series of involved steps requiring skilled artists and offset lithography tradesmen. Before computers played a role in graphic design and printing, the process was photomechanical, that is, it required film photography to make the final printing plate. The sequence included design and layout of the original artwork by the artists; photographing the artwork and creating film negatives; stripping the film positives and negatives in preparation for exposure on the printing plates; and the production of the final printing plates.

The following four sections give a closer look at each of these pre-press steps as they relate to the creation of the rock posters.[13]

THE MECHANICAL

"Mechanical," or "paste-up," is the technical name for the design elements compiled and created by the artist in black and white, ready to be photographed and eventually made into printing

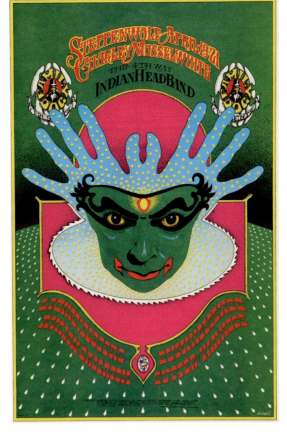

plates.[14] Rock poster artists broke every rule of conventional design, producing rich and complicated compositions that transcended the confines of traditional advertisements. For that reason, the mechanicals for rock posters were often unusually complicated and required the artists to develop a good understanding of photo-offset lithography and a means of communicating their vision to the offset tradesmen (figs. 67–68).

Some artists had extensive backgrounds in the preparation of graphic art for offset, while others had little or no experience with offset lithography and had to learn along the way. Victor Moscoso, Robert Fried, and Bob Schnepf came from academic and professional backgrounds, honing their skills in the commercial art world of New York City before coming to San Francisco. Wes Wilson learned the ropes of offset lithography by designing and printing posters at Contact Printing, a small operation in the Financial District owned by Bob Carr, where he handled jobs for the San Francisco Mime Troupe, the Trips Festival, and the Family Dog. Bonnie MacLean, a self-trained artist, developed her psychedelic style while painting the billboards in the hallways at the Fillmore in colorful acrylic paints. She credits the printers at the offset lithography shops with educating her on preparing art for print, notably Levon Mosgofian, the founder of Tea Lautrec Lithography.[15] Rick Griffin began his career in the surf culture of Los Angeles, creating the beloved comic strip *Murphy* for *Surfer Magazine*. Though he was exposed to the world of publishing through his comics, it wasn't until he started to make rock posters that he truly began to learn the process of preparing art for print.[16]

The mechanicals for the rock posters were primarily composed of line art and continuous-tone art. "Line art" is the term for design elements comprising solid shapes, lines, and dots. "Continuous-tone art" refers to images such as photographs and wash drawings that consist of shades and gradations.[17]

Most of the design elements for the mechanicals were made using dense black ink. Artists also used screentones such as Zip-a-Tone and masking films such as Rubylith (fig. 69).[18] Both of these were adhesive-backed, dry-transfer acetate films that could

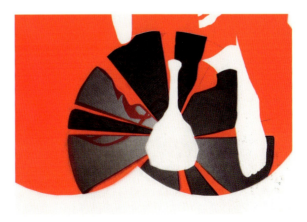

67
Color sketch for Robert Fried, "The Sorcerer," Steppenwolf, Charlie Musselwhite, 4th Way, Indian Head Band, April 19–21, Avalon Ballroom, 1968 (fig. 68). Porous point pen and black ink on paper, showing the instructions for the stripper and printer to make the poster.
CENTER FOR COUNTERCULTURAL STUDIES

68
Robert Fried, "The Sorcerer," Steppenwolf, Charley Musselwhite, 4th Way, Indian Head Band, April 19–21, Avalon Ballroom, 1968. Color offset lithograph poster, 21 3/8 x 14 in. (54.3 x 35.5 cm).
FINE ARTS MUSEUMS OF SAN FRANCISCO, MUSEUM PURCHASE, ACHENBACH FOUNDATION FOR GRAPHIC ARTS ENDOWMENT FUND, 1974.13.150

69
Mechanical for the preparation of a printing plate for Jack Hatfield, *Blue Cheer, the Other Half, the Wildflower*, October 20 & 21, The Western Front, 1967, showing a detail of the adhesive-backed dry transfer Rubylith (red) and screentone (black dotted pattern) on acetate overlay.
HAIGHT STREET ART CENTER

301

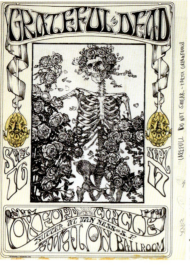

70
Acetate overlay mechanical for the preparation of printing plates for Stanley Mouse and Alton Kelley, *"Skeleton and Roses,"* 1966, with separation on illustration board for the black printing plate (left), separation on acetate overlay for the blue printing plate (center), and separation on acetate overlay for the red printing plate (right).
HAIGHT STREET ART CENTER

71
Stanley Mouse and Alton Kelley, *"Skeleton and Roses," Grateful Dead, Oxford Circle, September 16 & 17, Avalon Ballroom,* 1966. Color offset lithograph poster, 20 x 14 in. (50.8 x 35.5 cm).
FINE ARTS MUSEUMS OF SAN FRANCISCO, MUSEUM PURCHASE, ACHENBACH FOUNDATION FOR GRAPHIC ARTS ENDOWMENT FUND, 1974.13.100

72
Edmund Sullivan, page from *The Rubáiyát of Omar Khayyám* (first published 1913). Letterpress, 6 3/8 x 3 7/8 in. (16.9 x 9.8 cm). Page used by Stanley Mouse and Alton Kelley for "Skeleton and Roses," 1966.
COLLECTION OF STANLEY MOUSE

be cut into shapes and attached to the mechanical. Screentones came in a variety of patterns, typically evenly spaced dots or lines, that gave the illusion of shading or could be used to create tints. Rick Griffin was particularly adept at adding dotted screentones to his artwork to create tonal variations in the finished poster, often selectively rubbing out the dots on the artwork with an eraser to create depth and gradation.[19] Rubylith was a transparent red film that photographed the same as black design elements since the orthochromatic film used to shoot the mechanicals did not distinguish between red and black. It could be cut into shapes by the artist and applied to the mechanical, affording cleaner and sharper edges than inked designs.

Artists appropriated images from a variety of sources such as books and magazines — everything was fair game (see Terry, this volume).

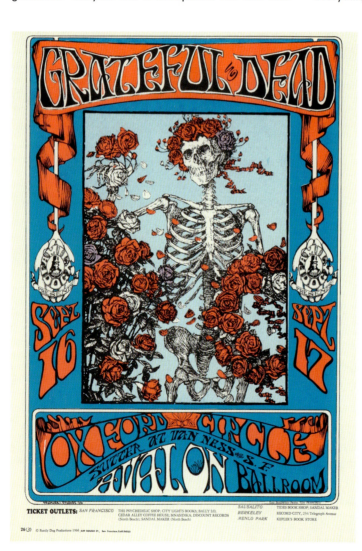
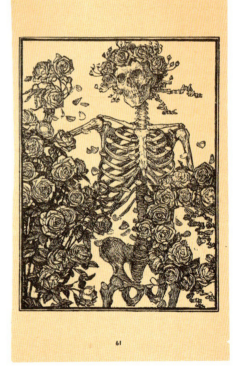

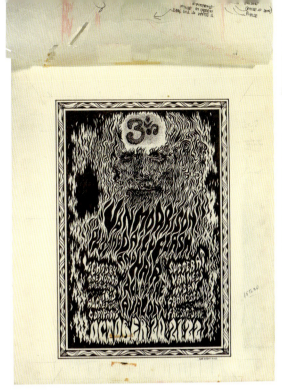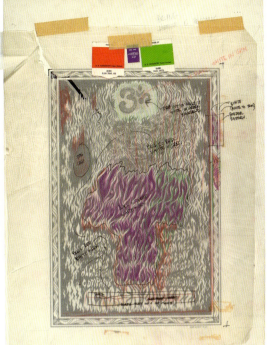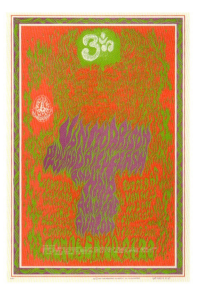

Bob Schnepf found a reproduction of a nineteenth-century French print by Gustave Doré blowing down a road in San Anselmo; he used it in his 1967 Family Dog poster featuring the Doors.[20] David Singer, who designed more posters for Bill Graham than any other artist, spent hours in junk shops and used bookstores building up his collection of images. He would intricately cut each piece and apply it to illustration board with spray adhesive, creating beautiful, otherworldly collages.[21] Artists also featured photographs in their designs, mostly of band members captured by photographers such as Herb Greene, Jim Marshall, Bob Seidemann, and Thomas Weir, although stock photographs supplied by bands' publicists also made their way into posters.[22]

The most important part of making a mechanical for flat multicolor printing was having a system clearly indicating or separating the design elements according to each color that was to be printed. The three methods primarily used by the rock poster artists were acetate overlays, key-line mechanicals, and bluelines.

With acetate overlay mechanicals, the artist, working only in black and white, executed the most complicated art corresponding to a single color on a smooth white illustration board. Then he placed designs representing other colors on their own clear plastic sheet acetate overlays (fig. 70). The artists often designated the colors used to make the final print with swatches or handwritten notes. Registration marks on each separation indicated proper alignment.[23]

Stanley Mouse preferred working with acetate overlays when making mechanicals. He would make his drawings on illustration board in black ink using a Pelikan Graphos fountain pen and sometimes sable-haired paintbrushes for lettering and filling in large areas. For the overlays he primarily used a thicker black ink applied with a brush.[24] Often he would attach photostats of images from various sources to the illustration board.[25] Mouse and his design partner Alton Kelley trolled bookstores and library stacks for inspiration and art historical images that related to the bands for which they were designing posters. One of the most famous examples is the image of the skeleton and roses on the 1966 Family Dog poster featuring the Grateful Dead (fig. 71). Mouse and Kelley found the 1913 Edmund Joseph Sullivan illustration in a copy of Edward FitzGerald's translation of the *Rubáiyát of Omar Khayyám* at the San Francisco Public Library. When they saw the grand skeleton and the bountiful roses, they knew immediately it was the perfect embodiment of the Grateful Dead. Though they usually made copies of their sources, it was only years later that Mouse found the original page from the *Rubáiyát of Omar Khayyám,* cut out of the book by Alton Kelley. Mouse has kept the book page to this day (fig. 72).

With a key-line mechanical, black-and-white art was also prepared on an illustration board. The color separations were indicated in colored pencil or watercolor on a single overlap of tracing paper (figs. 73–75). This method required much more work from the camera operator and stripper. The illustration board mechanical had to be photographed and made into many positives and negatives for the stripper to cut apart and re-assemble for each color plate.[26]

73, 74
Key-line mechanical for the preparation of printing plates for Wes Wilson, *"Ohm," Van Morrison, Daily Flash, Hair, October 20–22, Avalon Ballroom,* 1967 (fig. 75). Illustration board with a black ink drawing (left) and tissue paper overlay with colored pencil demarcating the color separations (right).
HAIGHT STREET ART CENTER

75
Wes Wilson, *"Ohm," Van Morrison, Daily Flash, Hair, October 20–22, Avalon Ballroom,* 1967. Offset color lithograph poster, 20⅛ x 14¼ in. (51 x 36.2 cm).
FINE ARTS MUSEUMS OF SAN FRANCISCO, MUSEUM PURCHASE, ACHENBACH FOUNDATION FOR GRAPHIC ARTS ENDOWMENT FUND, 1974.13.172

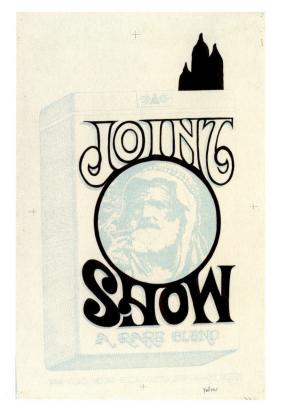
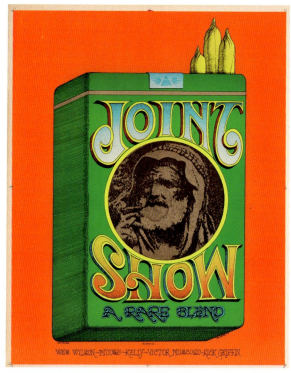

76
Blueline mechanical for the preparation of the printing plate for Rick Griffin, *"Joint Show," Moore Gallery, July 17*, 1967 (fig. 75), showing the blueline (contact photographic print) on the illustration board with a black ink drawing to indicate the separation for the yellow printing plate.
FINE ARTS MUSEUMS OF SAN FRANCISCO, GIFT OF THE GARY WESTFORD COLLECTION, IN MEMORY OF RICK GRIFFIN, 2017.7.10

77
Rick Griffin, *"Joint Show," Moore Gallery, July 17*, 1967. Color offset lithograph poster, 29 1/8 x 23 3/8 in. (73.9 x 58.7 cm).
FINE ARTS MUSEUMS OF SAN FRANCISCO, GIFT OF THE GARY WESTFORD COLLECTION, IN MEMORY OF RICK GRIFFIN, 2017.7.9

Wes Wilson and Victor Moscoso both at times produced mechanicals using the key-line method. They worked with various design tools, in particular black ink and Rapidograph pens.[27] Wilson mostly worked freehand, organically filling up space on the illustration board with his iconic forms and lettering.[28] Moscoso built up his sophisticated designs, intricate line work, and lettering, often using tools such as T-squares, triangles, and compasses.[29] Both artists used tissue-paper overlays marked with colored pencil demarcating color separations and precise instructions on color, type, and placement.

"Blueline" is a technical term for a photographic print on a surface of plastic, glass, metal, or paper that typically yields a blue image. In the creation of rock posters the blueline process was mostly used for proofing and alignment of the negatives. At California Litho Plate, a well-outfitted shop run by Ewald Treude and Louis W. Longwenus in the South of Market neighborhood, the blueline method was often used to assist the artists in creating mechanicals.[30] With this method, the artist's original drawing in black ink was photographed to make a negative. The resulting negative was then contact printed on illustration boards or papers sensitized with iron compounds to produce several blueline images. Working from these identical bluelines, the artist used black ink to demarcate the design elements corresponding to different colors on each board (figs. 76–77). The beauty of the blueline is that when the mechanical is photographed, the blue is not recorded by the orthochromatic film, thus, the negatives produced showed only the design elements inked by the artist. This method was used by the artists Rick Griffin, Bob Schnepf, Robert Fried, and William Henry.[31]

CAMERA WORK

The finished mechanical and all its separations were photographed individually on a copy stand. The mechanical was held in place at one end by a copyboard, and the film was inserted at the other end in a film holder where it was exposed to light. The film used to shoot the artwork was a high-contrast graphic arts film made especially for black-and-white line art. Since the film was high contrast, continuous-tone artwork such as photographs and washes was shot separately using halftone screens placed within the camera. The halftone screens broke up the continuous-tone images into dots of various sizes so that the images could be translated into print. The highlights were smaller-sized dots and the shadows larger. The sum of the dots yielded an overall sense of tone called a "halftone." However, sometimes the artists preferred a more contrasty look and would forego the halftone screen when shooting photographs and other continuous-tone images.[32] The camera operator exposed and developed, and enlarged and reduced as many negatives as needed by the stripper for the next stage of production.

STRIPPING

The stripper assembled the film in preparation for making a printing plate for each color. He would reproduce the films into negatives or positives as necessary, and then, working on a light table, carefully cut them apart and place the elements together to achieve the final composition. The layers of film were often taped in place on goldenrod, an orange-colored opaque masking paper, in which windows were cut out to reveal the desired composition to be exposed on a particular printing plate. The sandwich-like assemblage of film on the masking paper was called a flat (fig. 78). Sometimes it would take many flats to create one printing plate, or the flats could be exposed onto one piece of film to create a master negative for each printing plate (figs. 79–81 and pl. 148).

Stripping was a complicated process that required a thorough understanding of the artist's layout and the forethought to translate this vision into separate color printing plates and a final full-color image. It often required converting negatives to positives, making corrections or additions to the films, and adding screens (plastic sheets of angled grids or dot patterns) to the flats to create shade and tints.

Strippers also played an important role in guiding artists and helping them to achieve their vision. Often print shops farmed their photography and stripping work to specialized trade shops. Early on, Tea Lautrec Lithography, one of the foremost printers of rock posters, would sometimes send their film work out to Errol Hendra's Camera Shop on Dore Street, a streamlined operation with activist leanings.[33] Hendra was known for his down-to-earth personality and was comfortable working with rock poster artists. He was a cameraman at Neal, Stratford & Kerr before it closed down where he worked with Levon Mosgofian, the founder of Tea Lautrec Lithography. The poster artist Lee Conklin remembers Hendra as a "generous spirit" who not only helped educate him on preparing art and film for print, but also lent him the keys to his shop and let him park the bread truck that he was living in at the time with his wife Joy outside the shop whenever he was in town.[34]

Bob Schnepf worked closely with the strippers at California Litho Plate when creating his posters for the Family Dog, and vividly recalled the strippers' enthusiasm and willingness to work with the rock poster artists to realize their complicated designs. For example, he described how in making the 1967 Family Dog poster featuring Country Joe and the Fish (pl. 148), often referred to as "Tree Frog," they experimented with a complicated technique known as "trapping," in which the size of an image in the films was expanded or contracted. This technique was typically used to adjust the film images so that they would register properly with no gaps or significant overlap when eventually printed; however, with Tree Frog they were able to expand

78
Film flat for Bob Schnepf, *"Tree Frog," Jim Kweskin Jug Band, Country Joe and the Fish, Lee Michaels, Blue Cheer, December 28, 29, 30, Avalon Ballroom,* 1967 (pl. 148), used to prepare the printing plate.
HAIGHT STREET ART CENTER

79, 80, 81
Acetate master films for Bob Schnepf, *"Tree Frog," Jim Kweskin Jug Band, Country Joe and the Fish, Lee Michaels, Blue Cheer, December 28, 29, 30, Avalon Ballroom,* 1967 (pl. 148), used to prepare printing plates for printing yellow (left), magenta (center), and cyan (right).
HAIGHT STREET ART CENTER

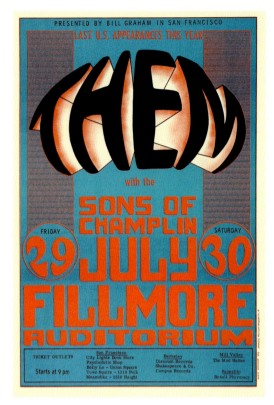
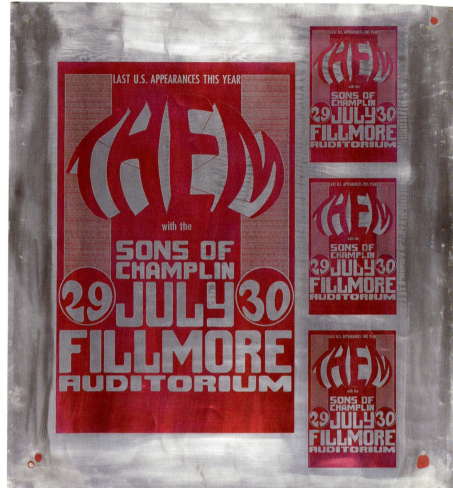

82
Wes Wilson, *Them, Sons of Champlin, July 29 & 30, Fillmore Auditorium*, 1966. Color offset lithograph poster, 20½ × 13¾ in. (52 × 35.1 cm).

FINE ARTS MUSEUMS OF SAN FRANCISCO, GIFT OF HAROLD AND EVELYN KORF, 1996.100.38

83
Aluminum printing plate for Wes Wilson, *Them, Sons of Champlin, July 29 & 30*, 1966 (fig. 82), used to print the blue ink for posters and handbills.

CENTER FOR COUNTERCULTURE STUDIES

and contract the films in such a way as to achieve a nimbus effect around the figure that produced a stunning electric feel in its final color scheme of orange, green, purple, and yellow.[35]

PLATEMAKING

The plates used by Tea Lautrec Lithography and California Litho Plate consisted of a thin and flexible aluminum base pre-sensitized with a light-sensitive material, typically a diazo compound. In general, to make the plates, the flat or the master negative that was created by the stripper for each color was placed in direct contact with the sensitized surface, emulsion to emulsion, and secured in a vacuum frame. The plate and flat or master negative were then exposed to a light source with strong ultraviolet output. Transparent areas of the film allowed the light through and exposed and hardened the adjacent light-sensitive surface of the printing plate. During development, the unexposed areas were washed away. The hardened areas on the plate became the ink-receptive surface that would carry the image during printing (figs. 82–83).[36]

PRINTING INKS

Many manufacturers produced offset lithographic inks during this period, including Van Son, Gans, Flint, Handschy, and Cal Ink. The inks used for sheet-fed presses usually consisted of pigments in oil and resin-based vehicles with various modifiers including driers, plasticizers, waxes, chelating agents, surfactants, antioxidants, and de-foamers.[37] The inks were tacky, with a paste-like consistency. During printing, the force of the rollers increased the fluidity of the inks and dispersibility of the pigments, creating a film 0.8 to 1.1 micrometers thick on the surface of the paper.[38] The film was very thin and generally transparent, thus, it was important that the pigments had a strong color strength and fine particle size.[39]

PAPER

In general, the rock posters were printed on a sturdy, fairly thick paper stock, variously described as vellum, index, Bristol, or tag, which appears to be composed of primarily chemical wood pulp. Most of the posters made between 1966 and 1968 were printed on uncoated papers. Surfaces ranged from an even and slightly porous vellum finish to a dense, smooth machine finish.[40] Glossy coated papers were used with greater frequency by Tea Lautrec Lithography for Bill Graham posters from 1968 onward, particularly for the artist David Singer's posters. The glossy surface absorbed less ink and

84
Levon Mosgofian, owner of Tea Lautrec Lithography, with a twenty-two-inch ATF Chief offset lithographic press, ca. late 1970s.
COLLECTION OF DENIS MOSGOFIAN

was conducive to sharper detail.[41] Many, but not all, of the papers were made using optical brighteners.[42]

The earlier posters were printed "one-up," one image per sheet of paper. Subsequent posters were usually printed on larger sheets of paper, containing either one poster with several handbills, postcards, or tickets, or two posters on the same sheet of paper. After printing, the posters, handbills, and tickets were cut to size. Most of the posters made for the Avalon Ballroom measured approximately twenty by fourteen inches. Fillmore Auditorium posters usually had slightly larger measurements. Variations in papers and dimensions were no doubt due to affordability and availability of the paper, and the size of the press.[43]

PRINTING

Many of the rock posters were printed using a one-color sheet-fed offset lithographic press. As the name "sheet-fed" suggests, individual sheets of paper, usually in large stacks, were pulled rapidly through the press one at a time. Whereas multicolor presses printed different color inks in fast succession in one run through the press, one-color presses printed only one color at a time, making it necessary to run a sheet of paper through the press several times to achieve a multicolor print.

A press operator had to have a good understanding of the complexities of the press to keep it running smoothly. Some of his many tasks included adjusting the paper feeder and delivery system, attaching the plates, and positioning the rollers. Maintenance of the inking and dampening systems required special attention in order to avoid issues such as offset of the ink onto the non-printed areas and picking up of ink from previous ink layers.

Tea Lautrec Lithography printed a number of the posters for the Avalon Ballroom concerts in 1968 and the majority of the Fillmore Auditorium's concerts from 1967 to 1973, and continued to print rock posters for Bill Graham events for more than a decade after the final Fillmore posters. Originally a division of Neal, Stratford & Kerr on Sansome Street, Tea Lautrec Lithography moved to Sheridan Street in the South of Market neighborhood not long after the former shut down. Tea Lautrec Lithography was owned and operated by Levon Mosgofian (fig. 84), a career pressman whose dedication and close working relationship with the artists made him one of the true forces behind the printing of the rock posters.[44] The shop had a sizable staff that included Mosgofian's son Denis, a stripper and platemaker. It also employed several press operators, including Monroe Schwartz and Joe Buchwald, both career pressmen who had

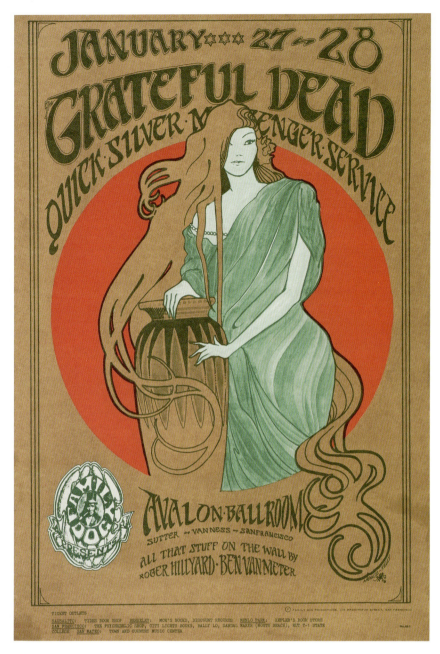

85
Stanley Mouse and Alton Kelley, *"Girl in the Red Circle," Grateful Dead, Quicksilver Messenger Service, January 27 & 28, Avalon Ballroom,* 1967. Color offset lithograph poster with metallic ink, 20 1/8 x 13 7/8 in. (51.1 x 35.2 cm).
FINE ARTS MUSEUMS OF SAN FRANCISCO, MUSEUM PURCHASE, ACHENBACH FOUNDATION FOR GRAPHIC ARTS ENDOWMENT FUND, 1974.13.34

worked with Mosgofian at Neal, Stratford & Kerr. Buchwald and Levon Mosgofian were close friends and colleagues for more than forty years. The father of Jefferson Airplane lead vocalist Marty Balin, Buchwald was the link between Mosgofian and Bill Graham.[45]

Buchwald's long career coupled with these intimate personal and professional relationships gave him unique insight into the experience of printing the rock posters.[46] In conversations with the author, he recalled that Tea Lautrec Lithography used a one-color Miehle sheet-feed press to make the rock posters.[47] The shop typically did one or more rock poster jobs a week, printing about 500 to 5,000 posters per job.[48] According to Buchwald, it took approximately fifteen minutes to run 1,000 sheets through the press and required about one pound of ink or more. At Tea Lautrec Lithography, they tried to print all of the colors for a single rock poster in one day. When the press was running well, it would produce 3,500 to 4,000 sheets an hour. Each print run was given approximately forty-five minutes to one hour drying time before the next color was printed. Buchwald referred to this period as the "make ready" time, in which the press was cleaned, a new plate attached, and fresh ink added. By this time, the prints would be dry enough to run through a second time, though the inks were not completely dry for a good twelve hours after printing.

ARTISTS, PRINTING, AND COLOR

What made Tea Lautrec Lithography and many of the other small offset lithographic companies so unusual was the willingness of the printers to work one-on-one with the rock poster artists, often at the press, helping them to achieve their visions, including the unconventional color combinations of the psychedelic experience. The artists were involved in the printing process to varying degrees: Some were more demanding, and some more hands-off. Likewise, some printers were more flexible than others. Deadlines were tight for both the printers and the artists, and often it was a push-and-pull negotiation. But everyone, it seemed, knew that they were on to something distinctive and meaningful.

Wes Wilson is often attributed with developing the psychedelic style of poster art with his fluid lettering and bold color choices. A self-trained artist, he studied philosophy for a period at San Francisco State College in 1963. His early firsthand experience working with offset lithography at Contact Printing allowed him to understand both the potential and the limitations of the press when working with other printers on his subsequent rock posters for the Avalon and the Fillmore. A number of his designs for the Fillmore were printed at West Coast Litho in the Financial District, with the British-trained pressman Ivor Powell, who Wilson described as an incredibly talented printer who appreciated collaboration and discussion.[49]

Such collaborations sometimes brought unexpected results as with the first printing of Wilson's 1966 Bill Graham poster featuring Jefferson Airplane (pl. 144), which he printed with Powell. The poster, depicting two pharaoh figures, is lit with a background of glowing bands of horizontal colors. Also known as split fountain or rainbow fountain, this rainbow background was a popular technique in early

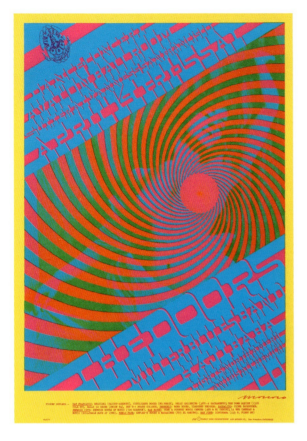
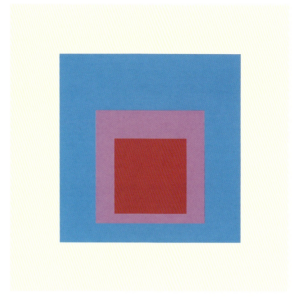

music posters. By placing several colors next to each other in the ink fountain, a colorful striped effect could be achieved when the paper was run through the press. The split fountain method usually resulted in uniform bands of soft color gradations, mostly due to the press's oscillating roller, which moved side to side as it rotated, ensuring even distribution of ink on the blanket cylinder and printing plate. While printing the poster, Wilson and Powell debated over whether or not to use the oscillating roller. Powell, who had never used the split fountain technique, thought that the roller might muddy the inks. Time was short and they decided to take the oscillating roller off the press, resulting in laser-like color bands of various widths that gave the poster an unexpected intensity.

Artist Stanley Mouse always preferred to be present for the printing of his posters. Mouse Studios was located in an old horse-drawn buggy fire station right around the corner from Bindweed Press, where he would sometimes play the pump organ to the sound of the printing press.[50] Mouse began drawing at an early age. He studied on and off at the Society for Arts and Crafts in Detroit from 1956 to 1959, but developed his individual style while creating monster and hot-rod art for car shows and mail orders. After moving to San Francisco in 1966 — arriving during the Trips Festival, no less — he worked independently as well as jointly with the artist Alton Kelley designing many of the rock posters for the Avalon and the Fillmore.[51] Mouse astutely recognized that using a one-color offset lithographic press was very similar to the process of screenprinting. Printing one color at a time allowed for greater control and experimentation, which could not be achieved within the confines of process color or multicolor presses.[52] Indeed, the versatility afforded by the one-color press was reflected in the artistic range of Mouse and Kelley's posters, from subtle and elegant hues to wildly colorful combinations. They also experimented with metallic inks and the split fountain technique (fig. 85 and pl. 143).

At Tea Lautrec Lithography, Levon Mosgofian and his printers were known for working closely with artists and helping them to translate their vision into print, particularly with regard to color work. Getting just the right ink mixtures and color combinations was a crucial component in the dynamics of rock posters. As printer Joe Buchwald recalled, the artists were usually present for the initial printing. Rough color choices were typically made from ink manufacturers' color books. Unless the artists picked a straight color that was already available in a can, the inks had to be mixed by eye on the spot. As Buchwald explained, it was not worth buying a five-pound can of ink for every color they were going to print. With the artist present, the ink mixture would be tapped on a piece of paper to give a better idea of how the color

86
Victor Moscoso, *"Swirley," Doors, Miller Blues Band, Haji Baba, April 14 & 15, Avalon Ballroom*, 1967 (pl. 142). Color offset lithograph poster, 19⁷⁄₈ x 14 in. (50.7 x 35.5 cm).
FINE ARTS MUSEUMS OF SAN FRANCISCO, MUSEUM PURCHASE, ACHENBACH FOUNDATION FOR THE GRAPHIC ARTS ENDOWMENT FUND, 1974.13.24

87
Josef Albers, *Full*, from the portfolio *Homage to the Square: Ten Works by Josef Albers*, 1962. Color screenprint, 17 x 17 in. (43.2 x 43.2 cm). Printed by R. H. Norton; published by Ives-Sillman, Inc.
FINE ARTS MUSEUMS OF SAN FRANCISCO, ANDERSON GRAPHIC ARTS COLLECTION, GIFT OF HARRY W. AND MARY MARGARET ANDERSON CHARITABLE FOUNDATION, 1996.74.6.6

would appear when it was printed. With the artist's approval, the printing would begin.[53] At Tea Lautrec they used the one-color press to their advantage. Typically starting with yellow, they would lay down heavy layers of ink to achieve thick, rich colors that popped, and then adjust the inks for the subsequent layers to get the effects that the artist wanted.[54] These thick ink layers could not be achieved with multicolor presses with many printing units, where the drying time between printings was a split second.[55] Stanley Mouse acknowledged that getting the right color combinations was often a matter of guesswork and pushing the printers to their limits.[56] Likewise, Buchwald noted that the artists were sometimes striving for the impossible, and that there was only so much color that could be laid down before it started "messing up or off-setting."[57]

One of the rock poster artists best known for exploiting visually competitive color combinations was Victor Moscoso. Moscoso came to San Francisco with a strong background in graphic arts. He attended both Cooper Union and Yale University, and later received his master's at the San Francisco Art Institute, where he also taught traditional stone lithography. Many of his rock posters exhibited wild vibrational effects achieved through his adept manipulation of color combinations, concepts he learned while studying color theory under Josef Albers at Yale. Using both CMYK and custom colors, Moscoso would juxtapose complementary colors to create a popping effect, making it difficult for the eye to focus on one color at a time (figs. 86–87). This technique, first used by Wes Wilson and later by many other artists, was perfected by Moscoso, who paid attention to the subtleties of value and brightness.

Some of Moscoso's most inventive posters exploited colors to give the illusion of animation when viewed under alternating colored lights. In his 1967 Family Dog poster featuring the Doors (pl. 165), he juxtaposed blue, yellow, and red still images from an 1895 Thomas Edison film of the dancer Annabelle Moore performing the serpentine dance in a flowing costume. When lights of alternating blue and red were flashed on the poster, the corresponding light canceled out either the blue or red, giving the effect of animation.[58] Moscoso was the first to admit that the realization of this effect was not deliberate: As the story goes, a friend hung one such poster under flickering Christmas lights and noticed that the image appeared to be moving. The artist was also quick to point out that it was an accident only once — in subsequent posters the effect was quite intentional.[59]

THE QUESTION OF DAYGLO INKS

The vibrant colors of daylight fluorescent inks and paints were created to fluoresce or glow under normal daylight and fluoresce even more brilliantly with artificial ultraviolet sources. Manufactured by the Day-Glo Corporation, they had become widely commercialized by the 1960s. During this time, DayGlo found its way into the world of fine arts, notably in a number of works by the Pop artist Andy Warhol. It was also very much a part of the psychedelic scene. At music and dance events, attendees would often paint their bodies with DayGlo, fluorescing brilliantly under ultraviolet or "blacklight."[60]

The rock posters printed for the Fillmore, Avalon, Matrix, and similar venues are often associated with colors that really pop, leading many people to assume that they were made using DayGlo; however, this is a misconception. Wilson, Moscoso, Singer, Conklin, MacLean, and Schnepf all adamantly denied using DayGlo inks, even in small amounts to brighten standard printing inks. Mouse recalled that he did not use DayGlo either, with the exception of one poster, his 1966 Family Dog poster "Keep California Green" (pl. 153).[61] All of the artists emphasized that the brilliant sense of color they achieved was due to color juxtapositions of standard printing inks (figs. 88–89).[62]

During the course of research for this essay, hundreds of Fillmore, Avalon, and Neon Rose rock posters in the collections of the Fine Arts Museums of San Francisco were examined under both normal illumination and long-wavelength ultraviolet radiation. Of these, only one exhibited the typical luminous color and bright fluorescence associated with DayGlo. This was the poster noted above by Mouse.[63]

It makes sense that these rock posters were not manufactured using inks containing daylight fluorescent colorants. DayGlo offset lithographic inks (as opposed to screen-printing inks) were very thin and not easy to work with, and they often required two runs through the press, which was both time-consuming and economically unfeasible for these venues to produce as advertisements for such popular events. With the success of these rock

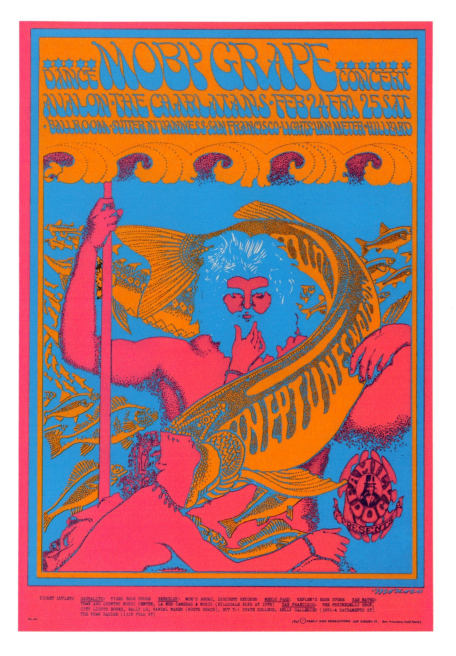

posters, came a proliferation of posters imitating their style. Within this growing market there were many posters, mostly screenprints, which were made using inks with daylight fluorescent colorants.

CONCLUSION

The psychedelic rock posters made in San Francisco in the late 1960s and early 1970s exemplify an energetic and rebellious period of creativity and collaboration comparable to that of the French Art Nouveau posters of the late nineteenth and early twentieth centuries. Whereas these historical predecessors are only accessible to us through texts and the art that remains, the rock posters hover on the edge of our contemporary world. We are fortunate that many of the artists and printers are available to us today to explain the intricacies of their particular approaches and processes. The complicated photomechanical techniques and sophisticated color manipulations used to make rock posters are the antecedents of contemporary graphics-editing programs, such as Adobe Photoshop and Illustrator, used in offset lithography today. The artists and print shops that created the rock posters pushed the capabilities of offset lithography, and in the process defined the look of an era. ❧

88
Victor Moscoso, *"Neptune's Notion," Moby Grape, The Charlatans, February 24 & 25, Avalon Ballroom,* 1967 (pl. 145). Color offset lithograph poster, 20 x 14 in. (50.8 x 35.5 cm).
FINE ARTS MUSEUMS OF SAN FRANCISCO, MUSEUM PURCHASE, ACHENBACH FOUNDATION FOR THE GRAPHIC ARTS ENDOWMENT FUND, 1974.13.33

89
Cyan, magenta, and orange PANTONE® chips demonstrating Victor Moscoso's use of standard printing inks to achieve popping color combinations for *"Neptune's Notion," Moby Grape, Charlatans, February 24 & 25, Avalon Ballroom,* 1967 (fig. 88)

ENDNOTES

This essay is an expansion of on an article written by the author and published in the American Institute's *Conservation, Book and Paper Group Annual*, vol. 29, 2010 (http://cool.conservation-us.org/coolaic/sg/bpg/annual/v29/bp29-01.pdf). Much of the technical information in this essay came from Arthur Eckstein and Bernard Stone, *Preparing Art for Printing* (New York: Reinhold, 1965).

1. Alphonse Mucha (1860–1939) was a Czech artist whose distinctive style helped shape French Art Nouveau. Bay Area rock poster artists of the late 1960s and early 1970s were inspired by this style, often imitating its look and imagery.
2. Stanley Mouse, in conversation with the author, San Francisco, March 4, 2016. Stanley Mouse identified 141 Noe Street as the location of Bindweed Press where many of the early rock posters were printed for Family Dog Productions. The press was located in the garage surrounded by Westlake's collection of pump organs; he lived upstairs. Bindweed Press later moved to 2180 Bryant Street.
3. Family Dog Productions, a collective led by Chet Helms, promoted concerts at the Avalon Ballroom. The numbered series of Family Dog posters dating between 1966 and 1968 were designated the prefix FD. Early concerts for the Family Dog were at the Fillmore Auditorium, where they alternated weekends with Bill Graham events. There are approximately 147 numbered Family Dog posters. The Family Dog also produced music events in Denver, Colorado, with posters designated FDD. In 1969, when the Family Dog lost their lease at the Avalon, they moved west to the Great Highway on Ocean Beach to a venue that was formerly the Edgewater Ballroom.

 Bill Graham's first numbered posters were used to promote concerts at the Fillmore Auditorium beginning in 1966. In 1968 the Fillmore was moved to a new location in San Francisco, the Fillmore West, formerly the Carousel Ballroom. Posters in the series also include events at the Winterland Ballroom and Cow Palace in San Francisco, the Oakland Coliseum, and the Berkeley Community Theater. Numbered Bill Graham posters dating between 1966 and 1973 were designated with the prefix BG. There are approximately 290 posters in this series. For more on Helms and Graham, see Terry, this volume.

 The Neon Rose series of posters was published independently by Victor Moscoso in 1966 and 1967. The posters were primarily produced for the Matrix, but also promoted shows at Webb's in Stockton and the Nourse Auditorium in San Francisco. Moscoso also created Neon Rose posters for local organizations and events such as the Blushing Peony boutique on Haight Street and the underground radio station KMPX. Numbered posters from Neon Rose were designated with the prefix NR. There are approximately 27 posters in this series.
4. At times the name of the offset lithography shops can be found in discreet locations on the posters. Printers' credits on posters include Bindweed Press, Cal Litho, West Coast Litho, Tea Lautrec Litho, and Double H. Many of the offset lithography shops were part of trade unions, including the Lithographers and Photoengravers International Trade Union (LPIU). Sometimes small union bugs can be seen on the posters identifying the shop's association with a particular union.
5. Ben Marks, "Was Levon Mosgofian of Tea Lautrec Litho the Most Psychedelic Printer in Rock?," *Collectors Weekly*, September 22, 2014, http://www.collectorsweekly.com/articles/was-levon-mosgofian-the-most-psychedelic-printer-in-rock/.
6. Lincoln Cushing, *All of Us or None: Social Justice Posters of the San Francisco Bay Area* (Berkeley: Heyday, 2012), includes a comprehensive directory of political counterculture print shops.
7. For more on the process of offset lithography, see R. H. Leach et al., eds., *The Printing Ink Manual*, 4th ed. (Berkshire, UK: Van Nostrand Reinhold International, 1988), and Kenneth F. Hird, *Introduction to Photo-offset Lithography* (Peoria, IL: Bennett, 1981), esp. chap. 12.
8. Hird, *Introduction to Photo-offset Lithography*, 8–11.
9. Arthur Eckstein and Bernard Stone, *Preparing Art for Printing* (New York: Reinhold, 1965), 153–155. Four-color process is also called "process color" and "full-color process." The flat multicolor process is also referred to as "spot color." Spot color is the term generally used in the design and print industry today.
10. Panchromatic film is a type of film that is sensitive to all visible colors in the spectrum.
11. Eckstein and Stone, *Preparing Art for Printing*, 175–181.
12. Ibid., 153–157. Tints of solid colors for flat multicolor printing can be achieved in two different ways. Screentones are adhesive-backed, dry-transfer acetate films with pre-printed patterns (typically dots) that the artist cuts to the desired shape and applies to the artwork. Tints can also be achieved during the stripping phase of pre-press work when preparing photographic film for the printing plate. Usually working from the artist's instructions, the stripper adds screens on top of the films. The strength of a tint is typically determined by dot size: the larger the dot, the darker the tone. Strength is indicated as a percentage of the original color. For example, a light magenta or pink tone might be 30% of a solid magenta. Tints can also be printed on top of another color to create new colors. This is called a "build" or "color build." For example, a 30% magenta on top of a solid yellow yields an orange tone.
13. The author thanks Phil Cushway at Art Rock, and the Haight Street Art Center in San Francisco for providing original printing artifacts used for this research, including dockets, mechanicals, negatives, flats, and printing plates.
14. "Mechanical" and "paste-up" are the technical terms used in offset lithography manuals. The rock poster artists considered here preferred the term "artwork."
15. Bonnie MacLean, taped phone interview with the author, November 9, 2016. It is a misconception that MacLean's weekly designs on the billboards in the hallways of the Fillmore were done using chalk. In fact, they were color acrylic paintings that were painted over for subsequent designs. She notes that using chalks for the billboard designs would have been impractical as patrons of the Fillmore often leaned on the boards, which would have resulted in smudging.
16. Paul Grushkin, *The Art of Rock: Posters from Presley to Punk* (New York: Artabras, 1987), 77–78.
17. Eckstein and Bernard, *Preparing Art for Printing*, 35–36.
18. Other commercial names for screentones are Letratone and Chart-Pak®. Rubylith is a brand name for transparent red masking films manufactured by the Ulano Corporation.
19. Bob Schnepf, taped phone interview with the author, February 18 and 26, 2016.
20. Ibid.
21. David Singer, in conversation with the author, Petaluma, CA, August 15, 2016.
22. Ben Marks, e-mail message to the author, April 25, 2016.
23. Eckstein and Bernard, *Preparing Art for Printing*, 160.
24. Stanley Mouse, e-mail messages to the author, March 9, 2016.
25. Luis Nadeau, *Encyclopedia of Printing, Photographic and Photomechanical Processes: A Comprehensive Reference to Reproduction Technologies, Containing Invaluable Information on over 1500 Processes*, vol. 2 (Fredericton, NB, Canada: Atelier Luis Nadeau, 1989), 382–383. A photostat is a copy on photographic paper of written or printed material made using a photostat machine equipped with a camera. Originally created in 1909 by the Photostat Corporation, photostats were negative images, appearing as white image and text on a black background. In 1953, Eastman Kodak Company created a direct positive photographic paper where the image or text appeared black on a white background.
26. Eckstein and Bernard, *Preparing Art for Printing*, 162.
27. "Type Confusion and Color Aggression: An Interview with Victor Moscoso," by Norman Hathaway, Cooper Union, New York, March 5, 2015, https://vimeo.com/122859594 (hereafter cited as "Type Confusion and Color Aggression"); Wes Wilson, e-mail message to the author, May 5, 2016.
28. Grushkin, *Art of Rock*, 72.
29. "Type Confusion and Color Aggression."
30. Schnepf interview.
31. Ibid.
32. Ibid.
33. Denis Mosgofian, e-mail message to the author, November 27, 2016. In later years, when Denis Mosgofian worked full-time at Tea Lautrec (1972–1982), they outsourced most black and white and duotone camera work to Circus Litho on Howard Street, and almost all four-color separations to Gregory and Falk.
34. Lee Conklin, in conversation with the author, TRPS Rock Art by the Bay at the Mission Masonic Center, San Francisco, August 6, 2016; Conklin, e-mail message to the author, August 16, 2016.
35. Schnepf interview.
36. Hird, *Introduction to Photo-offset Lithography*, 173–180.
37. While working at the Museum of Fine Arts, Boston

in 2008, the author analyzed samples of printing inks from seven rock posters using Raman spectroscopy. The majority of the colorants identified were synthetic organic pigments. Frequently occurring colorants were diarylide yellows, beta-oxynaphthoic acid calcium and barium reds, and copper phthalocyanine blues. Raman spectroscopy was conducted with the Bruker Optics Senterra dispersive microscope using a 785-nm laser and a 50x objective for an analytical spot size of 2 microns. The rock posters analyzed were donated by Jim Northrup from Sixties Posters, Inc., and included FD-2 by Wes Wilson and Chet Helms, FD-9 by Wes Wilson, FD-63 by Rick Griffin, FD-114 by Jaxon, BG-13 by Wes Wilson, BG/FE-5 by David Byrd, and NR-17 by Victor Moscoso.

38 Willy Herbst, Klaus Hunger, and Gerhard Wilker, *Industrial Organic Pigments: Production, Properties, Applications*, 3rd ed. (Weinheim, Germany: Wiley-VCH, 2004), 144.

39 Leach et al., *Printing Ink Manual*, 314.

40 *The Dictionary of Paper, Including Pulp, Paperboard, Paper Properties, and Related Papermaking Terms*, 3rd ed. (New York: American Paper and Pulp Association, 1965), 286 and 459.

41 Marks, "Was Levon Mosgofian?"

42 Paul Messier, Valerie Baas, Diane Tafilowski, and Lauren Varga, "Optical Brightening Agents in Photographic Paper," *Journal of the American Institute for Conservation* 44, no. 1 (2005): 1–12. Beginning in the mid-1950s, the paper manufacturing industry started using optical brighteners or optical brightening agents. These fluorescent compounds imparted a bright-white look to the paper stock. Under ultraviolet radiation, optical brighteners fluoresce a cold blue color.

43 Several of the original printing dockets from Tea Lautrec list the paper type ordered. These include a 22.5-by-28.5-inch 125 basis Springhill tag purchased in 1967; a 22.5-by-28.5-inch 125 basis ivory Springhill vellum Bristol purchased in 1968; and a 22.5-by-28.5-inch 184M Foldecut purchased in 1968. Pressman Joe Buchwald recalled that Tea Lautrec used either 70- or 80-pound vellum stock for their early rock posters printed for Bill Graham, and used one-sided coated stock when they started printing posters with the artist David Singer in 1969.

44 Grushkin, *The Art of Rock: Posters from Presley to Punk*, 81–82; Marks, "Was Levon Mosgofian?"; Mosgofian, e-mail message to the author, November 27, 2016. Neal, Stratford & Kerr was a long-established shop known for its letterpress printing and located in an industrial building at 1025 Sansome Street. Levon Mosgofian began working at the print shop in 1946 and spearheaded the development of the offset lithography department. In early 1967, with Mosgofian's introduction to Bill Graham and the increased rock poster work coming into Neal, Stratford & Kerr, Mosgofian formed a separate division for the production of rock posters. After Neal, Stratford & Kerr shut down in late 1967, in lieu of back payments for overtime work done during the long shutting down period, Mosgofian acquired sufficient offset lithography equipment to set up shop in the loading dock area of the former Neal, Stratford & Kerr plant. They stayed on for a short while at 1005 Sansome Street, but were eventually pushed out by an antique shop with questionable business practices that inhabited the former main plant of Neal, Stratford & Kerr. Around 1968, Mosgofian set up a new shop at 41 Sheridan Street, where Tea Lautrec Lithography operated into 1991.

While at Neal, Stratford & Kerr, Levon Mosgofian named the new division dedicated to rock posters Toulouse Lautrec Posters, an homage to the late-nineteenth-century artist who produced a number of vivid posters using stone lithography. As the name of the new division seemed too long, Mosgofian shortened it to T. Lautrec Lithography. The name was eventually changed to Tea Lautrec Lithography on the recommendation of the poster artist David Singer, who cleverly noted that "tea" was also a slang word for marijuana. Mosgofian usually used just "Tea Lautrec Litho" on the posters.

45 Joseph Buchwald owned and operated a small offset lithographic shop on 16th Street named Rapid Reproductions before joining Neal, Stratford & Kerr. There, he printed the first poster for the Family Dog, from October 1965, with hand-drawn artwork by Alton Kelley. The concert, "A Tribute to Dr. Strange," featured the Charlatans, the Great Society, and Jefferson Airplane. See Selvin, this volume.

46 Joseph Buchwald, taped interview with the author, San Francisco, August 2008.

47 Marks, "Was Levon Mosgofian?" Denis Mosgofian recalled that Tea Lautrec had two one-color twenty-nine-inch Miehle presses, and a 22-inch ATF Chief press. Buchwald interview: Joseph Buchwald recalled that Tea Lautrec had a one-color thirty-six-inch Miehle sheet-fed press and a one-color twenty-two-inch press.

48 Numbers for print runs are based on printing dockets from Tea Lautrec.

49 Wilson discussed his collaborations with Powell in phone interviews with the author, June 10, 2010, and May 3, 2016.

50 Stanley Mouse, in conversation with the author, Sebastopol, 2009, and April 3, 2010 (hereafter cited as Mouse interviews). Mouse Studios on Henry Street was where Janis Joplin first played with Big Brother and the Holding Company, while Mouse and Alton Kelley worked in the loft space upstairs. Later that night, after everyone had left, the police knocked on the door to inquire about reports from neighbors of a woman screaming in the firehouse. Mouse explained to them that it was a new singer auditioning with a band.

51 Organized by Ramon Sender, Stewart Brand, and author Ken Kesey, the Trips Festival ran from January 21 to 23, 1966, and is credited with launching the hippie counterculture. See McNally, this volume.

52 Ibid.

53 Buchwald interview.

54 Ibid.; Marks, "Was Levon Mosgofian?"

55 Denis Mosgofian, e-mail message to the author, June 14, 2016.

56 Mouse interviews.

57 Buchwald interview.

58 The effect of animation can also be achieved wearing 3-D glasses with red and blue lenses and alternately closing the right and left eyes.

59 Victor Moscoso, in conversation with the author, TRPS Festival of Rock Posters, San Francisco, October 10, 2009; "Type Confusion and Color Aggression."

60 Margaret Holben Ellis, Christopher W. McGlinchey, and Esther Chao, "Daylight Fluorescent Colors as Artistic Media," in *The Broad Spectrum: Studies in the Materials, Techniques, and Conservation of Color on Paper 2002*, eds. Harriet Stratis and Britt Salvesen (London: Archetype, 2002), 160–166.

61 Mouse interviews. He also noted one handbill printed with a pink DayGlo ink, "Five Men in a Boat," FD-20, Longshoremen's Hall, August 1966. Another Family Dog advertisement that appears to use DayGlo is Bob Fried's 1969 billboard *The Family Dog is coming down to Earth* (pl. 224), which consists of 14 screen-printed sheets of paper, a total dimension of 9' 9" x 21' 5". The billboard was created to advertise the Family Dog's new location on the Great Highway in the former Edgewater Ballroom after losing their lease at the Avalon.

62 Wes Wilson, phone interview with the author, June 10, 2010.

63 Mouse interviews.

the sixties in san francisco

not just sex, drugs, and rock and roll

BEN VAN METER

WHEN I MOVED to San Francisco and enrolled in San Francisco State University in 1963, the Photography Department faculty was all into the Group f.64 school of photography, represented by photographers such as Edward Weston and Ansel Adams. My instructor, Don West, was doing the same kind of thing but in color. His mission was to make and to teach his students how to make beautiful and technically perfect color close-ups of rocks, green and red peppers, rusty railroad cars, etc. "Eternity in a grain of sand" kind of thing, I guess. The second-semester students were already meticulously striving for darkroom perfection, and the beginning students were just being introduced to the mysteries of color balance and dodging and burning in and... and... I just wasn't interested in this path.

Instead of shooting a lot of new color pictures, I took my old black-and-white view-camera negatives and scratched on them, punched holes in them, and collaged them together. Then I made color prints and drew and painted on the prints. I re-photographed the prints and repeated the process until I had something I considered intriguing. Remember, this was more than twenty-five years before Photoshop 1.0 was released. Photoshop? Hell, Steve Jobs was nine years old.

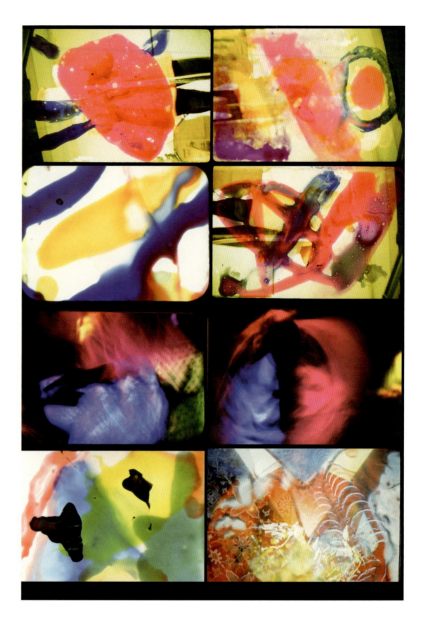

90
Ben Van Meter, *Eight Hand-Painted & Curious Photo Slides*, 1967. Eight 35mm slides.
COLLECTION OF BEN VAN METER AND JOHN J. LYONS

During critique, as I put up my eight or ten outrageous transgressions of the rules of photographic purity, there was a stunned silence. Finally Don muttered, "Interesting . . . interesting, but is it photographic?" "I don't give a crap about that, man," I replied, "I'm trying to make Art."

In my very first film class the instructor, Jim Goldner, gave us a list of things that you should never, never do. One of them was never to do a superimposition (double exposure) in the camera. Jim explained that you had no control over the results, and that superimpositions had to be carefully planned in advance and laid out as A and B rolls to be printed together in the laboratory, otherwise you were likely to turn out something "weird and confusing."

When he said this, a flashbulb went off in my head. This was the clue I had been searching for. "Weird and confusing" sounded just like my life itself, and that was what I wanted to express in my films. Jim not only (inadvertently) gave me the inspiration for the technique I wanted to express, he also introduced me to the tool I needed. It was called the Bolex REX. Jazz musicians call their chosen instrument their "axe," and that is truly what the Bolex became to me. It was a wonderful tool for creative filmmaking. The things you could do with a Bolex have never been available in any video camera I have ever seen.

I set about seeing if I could make something new by breaking the no-multiple-exposure rule. I doubled the ASA [film speed] to allow for exposing each roll two times and set to work. My method was to take one roll with me when I went somewhere I thought might offer unique images. For example, a trip to the zoo. I put one layer of images on one roll and then rewound the roll in the darkroom and put it back in the can and labeled it "zoo." I went on to make a first layer of exposure on the other three rolls and rewind and label them. After all four had a first layer of images, I had four locations to choose from and could, for example, choose the zoo roll to take to North Beach on New Year's Eve for a second layer.

While shooting, I also moved the camera around, sometimes upside down, and used my fingers in random ways in front of the lens to create mattes (black spaces) where the layers could come through one another in "weird and confusing" ways. I made a soundtrack with two tape recorders in much the same way.

The resulting film I initially called "Oldsmo-bile," for no real reason, for many years until it told me that its title was "Bolex Peyote Bardo." I had created the technique that I would use for the next three years on *Colorfilm, Up Tight, L.A. Is Burning . . . Shit, S.F. Trips Festival, An Opening,* and, finally, *Acid Mantra*. I was trying to create something like the river of images in *Siddhartha*, which represents life itself, flowing through time, and the path to enlightenment. As a representation of life, it provides knowledge without words, and one's reward for studying it is an intuitive understanding of its divine essence.

THE FIRST TRIPS FESTIVAL was held in San Francisco on January 21, 22, and 23, 1966 (pls. 22–35). I went alone with my Bolex and three rolls of precious color film. It was a three-night event, so I planned to expose each roll once a night and rewind all of them in the darkroom the next day. The first roll had already been exposed once, at the opening of the Thelin brothers' Psychedelic Shop on Haight Street on January 3. In addition to the opening of the shop it was an art/photography exhibit opening of Bob Ballard's paintings and Susan Elting's photos, so the full title of the finished piece was *S.F. Trips Festival, An Opening* (pl. 27). The opening refers both to the shop's openings and the significance of this event for the whole scene.

After having the triple-exposed film developed, I pretty much just spliced the rolls together, scratched titles on the emulsion, made a soundtrack by messing with quarter-inch tapes until I had something that seemed to fit the footage, and had it printed. This little film is the one that has drawn the most attention from film academics. They have written things about it like the following from *Allegories of Cinema: American Film in the Sixties* by David E. James: "Instead of being either displaced from its subcultural location or obliged to enter into social transactions antithetical to it, the film participated in developing and reproducing the rituals of the subculture." I have always just called it, "A documentary of the event from the POV of a goldfish in the Kool-Aid bowl."

BILL GRAHAM ACQUIRED the old Fillmore Auditorium in San Francisco in early 1966, and every weekend there was a line of "freaks" a block long to get into the shows. I was in the line with my trusty Bolex the first week and shot multiple-exposed footage. Tony Martin was doing liquid projections from the rear balcony onto the wall behind the bandstand with my friend Roger Hillyard assisting him. Tony had a 16mm projector but just some stock footage, so I started bringing last week's footage and projecting it into Tony's liquids.

In May of 1966 Graham presented Andy Warhol's *Exploding Plastic Inevitable* (pl. 239). This was a multimedia show headlined by Lou Reed and Nico. Graham had to put up plastic screens along the one-hundred-foot-long side wall of the hall for Warhol to project his films on, and I knew that he was not going to take them down. Roger Hillyard and I convinced him to hire us to fill them the coming week, and he agreed. We set up in the balcony opposite the screens and began trying to fill them with a couple

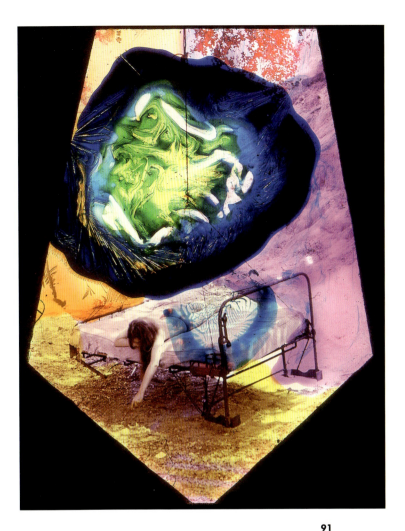

91
Ben Van Meter, *A Grain of Sand*, 1967. Painted and masked 35mm slide.
COLLECTION OF BEN VAN METER AND JOHN J. LYONS

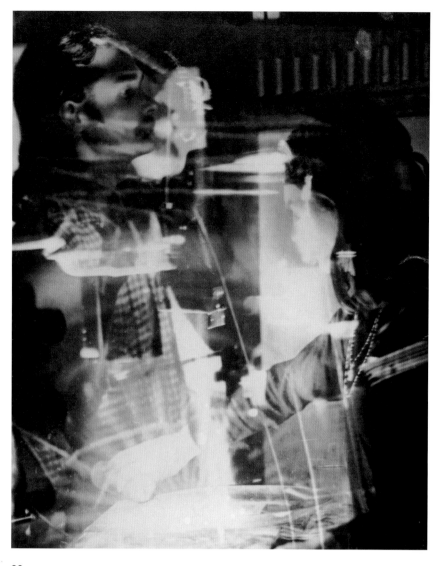

92
Ben Van Meter and
Roger Hillyard, *Ben Van Meter by Roger Hillyard & Roger Hillyard by Ben Van Meter*, 1967. Double-exposed photograph, 11 x 8½ in. (27.9 x 21.6 cm).
COLLECTION OF BEN VAN METER

of overhead projectors for liquids, one 16mm and one 8mm movie projector, and one Kodak Carousel slide projector. So began the Light Show Daze.

Roger and I worked for Graham until the middle of the summer for $35 each a night. We had to supply our own equipment and materials. I still shot film and slides each week in the hall and on Haight Street during the week. The word had gone out that something was going on in San Francisco, and pilgrims were beginning to arrive from all over the country. I added images to my projections on a weekly basis.

AFTER WE QUIT the Fillmore, we got a call from Chet Helms, who ran the dance and concert promotion company Family Dog. The Dog had a large contingent of hard-core hipsters (not yet called "hippies"), and it had a tribal, communal feel about it. He was the quintessential hippie — idealistic, artistic, spiritual, outgoing, and friendly. He had started in the music business by putting on benefits for the civil rights movement in Texas during the early sixties. He knew Janis Joplin there and later brought her to San Francisco and introduced her to the world fronting his band, Big Brother and the Holding Company, at his venue, the Avalon Ballroom. We provided the light show the night of her debut.

Roger and I went to work doing the light show at the Avalon in the fall of 1966 and worked there continuously as the house show for more than a year. We replaced Bill Ham, who had been with the Family Dog since the beginning. In fact, I had been to the Dog's Page Street house for one of their early gatherings and seen liquid projections for the first time. Bill was a painter with an overhead projector. He may not have been the first to use this technique, but he certainly kept at it longer than most — and, as far as I know, he and Tony Martin are the only ones who have continued to practice this unique art form throughout their lives. I remember visiting him during the 1980s in his warehouse studio and being impressed with how he had advanced the techniques and his own artistic expression. I don't know why exactly he left the Avalon — probably exhaustion, which is what finally got to me. Anyway, we were far from exhausted when we took over. We were full of energy and enthusiasm, living on diet number 13 (brown rice and marijuana). I can't remember what Chet paid us initially but it was more than Bill Graham had, and it allowed us to slowly add equipment, slides, and film.

Where Bill Ham's show had been entirely liquid projections, I had that river of images idea in my mind and wanted to integrate film and stills into the liquids to try to create what I called a "moving Rauschenberg." We started with a few projectors, but by the time the Summer of Love rolled around, we had four 1,000-watt overheads in banks of two on dimmers so that we could fade and cross fade, twelve Kodak Carousels on lazy Susans that could be panned around the hall, two 16mm and two 8mm movie projectors, a trooper spotlight for the stage, and the mirror ball and a killer strobe light made by Don Buchla.

We had attracted a band of artists, mostly painters: Ernie Palomino, Bob Comings, Lenny Silverberg, Howard Fox, and, last but far from least, Bruce Conner. At the height of the whole thing we were grooving together like a finely attuned jazz combo. We made moving one-hundred-foot-long collages on the screen, the band, the dancers, and

the ceiling. During a band's set we would create a fantastic, moving mural of saints and nudes and flowers and people of all stripes, from film Bruce and I shot; found film; slides of art, classical and original, hand painted; flowing liquid projections; and flashing lights of various kinds. As the Doors song said, "When the music's over, turn out the lights." Which we did. At the end of the band's set we would leave the finished piece on the screens for a few moments to admire, then we would destroy it and all go up on the roof to smoke weed to get ready for the next band. We had several helpers who were paid fifteen dollars a night to wash the clock faces used for the projections for the next set. It was a unique kind of artistic collaboration the likes of which I haven't seen since, and the most fun I have ever had out of bed.

The light show fit the music, tailored by us for each band. I created new film and slides each week for the show. I shot at events in Golden Gate Park using my multiple-exposure method, and I shot slides on a weekly tour of Haight Street. Some of the new pilgrims to the gathering had the experience of entering the Avalon and seeing themselves on the screen. The list of bands we backed up visually is long and varied: the Grateful Dead, Janis and the Holding Company, Steve Miller, the Doors, etc. When our posse had grown we came up with a grandiose name for the show, the North American Ibis Alchemical Company.

By the end of the Summer of Love, the Thelin brothers declared the "Death of the Hippie" and had a mock funeral in the Panhandle of Golden Gate Park. We were all dead tired after a summer of six nights a week from 7 pm to 2 am of energetic extemporaneous art improvising. Roger had bailed out before this and gone to live in a commune in New Mexico, and I was exhausted. The light shows were never paid even as much as the third band on the bill, and after a certain point the fun and satisfaction weighed against the financial returns versus the energy output required zeroed out. The last sizable gig I can remember was at the Palace of Fine Arts Festival, August 30 and 31, and September 1 and 2, 1968.

What I considered the most artistically successful show, however, was one set backing up flautist Charles Lloyd in a little venue in North Beach. It was actually a showcase for a girl band, the Ace of Cups, and Lloyd was the second act. I don't remember which members of my crew were on board for this, but the intricacies of the music inspired our most fantastic work. It felt like one could have walked into that screen and ended up in another dimension, another abstract reality. I once saw the original of Pablo Picasso's *Guernica* and had the same feeling. Minds were blown that evening without chemical assistance, just from listening and watching the screen. ❀

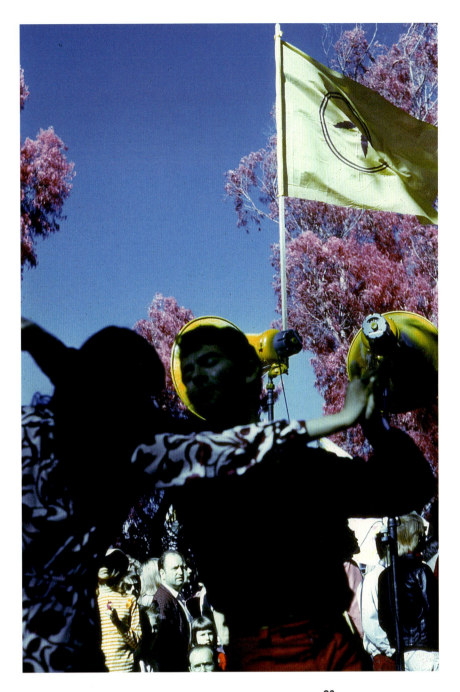

93
Ben Van Meter,
A Spring Day, 1967.
35mm slide; infrared aero film.

COLLECTION OF BEN VAN METER
AND JOHN J. LYONS

This text is drawn from the unpublished memoirs, *Rebirth of a Nation* by the author and John J. Lyons.

time line

NOTE TO READER: This time line features key events in the Bay Area leading up to, during, and following the Summer of Love to give the full cultural context of the period, including its inspirations and legacies.

1955

Allen Ginsberg writes "Howl," a poem that will become an anthem for the Beat precursors to the Summer of Love counterculture.

1960

Students from the University of California, Berkeley (UC Berkeley) and San Francisco State College (SF State) challenge the House Un-American Activities Committee (HUAC) at their hearings at San Francisco's city hall. With support from the Longshoremen's Union, they diminish HUAC's power considerably.

1962

Ken Kesey publishes *One Flew Over the Cuckoo's Nest* (PL. 348); Alan Watts publishes *The Joyous Cosmology: Adventures in the Chemistry of Consciousness.*

Composers Morton Subotnick and Ramon Sender open the San Francisco Tape Music Center as a nonprofit cultural and educational corporation, to present concerts and offer learning opportunities about the tape music medium.

1964

SPRING ... Students from UC Berkeley and SF State join forces with the Congress of Racial Equality (CORE) to picket car dealers on Van Ness Avenue and also the Sheraton Palace Hotel for their discriminatory hiring policies. The students win.

SPRING ... Michael Ferguson opens the first head shop in San Francisco. Known as the "Magic Theater for Madmen Only," it was located on Divisadero Street, next door to the Tape Music Center.

AUGUST 19 ... The Beatles open their first North American tour at Cow Palace near San Francisco; more than 17,000 people, including Ken Kesey and a group of Merry Pranksters, attend. Caught up in the crowd's adoration, Kesey realizes the potential such gatherings have for harnessing a new collective spirit that he will eventually shape into his legendary Acid Tests.

OCTOBER TO DECEMBER ... Student on-campus activism reaches an early height during the Free Speech Movement at UC Berkeley.

1965

JANUARY 1 ... Council on Religion and the Homosexual throws a Mardi Gras–themed costume ball at California Hall on Polk Street that is harassed and raided by San Francisco Police Department (SFPD). Religious authorities condemn this action, and the gay community wins public support that will fuel the gay rights movement in San Francisco.

FEBRUARY 21 ... Augustus Owsley Stanley III is detained for running a Methedrine lab when state narcotics agents raid his Berkeley home and find a suspicious substance. When it later turns out to be something other than Methedrine (probably a form of LSD), he sues law enforcement for the return of his laboratory equipment, and wins.

APRIL 24 ... Police raid Ken Kesey's compound in La Honda and arrest him along with fourteen Pranksters for possession of marijuana.

MAY 5 ... The Grateful Dead begin their career as the Warlocks, publically playing together for the first time at Magoo's Pizza, in suburban Menlo Park.

MAY 14 ... The Rolling Stones play the Civic Auditorium in San Francisco during their first American tour.

MAY 21 ... The Rolling Stones play the Civic Auditorium in San Jose.

JUNE 21 ... The Charlatans begin a residency at the Red Dog Saloon in Virginia City, Nevada (PL. 226). There, the group assumes a Wild West persona through vintage clothing and accessories to capitalize on the outlaw lifestyle that characterized the Gold Country's celebrated past (PL. 7). Bill Ham's light shows visually augment the music.

AUGUST 7 ... Ronnie Davis and the San Francisco Mime Troupe attempt to perform *Il Candelaio* in San Francisco's Lafayette Park; the show is interrupted by the SFPD, which arrests Davis for performing without a permit.

AUGUST 13 ... The Matrix nightclub opens, with Jefferson Airplane debuting as the house band.

AUGUST 13 ... Max Scherr begins the *Berkeley Barb*, an antiwar, pro-student weekly periodical that grows to include a liberal readership throughout the Bay Area.

AUGUST 30 ... The Charlatans play in San Francisco for the first time at 622 Broadway in North Beach, the original home of the satirical theater group the Committee.

SEPTEMBER 8 ... Agricultural Workers Organizing Committee (AWOC) and the United Farm Workers (UFW) organize the Delano grape strike against grape growers in California. The strike lasts more than five years before ending with a victory for the workers.

SEPTEMBER 13 ... With North Beach satirical theater group the Committee, Stewart Brand begins a series of Monday multimedia happenings called "America Needs Indians," which consist of movie projectors, Native American dancers, and multiple musical sound tracks.

OCTOBER ... Peggy Caserta opens Mnasidika, the first hip clothing boutique, in Haight-Ashbury.

OCTOBER 15 ... Country Joe and the Fish play at the San Francisco State College Vietnam Day Committee (VDC) Teach-In.

OCTOBER 16 ... VDC antiwar march from UC Berkeley campus through Oakland meets police resistance at Oakland city border. That evening, many participants find their way across the Bay Bridge to attend the first Family Dog concert: "A Tribute to Dr. Strange" (PL. 227). Performers include Jefferson Airplane, the Charlatans, the Marbles, and the Great Society.

OCTOBER 24 ... Family Dog hosts their second dance concert, "A Tribute to Sparkle Plenty," at Longshoremen's Hall.

NOVEMBER 6 ... Bill Graham stages a San Francisco Mime Troupe appeal party at 924 Howard Street, to raise funds for Davis's growing legal fees and protest the Department of Recreation and Parks' restrictions on parkland use. Artists who appear in support of the Mime Troupe include Jefferson Airplane, the Fugs, and Sandy Bull. The same night, the Family Dog hosts their third dance concert, "A Tribute to Ming the Merciless."

NOVEMBER 16 ... University Art Gallery at UC Berkeley opens *Jugendstil Expressionism in German Posters*, an exhibition featuring artwork that artist Wes Wilson credits for inspiring his style of hand-lettered posters.

NOVEMBER 27 ... Kesey and the Merry Pranksters host their first Acid Test at the Spread, a chicken ranch owned by Prankster Ken Babbs, near Santa Cruz.

DECEMBER 4 ... Kesey and the Merry Pranksters host an Acid Test in San Jose, and the Grateful Dead performs there for the first time under that name.

DECEMBER 11 ... Kesey and the Merry Pranksters bring the Acid Tests to Marin County, at a lodge on Muir Beach (PL. 28).

DECEMBER 18 ... Michael McClure's controversial play *The Beard* debuts at the Actor's Workshop Theatre. Unbeknownst to McClure and the actors, the SFPD tape-records this and a second performance that occurs on July 24, 1966, at the Fillmore Auditorium. On August 8, 1966, after three performances at the Committee in North Beach, the SFPD raids the venue and arrests actors Billie Dixon and Richard Bright, who are charged first with obscenity, and later with "conspiracy to commit a felony" and "lewd or dissolute conduct in a public place." After months of legal deliberations, charges are eventually dropped, but the play can no longer be performed in San Francisco.

1966

César Chávez and sixty-six other National Farm Workers Association (NFWA) members march two hundred fifty miles from Delano to Sacramento, California, to promote the farmworker cause. NFWA reaches a settlement and the boycott is called off. The contract is the first ever signed for farmworkers in the United States. NFWA merges with the Agriculture Workers Organizing Committee (AWOC) to become the United Farm Workers Organizing Committee (UFWOC).

JANUARY 3 ... Near the corner of Haight and Ashbury Streets, brothers Ron and Jay Thelin open the Psychedelic Shop, which soon becomes a neighborhood hangout.

JANUARY 14 ... Third San Francisco Mime Troupe appeal, headlined by the Great Society, the Mystery Trend, the Grateful Dead, and the Gentlemen's Band.

JANUARY 21–23 ... Trips Festival, Longshoremen's Hall (PLS. 22–27).

FEBRUARY 4–6 ... For the Jefferson Airplane concerts at the Fillmore this weekend, East Winds Printer prints the first numbered Bill Graham poster (PL. 231).

FEBRUARY 19 ... Fillmore hosts its first Family Dog production; first numbered Family Dog Poster (pl. 13) is printed at Contact Printing advertising the event.

MARCH 11–12 ... Fillmore hosts "The Great Blondin," a two-day dance benefit for filmmaker Robert Nelson's *The Great Blondino*.

MARCH 25 ... Rock and Roll Dance Benefit is staged for the VDC at UC Berkeley.

MARCH 26 ... Protestors march up Market Street to Civic Center as part of international day of protest against the war in Vietnam (PL. 20).

APRIL 9 ... Angry Arts Vietnam Mobilization fundraiser takes place this week at Longshoremen's Hall.

APRIL 15 ... Fifth Annual San Francisco State College Folk Festival (PL. 236)

MAY 10 ... First meeting of the Artists Liberation Front (ALF) is held at the Mime Troupe studio on Howard Street.

MAY 12 ... California gubernatorial candidate Ronald Reagan speaks to crowds gathered at Cow Palace, calling behaviors observed at UC Berkeley's Vietnam Day benefit a few weeks earlier, "so contrary to our standards of human behavior that I couldn't possibly recite them to you." (As quoted in Michael J. Kramer, *Republic of Rock*, 15).

MAY 27–29 ... Andy Warhol's Exploding Plastic Inevitable, featuring the Velvet Underground, is staged at the Fillmore (PL. 239); in his review, *San Francisco Chronicle* music critic Ralph J. Gleason pans the show, which he contends is designed to be "watched" rather than experienced.

JUNE ... Singer Janis Joplin performs with Big Brother and the Holding Company at the Avalon Ballroom for the first time.

JULY 10 ... UFW holds benefit concert at the Fillmore.

AUGUST ... Record stores and concerts begin to carry Greg Shaw's first issue of *Mojo-Navigator Rock 'n' Roll News*, which features interviews with local bands, record reviews, and industry gossip.

AUGUST 6 ... Three thousand people march up Market Street to Civic Center, for peace in Vietnam.

AUGUST 29 ... The Beatles perform at Candlestick Park, their final live concert together.

SEPTEMBER ... San Francisco Tape Music Center receives $15,000 grant from Rockefeller Foundation and moves to Mills College, where it becomes the Mills Tape Music Center (later the Center for Contemporary Music).

SEPTEMBER 2 ... *P. O. Frisco*, the short-lived Haight-Ashbury neighborhood newspaper and precursor to the *San Francisco Oracle*, hits the streets.

SEPTEMBER 20 ... Under the direction of Allen Cohen (editor) and Michael Bowen (art director), the first issue of the underground *San Francisco Oracle* newspaper is published (PLS. 108–119).

SEPTEMBER 27 ... Riots break out in Bay View–Hunter's Point neighborhood after a white police officer shoots and kills African-American teenager Matthew Johnson Jr. The radical street performer–activist group, the Diggers, forms in the aftermath, organizing to break a curfew that the SFPD has put in place.

SEPTEMBER 30 ... ALA series of street fairs debuts in the Mission District, with mariachi bands, El Teatro Campesino, and the San Francisco Mime Troupe.

SEPTEMBER 30–OCTOBER 2 ... SF State holds "Whatever It Is" (also known as the Awareness Festival), a three-day Acid Test presented by the Associated Students and the Experimental College. Stewart Brand participates, and Kesey makes an appearance, having recently returned from Mexico as a fugitive in connection with previous drug arrests.

OCTOBER 6 ... LSD becomes illegal. Allen Cohen and Michael Bowen organize Love Pageant Rally in the Panhandle of Golden Gate Park; the Grateful Dead and Big Brother and the Holding Company perform.

OCTOBER 15 ... Huey P. Newton and Bobby Seale create the Black Panther Party for Self Defense. ALF Free Fair held in the Panhandle.

OCTOBER 16 ... Singer Grace Slick joins Jefferson Airplane.

OCTOBER 20 ... Kesey arrested while driving on the Bayshore Freeway just south of San Francisco and put in jail.

OCTOBER 27 ... First issue of the *San Francisco Bay Guardian*, an alternative weekly paper, is published; Bruce Brugmann is publisher and editor.

OCTOBER 31 ... To be released from the San Mateo County jail on bail, Kesey agrees to warn young people of the dangers of LSD; he plans an event on Halloween at Winterland that he calls the Acid Test Graduation, in which he intends to encourage young people to move "beyond acid" (PLS. 33 AND 35); plans fall through when Bill Graham cancels the venue contract and a much smaller gathering takes at the Pranksters' downtown warehouse. At the corner of Haight and Ashbury, the Diggers initiate the Intersection Game, an activity intended to expose the perils faced by pedestrians and offering a new take on civil rights sit-ins with the disruption of automobile traffic.

NOVEMBER 4 ... The first Digger free store, called the Free Frame of Reference, opens at 1762 Page Street this week.

NOVEMBER 15 ... SFPD raids the Psychedelic Shop and arrests Allen Cohen for selling a book of obscene poetry. They seize all copies of the book in question, Lenore Kandel's *A Love Book* (1966). Within an hour, demonstrators protest police action outside the shop.

NOVEMBER 20 ... Student Nonviolent Coordinating Committee (SNCC) fundraiser held at the Fillmore.

NOVEMBER 22 ... Entrepreneurs in the Haight organize to form the Haight Independent Proprietors (HIP) society of merchants.

DECEMBER 1 ... Print Mint store opens at 1542 Haight Street as a retailer of rock posters; it later evolves into a publisher and printer of underground comics and becomes a center of countercultural activity in the neighborhood.

DECEMBER 17 ... Nearly 200 people, including members of the Hells Angels Motorcycle Club, follow a coffin down Haight Street, singing "Get out my life, why don't you babe?" to the tune of Chopin's funeral march as they participate in "Now Day." This parade and demonstration staged by the Diggers and the Mime Troupe calls for the death of money now.

1967

JANUARY 1 ... Approximately 2,000 people gather for a New Year's Wail in the Panhandle; the folk rock musical event is sponsored by the Hells Angels and the Diggers.

JANUARY 8 ... The Diggers' second free store, at 520 Frederick, is raided by the SFPD.

JANUARY 14 ... Roughly 40,000 people assemble at the Polo Fields in Golden Gate Park for the Human Be-In; Allen Ginsberg, Lenore Kandel, Timothy Leary, Michael McClure, and others address the crowd (PLS. 36–42).

FEBRUARY 12 ... In a move that would change the face of FM radio, Larry Miller begins the midnight to 6 am radio shift on KMPX, and plays "folk rock" whenever the on-air broadcast is not otherwise scheduled.

FEBRUARY 20 ... Filmmakers, including Bruce Baillie, Bruce Conner, Lawrence Jordan, Robert Nelson, and Ben Van Meter, formally incorporate Canyon Cinema as a cooperative to distribute independent films and make available to the public free or low-cost showings of members' work.

FEBRUARY 24–26 ... In response to the previous year's Trips Festival, the Diggers host the Invisible Circus at Glide Church in the Tenderloin, advertised as a "72-hour environmental community happening" (PL. 134).

FEBRUARY 28 ... After a raid of Digger crash pads in the Haight the night before, demonstrations erupt at the SFPD's Park Station, protesting the raids and police harassment.

MARCH 3 ... The Love Conspiracy Commune stages the first Love Circus at Winterland.

MARCH 5 ... Warren Hinckle III, editor of *Ramparts*, hosts a "rock dance-environment happening" to benefit the Communication Company in honor of the CIA (Citizens for Interplanetary Activity) at California Hall. Participants include the S. F. League for Sexual Freedom, the Diggers, and the Mime Troupe.

MARCH 19 ... "Chalk-In" at the Panhandle sponsored by the city's Recreation and Parks Department, coopting a custom of the Haight-Ashbury neighborhood that had previously been undermined. According to the *Chronicle*, each participant was given a four-foot-square area, and handed an envelope filled with chalk, which had been donated by Pacific School Supply.

MARCH 22 ... Police chief Thomas J. Cahill announces that "law, order and health regulations must prevail" in the face of any influx of hippie "pilgrims" coming to the city for the summer.

MARCH 24 ... San Francisco Health Department announces an initiative to clean up the Haight, which health director Dr. Ellis D. Sox characterizes as a slum.

MARCH 26 ... At the Easter Sunday "Mill-In" at the corner of Haight and Ashbury, hundreds block traffic for hours, playing the Intersection Game and telling the tourists in their cars to "get out and turn on."

MARCH 27 ... Health inspectors lead raids on apartments throughout the Haight, looking for violations of the city's health code.

MARCH 28 ... At the request of members of the Public Utilities Commission to "protect" people living in the Sunset so they will not have to pass through the "Sodom" of Haight Street, San Francisco Municipal Railway announces plans to reroute city buses on weekends and holidays.

MARCH 31 ... Mime Troupe appears at Fluxfest at Longshoremen's Hall.

APRIL 1 ... A "Clean-In" takes place in the Haight in response to Health Department inspections.

APRIL 5 ... A press conference announces the formation of a Council for the Summer of Love, which intends to "serve as a central clearing house for theatrical, musical, and artistic events, dances, concerts and happenings in the Haight Ashbury"; Gray Line begins bus tour of the Haight, billed as "the only foreign tour within the continental limits of the United States."

APRIL 7 ... Tom Donahue, a major AM radio personality, takes over a slot on KMPX, from 8 pm to midnight. In August, Donahue's rock programming extends to full time.

APRIL 14–16 ... Spring Mobilization to End the War in Vietnam is organized in San Francisco and New York City as part of an initiative led by Angry Arts. The San Francisco effort includes a march from Second and Market Streets to Kezar Stadium on April 15 (PLS. 43–46).

MAY 4 ... To convince the establishment that "love is where it's at" and to open a conversation with city officials about assisting the large numbers of young people entering the city, the Diggers move their free-food operation from the Haight to the steps of city hall, providing free spaghetti and meat sauce to city employees and passersby.

MAY 13 ... Singer Scott McKenzie releases *"San Francisco (Be Sure to Wear Flowers in Your Hair),"* a hit song written to promote the upcoming Monterey International Pop Music Festival.

MAY 13 ... A panel discussion of spokesmen for the Haight-Ashbury and local government takes place at UC Medical Center to discuss the impending influx of hippie teenagers to the city; the conversation is broadcast live over KQED.

MAY 17 ... Martin Luther King Jr. addresses crowds from the steps of Sproul Hall on the campus of UC Berkeley.

JUNE 7 ... Dr. David Smith opens the Haight-Ashbury Free Medical Clinic to those in need of medical services 24 hours a day.

JUNE 10–11 ... Festival honoring Muhammad Ali is held in Hunter's Point, with performances by Steve Miller Blues Band, Sonny Lewis Quintet, B/A. Q. Orkustra, The Loading Zone, Afro Blue Persuasion, Haight Street Jazz Band, and others. Magic Mountain Music Festival is held on Mount Tamalpais to benefit the Hunter's Point Child Care Center. Musical guests include Country Joe and the Fish, Jefferson Airplane, and Moby Grape (PL. 252).

JUNE 15 ... Private "christening" of new, alternative performance venue in the Haight, the Straight Theater, is held with the Grateful Dead and Wildflower, a band from Oakland.

JUNE 16–18 ... Monterey International Pop Festival is held in Monterey (PL. 250).

JUNE 18 ... With the support of the Glide Foundation and the San Francisco Foundation, Huckleberry House opens at 1 Broderick Street, to provide services to runaway youth in San Francisco.

JUNE 21 ... Summer Solstice Celebration begins at 4:30 am with a sunrise gathering atop Twin Peaks; festivities continue in Golden Gate Park, just east of the Polo Fields, with a psychedelic picnic and dance concert, before revelers make their way to Ocean Beach for sunset (PLS. 50, 54, 56, AND 58).

JULY 11 ... After performing in the Royal Ballet company's presentation of Romeo and Juliet at the War Memorial Opera House, ballet superstars Rudolf Nureyev and Dame Margot Fonteyn visit a party in the Haight that is broken up by SFPD. They, along with other partygoers, are arrested for disturbing the peace and being in a house where marijuana is found, and are held at Park Station. No charges against the dancers are filed, with district attorney Frederick J. Whisman claiming lack of evidence.

JULY 13 ... Bill Graham hosts a benefit for the Haight-Ashbury Free Medical Clinic at the Fillmore Auditorium. The Charlatans, Blue Cheer, and Big Brother and the Holding Company play.

JULY 17 ... Joint Show of work by rock poster artists Rick Griffin, Alton Kelley, Victor Moscoso, Stanley Mouse, and Wes Wilson opens at the Moore Gallery on Sutter Street.

JULY 21 ... Following the long-awaited approval of city permits, the Straight Theater opens for business.

AUGUST 7 ... Beatle George Harrison visits the Haight.

AUGUST 28 ... Wake for Hells Angel Chocolate George (Charles G. Henricks), who died in an accident in the Haight. Grateful Dead and Big Brother and the Holding Company play for the crowd gathered to send him off in style in Golden Gate Park's Lindley Meadow.

SEPTEMBER 21 ... Equinox of the Gods benefit for filmmaker Kenneth Anger's *Lucifer Rising* held at the Straight Theater (PL. 82).

OCTOBER 2 ... State narcotics agents and SFPD, followed by reporters and television crews, raid the Grateful Dead house at 710 Ashbury; musicians "Pigpen" and Bob Weir, band managers Rock Scully and Danny Rifkin, equipment manager Bob Matthew, and six friends are arrested for marijuana possession.

OCTOBER 6 ... Diggers stage a mock funeral in Yerba Buena Park, marking the "Death of the Hippie" (PL. 135). Soon after, some Diggers rename themselves the Free City Collective, expanding the reach of their initiatives beyond the Haight.

OCTOBER 8 ... "Dr. Sunday's Medicine Show," a benefit for the Haight-Ashbury Free Medical Clinic, held at Family Park, San Jose.

OCTOBER 16 ... Stop the Draft Week demonstrations take place across the nation; Joan Baez and others are arrested in Oakland; crowds brutalized by police.

OCTOBER 29 ... "Citizens for a Yes on Proposition P" benefit at the Fillmore, featuring Jefferson Airplane, Mother Earth, and Mad River. Proposition P, which called for the withdrawal of troops from Vietnam, was on the San Francisco Municipal ballot the following week, where it failed to pass by a two-to-one margin.

NOVEMBER 9 ... Jann Wenner releases first issue of *Rolling Stone*.

1968

JANUARY 7 ... Fillmore hosts Stop the Draft Week defense fund concert, featuring Phil Ochs, Loading Zone, and the Committee (PL. 316).

FEBRUARY 25 ... Robert Crumb launches Zap Comix, in which his iconic Mr. Natural character first appears. Crumb's wife, Dana, sells issues out of a baby carriage on the streets of the Haight.

FEBRUARY ... Final issue of the *San Francisco Oracle* is published.

MARCH 3 ... With a farewell concert in the Haight, Grateful Dead relocate to Marin County (PL. 75).

MARCH 16 ... During an offsite meeting of KMPX radio staff, Donahue suggests that his employees take action to stand up to changes instituted by the station's management, including increased censorship of disk jockeys. Conversation leads to the formation of a radio staff union and a strike that is ultimately supported by rock musicians and their record companies, as well as local businesses and unions.

APRIL 5 ... Mayor Joseph Alioto issues a proclamation, condemning the assassination of Martin Luther King Jr.

APRIL 27 ... Peace march and rally to end the war, led by GIs for Peace.

MAY 21 ... Donahue and KMPX staffers move over to new station, KSAN.

MAY 28–29 ... "Spring Medicine Show" held as a benefit for the Haight-Ashbury Free Medical Clinic at the Avalon Ballroom. Performers include Crystal Syphon, Allmen Joy, Phoenix, Country Weather, Indian Head Band, Linn County, Mint Tattoo, Santana Blues Band, Initial Shock, A. B. Skhy, and It's a Beautiful Day (PL. 125).

JUNE ... Galleries throughout the city organize "Rolling Renaissance," a celebration of San Francisco underground art made from 1945 to 1968.

JULY ... Bill Graham moves his operations to Fillmore West, formerly known as the Carousel Ballroom.

JULY 1 ... KSAN Stereo Radio 95 Family Freakout held at the Avalon.

AUGUST 20 ... Zap Show, featuring original artwork by Crumb, Griffin, Moscoso, and Wilson, opens at Bill Ham's Light Sound Dimension Theater gallery at 1572 California Street.

FALL ... Stewart Brand's *Whole Earth Catalog* (PL. 358) begins publication.

SEPTEMBER 25 ... Five-day Radical Theatre Festival is held at SF State, featuring Bread and Puppet Theater, El Teatro Campesino, and the San Francisco Mime Troupe.

OCTOBER 12 ... In direct defiance of US Army orders, GIs for Peace organize and lead a march of GIs and veterans in San Francisco, to end the war in Vietnam.

OCTOBER 14 ... With newspaper headlines proclaiming "Mutiny in the Presidio," prisoners in San Francisco's Presidio stockade protest crowded living conditions and the execution of one of their own, singing "We Shall Overcome"; they are charged with desertion, which comes with a possible death sentence. This marks the beginning of a string of protests and riots that call attention to antiwar sentiment within the military.

OCTOBER 18 ... Photographs by Ruth-Marion Baruch, a photographic essay on the Haight-Ashbury, opens at the de Young.

NOVEMBER 6 ... SF State's Black Student Union and a coalition of student groups known as the Third World Liberation Front lead a strike lasting nearly five months, demanding equal access to higher education, greater representation of faculty of color at the senior level, and a new, inclusive curriculum.

NOVEMBER ... Upon losing their lease at the Avalon, Family Dog begins searching for new venue.

DECEMBER 7 ... *A Photographic Essay on the Black Panthers* opens at the de Young, featuring the photographs of husband and wife Pirkle Jones and Ruth-Marion Baruch (PLS. 326 AND 329–331).

1969

JANUARY ... San Francisco-based women's liberation group Sudsofloppen organizes a conference, bringing together like-minded women throughout the Bay Area.

JANUARY 17 ... Four friends from Austin, Texas, found Rip Off Press in San Francisco with the goal of printing promotional posters for rock bands and publishing comics on the side. Early successes with the latter include *The Fabulous Furry Freak Brothers* and *Rip Off Comix*.

MARCH 12 ... Impresarios from the San Francisco music scene gather at the Jefferson Airplane mansion for a breakfast organized by Ron Polte, manager of Quicksilver Messenger Service, with a goal of returning to the industry some of the original optimism and energies. They plan a music festival (what would take shape as the Wild West Festival) to recover the countercultural movement's original goals, promoting a new form of social consciousness and engagement.

MARCH 21 ... SF State strike ends.

APRIL 29 ... Mayor Alioto announces the introduction of an "anti-hoodlum patrol" after a member of the Black Panthers allegedly aims a gun at a police officer the previous day.

MAY 15 ... "Bloody Thursday": A rally at UC Berkeley to discuss the Arab-Israeli conflict takes on a local dimension when Associated Students of the University of California Student Body President Dan Siegel shouts "Let's take the park!" This declaration sparks a violent protest and riot. The park mentioned was People's Park, a lot owned by the University that student activists had, without official authorization, turned into a public park a month earlier.

MAY 24 ... "The Rock of the Ages" Haight-Ashbury Festival, a benefit for the Haight-Ashbury Children's Center, is held in the Panhandle, with performances by Country Joe McDonald, The Pitschell Players, Johnny Sunshine, Pipe Joint Compound, Billy T. Grey Quintet, Angel's Own Social Grace and Blessed Deliverance Band, John Fromer, The Lamb - Dennis Doyle and Co., Sky, Andy Rice, Drake Deknatel, and The Afro-Cubanos.

MAY 28 ... People's Park Bail Ball benefit takes place at Winterland, featuring Creedence Clearwater Revival, Bangor Flying Circus, Elvin Bishop Group, Grateful Dead, Jefferson Airplane, and Santana.

JUNE 13 ... Family Dog on the Great Highway opens with performance by Jefferson Airplane.

AUGUST ... Light Artists Guild strikes for equitable payment and a percentage of ticket sales. Their plan backfires, however, when promoters scale back their events and cancel the light show element of the dance concerts.

AUGUST 13 ... Plans for three-day Wild West Festival to be held in Golden Gate Park dissolve in disagreements regarding the event's cost to attendees. The event was to take place August 22–24.

NOVEMBER 10 ... Mohawk Richard Oakes reads a proclamation to federal official Mr. Hammon: "We the Native Americans reclaim this land known as Alcatraz Island in the name of all American Indians by right of discovery. We wish to be fair and honorable in our dealings with the Caucasian inhabitants of this land and hereby offer the following treaty. We will purchase said Alcatraz Island for $24 and glass beads and red cloth, a precedent set by the white man's purchase of a similar island about 300 years ago." (KRON News)

NOVEMBER 15 ... Following demonstrations earlier in the day throughout the country, thousands participate in the Vietnam War Moratorium Peace March in San Francisco.

NOVEMBER 20 ... Alcatraz Island is occupied by eighty-nine members of Indians of All Tribes (IOAT); occupation lasts for nineteen months and is forcibly ended by the US government.

DECEMBER 6 ... Headlined by the Rolling Stones, Altamont Speedway Free Festival in the East Bay is cut short following a string of violent encounters culminating with the murder of Meredith Curly Hunter Jr. at the hands of Hells Angel Alan Passaro. Members of the Hells Angels had been hired as security guards for the event, which drew a crowd of approximately 300,000.

DECEMBER 31 ... Cockettes, the flamboyant drag theater group, first perform at the Palace Theater in North Beach.

1970

FEBRUARY 16 ... A homemade bomb explodes outside Park Station, fatally injuring one, and severely wounding several. Though the Black Panthers come under suspicion, an investigation implicates the Weather Underground.

APRIL 15 ... San Francisco–based publisher and distributor Last Gasp publishes its first comic book, Slow Death Funnies #1, as a benefit for a local ecology center. With short stories targeting the world's corporate polluters, it was also a timely publication, marking the first Earth Day on April 22.

MAY ... Government shuts off power and stops delivery of fresh water to Native Americans occupying Alcatraz. A fire breaks out on the island in June, destroying three historical buildings.

1971

JUNE 10 ... Federal marshals, FBI agents, and Special Forces swarm Alcatraz, removing occupiers.

JULY 4 ... Bill Graham closes Fillmore West.

AUGUST 26 ... Members of the San Francisco chapter of the National Organization for Women distribute leaflets downtown about equal pay, child care, and the Equal Rights Amendment. This action corresponds with the second annual Strike for Equality march that occurs in major urban centers throughout the country.

selected bibliography

ALBRIGHT, THOMAS. *Art in the San Francisco Bay Area 1945–1980: An Illustrated History.* Berkeley and Los Angeles: University of California Press, 1985.

ANTHONY, GENE. *Magic of the Sixties.* Layton, UT: Gibbs Smith, 2004.

———. *Summer of Love: A Photo-Documentary.* With a foreword by Michael McClure. Berkeley: Celestial Arts, 1980.

ARMSTRONG, DON, and **JESSICA ARMSTRONG.** "Dispatches from the Front: The Life and Writings of Ralph J. Gleason," *Rock Music Studies* 1/1 (2014): 3–34.

AUTHER, ELISSA, and **ADAM LERNER,** eds. *West of Center: Art and the Counterculture Experiment in America, 1965–1977.* Minneapolis: University of Minnesota Press, 2012.

BARUCH, RUTH-MARION, JEFF GUNDERSON, and **PAUL LIBERATORE.** *Black Power Flower Power,* Novato, California, The Pirkle Jones Foundation, 2012.

BERGER, MAURICE. *For All the World To See: Visual Culture and the Struggle for Civil Rights,* New Haven and London, Yale University Press, 2010.

Berkeley in the Sixties. New York: First Run Features, 2002. DVD: sd., col. and b&w, 4¾ in.

BERNSTEIN, DAVID W. *The San Francisco Tape Music Center: 1960s Counterculture and the Avant-Garde.* Berkeley: University of California Press, 2008.

BLAUVELT, ANDREW. *Hippie Modernism: The Struggle for Utopia.* Minneapolis: Walker Art Center, 2015.

BRAUNSTEIN, PETER, and **MICHAEL WILLIAM DOYLE.** *Imagine Nation: The American Counterculture of the 1960s and '70s.* New York: Routledge, 2002.

COYOTE, PETER. *Sleeping Where I Fall.* Washington, DC: Counterpoint, 1999.

ECHOLS, ALICE. *Shaky Ground: The Sixties and Its Aftershocks.* New York: Columbia University Press, 2000.

GRAHAM, BILL, and **ROBERT GREENFIELD.** *Bill Graham Presents: My Life Inside Rock and Out.* Cambridge, MA: Da Capo, 2004.

GRUNENBERG, CHRISTOPH. *Summer of Love: Art of the Psychedelic Era.* London: Tate Publishing, 2005.

GRUSHKIN, PAUL. *The Art of Rock: Posters from Presley to Punk.* New York: Abbeville, 1987.

HARRIS, JONATHAN, and **CHRISTOPH GRUNENBERG.** *Summer of Love: Psychedelic Art, Social Crisis and Counterculture in the 1960s.* Liverpool, UK: Liverpool University Press, 2006.

HILL, SARAH. *San Francisco and the Long 60s.* London: Bloomsbury Academic, 2016.

JACOPETTI, ALEXANDRA, and **JERRY WAINWRIGHT.** *Native Funk & Flash: An Emerging Folk Art.* San Francisco: Scrimshaw, 1974.

JONES, LANDON Y. *Great Expectations: America and the Baby Boom Generation.* New York: Ballantine Books, 1981.

KING, ERIC. *The Collector's Guide to Psychedelic Rock Concert Posters, Postcards and Handbills 1965–1973,* vol. 1, 10th ed. [Berkeley?]: printed by author, 2011.

KLASSEN, MICHAEL. *Hippie, Inc.: The Misunderstood Subculture That Changed the Way We Live and Generated Billions of Dollars in the Process.* Boston: SixOneSeven, 2016.

KRAMER, MICHAEL J. *The Republic of Rock: Music and Citizenship in the Sixties Counterculture.* New York: Oxford University Press, 2013.

LEMKE, GAYLE. *Bill Graham Presents the Art of the Fillmore: The Poster Series 1966–1991.* New York: Thunder's Mouth, 1999.

LOBENTHAL, JOEL. *Radical Rags: Fashions of the Sixties.* New York: Abbeville, 1990.

MACDONALD, SCOTT. *Canyon Cinema: The Life and Times of An Independent Film Distributor.* Berkeley: University of California Press, 2008.

MAILE, ANNE. *Tie and Dye as a Present Day Craft.* New York: Ballantine, 1963.

MCKENNA, KRISTINE, and **DAVID HOLLANDER.** *Notes From a Revolution: Com/Co, the Diggers & the Haight.* Santa Monica, Calif.: Foggy Notion Books, 2012.

MCNALLY, DENNIS. *A Long Strange Trip: The Inside History of the Grateful Dead.* New York: Broadway, 2002.

MEDEIROS, WALTER. *San Francisco Rock Poster Art.* San Francisco: San Francisco Museum of Modern Art, 1976.

MEIER, AUGUST, JOHN BRACEY JR., and **ELIOT RUDWICK,** eds. *Black Protest in the Sixties,* New York: Markus Wiener Publishing, 1991.

MELLY, GEORGE. *Revolt Into Style: The Pop Arts.* Garden City, New York: Anchor Books, 1971.

MILES, BARRY, and **GRANT SCOTT.** *Hippie.* New York: Sterling, 2003.

MILLIKEN, ROBERT. *Lillian Roxon: Mother of Rock.* New York: Thunder's Mouth, 2005.

OWEN, TED. *High Art: A History of the Psychedelic Poster.* London: Sanctuary, 1999.

PERRY, CHARLES. *The Haight-Ashbury: A History.* New York: Random House, 1984.

ROSZAK, THEODORE. *The Making of a Counter Culture: Reflections on the Technocratic Society and Its Youthful Opposition.* New York: Doubleday, 1968.

SEALE, BOBBY, and **STEPHEN SHAMES.** *Power to the People: The World of the Black Panthers.* New York: Harry N. Abrams, 2016

SELVIN, JOEL. *Summer of Love: The Inside Story of LSD, Rock and Roll, Free Love and High Times in the Wild West.* New York: Dutton, 1994.

SMITH, SHERRY L. *Hippies, Indians, and the Fight for Red Power.* Oxford: Oxford University Press, 2012.

STEELE, VALERIE. *Fifty Years of Fashion: New Look to Now.* New Haven: Yale University Press, 2009.

TALBOT, DAVID. *Season of the Witch: Enchantment, Terror, and Deliverance in the City of Love.* New York: Free Press, 2012.

TOMLINSON, SALLY, and **WALTER MEDEIROS.** *High Societies: Psychedelic Rock Posters of Haight-Ashbury.* San Diego: San Diego Museum of Art, 2001.

VON HOFFMAN, NICHOLAS. *We Are the People Our Parents Warned Us Against: The Classic Account of the 1960s Counter-Culture in San Francisco.* Chicago: Ivan R. Dee, 1968.

WALKER, CUMMINGS G., ed. *The Great Poster Trip: Art Eureka.* Palo Alto, CA: Coyne & Blanchard, 1968.

WHITLEY, LAUREN D. *Hippie Chic.* Boston: Museum of Fine Arts, 2013.

WOLF, LEONARD. *Voices from the Love Generation.* Boston: Little, Brown, 1968.

WOLFE, TOM. *The Electric Kool-Aid Acid Test,* 6th ed. New York: Picador, 2008. First published 1968.

WOLMAN, BARON. *Rags* (magazine). 1970–1971.

checklist

NOTE TO READER: This checklist documents the exhibition *The Summer of Love Experience: Art, Fashion, and Rock and Roll* as presented at the Fine Arts Museums of San Francisco. This list is arranged alphabetically by artists' names under media categories and reflects the most complete information available at the time of publication. All artists are American unless otherwise noted; life dates for artists, if known, are given in an artist's first record in each section. Unless otherwise noted, all dimensions for works on paper reflect sheet dimensions, with height preceding width. When available, catalogue raisonné information is provided for posters in the Bill Graham and Family Dog sequences as documented in Eric King, *The Collector's Guide to Psychedelic Rock Concert Posters, Postcards and Handbills 1965–1973*, vol. 1, 10th ed. ([Berkeley?]: self-published, 2011). For publications, dates reflect those for the copies featured in the exhibition, not necessarily the original dates of publication.

COLLAGES AND ASSEMBLAGES

MICHAEL BOWEN (1937–2009), *Nervous System, pages from the artist's diary*, 1963 (PL. 6). Collage of stained paper with color lithograph book page, brush and black ink and gray wash, red and clear wax droplets, red pencil, pen and blue ink, black ink leaf imprints, brown crayon, and graphite, 9 3/8 x 14 in. (23.7 x 35.7 cm). FINE ARTS MUSEUMS OF SAN FRANCISCO, GIFT OF PHIL AND VICKI JOHNSON, 1997.163

MICHAEL BOWEN, *New Direction, pages from the artist's diary*, 1963 (PL. 5). Collage of stained paper with pen and black ink, albumen silver print on card, rotogravure segment, and torn gelatin silver print, with black ink rubber stamps, 9 1/2 x 14 in. (24 x 35.6 cm). FINE ARTS MUSEUMS OF SAN FRANCISCO, GIFT OF MICHAEL AND ISABELLA BOWEN, 1997.157.4

BRUCE CONNER (1933–2008), WEDNESDAY, 1960 (PL. 2). Wood cabinet, mannequin, costume jewelry, fabric, taxidermied bird, sequins, beads, mirror, metal, yarn, wallpaper, fur, and paint, 84 x 26 1/2 x 24 3/4 in. (213.4 x 67.3 x 62.9 cm). FINE ARTS MUSEUMS OF SAN FRANCISCO, GIFT OF BRUCE AND JEAN CONNER AND PETER AND CAROLE SELZ, 1998.189

JESS (JESS COLLINS) (1923–2004), *Echo's Wake Part IV*, 1961–1966 (PL. 211). Paste-up: mixed media collage, 10 1/4 x 14 1/2 in. (26 x 36.8 cm). PRIVATE COLLECTION, COURTESY ANGLIM GILBERT GALLERY

WILFRIED SÄTTY (1939–1982), *Untitled (Arabesque Interior)*, 1968 (PL. 209). Collage of cut printed paper (letterpress halftone, offset lithograph, etching, and woodcut) with brush and black ink, mounted to black board, diameter: 14 1/4 in. (36.2 cm). FINE ARTS MUSEUMS OF SAN FRANCISCO, GIFT OF WALTER AND JOSEPHINE LANDOR, 2001.97.22

COSTUMES AND ACCESSORIES

"PATHFINDER" FRANK BERRY (ACTIVE 1960S–1970S), man's ensemble (jacket and pants), ca. 1970 (PL. 9). Leather with silver buttons, bone and brass beads, tin cones with horsehair, and nineteenth-century sinew-sewn Sioux beadwork strip. COLLECTION OF PETER KAUKONEN

BIRGITTA BJERKE (100% BIRGITTA) (SWEDISH, B. 1940), "Hands" dress, ca. 1967–1968. Crocheted wool. COLLECTION OF THE ARTIST

BIRGITTA BJERKE (100% BIRGITTA), jacket, 1972 (PL. 304). Crocheted wool. Worn by Susila (Kreutzmann) Ziegler during the Grateful Dead's Europe 1972 tour. COLLECTION OF SUSILA ZIEGLER

BIRGITTA BJERKE (100% BIRGITTA), T-shirt, 1972 (PL. 305). Hand-painted cotton knit with acrylic paint. COLLECTION OF THE ARTIST

BIRGITTA BJERKE (100% BIRGITTA), wedding dress, 1972 (PL. 337). Crocheted wool. COLLECTION OF BARBARA KAYFETZ

BRIDGET (ACTIVE 1960S–1970S), ensemble (jacket and miniskirt), ca. 1969 (PL. 97). Dyed suede with glass beads and brass bells. COLLECTION OF HELENE ROBERTSON

OSSIE CLARK (BRITISH, 1942–1996), evening dress, 1968–1969 (PL. 336). Printed rayon crepe. FINE ARTS MUSEUMS OF SAN FRANCISCO, GIFT OF MRS. DAGMAR DOLBY, 2014.98.4

MARIKA CONTOMPASIS (b. 1948), "Snake" pants, ca. 1970 (PL. 63). Wool knit. COLLECTION OF JEANNE ROSE

DUNLAP & CO., Jerry Garcia's "Captain Trips" hat, 1883, with later alterations (PL. 262). Hand-painted silk with ribbon and flag. Worn by Jerry Garcia. PRIVATE COLLECTION

ALVIN DUSKIN (SAN FRANCISCO, ACTIVE 1964–1971) by Marsha Fox, "Peace" dress, 1967 (PL. 310). Acrylic knit. FINE ARTS MUSEUMS OF SAN FRANCISCO, GIFT OF LESLEE BUDGE, 2016.56

EAST WEST MUSICAL INSTRUMENTS COMPANY (SAN FRANCISCO, ACTIVE 1967–1980), "Camel" jacket, ca. 1973–1975 (PL. 193). Appliquéd leather with pelt. FINE ARTS MUSEUMS OF SAN FRANCISCO, MUSEUM PURCHASE, ART TRUST FUND, 2016.42.1

EAST WEST MUSICAL INSTRUMENTS COMPANY, "Gree Gree" tunic, ca. 1969 (PL. 93). Suede with leather appliqués and brass belt buckle. FINE ARTS MUSEUMS OF SAN FRANCISCO, MUSEUM PURCHASE, ART TRUST FUND, 2016.42.2A–B

EILEEN EWING (b. 1943), dress, 1967–1968 (PL. 59). Block-printed cotton plain weave with crochet insertions. COLLECTION OF JUDY GOLDHAFT

RENAIS FARYAR (b. 1937), tank top, ca. 1969 (PL. 98). Tie-dyed cotton knit. COLLECTION OF HELENE ROBERTSON

GRETCHEN FETCHIN (PAULA DOUGLAS) (b. 1943), Zonker's "Merry Prankster Acid Test" shirt, 1964 (PL. 31). Appliquéd cotton plain weave with rayon fringe. Worn by Zonker (Steve Lambrecht). COLLECTION OF LAMBRECHT FAMILY

GENIE THE TAILOR (BRITISH, 1942–1969), shirt, ca. 1968 (PL. 10). Chamois with silver buttons. COLLECTION OF PETER KAUKONEN

LINDA GRAVENITES (1939–2002), cape, ca. 1969 (PL. 102). Suede with leather appliqués and hand lacing (cordovan and cross stitches). Made for Bill "Sweet Willie Tumbleweed" Fritsch. COLLECTION OF ROSLYN L. ROSEN

LINDA GRAVENITES, handbag, ca. 1967 (PL. 262). Goatskin with silk embroidery (chain stitch) and glass beads. Made for Janis Joplin. COLLECTION OF ROSLYN L. ROSEN

LINDA GRAVENITES, vest, ca. 1969 (PL. 101). Leather and suede with rivets and metalwork. Made for Lenore Kandel. COLLECTION OF ROSLYN LISA KNOT ROSEN

ALEXANDRA JACOPETTI HART (b. 1939), "Phoenix" jeans, 1968–1973. Levi's denim jeans; embroidery (button-hole, chain, cross satin, fly, French knot, herringbone, insertion, and running stitches). OAKLAND MUSEUM OF CALIFORNIA, H83.103.1

BETSEY JOHNSON (b. 1942), dress, 1970–1972 (PL. 338). Knitted wool. FINE ARTS MUSEUMS OF SAN FRANCISCO, GIFT OF JAMES ELLIOT, 1983.95

KAIBAB BUCKSKIN INC. (later **KAIBAB SHOP**) (TUCSON, ACTIVE 1949–2008), "Navajo boot," suede, rawhide sole, stamped silver buttons. PRIVATE COLLECTION

CANDACE KLING (b. 1948), minidress, ca. 1968 (PL. 297). Printed synthetic plain weave. COLLECTION OF THE ARTIST

CANDACE KLING and **FRED KLING** (b. 1944), "Tree" dress, ca. 1970 (PL. 48). Hand-painted cotton knit. COLLECTION OF MARNA CLARK

FRED KLING, dress, 1969 (PL. 49). Hand-painted cotton plain weave. COLLECTION OF CANDACE KLING

JOHN W. LOADER (ACTIVE 1877–1905), man's top hat, 1903 (PL. 87). Silk plain weave, beaver fur, and leather. FINE ARTS MUSEUMS OF SAN FRANCISCO, GIFT OF MISS EVELYN ERICKSON, 52.9A–B

K. LEE MANUEL (1936–2003), tunic blouse, 1964–1965 (PL. 201). Hand-painted cotton plain weave. FINE ARTS MUSEUMS OF SAN FRANCISCO, GIFT OF BARBARA FEIGEL, 1990.57.2

K. LEE MANUEL, tunic blouse, 1964–1965 (PL. 202). Hand-painted cotton plain weave. FINE ARTS MUSEUMS OF SAN FRANCISCO, GIFT OF BARBARA FEIGEL, 1990.57.4

MICKEY MCGOWAN (APPLE COBBLER) (b. 1946), "Cub Scout" boot, ca. 1975 (PL. 321). Appliquéd cotton twill weave Cub Scout uniform, machine-embroidered patches, and neoprene rubber soles. Worn by Mickey McGowan. COLLECTION OF THE ARTIST

MICKEY MCGOWAN (APPLE COBBLER), "Gambling" boot, ca. 1975 (PL. 323). Appliquéd gambling-table felt, chips, playing cards, dice, and neoprene rubber soles. COLLECTION OF THE ARTIST

MICKEY MCGOWAN (APPLE COBBLER), "Mandala" boot, ca. 1975 (PL. 324). Appliquéd Chinese silk complex weaves, silk velvet, and neoprene rubber soles. COLLECTION OF FINNLANDIA

MICKEY MCGOWAN (APPLE COBBLER), "Ocean Tantra" boot, ca. 1975 (PL. 322). Appliquéd silk and cotton complex weave, brass button, wood beads, and neoprene rubber soles. COLLECTION OF THE ARTIST

DUG MILES (ACTIVE 1970S), customized jeans, ca. 1973 (PL. 136). Hand-painted white denim with applied coix seeds, leather, glass beads, and patches. COLLECTION OF LEVI STRAUSS & CO. ARCHIVES

NORTH BEACH LEATHER (ACTIVE 1967–2002), coat, ca. 1970 (PL. 91). Suede with hand lacing (cross and double cordovan stitches). FINE ARTS MUSEUMS OF SAN FRANCISCO, GIFT OF RICKY SERBIN, 2016.60

BURRAY OLSON (b. 1944), dress, ca. 1970 (PL. 206). Appliquéd dyed chamois with glass crystal, bone, brass, and shell beads. COLLECTION OF BARBARA MOORE

BURRAY OLSON with **BARBARA MOORE** (b. 1948), long coat, ca. 1970 (PL. 205). Leather with Afghani beaded medallions, embroidered band appliqués, and applied silver coins and brass beads. COLLECTION OF BARBARA MOORE

EVA ORSINI (1931–2007), "Watergate" jeans, ca. 1973 (PL. 320). Cotton denim with printed, hand-drawn, stamped cotton plain weave appliqués. COLLECTION OF LEVI STRAUSS & CO. ARCHIVES

YVONNE PORCELLA (1936–2016), dress, ca. 1970 (PL. 196). Cotton with supplementary-weft patterning, printed cotton, ribbons, appliqué, and reverse-appliqué San Blas Island (Panama) cotton *mola*. PRIVATE COLLECTION

YVONNE PORCELLA, tunic, ca. 1971 (PL. 95). Pieced and appliquéd fabrics including Guatemalan cotton paired-thread warp-resist dyeing (ikat) and paired warp- and weft-resist dyeing (double ikat); San Blas Island (Panama) cotton *molas* (appliqué and reverse appliqué); and Kutch (India) cotton plain weave with cotton embroidery (cross, chain, interlaced, arrowhead, and feather stitches); woven and embroidered silk ribbons; printed cotton plain weave; and applied buttons, keys, pendants, fasteners, and museum buttons. FINE ARTS MUSEUMS OF SAN FRANCISCO, GIFT OF YVONNE B. PORCELLA IN MEMORY OF MARGARET A. BROSNAN, 1994.161.2

RAINBOW COBBLERS (SAN FRANCISCO, ACTIVE 1960S–1970S), "Sequoia" boots, ca. 1970 (PL. 204). Appliquéd dyed leather. COLLECTION OF JEANNE ROSE

LUNA MOTH ROBBINS (JODI PALADINI) (1936–1998), skirt, ca. 1970 (PL. 141). Pieced Levi's denim, cotton ticking with embroidery, and applied mica sequins. COLLECTION OF JANE QUATLANDER

HELENE ROBERTSON (b. 1935), customized "Farah of Texas" jacket, ca. 1960s (PL. 138). Denim jacket with cotton patches and metal studs. COLLECTION OF THE ARTIST

HELENE ROBERTSON, tank top, mid-1960s (PL. 341). Ribbed cotton with appliqué patch. COLLECTION OF THE ARTIST

HELENE ROBERTSON for ANASTASIA'S (SAN FRANCISCO AND SAUSALITO, ACTIVE 1962–1972), dress, 1970 (PL. 61). Printed cotton plain weave with muslin and lace insertions. PRIVATE COLLECTION

HELENE ROBERTSON, with handwork by Marie Robertson (b. 1914), chubby, mid-1960s (PL. 340). Crocheted and hooked acrylic yarn. COLLECTION OF THE ARTIST

HELENE ROBERTSON, with handwork by Marie Robertson, vest, ca. 1967 (PL. 343). Crocheted wool. COLLECTION OF THE ARTIST

JAHANARA ROMNEY (b. 1941), "Rainbow Jumpsuit" for Wavy Gravy, early 1970s (PL. 32). Appliquéd printed cotton, synthetic knit, striped cotton plain weave, Lurex plain weave, and complex-weave cotton with appliquéd patches and metal, shell, and plastic buttons. Worn by Wavy Gravy. COLLECTION OF JAHANARA ROMNEY AND WAVY GRAVY

JEANNE ROSE (b. 1937), "DMT" dress, 1968 (PL. 293). Synthetic knit. COLLECTION OF THE ARTIST

JEANNE ROSE, ensemble (jacket and pants), 1967–1968 (PL. 199). Cotton and silk cut and uncut velvet with guipure trim and pewter buttons. COLLECTION OF THE ARTIST

JEANNE ROSE, jacket, ca. 1969 (PL. 85). Denim with braid trim. COLLECTION OF THE ARTIST

JEANNE ROSE, "Morning Glory" top, ca. 1969 (PL. 62). Printed silk chiffon with metallic supplementary-weft thread. COLLECTION OF THE ARTIST

JEANNE ROSE, "Persian Nights" dress, 1966 (PL. 195). Silk chiffon and printed cotton plain weave. COLLECTION OF THE ARTIST

LESLIE ROWAN (b. 1947), top, ca. 1970 (PL. 301). Cotton velvet with sequin flower appliqués and ribbon trim. COLLECTION OF PETER KAUKONEN

MELODY SABATASSO (LOVE, MELODY ORIGINALS) (b. 1948), pants, ca. 1970 (PL. 92). Pieced recycled denim with Swarovski rhinestones. COLLECTION OF LAURA MELENDY

MELODY SABATASSO (LOVE, MELODY ORIGINALS), pantsuit, ca. 1970 (PL. 140). Pieced recycled denim with leather and suede fringe and Swarovski rhinestones. COLLECTION OF LINDA GARTH

YVES SAINT LAURENT (FRENCH, b. ALGERIA, 1936–2008), evening dress, autumn–winter 1971–1972 (PL. 335). Printed silk with velvet flower. FINE ARTS MUSEUMS OF SAN FRANCISCO, GIFT FROM THE COLLECTION OF RUTH QUIGLEY, 2016.35.36

GIORGIO DI SANT' ANGELO (AMERICAN, b. ITALY, 1933–1989), dress, ca. 1971 (PL. 339). Block-printed plain-weave cotton with machine embroidery, appliqués, and cording. FINE ARTS MUSEUMS OF SAN FRANCISCO, GIFT OF BARBARA L. TRAISMAN, 2015.82

JACKY SARTI (b.1944), choker, ca. 1970 (PL. 303). Leather with beads. COLLECTION OF PETER KAUKONEN

JACKY SARTI, customized landlubber jeans, ca. 1970 (PL. 302). Denim with cotton patches, ribbons, appliqué and reverse appliqué San Blas Island (Panama) cotton *mola*, and applied rhinestone studs. COLLECTION OF PETER KAUKONEN

JOHN B. STETSON COMPANY (PHILADELPHIA, EST. 1865), hat, 1960s. Wool felt and grosgrain ribbon. COLLECTION OF MEREL GLAUBIGER

JEAN STEWART (ACTIVE 1960S TO PRESENT), shirt, ca. 1974. Pieced printed cotton plain weave (ca. 1920s–1930s) with Bakelite buttons. COLLECTION OF CHARLIE AND JEAN STEWART

RICHARD TAM (b. 1941), minidress, ca. 1966 (PL. 294). Printed silk chiffon. FINE ARTS MUSEUMS OF SAN FRANCISCO, GIFT OF DORIS LEE, 1997.190.4

WHITE DUCK WORKSHOP (BERKELEY, ACTIVE LATE 1960S–1970S), maxi dress, ca. 1970 (PL. 60). Cotton plain weave with cotton corduroy appliqués and cotton piping. FINE ARTS MUSEUMS OF SAN FRANCISCO, GIFT OF DR. WANDA CORN, 2001.158.2

ZIG-ZAG (SAN FRANCISCO, ACTIVE 1969–1970S), top, ca. 1969 (PL. 99). Leather with metal grommets. COLLECTION OF DECADES OF FASHION

Afghanistan, Kuchi people, dress, ca. 1960 (PL. 194). Pieced synthetic velvet with cotton cross-stitch embroidery and paste stones, applied glass-bead medallion, couched metallic braid, galloon trim, mirror-work embroidery (button-hole, chain, and satin stitches), printed plain-weave cotton, printed synthetic and Lurex plain weave, and machine embroidery. COLLECTION OF ROSE SOLOMON

Bell-bottoms, ca. 1969 (PL. 306). Levi's denim jeans. COLLECTION OF LEVI STRAUSS & CO. ARCHIVES

Customized bell-bottoms, ca. 1969 (PL. 94). Levi's denim jeans with printed cotton bandana insertions. COLLECTION OF LEVI STRAUSS & CO. ARCHIVES

Customized bell-bottoms, ca. 1969 (PL. 96). Levi's denim jeans with appliqués. COLLECTION OF LEVI STRAUSS & CO. ARCHIVES

Customized "Big Smith" jacket, ca. 1970 (PL. 312). Cotton denim with plastic and metal buttons, cotton patches, and printed plain-weave cotton, lace, and embroidered (satin stitch) velvet appliqués. COLLECTION OF CHARLIE AND JEAN STEWART

Dress, ca. 1920s (altered ca. 1970) (PL. 299). Silk satin with embroidery (satin stitch), glass beads, and rhinestones. COLLECTION OF THE KLING FAMILY

Embroidered hospital scrub top, ca. 1968 (PL. 221). Cotton plain weave with cotton embroidery (bullion knots, encroaching satin, fly, running, and satin stitches). COLLECTION OF ARTHUR LEEPER AND CYNTHIA SHAVER

Ensemble, ca. 1890s (PL. 8). Cotton plain-weave blouse with drawnwork cuffs and collar trimmed with machine-made lace and shell buttons; silk supplementary-weft patterned vest; striped cotton plain-weave skirt; and plaited synthetic hat with grosgrain ribbon, synthetic flowers, net, and metal hatpin. COLLECTION OF JEAN STEWART

Ensemble, ca. 1890–1960s (PL. 7). Wool-blend twill-weave jacket; wool twill-weave vest with metal watch fob chain; cotton plain-weave shirt with striped bib and starched cotton plain-weave detachable collar; cotton twill pants; leather shoes; and plaited straw hat with grosgrain ribbon. Worn by George Hunter of the Charlatans. COLLECTION OF GEORGE HUNTER

Ensemble (dress and pants), 1920s (PL. 193). Silk chiffon dress with glass-bead embroidery and attached silk sleeves; crushed synthetic velvet pants, 1960s. COLLECTION OF HELENE ROBERTSON

Hot pants, mid-1960s (PL. 342). Synthetic satin. COLLECTION OF HELENE ROBERTSON

"Mr. Freedom" tank top, ca. 1960s (PL. 139). Printed cotton. COLLECTION OF HELENE ROBERTSON

Navajo, "Squash Blossom" necklace, 1900–1915. Silver, turquoise, and leather. FINE ARTS MUSEUMS OF SAN FRANCISCO, GIFT OF HAROLD L. FULLER, 1983.11.4

Pants, ca. 1960s (PL. 137). Silkscreened Levi's denim jeans. COLLECTION OF HELENE ROBERTSON

Pants, ca. 1967 (PL. 344). Crushed velvet. COURTESY OF HELENE ROBERTSON

Pants, ca. 1969 (PL. 86). Striped cotton twill. COLLECTION OF DECADES OF FASHION

Pants, ca. 1969 (PL. 100). Cotton plain weave with machine-embroidered cuffs. COLLECTION OF DECADES OF FASHION

Shawl, ca. 1920 (PL. 300). Silk mesh with metallic and silk-thread embroidery (chain stitch). COLLECTION OF MARNA CLARK

Top (worn as dress), ca. 1910 (PL. 298). Silk net with glass bugle-bead and sequin embroidery. Worn by Cicely Hansen to the Monterey International Pop Festival in 1967. COLLECTION OF CICELY HANSEN

LIGHT SHOWS AND FILMS

SCOTT BARTLETT (1943–1990), *OffOn*, 1968 (PL. 223). Film (color), duration: 1.37.9 minutes, sound. COURTESY OF THE ESTATE OF SCOTT BARTLETT, CANYON CINEMA, AND BERKELEY ART MUSEUM AND PACIFIC FILM ARCHIVE

BILL HAM (b. 1932), *Kinetic Light Painting*, 2016–2017 (PL. 219). Four films (color), duration: 64 minutes. COURTESY OF THE ARTIST

LAWRENCE JORDAN (b. 1934), *Hamfat Asar*, 1965 (PL. 212). 16mm film (black and white), duration: 15 minutes, sound. COURTESY OF THE ARTIST AND CANYON CINEMA

BEN VAN METER (b. 1941), *S.F. Trips Festival, An Opening*, 1966 (PL. 27). Film (color), duration: 9 minutes, sound. COURTESY OF THE ARTIST

BEN VAN METER, *Trip-Tych*, 1967/2016 (PL. 238). Film (color) from 35mm slides, duration: 10 minutes, 4 seconds. COLLECTION OF BEN VAN METER AND JOHN J. LYONS

BEN VAN METER / ROGER HILLYARD (b. 1942) **/ NORTH AMERICAN IBIS ALCHEMICAL COMPANY**, slides from *Appropriations*, ca. 1967 (PL. 11). Film (color) from 35mm slides, duration: 3 minutes. COLLECTION OF BEN VAN METER AND JOHN J. LYONS

Jerry Garcia and the Grateful Dead, 1967, from a CBS-TV documentary about the Grateful Dead and the Growing Hippie Scene in Haight-Ashbury, San Francisco, https://www.youtube.com/watch?v=HA8F3JNxK1c

KPIX Reports: The Maze—Haight-Ashbury, 1967, narrated by Michael McClure and Rod Sherry, produced by Alan Goldberg for KPIX TV, https://www.youtube.com/watch?v=yOrZk4u54tg

Report from the Haight-Ashbury District of San Francisco, the centre of the new hippie movement, 1967, https://www.youtube.com/watch?v=tSaAEtGBBbMo

Sound clips from the Human Be-In, Golden Gate Park, January 14, 1967. Courtesy of John J. Lyons and Ben Van Meter

Rev. Martin Luther King, Jr. in Sproul Plaza, KPIX Eyewitness News, 1967/1968, https://diva.sfsu.edu/collections/sfbatv/bundles/190086

VDC March Against Vietnam War, KPIX News Report by Ben Williams, October 15, 1966, https://diva.sfsu.edu/collections/sfbatv/bundles/190425

The Way It Is: San Francisco Summer of 1967, 1968, directed by Donald Shebib for CBC-TV, https://www.youtube.com/watch?v=pEejp5_UMyQ&t=2s

EPHEMERA, ALBUMS, AND BOOKS

MARTY BALIN (b. 1942), *Jefferson Airplane—Surrealistic Pillow,* 1967 (PL. 276). RCA Victor label. Color offset lithograph album cover, 12 3/8 x 12 3/8 in. (31.4 x 31.4 cm). COURTESY OF MICKEY MCGOWAN, SAN RAFAEL, CA

ROBERT ("BOB") BRANAMAN (b. 1933), "Politics of Ecstasy," cover of *San Francisco Oracle* 1, no. 10, October 1967 (PL. 117). Color offset lithograph newspaper, 17 1/2 x 11 3/8 in. (44.5 x 28.8 cm). COLLECTION OF JAY THELIN

STEWART BRAND (b. 1938), *Whole Earth Catalog: Access to Tools,* Spring 1969 (PL. 358). Offset lithograph book cover, 14 1/2 x 10 7/8 in. (36.8 x 27.6 cm). COURTESY OF MICKEY MCGOWAN, SAN RAFAEL, CA

RICHARD BRAUTIGAN (1935-1984), *Trout Fishing in America,* 1964 (PL. 351). Published by Dell Publishing Co., Inc. Offset lithograph book cover, 8 x 5 1/4 in. (20.3 x 13.3 cm). COLLECTION OF JOHN J. LYONS

JOEL BRODSKY (1939-2007), *Country Joe and the Fish—I-Feel-Like-I'm-Fixin'-to-Die,* 1967 (PL. 281). Vanguard label. Color offset lithograph album cover, 12 3/8 x 12 3/8 in. (31.4 x 31.4 cm). COURTESY OF MICKEY MCGOWAN, SAN RAFAEL, CA

GUY CARAWAN (1927-2015) and **CANDIE CARAWAN** (b. 1939) for the Student Non-Violent Coordinating Committee, *We Shall Overcome! Songs of the Southern Freedom Movement,* 1963 (PL. 350). Published by Oak Publications. Color offset lithograph book cover, 8 1/2 x 5 1/2 in. (21.6 x 14 cm). COLLECTION OF JOHN J. LYONS

LAURIE CLIFFORD (b. ca. 1947), *Creedence Clearwater Revival,* 1968 (PL. 285). Fantasy Records label. Color offset lithograph album cover, 12 3/8 x 12 3/8 in. (31.4 x 31.4 cm). COURTESY OF MICKEY MCGOWAN, SAN RAFAEL, CA

LEE CONKLIN (b. 1941), *Santana,* 1969 (PL. 290). Columbia Records label. Color offset lithograph album cover, 12 3/8 x 12 3/8 in. (31.4 x 31.4 cm). COURTESY OF MICKEY MCGOWAN, SAN RAFAEL, CA

BRUCE CONNER (1933-2008), *Mandala,* cover of Trips Festival program, 1966 (PL. 22). Stencil duplicate print (mimeograph) pamphlet on pink paper, 7 x 7 in. (17.8 x 17.8 cm). COLLECTION OF JOHN J. LYONS

BRUCE CONNER, "Psychedelics, Flowers & War," cover of *San Francisco Oracle* 1, no. 9, August 1967 (PL. 116). Color offset lithograph newspaper, 15 x 11 1/2 in. (38 x 29 cm). COLLECTION OF JAY THELIN

ROBERT CRUMB (b. 1943), *Big Brother & the Holding Company—Cheap Thrills,* 1968 (PL. 287). Columbia Records label. Color offset lithograph album cover, 12 3/8 x 12 3/8 in. (31.4 x 31.4 cm). COURTESY OF MICKEY MCGOWAN, SAN RAFAEL, CA

MARK DEVRIES (ACTIVE 20TH CENTURY) and **HETTY MCGEE MACLISE** (1931-2011), "The Houseboat Summit", cover of *San Francisco Oracle* 1, no. 7, April 1967 (PL. 114). Color offset lithograph newspaper, 14 7/8 x 11 1/4 in. (37.8 x 28.6 cm). COLLECTION OF JAY THELIN

ALLEN GINSBERG (1926-1997), *Howl and Other Poems,* 1959 (PL. 347). Published by City Lights Books. Offset lithograph book cover, 6 1/4 x 4 7/8 in. (15.9 x 12.4 cm). COLLECTION OF JOHN J. LYONS

RICK GRIFFIN (1944-1991), "The Aquarian Age," cover of *San Francisco Oracle* 1, no. 6, February 1967 (PL. 113). Color offset lithograph newspaper, 15 x 11 1/4 in. (38 x 28.5 cm). COLLECTION OF JAY THELIN

RICK GRIFFIN, *The Grateful Dead—Aoxomoxoa,* 1969 (PL. 289). Warner Bros.–Seven Arts label. Color offset lithograph album cover, 12 3/8 x 12 3/8 in. (31.4 x 31.4 cm). COURTESY OF MICKEY MCGOWAN, SAN RAFAEL, CA

JULES HALFANT (1909-2001), *Country Joe and the Fish—Electric Music for the Mind and Body,* 1967 (PL. 278). Vanguard label. Color offset lithograph album cover, 12 3/8 x 12 3/8 in. (31.4 x 31.4 cm). COURTESY OF MICKEY MCGOWAN, SAN RAFAEL, CA

JULES HALFANT, *The Serpent Power,* 1967 (PL. 283). Vanguard label. Color offset lithograph album cover, 12 3/8 x 12 3/8 in. (31.4 x 31.4 cm). COURTESY OF MICKEY MCGOWAN, SAN RAFAEL, CA

WILLIAM S. HARVEY (d. 1992) and **BOB PEPPER** (b. 1938), *Love—Forever Changes,* 1967 (PL. 282). Elektra label. Color offset lithograph album cover, 12 3/8 x 12 3/8 in. (31.4 x 31.4 cm). COURTESY OF MICKEY MCGOWAN, SAN RAFAEL, CA

HERMAN HESSE (SWISS, b. GERMANY, 1877-1962), *Siddhartha,* 1951 (PL. 345). Published by New Directions Books. Offset lithograph book cover, 8 1/4 x 5 5/8 in. (21 x 14.3 cm). COLLECTION OF JOHN J. LYONS

GEORGE HUNTER (b. 1942), *It's a Beautiful Day,* 1969 (PL. 291). Columbia Records CBC label. Color offset lithograph album cover, 12 3/8 x 12 3/8 in. (31.4 x 31.4 cm). COURTESY OF MICKEY MCGOWAN, SAN RAFAEL, CA

GEORGE HUNTER, *Quicksilver Messenger Service—Happy Trails,* 1969 (PL. 288). Capitol Records label. Color offset lithograph album cover, 12 3/8 x 12 3/8 in. (31.4 x 31.4 cm). COURTESY OF MICKEY MCGOWAN, SAN RAFAEL, CA

ALDOUS HUXLEY (BRITISH, 1894-1963), *The Doors of Perception,* 1954 (PL. 346). Published by Chatto & Windus. Color offset lithograph book cover, 7 5/8 x 5 1/8 in. (18.7 x 13 cm). COLLECTION OF JOHN J. LYONS

LENORE KANDEL (1932-2009), *The Love Book,* 1966 (PL. 356). Published by Stolen Paper Review Editions. Color offset lithograph book cover, 8 x 7 1/4 in. (20.3 x 18.4 cm). COLLECTION OF JOHN J. LYONS

GABRIEL ("GABE") KATZ (ACTIVE 20TH CENTURY), "Dr. Leary and the Love Book," cover of *San Francisco Oracle* 1, no. 4, December 1966 (PL. 111). Offset lithograph newspaper, 16 3/8 x 11 1/2 in. (40.5 x 29 cm). COLLECTION OF JAY THELIN

KEN KESEY (1935-2001), *One Flew Over the Cuckoo's Nest,* 1962 (PL. 348). Published by New American Library. Color offset lithograph book cover, 7 x 4 1/4 in. (17.8 x 10.8 cm). COLLECTION OF JOHN J. LYONS

TIMOTHY LEARY (1920-1996), **RALPH METZNER** (b. 1936), and **RICHARD ALPERT** (b. 1931), *The Psychedelic Experience: A Manual Based on the Tibetan Book of the Dead,* 1964 (PL. 352). Published by University Books. Color offset lithograph book cover, 9 1/2 x 8 3/16 in. (24.1 x 20.8 cm). COLLECTION OF JOHN J. LYONS

HETTY MCGEE MACLISE, "The American Indian," cover of *San Francisco Oracle* 1, no. 8, June 1967 (PL. 115). Color offset lithograph newspaper, 15 x 11 3/8 in. (38.1 x 28.8 cm). COLLECTION OF JAY THELIN

JIM MARSHALL (1936-2010), *Moby Grape,* 1967 (PL. 279). Columbia Records label. Color offset lithograph album cover, 12 3/8 x 12 3/8 in. (31.4 x 31.4 cm). COURTESY OF MICKEY MCGOWAN, SAN RAFAEL, CA

PETER MATTHIESSEN (1927-2014), *Sal Si Puedes: Cesar Chavez and the New American Revolution,* 1969 (PL. 359). Published by Random House, Inc. Color offset lithograph book cover, 8 1/4 x 5 1/2 in. (21.6 x 14.9 cm). COLLECTION OF JOHN J. LYONS

MARSHALL MCLUHAN (CANADIAN, 1911-1980) and **QUENTIN FIORE** (b. 1920), *The Medium is the Massage: An Inventory of Effects,* 1967 (PL. 357). Published by Bantam Books. Offset lithograph book cover, 7 x 4 1/4 in. (17.8 x 10.8 cm). COLLECTION OF JOHN J. LYONS

VICTOR MOSCOSO (b. 1936), *Steve Miller Band—Children of the Future,* 1968 (PL. 286). Capitol Records label. Color offset lithograph album cover, 12 3/8 x 12 3/8 in. (31.4 x 31.4 cm). COURTESY OF MICKEY MCGOWAN, SAN RAFAEL, CA

STANLEY MOUSE (b. 1940) and **ALTON KELLEY** (1940-2008), *The Grateful Dead,* 1967 (PL. 277). Warner Bros. label. Color offset lithograph album cover, 12 3/8 x 12 3/8 in. (31.4 x 31.4 cm). COURTESY OF MICKEY MCGOWAN, SAN RAFAEL, CA

STANLEY MOUSE, ALTON KELLEY, and **MICHAEL BOWEN** (1937-2009), "The Human Be-In," cover of *San Francisco Oracle* 1, no. 5, January 1967 (PL. 112). Color offset lithograph newspaper, 15 1/4 x 11 3/8 in. (38.7 x 28.9 cm). COLLECTION OF JAY THELIN

FRANK OBERLÄNDER (ACTIVE 20TH CENTURY) for River of Many Streams Productions in association with Dickie Peterson, *Blue Cheer—Vincebus Eruptum,* 1968 (PL. 284). Philips label. Color offset lithograph album cover, 12 3/8 x 12 3/8 in. (31.4 x 31.4 cm). COURTESY OF MICKEY MCGOWAN, SAN RAFAEL, CA

STEVE SCHAFER (ACTIVE 20TH CENTURY), "The City of God," cover of *San Francisco Oracle* 1, no. 11, December 1967 (PL. 118). Color offset lithograph newspaper, 17 1/2 x 11 3/8 in. (44.5 x 28.7 cm). COLLECTION OF JAY THELIN

BOB SCHNEPF (b. 1937), "Symposium 2000 AD & the Fall," cover of *San Francisco Oracle* 1, no. 12, February 1968 (PL. 119). Color offset lithograph newspaper, 17 1/2 x 11 1/2 in. (44.5 x 29.1 cm). COLLECTION OF JAY THELIN

HAP SMITH (ACTIVE 20TH CENTURY), "Love Pageant Rally," cover of *San Francisco Oracle* 1, no. 1, September 1966 (PL. 108). Offset lithograph newspaper, 16 x 11 3/8 in. (40.5 x 28.7 cm). COLLECTION OF JAY THELIN

GARY SNYDER (b. 1930), *Earth House Hold,* 1969 (PL. 360). Published by New Directions Books. Offset lithograph book cover, 8 x 5 3/8 in. (20.3 x 13.2 cm). COLLECTION OF JOHN J. LYONS

EDMUND SULLIVAN (BRITISH, 1869-1933), page from *The Rubáiyát of Omar Khayyám* (first published 1913) (PL. 72). Letterpress, 6 3/8 x 3 7/8 in. (16.9 x 9.8 cm). Page used by Stanley Mouse and Alton Kelley for "Skeleton and Roses," 1966. COLLECTION OF STANLEY MOUSE

HENRY DAVID THOREAU (1817-1862), *Walden,* 1962 (PL. 349). Published by Time Reading Program. Color offset lithograph book cover, 8 x 5 1/4 in. (20.3 x 13.3 cm). COLLECTION OF JOHN J. LYONS

GEORGE TSONGAS (1926-2010) and **JOHN BROWNSON** (ACTIVE 20TH CENTURY), "Youth Quake," cover of *San Francisco Oracle* 1, no. 2, October 1966 (PL. 109). Offset lithograph newspaper, 16 x 11 3/8 in. (40.5 x 28.7 cm). COLLECTION OF JAY THELIN

"The Acid Test," Grateful Dead, Ken Kesey Acid Test, *January 29,* 1966 (PL. 30). Offset lithograph album cover, 12 3/8 x 12 3/8 in. (31.4 x 31.4 cm). COURTESY OF MICKEY MCGOWAN, SAN RAFAEL, CA

Assortment of buttons (PL. 122). COURTESY OF MICKEY MCGOWAN, SAN RAFAEL, CA

Assortment of notes and poems posted at the Psychedelic Shop, 1967 (PL. 127). Various dimensions. COLLECTION OF JAY THELIN

Big Brother & the Holding Company, 1967 (PL. 280). Mainstream Columbia Records label. Color offset lithograph album cover, 12 3/8 x 12 3/8 in. (31.4 x 31.4 cm). COURTESY OF MICKEY MCGOWAN, SAN RAFAEL, CA

Cover of *The Digger Papers,* 1968 (PL. 129). Offset lithograph newspaper, 10 7/8 x 8 1/2 in. (27.5 x 21.5 cm). COLLECTION OF JOHN J. LYONS

Evergreen, review no. 42, August 1966 (PL. 355). Color offset lithograph journal cover, 11 x 8 1/2 in. (21.6 x 17.8 cm). COLLECTION OF JOHN J. LYONS

Cover of *Haight-Ashbury Tribune* 1, no. 7, 1967 (PL. 121). Color offset lithograph newspaper, 15 1/8 x 11 7/16 in. (38.4 x 29.1 cm). COURTESY OF MICKEY MCGOWAN, SAN RAFAEL, CA

Invitation to the preview opening of the Psychedelic Shop, 1965. Pen and black ink and brush and green opaque watercolor on postcard, 4 x 6 3/4 in. (10.2 x 17 cm). COLLECTION OF JOHN J. LYONS

"Ken Kesey's Graduation Party," cover of *San Francisco Oracle* 1, no. 3, November 1966 (PL. 110). Offset lithograph newspaper, 15 3/4 x 11 1/4 in. (40 x 28.6 cm). COLLECTION OF JAY THELIN

Now Now, 1965 (PL. 353). Published by Ari Publications. Color offset lithograph journal cover, 8 1/2 x 7 in. (21.6 x 17.8 cm). COLLECTION OF JOHN J. LYONS

"Sock it to Me!," cover of *Haight-Ashbury Tribune* 2, no. 4, 1968 (PL. 120). Color offset lithograph newspaper, 15 x 11 5/16 in. (38.1 x 28.7 cm). COURTESY OF MICKEY MCGOWAN, SAN RAFAEL, CA

We Accuse: A powerful statement of the new political anger in America, as revealed in the speeches given at the 36-hour "Vietnam Day" protest in Berkeley, California, 1965 (PL. 354). Published by Diablo Press. Color offset lithograph book cover, 6 7/8 x 4 1/4 in. (17.5 x 10.8 cm). COLLECTION OF JOHN J. LYONS

PHOTOGRAPHS

GENE ANTHONY (b. 1932), *Calm center, Waiting at the Haight-Ashbury Free Medical Clinic. 558 Clayton St.*, 1966 (PL. 124). Gelatin silver print, 16 x 20 in. (40.6 x 50.8 cm). COURTESY OF THE BANCROFT LIBRARY, UNIVERSITY OF CALIFORNIA, BERKELEY, BANC PIC 2001.196:27-B

GENE ANTHONY, *Large Crowd at the Human Be-In at Polo Fields. Golden Gate Park, January 14*, 1967 (PL. 40). Gelatin silver print, 16 x 20 in. (40.6 x 50.8 cm). COURTESY OF THE BANCROFT LIBRARY, UNIVERSITY OF CALIFORNIA, BERKELEY, BANC PIC 2001.196:60-B

GENE ANTHONY, *Man with arms spread open being lifted up. Trips Festival at Longshoremen's Hall, January 21, 1966* (PL. 24). Gelatin silver print, 16 x 20 in. (40.6 x 50.8 cm). COURTESY OF THE BANCROFT LIBRARY, UNIVERSITY OF CALIFORNIA, BERKELEY, BANC PIC 2001.196:49-B

GENE ANTHONY, *Soundboard mixer Ken Babbs and crowd in background. Trips Festival at Longshoremen's Hall, January 21, 1966* (PL. 25). Gelatin silver print, 16 x 20 in. (40.6 x 50.8 cm). COURTESY OF THE BANCROFT LIBRARY, UNIVERSITY OF CALIFORNIA, BERKELEY, BANC PIC 2001.196:41-B

GENE ANTHONY, *Timothy Leary on stage at Human Be-In at Polo Fields. Golden Gate Park, January 14*, 1967 (PL. 41). Gelatin silver print, 16 x 20 in. (40.6 x 50.8 cm). COURTESY OF THE BANCROFT LIBRARY, UNIVERSITY OF CALIFORNIA, BERKELEY, BANC PIC 2001.196:62-B

GENE ANTHONY, *Wide-angle view of center stage and crowd. Trips Festival at Longshoremen's Hall, January 21, 1966* (PL. 26). Gelatin silver print, 16 x 20 in. (40.6 x 50.8 cm). COURTESY OF THE BANCROFT LIBRARY, UNIVERSITY OF CALIFORNIA, BERKELEY, BANC PIC 2001.196:45-B

GENE ANTHONY, *Woman holding peace sign in front of microphone at Human Be-In at Polo Fields. Golden Gate Park, January 14*, 1967 (PL. 42). Gelatin silver print, 20 x 16 in. (50.8 x 40.6 cm). COURTESY OF THE BANCROFT LIBRARY, UNIVERSITY OF CALIFORNIA, BERKELEY, BANC PIC 2001.196:64-B

RUTH-MARION BARUCH (1922–1997), *"560 558" (sign), Haight Ashbury*, 1967 (PL. 123). Gelatin silver print, 10 x 8 in. (25.4 x 20.3 cm). COURTESY SPECIAL COLLECTIONS, UNIVERSITY LIBRARY, UNIVERSITY OF CALIFORNIA, SANTA CRUZ. PIRKLE JONES AND RUTH-MARION BARUCH PHOTOGRAPHS

RUTH-MARION BARUCH, *All the Symbols of the Haight*, 1967 (PL. 67). Gelatin silver print, 8 x 10 in. (20.3 x 25.4 cm). LUMIÈRE GALLERY, ATLANTA, AND ROBERT A. YELLOWLEES

RUTH-MARION BARUCH, *Hare Krishna Dance in Golden Gate Park, Haight Ashbury*, 1967 (PL. 55). Gelatin silver print, image: 8 7/8 x 13 1/4 in. (21.8 x 33.7 cm); mount: 14 x 18 in. (35.6 x 45.7 cm). LUMIÈRE GALLERY, ATLANTA, AND ROBERT A. YELLOWLEES

RUTH-MARION BARUCH, *"Jesus" Selling the Oracle, Haight Ashbury*, 1967 (PL. 107). Gelatin silver print, 10 x 8 in. (25.4 x 20.3 cm). LUMIÈRE GALLERY, ATLANTA, AND ROBERT A. YELLOWLEES

RUTH-MARION BARUCH, *Mother and Child, Free Huey Rally, DeFremery Park, Oakland, July 28*, 1968 (PL. 326). Gelatin silver print, mount: 14 x 11 in. (35.6 x 27.9 cm). LUMIÈRE GALLERY, ATLANTA, AND ROBERT A. YELLOWLEES

RUTH-MARION BARUCH, *Sailor Couple, Haight Ashbury*, 1967 (PL. 77). Gelatin silver print, 10 x 8 in. (25.4 x 20.3 cm). LUMIÈRE GALLERY, ATLANTA, AND ROBERT A. YELLOWLEES

RUTH-MARION BARUCH, *"San Francisco" (sign), Haight Ashbury*, 1967 (PL. 18). Gelatin silver print, 8 x 10 in. (20.3 x 25.4 cm). COURTESY SPECIAL COLLECTIONS, UNIVERSITY LIBRARY, UNIVERSITY OF CALIFORNIA, SANTA CRUZ. PIRKLE JONES AND RUTH-MARION BARUCH PHOTOGRAPHS

RUTH-MARION BARUCH, *Young Woman, Free Huey Rally, DeFremery Park, Oakland, July 14*, 1968 (PL. 329). Gelatin silver print, 10 x 8 in. (25.4 x 20.3 cm). LUMIÈRE GALLERY, ATLANTA, AND ROBERT A. YELLOWLEES

HERB GREENE (b. 1942), *Big Brother and the Holding Company* (left to right: Sam Andrews, David Getz, Janis Joplin, James Gurley, and Peter Albin), 1966, from the portfolio *The Acid Age of San Francisco Rock*, 1966, printed 2006 (PL. 267). Gelatin silver print, 22 x 18 in. (55.9 x 45.7 cm). Printed by Palm Press, Inc. FINE ARTS MUSEUMS OF SAN FRANCISCO, GIFT OF THE LASDON FOUNDATION, 2016.87.8

HERB GREENE, *The Charlatans* (left to right: George Hunter, Richie Olsen, Mike Wilhelm, Dan Hicks, and Mike Ferguson), 1967, from the portfolio *The Acid Age of San Francisco Rock*, printed 2006 (PL. 270). Gelatin silver print, 22 x 18 in. (55.9 x 45.7 cm). Printed by Palm Press, Inc. FINE ARTS MUSEUMS OF SAN FRANCISCO, GIFT OF THE LASDON FOUNDATION, 2016.87.3

HERB GREENE, *Couple on Haight Street (Allen Cohen and Monica Collier)*, 1967 (printed 2006) (PL. 69). Gelatin silver print, 11 x 14 in. (27.9 x 35.6 cm). FINE ARTS MUSEUMS OF SAN FRANCISCO, GIFT OF RENE AND JIM CRESS, 2016.88

HERB GREENE, *Dead on Haight* (left to right: Jerry Garcia, Ron "Pigpen" McKernan, Phil Lesh, Bob Weir, and Bill Kreutzmann), 1967 (printed 2006) (PL. 66). Platinum print, 24 x 20 in. (61 x 50.8 cm). PRIVATE COLLECTION

HERB GREENE, *Jefferson Airplane* (back row, left to right: Jack Casady, Grace Slick, and Marty Balin; front row, left to right: Jorma Kaukonen, Paul Kantner, and Spencer Dryden), 1966, from the portfolio *The Acid Age of San Francisco Rock*, printed 2006 (PL. 269). Gelatin silver print, 22 x 18 in. (55.9 x 45.7 cm). Printed by Palm Press, Inc. FINE ARTS MUSEUMS OF SAN FRANCISCO, GIFT OF THE LASDON FOUNDATION, 2016.87.2

HERB GREENE, *Pine Street*, 1967, printed 2016 (PL. 271). Gelatin silver print, 18 x 22 in. (45.7 x 55.9 cm). FINE ARTS MUSEUMS OF SAN FRANCISCO, GIFT OF STEVEN EISENHAUER, 2016.89

HERB GREENE, *Quicksilver Messenger Service* (left to right: David Freiberg, Greg Elmore, Gary Duncan, John Cipollina, and Jim Murray), 1967, from the portfolio *The Acid Age of San Francisco Rock*, 1967 (printed 2006) (PL. 268). Gelatin silver print, 22 x 18 in. (55.9 x 45.7 cm). Printed by Palm Press, Inc. FINE ARTS MUSEUMS OF SAN FRANCISCO, GIFT OF THE LASDON FOUNDATION, 2016.87.12

FAYETTE HAUSER (b. 1945), *The Cockettes* (left to right: John Flowers, Marshall Olds, Link Martin, Pristine Condition, Sweet Pam Tent), 1971 (PL. 71). Gelatin silver print, 9 3/4 x 6 7/8 in. (24.8 x 17.5 cm). COLLECTION OF THE ARTIST

PIRKLE JONES (1914–2009), *Black Panthers during drill, De Fremery Park, Oakland, #57*, 1968 (PL. 331). Gelatin silver print, 8 x 10 in. (20.3 x 25.4 cm). COURTESY SPECIAL COLLECTIONS, UNIVERSITY LIBRARY, UNIVERSITY OF CALIFORNIA, SANTA CRUZ. PIRKLE JONES AND RUTH-MARION BARUCH PHOTOGRAPHS

PIRKLE JONES, *Black Panthers from Sacramento, Free Huey Rally, Bobby Hutton Park, Oakland, #62, August 25, 1968* (PL. 330). Gelatin silver print, 8 x 10 in. (20.3 x 25.4 cm). COURTESY SPECIAL COLLECTIONS, UNIVERSITY LIBRARY, UNIVERSITY OF CALIFORNIA, SANTA CRUZ. PIRKLE JONES AND RUTH-MARION BARUCH PHOTOGRAPHS

LARRY KEENAN (1943–2012), *Michael McClure, Bob Dylan, Allen Ginsberg*, 1965 (PL. 4). Gelatin silver print, 11 x 14 in. (27.9 x 35.6 cm). COURTESY OF THE BANCROFT LIBRARY, UNIVERSITY OF CALIFORNIA, BERKELEY, BANC PIC 2009.050.001:049-AX

LARRY KEENAN, *Peace Rally, Kezar Stadium, San Francisco*, 1967 (PL. 53). Gelatin silver print, 11 x 14 in. (27.9 x 35.6 cm). COURTESY OF THE BANCROFT LIBRARY, UNIVERSITY OF CALIFORNIA, BERKELEY, BANC PIC 2009.050.001:004 AX VAULT

LARRY KEENAN, *Section of the Runaway Board at Park Police Station*, 1968 (PL. 128). Gelatin silver print, 11 x 14 in. (27.9 x 35.6 cm). COURTESY OF THE BANCROFT LIBRARY, UNIVERSITY OF CALIFORNIA, BERKELEY, BANC PIC 2009.050.001:067

JIM MARSHALL (1936–2010), *Fillmore light show*, March/April 1967, printed 2016 (PL. 296). Inkjet print, 11 x 14 in. (27.9 x 35.6 cm). COURTESY OF JIM MARSHALL PHOTOGRAPHY LLC

JIM MARSHALL, *Florence Nathan, later Rosie McGee, dancing in the strobe lights at the Fillmore Auditorium*, summer 1968, printed 2016 (PL. 295). Inkjet print, 11 x 14 in. (27.9 x 35.6 cm). COURTESY OF JIM MARSHALL PHOTOGRAPHY LLC

JIM MARSHALL, *Grace & Janis*, 1967, printed 1991 (PL. 275). Color dye transfer print, 12 x 11 1/2 in. (30.5 x 29.2 cm) (sight). COLLECTION OF JOHN J. LYONS

JIM MARSHALL, *Grateful Dead playing on Haight Street*, March 1968, printed 2016 (PL. 75). Inkjet print, 11 x 14 in. (27.9 x 35.6 cm). COURTESY OF JIM MARSHALL PHOTOGRAPHY LLC

JIM MARSHALL, *Krishna/Digger March*, June 1967, printed 2016 (PL. 133). Inkjet print, 11 x 14 in. (27.9 x 35.6 cm). COURTESY OF JIM MARSHALL PHOTOGRAPHY LLC

ELAINE MAYES (b. 1936), *Composite photo, Straight Theater with Jerry Garcia and Dancing*, 1967 (PL. 84). Gelatin silver print, 14 x 11 in. (35.6 x 27.9 cm). COLLECTION OF THE ARTIST

ELAINE MAYES, *Couple with Child, Golden Gate Park, San Francisco*, 1968 (PL. 51). Gelatin silver print, 14 x 11 in. (35.6 x 27.9 cm). COURTESY OF JOSEPH BELLOWS GALLERY

ELAINE MAYES, *Dancing, Straight Theater, Haight Ashbury, San Francisco*, 1967 (PL. 83). Gelatin silver print, 14 x 11 in. (35.6 x 27.9 cm). COLLECTION OF THE ARTIST

ELAINE MAYES, *Eugene, Pan Handle, Haight Ashbury*, 1968 (PL. 52). Gelatin silver print, 14 x 11 in. (35.6 x 27.9 cm). COURTESY OF JOSEPH BELLOWS GALLERY

ELAINE MAYES, *Funky Sam, Central Street, Haight Ashbury*, 1967 (PL. 78). Gelatin silver print, 10 x 8 in. (25.4 x 20.3 cm). COLLECTION OF THE ARTIST

ELAINE MAYES, *Grateful Dead, Solstice, Golden Gate Park*, 1967 (PL. 58). Gelatin silver print, 11 x 14 in. (27.9 x 35.6 cm). COLLECTION OF THE ARTIST

ELAINE MAYES, *Haight Ashbury (woman in checkered outfit)*, 1968 (PL. 76). Gelatin silver print, 14 x 11 in. (35.6 x 27.9 cm). COURTESY OF JOSEPH BELLOWS GALLERY

ELAINE MAYES, *Haight Ashbury (young man against plywood)*, 1968 (PL. 73). Gelatin silver print, 14 x 11 in. (35.6 x 27.9 cm). COURTESY OF JOSEPH BELLOWS GALLERY

ELAINE MAYES, *Hugging and Dancing, Summer Solstice, Golden Gate Park*, 1967 (PL. 54). Gelatin silver print, 16 x 20 in. (40.6 x 50.8 cm). COLLECTION OF THE ARTIST

ELAINE MAYES, *Jimi Hendrix, Fillmore, San Francisco*, 1967 (PL. 274). Gelatin silver print, 11 x 14 in. (27.9 x 35.6 cm). COLLECTION OF THE ARTIST

ELAINE MAYES, *Kathleen and Baby Max Damen, Age 22, 1 Year*, 1968 (PL. 79). Gelatin silver print, 20 x 16 in. (50.8 x 40.6 cm). COLLECTION OF THE ARTIST

ELAINE MAYES, *Katrinka Haraden (Trinka), Age 19, Haight Street*, 1968 (PL. 74). Gelatin silver print, 14 x 11 in. (35.6 x 27.9 cm). COLLECTION OF NION MCEVOY

ELAINE MAYES, *Linda, 20, Haight Ashbury*, 1968 (PL. 64). Gelatin silver print, 14 x 11 in. (35.6 x 27.9 cm). COURTESY OF JOSEPH BELLOWS GALLERY

ELAINE MAYES, *The Print Mint, Haight Street*, 1967 (FIG. 33). Gelatin silver print, 11 x 14 in. (27.9 x 35.6 cm). COLLECTION OF THE ARTIST

ELAINE MAYES, *Shari Maynard, Bunny Bael (Red Pappas), Stefani Wyatt, Michael, and Sean Hervick, Haight Street*, 1968 (PL. 70). Gelatin silver print, 14 x 11 in. (35.6 x 27.9 cm). COLLECTION OF NION MCEVOY

ELAINE MAYES, *Solstice Metal Dress*, 1967 (PL. 56). Gelatin silver print, 8 x 10 in. (20.3 x 25.4 cm). COLLECTION OF THE ARTIST

ELAINE MAYES, *Steve Miller at Home, Haight-Ashbury*, 1967 (PL. 273). Gelatin silver print, 11 x 14 in. (27.9 x 35.6 cm). COLLECTION OF THE ARTIST

ELAINE MAYES, *Summer Solstice, God's Eye, Golden Gate Park*, 1967 (PL. 50). Gelatin silver print, 20 x 16 in. (50.8 x 40.6 cm). COLLECTION OF THE ARTIST

ELAINE MAYES, *Young Man with Guitar "Preacher," Haight Ashbury, San Francisco*, 1968 (PL. 68). Gelatin silver print, 14 x 11 in. (35.6 x 27.9 cm). COLLECTION OF THE ARTIST

LELAND RICE (b. 1940), *Golden Gate Park*, 1967 (PL. 57). Gelatin silver print, image: 5 1/8 x 5 5/8 in. (13 x 14.3 cm); mount: 15 1/8 x 13 1/8 in. (38.4 x 33.3 cm). COLLECTION OF THE ARTIST

LELAND RICE, *Haight Street*, 1967 (PL. 65). Gelatin silver print, image: 7 1/4 x 7 5/8 in. (18.4 x 19.4 cm); mount: 15 1/8 x 13 1/2 in. (38.4 x 34.3 cm). COLLECTION OF THE ARTIST

LELAND RICE, *The Print Mint, Haight Street*, 1967 (PL. 105). Gelatin silver print, 10 x 8 in. (25.4 x 20.3 cm). COLLECTION OF THE ARTIST

BOB SEIDEMANN (b. 1941), *Alton Kelley*, 1967 (PL. 80). Gelatin silver print, 8 x 10 in. (20.3 x 25.4 cm). COLLECTION OF THE ARTIST

BOB SEIDEMANN, *Five San Francisco Poster Artists* (left to right: Alton Kelley, Victor Moscoso, Rick Griffin, Wes Wilson, and Stanley Mouse), 1967 (FIG. 17). Gelatin silver print, 11 x 14 in. (27.9 x 35.6 cm). COLLECTION OF THE ARTIST

BOB SEIDEMANN, *Grateful Dead* (left to right: Ron "Pigpen" McKernan, Bob Weir, Phil Lesh, Jerry Garcia, and Bill Kreutzmann), Daly City, 1967 (PL. 272). Gelatin silver print, 16 x 20 in. (40.6 x 50.8 cm). COLLECTION OF THE ARTIST

BOB SEIDEMANN, *Haight Street*, 1967 (PL. 72). Gelatin silver print, 11 x 14 in. (27.9 x 35.6 cm). COLLECTION OF THE ARTIST

STEPHEN SHAMES (b. 1947), *David Hilliard, Panther Chief of Staff, Looks over a Drawing by Emory Douglas in the March 7, 1970 issue of "The Black Panther," Oakland, California*, printed ca. 1970 (PL. 328). Gelatin silver print, 9 1/2 x 6 in. (24.1 x 15.2 cm). STEVEN KASHER GALLERY

STEPHEN SHAMES, *Free Food Program, California, 1972*, ca. 1972 (PL. 332). Gelatin silver print, 9 1/2 x 6 1/2 in. (24.1 x 16.5 cm). STEVEN KASHER GALLERY

STEPHEN SHAMES, *Oakland Courthouse at First Huey P. Newton Trial for "Murder," October 1968*, printed ca. 1968 (PL. 327). Gelatin silver print, 10 x 8 in. (25.4 x 20.3 cm). STEVEN KASHER GALLERY

STEPHEN SHAMES, *Two Women with Bags of Food at the People's Free Food Program, One of the Panthers' Survival Programs, Palo Alto, California, October 1972*, ca. 1972 (PL. 333). Gelatin silver print, 8 7/8 x 6 1/8 in. (22.4 x 15.5 cm). STEVEN KASHER GALLERY

JOHN SPENCE WEIR (b. 1930), *Window of the Print Mint*, ca. 1967 (PL. 104). Gelatin silver print, 16 x 20 in. (40.6 x 50.8 cm). COLLECTION OF THE ARTIST

Santana (left to right: Bob "Doc" Livingston, David Brown, Carlos Santana, Michael Carabello, and Gregg Rolie), 1968 (FIG. 61). Gelatin silver print, 10 x 8 in. (25.4 x 20.3 cm). THE SELVIN COLLECTION

Staff photographer for the *San Francisco Examiner*, Anti-Vietnam demonstrators carry flag-draped "caskets" in Market Street parade, March 1966 (PL. 20). Gelatin silver print with ink corrections, 7 5/8 x 11 3/4 in. (19.3 x 29.7 cm). COLLECTION OF JOHN J. LYONS

Staff photographer for the *San Francisco Examiner*, "Vietnam reactions in U.S.," March 1966 (PL. 21). Gelatin silver print with ink corrections, 8 3/8 x 12 3/8 in. (21.2 x 31.3 cm). COLLECTION OF JOHN J. LYONS

POSTERS, PRINTS, AND HANDBILLS

JON ADAMS (b. ca. 1939), *The Blues Project, September 7–15, the Matrix*, 1966 (PL. 237). Color offset lithograph poster, 19 7/8 x 14 1/4 in. (50.5 x 36.1 cm). Printed by the Bindweed Press. CENTER FOR COUNTERCULTURE STUDIES

JOSEF ALBERS (AMERICAN, b. GERMANY, 1888–1976), *Full*, from the portfolio *Homage to the Square: Ten Works by Josef Albers*, 1962 (FIG. 87). Color screenprint, 17 x 17 in. (43.2 x 43.2 cm). Printed by R. H. Norton; published by Ives-Sillman, Inc. FINE ARTS MUSEUMS OF SAN FRANCISCO, ANDERSON GRAPHIC ARTS COLLECTION, GIFT OF THE HARRY W. AND MARY MARGARET ANDERSON CHARITABLE FOUNDATION, 1996.74.6.6

RAY ANDERSEN (ca. 1939–2016), *The Great Little Walter, The Quicksilver Messenger Service, Opens August 9, The Matrix*, 1966 (PL. 228). Stencil duplicate print (mimeograph) handbill, 11 x 8 1/2 in. (27.9 x 21.6 cm). COLLECTION OF JOHN J. LYONS

STEVEN ARNOLD (1943–1994), *In Gear, 1580 Haight St*, 1967. Offset lithograph poster, 22 1/4 x 17 1/2 in. (56.5 x 44.5 cm). FINE ARTS MUSEUMS OF SAN FRANCISCO, GIFT OF THE GARY WESTFORD COLLECTION, IN HONOR OF LYDIA PENSE, 2016.32.2

JOAN BAEZ (b. 1941), *Draft-Age? Listen*, ca. 1968. Electrophotographic print (Xerox) handbill on orange paper, 14 x 8 1/2 in. (35.6 x 21.6 cm). COLLECTION OF JOHN J. LYONS

PETER BAILEY (1924–1991), *The Jefferson Airplane, February 4–6, Fillmore Auditorium*, 1966 (PL. 231). Color offset lithograph poster, 20 x 14 3/8 in. (50.6 x 36.3 cm). Printed by Creative Lithograph Co.; published by Bill Graham (BG-1-RP-3). FINE ARTS MUSEUMS OF SAN FRANCISCO, MUSEUM PURCHASE, ACHENBACH FOUNDATION FOR GRAPHIC ARTS ENDOWMENT FUND, 1972.53.28

MICHAEL BOWEN (1937–2009), *Pow-Wow: A Gathering of the Tribes For A Human Be-In, January 14, Polo Grounds, Golden Gate Park*, 1967 (PL. 38). Offset lithograph handbill, 11 x 8 1/2 in. (27.9 x 21.6 cm). Printed by Double-H Press. COLLECTION OF JOHN J. LYONS

C. BRAGA (CHRIS BRAGA) (ACTIVE 20TH CENTURY), *Kaleidoscope, Lightning Hopkins, Martha's Laundry, October 13, Straight Theater*, 1967 (PL. 81). Color offset lithograph poster, 22 1/2 x 16 1/4 in. (57 x 41.3 cm). Printed by Double-H Press. FINE ARTS MUSEUMS OF SAN FRANCISCO, GIFT OF THE GARY WESTFORD COLLECTION, IN MEMORY OF LIGHTNING HOPKINS, 2017.7.14

STEWART BRAND (b. 1938), *"Whatever It Is," Acid Test with Ken Kesey, the Merry Pranksters, Grateful Dead; The Final Solution, Wildflower, Congress of Wonders, San Francisco Mime Troupe, The Committee, Mimi Farina, and many more, September 30–October 2, San Francisco State College*, 1966. Electrophotographic print (Xerox) handbill, 8 5/8 x 8 5/8 in. (21.7 x 21.7 cm). FINE ARTS MUSEUMS OF SAN FRANCISCO, GIFT OF THE GARY WESTFORD COLLECTION, IN HONOR OF STEWART BRAND, 2017.7.44

DAVE BROWN (ACTIVE 20TH CENTURY), *Steve Miller Blues Band, Curly Cooke's Hurdy Gurdy Band, June 19, The Ark, Sausalito*, 1968 (PL. 259). Color offset lithograph poster, 16 1/2 x 10 3/8 in. (42 x 26.4 cm). CENTER FOR COUNTERCULTURE STUDIES

THE COMMUNICATION COMPANY (1967), *Candle Opera, As A Part of the Spring Mobilization, Country Joe and the Fish, The New Age, The Made River, The All Night Apothecary, The Group, The Morning Glory, The Möebius, etc., Panhandle*, 1967 (PL. 45). Electrophotographic print (Xerox) handbill, 10 1/2 x 8 in. (26.6 x 20.3 cm). Printed by The Communication Company. COLLECTION OF JOHN J. LYONS

THE COMMUNICATION COMPANY, *"A Moving Target is Hard to Hit," March 29, Church of One*, 1967 (PL. 131). Red and black stencil duplicate print (mimeograph) handbill, 11 x 8 1/2 in. (27.9 x 21.6 cm). Printed by The Communication Company. COLLECTION OF JOHN J. LYONS

THE COMMUNICATION COMPANY, *Press Release, January 24*, 1967 (PL. 132). Stencil duplicate print (mimeograph) handbill, 14 x 8 1/2 in. (35.4 x 21.5 cm). Printed by The Communication Company. COLLECTION OF JOHN J. LYONS

THE COMMUNICATION COMPANY, *"Survival School," How to Stay Alive on Haight Street for Newcomers and Others*, 1967 (PL. 130). Stencil duplicate print (mimeograph) handbill, 11 x 8 1/2 in. (27.9 x 21.6 cm). COLLECTION OF JOHN J. LYONS

THE COMMUNICATION COMPANY with drawing by Georges Seurat, *Free Spring Mobilization Poetry Reading, April 6, Glide Church*, 1967 (PL. 44). Stencil duplicate print (mimeograph) handbill, 11 x 8 1/2 in. (27.9 x 21.6 cm). Printed by The Communication Company. COLLECTION OF JOHN J. LYONS

LEE CONKLIN (b. 1941), *Butterfield Blues Band, Santana, Hello People, Iron Butterfly, Canned Heat, Initial Shock, July 30–August 4, Fillmore West*, 1968 (PL. 158). Color offset lithograph poster, 21 x 14 in. (53.4 x 35.6 cm). Printed by Tea Lautrec Litho; published by Bill Graham (BG-131-OP-1). FINE ARTS MUSEUMS OF SAN FRANCISCO, MUSEUM PURCHASE, ACHENBACH FOUNDATION FOR GRAPHIC ARTS ENDOWMENT FUND, 1972.53.147

LEE CONKLIN, *Canned Heat, Gordon Lightfoot, Cold Blood, October 3–5, Fillmore West*, 1968 (PL. 220). Color offset lithograph poster, 21 1/8 x 14 1/8 in. (53.7 x 35.8 cm). Printed by Tea Lautrec Litho; published by Bill Graham (BG-139-OP-1). FINE ARTS MUSEUMS OF SAN FRANCISCO, MUSEUM PURCHASE, ACHENBACH FOUNDATION FOR GRAPHIC ARTS ENDOWMENT FUND, 1972.53.272

LEE CONKLIN, *Jeff Beck Group, Spirit, Linda Tillery, Sweet Linda Divine, Sweetwater, December 5–8, Fillmore West*, 1968 (FIG. 22). Color offset lithograph poster, 21 1/4 x 14 in. (54 x 35.6 cm). Printed by Tea Lautrec Litho; published by Bill Graham (BG-148-OP-1). FINE ARTS MUSEUMS OF SAN FRANCISCO, MUSEUM PURCHASE, ACHENBACH FOUNDATION FOR GRAPHIC ARTS ENDOWMENT FUND, 1972.53.281

LEE CONKLIN, *Procol Harum, Santana, Salloom-Sinclair, October 31–November 2, Fillmore West*, 1968 (PL. 255). Color offset lithograph poster, 21 1/4 x 14 1/8 in. (53.9 x 35.9 cm). Printed by Tea Lautrec Litho; published by Bill Graham (BG-143-OP-1). FINE ARTS MUSEUMS OF SAN FRANCISCO, MUSEUM PURCHASE, ACHENBACH FOUNDATION FOR GRAPHIC ARTS ENDOWMENT FUND, 1972.53.276

LEE CONKLIN, *Quicksilver Messenger Service, Grateful Dead, Linn County, November 7–10, Fillmore West*, 1968 (PL. 258). Color offset lithograph poster, 21 1/4 x 14 in. (53.8 x 35.5 cm). Printed by Tea Lautrec Litho; published by Bill Graham (BG-144-OP-1). FINE ARTS MUSEUMS OF SAN FRANCISCO, MUSEUM PURCHASE, ACHENBACH FOUNDATION FOR GRAPHIC ARTS ENDOWMENT FUND, 1972.53.277

LEE CONKLIN, *Steppenwolf, Staple Singers, Santana, August 27–29, Grateful Dead, Preservation Hall Jazz Band, Sons of Chaplan* [sic], *August 30–September 1, Fillmore West*, 1968 (PL. 162). Offset lithograph poster, 21 x 14 in. (53.2 x 35.6 cm). Published by Bill Graham (BG-134-OP-1). FINE ARTS MUSEUMS OF SAN FRANCISCO, MUSEUM PURCHASE, ACHENBACH FOUNDATION FOR GRAPHIC ARTS ENDOWMENT FUND, 1972.53.149

LEE CONKLIN, *The Who, Cannonball Adderly, The Vagrants, February 22, Fillmore Auditorium, February 23 & 24, Winterland*, 1968 (PL. 159). Color offset lithograph poster, 21 x 13 7/8 in. (53.4 x 35.2 cm). Printed by Tea Lautrec Litho; published by Bill Graham (BG-108-OP-1). FINE ARTS MUSEUMS OF SAN FRANCISCO, MUSEUM PURCHASE, ACHENBACH FOUNDATION FOR GRAPHIC ARTS ENDOWMENT FUND, 1972.53.3

EARL CRABB (1941–2015) and **RICK SHUBB** (b. 1945), *Humbead's Map of the World*, 1968 (PL. 3). Color offset lithograph poster, 22 1/4 x 17 in. (56.5 x 43.2 cm). COLLECTION OF JOHN J. LYONS

ROBERT CRUMB (b. 1943), *"Bedrock One," Music, Lights, Ceremonies, Happenings, Poetry, Hosts, Plus Surprises, March 5, California Hall*, 1967 (PL. 147). Electrophotographic print (Xerox) handbill on pink paper, 11 x 8 1/2 in. (27.8 x 21.5 cm). COLLECTION OF JOHN J. LYONS

DOTTIE (DOTTIE H. SIMMONS) (b. 1951), *"Alice Griffin," Iron Butterfly, Indian Head Band, The Collectors, July 4–7, Avalon Ballroom*, 1968 (PL. 161). Color offset lithograph poster, 20 5/8 x 14 in. (52.3 x 35.5 cm). Published by Family Dog (FD-126-OP-1). FINE ARTS MUSEUMS OF SAN FRANCISCO, MUSEUM PURCHASE, ACHENBACH FOUNDATION FOR GRAPHIC ARTS ENDOWMENT FUND, 1974.13.134

MICHAEL FERGUSON (1939–1979), *5th Annual S.F. State Folk Festival, Mark Spoelstra, Dan Hicks, Guy Carawan, Dick and Mimi Fariña, Malvina Reynolds, Doc Watson, Clint Howard & Fred Price, The Moving Star Hall Singers, and The Blues Project Blues Band, April 15*, 1966 (PL. 236). Color offset lithograph poster, 11 x 17 in. (27.8 x 43.2 cm). COLLECTION OF PETER ALBIN

MICHAEL FERGUSON and **GEORGE HUNTER** (b. 1942), *"The Seed," The Amazing Charlatans, June 1–15, Red Dog Saloon, Virginia City, Nevada*, 1965 (PL. 226). Offset lithograph poster printed in blue ink, 13 7/8 x 10 in. (35.2 x 25.2 cm). CENTER FOR COUNTERCULTURE STUDIES

PAUL FOSTER (1934–2003), *Acid Test Graduation Diploma for Jerry Garcia*, 1966 (PL. 35). Offset lithograph, 8 1/2 x 11 in. (21.6 x 27.9 cm). ED WALKER/ROCKPOSTERS.COM

PAUL FOSTER, *"Can You Pass the Acid Test?" The Fugs, Allen Ginsberg, The Merry Pranksters, Neal Cassady, The Grateful Dead, Roy's Audioptics, December, Muir Beach, California*, 1965 (PL. 28). Offset lithograph poster, with hand coloring in porous-point pen on blue paper, 22 3/8 x 17 in. (56.8 x 43.2 cm). HAIGHT STREET ART CENTER

ROBERT FRIED (1937–1975), *Big Brother & the Holding Company, Crazy World of Arthur Brown, Foundations, June 13, Fillmore Auditorium, June 14 & 15, Winterland*, 1968 (PL. 160). Color offset lithograph poster, 21 7/8 x 13 7/8 in. (55.5 x 35.3 cm). Published by Bill Graham (BG-124-OP-1). FINE ARTS MUSEUMS OF SAN FRANCISCO, MUSEUM PURCHASE, ACHENBACH FOUNDATION FOR GRAPHIC ARTS ENDOWMENT FUND, 1972.53.40

ROBERT FRIED, *The Family Dog is coming down to Earth*, 1969 (PL. 224). Color screenprint billboard with daylight fluorescent inks, in 14 sheets, 120 x 252 in. (304.8 x 640.1 cm) overall. FINE ARTS MUSEUMS OF SAN FRANCISCO, GIFT OF THE GARY WESTFORD COLLECTION, IN MEMORY OF ROBERT FRIED, AND IN HONOR OF ALL OF THE SAN FRANCISCO POSTER MAKERS AND MUSICIANS WHO MADE MAGIC HAPPEN, 2016.32.1

ROBERT FRIED, *"Sky Web," Charlatans, Buddy Guy, September 22–24, Avalon Ballroom*, 1967 (PL. 169). Color offset lithograph poster, 20 x 14 in. (50.8 x 35.5 cm). Published by Family Dog (FD-83-OP-1). FINE ARTS MUSEUMS OF SAN FRANCISCO, MUSEUM PURCHASE, ACHENBACH FOUNDATION FOR GRAPHIC ARTS ENDOWMENT FUND, 1974.13.179

ROBERT FRIED, *"The Sorcerer," Steppenwolf, Charley Musselwhite, 4th Way, Indian Head Band, April 19–21, Avalon Ballroom*, 1968 (FIG. 68). Color offset lithograph poster, 21 3/8 x 14 in. (54.3 x 35.5 cm). Published by Family Dog (FD-115-OP-1). FINE ARTS MUSEUMS OF SAN FRANCISCO, MUSEUM PURCHASE, ACHENBACH FOUNDATION FOR GRAPHIC ARTS ENDOWMENT FUND, 1974.13.150

ROBERT FRIED, *"TANS," Charlatans, Youngbloods, Other Half, July 13–16, Avalon Ballroom*, 1967. Color offset lithograph poster, 21 3/8 x 13 7/8 in. (54.2 x 35.2 cm). Published by Family Dog (FD-71-RP-2). FINE ARTS MUSEUMS OF SAN FRANCISCO, MUSEUM PURCHASE, ACHENBACH FOUNDATION FOR GRAPHIC ARTS ENDOWMENT FUND, 1974.13.191

RUPERT GARCIA (b. 1941), *The War and Children*, 1967 (PL. 317). Etching, plate: 15 3/4 x 11 1/4 in. (40 x 28.4 cm). FINE ARTS MUSEUMS OF SAN FRANCISCO, GIFT OF MR. AND MRS. ROBERT MARCUS, 1990.1.55

JOE GOMEZ (ACTIVE 20TH CENTURY), *"Optical Occlusion," Big Brother and the Holding Company, Mt. Rushmore, November 23–25, Avalon Ballroom*, 1967 (PL. 146). Color offset lithograph poster, 20 x 14 in. (50.7 x 35.6 cm). Published by Family Dog (FD-93-OP-1). FINE ARTS MUSEUMS OF SAN FRANCISCO, MUSEUM PURCHASE, ACHENBACH FOUNDATION FOR GRAPHIC ARTS ENDOWMENT FUND, 1974.13.171

RICK GRIFFIN (1944–1991), *"CHA," Charlatans, Salvation Army Banned, Blue Cheer, May 26–28, Avalon Ballroom*, 1967. Color offset lithograph poster, 21 7/8 x 14 in. (55.4 x 35.5 cm). Published by Family Dog (FD-63-RP-2). FINE ARTS MUSEUMS OF SAN FRANCISCO, MUSEUM PURCHASE, ACHENBACH FOUNDATION FOR GRAPHIC ARTS ENDOWMENT FUND, 1974.13.199

RICK GRIFFIN, *"Eternal Reservoir" (or "The Source"), Quicksilver Messenger Service, Kaleidoscope, Charley Musselwhite, January 12, 13, 14, Avalon Ballroom*, 1968. Color offset lithograph poster, 20 1/8 x 14 in. (50.9 x 35.5 cm). Published by Family Dog (FD-101-OP-5). FINE ARTS MUSEUMS OF SAN FRANCISCO, MUSEUM PURCHASE, ACHENBACH FOUNDATION FOR GRAPHIC ARTS ENDOWMENT FUND, 1974.13.160

RICK GRIFFIN, *Jimi Hendrix Experience, John Mayall & the Blues Breakers, Albert King, February 1 & 4, Fillmore Auditorium, February 2 & 3, Winterland*, 1968 (PL. 253). Color offset lithograph poster, 21 5/8 x 14 in. (54.7 x 35.6 cm). Printed by Tea Lautrec Litho; published by Bill Graham (BG-105-OP-1). FINE ARTS MUSEUMS OF SAN FRANCISCO, GIFT OF THACKREY AND ROBERTSON, 1981.1.34

RICK GRIFFIN, *"Mornin' Papa," Quicksilver Messenger Service, Sons of Champlin, Taj Mahal, October 27–29, Avalon Ballroom*, 1967 (PL. 149). Color offset lithograph poster, 20 x 14 1/4 in. (50.6 x 36.1 cm). Published by Family Dog (FD-89-OP-1). FINE ARTS MUSEUMS OF SAN FRANCISCO, MUSEUM PURCHASE, ACHENBACH FOUNDATION FOR GRAPHIC ARTS ENDOWMENT FUND, 1974.13.173

RICK GRIFFIN, *"Motherload," Big Brother & the Holding Company, Sir Douglas Quintet, The Orkustra, May 5–7, Avalon Ballroom*, 1967. Color offset lithograph poster, 20 x 14 in. (50.7 x 35.5 cm). Published by Family Dog (FD-60-OP-1). FINE ARTS MUSEUMS OF SAN FRANCISCO, MUSEUM PURCHASE, ACHENBACH FOUNDATION FOR GRAPHIC ARTS ENDOWMENT FUND, 1974.13.21

RICK GRIFFIN, *The New Improved Psychedelic Shop and Jook Savage Art Show*, 1966 (PL. 88). Offset lithograph poster, 20 x 14 in. (50.7 x 35.4 cm). Printed by Double-H Press. FINE ARTS MUSEUMS OF SAN FRANCISCO, GIFT OF THE GARY WESTFORD COLLECTION, 2017.7.12

RICK GRIFFIN, *Pow-Wow: A Gathering of the Tribes Human Be-In, Timothy Leary, Richard Alpert, Dick Gregory, Lenore Kandel, Jerry Rubin, All San Francisco Rock Bands, Allen Ginsberg, Lawrence Ferlinghetti, Larry Snyder, Michael McClure, Robert Baker, Buddha, January 14, Polo Grounds, Golden Gate Park*, 1967 (PL. 39). Offset lithograph poster, 22 1/2 x 14 1/4 in. (57 x 36.1 cm). FINE ARTS MUSEUMS OF SAN FRANCISCO, GIFT OF THE GARY WESTFORD COLLECTION, IN CELEBRATION OF GOLDEN GATE PARK AND THE CITY OF SAN FRANCISCO, 2017.7.13

RICK GRIFFIN, *"RLAT," The Charlatans, 13th Floor Elevators, June 22–25, Avalon Ballroom*, 1967. Color offset lithograph poster, 21 3/8 x 14 in. (54.2 x 35.5 cm). Published by Family Dog (FD-67-RP-2). FINE ARTS MUSEUMS OF SAN FRANCISCO, MUSEUM PURCHASE, ACHENBACH FOUNDATION FOR GRAPHIC ARTS ENDOWMENT FUND, 1974.13.197

RICK GRIFFIN, *"Three Indian Dudes," Grateful Dead, Quicksilver Messenger Service, John Hammond & His Screaming Nighthawks, Robert Baker, March 24–26, Avalon Ballroom*, 1967. Color offset lithograph poster, 20 x 14 1/2 in. (50.8 x 36.6 cm). Published by Family Dog (FD-54-OP-1). FINE ARTS MUSEUMS OF SAN FRANCISCO, MUSEUM PURCHASE, ACHENBACH FOUNDATION FOR GRAPHIC ARTS ENDOWMENT FUND, 1974.13.27

RICK GRIFFIN and **ALTON KELLEY** (1940–2008), *KSAN Radio, San Francisco*, 1969 (PL. 264). Color offset lithograph, 29 1/8 x 20 1/8 in. (74 x 51 cm). FINE ARTS MUSEUMS OF SAN FRANCISCO, GIFT OF THE GARY WESTFORD COLLECTION, IN MEMORY OF TOM DONAHUE AND ALL THE DJS, 2017.7.7

RICK GRIFFIN and **VICTOR MOSCOSO** (b. 1936), *"Avalon Splash," Jim Kweskin Jug Band, Sons of Champlin, December 8–10, Avalon Ballroom*, 1967 (PL. 172). Color offset lithograph poster, 20 x 14 1/8 in. (50.7 x 35.7 cm). Published by Family Dog (FD-95-OP-1). FINE ARTS MUSEUMS OF SAN FRANCISCO, MUSEUM PURCHASE, ACHENBACH FOUNDATION FOR GRAPHIC ARTS ENDOWMENT FUND, 1974.13.137

RICK GRIFFIN, STANLEY MOUSE (b. 1940), and **ALTON KELLEY**, *"HALO," Benefit for Haight Ashbury Legal Organization, Jefferson Airplane, Big Brother & The Holding Co., Quicksilver-Messenger Service, The Charlatans, The Grateful Dead, May 30th, Winterland*, 1967 (PL. 126). Color offset lithograph poster, 18 1/4 x 14 in. (46.4 x 35.6 cm). COLLECTION OF JOHN J. LYONS

GUT (ALLEN TURK) (ACTIVE 20TH CENTURY), *Acid Test Graduation: Grateful Dead, Merry Pranksters, Neal Cassady, Caliope Co., Ken Kesey, and Many Guest Stars, October 31, Winterland*, 1966 (PL. 33). Offset lithograph poster printed on red daylight fluorescent paper, 20 x 12 5/8 in. (50.7 x 31.9 cm). CENTER FOR COUNTERCULTURE STUDIES

GUT (ALLEN TURK), *"Hells Angels Dance," Big Brother & the Holding Company, Blue Cheer, February 3, California Hall*, 1967. Color offset lithograph poster, 20 x 14 1/4 in. (50.8 x 36.2 cm). Printed by Bindweed Press. FINE ARTS MUSEUMS OF SAN FRANCISCO, GIFT OF THE GARY WESTFORD COLLECTION, 2017.7.6

GUT (ALLEN TURK), *The Hell's Angels M.C. Present Big Brother and the Holding Co. and the Merry Pranksters, November 12, Sokol Hall*, 1966 (PL. 240). Color offset lithograph poster, 19 7/8 x 14 1/8 in. (50.6 x 36 cm). COLLECTION OF PETER ALBIN

JACK HATFIELD (b. 1947), *Magic Mountain Music Festival KFRC Benefit For the Hunters Point Child Care Center, Mojo Men, The Sparrow, The Doors, Country Joe and the Fish, The Seeds, Moby Grape, Tim Hardin, The Byrds, Miller Blues Band, Tim Buckley, P. F. Sloan, Smokey and His Sister, Every Mothers' Son, Hugh Masekela, Blackburn and Snow, Wilson Picket, Jefferson Airplane, The Miracles, The Loading Zone, The Grass Roots, The Merry Go Round, Roger Collins, Blues Magoos, Kim Weston, June 10 and 11, Mt. Tamalpais*, 1967 (PL. 252). Color offset lithograph poster printed on two sheets, 22 x 13 7/8 in. (44.9 x 35.2 cm) (left) and 22 x 14 1/8 in. (55.9 x 35.9 cm) (right). Printed by Pacific Rota Printing Co. CENTER FOR COUNTERCULTURE STUDIES

WILLIAM HENRY (ACTIVE 20TH CENTURY), *"2.45765," Junior Wells, Sons of Champlin, Santana, May 17–19, Avalon Ballroom*, 1968. Color offset lithograph poster, 19 7/8 x 13 7/8 in. (50.5 x 35.2 cm). Published by Family Dog (FD-119-OP-1). FINE ARTS MUSEUMS OF SAN FRANCISCO, MUSEUM PURCHASE, ACHENBACH FOUNDATION FOR GRAPHIC ARTS ENDOWMENT FUND, 1974.13.142

WILLIAM HENRY, *"One Hundred Six," Youngbloods, Mount Rushmore, Phoenix, February 16–18, Avalon Ballroom*, 1968 (PL. 156). Color offset lithograph poster, 19 7/8 x 14 in. (50.5 x 35.6 cm). Published by Family Dog (FD-106-OP-1). FINE ARTS MUSEUMS OF SAN FRANCISCO, MUSEUM PURCHASE, ACHENBACH FOUNDATION FOR GRAPHIC ARTS ENDOWMENT FUND, 1974.13.159

DAVID HODGES (ACTIVE 20TH CENTURY), *"The Invisible Circus," Sponsored by The Diggers, Artists Liberation Front, Glide Foundation, Feb. 24–26, Glide Church*, 1967 (PL. 134). Color offset lithograph poster, 14 1/4 x 20 in. (36.2 x 50.7 cm). Printed by the Bindweed Press. FINE ARTS MUSEUMS OF SAN FRANCISCO, GIFT OF THE GARY WESTFORD COLLECTION, 2017.7.25

GEORGE HUNTER (b. 1942), *"Rock & Roll," The Charlatans, The Jefferson Airplane, January 8, California Hall*, 1966 (PL. 230). Offset lithograph handbill, 11 1/4 x 8 3/4 in. (28.6 x 22.1 cm). Published by Family Dog (FD-IV). FINE ARTS MUSEUMS OF SAN FRANCISCO, MUSEUM PURCHASE, ACHENBACH FOUNDATION FOR GRAPHIC ARTS ENDOWMENT FUND, 1974.13.116

GREG IRONS (1947–1984), *Butterfield Blues Band, Bloomfield & Friends, Birth, March 27–30, Fillmore Auditorium*, 1969 (PL. 178). Color offset lithograph poster, 21 5/8 x 13 1/8 in. (54.8 x 33.3 cm). Printed by Tea Lautrec Litho; published by Bill Graham (BG-166-OP-1). FINE ARTS MUSEUMS OF SAN FRANCISCO, MUSEUM PURCHASE, ACHENBACH FOUNDATION FOR GRAPHIC ARTS ENDOWMENT FUND, 1972.53.252

GREG IRONS, *KMPX Multiplex Stereo in San Francisco*, 1967 (PL. 266). Stencil duplicate print (mimeograph) on red daylight fluorescent paper, 11 x 8 1/2 in. (27.9 x 21.6 cm). COLLECTION OF JOHN J. LYONS

GREG IRONS, *Santana, Collectors, Melanie, February 14–16, Fillmore West,* 1969 (PL. 151). Color offset lithograph poster, 22 1/8 x 13 1/8 in. (56.1 x 33.2 cm). Printed by Tea Lautrec Litho; published by Bill Graham (BG-160-OP-1). FINE ARTS MUSEUMS OF SAN FRANCISCO, MUSEUM PURCHASE, ACHENBACH FOUNDATION FOR GRAPHIC ARTS ENDOWMENT FUND, 1972.53.258

DANA W. JOHNSON (ACTIVE 20TH CENTURY), *Country Joe and the Fish, Steppenwolf, Flamin' Groovies, March 28–30, Fillmore Auditorium,* 1968 (PL. 197). Color offset lithograph poster, 22 x 14 in. (55.8 x 35.5 cm). Published by Bill Graham (BG 113-OP-1). FINE ARTS MUSEUMS OF SAN FRANCISCO, MUSEUM PURCHASE, ACHENBACH FOUNDATION FOR GRAPHIC ARTS ENDOWMENT FUND, 1972.53.129

DANA W. JOHNSON, *Eric Burdon and the Animals, Quicksilver Messenger Service, Sons of Champlin, April 4, Fillmore Auditorium, April 5 & 6, Winterland,* 1968 (PL. 198). Color offset lithograph poster, 22 x 14 1/4 in. (55.8 x 36.1 cm). Published by Bill Graham (BG-114-OP-1). FINE ARTS MUSEUMS OF SAN FRANCISCO, MUSEUM PURCHASE, ACHENBACH FOUNDATION FOR GRAPHIC ARTS ENDOWMENT FUND, 1972.53.130

PAUL KAGAN (1943–1993), *Yab-Yum,* 1967 (PL. 177). Color offset lithograph poster, 28 3/8 x 22 3/8 in. (72 x 56.7 cm). Printed by Neal, Stratford & Kerr; published by Family Dog. FINE ARTS MUSEUMS OF SAN FRANCISCO, MUSEUM COLLECTION, Z2015.10

ALTON KELLEY (1940–2008), *"Wanted," Charlatans, Electric Chamber Orkustra, Lynne Hughes, March 4, Sokol Hall,* 1966 (PL. 229). Offset lithograph handbill, 11 x 8 1/2 in. (27.9 x 21.6 cm). COLLECTION OF JOHN J. LYONS

ALTON KELLEY and **AMI MAGILL** (b. ca. 1941), *The Family Dog Presents A Tribute to Dr. Strange, Russ the Moose Syracuse, Jefferson Airplane, The Charlatans, The Marbles, The Great Society, October 16, Longshoremen's Hall,* 1965 (PL. 227). Stencil duplicate print (mimeograph) handbill on goldenrod paper, 11 x 8 1/2 in. (27.8 x 21.6 cm). Published by Family Dog (FD-I). CENTER FOR COUNTERCULTURE STUDIES

NICHOLAS KOUNINOS (1943–2010), *Procol Harum, Pink Floyd, H. P. Lovecraft, November 9, Fillmore Auditorium, November 10–11, Winterland,* 1967 (PL. 249). Color offset lithograph poster, 21 x 14 in. (53.3 x 35.6 cm). Published by Bill Graham (BG-92-OP-1). FINE ARTS MUSEUMS OF SAN FRANCISCO, MUSEUM PURCHASE, ACHENBACH FOUNDATION FOR GRAPHIC ARTS ENDOWMENT FUND, 1972.53.114

LICHTENWALNER (ACTIVE 20TH CENTURY), *Moby Grape, Big Brother and the Holding Company, Sons of Champlin, October 13 & 14, The Ark,* 1967 (PL. 174). Color offset lithograph poster, 22 1/8 x 16 1/8 in. (56 x 40.8 cm). FINE ARTS MUSEUMS OF SAN FRANCISCO, GIFT OF THE GARY WESTFORD COLLECTION, 2017.7.8

PATRICK LOFTHOUSE (b. 1937), *Love, Staple Singers, Roland Kirk, April 18, Fillmore Auditorium, April 19 & 20, Winterland,* 1968. Color offset lithograph poster, 21 1/8 x 14 in. (53.5 x 35.6 cm). Published by Bill Graham (BG-116-OP-1). FINE ARTS MUSEUMS OF SAN FRANCISCO, MUSEUM PURCHASE, ACHENBACH FOUNDATION FOR GRAPHIC ARTS ENDOWMENT FUND, 1972.53.132

BONNIE MACLEAN (b. 1939), *Butterfield Blues Band, Roland Kirk Quartet, New Salvation Army Band, Mt. Rushmore, July 11–16, Fillmore Auditorium,* 1967 (PL. 157). Color offset lithograph poster, 21 x 14 in. (53.4 x 35.4 cm). Printed by Neal, Stratford & Kerr; published by Bill Graham (BG-72-OP-1). FINE ARTS MUSEUMS OF SAN FRANCISCO, MUSEUM PURCHASE, ACHENBACH FOUNDATION FOR GRAPHIC ARTS ENDOWMENT FUND, 1972.53.101

BONNIE MACLEAN, *Chambers Brothers, Sunshine Company, Siegal Schwall [sic], January 11–13, Fillmore Auditorium,* 1968 (PL. 168). Color offset lithograph poster, 21 x 14 in. (53.3 x 35.6 cm). Printed by Tea Lautrec Litho; published by Bill Graham (BG-102-OP-1). FINE ARTS MUSEUMS OF SAN FRANCISCO, MUSEUM PURCHASE, ACHENBACH FOUNDATION FOR GRAPHIC ARTS ENDOWMENT FUND, 1972.53.122

BONNIE MACLEAN, *Jefferson Airplane, Big Brother and the Holding Company, Quicksilver Messenger Service, Freedom Highway, December 31, Winterland,* 1967. Color offset lithograph poster, 21 1/8 x 14 1/8 in. (53.6 x 35.8 cm). Printed by Tea Lautrec Litho; published by Bill Graham (BG-100-RP-2). FINE ARTS MUSEUMS OF SAN FRANCISCO, MUSEUM PURCHASE, ACHENBACH FOUNDATION FOR GRAPHIC ARTS ENDOWMENT FUND, 1972.53.120

BONNIE MACLEAN, *Paul Butterfield Blues Band, Cream, Southside Sound System, August 22–27, Fillmore Auditorium,* 1967. Color offset lithograph poster, 21 x 14 1/8 in. (53.2 x 35.7 cm). Printed by Neal, Stratford & Kerr; published by Bill Graham (BG-79-OP-1). FINE ARTS MUSEUMS OF SAN FRANCISCO, MUSEUM PURCHASE, ACHENBACH FOUNDATION FOR GRAPHIC ARTS ENDOWMENT FUND, 1972.53.95

BONNIE MACLEAN, *Yardbirds, The Doors, James Cotton Blues Band, Richie Havens, July 25–30, Fillmore Auditorium,* 1967 (PL. 200). Color offset lithograph poster, 21 3/8 x 14 in. (54.1 x 35.6 cm). Published by Bill Graham (BG-75-RP-3). FINE ARTS MUSEUMS OF SAN FRANCISCO, MUSEUM PURCHASE, ACHENBACH FOUNDATION FOR GRAPHIC ARTS ENDOWMENT FUND, 1972.53.103

Photograph by **JIM MARSHALL** (1936–2010), *GIRLS SAY YES to Boys Who Say NO,* 1968 (PL. 314). Offset lithograph poster, 42 x 29 1/2 in. (106.7 x 74.9 cm). COLLECTION OF JOAN BAEZ

LARRY MILLER (1940–2016), *Larry Miller, Folk Rock, Midnight to 6 A.M., KMPX, 106.9 FM Stereo,* 1967 (PL. 265). Stencil duplicate print (mimeograph) handbill, 11 x 8 1/2 in. (27.9 x 21.6 cm). COLLECTION OF JOHN J. LYONS

VICTOR MOSCOSO (b. 1936), *"Avalon Ballroom," Quicksilver Messenger Service, Mount Rushmore, Big Brother & the Holding Company, Horns of Plenty, June 29–July 2, Avalon Ballroom,* 1967. Color offset lithograph poster, 20 1/4 x 14 in. (51.4 x 35.6 cm). Published by Family Dog (FD-68-OP-1). FINE ARTS MUSEUMS OF SAN FRANCISCO, MUSEUM PURCHASE, ACHENBACH FOUNDATION FOR GRAPHIC ARTS ENDOWMENT FUND, 1974.13.194

VICTOR MOSCOSO, *Big Brother and the Holding Company, January 17–22, The Matrix,* 1967 (PL. 244). Color offset lithograph poster, 20 x 14 in. (50.8 x 35.6 cm). Published by Neon Rose (NR-3-OP-1). FINE ARTS MUSEUMS OF SAN FRANCISCO, GIFT OF THE GARY WESTFORD COLLECTION, IN HONOR OF MARTY BALIN AND THE MATRIX, 2017.7.21

VICTOR MOSCOSO, *The Blushing Peony, 1571–73 Haight,* 1967 (PL. 89 AND FIGS. 65–66). Color offset lithograph poster, 20 x 14 in. (50.8 x 35.6 cm). Published by Neon Rose (NR-17-OP-1). FINE ARTS MUSEUMS OF SAN FRANCISCO, GIFT OF THE GARY WESTFORD COLLECTION, 2016.32.4

VICTOR MOSCOSO, *"Break on Through to the Other Side," The Doors, The Sparrow, Country Joe & the Fish, March 3 & 4, Avalon Ballroom,* 1967 (PL. 218). Color offset lithograph poster, 20 x 14 in. (50.6 x 35.6 cm). Published by Family Dog (FD-50-RP-2). FINE ARTS MUSEUMS OF SAN FRANCISCO, MUSEUM PURCHASE, ACHENBACH FOUNDATION FOR GRAPHIC ARTS ENDOWMENT FUND, 1974.13.28

VICTOR MOSCOSO, *"Butterfly Lady," The Doors, The Sparrow, November 23–25, Avalon Ballroom,* 1967 (PL. 165). Color offset lithograph "animated" poster, 20 x 14 in. (50.8 x 35.6 cm). Published by Family Dog (FD-61-RP-2). FINE ARTS MUSEUMS OF SAN FRANCISCO, MUSEUM PURCHASE, ACHENBACH FOUNDATION FOR GRAPHIC ARTS ENDOWMENT FUND, 1974.13.18

VICTOR MOSCOSO, *"Flower Pot," Blue Cheer, Lee Michaels, Clifton Chenier, October 6–8, Avalon Ballroom,* 1967 (PL. 182). Color offset lithograph poster, 20 x 14 in. (50.8 x 35.5 cm). Published by Family Dog (FD-86-OP-1). FINE ARTS MUSEUMS OF SAN FRANCISCO, MUSEUM PURCHASE, ACHENBACH FOUNDATION FOR GRAPHIC ARTS ENDOWMENT FUND, 1974.13.176

VICTOR MOSCOSO, *"God's Eye," Big Brother & the Holding Company, The Charlatans, Blue Cheer, March 31–April 1, Avalon Ballroom,* 1967 (PL. 17). Color offset lithograph poster, 20 x 14 in. (50.8 x 35.5 cm). Published by Family Dog (FD-55-OP-1). FINE ARTS MUSEUMS OF SAN FRANCISCO, MUSEUM PURCHASE, ACHENBACH FOUNDATION FOR GRAPHIC ARTS ENDOWMENT FUND, 1974.13.22

VICTOR MOSCOSO, *Haight Ashbury Neighborhood "Clean-In,"* Spring 1967. Color offset lithograph poster, 14 1/8 x 20 1/8 in. (35.7 x 50.9 cm). Published by Neon Rose (NR-15-OP-1). FINE ARTS MUSEUMS OF SAN FRANCISCO, GIFT OF THE GARY WESTFORD COLLECTION, 2017.7.39

VICTOR MOSCOSO, *"Incredible Poetry Reading," Ferlinghetti, Wieners, Meltzer, Whalen, Welch, McClure, Ginsberg, June 8, Nourse Auditorium,* 1968 (PL. 164). Color offset lithograph "animated" poster, 28 3/16 x 22 1/16 in. (71.6 x 56 cm). Published by Neon Rose (NR-24[B-5]-OP-1). FINE ARTS MUSEUMS OF SAN FRANCISCO, GIFT OF THE GARY WESTFORD COLLECTION, IN HONOR OF VICTOR MOSCOSO AND ALL THE POETS, 2017.7.27

VICTOR MOSCOSO, *"Indian with the Swirling Eyes," Big Brother & the Holding Company, Oxford Circle, Lee Michaels, December 9 & 10, Avalon Ballroom,* 1966 (PL. 208). Color offset lithograph poster, 18 x 14 1/4 in. (45.6 x 36.1 cm). Printed by the Bindweed Press; published by Family Dog (FD-38-OP-1). FINE ARTS MUSEUMS OF SAN FRANCISCO, MUSEUM PURCHASE, ACHENBACH FOUNDATION FOR GRAPHIC ARTS ENDOWMENT FUND, 1974.13.78

VICTOR MOSCOSO, *The Miller Blues Band, January 10–15, Matrix,* 1967 (PL. 243). Color offset lithograph poster, 20 x 14 1/8 in. (50.8 x 35.9 cm). Published by Neon Rose (NR-2-OP-1). HAIGHT STREET ART CENTER

VICTOR MOSCOSO, *"Neptune's Notions," Moby Grape, The Charlatans, February 24 & 25, Avalon Ballroom,* 1967 (PL. 145 AND FIG. 88). Color offset lithograph poster, 20 x 14 in. (50.8 x 35.5 cm). Published by Family Dog (FD-49-RP-2). FINE ARTS MUSEUMS OF SAN FRANCISCO, MUSEUM PURCHASE, ACHENBACH FOUNDATION FOR GRAPHIC ARTS ENDOWMENT FUND, 1974.13.33

VICTOR MOSCOSO, *Pablo Ferro film advertisement,* 1967 (PL. 166). Color offset lithograph "animated" poster, 27 7/8 x 21 7/8 in. (70.8 x 55.6 cm). Published by Neon Rose (NR-22[B-3]-OP-1). HAIGHT STREET ART CENTER

VICTOR MOSCOSO, *"Peacock Ball," Quicksilver Messenger Service, Miller Blues Band, The Daily Flash, March 10 & 11, Avalon Ballroom,* 1967 (PL. 251). Color offset lithograph poster, 20 x 14 in. (50.8 x 35.5 cm). Published by Family Dog (FD-51-RP-4). FINE ARTS MUSEUMS OF SAN FRANCISCO, MUSEUM PURCHASE, ACHENBACH FOUNDATION FOR GRAPHIC ARTS ENDOWMENT FUND, 1974.13.30

VICTOR MOSCOSO, *Steve Miller promotion for Capitol Records,* 1969 (PL. 163). Color offset lithograph "animated" poster, 27 7/8 x 21 7/8 in. (70.8 x 56.2 cm). Published by Neon Rose (NR-23[B-4]-OP-1). HAIGHT STREET ART CENTER

VICTOR MOSCOSO, *"Strongman," Youngbloods, Siegal Schwall Band [sic] Band, June 15–18, Avalon Ballroom,* 1967 (PL. 167). Color offset lithograph "animated" poster, 20 x 14 in. (50.8 x 35.6 cm). Published by Family Dog (FD-66-OP-1). FINE ARTS MUSEUMS OF SAN FRANCISCO, MUSEUM PURCHASE, ACHENBACH FOUNDATION FOR GRAPHIC ARTS ENDOWMENT FUND, 1974.13.114

VICTOR MOSCOSO, *"Swirley," Doors, Miller Blues Band, Haji Baba, April 14 & 15, Avalon Ballroom,* 1967 (FIG. 86 AND PL. 142). Color offset lithograph poster, 20 x 14 in. (50.7 x 35.5 cm). Published by Family Dog (FD-57-RP-2). FINE ARTS MUSEUMS OF SAN FRANCISCO, MUSEUM PURCHASE, ACHENBACH FOUNDATION FOR GRAPHIC ARTS ENDOWMENT FUND, 1974.13.24

VICTOR MOSCOSO and **WES WILSON** (b. 1937), *"Wild West," Joan Baez, It's a Beautiful Day, July 7, 660 Great Highway; Jefferson Airplane, Fourth Way, Ace of Cups, July 7, Fillmore West,* 1969 (PL. 256). Color offset lithograph poster, 14 x 20 1/4 in. (35.6 x 51.3 cm). Published by Family Dog (FD-690707). FINE ARTS MUSEUMS OF SAN FRANCISCO, GIFT OF THE GARY WESTFORD COLLECTION, IN HONOR OF THE JEFFERSON AIRPLANE, MARTY BALIN, JACK CASADY, JORMA KAUKONEN, PAUL KANTNER, SPENCER DRYDEN, AND GRACE SLICK, 2017.7.31

STANLEY MOUSE (b. 1940), *"Libertie," Blood, Sweat and Tears, John Handy, Son House, March 15–17, Avalon Ballroom,* 1968 (PL. 318). Color offset lithograph poster, 20 x 13 7/8 in. (50.7 x 35.3 cm). Published by Family Dog (FD-110-OP-1). FINE ARTS MUSEUMS OF SAN FRANCISCO, MUSEUM PURCHASE, ACHENBACH FOUNDATION FOR GRAPHIC ARTS ENDOWMENT FUND, 1974.13.151

STANLEY MOUSE, *The Mind Is, Like the Moon, Full and Solitary, Its Light Swallows Up Ten Thousand Things, February 3–5, Light Sound Dimension,* 1967. Color screenprint poster, including metallic ink, with airbrush additions, printed on metallic paper, 29 x 23 in. (73.7 x 58.4 cm). FINE ARTS MUSEUMS OF SAN FRANCISCO, BEQUEST OF JOHN GUTMANN, 2000.119.4.21

STANLEY MOUSE, "Peace and Freedom Party Dinner," *Cleveland Wrecking Co., March 18, Ribeltad Vorden,* 1968 (PL. 308). Offset lithograph poster, 17 1/8 x 13 in. (43.3 x 33 cm). FINE ARTS MUSEUMS OF SAN FRANCISCO, GIFT OF THE GARY WESTFORD COLLECTION, IN HONOR OF PEACE AND FREEDOM EVERYWHERE, 2017.7.41

STANLEY MOUSE, "Port Chicago Vigil Benefit," *Country Joe & the Fish, Steve Miller Blues Band, S.F. Mime Troupe, Robert Baker, February 19, California Hall,* 1967. Color offset lithograph poster, 21 5/8 x 13 1/8 in. (54.7 x 33.2 cm). Printed by Berkeley Free Press. FINE ARTS MUSEUMS OF SAN FRANCISCO, GIFT OF THE GARY WESTFORD COLLECTION, 2017.7.2

STANLEY MOUSE and **ALTON KELLEY** (1940–2008), *10th Biennial Wilderness Conference sponsored by the Sierra Club, April 7, 8, 9, Hilton Hotel,* 1967 (PL. 325). Color offset lithograph poster, 19 7/8 x 13 7/8 in. (50.5 x 35.2 cm). Printed by the Bindweed Press. COLLECTION OF JOHN J. LYONS

STANLEY MOUSE and **ALTON KELLEY,** "Earthquake," *Bo Diddley, Big Brother and the Holding Company, August 12 & 13, Avalon Ballroom,* 1966 (PL. 12). Color offset lithograph poster, 20 x 13 7/8 in. (40.3 x 35.2 cm). Published by Family Dog (FD-21-OP-1). FINE ARTS MUSEUMS OF SAN FRANCISCO, GIFT OF THACKERY AND ROBERTSON, 1981.1.33

STANLEY MOUSE and **ALTON KELLEY,** "Edgar Allan Poe," *Daily Flash, Country Joe & the Fish, October 21 & 22, Avalon Ballroom,* 1966 (PL. 191). Offset lithograph poster, 20 x 14 1/4 in. (50.7 x 36 cm). Printed by the Bindweed Press; published by Family Dog (FD-31-OP-2). FINE ARTS MUSEUMS OF SAN FRANCISCO, MUSEUM PURCHASE, ACHENBACH FOUNDATION FOR GRAPHIC ARTS ENDOWMENT FUND, 1974.13.93

STANLEY MOUSE and **ALTON KELLEY,** "Edwardian Ball, San Francisco State College Homecoming Dance," *Jefferson Airplane, November 6, Fillmore Auditorium,* 1966 (PL. 14). Color offset lithograph poster, 20 x 14 1/4 in. (50.7 x 36.1 cm). Printed by the Bindweed Press. FINE ARTS MUSEUMS OF SAN FRANCISCO, GIFT OF THE GARY WESTFORD COLLECTION, IN HONOR OF STANLEY MOUSE, ALTON KELLEY, AND SAN FRANCISCO STATE COLLEGE, 2017.7.20

STANLEY MOUSE and **ALTON KELLEY,** "Five Men in a Boat," *Bo Diddley, Sons of Adam, Little Walter, August 5 & 7, Longshoremen's Hall, August 6, Avalon Ballroom,* 1966 (PL. 143). Color offset lithograph poster with split fountain, 18 x 11 1/8 in. (45.5 x 29.7 cm) (trimmed). Published by Family Dog (FD-20-OP-1). FINE ARTS MUSEUMS OF SAN FRANCISCO, MUSEUM PURCHASE, ACHENBACH FOUNDATION FOR GRAPHIC ARTS ENDOWMENT FUND, 1974.13.112

STANLEY MOUSE and **ALTON KELLEY,** "Girl in the Red Circle," *Grateful Dead, Quicksilver Messenger Service, January 27 & 28, Avalon Ballroom,* 1967 (FIG. 85). Color offset lithograph poster with metallic ink, 20 1/8 x 13 7/8 in. (51.1 x 35.2 cm). Published by Family Dog (FD-45). FINE ARTS MUSEUMS OF SAN FRANCISCO, MUSEUM PURCHASE, ACHENBACH FOUNDATION FOR GRAPHIC ARTS ENDOWMENT FUND, 1974.13.34

STANLEY MOUSE and **ALTON KELLEY,** "Gloria Swanson," *Big Brother & the Holding Company, Sir Douglas Quintet, October 15 & 16, Avalon Ballroom,* 1966 (PL. 186). Color offset lithograph poster, 20 x 14 1/4 in. (50.7 x 36.1 cm). Printed by the Bindweed Press; published by Family Dog (FD-30-OP-1). FINE ARTS MUSEUMS OF SAN FRANCISCO, GIFT OF MR. JULIAN SILVA, 1997.64.12

STANLEY MOUSE and **ALTON KELLEY,** "The Golden Road to Unlimited Devotion," *Grateful Dead Fan Club,* 1967. Color offset lithograph poster, 20 x 14 1/8 in. (50.6 x 35.9 cm). FINE ARTS MUSEUMS OF SAN FRANCISCO, GIFT OF THE GARY WESTFORD COLLECTION, IN HONOR OF THE GRATEFUL DEAD AND IN MEMORY OF JERRY GARCIA, 2017.7.29

STANLEY MOUSE and **ALTON KELLEY,** *Grateful Dead poster for Warner Brothers album production,* 1967 (FIG. 26). Color offset lithograph poster, 16 3/4 x 22 1/8 in. (42.4 x 56.1 cm). COLLECTION OF JOHN J. LYONS

STANLEY MOUSE and **ALTON KELLEY,** "Howlin' Wolf," *Howlin' Wolf, Big Brother and the Holding Company, September 23 & 24, Avalon Ballroom,* 1966. Color offset lithograph poster, 20 x 14 1/4 in. (50.6 x 36 cm). Printed by the Bindweed Press; published by Family Dog (FD-27-OP-2). FINE ARTS MUSEUMS OF SAN FRANCISCO, MUSEUM PURCHASE, ACHENBACH FOUNDATION FOR GRAPHIC ARTS ENDOWMENT FUND, 1974.13.101

STANLEY MOUSE and **ALTON KELLEY,** "Indian," *Quicksilver Messenger Service, Great Society, September 9 & 10, Avalon Ballroom,* 1966. Color offset lithograph poster, 20 x 13 5/8 in. (50.7 x 34.7 cm). Printed by the Bindweed Press; published by Family Dog (FD-25-OP-1). FINE ARTS MUSEUMS OF SAN FRANCISCO, MUSEUM PURCHASE, ACHENBACH FOUNDATION FOR GRAPHIC ARTS ENDOWMENT FUND, 1974.13.103

STANLEY MOUSE and **ALTON KELLEY,** "Keep California Green," *Sir Douglas Quintet, Everpresent Fullness, July 8–10, Avalon Ballroom,* 1966 (PL. 153). Color offset lithograph poster with green daylight fluorescent ink, 20 x 14 1/4 in. (50.7 x 36.2 cm). Printed by the Bindweed Press; published by Family Dog (FD-16-OP-1). FINE ARTS MUSEUMS OF SAN FRANCISCO, MUSEUM PURCHASE, ACHENBACH FOUNDATION FOR GRAPHIC ARTS ENDOWMENT FUND, 1974.13.48

STANLEY MOUSE and **ALTON KELLEY,** "Moby Grape," *Moby Grape, Sparrow, Charlatans, January 13 & 14, Avalon Ballroom,* 1967 (PL. 188). Color offset lithograph poster, 20 x 14 in. (50.8 x 35.5 cm). Printed by Double-H Press; published by Family Dog (FD-43). FINE ARTS MUSEUMS OF SAN FRANCISCO, MUSEUM PURCHASE, ACHENBACH FOUNDATION FOR GRAPHIC ARTS ENDOWMENT FUND, 1974.13.38

STANLEY MOUSE and **ALTON KELLEY,** "Peace," *Joan Baez, Mimi Farina, Grateful Dead, Quick Silver Messenger Service, Ed Keating, Don Duncan, October 8, Mt. Tamalpais Outdoor Theater,* 1966. Color offset lithograph poster, 20 1/8 x 14 1/4 in. (51.2 x 36.1 cm). HAIGHT STREET ART CENTER

STANLEY MOUSE and **ALTON KELLEY,** "Redskin," *Youngbloods, Sparrow, Sons of Champlin, December 16 & 17, Avalon Ballroom,* 1966 (PL. 207). Color offset lithograph poster, 20 x 13 7/8 in. (50.6 x 35.1 cm). Printed by the Bindweed Press; published by Family Dog (FD-39-OP-1). FINE ARTS MUSEUMS OF SAN FRANCISCO, MUSEUM PURCHASE, ACHENBACH FOUNDATION FOR GRAPHIC ARTS ENDOWMENT FUND, 1974.13.77

STANLEY MOUSE and **ALTON KELLEY,** "Skeleton and Roses," *Grateful Dead, Oxford Circle, September 16 & 17, Avalon Ballroom,* 1966 (FIG. 71). Color offset lithograph poster, 20 x 14 in. (50.8 x 35.5 cm). Printed by the Bindweed Press; published by Family Dog (FD-26-RP-3). FINE ARTS MUSEUMS OF SAN FRANCISCO, MUSEUM PURCHASE, ACHENBACH FOUNDATION FOR GRAPHIC ARTS ENDOWMENT FUND, 1974.13.100

STANLEY MOUSE and **ALTON KELLEY,** "Snake Lady," *Jefferson Airplane; Great Society, July 22 & 23, Avalon Ballroom,* 1966 (PL. 185). Color offset lithograph poster, 20 1/8 x 14 in. (50.9 x 35.6 cm). Published by Family Dog (FD-17-RP-4). FINE ARTS MUSEUMS OF SAN FRANCISCO, MUSEUM PURCHASE, ACHENBACH FOUNDATION FOR GRAPHIC ARTS ENDOWMENT FUND, 1974.13.45

STANLEY MOUSE and **ALTON KELLEY,** "The Woman with Green Hair," *Jim Kweskin Jug Band, Big Brother and the Holding Company, Electric Train, October 7 & 8, Avalon Ballroom,* 1966 (PL. 184). Color offset lithograph poster, 20 x 14 1/4 in. (50.6 x 36.1 cm). Printed by the Bindweed Press; published by Family Dog (FD-29-OP-1). FINE ARTS MUSEUMS OF SAN FRANCISCO, MUSEUM PURCHASE, ACHENBACH FOUNDATION FOR GRAPHIC ARTS ENDOWMENT FUND, 1974.13.94

STANLEY MOUSE and **ALTON KELLEY,** "Zebra Man," *13th Floor Elevators, Quicksilver Messenger Service, September 30–October 1, Avalon Ballroom,* 1966 (PL. 190). Color offset lithograph poster, 20 x 14 1/4 in. (50.7 x 36 cm). Printed by the Bindweed Press; published by Family Dog (FD-28-OP-1). FINE ARTS MUSEUMS OF SAN FRANCISCO, MUSEUM PURCHASE, ACHENBACH FOUNDATION FOR GRAPHIC ARTS ENDOWMENT FUND, 1974.13.102

STANLEY MOUSE and **ALTON KELLEY,** "Zig-Zag Man," *Big Brother & the Holding Company, Quicksilver Messenger Service, June 24 & 25, Avalon Ballroom,* 1966 (PL. 189). Color offset lithograph poster, 19 3/4 x 14 1/8 in. (50.1 x 35.9 cm). Printed by the Bindweed Press; published by Family Dog (FD-14-OP-1). FINE ARTS MUSEUMS OF SAN FRANCISCO, MUSEUM PURCHASE, ACHENBACH FOUNDATION FOR GRAPHIC ARTS ENDOWMENT FUND, 1974.13.50

STANLEY MOUSE and **ALTON KELLEY,** and **MICHAEL BOWEN** (1937–2009), "A Gathering of the Tribes for a Human Be-In," *Allen Ginsberg, Timothy Leary, Richard Alpert, Michael McClure, Jerry Ruben, Dick Gregory, Gary Snyder, Jack Weinburg, Lenore Kandel, All S.F. Rock Groups, January 14, Polo Field, Golden Gate Park,* 1967 (PL. 37). Color offset lithograph poster, 19 7/8 x 14 1/4 in. (50.5 x 36.1 cm). Printed by the Bindweed Press. COLLECTION OF JOHN J. LYONS

NORMAN ORR (b. 1949), *Cold Blood, Boz Scaggs, Voices of East Harlem, Elvin Bishop, Stoneground, December 31–January 3, Fillmore West,* 1970 (PL. 257). Color offset lithograph poster, 20 7/8 x 13 7/8 in. (53.1 x 35.2 cm). Printed by Tea Lautrec Litho; published by Bill Graham (BG-264-OP-1). FINE ARTS MUSEUMS OF SAN FRANCISCO, MUSEUM PURCHASE, ACHENBACH FOUNDATION FOR GRAPHIC ARTS ENDOWMENT FUND, 1972.53.167

NORMAN ORR, *Incredible String Band, December 14, Ravi Shankar, December 16, Butterfield Blues Band, Buddy Miles, Quatermass, December 17–20, Fillmore West,* 1970 (PL. 260). Color offset lithograph poster, 21 x 14 in. (53.4 x 35.5 cm). Printed by Tea Lautrec Litho; published by Bill Graham (BG-261-OP-1). FINE ARTS MUSEUMS OF SAN FRANCISCO, MUSEUM PURCHASE, ACHENBACH FOUNDATION FOR GRAPHIC ARTS ENDOWMENT FUND, 1972.53.169

LOREN REHBOCK (b. 1941), *Mnasidika, 1510 Haight,* 1967 (PL. 90). Color offset lithograph poster, 20 x 14 in. (50.8 x 35.6 cm). FINE ARTS MUSEUMS OF SAN FRANCISCO, GIFT OF THE GARY WESTFORD COLLECTION, IN MEMORY OF JANIS JOPLIN, 2016.32.3

RANDY SALAS (ACTIVE 20TH CENTURY), "The Equinox of the Gods," *The Magick Powerhouse of Oz, Kenneth Anger, The Congress of Wonders, The Charlatans, The Mime Troupe, The Duncan Company, The Straight Dancers, September 21, Straight Theater,* 1967 (PL. 82). Color offset lithograph poster, 28 5/8 x 20 7/8 in. (72.7 x 52.9 cm). FINE ARTS MUSEUMS OF SAN FRANCISCO, GIFT OF THE GARY WESTFORD COLLECTION, IN MEMORY OF THE STRAIGHT THEATER, 2017.7.33

WILFRIED SÄTTY (1939–1982), *Stone Garden,* 1967 (PL. 154). Color offset lithograph poster, 34 x 23 in. (86.4 x 58.4 cm). Published by East Totem West. FINE ARTS MUSEUMS OF SAN FRANCISCO, BEQUEST OF JOHN GUTMANN, 2000.119.4.9

WILFRIED SÄTTY, *Turn on Your Mind (Jerry Garcia Wearing Flag Top Hat),* ca. 1967 (PL. 155). Color offset lithograph poster, 32 3/4 x 21 3/4 in. (83.2 x 55.3 cm). Published by East Totem West. FINE ARTS MUSEUMS OF SAN FRANCISCO, GIFT OF WALTER AND JOSEPHINE LANDOR, 2001.97.29A

WILFRIED SÄTTY, *Untitled (James Gurley),* ca. 1967 (PL. 203). Color offset lithograph poster, 30 1/8 x 21 in. (76.4 x 53.3 cm). FINE ARTS MUSEUMS OF SAN FRANCISCO, GIFT OF WALTER AND JOSEPHINE LANDOR, 2001.97.30

BOB SCHNEPF (b. 1937), "Sitting Pretty," *Blue Cheer, Country Joe & the Fish, Lee Michaels, Flamin' Groovies, Mad River, Mount Rushmore, December 31, Avalon Ballroom,* 1967. Color offset lithograph poster, 11 x 28 in. (28 x 71 cm). Published by Family Dog (FD-99-OP-1). FINE ARTS MUSEUMS OF SAN FRANCISCO, MUSEUM PURCHASE, ACHENBACH FOUNDATION FOR GRAPHIC ARTS ENDOWMENT FUND, 1974.13.200

BOB SCHNEPF, *Summer of Love/City of San Francisco,* 1967 (PL. 47). Color offset lithograph poster, 20 1/2 x 14 1/8 in. (52 x 35.7 cm). Printed by Berkeley Bonaparte. FINE ARTS MUSEUMS OF SAN FRANCISCO, GIFT OF THE GARY WESTFORD COLLECTION, IN HONOR OF BOB (RAF) SCHNEPF, 2017.7.11

BOB SCHNEPF, "Tree Frog," *Jim Kweskin Jug Band, Country Joe and the Fish, Lee Michaels, Blue Cheer, December 28, 29, 30, Avalon Ballroom,* 1967 (PL. 148). Color offset lithograph poster, 26 5/8 x 10 1/4 in. (67.7 x 26 cm). Published by Family Dog (FD-98-OP-1). FINE ARTS MUSEUMS OF SAN FRANCISCO, MUSEUM PURCHASE, ACHENBACH FOUNDATION FOR GRAPHIC ARTS ENDOWMENT FUND, 1974.13.201

EDMUND SHEA (1942–2004), *Better Living Thru Chemistry*, 1967 (PL. 176). Offset lithograph poster, 28 1/4 x 22 1/8 in. (71.9 x 56.1 cm). Published by American Newsrepeat Company. COLLECTION OF JOHN J. LYONS

RICK SHUBB (b. 1945), *Thelonious Monk, Dr. John the Night Tripper, The Charlatans, May 3–5, Carousel Ballroom*, 1968 (PL. 241). Color offset lithograph poster, 14 1/8 x 11 in. (35.7 x 28 cm). FINE ARTS MUSEUMS OF SAN FRANCISCO, GIFT OF THE GARY WESTFORD COLLECTION, 2017.7.3

DAVID SINGER (b. 1941), *Bill Graham Presents in San Francisco: The Rolling Stones, June 6 & 8, Winterland*, 1972. Color offset lithograph poster, 27 7/8 x 22 in. (70.8 x 55.9 cm). Published by Bill Graham (BG-289). FINE ARTS MUSEUMS OF SAN FRANCISCO, GIFT OF MARTIN AND PIRJO BOVILL, 2002.179

DAVID SINGER, *Boz Scaggs, Cold Blood, Flamin' Groovies, Stoneground, June 30, It's a Beautiful Day, Elvin Bishop Group, Grootna, Lamb, July 1, Grateful Dead, New Riders of the Purple Sage, Rowan Brothers, July 2, Quicksilver Messenger Service, Hot Tuna, Yogi Phlegm, July 3, Santana, Creedence Clearwater Revival, Tower of Power, San Francisco Music Jam, July 4, Fillmore West*, 1971 (PL. 261). Color offset lithograph poster, 21 7/8 x 27 7/8 in. (55.5 x 70.7 cm). Printed by Tea Lautrec Litho; published by Bill Graham (BG-287-OP-1). FINE ARTS MUSEUMS OF SAN FRANCISCO, MUSEUM PURCHASE, ACHENBACH FOUNDATION FOR GRAPHIC ARTS ENDOWMENT FUND, 1972.53.22

DAVID SINGER, *Quicksilver Messenger Service, Mott the Hoople, Silver Metre, July 9–12, Fillmore West*, 1970 (PL. 210). Color offset lithograph poster, 21 x 14 in. (53.4 x 35.5 cm). Printed by Tea Lautrec Litho; published by Bill Graham (BG-242-OP-1). FINE ARTS MUSEUMS OF SAN FRANCISCO, MUSEUM PURCHASE, ACHENBACH FOUNDATION FOR GRAPHIC ARTS ENDOWMENT FUND, 1972.53.183

SOOT PRODUCTIONS (ACTIVE 20TH CENTURY), *"A Tribute to J. Edgar Hoover," The Jook Savages, Blue Cheer, The Congress of Wonders, The Mojo Men, February 10, California Hall*, 1967 (PL. 245). Color offset lithograph poster, 20 x 14 1/4 in. (50.7 x 36.2 cm). Printed by the Bindweed Press. FINE ARTS MUSEUMS OF SAN FRANCISCO, GIFT OF THE GARY WESTFORD COLLECTION, 2017.7.19

SP/4 VIETNAM (ACTIVE 20TH CENTURY), *Cry Freedom*, 1967 (PL. 319). Color offset lithograph poster, 35 x 23 1/8 in. (88.9 x 58.7 cm). Published by East Totem West. COLLECTION OF JOHN J. LYONS

SPRING MOBILIZATION COMMITTEE with **KENNETH PATCHEN** (1911–1972), *"Joyful Alternative Peace Poets Dance," Country Joe and the Fish, Richard Brautigan, and more, April 13, California Hall*, 1967 (PL. 46). Stencil duplicate print (mimeograph) handbill printed in red and black ink on green-brown paper, 11 x 8 1/2 in. (27.9 x 21.6 cm). COLLECTION OF JOHN J. LYONS

LARRY STARK (b. 1940), *"Rorschach Test II," Frumius Bandersnatch [sic], Clear Light, Buddy Guy, June 14–16, Avalon Ballroom*, 1968 (PL. 215). Offset lithograph poster, 22 x 14 in. (55.8 x 35.4 cm). Published by Family Dog (FD-123-OP-1). FINE ARTS MUSEUMS OF SAN FRANCISCO, MUSEUM PURCHASE, ACHENBACH FOUNDATION FOR GRAPHIC ARTS ENDOWMENT FUND, 1974.13.139

MARI TEPPER (b. 1948), *Hallelujah the Pill!!*, 1967 (PL. 313). Color offset lithograph poster, 22 x 22 in. (55.9 x 55.9 cm). COLLECTION OF RON AND JASMINE SCHAEFFER, THE ROCK POSTER SOCIETY

RANDY TUTEN (b. 1946), *Grateful Dead, Junior Walker & the All Stars, Glass Family, June 5–8, Fillmore West*, 1969. Color offset lithograph poster, 21 x 14 in. (53.4 x 35.5 cm). Printed by Tea Lautrec Litho; published by Bill Graham (BG-176-OP-1). FINE ARTS MUSEUMS OF SAN FRANCISCO, MUSEUM PURCHASE, ACHENBACH FOUNDATION FOR GRAPHIC ARTS ENDOWMENT FUND, 1972.53.242

RANDY TUTEN, *Led Zeppelin, Bonzo Dog Band, Rahsaan Roland Kirk & His Vibration Society, November 6–8, Winterland, Rolling Stones, November 9, Oakland Coliseum*, 1969 (PL. 152). Color offset lithograph poster, 21 1/2 x 13 3/4 in. (54.4 x 34.9 cm). Printed by Tea Lautrec Litho; published by Bill Graham (BG-199-OP-1). FINE ARTS MUSEUMS OF SAN FRANCISCO, MUSEUM PURCHASE, ACHENBACH FOUNDATION FOR GRAPHIC ARTS ENDOWMENT FUND, 1972.53.219

RANDY TUTEN and **D. BREAD (WILLIAM BOSTEDT)**, aka **"DADDY BREAD"** (1945–1998), *Country Joe & the Fish, Led Zeppelin, Taj Mahal, January 9–11, Fillmore West*, 1969 (PL. 254). Color offset lithograph poster, 21 1/2 x 14 in. (54.6 x 35.6 cm). Printed by Tea Lautrec Litho; published by Bill Graham (BG-155-OP-1). FINE ARTS MUSEUMS OF SAN FRANCISCO, MUSEUM PURCHASE, ACHENBACH FOUNDATION FOR GRAPHIC ARTS ENDOWMENT FUND, 1972.53.263

DAVID WARREN (1940–1998), *"Alice Jaundice," Youngbloods, It's a Beautiful Day, Dog, Santana, June 28–30, Avalon Ballroom*, 1968 (PL. 187). Color offset lithograph poster, 20 x 14 in. (50.6 x 35.6 cm). Published by Family Dog (FD-125-OP-1). FINE ARTS MUSEUMS OF SAN FRANCISCO, MUSEUM PURCHASE, ACHENBACH FOUNDATION FOR GRAPHIC ARTS ENDOWMENT FUND, 1974.13.136

WILFRED WEISSER (GERMAN, ACTIVE 20TH CENTURY), *Country Joe & the Fish, Incredible String Band, Albert Collins, May 16–18, Fillmore Auditorium*, 1968 (PL. 180). Color offset lithograph poster, 21 1/8 x 13 7/8 in. (53.5 x 35.3 cm). Published by Bill Graham (BG 120-OP-1). FINE ARTS MUSEUMS OF SAN FRANCISCO, MUSEUM PURCHASE, ACHENBACH FOUNDATION FOR GRAPHIC ARTS ENDOWMENT FUND, 1972.53.136

TOM WILKES (1939–2009), *Monterey International Pop Festival, June 16, 17, 18*, 1967 (PL. 250). Color offset lithograph poster on metallic foil paper, 21 3/8 x 12 1/4 in. (54.3 x 31.1 cm). COLLECTION OF RON AND JASMINE SCHAEFFER, THE ROCK POSTER SOCIETY

WES WILSON (b. 1937), *Andy Warhol and His Plastic Inevitable, The Velvet Underground, Nico, The Mothers, May 27–29, Fillmore Auditorium*, 1966 (PL. 239). Color offset lithograph poster, 20 x 13 3/4 in. (50.8 x 35 cm). Printed by West Coast Lithograph Company; published by Bill Graham (BG-8-RP-2). FINE ARTS MUSEUMS OF SAN FRANCISCO, MUSEUM PURCHASE, ACHENBACH FOUNDATION FOR GRAPHIC ARTS ENDOWMENT FUND, 1972.53.36

WES WILSON, *Are We Next?*, 1965 (PL. 19). Color offset lithograph poster, 21 x 11 3/8 in. (53.4 x 28.8 cm). Printed by West Coast Lithography Company. FINE ARTS MUSEUMS OF SAN FRANCISCO, GIFT OF THE GARY WESTFORD COLLECTION, IN HONOR OF WES WILSON AND THE TRUTH, 2017.7.35

WES WILSON, *Association, Quicksilver Messenger Service, Grass Roots, Sopwith Camel, July 22 & 23, Fillmore Auditorium*, 1966 (PL. 179). Color offset lithograph poster, 20 x 14 in. (50.7 x 35.4 cm). Published by Bill Graham (BG-18-OP-1A). FINE ARTS MUSEUMS OF SAN FRANCISCO, GIFT FROM THE ESTATE OF FRED A. COUNTRYMAN, 2005.3.13

WES WILSON, *Butterfield Blues Band, Charles Lloyd Quartet, January 27–29, Fillmore Auditorium*, 1967 (PL. 242). Color offset lithograph poster, 22 7/8 x 14 1/2 in. (58.1 x 36.6 cm). Printed by West Coast Lithograph Company; published by Bill Graham (BG-47-OP-1). FINE ARTS MUSEUMS OF SAN FRANCISCO, MUSEUM PURCHASE, ACHENBACH FOUNDATION FOR GRAPHIC ARTS ENDOWMENT FUND, 1972.53.71

WES WILSON, *Butterfield Blues Band, Jefferson Airplane, Grateful Dead, October 7 & 8, Winterland*, 1966 (PL. 170). Color offset lithograph poster, 24 3/8 x 11 7/8 in. (61.8 x 30.1 cm). Printed by West Coast Lithograph Company; published by Bill Graham (BG-30-RP-2). FINE ARTS MUSEUMS OF SAN FRANCISCO, MUSEUM PURCHASE, ACHENBACH FOUNDATION FOR GRAPHIC ARTS ENDOWMENT FUND, 1972.53.54

WES WILSON, *Byrds, Moby Grape, Andrew Staples, March 31 & April 1, Winterland, April 2, Fillmore Auditorium*, 1967 (PL. 183). Color offset lithograph poster, 22 1/8 x 13 3/4 in. (56.2 x 35 cm). Printed by West Coast Lithograph Company; published by Bill Graham (BG-57-OP-1). FINE ARTS MUSEUMS OF SAN FRANCISCO, GIFT OF HAROLD AND EVELYN KORF, 1996.100.31

WES WILSON, *"Can You Pass the Acid Test?": The Merry Pranksters And Their Psychedelic Symphony, Neil Cassady Vs. Ann Murphy Vaudeville, The Grateful Dead Rock 'n' Roll, Roy's Audioptics, Movies, Ron Boise And His Electric Thunder Sculpture, The Bus, Ecstatic Dress, Many Noted Outlaws, And The Unexpectable*, ca. 1966 (PL. 29). Offset lithograph handbill printed in blue ink on pink paper, 11 x 8 1/2 in. (28 x 21.6 cm). CENTER FOR COUNTERCULTURE STUDIES

WES WILSON, *Captain Beefheart, Chocolate Watchband, Great Pumpkin, October 28–30, Fillmore Auditorium*, 1966 (PL. 15). Color offset lithograph poster, 19 1/4 x 13 3/4 in. (48.7 x 34.8 cm). Printed by West Coast Lithograph Company; published by Bill Graham (BG-34-OP-1). FINE ARTS MUSEUMS OF SAN FRANCISCO, GIFT OF MR. JULIAN SILVA, 1997.64.6

WES WILSON, *"Euphoria," The Daily Flash, The Rising Sons, Big Brother & the Holding Company, The Charlatans, May 6 & 7, Avalon Ballroom*, 1966 (PL. 216). Color offset lithograph poster, 20 1/2 x 14 in. (52 x 35.4 cm). Published by Family Dog (FD-7-RP-4). FINE ARTS MUSEUMS OF SAN FRANCISCO, MUSEUM PURCHASE, ACHENBACH FOUNDATION FOR GRAPHIC ARTS ENDOWMENT FUND, 1974.13.61

WES WILSON, *Grateful Dead, Junior Wells Chicago Blues Band, The Doors, January 13–15, Fillmore Auditorium*, 1967 (PL. 246). Color offset lithograph poster, 21 7/8 x 14 in. (55.5 x 35.5 cm). Published by Bill Graham (BG-45-RP-3). FINE ARTS MUSEUMS OF SAN FRANCISCO, MUSEUM PURCHASE, ACHENBACH FOUNDATION FOR GRAPHIC ARTS ENDOWMENT FUND, 1972.53.69

WES WILSON, *Jefferson Airplane, Great Society, Heavenly Blues Band, June 10 & 11, Fillmore Auditorium*, 1966 (PL. 234). Color offset lithograph poster, 20 x 14 in. (50.8 x 35.6 cm). FINE ARTS MUSEUMS OF SAN FRANCISCO, MUSEUM PURCHASE, ACHENBACH FOUNDATION FOR GRAPHIC ARTS ENDOWMENT FUND, 1972.53.38

WES WILSON, *Jefferson Airplane, James Cotton Chicago Blues Band, Moby Grape, November 25–27, Fillmore Auditorium*, 1966 (PL. 144). Color offset lithograph poster with split fountain, 22 3/8 x 13 1/2 in. (56.6 x 34.2 cm). Printed by West Coast Lithograph Company; published by Bill Graham (BG-39-OP-1). FINE ARTS MUSEUMS OF SAN FRANCISCO, GIFT OF MR. JULIAN SILVA, 1997.64.8

WES WILSON, *Lenny Bruce, The Mothers, June 24 & 25, Fillmore Auditorium*, 1966 (PL. 235). Color offset lithograph poster, 20 1/8 x 14 1/8 in. (51.1 x 35.8 cm). Published by Bill Graham (BG-13-RP-2). FINE ARTS MUSEUMS OF SAN FRANCISCO, MUSEUM PURCHASE, ACHENBACH FOUNDATION FOR GRAPHIC ARTS ENDOWMENT FUND, 1972.53.41

WES WILSON, *Mystery Trend, Big Brother & the Holding Company, Quicksilver Messenger Service, March 18–20, Fillmore Auditorium*, 1966 (PL. 232). Offset lithograph poster on yellow paper, 20 x 14 in. (50.8 x 35.6 cm). Published by Bill Graham (BG-2-RP-3). FINE ARTS MUSEUMS OF SAN FRANCISCO, MUSEUM PURCHASE, ACHENBACH FOUNDATION FOR GRAPHIC ARTS ENDOWMENT FUND, 1972.53.29

WES WILSON, *"Ohm," Van Morrison, Daily Flash, Hair, October 20–22, Avalon Ballroom*, 1967 (FIG. 76). Color offset lithograph poster, 20 1/8 x 14 1/4 in. (51 x 36.2 cm). Published by Family Dog (FD-88-OP-1). FINE ARTS MUSEUMS OF SAN FRANCISCO, MUSEUM PURCHASE, ACHENBACH FOUNDATION FOR GRAPHIC ARTS ENDOWMENT FUND, 1974.13.172

WES WILSON, *Otis Redding & His Orchestra, Grateful Dead, Johnny Talbot & de Thangs, Country Joe & the Fish, December 20–22, Fillmore Auditorium*, 1966. Color offset lithograph poster, 22 5/8 x 14 in. (57.3 x 35.5 cm). Printed by West Coast Lithograph Company; published by Bill Graham (BG-43-OP-1). FINE ARTS MUSEUMS OF SAN FRANCISCO, MUSEUM PURCHASE, ACHENBACH FOUNDATION FOR GRAPHIC ARTS ENDOWMENT FUND, 1972.53.58

WES WILSON, *Otis Rush & His Chicago Blues Band, Grateful Dead, The Canned Heat Blues Band, February 24–26, Fillmore Auditorium*, 1967 (PL. 175). Color offset lithograph poster, 22 x 13 3/4 in. (55.9 x 34.7 cm). Printed by West Coast Lithograph Company; published by Bill Graham (BG-51-RP-2). FINE ARTS MUSEUMS OF SAN FRANCISCO, MUSEUM PURCHASE, ACHENBACH FOUNDATION FOR GRAPHIC ARTS ENDOWMENT FUND, 1972.53.75

WES WILSON, "The Quick and the Dead," The Grateful Dead, The Quicksilver Messenger Service, The New Tweedy Brothers, June 10 & 11, Avalon Ballroom, 1966 (PL. 233). Offset lithograph poster, 20 1/8 x 14 3/8 in. (50.9 x 36.3 cm). Published by Family Dog (FD-12-OP-1). FINE ARTS MUSEUMS OF SAN FRANCISCO, MUSEUM PURCHASE, ACHENBACH FOUNDATION FOR GRAPHIC ARTS ENDOWMENT FUND, 1974.13.57

WES WILSON, "Rorschach Test," Blues Project, It's a Beautiful Day, Nazz-Are Blues Band, April 5–7, Avalon Ballroom, 1968 (PL. 217). Color offset lithograph poster, 20 5/8 x 13 3/4 in. (52.2 x 35 cm). Published by Family Dog (FD-113-OP-1). FINE ARTS MUSEUMS OF SAN FRANCISCO, MUSEUM PURCHASE, ACHENBACH FOUNDATION FOR GRAPHIC ARTS ENDOWMENT FUND, 1974.13.148

WES WILSON, "The Sound," Jefferson Airplane, Butterfield Blues Band, Muddy Waters, September 23, 24, 30, & October 1, Winterland, September 25 & October 2, Fillmore Auditorium, 1966. Color offset lithograph poster, 24 1/2 x 13 1/2 in. (62.2 x 34.2 cm). Published by Bill Graham (BG-29). FINE ARTS MUSEUMS OF SAN FRANCISCO, MUSEUM PURCHASE, ACHENBACH FOUNDATION FOR GRAPHIC ARTS ENDOWMENT FUND, 1972.53.53

WES WILSON, Them, Sons of Champlin, July 29 & 30, Fillmore Auditorium, 1966 (FIG. 82). Color offset lithograph poster, 20 1/2 x 13 3/4 in. (52 x 35.1 cm). Printed by West Coast Lithograph Company; published by Bill Graham (BG-20-RP-2). FINE ARTS MUSEUMS OF SAN FRANCISCO, GIFT OF HAROLD AND EVELYN KORF, 1996.100.38

WES WILSON, "A Tribal Stomp," Jefferson Airplane, Big Brother and the Holding Company, February 19, Fillmore Auditorium, 1966 (PL. 13). Offset lithograph poster, 20 3/8 x 14 1/4 in. (51.8 x 36 cm). Published by Family Dog (FD-1-RP-2). FINE ARTS MUSEUMS OF SAN FRANCISCO, MUSEUM PURCHASE, ACHENBACH FOUNDATION FOR GRAPHIC ARTS ENDOWMENT FUND, 1974.13.196

WES WILSON, front and back of the program for "Trips Festival," Ken Kesey, Merry Pranksters, Allen Ginsberg, Stewart Brand, Grateful Dead, Big Brother & the Holding Company, and many, many others, January 21–23, Longshoremen's Hall, 1966 (PL. 23). Offset lithograph handbill, 9 1/2 x 6 1/2 in. (24 x 16.5 cm). Printed by Contact Printing Co. COLLECTION OF JOHN J. LYONS (FRONT) AND FINE ARTS MUSEUMS OF SAN FRANCISCO, GIFT OF THE GARY WESTFORD COLLECTION IN MEMORY OF KEN KESEY, 2017.7.43 (BACK)

WES WILSON, The Turtles, Oxford Circle, July 6, Fillmore Auditorium, 1966 (PL. 150). Color offset lithograph poster, 19 7/8 x 14 in. (50.4 x 35.4 cm). Printed by West Coast Lithograph Company; published by Bill Graham (BG-15-RP-2). FINE ARTS MUSEUMS OF SAN FRANCISCO, MUSEUM PURCHASE, ACHENBACH FOUNDATION FOR GRAPHIC ARTS ENDOWMENT FUND, 1972.53.43

Aid to Vietnam & Mississippi Sunflower—Phoenix Dance Benefit, Country Joe and the Fish, Big Brother & the Holding Company, Steve Miller Blues Band, Quicksilver Messenger Service, 1967 (PL. 309). Stencil duplicate print (mimeograph) handbill, 11 x 8 1/2 in. (27.9 x 21.6 cm). COLLECTION OF JOHN J. LYONS

Death of the Hippie, 1967 (PL. 135). Stencil duplicate print (mimeograph) handbill on tan paper, 8 1/2 x 11 in. (21.6 x 27.9 cm). COLLECTION OF JOHN J. LYONS

Help The Oracle Needs You Today for the Loving Insertion, ca. 1967 (PL. 106). Porous-point pen over graphite on yellow paper, 21 7/8 x 14 in. (55.7 x 35.4 cm). COLLECTION OF JOHN J. LYONS

Hugh Masekela, January 31–February 12, Letta Mbulu, February 14–26, Both/And Jazz Club, ca. 1967 (PL. 247). Color offset lithograph poster, 22 5/8 x 14 3/8 in. (57.4 x 36.4 cm). FINE ARTS MUSEUMS OF SAN FRANCISCO, GIFT OF THE GARY WESTFORD COLLECTION, IN HONOR OF THE BOTH/AND CLUB, 2017.7.16

Kiss In, April 7, Hall of Justice Steps, 1967 (PL. 315). Color screenprint, 18 5/8 x 10 1/8 in. (47.3 x 25.8 cm). COLLECTION OF JOHN J. LYONS

Krishna Consciousness Comes West: Swami Bhaktivedanta, Allen Ginsberg, The Grateful Dead, Moby Grape, Big Brother & The Holding Company Mantra Rock Dance, January 29, Avalon Ballroom, 1967 (PL. 16). Color offset lithograph handbill, 11 x 8 1/2 in. (27.9 x 21.6 cm). COLLECTION OF JOHN J. LYONS

Magic at the Edge of the Western World, Taj Mahal, Mike Bloomfield and Nick Gravenites with Southern Comfort, Brotherhood Lights, August 15, Devil's Kitchen, August 16 and 17, Family Dog on the Great Highway, 1969 (PL. 173). Color offset lithograph poster, 22 5/8 x 13 7/8 in. (57.4 x 35.2 cm). Printed by Jellyroll Press; published by Family Dog (FD-690815). FINE ARTS MUSEUMS OF SAN FRANCISCO, GIFT OF THE GARY WESTFORD COLLECTION, IN MEMORY OF CHET HELMS, 2017.7.15

A Musical Concert for the Benefit and Welfare of The Widow and Children of Dr. Martin Luther King Jr., April 27, Fillmore Auditorium, 1968 (PL. 334). Offset lithograph poster, 20 x 14 in. (50.7 x 35.4 cm). COLLECTION OF JOHN J. LYONS

Pow-Wow: A Gathering of the Tribes for a Human Be-In, January 14, Polo Grounds, Golden Gate Park, 1967 (PL. 36). Electrophotographic print (Xerox) handbill printed on yellow paper, 11 3/8 x 8 1/2 in. (28.9 x 21.7 cm). CENTER FOR COUNTERCULTURE STUDIES

Preview Opening of the Psychedelic Shop, 1967. Pen and black ink and brush and green opaque watercolor on postcard, 4 x 6 3/4 in. (10.2 x 17 cm). COLLECTION OF JOHN J. LYONS

The Print Mint Opening, December 1, 1542 Haight, 1966 (PL. 103). Color offset lithograph poster, 20 3/8 x 15 5/8 in. (51.8 x 39.5 cm). FINE ARTS MUSEUMS OF SAN FRANCISCO, GIFT OF THE GARY WESTFORD COLLECTION, 2017.7.37

Spring Mobilization March to End the War in Vietnam, April 15, Montgomery and Market to Kezar Stadium, 1967 (PL. 43). Screenprint, 14 x 10 7/8 in. (35.5 x 27.7 cm). COLLECTION OF JOHN J. LYONS

Stop the Draft Week Defense Fund dance concert, Phil Ochs, Loading Zone, Blue Cheer, Mad River, Mt. Rushmore, The Committee, Light Show, January 7, Fillmore, 1968 (PL. 316). Red and blue stencil duplicate print (mimeograph) handbill, 11 x 8 1/2 in. (27.9 x 21.6 cm). Printed for Campus SDS (Students for a Democratic Society). COLLECTION OF JOHN J. LYONS

TRIPS?, The Grateful Dead, The Loading Zone, Celebrity Drop In's, Trips Regulars, April 22–24, Longshoremen's Hall, 1966 (PL. 34). Offset lithograph handbill printed in blue ink, 8 5/8 x 5 1/2 in. (21.8 x 13.9 cm). Printed by Tilghman Press. CENTER FOR COUNTERCULTURE STUDIES

The We Five, September 25, ca. 1965 (PL. 225). Color offset lithograph poster, 18 5/8 x 13 1/4 in. (47.3 x 33.7 cm). FINE ARTS MUSEUMS OF SAN FRANCISCO, GIFT OF THE GARY WESTFORD COLLECTION, IN HONOR OF THE WE FIVE, 2017.7.48

PROCESS MATERIALS

ROBERT FRIED (1937–1975), color sketch for "The Sorcerer," Steppenwolf, Charlie Musselwhite, 4th Way, Indian Head Band, April 19–21, Avalon Ballroom, 1968, showing the instructions for the stripper and printer to make the poster (FIG. 67). Porous-point pen and black ink on paper, 24 x 15 1/8 in. (60.9 x 38.4 cm). CENTER FOR COUNTERCULTURE STUDIES

RICK GRIFFIN (1944–1991), "Eternal Reservoir" (or "The Source"), Quicksilver Messenger Service, Kaleidoscope, Charley Musselwhite, January 12–14, Avalon Ballroom, 1968. Uncut color offset lithograph proof with posters and handbills, 22 1/2 x 28 1/2 in. (57.1 x 72.3 cm). COLLECTION OF JOHN J. LYONS

RICK GRIFFIN, film flat for preparation of printing plates for "Motherload," Big Brother and the Holding Company, Sir Douglas Quintet Orkustra, May 5–7, Avalon Ballroom, 1967. Acetate film and goldenrod paper, 25 x 19 in. (63.5 x 48.2 cm). HAIGHT STREET ART CENTER

WILLIAM HENRY (ACTIVE 20TH CENTURY), blueline mechanical for preparation of cyan and brown printing plates for "2.45765," Junior Wells, Sons of Champlin, Santana, May 17–19, Avalon Ballroom, 1968. Two blueline prints with brush and black ink on illustration board, 20 1/8 x 15 in. (51.1 x 38.1 cm) each. COLLECTION OF JOHN J. LYONS

VICTOR MOSCOSO (b. 1936), three master acetate film negatives for preparation of cyan, magenta, and green printing plates for "Avalon Ballroom," Quicksilver Messenger Service, Mount Rushmore, Big Brother & the Holding Company, Horns of Plenty, June 29–July 2, Avalon Ballroom, 1967. Three acetate films, 23 x 16 in. (58.4 x 40.6 cm) each. HAIGHT STREET ART CENTER

STANLEY MOUSE (b. 1940) and **ALTON KELLEY** (1940–2008), mechanical for preparation of printing plate for Appeals IV Mime Troupe Benefit "Busted," Jefferson Airplane, Grateful Dead, Quicksilver Messenger Service, Moby Grape, Andrew Staples, Loading Zone, May 12, Fillmore Auditorium, 1967. Black ink, black porous point pen, offset lithograph cutouts, and white opaque paint with traces of graphite on illustration board, 15 x 19 7/8 in. (38 x 50.6 cm). COLLECTION OF JOHN J. LYONS

STANLEY MOUSE and **ALTON KELLEY,** acetate overlay mechanical for preparation of black, red, and blue printing plates for "Howlin' Wolf," Howlin' Wolf, Big Brother and the Holding Company, September 23 & 24, Avalon Ballroom, 1966. Pen and brush and black ink over graphite, with white opaque paint, and photostat on illustration board with two acetate overlays with brush and black ink, 20 x 15 in. (50.8 x 38.1 cm) each. HAIGHT STREET ART CENTER

STANLEY MOUSE and **ALTON KELLEY,** mechanical for the preparation of printing plate for "Skeleton and Roses," 1966, (FIG. 70). Pen and brush and black ink over graphite, with white opaque paint, and photostat with offset lithograph tracing paper insignias on illustration board, 20 x 15 in. (50.8 x 38.1 cm). HAIGHT STREET ART CENTER

SAN ANDREAS FAULT (TAD HUNTER) (ACTIVE 20TH CENTURY), mechanical for the preparation of printing plate for Spring Medicine Show: A Benefit for the Haight-Ashbury Free Medical Clinic, Crystal Syphon, All Men Joy, Phoenix, Country Weather Band, Indian Head Band, Linn County Band, Mint Tattoo, Santana Blues Band, Initial Shock, A. B. Skhy, It's a Beautiful Day, Loading Zone, May 28 and 29, Avalon Ballroom, 1968 (PL. 125). Black ink with white opaque paint and blue and red ink notations on illustration board, 23 1/8 x 14 in. (58.6 x 35.4 cm). COLLECTION OF JOHN J. LYONS

WES WILSON (b. 1937), Key-line mechanical for the preparation of red, green, and purple printing plates for "Ohm," Van Morrison, Daily Flash, Hair, October 20–22, Avalon Ballroom, 1967 (FIGS. 73–74). Pen and brush and black ink over graphite on illustration board with tracing paper overlay with pen and black ink and colored pencil demarcating printing colors, and attached color chips, 20 x 15 1/8 in. (50.8 x 38.4 cm). HAIGHT STREET ART CENTER

WES WILSON, printing plate for Them, Sons of Champlin, July 29 & 30, Fillmore Auditorium, 1966, used to print the blue ink for posters and handbills (FIG. 83). Aluminum printing plate, 25 1/2 x 24 in. (64.7 x 60.9 cm). CENTER FOR COUNTERCULTURE STUDIES

TEXTILES

BIRGITTA BJERKE (100% BIRGITTA) (SWEDISH, b. 1940), Pioneer, ca. 1972–1973 (PL. 222). Crocheted wool, 105 x 128 in. (266.7 x 325.1 cm). Commissioned by Frankie Azzara. COLLECTION OF THE ARTIST

MARIAN CLAYDEN (AMERICAN, b. ENGLAND, 1937–2015), Ceremonial Enclosure, ca. 1968 (PL. 1). Silk; stitch-resist and discharge dyeing, 94 x 178 in. (238.8 x 452.1 cm). COLLECTION OF THE CLAYDEN FAMILY

MARIAN CLAYDEN, Untitled, ca. 1968 (PL. 213). Cotton; stitch-resist and discharge dyeing, 74 1/2 x 52 in. (189.2 x 132.1 cm). COLLECTION OF THE CLAYDEN FAMILY

MARIAN CLAYDEN, Untitled, ca. 1968 (PL. 214). Silk; stitch-resist and discharge dyeing, 78 1/2 x 45 in. (199.4 x 114.3 cm). COLLECTION OF THE CLAYDEN FAMILY

COURTENAY POLLOCK (BRITISH, b. 1946), Pastel Stellar Blue Mandala, ca. 1972 (PL. 292). Cotton; resist-dyed (fold-resist), 102 x 92 in. (259 x 234 cm). Displayed in the Grateful Dead's San Rafael office. COLLECTION OF THE ARTIST

index

NOTE TO READER: Page numbers in *italics* indicate illustrations.

A

Acid Tests, 25, 34, 50n21, 82, 107, *112*, *113*, *114*, 320, 321; Acid Test Graduation, *54–55*, *115*, 322
Actor's Workshop, 21, *21*, 23–24, 321
Adams, Jon, 237
Albers, Josef, 36, 38, *309*, 310
Albright, Thomas, 31, 32, 38, 41–42, 43, 61
album covers, 43, 77n48, *113*, *262*, *263*
Ali, Muhammad, 42, 322
Alioto, Joseph, 323, 324
Alpert, Richard, 69, 117, *118*
Andersen, Ray, *234*
Anthony, Gene, 47, 50n13; *Calm Center, Haight-Ashbury Free Clinic*, *159*; *Large Crowd at the Human Be-In*, *119*; *Man being lifted up. Trips Festival*, *109*; *Soundboard mixer Ken Babbs and crowd. Trips Festival*, *109*; *Timothy Leary on stage at Human Be-In*, *119*; *Wide-angle view of stage and crowd. Trips Festival*, *109*; *Woman Holding Peace Sign at Human Be-In*, *119*
Avalon Ballroom, 27, 33, 34, 38, 44, *44*, 63, 81, 83, 84, 85, 91, 231, 312n3, 313n61, 318, 319, 321, 323; handbills/posters for, 33, 35, *37*, 38, 40–41, 44, *102*, *103*, *160*, *175*, *176*, *177*, *178*, *179*, *182*, *184*, *187*, *188*, *190*, *191*, *195*, *199*, *200*, *211*, *219*, *236*, *247*, *279*, *297*, *301*, *302*, *303*, *305*, *307*, *308*, *308*, *309*, *309*, *310*, *311*

B

Baez, Joan, 57, *251*, *272*, 323
Bailey, Peter, *235*, 321
Balin, Marty, 84, *258*, *262*, *308*
Bartlett, Scott, 197, *226*, *227*
Baruch, Ruth-Marion, 271, 323; *All the Symbols of the Haight*, *133*; "560 558," 51n74, *158*; *Hare-Krishna Dance in Golden Gate Park*, *126*; "*Jesus" Selling the Oracle*, *151*; *Mother and Child, Free Huey Rally*, *284*; *Sailor Couple*, *136*; "*San Francisco*," *104*; *Young Woman, Free Huey Rally*, *284*
Beatles, 25, 80–81, 82, 86–87, 320, 321, 323
Beats, 20, 21, 23, 25, 27, 41, 51n55, 58, 63, 69, 85, 91, 117, 131, 320
bell-bottoms, 60, *144*, *145*, *269*
Berry, "Pathfinder" Frank, *99*
Big Brother and the Holding Company, 25, *25*, 27, 28, 60, *64*, 65, 82, 84, 86, *86*, 107, 117, 131, 231, *258*, 313n50, 318, 321, 323; album covers, *262*, *263*; handbills/posters for, 35, *102*, *103*, *108*, *161*, *177*, *183*, *191*, *199*, *200*, *211*, *219*, *236*, *241*, *242*, *273*
Bindweed Press, 297, 298, 309, 312n2, 312n4
Bjerke, Birgitta, *72*, 74–76, *75*; "Hands" dress, 271, *275*; jacket, *269*; *Pioneer*, *76*, *225*; T-shirt, *269*; wedding dress, *289*
Black Panther Party, 271, *284*, *285*, 321, 323, 324
Blau, Herbert, 21, 23

Bloomfield, Mike, 83, 85, 86, *191*, *194*
Blushing Peony, 131, *142*, *300*, 312n3
boots, 33, 54, 60, 67, 68, *209*, *271*, *282*
Bowen, Michael, 27, 91, 117, 321; "*Gathering of the Tribes for a Human Be-In*" (with Kelley and Mouse), *118*; "*Human Be-In*" (with Kelley and Mouse), *152*; *Nervous System*, *97*; *New Directions*, *96*; *Pow-Wow*, *118*
Braga, C., *138*
Branaman, Robert ("Bob"), *153*
Brand, Stewart, 34, 67, 107, *108*, 313n51, 320, 321; *Whole Earth Catalog*, *293*, 323
Brautigan, Richard, *121*, *292*
Bridget, *146*
Brodsky, Joel, *262*
Brown, Dave, *252*
Brownson, John, *152*
Bruce, Lenny, *24*, 25, *236*
Buchwald, Joe, 307–308, *309*, 309–310, 313n43, 313n45, 313n47
buttons, *156–157*

C

Caen, Herb, 20, 58
California Litho Plate Co., 175, 298, 304, 305, 306
cape, *147*
Carawan, Guy and Candie, *292*
Carr, Bob, 34, 301
Caserta, Peggy, 60, 320
Castell, Luria, 33, 34
Charlatans, 24, 25, 31, 32–33, 55, 82, 83, 91, 131, 231, *258*, 313n45, 320, 321, 323; handbills/posters for, 32–33, *37*, *37*, *103*, *138*, *161*, *177*, *188*, *200*, *219*, *233*, *234*, *241*, *311*
Chávez, César, *293*, 321
Civil Rights movement, 69, 271, 318
Clark, Ossie, *288*
Clayden, Marion, 71–73, 77n73; *Ceremonial Enclosure*, *92*; *Untitled*, *218*
Clifford, Laurie, *263*
coats, 54, 63, 64, 66, *144*, *210*
Cohen, Allen, 27, 117, *133*, 321, 322
Communication Company, 322; *Candle Opera*, *121*; *Free Spring Mobilization Poetry Reading*, *121*; "*Moving Target is Hard to Hit*," *168*; *Press Release*, *169*; "*Survival School*," *167*
Conklin, Lee, 297, *305*, 310; *Butterfield Blues Band, Santana, Hello People, Iron Butterfly, Canned Heat, Initial Shock*, *183*; *Canned Heat, Gordon Lightfoot, Cold Blood*, *222*; *Jeff Beck Group, Spirit, Linda Tillery, Sweet Linda Divine, Sweetwater*, *37*, *38*; *Procol Harum, Santana, Salloom-Sinclair*, *251*; *Quicksilver Messenger Service, Grateful Dead, Linn County*, *252*; *Santana*, *263*; *Steppenwolf, Staple Singers, Santana*, *185*; *Who, Cannonball Adderley, Vagrants*, *183*
Conner, Bruce, 21, 41, 45, 91, 318, 322; *Mandala*, *108*; "*Psychedelics, Flowers & War*," *153*; REPORT, 45, *45*; WEDNESDAY, *93*
Contompasis, Marika, *129*

Country Joe and the Fish, 81, *81*, 82, 85, 86, 320, 322; album covers, *262*; handbills/posters for, *121*, *178*, *204*, *248–249*, *273*, *305*, *305*
Crabb, Earl, *94*
Crumb, Robert, 323; "*Bedrock One*," *178*; *Big Brother & the Holding Company*, *263*

D

Davis, Ronnie, 24, 34, 320, 321
"Death of the Hippie," *170*, 319, 323
DeFeo, Jay, 20–21, *21*
Devries, Mark, *153*
Diggers, 27, *28*, 71, 77n68, 117, 131, *170*, 321, 322, 323; *Digger Papers*, *166*
Donahue, Tom, 69, 81, 85, 322, 323
Donaldson Litho Co., 35
Doors, 81, 319; handbills/posters for, *176*, *187*, *206*, *219*, *243*, *248–249*, *303*, *309*, 310
Dottie, *184*
Double-H Press, 298
dresses, *39*, 54, 55–56, *56*, *57*, *58*, 61, 63, 66, 68, 70, 75, *123*, *128*, *129*, *202*, *203*, *210*, *268*, *290*; "DMT," 66, *265*; evening, *288*; "Hands," 271, *275*; mini-, 56, *57*, *58*, *265*, *267*; "Peace," 58, *274*; "Persian Nights," *203*; "Tree," *123*; wedding, 69, 70, *289*
Dries, Acacia, *55*
Duncan, Gary, *64*, 84, *84*, 85, *258*
Dunlap & Co., 56; Jerry Garcia's "Captain Trips" hat, 56–57, *254*
Duskin, Alvin, 58; "Peace" dress, 58, 271, *274*
Dylan, Bob, 57, *95*

E

East West Musical Instruments Company, 62–63; "Camel" jacket, *201*; "Gree Gree" tunic, *145*
ensembles, 56, 62, 67, *98*, *99*, *146*, *202*, *205*
Evergreen, *293*
Ewing, Eileen, *128*

F

Family Dog Productions, 33, 34, 50n17, 51n79, 83, 131, 313n3, 318, 321, 323, 324; handbills/logo/posters for, 35–36, *36*, *37*, 38, 40–41, 48, 49n9, *191*, *228–229*, *234*, 297, 298, 301, 303, 305, 310, 312nn2–3, 313n37, 313n45, 313n61, 321; "Tribute to Dr. Strange," 33–34, 82–83, 85, *234*, 313n45, 321
Faryar, Renais, *146*
Ferguson, Michael, 24, *258*, 320; *5th Annual S.F. State Folk Festival*, *237*; "Seed" (with Hunter), 31, 32–33, *233*
Ferlinghetti, Lawrence, 20, 85, 91, *118*, 187
Fetchin, Gretchen, *114*
Fillmore Auditorium, 27, 33, 34, 38, 42–43, 44, 63, 77n48, 81, 83, 84, 85–86, 87, 91, 231, *260*, *266*, 312n3, 317–318, 321, 322, 323, 324; billboards in, *301*, 312n15; handbills/posters for, 34–35, *35*, *37*, *37*, 38, 43, 44, 48, 50n39, *102*, *175*, *177*, *179*, *183*, *185*, *188*, *191*, *194*, *198*, *204*, *206*, *213*, *222*,

235, *236*, *240*, *242*, *243*, *244*, *245*, *250*, *251*, *252*, *253*, *279*, *287*, *297*, *299*, *306*, *307*, *308*, *309*, *310*, *312*n3, *321*
Fiore, Quentin, *293*
Foster, Paul: *Acid Test Graduation Diploma for Jerry Garcia*, *115*; "Can You Pass the Acid Test?," *112*
Fox, Marsha, 58, *274*
Free Speech Movement (FSM), 22–23, *320*
Fried, Robert, 33, 51n79, *301*, *304*; *Big Brother & the Holding Company, Crazy World of Arthur Brown, Foundations*, *183*; *Family Dog is coming down to Earth*, *228–229*, 313n61; "Sky Web," *188*; "Sorcerer," *301*
Friedman Enterprises, 175

G

Garcia, Jerry, 25, 27, *70*, 74, *81*, 84, 85, 130, *132*, *139*, *181*, *260*; acid test diploma for, *115*; "Captain Trips" hat for, *56–57*, *254*
Garcia, Rupert, *279*
Genie the Tailor, *99*
Getz, Dave, 21, 27, *86*, *258*
Ginsburg, Allen, 20, *20*, 27, 47, 51n55, 85, 90, 91, *95*, *103*, *108*, *112*, 117, *118*, 131, *187*, *322*; "Howl," 20, *292*, 320
Gleason, Ralph J., 34, 43, 231, *321*
Gomez, Joe, *177*
Graham, Bill, 33, 34–35, 36, 39, 44, 48, 49n9, 50nn22–23, 76n4, 83, 107, 298, 303, 306, 307, 308, 313nn43–44, 321, 322; Fillmore and, 27, 33, 34, 43, 63, 185, 312n3, 317–318, 321, 323, 324
Grateful Dead, 25, 27, *27*, 28, 50n21, 54, 60, 63, 65, 68, 74, 75, 76, 76n4, 81, *81*, 84, 86, 107, 117, *127*, 131, *135*, 231, 260, 319, 320, 321, 322, 323, 324; Acid Tests and, 25, 82, *113*, *115*, *321*; album covers, 43, *262*, *263*; debut album, 43, 85, *262*; handbills/posters for, *41*, *103*, *108*, *112*, *113*, *115*, *161*, *185*, *189*, *191*, *236*, *243*, *244*, *252*, *253*, *302*, *303*, *308*; performance set, *70*, *71*
Gravenites, Linda: cape, *147*; handbag, *255*; vest, *147*
Gravy, Wavy, 25; "Rainbow" jumpsuit for, *114*
Great Society, *82*, *83*, *84*, 231, 313n45, 321; handbills/posters for, *199*, *234*, *236*
Greene, Herb, 33, 37, 231, *303*; *Big Brother and the Holding Company*, *258*; *Charlatans*, *258*; *Couple on Haight Street*, *133*; *Dead on Haight*, *132*; *Jefferson Airplane*, *258*; *Pine Street*, *259*; *Quicksilver Messenger Service*, *258*
Griffin, Rick, 32, 33, *33*, 39–40, 50n40, 51n63, 297, 301, 302, 304, 313n37, 323; "Aquarian Age," *152*; "Avalon Splash" (with Moscoso), *190–191*; "Charlatans Front Porch" (with Hunter), 37, *37*; *Grateful Dead*, *263*; "Halo" (with Mouse and Kelley), *161*; *Jimi Hendrix Experience, John Mayall & the Blues Breakers, Albert King*, *250*; "Joint Show," *304*; *KSAN Radio* (with Kelley), *256*; "Mornin' Papa," *178*; *New Improved Psychedelic Shop and Jook Savage Art Show*, *141*; *Pow-Wow*, 117, *118*

Gurley, James, 25, 85, *86*, *208*, *258*
Gut: *Acid Test Graduation*, *115*; *Hell's Angels M.C. Present Big Brother and the Holding Co. and the Merry Pranksters*, *241*

H

Haight-Ashbury Free Medical Clinic, 46, 47, 131, *159*, *160*, 322, 323
Haight-Ashbury Tribune, 131, *154*, *155*
Halfant, Jules, *262*
Ham, Bill, 23–24, 27, 44, 50n13, 197, 318, 320, 323; *Kinetic Light Painting*, *220–221*
handbag, *255*
Hansen, Cicely, *55*
Hare Krishnas, *103*, 117, *126*, *170*
Harvey, William S., *262*
Hatfield, Jack: *Blue Cheer, Other Half, Wildflower*, *301*; *Magic Mountain Music Festival KFRC Benefit*, *248–249*
hats, 33, 54, *56–57*, *140*, *254*
Hauser, Fayette, *134*
Heavenly Blues Band, 231, *236*
Hedrick, Wally, 20–21
Hells Angels, *322*, *323*, *324*
Helms, Chet, 25, 27, 33, 34, 39, 41, 44, 48, 49, 50n42, 63, 84–85, 175, 313n37; Family Dog and, 33, 34, 35, 50n17, 51n79, 83, 312n3, 318
Hendrix, Jimi, 79, 80, *80*, 85–86, *250*, *260*
Henry, William, *304*; "One Hundred Six," *182*
Hesse, Hermann, *292*, 317
Hesseman, Howard, 24, 25
Hicks, Dan, 25, 67, 68, *237*, *258*
Hillyard, Roger, 44, 45, 51n68, *314*, 317–318, *318*, 319
Hinckle, Warren, III, 36, 322
Hodges, David, *170*
hot pants, *57*, *291*
House Un-American Activities Committee (HUAC), 21–22, *22*, 320
Human Be-In, 27–28, *29*, 50n22, 85, 117, *118*, *119*, *152*, 322
Hunter, George, 55, 91, *258*; "Charlatans Front Porch" (with Griffin), 37, *37*; *It's a Beautiful Day*, *263*; *Quicksilver Messenger Service*, *263*; "Rock & Roll," *234*; "Seed" (with Ferguson), 31, 32–33, *233*
Huxley, Aldous, *292*

I

Irons, Greg: *Butterfield Blues Band, Bloomfield & Friends, Birth*, *194*; *KMPX Multiplex Stereo*, *257*; *Santana, Collectors, Melanie*, *179*
It's a Beautiful Day, 68, 86, *160*, *199*, *219*, *251*, *253*, *263*, *323*

J

jackets, 57, 60, 61, 66, *98*, *99*, *140*, *146*, *205*, *269*; "Big Smith," *276*; "Camel," *201*; "Farah of Texas," *172*
Jefferson Airplane, 25, 28, 60, *62*, 63, *64*, 65, 68, 79, 81, 82, 83, *83*, 84, 85–86, 87, 117, 131, 231, *258*, 308, 313n45, 320, 321, 322, 323, 324;

handbills/posters for, 35, *102*, *161*, *177*, *189*, *199*, *234*, *235*, *236*, *244*, *248–249*, *251*, 308–309; second album/*Surrealistic Pillow*, 81, 85, *262*
Jess, 41, 197; *Echo's Wake Part IV*, *214–215*
Johnson, Betsey, 58, *290*
Johnson, Dana W., *204*
Jones, Pirkle, 271, *323*; *Black Panthers during drill*, *285*; *Black Panthers from Sacramento, Free Huey Rally*, *285*
Joplin, Janis, 25, *25*, 28, 60, 65, 71, *78*, 79, 85, 86, *86*, *258*, *299*, *300*, 313n50, 318, 321
Jordan, Lawrence, 45, 322; *Hamfat Asar*, 197, *216–217*
jumpsuits, 61, *114*

K

Kagan, Paul, 47, *193*
Kandel, Lenore, 117, *118*, 131, 270, 322; *Love Book*, *152*, *293*, 322
Kantner, Paul, 25, *64*, 82, 84, *258*
Katz, Gabriel ("Gabe"), *152*
Kaukonen, Jorma, 25, *64*, 65, 84, 85, *258*
Kaukonen, Peter, *64*, 91
Keenan, Larry: *Michael McClure, Bob Dylan, Allen Ginsberg*, *95*; *Peace Rally*, *125*; *Section of the Runaway Board at Park Police Station*, *164–165*
Kelley, Alton, 32, 33, *33*, 34, 41, 51n50, *137*, 297–298, 313n45, 323; *Appeals IV Mime Troupe Benefit*, "Busted" (with Mouse), *244*; "Earthquake" (with Mouse), *102*; "Edgar Allan Poe" (with Mouse), *200*; "Edwardian Ball" (with Mouse), *102*; *Family Dog Presents A Tribute to Dr. Strange* (with Magill), *234*; "Five Men in a Boat" (with Mouse), *177*, 313n61; "Gathering of the Tribes for a Human Be-In" (with Bowen and Mouse), *118*; "Girl in the Red Circle" (with Mouse), *308*; "Gloria Swanson" (with Mouse), 38, *199*; *Grateful Dead* (with Mouse), *262*; "Halo" (with Griffin and Mouse), *161*; "Human Be-In" (with Bowen and Mouse), *152*; "Keep California Green" (with Mouse), *179*, *310*; *KSAN Radio* (with Griffin), *256*; "Moby Grape" (with Mouse), *200*; "Redskin" (with Mouse), *211*; "Skeleton and Roses" (with Mouse), *302*, *303*; "Snake Lady" (with Mouse), 50n43, *199*; *10th Biennial Wilderness Conference* (with Mouse), *283*; "Wanted," *234*; "Woman with Green Hair" (with Mouse), 38, *199*; "Zebra Man" (with Mouse), 40, *200*; "Zig-Zag Man" (with Mouse), *200*
Kerouac, Jack, 51n55, 91; *On the Road*, 20, 25
Kesey, Ken, 25, 34, 50n21, *54*, 106, 107, *108*, *113*, *115*, *152*, 313n51, 321, 322; Merry Pranksters and, 25, 34, 47, 50n21, 54, *54*, 75, 82, 107, *108*, *112*, *113*, *114*, *115*, *241*, 320, 321, 322; *One Flew Over the Cuckoo's Nest*, *292*, 320
King, Martin Luther, Jr., *287*, 322, 323
Kiss In, *279*
Kling, Candace and Fred, 68, 69–70, *123*, *267*
Kouninos, Nicholas, *245*
Kreutzmann, Bill, 54, 68, 76, *132*, *260*

337

L

Leary, Timothy, 27, 38, 47, 50–51n44, 85, 117, *118*, *119*, *152*, 197, 322; *Psychedelic Experience* (with Metzner and Alpert), 69, *292*
leather, 53, 60, 62–64, 67
Levi's, 58, 59–61, *59*, 62, 77n29, *144*, *145*, *172*, *173*, *269*
Lichtenwalner, *191*
Life, 31, *32*, 35, *39*, 40, 50n26
light shows, 27, *42–43*, 44–45, 47, 50n13, 50n21, 58, 66, 91, 197, 231, *266*, *279*, 318–319, 320, 324
Loader, John W., *140*
Lofthouse, Patrick, *194*
Love Pageant Rally, 27, *152*, 321
LSD, 25, 27, 28, 44, 50n21, 64, 73, 81, 82, 107, 197, 320, 321, 322

M

MacLean, Bonnie, 38–39, 297–298, 301, 310, 312n15; *Butterfield Blues Band, Roland Kirk Quartet, Chamber Brothers, Sunshine Company, Siegel Schwall*, *183*, *188*; *Yardbirds, Doors, James Cotton Blues Band, Richie Havens*, *206*
MacLise, Hetty McGee, *153*
Magic Theater for Madmen Only, 24, 25, 320
Magill, Ami, *234*
Maginnis, William, 22, 23
Mahoney, Mike, 116
Mamas and the Papas, 28, 71, 79, 80
Manuel, K. Lee, *207*
Marbles, 83, *234*, 321
Marshall, Jim, *30*, *46*, 47, *80*, 83, 231, 300, 303; *Fillmore light show*, *266*; *Florence Nathan*, *266*; *GIRLS SAY YES to boys who say NO*, *278*; *Grace & Janis*, *261*; *Grateful Dead playing on Haight Street*, *135*; *Krishna/Digger March*, *170*; *Moby Grape*, *262*
Martin, Tony, 22, 23, 27, 44, 317, 318
Masekela, Hugh, *244*, *248–249*
Matrix, 25, 38, 83, *83*, *234*, *237*, *242*, 297, 310, 312n3, 320
Matthiessen, Peter, *293*
Mayes, Elaine, 32, *46*, 47, 51n74; *Couple with Child*, *124*; *Dancing, Straight Theater*, *139*; *Eugene*, *124*; *Funky Sam*, *136*; *Grateful Dead, Solstice*, *127*; *Haight-Ashbury (woman in checkered outfit)*, *136*; *Haight-Ashbury (young man against plywood)*, *134*; *Hugging and Dancing, Summer Solstice*, *125*; *Jimi Hendrix*, *260*; *Kathleen and Baby Max Damen*, *137*; *Katrinka Haraden*, *135*; *Linda*, *132*; *Shari Maynard, Bunny Bael*, *134*; *Solstice Metal Dress*, *126*; *Steve Miller at Home*, *260*; *Straight Theater with Jerry Garcia and Dancing*, *139*; *Summer Solstice*, *124*; *Young Man with Guitar "Preacher,"* *133*
McClure, Michael, 21, 27, 69, *95*, *118*, 131, *187*, 321, 322
McGowan, Mickey, 67–69, 75, 271; "Cub Scout" boot, 68, *282*; "Gambling" boot, *68*, *282*; "Mandala" boot, 68, *282*; "Ocean Tantra" boot, 68, *282*
McKernan, Ron "Pigpen," *81*, *84*, *132*, *260*
McLuhan, Marshall, 6, 35, 43, 50n25, 51n44, *293*
Melton, Barry, *81*, *85*
Metzner, Ralph, 69, *292*
Miles, Dug, *59*, 61, *171*
Miller, Larry, 85, *257*, 322
Miller, Steve, 85, 86, *260*, 319, 322; album cover, *263*; handbills/posters for, *176*, *186*, *242*, *247*, *248–249*, *252*, *273*, *309*
Mnasidika, 27, 60, 131, *143*, 320
Moby Grape, 85, 86, 322; album cover, *262*; handbills/posters for, *103*, *177*, *191*, *198*, *200*, *244*, *248–249*, *311*
Monterey International Pop Festival, 28, *46*, 47, 55, 79–80, *80*, 81, 85, 86, 231, *246*, 322

Moore, Barbara, 64, *210*
Morgan, Bill, 63
Moscoso, Victor, 32, *33*, 36–37, 38–39, 44, 49n9, 50n35, 60, 297–298, 301, 304, 310, 312n3, 313n37, 323; "Avalon Splash" (with Griffin), *190–191*; *Big Brother and the Holding Company*, *242*; *Blushing Peony*, *142*, *300*; "Break on Through to the Other Side," *219*; "Butterfly Lady," *187*; "Flower Pot," *195*; "God's Eye," *103*; "Incredible Poetry Reading," *187*; "Indian with the Swirling Eyes," 36, 50n29, *211*, 297; *Miller Blues Band*, *242*; "Neptune's Notion," *177*, *311*; Pablo Ferro film ad, *187*; "Peacock Ball," *247*; *Steve Miller Band*, *263*; Steve Miller promotion, *186*; "Strongman," *187*; "Swirley," *176*, *309*; "Wild West" (with Wilson), *251*
Mosgofian, Levon, *296*, 301, 305, 307, *307*, 308, 309, 313n44
Mouse, Stanley, 32, *33*, 40, 41, 43, 51n63, 60, 75, 297–298, 303, 309, 310, 312n2, 313n50, 313n61, 323; *Appeals IV Mime Troupe Benefit*, "Busted" (with Kelley), *244*; "Earthquake" (with Kelley), *102*; "Edgar Allan Poe" (with Kelley), *200*; "Edwardian Ball" (with Kelley), *102*; "Five Men in a Boat" (with Kelley), *177*, 313n61; "Gathering of the Tribes for a Human Be-In" (with Kelley and Bowen), *118*; "Girl in the Red Circle" (with Kelley), *308*; "Gloria Swanson" (with Kelley), 38, *199*; *Grateful Dead* (with Kelley), *262*; *Grateful Dead* poster for Warner Brothers (with Kelley), *41*; "Halo" (with Griffin and Kelley), *161*; "Human Be-In" (with Kelley and Bowen), *152*; "Keep California Green" (with Kelley), *179*, 310; "Libertie," *279*; "Moby Grape" (with Kelley), *200*; "Peace and Freedom Party Dinner," *273*; "Redskin" (with Kelley), *211*; "Skeleton and Roses" (with Kelley), *302*, *303*; "Snake Lady" (with Kelley), 50n43, *199*; 10th Biennial Wilderness Conference (with Kelley), *283*; "Woman with Green Hair" (with Kelley), 38, *199*; "Zebra Man" (with Kelley), 40, *200*; "Zig-Zag Man" (with Kelley), *200*

N

Nelson, Robert, 45, 321, 322
Neon Rose, 298, 310, 312n3
Neutrogena Soap, *48*
Newton, Huey P., 271, *284*, 321
New Tweedy Brothers, 231, *236*
North Beach Leather, 62–63, *144*
Now Now, *293*

O

Oberländer, Frank, *263*
Oliveros, Pauline, 22, 23
Olson, Burray, 63–64, *210*
Op Art, 38–39, *39*, 51n46
Orr, Norman, *252*
Orsini, Eva, 61, *281*

P

pants, 56, 57, 61, 66, *98*, *99*, *129*, *140*, *144*, *146*, *172*, *202*, *205*, *291*
pantsuit, *173*
Patchen, Kenneth, *121*
Paul Butterfield Blues Band, 83–84
Pepper, Bob, *262*
Phillips, John, 28, 79–80, 81
Pollock, Courtenay, 70, 71, *71*, 73–74; *Pastel Stellar Blue Mandala*, *264*
Pop Art, 40, 51n49, 69, 310

Porcella, Yvonne, *66*, 66–67; dress, *203*; tunic, *145*
posters, 31–51, 175, 297–313. *See also specific artists, subjects, and venues*
Print Mint, 31, *47*, 48, 131, *148*, *149*, 175, 322
Psychedelic Shop, 27, 131, *141*, *162–163*, 317, 321, 322

Q

Quicksilver Messenger Service, 25, 63, *64*, 81, 82, 84, *84*, 85, 86, 117, 231, *258*, 325; album cover, *263*; handbills/posters for, *160*, *178*, *194*, *200*, *204*, *213*, *234*, *236*, *244*, *247*, *252*, *253*, *273*, *308*

R

Rainbow Cobblers, *209*
Ramparts, 36, 43, 322
Rauschenberg, Robert, *40*, 41, 318
Redding, Otis, 79, 86, 91
Rehbock, Loren, *143*
Rice, Leland: *Golden Gate Park*, *127*; *Haight Street*, *132*; *Print Mint*, *149*
Robbins, Luna Moth, 70–71, *173*
Robertson, Helene, *56*, 57–58, *57*, 67, 75; chubby, *291*; dress, *129*; "Farah of Texas" jacket, *172*; tank top, *291*; vest, *291*
Rolling Stone, 31, *64*, 65–66, 231, 323
Rolling Stones, 36, 82, *179*, 320, 324
Romero, Elias, 24
Romney, Jahanara, *114*
Rose, Jeanne, 64–66, *64*, *65*, 77n50; "DMT" dress, 66, *265*; ensemble, *205*; jacket, *140*; "Morning Glory" top, *129*; "Persian Nights" dress, *203*
Roshi, Shunryu Suzuki, 27, *29*
Roszak, Theodore, 4, 49n5, 76n3
Rowan, Leslie, *269*

S

Sabatasso, Melody, 61–62, *61*; pants, *144*; pantsuit, *173*
Saint Laurent, Yves, *288*
Salas, Randy, *138*
San Andreas Fault, *160*
San Francisco Chronicle, 31, 34, 36, 48, 53, 55, 58, 61, 65, 69, 231, 321, 322
San Francisco Examiner, 34, *105*
San Francisco Mime Troupe, 23, 24, 27, 34, *35*, 50n22, 83, 117, *138*, *244*, 301, 320, 321, 322, 323
San Francisco Oracle, 27, 35, 47, 50n26, 62, 117, 131, *150*, *151*, *152*, *153*, 321, 323
San Francisco Sound, 38, 50n42, 51n60, 81, 231
San Francisco State College (SF State), 21, 22, 24, 48, 51n71, *102*, 131, 308, 320, 321, 323, 324
San Francisco Tape Music Center, 22, 23–24, 25, 107, 320, 321
Santana, 63, 86, *87*, *160*, *179*, *183*, *185*, *199*, *251*, *253*, *263*, 323, 324
Sant' Angelo, Giorgio di, 71, 77n43, *290*
Sarti, Jacky, *269*
Sätty, Wilfried, 197; *Stone Garden*, *180*; *Turn on Your Mind*, *181*; *Untitled (Arabesque Interior)*, *212*; *Untitled (James Gurley)*, *208*
Schafer, Steve, *153*
Schnepf, Bob, 39–40, 301, 303, 304, 305–306, 310; "Sitting Pretty," *190*; *Summer of Love*, *122*; "Symposium 2000 AD & the Fall," *153*; "Tree Frog," *178*, *305*
Seale, Bobby, 271, 321
Sebastian, John, 43, 71
Seidemann, Bob, *33*, 75, 303; *Alton Kelley*, *137*; *Grateful Dead*, *260*; *Haight Street*, *134*
Sender, Ramon, 22, 23, 27, 34, 107, 313n51, 320
Shames, Stephen, 271; *David Hilliard*, *284*; *Free Food Program*, *286*; *Oakland Courthouse at First Huey P. Newton Trial*, *284*; *Two Women with Bags of Food*, *286*

shawl, 54, *268*
Shea, Edmund, *24*
Shubb, Rick: *Humbead's Map of the World* (with Crabb), *94*; *Thelonious Monk, Dr. John the Night Tripper, Charlatans*, *241*
Singer, David, 42, 197, 298, 303, 306, 310, 313nn43–44; *Boz Scaggs, Cold Blood, Flamin' Groovies, Stoneground*, 43, *253*; *Quicksilver Messenger Service, Mott the Hoople, Silver Metre*, 43, *213*
skirts, 60, 61, 69, 70, *98*, *146*, *173*
Slick, Grace, *52*, 60, *62*, 63, 68, *82*, 83, *83*, 84, *258*, 321
Smith, Hap, *152*
Snyder, Gary, 20, 27, 47, 117, *118*; *Earth House Hold*, *293*
Soot Productions, *242*
SP/4 Vietnam, *280*
Stanley, Augustus Owsley, III, 25, 28, 82, 107, 320
Stark, Larry, 44, *219*
Stewart, Charlie and Jean, 55, *55*, 67
Straight Theater, 131, *138*, *139*, 322, 323
Subotnick, Morton, *22*, 23, 320
Sullivan, Edmund, *302*, 303

T

Tam, Richard, *265*
Tea Lautrec Lithography, 175, 298, 301, 305, 306, 307–308, 309–310, 312n4, 312n33, 313nn43–44, 313nn47–48
Tepper, Mari, *277*
Thoreau, Henry David, 19, 28, *292*
tie-dye, 53, 70–74, *70*, *71*, *146*
tops, 61, *223*, *268*; "Morning Glory," *129*; tank, *146*, *172*, *291*
Trips Festival, *16–17*, 25, *27*, 34, 45, 50n22, 107, *108*, *109*, *113*, *115*, 301, 309, 313n51, 317, 321, 322
Tsongas, George, *152*
Tuten, Randy: *Country Joe & the Fish, Led Zeppelin, Taj Mahal* (with D. Bread), *251*; *Janis Joplin and Her Band, Savoy Brown* (with D. Bread), *299*, 300; *Led Zeppelin, Bonzo Dog Band, Rahsaan Roland Kirk & His Vibration Society*, *179*

U

University of California, Berkeley (UC Berkeley), 21, 22, 84, 85, 320, 321, 322, 324

V

Van Meter, Ben, 44, 45, 51n68, 51n71, 107, *294–295*, 315–319, 322; *Acid Mantra*, 45, 47, 317; *Appropriations* (with Hillyard), *100–101*; *Ben Van Meter by Roger Hillyard & Roger Hillyard by Ben Van Meter* (with Hillyard), *318*; *Eight Hand-Painted & Curious Photo Slides*, *316*; *Grain of Sand*, *317*; *S.F. Trips Festival, An Opening*, *16–17*, 45–47, 107, *110–111*, 317; *Spring Day*, *319*; *Trip-Tych*, *238–239*
vests, 54, *98*, *147*, *291*
Vietnam War, 27, 61, 82, 91, *105*, *120*, *121*, 131, 271, *273*, *279*, *280*, *293*, 320, 321, 322, 323, 324

W

Warhol, Andy, 40, *240*, 310, 317, 321
Warren, David, *199*
Watts, Alan, 20, 47, 67, 73, 117, 320
We Five, *232*
Weir, Bob, 74, *76*; *132*, *260*, 323
Weir, John Spence, *148*
Weisser, Wilfred, *194*
Whalen, Philip, 20, *187*
White Duck Workshop, *128*
Who, 28, 75, 79, *183*

Wilkes, Tom, *246*
Wilson, Wes, 32, *33*, 36, 37–39, 43, 44, 49, 49n9, 50n22, 50n39, 50n43, 271, 297–298, 301, 304, 308, 310, 313n37, 321, 323; *Andy Warhol and His Plastic Inevitable, Velvet Underground, Nico, Mothers*, *240*; *Are We Next?*, *104*; *Association, Quicksilver Messenger Service, Grass Roots, Sopwith Camel*, 36, *194*; *Butterfield Blues Band, Charles Lloyd Quartet*, *242*; *Butterfield Blues Band, Jefferson Airplane, Grateful Dead*, *189*; *Byrds, Moby Grape, Andrew Staples*, *198*; "Can You Pass the Acid Test?," *113*; *Captain Beefheart, Chocolate Watchband, Great Pumpkin*, *102*; "Euphoria," *219*; *Grateful Dead, Junior Wells Chicago Blues Band, Doors*, *243*; *Jefferson Airplane, Great Society, Heavenly Blues Band*, *236*; *Jefferson Airplane, James Cotton Chicago Blues Band, Moby Grape*, *117*, 308–309; *Lenny Bruce, Mothers*, *236*; *Mystery Trend, Big Brother & the Holding Company, Quicksilver Messenger Service*, 34–36, *236*; "Ohm," *303*; *Otis Rush & His Chicago Blues Band, Grateful Dead, Canned Heat Blues Band*, *191*; "Quick and the Dead," *236*; "Rorschach Test," *219*; *Them, Sons of Champlin*, *306*; "Tribal Stomp," *102*; "Trips Festival," *108*; *Turtles*, *179*; "Wild West" (with Moscoso), *251*
Wolfe, Tom, 50n21, 54–55

Z

Zig-Zag, *146*

acknowledgments

The Fine Arts Museums' exhibition *The Summer of Love Experience: Art, Fashion, and Rock and Roll* and its accompanying scholarly catalogue would not have been possible without the full support of our generous donors: Anonymous, in honor of Max Hollein; the Lisa and Douglas Goldman Fund; Diane B. Wilsey; Nion McEvoy and Leslie Berriman; the Ray and Dagmar Dolby Family Fund; Levi's; Yurie and Carl Pascarella; Edith and Joseph O. Tobin II; M.H. de Young Tobin II; and The Paul L. Wattis Foundation. Additional support has been provided by Nancy and Joachim Bechtle; Jack Calhoun and Trent Norris; Lauren Hall and David Hearth; Debbie and Blake Jorgensen; Fred Levin and Nancy Livingston, The Shenson Foundation, in memory of Ben and A. Jess Shenson; and Dorothy Saxe. Along with those who gave their financial support, many gracious collectors were inspired by this project to donate costumes, photographs, and posters to our Museums. We extend our heartfelt thanks to Leslee Budge, Rene and Jim Cress, Dagmar Dolby, Steven Eisenhauer, the Lasdon Foundation, Ruth Quigley, Ricky Serbin, Barbara L. Traisman, and Gary Westford.

This presentation has been made all the more bountiful by the kindness of our many lenders who have shared their works of art with us. We gratefully acknowledge Peter Albin; Joan Baez; The Bancroft Library, University of California, Berkeley; Joseph Bellows Gallery, La Jolla, CA; Birgitta Bjerke; Center for Counterculture Studies, San Francisco; Marna Clark; the Clayden Family; Decades of Fashion, San Francisco; Finnlandia; Linda Garth; Merel Glaubiger; Judy Goldhaft and Ocean Berg; Haight Street Art Center, San Francisco; Cicely Hansen; Fayette Hauser; George Hunter; Steven Kasher Gallery, New York; Peter Kaukonen; Barbara Kayfetz; Candace Kling; The Kling Family; The Lambrecht Family (Candace, Max, and Zachary Lambrecht); Arthur Leeper and Cynthia Shaver; Levi Strauss & Co. Archives, San Francisco; Lumière Gallery, Atlanta, and Robert A. Yellowlees; Jim Marshall Photography LLC; Elaine Mayes; Nion McEvoy; Mickey McGowan; Grant McKinnon; Laura Melendy; Barbara Moore; Stanley Mouse; Oakland Museum of California; Courtenay Pollock; Jane Quatlander; Leland Rice; Helene Robertson; Jeanne Rose; Roslyn L. Rosen; Ron and Jasmine Schaeffer; Bob and Belinda Seidemann; Joel Selvin; Rose Solomon; Charlie and Jean Stewart; Jay Thelin; Ed Walker; Wavy Gravy and Jahanara Romney; John Spence Weir; University of California, Santa Cruz; Susila Ziegler; and various private collections. We also thank Toni Hall and Tracey Panek at Levi Strauss & Co., San Francisco, and Monica Powers and Scarlett Winningham on behalf of the Goorin Bros., San Francisco, for supplying accessories for costume mounting. Light artist Bill Ham, along with Ben Van Meter, are thanked especially for creating special commissions for the exhibition at the de Young. We also specifically acknowledge John J. Lyons, who not only shared his works of art with us for the exhibition, but made his collection available to help with the research for and production of the catalogue.

The staff at the Museums has worked together to bring the show and this book to our audiences. Jill D'Alessandro, curator of costume and textile arts, The Caroline and H. McCoy Jones Department of Textile Arts, and Colleen Terry, assistant curator of the Achenbach Foundation for Graphic Arts (AFGA), conceived the exhibition, with support from chief curator and founding curator of photography Julian Cox, and associate paper conservator Victoria Binder. Special thanks are due to Laura Camerlengo, assistant curator of costume and textile arts, who offered research assistance and led the costume-mounting efforts for both the catalogue and exhibition, admirably constructing complete ensembles that capture the spirit of the times. Appreciation is also extended to Larry Banka and Tim Brown, AFGA curatorial volunteers, for their extraordinary dedication to the detailed research required for this project — both helped to uncover stories of San Francisco's Summer of Love that had become buried and blurred over the last fifty years. We are also grateful of the counsel we have received from our other curators throughout the Museums, including Karin Breuer, curator in charge of the AFGA; Jim Ganz, curator of the AFGA; Steve Woodall, collections specialist for the AFGA; Timothy Anglin Burgard, the Ednah Root Curator in Charge of American Art; and Lauren Palmor, curatorial assistant in the American Art department.

Our curatorial programs are bolstered by the work of our colleagues throughout the Museums. Our conservators have assisted us with the preparation of art for the show and book, including head conservators Debra Evans and Sarah Gates, with assistance from Heather Brown, Anne Getts, and Anisha Gupta. We acknowledge the Exhibitions team, led by Krista Brugnara and including Sara Chang and Sarah Hammond; Ryan Butterfield and his staff of technicians, including Aldalberto Castrillon, Robert Haycock, Don Larsen, and Emily Meyer; and Tomomi Itakura of the Exhibition Design department, assisted by Emilia Bevilacqua. In Registration and Collections Management, we are grateful to Deanna Griffin and her team, including Julian Drake, Egle Mendoza, and Christina Stone; we also specially call out Kimberley Montgomery, who served as the lead registrar for this exhibition. In Education, we thank Sheila Pressley alongside her staff, including Emily Jennings, Andrea Martin, and Emily Stoller-Patterson. We are appreciative of Susan Klein and her staff in the Marketing and Communications department, including Miriam Newcomer and Francisco Rosas. In Development, Amanda Riley is acknowledged, alongside Kathleen Brennan, Carrie Cottini, Chloe Mecum, Katie Saunders, and Larissa Trociuk. In Information and Technology, we acknowledge the significant contributions of Rich Rice and Travis White. We are also truly grateful of Abigail Dansiger, our librarian.

This catalogue was produced by the Publications department at the Museums and overseen by Leslie Dutcher, director of Publications, with the help of Danica Michels Hodge, Jane Hyun, and Diana K. Murphy. Kathryn Shedrick mindfully edited this volume, Martin Venezky of Appetite Engineers crafted its handsome design, and Adrian Kitzinger made the detailed map that is found in its front matter. In addition to the exhibition's curators, catalogue essayists Dennis McNally, Joel Selvin, and Ben Van Meter provided enriching perspectives on the times. The publication was greatly enhanced due to the tremendous efforts of the Photo Services team, led by Sue Grinols. Randy Dodson, head photographer, created the mannequin and background photography found throughout these pages and, with Jorge Bachman, made digital photography of many of the Museums' works and incoming loans so that the objects could be reproduced here. Special thanks are extended to Jim Siegel for opening his historic Victorian home, the William Westerfeld House, for catalogue photography. We thank Tony Manzella, Rusty Sena, and their colleagues at Echelon Color for the incredible prepress work done on these images, and Joe Avery, Jeff Baker, and their colleagues at Shapco for the book's beautiful printing. We are grateful of our partnership with the University of California Press for the distribution of this book in the trade; there, we acknowledge Kim Robinson and Nadine Little in the editorial offices, and Peter Perez and Aimée Goggins in the marketing division. This catalogue is published with the assistance of the Andrew W. Mellon Foundation Endowment for Publications.

The exhibition and catalogue have benefited tremendously from the generosity of many people who graciously shared their time and knowledge with the curatorial team. Among the many individuals who have offered information, suggestions, and access to artworks are Engrid Barnett (University of Nevada, Reno), Jay Blakesberg (Jim Marshall Estate, San Francisco), Antonella Bonfanti (Canyon Cinema, San Francisco), Inez Brooks-Myers (formerly of the Oakland Museum

of California), Anna Bunting (Oakland Museum of California), Tony Casadonte (Lumière Gallery, Atlanta), Bob Comings, Renée de Cossio (Haight Street Art Center, San Francisco), Michael Cyprus, Anastasia Fink (Levi Strauss & Co., San Francisco), Jonathan Fogel, Rita Gentry (Bill Graham Memorial Foundation, Berkeley), Ed Gilbert (Anglim Gilbert Gallery, San Francisco), Herb Greene, Cicely Hansen, Judith Hill, Emi and Kimihiko Ito, Steven Kasher, Eric King, Lourdes Livingston, Nancy Lutzow, John J. Lyons, Ben Marks (Collectors Weekly and The Rock Poster Society, Oakland), Philip B. Martin (on behalf of Wolfgang's Vault, San Francisco), Peter McQuaid (Haight Street Art Center), Seth Mitter (Canyon Cinema), Teresa Mora (University of California, Santa Cruz), Tracey Panek (Levi Strauss & Co.), John-Carlos Perea (San Francisco State University), Kelsey Rudd (Bellevue Art Museum, Washington), Leonard Silverberg, Bonnie Simmons (Bill Graham Memorial Foundation), Adriane Tafoya (Oakland Museum of California), Elaine Tennant (University of California, Berkeley), Peggy Tran-Le (San Francisco Museum of Modern Art), Shannon Trimble (Anglim Gilbert Gallery), Jack von Euw (University of California, Berkeley), Gentle Wagner, and Reginald E. "Reggie" Williams.

We are grateful for the many artists and other participants in the Summer of Love whom we were able to interview in connection with our project, including Birgitta Bjerke, Joseph Buchwald, Peggy Caserta, Marna Clark, Roger Clayden, Lee Conklin, Marika Contompasis, Dottie (Dottie H. Simmons), Paula Douglas (Gretchen Fetchin), Carolyn ("Mountain Girl") Garcia, David Lance Goines, Judy Goldhaft, Bill Ham, Cicely Hansen, Fayette Hauser, Marsha Holmquist, George Hunter, Peter Kaukonen, Candace Kling, Fred Kling, Candace Lambrecht, Patrick Lofthouse, Bonnie MacLean, Elaine Mayes, Mickey McGowan, Trixie Merkin, Barbara Moore, Bill Morgan, Victor Moscoso, Denis Mosgofian, Stanley Mouse, Burray Olson, Courtenay Pollock, Peter Pynchon, Johanna Ramsey, Loren Rehbock, Helene Robertson, Rick Rodriquez, Jeanne Rose, Melody Sabatasso, Raphael (Bob) Schnepf, David Singer, Rose Solomon, Gary Spratt, Jean and Charlie Stewart, Louis Stykes, Jay Thelin, Randy Tuten, Wavy Gravy, Wes Wilson, Baron Wolman, and Susila Ziegler.

And appreciation is extended to those individuals who helped specifically with the research on the making of the posters and its textual component contained in Victoria Binder's essay in this book, including Damon Beale, Michele Derrick, Albert Lewis, Alison Luxner, Annette Manick, Patrick Murphy, Katrina Newbury, Richard Newman, and Roy Perkinson at the Museum of Fine Arts, Boston; scientists Daniel Burge, Doug Nishimura, Gregory D. Smith, and Paul Whitmore; rock poster collectors and historians Lincoln Cushing, Phil Cushway, Ben Marks, and Jim Northrup; Renée de Cossio, Ann McNamee, Roger McNamee, Peter McQuaid, Emma Roper, and Chris Shaw at the Haight Street Art Center; printers Howie Epstein, Joseph Forloney, David Lance Goines, and Grendl Lofkvist; and Drew Langsner, who provided historic consultation.

Last, but not least, we extend a general and hearty thanks to all of the artists who participated in the Summer of Love. We are honored and proud to share their cultural legacy with our audiences in San Francisco, and to celebrate the fifty-year anniversary of this extraordinary event that still resonates in our lives today.

MAX HOLLEIN

DIRECTOR AND CEO
FINE ARTS MUSEUMS OF SAN FRANCISCO

picture credits

For the fashion photography in the catalogue, all mannequin and scenic backgrounds were photographed by Randy Dodson, © Fine Arts Museums of San Francisco, and all decorative backgrounds were designed by Martin Venezky, Appetite Engineers. All two-dimensional works in the collection of the Fine Arts Museums of San Francisco were photographed by Randy Dodson and Jorge Bachman, © Fine Arts Museums of San Francisco.

DETAIL ILLUSTRATIONS

Front and back cover and pp. 10–11, 90–91, 106–107, 116–117, 130–131, 174–175, 196–197, 230–231, and 270–271: Bill Ham, *Kinetic Light Painting*, 2016–2017 (pl. 219), © Bill Ham Lights. Endpapers: Martin Venezky, Appetite Engineers; pp. 2–7, 88–89, and 294–295: Ben Van Meter, stills, 1967/2016 (pl. 238), © Ben Van Meter; pp. 8–9: Ben Van Meter, *Tom Dewitt Ditto in the Panhandle*, 1967. 35mm slide; infrared aero film. Collection of Ben Van Meter and John J. Lyons, © Ben Van Meter; pp. 14–15: Map by Adrian Kitzinger; pp. 16–17: Ben Van Meter, film stills from *S. F. Trips Festival, An Opening*, 1966 (pl. 27), © Ben Van Meter; p. 18: Police attack protesters, 1960. Photo by Bob Campbell (fig. 5), 0512292, Bob Campbell / *San Francisco Chronicle* / Polaris Images; p. 30: School bus interior, 1967. Photo by Jim Marshall (fig. 32), © Jim Marshall Photography LLC; p. 52: Helene Robertson and an employee wearing mod fashions, ca. 1970. Photo by Baron Wolman (fig. 39), © Baron Wolman Photography 2017. All rights reserved; p. 78: Janis Joplin, 1967. Photo by Baron Wolman (fig. 60), © Baron Wolman Photography 2017. All rights reserved; p. 296: Levon Mosgofian, ca. late 1970s (fig. 84), courtesy of Denis Mosgofian; and p. 314: *Ben Van Meter by Roger Hillyard & Roger Hillyard by Ben Van Meter*, 1967. Photo by Ben Van Meter and Roger Hillyard (fig. 92), © Ben Van Meter.

FIGURES

1: © Gui Mayo (de Angulo); 2–3: © Estate of Jerry Burchard; 4: © Estate of Hank Kranzler; 5: 05122992 Bob Campbell / *San Francisco Chronicle* / Polaris Images; 6: © San Francisco Tape Music Center; 7: © Erik Weber; 8: © 2016 by Steve Rees; 9: © Edmund Shea Trust; 10: © Marjorie Alette; 11: © Estate of Michael Raichoff, in Trust to Peter Albin; 12–13: © Susan Elting Hillyard; 14: © Chuck Gould; 15, 59: © Lisa Law; 16, 27: Ted Streshinsky Photographic Archive / Corbis Historical Collection / Getty Images; 17: © Bob Seidemann; 18: Library of Congress, Prints & Photographs Division, POS-MAG-.K37, no. 2 (C size) [P&P]; 19: San Francisco Mime Troupe; 20: Courtesy of the University of British Columbia Library, Uno Langmann Collection; 21: Artwork by Rick Griffin and George Hunter. © 1966, 1984, 1994 Rhino Entertainment Company. Used with permission. All rights reserved. www.familydog.com; 22, 63–64, 82–83: © Bill Graham Archives, LLC. All rights reserved; 23: Photograph by Milton H. Greene © 2017 Joshua Greene www.archiveimages.com; 24: Ralph Morse / The LIFE Premium Collection / Getty Images; 25: © 2016 Robert Rauschenberg Foundation. All rights reserved; 26: © Stanley Mouse and the Estate of Alton Kelley; 28: Steve Schapiro / Corbis Premium Historical / Getty Images; 29: © Conner Family Trust, San Francisco / Artists Rights Society (ARS), New York; 30: © Ben Van Meter / Courtesy Bonhams Auctioneers; 31, 33: © Elaine Mayes; 32, 52, 56–57: © Jim Marshall Photography LLC; 34: © Copyright Johnson & Johnson Services, Inc. 1997–2017 / Neutrogena®; 35: 05343881 Joe Rosenthal / *San Francisco Chronicle* / Polaris Images; 36: Courtesy of *Amica*; 37: Courtesy of Cicely Hanson; 38: © Lloyd Johnson; 39–40, 43, 60: © Baron Wolman Photography 2017 All rights reserved; 41: © David Keller; 42: Archive Photos / Getty Images; 44: Courtesy of the *San Francisco Chronicle*; 45: Printed in *Creating Body Coverings*, by Jean Ray Laury and Joyce Aiken (1974); 46–47: © John Bagley; 48–49: Rosie McGee / rosiemcgee.com; 50: © Karl Ferris; 51: © Lennart Osbeck; 53: © Berry Oliver; 54: © Bob Campbell; 58: © Fred Roth; 62: Diagram by Victoria Binder; 65–66: © Victor Moscoso; 67–68: Artwork by Robert Fried. © 1966, 1984, 1994 Rhino Entertainment Company. Used with permission. All rights reserved. www.familydog.com; 69: © Jack Hatfield; 70–71, 85: Artwork by Stanley Mouse and Alton Kelley. © 1966, 1984, 1994 Rhino Entertainment Company. Used with permission. All rights reserved. www.familydog.com; 73–75: Artwork by Wes Wilson. © 1966, 1984, 1994 Rhino Entertainment Company. Used with permission. All rights reserved. www.familydog.com; 76–77: © Rick Griffin; 78–81: © Bob Schnepf; 84: Courtesy Denis Mosgofian; 86, 88: Artwork by Victor Moscoso. © 1966, 1984, 1994 Rhino Entertainment Company. Used with permission. All rights reserved. www.familydog.com; 87: © 2017 The Josef and Anni Albers Foundation / Artists Rights Society (ARS), New York; 89: PANTONE® and other Pantone trademarks are the property of Pantone LLC. PANTONE Colors may not match PANTONE-identified standards; and 90–93: © Ben Van Meter.

PLATES

1, 213–214: © Marian Clayden Inc.; 2, 22, 116: © Conner Family Trust, San Francisco / Artists Rights Society (ARS), New York; 3: © Earl Crabb and Rick Shubb; 4, 24–26, 40–42, 53, 124, 128: © Wolfgang's Vault, Courtesy of the Bancroft Library, University of California, Berkeley; 5–6: © Michael Bowen; 11, 27, 238: © Ben Van Meter; 12, 143, 153, 184–186, 188–191, 207: Artwork by Stanley Mouse and Alton Kelley. © 1966, 1984, 1994 Rhino Entertainment Company. Used with permission. All rights reserved. www.familydog.com; 13, 216–217, 233–234: Artwork by Wes Wilson. © 1966, 1984, 1994 Rhino Entertainment Company. Used with permission. All rights reserved. www.familydog.com; 14, 325: © Stanley Mouse and the Estate of Alton Kelley; 15, 144, 150–152, 157–160, 162, 168, 175, 178–181, 183, 197–198, 200, 210, 220, 231–232, 235, 239, 242, 246, 248–249, 253–255, 257–258, 260–261, 334: © Bill Graham Archives, LLC. All rights reserved; 17, 142, 145, 165, 167, 182, 208, 218, 251: Artwork by Victor Moscoso. © 1966, 1984, 1994 Rhino Entertainment Company. Used with permission. All rights reserved. www.familydog.com; 18, 55, 67, 77, 107, 123, 326, 329–331: Courtesy Special Collections, University Library, University of California, Santa Cruz. Pirkle Jones and Ruth-Marion Baruch Photographs; 19, 23, 29, 170: © Wes Wilson; 20–21: Courtesy of the *San Francisco Examiner*; 28: © Paul Foster; 33, 240: © Allen Turk; 35: © Paul Foster / Courtesy Bonhams Auctioneers; 37, 112: © Stanley Mouse, the Estate of Alton Kelley, and Michael Bowen; 38: © Michael Bowen; 39, 88, 113: © Rick Griffin; 44–45, 130–132: © The Communication Company; 46: © Spring Mobilization Committee and Kenneth Patchen; 47, 119, 148: © Bob Schnepf; 50–52, 54, 56, 58, 64, 68, 70, 73–74, 76, 78–79, 83–84, 273–274: © Elaine Mayes; 57, 65, 105: Collection of the artist. © Leland Rice. All rights reserved; 66, 69, 267–271: © Herb Greene; 71: © Fayette Hauser; 72, 80, 272: © Bob Seidemann; 75, 133, 275, 295–296, 314: © Jim Marshall Photography LLC; 81: © Chris Braga; 82: © Randy Salas; 89, 163–164, 166, 243–244: © Victor Moscoso; 90: © Loren Rehbock; 104: Collection of the artist. © John Spence Weir; 108: © Hap Smith; 109: © George Tsongas and John Brownson; 111: © Gabriel Katz; 114: © Mark Devries and Hetty McGee MacLise; 115: Hetty McGee MacLise; 117: Robert Branaman; 118: Steve Schafer; 125: © Tad Hunter; 126: © Rick Griffin, Stanley Mouse, and the Estate of Alton Kelley; 134: © David Hodges; 146: Artwork by Joe Gomez. © 1966, 1984, 1994 Rhino Entertainment Company. Used with permission. All rights reserved. www.familydog.com; 147: © Robert Crumb; 149: Artwork by Rick Griffin. © 1966, 1984, 1994 Rhino Entertainment Company. Used with permission. All rights reserved. www.familydog.com; 154–155, 203, 209: © Walter Medeiros / Sätty Estate; 156: Artwork by William Henry. © 1966, 1984, 1994 Rhino Entertainment Company. Used with permission. All rights reserved. www.familydog.com; 161: Artwork by Dottie. © 1966, 1984, 1994 Rhino Entertainment Company. Used with permission. All rights reserved. www.familydog.com; 169: Artwork by Robert Fried. © 1966, 1984, 1994 Rhino Entertainment Company. Used with permission. All rights reserved. www.familydog.com; 171: Artwork by Bob Schnepf and Thomas Weir. © 1966, 1984, 1994 Rhino Entertainment Company. Used with permission. All rights reserved. www.familydog.com; 172: Artwork by Rick Griffin and Victor Moscoso. © 1966, 1984, 1994 Rhino Entertainment Company. Used with permission. All rights reserved. www.familydog.com; 173: © 1966, 1984, 1994 Rhino Entertainment Company. Used with permission. All rights reserved. www.familydog.com; 174: © Lichtenwalner; 176: © Edmund Shea; 177: Artwork by Paul Kagan. © 1966, 1984, 1994 Rhino Entertainment Company. Used with permission. All rights reserved. www.familydog.com; 187: Artwork by David Warren. © 1966, 1984, 1994 Rhino Entertainment Company. Used with permission. All rights reserved. www.familydog.com; 211: © The Jess Collins Trust and used by permission; 212: Courtesy Lawrence Jordan and Canyon Cinema; 215: Artwork by Larry Stark. © 1966, 1984, 1994 Rhino Entertainment Company. Used with permission. All rights reserved. www.familydog.com; 219: © Bill Ham Lights; 223: Courtesy of the Estate of Scott Bartlett, Canyon Cinema, and Berkeley Art Museum and Pacific Film Archive; 224: © Estate of Bob Fried; 226, 236: © Michael Ferguson; 227: © Estate of Alton Kelley and Ami Magill; 228: © Ray Andersen; 229: © Estate of Alton Kelley; 230: Artwork by George Hunter. © 1966, 1984, 1994 Rhino Entertainment Company. Used with permission. All rights reserved. www.familydog.com; 237: © Jon Adams; 241: © Rick Shubb; 245: © Soot Productions; 250: © Tom Wilkes; 252: © Jack Hatfield; 256: Artwork by Victor Moscoso and Wes Wilson. © 1966, 1984, 1994 Rhino Entertainment Company. Used with permission. All rights reserved. www.familydog.com; 259: © Dave Brown; 262: © 2015 Christie's Images Limited; 264: © Rick Griffin and the Estate of Alton Kelley; 265: © Larry Miller; 266: © Greg Irons; 278, 281, 283: Courtesy of Vangard Records, a division of Concord Music Group, Inc.; 292: © Courtenay Pollock; 307: © Joan Baez; 308: © Stanley Mouse; 313: © Mari Tepper; 317: © Rupert Garcia; 318: Artwork by Stanley Mouse. © 1966, 1984, 1994 Rhino Entertainment Company. Used with permission. All rights reserved. www.familydog.com; 319: © SP / 4 Vietnam; 327–328, 332–333: Courtesy the artist and Steven Kasher Gallery, New York; and 358: © Stewart Brand.

contributors

JILL D'ALESSANDRO is the curator of costume and textile arts, The Caroline and H. McCoy Jones Department of Textile Arts, Fine Arts Museums of San Francisco. Her recent publications include *Pulp Fashion* (2011) and *Lines on the Horizon: Native American Art from the Weisel Family Collection* (2013).

COLLEEN TERRY is an assistant curator, Achenbach Foundation for Graphic Arts, Fine Arts Museums of San Francisco. She is the author of *Artful Animals* (2013), and has contributed to such catalogues as *Jewel City: Art from San Francisco's Panama-Pacific International Exposition* (2015) and *Ed Ruscha and the Great American West* (2016).

VICTORIA BINDER is an associate paper conservator, Fine Arts Museums of San Francisco. She has published articles in numerous art conservation journals.

DENNIS MCNALLY is a cultural historian who specializes in the bohemian fringes of American culture. His previous books include *Desolate Angel* (1979), *A Long Strange Trip: The Inside History of the Grateful Dead* (2001), and *On Highway 61: Music, Race, and the Evolution of Cultural Freedom* (2014).

JOEL SELVIN is a writer who has covered pop music for the *San Francisco Chronicle* since 1970. He has authored fourteen books, including *Altamont: The Rolling Stones, the Hells Angels, and the Inside Story of Rock's Darkest Day* (2016).

BEN VAN METER is a photographer, filmmaker, and light show artist. He taught at the San Francisco Art Institute, and, with John J. Lyons, has written a photographic memoir *Rebirth of a Nation*.

Published by the Fine Arts Museums of San Francisco and the University of California Press on the occasion of the exhibition *The Summer of Love Experience: Art, Fashion, and Rock and Roll* at the de Young, San Francisco, from April 8 through August 20, 2017.

This exhibition is organized by the Fine Arts Museums of San Francisco.

Presenting Sponsor
Anonymous, in honor of Max Hollein

President's Circle
Lisa and Douglas Goldman Fund
Diane B. Wilsey

Benefactor's Circle
Nion McEvoy and Leslie Berriman
Ray and Dagmar Dolby Family Fund

Patron's Circle
Levi's®
Yurie and Carl Pascarella
Edith and Joseph O. Tobin II
M.H. de Young Tobin II
The Paul L. Wattis Foundation

Additional support is provided by Nancy and Joachim Bechtle; Jack Calhoun and Trent Norris; Lauren Hall and David Hearth; Debbie and Blake Jorgensen; Fred Levin and Nancy Livingston, The Shenson Foundation, in memory of Ben and A. Jess Shenson; and Dorothy Saxe.

This catalogue is published with the assistance of the Andrew W. Mellon Foundation Endowment for Publications.

Every effort has been made to identify the rightful copyright holders of material not specifically commissioned for use in this publication and to secure permission, where applicable, for reuse in all such material. Credit, if any and as available, has been provided for all borrowed material either on page, on this copyright page, or in the acknowledgments or picture credits section of the book. Errors and omissions in credit citations or failure to obtain permission if required by copyright law have been either unavoidable or unintentional. The authors and the publishers welcome any information that would allow them to correct future reprints.

Copyright © 2017 Fine Arts Museums of San Francisco

Library of Congress Cataloging in Publication Control Number: 2017001923

ISBN: 978-0-520-29482-0

Published by the Fine Arts Museums of San Francisco
Golden Gate Park
50 Hagiwara Tea Garden Drive
San Francisco, CA 94118-4502
famsf.org

Leslie Dutcher, *Director of Publications*
Danica Michels Hodge, *Editor*
Jane Hyun, *Editor*
Diana K. Murphy, *Editorial Assistant*

University of California Press, one of the most distinguished university presses in the United States, enriches lives around the world by advancing scholarship in the humanities, social sciences, and natural sciences. Its activities are supported by the UC Press Foundation and by philanthropic contributions from individuals and institutions. For more information, visit www.ucpress.edu.

University of California Press
Oakland, California

Edited by Kathryn Shedrick
Designed and typeset by Martin Venezky, Appetite Engineers
Proofread by Susan Richmond
Indexed by Jane Friedman
Picture research by Diana K. Murphy
Museum photography by Randy Dodson and Jorge Bachman
Mannequin and backdrop photography by Randy Dodson
Color separations by Echelon Color
Printed and bound by The Avery Group at Shapco Printing, Inc.

Cover: Detail from Bill Ham, *Kinetic Light Painting*, 2016–2017 (PL. 219), © Bill Ham Lights

All other image credits may be found in the picture credits section of this book.

Sources for quotations and titles:
p. 2: Joan Baez, quoted in "Artist, Activist, Catalyst," Bruce Mason, *Common Ground*, January 7, 2014.
p. 4: Theodore Roszak, *The Making of a Counter Culture* (Berkeley: UC Press, 1968), 9.
p. 6: Marshall McLuhan, quoted in "Baby It Will Be Cool," George Dusheck, *San Francisco Examiner*, January 9, 1966.
p. 79: "If you're going to San Francisco," is a lyric from The Mamas & the Papas' song "San Francisco (Be Sure to Wear Flowers in Your Hair)," written by John Phillips in early 1967.
p. 90: Allen Ginsberg in "The Avant Garde," *Firing Line with William F. Buckley Jr.*, taped on May 7, 1968.
p. 91: "(Sittin' on) The Dock of the Bay" is the title of a song written by Otis Redding and Steve Cropper in 1967; Redding wrote the first verse of the song while staying on a houseboat on the San Francisco Bay in Sausalito not long after performing at the Monterey International Pop Festival.
p. 106: Message written and projected by Ken Kesey at the Trips Festival at Longshoremen's Hall in San Francisco on January 23, 1966, as reported in Carol Brightman, *Sweet Chaos: The Grateful Dead's American Adventure* (New York: Pocket Books, 1998), 21.
p. 107: "A Trip Without a Ticket" is the title of a manifesto written by Peter Berg and published by the Diggers in the winter of 1966/1967.
p. 116: Mike Mahoney, "Good Hippies' Summer Plans," *San Francisco Chronicle*, April 6, 1967.
p. 130: Jerry Garcia in "The Hippie Temptation," a CBS News special hosted by Harry Reasoner, which aired on August 22, 1967.
p. 174: Herbert Gold, "Pop Goes the Poster," *Saturday Evening Post*, March 23, 1968, 34.
p. 196: *Time*, April 7, 1967.
p. 197: "Feed Your Head" is a lyric from Jefferson Airplane's "White Rabbit," written by Grace Slick in the winter of 1965/1966.
p. 230: Plato, *Republic*, as quoted by Ralph J. Gleason in a review of the Bay Area music scene, *San Francisco Chronicle*, May 3, 1967.
p. 231: "The Music Never Stopped" is the title of a 1975 Grateful Dead song, with lyrics by John Perry Barlow and music by Bob Weir.
p. 270: Lenore Kandel, quoted in Leonard Wolf, ed., *Voices from the Love Generation* (Boston: Little, Brown, 1968), 30.
p. 271: "What are we fighting for?" is a lyric from Country Joe and the Fish's "I-Feel-Like-I'm-Fixin'-to-Die Rag," written by Country Joe McDonald in 1965.

San Francisco sites featured in the background photographs in the catalogue: pp. 98, 202–203, 207: William Westerfeld House at 1198 Fulton Street; pp. 123, 210: Golden Gate Park; pp. 128–129: Hippie Hill, Golden Gate Park; p. 140: Clayton Street at Haight Street; pp. 146–147: Panhandle; p. 201: corner of Haight Street and Ashbury Street; and p. 205: Jefferson Airplane Mansion at 2400 Fulton Street.